THE HALL

THE OFFICIAL 75TH ANNIVERSARY BOOK

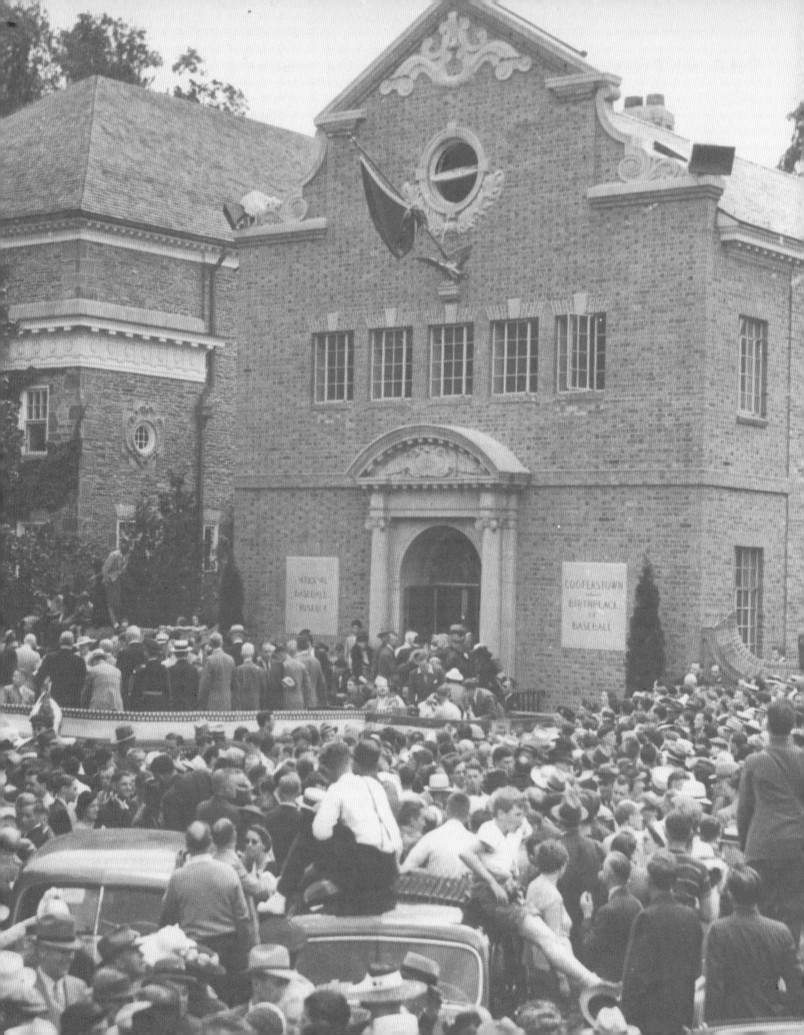

THE NATIONAL BASEBALL HALL OF FAME AND MUSEUM

THE HALL

A CELEBRATION OF BASEBALL'S GREATS

IN STORIES AND IMAGES,
THE COMPLETE ROSTER OF INDUCTEES

Exclusive Essays by

Hank Aaron, George Brett, Orlando Cepeda, Carlton Fisk, Tommy Lasorda,
Joe Morgan, Jim Rice, Cal Ripken Jr., Nolan Ryan, and Robin Yount

FOREWORD BY TOM BROKAW

LITTLE, BROWN AND COMPANY

NEW YORK BOSTON LONDON

Little, Brown and Company
Hachette Book Group
237 Park Avenue, New York, NY 10017
littlebrown.com

First Edition: May 2014

Little, Brown and Company is a division of Hachette Book Group, Inc.
The Little, Brown name and logo are trademarks of Hachette Book Group, Inc.

The publisher is not responsible for websites (or their content)
that are not owned by the publisher.

Images courtesy of the National Baseball Hall of Fame Library,
Cooperstown, New York.
The endpapers are of the National Baseball Hall of Fame Gallery.
The image on page ii is of crowds gathering outside the Museum on June 12, 1939.
The Hall of Fame was dedicated that day.

ISBN 978-0-316-21302-8
Library of Congress Control Number 2013956786

10 9 8 7 6 5 4 3 2 1

SC

Designed by Patrick Ciano and Jean Wilcox, Wilcox Design

Printed in China

This book is dedicated to the nearly sixteen million baseball fans who have made the journey to Cooperstown to visit the National Baseball Hall of Fame and Museum since it first opened on June 12, 1939.

CONTENTS

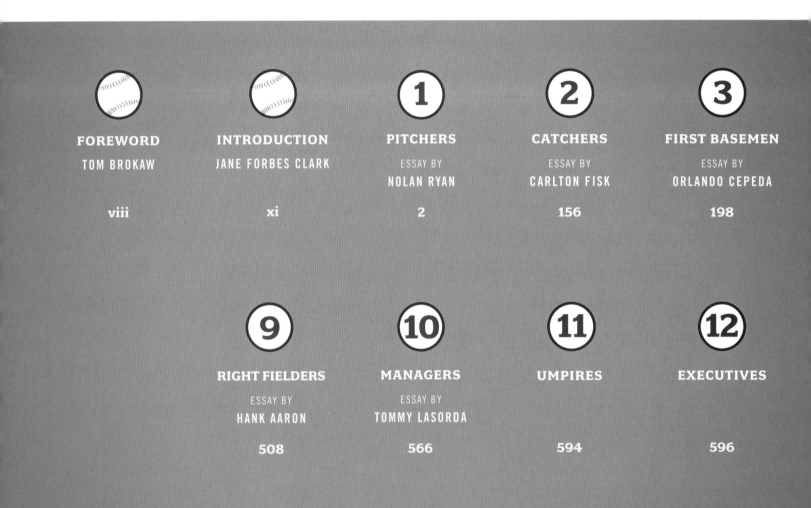

FOREWORD
TOM BROKAW

viii

INTRODUCTION
JANE FORBES CLARK

xi

1 PITCHERS
ESSAY BY
NOLAN RYAN

2

2 CATCHERS
ESSAY BY
CARLTON FISK

156

3 FIRST BASEMEN
ESSAY BY
ORLANDO CEPEDA

198

9 RIGHT FIELDERS
ESSAY BY
HANK AARON

508

10 MANAGERS
ESSAY BY
TOMMY LASORDA

566

11 UMPIRES

594

12 EXECUTIVES

596

4

SECOND BASEMEN

ESSAY BY
JOE MORGAN

250

5

THIRD BASEMEN

ESSAY BY
GEORGE BRETT

300

6

SHORTSTOPS

ESSAY BY
CAL RIPKEN JR.

342

7

LEFT FIELDERS

ESSAY BY
JIM RICE

398

8

CENTER FIELDERS

ESSAY BY
ROBIN YOUNT

450

ACKNOWLEDGMENTS

602

CREDITS

603

INDEX

604

ABOUT THE
HALL OF FAME

612

FOREWORD BY TOM BROKAW

Somewhere in the Americas, a young man is in a backyard, bat in hand, checking his cuts, making sure the wrists roll over and the legs provide the power. Or he is rehearsing the overhand motion with two fingers tucked along the baseball seam, trying to release just as his body pushes off the rubber.

Then he looks around, stands on a small rise, and rehearses the speech he will give one day. His speech at the National Baseball Hall of Fame in Cooperstown, New York, that monument to the game and the men who played it at levels beyond the ability ordinary mortals can achieve.

The Hall of Fame is also something beyond that honorable calling of game, players, and supporting cast.

It occupies a central role in the American idea of an immigrant nation constantly evolving as a society of different origins; of rules that govern the strongest as well as the weakest player; of loyalties to teams that can be momentarily tempered in appreciation of the great player in the other colors.

To get into the Hall of Fame as a player is hard, very hard; the career must be long, consistent, and bold in that most cherished standard for baseball worthiness: the stats. If you don't have the numbers, you don't get in.

The original organizers sent a message with their first class in 1936: Tyrus "Ty" Cobb, the Georgia Peach with the spikes up and the bat on the ball; Walter "Big Train" Johnson, a pitcher so dominant his record of 3,509 strikeouts held up for more than fifty years; John "Honus" Wagner, a coal miner's son who left the mines for the new game spreading across America and within a few years was one of its biggest stars, a power-hitting shortstop for the Pittsburgh Pirates who, for fifteen consecutive seasons, hit .300 or better.

Another pitcher (the most represented position in the Hall) was in that first class: Christopher "Christy" Mathewson, a college man, a rarity in the early city streets and country-boy origins of baseball. Mathewson's career as a pitcher for the Giants is best summed up by two stats: in the era of the so-called dead ball, he had a 2.13 ERA over seventeen seasons—including one in which he won thirty-seven games.

The final inductee for that first class: George Herman "Babe" Ruth, a baseball player, yes, but more than that, a legend of such outsized proportions in life and death there is little I can add to his stats or story. He was in his day the best-known American in the world. He loved the game and played it at the highest levels, first as a pitcher and then as a hitter. To this day the name Babe Ruth is at once mythical, and yet we feel as if he walks among us still.

So that was the standard in 1936 for this new shrine to the game and the best who played it. Cooperstown was chosen in the mistaken belief that baseball was first played in that picturesque town nestled between the foothills of the Catskill and Adirondack mountains, about an hour's drive west of Albany, New York.

Never mind the historic hiccup. I believe shrines should have bucolic settings and connections to that which they honor. Cooperstown, by its location and size, pays tribute to a game and players who came of age in rural America, largely working-class young men with the right physiology and determination to dominate a game that quickly became our National Pastime.

Selecting that first class, small and so elite, the organizers sent a message that remains: This is the baseball shrine. It is our national game, attracting presidents for the first pitch, movie stars who shrink in the presence of our stars, ballparks filled with the moneyed and the barely making it, side by side in their loyalty to the home team.

This is the Hall of Fame.

There will be others, in all the major sports and even in business, broadcasting, bowling, door-to-door sales, whatever a promoter can dream up.

But there's really only one founding Hall of Fame, and you'll find it in Cooperstown. The first visit is probably a fan's pilgrimage to a favorite player. It quickly becomes a walk through America: the early days of the immigrant-family stars from the German and Welsh coalfields, the Polish and Italian neighborhoods. The Irish city kids and the first Jewish superstar. Farm boys with big hands and sinewy backs.

When so many of them interrupted their careers to fight in World War II, they came home to a different country and a game that was ready to let African American ballplayers take their place in the show. Branch Rickey knew, for many reasons, it was time to bring a Negro Leagues player to the majors, and the man he chose was destined to become a historic figure from the moment he pulled on a Dodgers uniform.

Jackie Robinson, number 42 on his uniform, number one in the historic break through baseball's color line.

As a lifelong Robinson fan—for his skills as a player and for his values as a man—I confess I wept as I stood in front of his bronze plaque in Cooperstown. I also realized he was inducted in 1962, and a full year later Alabama governor George Wallace was standing in the schoolhouse door, promising "segregation forever."

Rickey and eventually all of baseball knew better—years earlier. Baseball was more than a game. It was a social force that fulfilled the promise of the American ideal.

Robinson, of course, was just the first, followed by the long roster of black superstars and those who had been stranded in the old Negro Leagues.

Then new names began to appear on the Hall roster: Marichal, Aparicio, Cepeda, Méndez, as the game moved deeper into the Americas and the Latin stars of little-known barrios found their place in major league All-Star Games and MVP voting.

How long before we read the names of Asian players who have crossed the Pacific and taken their place in the everyday lineup, determined to get into Cooperstown?

In this book you'll revisit the glory that made each Hall of Famer a member of sport's most cherished club. You'll also hear fresh perspectives of the chosen as they reflect anew on the honor that will never diminish.

You will be reminded that baseball, as the late commissioner Bart Giamatti once put it, is a game "designed to break your heart. [It] begins in the spring, when everything else begins again, and it blossoms in the summer, filling the afternoons and evenings, and then as soon as the chill rains come, it stops and leaves you to face the fall alone."

Giamatti's eloquent melancholy, expressed as only a Renaissance scholar and true fan could, has an antidote.

The stories of the men who loved a game, played it so we could share their joy and remember their breathtaking plays—these are the stories that get you through the lonely fall and see that you don't face the winter alone.

INTRODUCTION

Since June 12, 1939, when the first four classes of Baseball Hall of Fame members were honored, every summer the newest inductees are welcomed into the Hall of Fame family, the most exclusive club in all of sports.

When the bronze plaque documenting an individual's career achievements is installed in the Hall of Fame Gallery, the culmination of a lifetime of baseball excellence is finally recognized for all future generations to witness.

Earning election to the National Baseball Hall of Fame is the top honor for those who have played, managed, umpired, or served as executives in our great National Pastime.

The roster is reserved simply for the best: those who have excelled at the highest level throughout their career and have done so with character, integrity, and sportsmanship.

At the time of this writing, only three hundred individuals have earned a bronze plaque in Cooperstown. There is no honor like it anywhere else in the sports world.

My grandfather Stephen C. Clark had the vision to honor baseball's greatest moments and greatest heroes by founding the National Baseball Hall of Fame and Museum.

The first five electees were chosen in 1936. The tradition of welcoming the newest members to the Hall of Fame coincided with the opening of our Museum in 1939 and has continued since, becoming the highlight of the summer baseball calendar.

Within these pages you will find the stories of the members of the National Baseball Hall of Fame. They are major league players; they are Negro Leagues stars. Umpires, managers, executives—they too are honored for being the best at their craft.

You will find not only biographies of players and managers in the Baseball Hall of Fame but also extended essays by ten Hall of Fame legends, talking about their careers, the people who influenced their lives in baseball, their position, and what earning baseball's highest honor means.

The Hall of Fame members. They are in a class by themselves.

The release of this unprecedented collection of stories and biographies celebrates our 75th Anniversary and our commitment that the National Baseball Hall of Fame and Museum preserve history, honor excellence, and connect generations.

We are looking forward to seeing you in Cooperstown!

Jane Forbes Clark
Chairman of the Board
National Baseball Hall of Fame and Museum

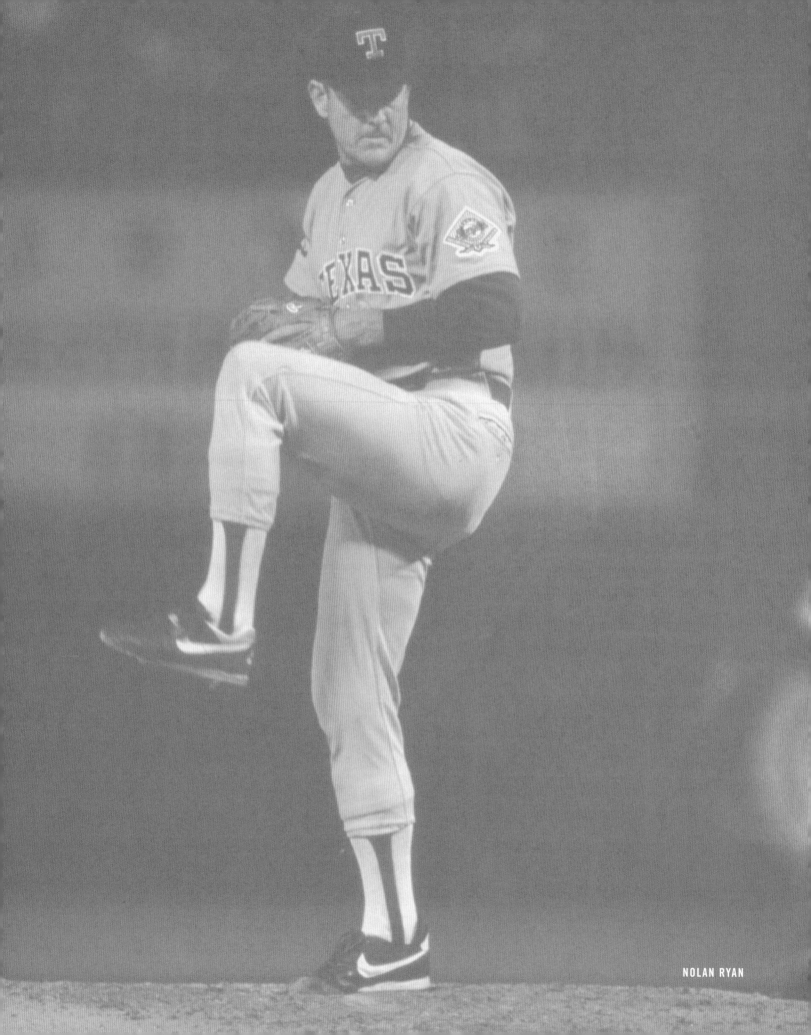
NOLAN RYAN

PITCHERS

PITCHERS BY NOLAN RYAN

During a remarkable career that lasted twenty-seven seasons and spanned four decades, flamethrower Nolan Ryan established fifty-three Major League Baseball records. Among them: most strikeouts in a career (5,714) and a modern-era record 383 in a season. "The Ryan Express" also threw a record seven no-hitters, including one against Toronto in 1991 at age forty-four. Ryan became the first player to have his number retired by three teams—the California Angels, the Houston Astros, and the Texas Rangers. His influence on the game and pitching continues to be felt today.

People are surprised to hear this, but when I was a kid, I wasn't this dominating, take-your-breath-away pitcher. I wasn't one of those phenoms you see who wow everybody at an early age by striking out seventeen, eighteen guys a game and throwing no-hitters every other start. I can assure you that no one was calling me "The Ryan Express" way back then. In fact, I didn't really throw any harder than other kids my age. I could always throw a ball farther than most, but not harder. Then I had this growth spurt during my sophomore year of high school, and all of a sudden it was like I had been struck by a lightning bolt. It was like someone had screwed a new right arm into my shoulder socket, and the baseball started coming out of my hand like a rocket being launched. I must have picked up a good twenty, thirty miles per hour on my fastball. I certainly didn't have an explanation for this other than the growth spurt, and being blessed. I felt like I had been given a gift.

I tried out for the varsity team at Alvin (Texas) High School my sophomore year, just hoping to make the team, and I wound up becoming our number two guy behind a senior pitcher, who was a very accomplished high school player. I was pretty wild in those days. I was still learning how to harness my gift, and it would be several years into my big league career before I finally got a handle on it and started making that transformation from thrower to pitcher.

Like millions of other boys growing up in the 1950s, early '60s, I followed Mickey Mantle and the Yankees. I also took a liking to Hank Aaron and those Milwaukee Braves World Series teams in '57 and '58. After I started to become really interested in pitching and started being able to throw hard, I gravitated toward Sandy Koufax. He became my favorite player because he was the most dominating pitcher of that time, maybe even of any time. I was just thrilled to see what he was accomplishing, and maybe in the back of my mind I was dreaming a little that one day that could be me.

My high school coach at Alvin was a guy named Jim Watson, who also was the school's football coach. Football was his true passion, but he worked hard at learning as much as he could about baseball. He made sure we were in great physical condition and he preached toughness. He also taught us how to play the game the right way and how to respect the game. Always hustle, always be thinking about what you were supposed to be doing next, whether you were on the mound, at the plate, or in the field—that's the stuff I learned from him.

Alvin was a pretty small town, tucked away in a rural region about twenty miles southeast of Houston. There were a lot of ranches in the area, a lot of good, hardworking people. It was a great place to grow up, and I continued to make it my home even after I made it to the big

leagues because I felt very comfortable there, and my wife, Ruth, and I thought it would be a great place to raise our family. I was the sixth and final child of Lynn Nolan Ryan Sr. and Martha Lee Hancock Ryan. Everybody knows me as Nolan, but I actually was named after my father, so my real first name is Lynn. You can stump a lot of people with that trivia question. I grew up doing things that most kids from that era and that area did. We played cowboys and Indians, climbed trees, and played whatever sport was in season—football in the fall, basketball in the winter, and baseball in the spring and summer. I would tag along with my older brother and his friends when they went to play pickup games at the ball diamond at a nearby school. They would stick me in right field or whatever position they needed me to fill. Those games against the older boys obviously had an impact on me, as far as sports were concerned. In those days, TV was just becoming popular, but there weren't sports on 24/7 the way there is today. So, basically, your exposure to sports was either through participation on the local level or what you read in the newspapers.

Through the years, much has been made about my work ethic, and when I look back, I owe a lot of that to my parents, especially my dad. He worked full-time as a supervisor for the old Stanton Oil Company. In addition to my older brother, I had four sisters, and to put them through college, my dad took on an extra job, delivering the *Houston Post* newspaper in Alvin and the rural areas beyond. His distribution route was about forty-five miles long, and he had 1,500 customers. It took a good four hours to complete each delivery, even longer if the weather was bad. And he would make those deliveries every morning, 365 days a year. It reminded me of being a dairy farmer, because cows have to be milked every day—including Christmas and Thanksgiving—and newspapers have to be delivered every day, too. There were no holidays with either endeavor; no days off. People depended on that paper, the same way those cows depended on being milked. My brother helped out, and when I was a first-grader, Dad added me to the workforce. At about one in the morning, the papers would be dropped off at a service station in the old part of Alvin, and I'd start rolling and bundling up those newspapers so they could be tossed onto stoops or tucked into those rural roadside mailboxes and newspaper holders. My dad finally gave up that route when I graduated from high school. By that time he had put each of my sisters through college. And he had taught me and my brother some valuable lessons about hard work.

I worked other odd jobs growing up. We lived in a wooden house, and because the blistering south Texas summers took their toll on that wood, we'd have to paint it every other year. I did my share of scraping and painting. I'd also pick up extra money mowing lawns, and I once worked on a survey crew.

Another thing I did was raise cattle. I started doing that when I was about eight years old. I rented a pasture from the local VFW at the rodeo grounds. I'd buy day-old dairy calves and get them started, get them up to about four hundred pounds, and then sell them. Once I got enough money, I bought a commercial beef heifer. By the time I was in the seventh grade, I had about seven or eight heifers, but I had to sell them because I was beginning to play more sports and I didn't have the time to do both. But I always had it in the back of my mind that one day I would get involved in the cattle business, and baseball afforded me that opportunity. I got back into it around 1973, when I bought a bunch of heifers, and it really took off from there, to the point

where we were ranching about 27,000 acres and running about eighteen hundred mama cows and about four hundred or five hundred heifers and steers. I've always enjoyed escaping to the ranch, especially in the offseason. I'd hop on one of my horses and go riding around. It was a great way to clear my mind. I learned how to round up cattle. I knew how to bulldog a steer. Some people have joked that my bulldogging skills came in handy years later when Robin Ventura charged the mound to fight me and I got him into that headlock. I suppose there's some truth to that. I can tell you this: getting a ballplayer into a headlock is a lot easier than getting one of those big ole steers into a headlock.

Another boyhood dream that I didn't pursue was becoming a veterinarian. I had considered it as a career path early on because of my interest in cows and horses and other animals. I think I could have become a good vet, but it was probably questionable whether I would have been smart enough to be accepted to veterinary school.

I'd say basketball was my second-favorite sport behind baseball, and I was decent at it. I liked it so much that I actually contemplated trying to land a college scholarship in hoops. I could shoot it pretty well—then again, everybody thinks they can shoot. Fortunately my pitching skills wound up overshadowing my basketball skills, because, quite frankly, I wasn't going to make a career out of playing basketball.

As I said, I wound up having this growth spurt as a sophomore that resulted in a velocity spurt in my pitches. But even though it was apparent I was throwing harder than my peers, I had no idea what this meant as far as a career in baseball was concerned. Alvin was a small high school, and we were playing small schools in rural areas, so I had no gauge as to how good I was. I figured there were a lot of guys, especially at bigger schools, who probably were throwing as fast as or even faster than me, so any dreams I had of becoming a major leaguer were just that—dreams.

But everything changed for me on April 25, 1963, thanks to a New York Mets scout by the name of John "Red" Murff, who decided to take a little detour on his way to Galveston so he could stop by a high school tournament that our team happened to be playing in. Red wasn't planning on staying long; he just wanted to thank the high school coach who was putting on the tournament, and he wanted to encourage him to keep scheduling these tournaments because they were helpful to the scouts.

While Red was there, Coach Watson summoned me in from the bullpen to pitch. Out of habit, Red pulled out his scouting notebook, and I really wowed him with my first pitch. Years later, when I was about to go into the Hall of Fame, Red told a reporter that that pitch had to be at least a hundred miles per hour and said it was the fastest pitch he had ever seen. If memory serves, I threw another pretty good heater on my second pitch, then tried to get fancy with a pretty bad curve that the batter doubled into right field. That started off a big inning for the other team—I don't even know if I got anybody out—and Coach Watson had to take me out of the game. But I guess my speed had really made an impression on Red. He waited around until after the game so he could talk to Coach. Red told him how impressed he was with me, and Coach thought his ears were playing tricks on him. Surely Red must have been talking about some other pitcher, because I had just stunk up the joint. But Red assured him it was me whose arm had caught his eye, and Coach called me over and introduced us. Red told me that he had just come from a major league

game the night before, and he said my arm was better than [any of the major leaguers' he saw that night]. I really thought he was pulling my leg. I had a tough time comprehending how a high school sophomore could be better than two veteran big league pitchers. But Red was dead serious. And I wound up seeing an awful lot of him over the next two years because he and the Mets were that interested in drafting me.

We actually have a copy of Red's scouting report on display at the Nolan Ryan Center on the Alvin Community College campus. He wrote, "This skinny high school junior has the best arm I have ever seen in my life. . . . Ryan has the potential to be a high-performance starting pitcher on a major league staff. A smiling, friendly faced kid. Wide shoulders, long arms and strong hands. Good athlete." Many years later a reporter asked him about that assessment, and Red told him, "In retrospect, I probably made the understatement of a lifetime on my report. I wrote, 'Best arm I've ever seen.' But that was pinpointing it to one person. I should have written, 'Best arm the world will ever see.'" I was flattered he would think that way, though I think there are many others who could lay claim to that "best arm the world will ever see" statement. I think you could definitely make a case for guys like Walter Johnson, Bob Feller, Sandy Koufax, Bob Gibson, Randy Johnson, and a few others. The funny thing is that Red's belief in me far exceeded my belief in myself. Never in a million years did I envision having the career I had. Heck, when I was struggling during my first few years of pro ball, I wasn't thinking Hall of Fame; I was thinking survival. My goal was to get to the big leagues and get at least four years of service in, because that's what you needed in order to qualify for a pension back then.

The bottom line is that I'll always be beholden to Red, because who knows what might have happened had he not taken that detour that day? I was just one of many diamonds in the rough he discovered. I think he had signed at least four guys on that 1969 Miracle Mets team, including me, catcher Jerry Grote, and pitcher Jerry Koosman. That's pretty amazing when you think about it. Four guys on a World Series championship team signed by the same scout. Red and I remained good friends through the years. I was so glad he lived long enough to be there for my induction ceremony and share in my day because he's the guy who helped me get it all launched.

My velocity continued to increase during the remainder of my junior year and throughout my senior year. I wound up pitching a no-hitter and establishing a national high school record by striking out twenty-one batters in a seven-inning game. But I wasn't polished like David Clyde, the Texas phenom who had something like six or seven no-hitters during his senior year of high school before jumping directly to the big leagues. I had wild spells where I had trouble finding the strike zone, and sometimes my ball would get away and hit a batter. My combination of speed and wildness struck fear into some of my opponents. I was told there were kids who would beg out of the lineup against me because they were afraid of being hit. I threw so hard that by the end of the season the kid who caught me had no feeling in the first two digits of his [glove] hand. I think my control problems coupled with the fact I played at a small school probably contributed to my lasting until the twelfth round of the 1965 draft. The Mets gave me a $12,000 signing bonus and shipped me off to their Appalachian League team in Marion, Virginia, where I made $500 a month. I was both excited and scared. I think I had been out of the state of Texas only twice in my life. So I had been pretty sheltered up to that point. I really had no idea what I was getting into. I had

no concept of whether I belonged or not. I was coming out of a small rural high school. I left for Marion feeling completely overwhelmed. But once I arrived there, I found out that a lot of the other kids on that rookie league team were in the same boat I was. So there was some comfort knowing most of my teammates were as green as I was.

My fastball allowed me to dominate at times. I struck out 115 batters in just seventy-eight innings that season. But I continued to have control problems, walking fifty-six guys. I made twelve starts and finished with a 3–6 record and a 4.38 earned run average. All in all, it was a good debut season. In 1966 the Mets sent me to their Class A team in Greenville, South Carolina, and I totally dominated. I struck out 272 batters in 183 innings, and although I continued to walk too many guys (127), I posted a 17–2 record and a 2.51 earned run average. That earned me a late-season promotion to the Mets, and I wound up appearing in two games. In three innings I struck out six, walked three, and gave up five earned runs—including a homer to Joe Torre. But it was a huge, huge thrill to put on a big league uniform as a nineteen-year-old kid.

The structure of organized baseball was a lot different back then. What people don't realize is that we didn't have any pitching coaches working with us at the minor league level. Shoot, I didn't have a pitching coach until I was promoted to the Mets and began working with Harvey Haddix. And I didn't have any managers in the minors who had been pitchers, so you and your teammates were kind of on your own to figure things out. My pitching coaches wound up being my teammates. You'd observe your teammates and they would observe you and then you would talk with one another and exchange information.

After the successes I had enjoyed in Greenville and during my brief stint with the Mets, I was expecting big things in 1967, but an arm injury and my Army Reserve obligations restricted me to a total of just four games—one with Winter Haven of the Florida State League and three with Jacksonville in the International League. Fortunately, I bounced back in spring training the following February and March and wound up making the Mets roster. I started eighteen games for New York that season, striking out 133 batters in 134 innings, and going 6–9. The Mets organization had put a heavy emphasis on drafting and developing hard-throwing pitchers, and our [organization] was loaded with live arms. We had Tom Seaver, Jerry Koosman, Gary Gentry, and myself. Each of us could really bring it. And there were other guys who threw just as hard as us. I remember two kids in the organization back then, in particular, who had tremendous fastballs but never made it. Both suffered arm injuries. Who knows what kind of careers they might have had. It's strange how those things work out.

I learned an awful lot just by watching Seaver go about his business. Tom was just out of the University of Southern California, so he was much more polished than I was. He was very professional, very disciplined, very focused about his work. He taught me, just by his actions, that I needed to develop a strategy for my career, a game plan for how to achieve my goals.

In 1969 I went 6–3 with ninety-two strikeouts and fifty-three walks in eighty-nine innings, but I made fewer starts, and pitched fifteen games out of the bullpen. I was still having control issues—as I would throughout my five seasons with the Mets. A lot of that was because I still hadn't ironed out deficiencies in my delivery. And some of it was that my Army Reserve duty prevented me from developing the routine and rhythm you need as a starting pitcher. I'm certainly not complaining.

I love my country and realize the sacrifices I made were nothing compared to the soldiers who were risking life and limb in Vietnam. Every other weekend I had to fly back to Houston for my reserve meetings, and I also was obligated to spend two weeks each summer at reserves camp. I'm just saying that those interruptions prevented me from pitching on a regular basis, and that certainly didn't help me solve my control issues.

Although I was disappointed with my overall performance in 1969, I was thrilled to be a part of the Amazing Mets' drive to the National League Pennant and World Series title against the heavily favored Baltimore Orioles. In the NLCS against the Atlanta Braves, I threw seven innings of relief in Game 3 to pick up the win. Then, in Game 3 of the World Series, I pitched 2⅓ shutout innings to pick up a save that gave us a two-games-to-one lead. Some people think that was the pivotal game of the Series. If we had lost that game, the Orioles might have regained their swagger and we might have begun questioning ourselves. But we wound up winning and then took the next two. It was incredible to be a part of that Mets team. Just seven years earlier, they had been an expansion franchise and the laughingstock of baseball, with just 40 wins and 120 losses. But they had undergone a dramatic turnaround, and they did so during the era before free agency, when there weren't any quick fixes. They took a very smart approach. They did so by stockpiling good young arms and building their teams through pitching.

I was hoping to become a bigger contributor the next season, but my struggles continued. I went 7–11 in 1970, and after a 10–14 record the following season, in which I walked 116 batters in 152 innings, the Mets traded me and three other players to the California Angels in exchange for shortstop Jim Fregosi. (Ironically, Fregosi would later manage me, and we would joke occasionally about how we were both involved in a trade that many Mets fans regard as the worst in franchise history. He was a good sport about it. He had been a heck of a shortstop and a good manager.) A lot of people thought I wanted out of New York, but that wasn't true at all. We had a great pitching staff, and I figured the Mets had the foundation to be good for a long time. I was disappointed because I felt like I could still turn it around and become a staple in that rotation along with Seaver and Koosman. So at the time, I felt a little betrayed and disappointed by the organization. In hindsight, though, they did me a huge favor by trading me to an organization that was rebuilding and would be able to let me pitch on a regular basis. The other thing about the timing of the trade is that it coincided with the completion of my Army Reserve obligations. So for the first time in my major league career, I'd be able to spend an entire season with my team and see if I could finally work out those control problems that had hamstrung me my first five seasons in the big leagues. The other thing that helped me right away in California was my work with pitching coach Tom Morgan. He was able to identify a lot of the things I had been doing wrong and help me correct them. Tom got me to stop rushing my pitches. He understood my delivery and helped me develop a sequence where I became more consistent with each pitch.

That 1972 season clearly was a turning point in my career. I wound up going 19–16 with a 2.28 earned run average. I threw a major-league-best nine shutouts and also led baseball with 329 strikeouts in just 284 innings. Yes, I still had problems with my control on occasion—I did lead the league in walks with 157—but I had really begun to make the transition from flamethrower to pitcher and had learned how to retain my cool and work my way out of jams. I surpassed twenty

wins in each of the next two seasons, and in 1973 I also set a modern-era record for most strike-outs in a season with 383 to break the record of my pitching idol Sandy Koufax.

That season also would be special because I threw the first two no-hitters of my career—one against Kansas City and one against Detroit. I would wind up with a record seven no-hitters, including my final one in 1991 against the Toronto Blue Jays at age forty-four. I'm really proud of that record. I don't want to sound greedy, but I could have had several more had I caught a break here or there, because in addition to the seven no-hitters, I threw twelve one-hitters and nineteen two-hitters—and I had five or six no-hitters broken up in the ninth inning. I remember a game against the Yankees—I induced Thurman Munson to pop up in the first inning and our shortstop and second baseman called each other off and watched the ball drop for what would be the only hit of the game. Another time I went into the ninth with a no-hitter against the White Sox, and Dick Allen hit a little bounder down to our third baseman and he couldn't get the ball out of his glove and it wound up being a bang-bang play at first and Dick was called safe. We wound up losing that game 2–1 in the ninth. Funny how all these years later, this old pitcher remembers things like that. I guess you never forget the ones that get away.

The one versus Toronto is probably the one people remember most because guys that age weren't supposed to even be playing, let alone blowing ninety-nine-mile-per-hour fastballs by guys young enough to be their sons. That may have been the most dominating game of my career. I had sixteen strikeouts that night and just two walks. I recall heading into that game feeling like I was sixty-four instead of forty-four. My back, head, Achilles tendon, and middle finger on my throwing hand were all ailing that night. Come to think of it, I also wasn't 100 percent when I pitched some of my other no-hitters. My back was throbbing before my sixth one, in 1990, against Oakland. And before I threw my first no-hitter, against Kansas City, way back in 1973, my stuff was so bad in my pregame bullpen session that I told our pitching coach to get somebody warming up right away because I wasn't going to last long that night. I don't know why I was able to pitch some of my best games when I was ailing like that. Maybe it's just a case of when things aren't right, it causes you to be more focused.

I was very blessed that the aging process didn't affect me as early as it did some people. And I was able to stay away from the career-crippling-type injury. I think part of it was really placing an emphasis on my conditioning and nutrition about midway through my career. I was fortunate to work with the Astros' Gene Coleman. He was one of the first strength and conditioning coaches in baseball, and he got me to go to the weight room to do exercises that were specific to pitching. I owe a lot to him and to my pitching coach Tom House. They definitely helped lengthen my career. I also think the development of an effective changeup aided me. On those nights when my fastball wasn't quite there, it would still look fast because of the contrast with the changeup. Of course, a huge part of my longevity was a result of being blessed with the type of arm that allowed me to be a power pitcher to the very end of my career. I also believe being able to spend the second half of my career in the Lone Star State, pitching for the Astros and then the Rangers, helped extend my career because it kept me near Ruth and the kids. And that was extremely important to me.

I still can't fathom that I was able to pitch twenty-seven seasons in the big leagues. Being around that long allowed me to set quite a few records. People ask me if I have a record that I'm most proud of, and I tell them I can't really choose just one because each milestone means something different to me. Clearly, I'm very proud of the fact I struck out close to six thousand batters in my career because I was a power pitcher, and I just loved that one-on-one competition between me and the batter. To me, that battle is still the best duel in all of sports. I enjoyed challenging the big boys, the sluggers. And I fared well against most of them. Power hitters like Reggie Jackson, Mark McGwire, and Dave Winfield usually didn't adjust their swings to the count. They went up there with the intent of hitting one of your pitches into the next county. That was their mind-set, and they weren't going to change it. The guys I had the most trouble with were the left-handed contact hitters that didn't swing at bad pitches. They would work the count, take pitches. The George Bretts, Tony Gwynns, Rod Carews, Pete Roses, and Don Mattinglys of the world were the guys who gave me problems. Of course, they gave just about every pitcher problems.

My work as [an executive] has given me a firsthand view of how much pitching has changed— and, in my opinion, not necessarily for the better. I've made known my views about pitch counts and the issue of coddling pitchers. Some people are obsessed with pitch counts these days. A pitcher hits a hundred pitches and people start acting as if the guy's arm is about to fall off. We're aware of pitch counts, but we believe you can't just throw some arbitrary number out there, because every individual is different.

When I played, a "quality start" was a complete game in which you gave up fewer than three runs. That was my goal. I was going to try to go all nine. Nowadays, we're looking at six innings and three runs or fewer. I think we are beginning to see a change in how pitchers are handled. They are being allowed to pitch deeper into games. A lot of the changes to pitching in the past few decades have been a result of baseball trying to get more offense into the game, and I under-stand that. The mound's been lowered, the strike zone has shrunk, pitchers are less prone to pitch inside, and the ballpark dimensions have gotten smaller—so there's less foul territory and the outfield fences are much closer to home plate than they used to be. I believe the advances in conditioning, nutrition, and sports medicine also have impacted pitching—for the better. Like I said, weight lifting and eating right helped lengthen my career. When I came up, lifting was taboo. It was supposed to make your arm tight and muscle-bound. The strides we've made with Tommy John surgery have been amazing. Eighty-five to 90 percent of these guys who develop elbow problems are able to come back to where they were prior to the injury. In my day, if you suffered that type of injury, you either tried to pitch through the pain or you retired.

Back in 1987, Dr. Frank Jobe told me I had a tear in my elbow and suggested surgery. I was forty at the time, the surgery wasn't as advanced as it is now, and I figured I was nearing the end of my career. So I decided against the surgery and went home and did my best to rest it and do any rehab or strengthening exercises I could. Not only was I blessed to be able to pitch for another six seasons, but I was able to do so as a power pitcher right to the very end.

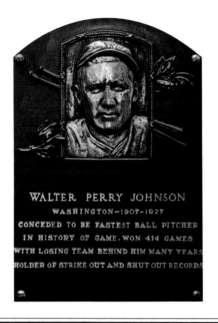

WALTER PERRY JOHNSON
WASHINGTON—1907–1927
CONCEDED TO BE FASTEST BALL PITCHER
IN HISTORY OF GAME. WON 414 GAMES
WITH LOSING TEAM BEHIND HIM MANY YEARS
HOLDER OF STRIKE OUT AND SHUT OUT RECORDS

WALTER JOHNSON

CLASS OF 1936

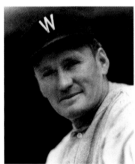

They called him "Big Train," and it seemed as if Walter Johnson could throw a fastball as fast as a freight train moved. Ty Cobb called him "the most threatening sight I ever saw on a ball field." Johnson won an incredible 417 games.

Johnson's favorite win didn't even count among those victories because it came in the 1924 World Series, when he got the triumph working in relief against the New York Giants. He had been in the sport for years and had accomplished so much, but his Washington Senators were losers most of the time despite his talents.

"It didn't look as if I'd ever see it come around," Johnson said of being part of a championship team. "After all, I was 36 years old and that's pretty far gone to be walking into the last game of a Series, especially when you couldn't blame people for remembering I'd lost two starts already." He won that seventh game, though.

What is almost never recalled about the phenomenal hurler's accomplishments—he was one of the first players elected to the new Hall of Fame when voting began in 1936, though the Hall didn't open until 1939—is that Johnson actually signed a contract with the upstart Federal League to jump teams. He had already established his greatness and wanted more money than Senators owner Clark Griffith wanted to give him. But then Johnson changed his mind and stuck with Washington.

Confusing the public mightily, Johnson actually wrote a bylined first-person story for *Baseball Magazine* to explain his thought process. "From the first I was always impressed with the Federal League," Johnson said. "They looked to me like a game crowd and I admired their courage. I think my attitude toward Washington was always clear. I have repeatedly said that I would play for Washington for less salary than I would anywhere else. I have proved that statement by doing exactly that thing." Johnson ended up returning a bonus paid to him by the Federal League and playing for the Senators for $7,500 less annually.

One year on Washington's Birthday, Johnson proved that people may not have been lying when they said that the first president tossed a silver dollar across the Rappahannock River. Before a crowd of six thousand, Johnson emulated the throw of 272 feet and then repeated it. Before accomplishing the feat, Johnson said the distance "looks like two miles to me."

On the occasion of his fiftieth birthday, friends in Maryland, where he lived, threw a major shindig to honor him. Johnson shocked the crowd when, dressed up formally, he got up to speak and said, "I cannot honestly say this is the happiest moment of my life." He paused. "The happiest moment of my life will be when I have finished my talk and have sat down again."

Johnson played for Washington for twenty-one years but died a relatively young man from a brain tumor at fifty-nine. Griffith called him "the greatest pitcher of all time."

—L.F.

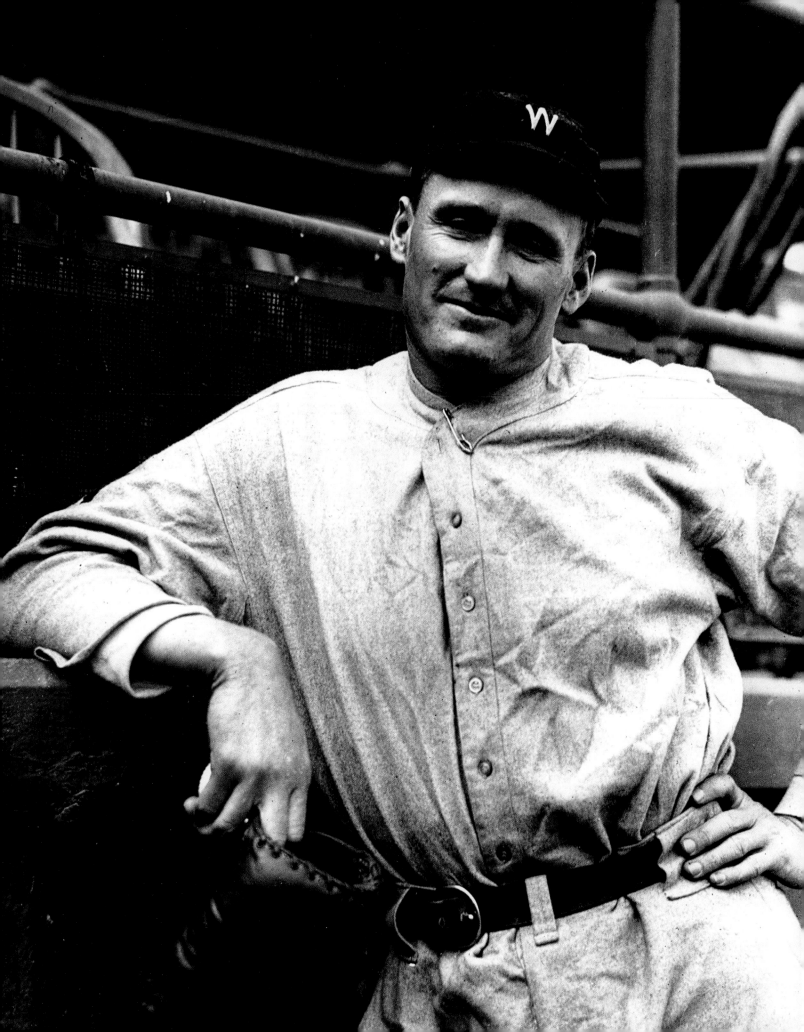

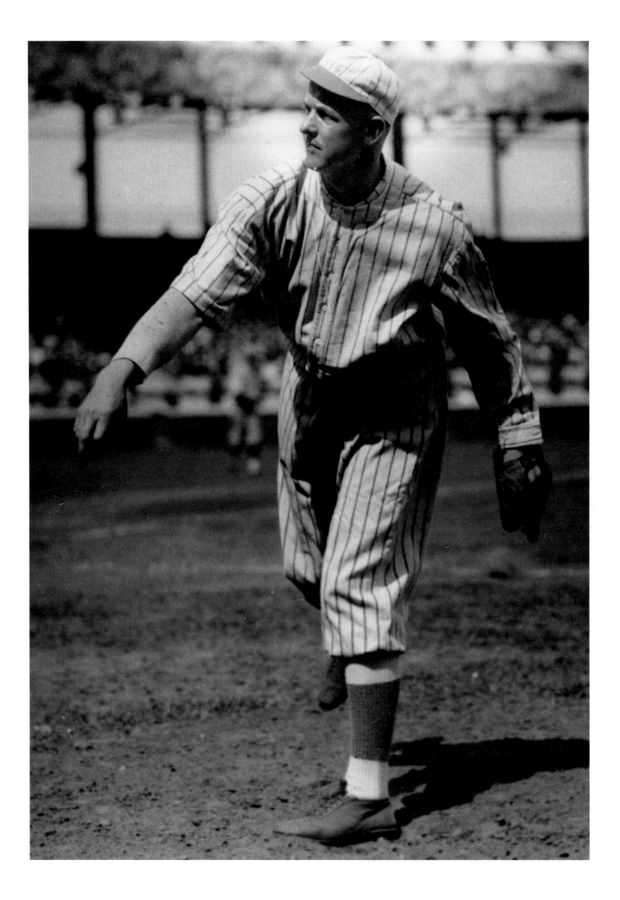

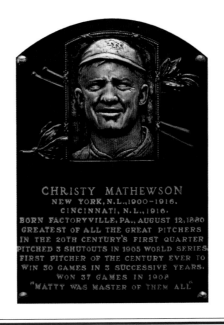

CHRISTY MATHEWSON
NEW YORK, N.L., 1900-1916.
CINCINNATI, N.L., 1916.
BORN FACTORYVILLE, PA., AUGUST 12, 1880
GREATEST OF ALL THE GREAT PITCHERS
IN THE 20TH CENTURY'S FIRST QUARTER
PITCHED 3 SHUTOUTS IN 1905 WORLD SERIES.
FIRST PITCHER OF THE CENTURY EVER TO
WIN 30 GAMES IN 3 SUCCESSIVE YEARS.
WON 37 GAMES IN 1908
"MATTY WAS MASTER OF THEM ALL"

CHRISTY MATHEWSON

CLASS OF 1936

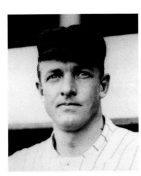

Chosen as a member of the first Hall of Fame class, the New York Giants' Christy Mathewson will always garner support as possibly the best pitcher of all time on the basis of his 373 victories, his winning at least twenty games in a season thirteen times, and his 2.13 earned run average.

Connie Mack, owner-manager of the Philadelphia Athletics who saw Mathewson in three World Series contests, said, "Christy Mathewson was the greatest pitcher who ever lived. He had knowledge, judgment, perfect control and form. It was wonderful to watch him pitch when he wasn't pitching against you."

A great of a future era was boggled by the statistics listed next to the right-hander's name in the record books. "There aren't a lot of people around anymore who can tell you what it was like to see him pitch, but the numbers Christy Mathewson left behind are staggering," said three-hundred-game winner Tom Seaver. "They're not even something you can calculate in your mind. That's how good he was."

Mathewson was born in Factoryville, Pennsylvania, attended Bucknell University, where he also played football, and was as popular as any player in the sport during his prime, while being regarded as a gentleman. He served during World War I and died at only forty-five, of tuberculosis. Mathewson had an unsullied reputation. He was religious enough that he refused to play ball on Sundays.

While blessed with more talent than most, when asked what it took to be a successful pitcher, Mathewson was self-effacing. "First, control," he said. "Second, knowledge, and third, ability. And through it all is the great factor of luck."

Mathewson occasionally penned magazine articles aimed at boys hoping to become ballplayers and also wrote several books, including *Pitching in a Pinch*. Mathewson said that when he was about eight years old he came under the influence of a cousin who had him throwing stones, and that built up his arm. "I got to be a great stone thrower," Mathewson said, "and this practice increased my throwing power and taught me something about curves. When I was nine years old I could throw a stone farther than any of the boys who were my chums."

Mathewson's real exposure to baseball came a little bit later, when he became the batboy for his hometown's adult team. "This Factoryville nine was composed of grown men and it was not uncommon for small-town men to wear whiskers in those days," he said. "Many of the players, too, were really fat men. But boy-like, I felt very important in being connected with this pretentious looking club."

The opportunity to play on his first team came when Mathewson was twelve, but he was stuck in right field. He got his pitching break with the Factoryville team at fourteen, when the regular starter took ill and the backup was out of town. He impressed with his workout and got the start. "That, I am sure," Mathewson said, "was the very proudest day of my life."

—L.F.

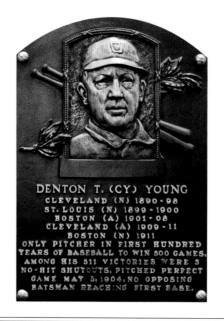

CY YOUNG

CLASS OF 1937

No pitcher in the history of baseball won more games—511 in total—than Cy Young.

In his twenty-two-year career, the durable right-hander was unmatched when it came to excellence and consistency. Young won thirty-plus games five times and topped twenty wins in a season an astounding fifteen times.

One of baseball's first hard throwers, Young broke in when the pitcher threw only fifty feet from home plate. That prompted his catcher, Chief Zimmer, to put a piece of thin steak inside his mitt to cushion the force of Young's throws.

Unlike many fireballers, though, Young exhibited pinpoint control and always sought to add another pitch to his repertoire.

"I had excellent control, throwing with four different deliveries and wheeling on the batter to hide the ball," he is quoted as saying in *Superstars of Baseball,* by Bob Broeg. "I saw some fast ones—Amos Rusie, Walter Johnson, Lefty Grove and [Bob] Feller, among others—but I was among them, too."

In 1901 Young enjoyed perhaps his finest season as he led the Junior Circuit in victories, strikeouts, and ERA. In 1903 he won two games in the first modern World Series to help Boston to the championship. In total, he led the American League in victories three times, and the National League once.

In putting up numbers that remain unequaled today, Young became a bridge between the game's beginning and the modern era. He was a member of the National Baseball Hall of Fame's second induction class, along with John McGraw, Nap Lajoie, Tris Speaker, George Wright, Ban Johnson, and Connie Mack, and was among the first to donate artifacts to the new Museum in Cooperstown.

"[He] had by far the best control records of his time," statistician Bill James once wrote, "leading the majors in fewest walks per nine innings many times, beginning in 1893 and not ending until 1901."

Later in his career, when his fastball had lost some velocity, Young also became known for a sharp-breaking curveball. "He had a fastball, a curve and a spitter that almost hypnotized the batter," Connie Mack said.

Although Young finished his career with the most innings ever pitched at the big league level (7,356), he admittedly wasn't much for long warm-ups. "I never warmed up 10, 15 minutes before a game like most pitchers do," he recalled after his playing days were over. "I'd loosen up three, four minutes. Five at the outside. . . . That's why I was able to work every other day."

Young added, "I figured the old arm had just so many throws in it, and there wasn't any use wasting them."

A year after Young's death, in 1956, Major League Baseball presented the first Cy Young Award for the game's top pitcher. Brooklyn's Don Newcombe was the initial winner, and originally the honor covered both leagues. Then, in 1967, the award was split between the National and American Leagues.

—T. Wendel

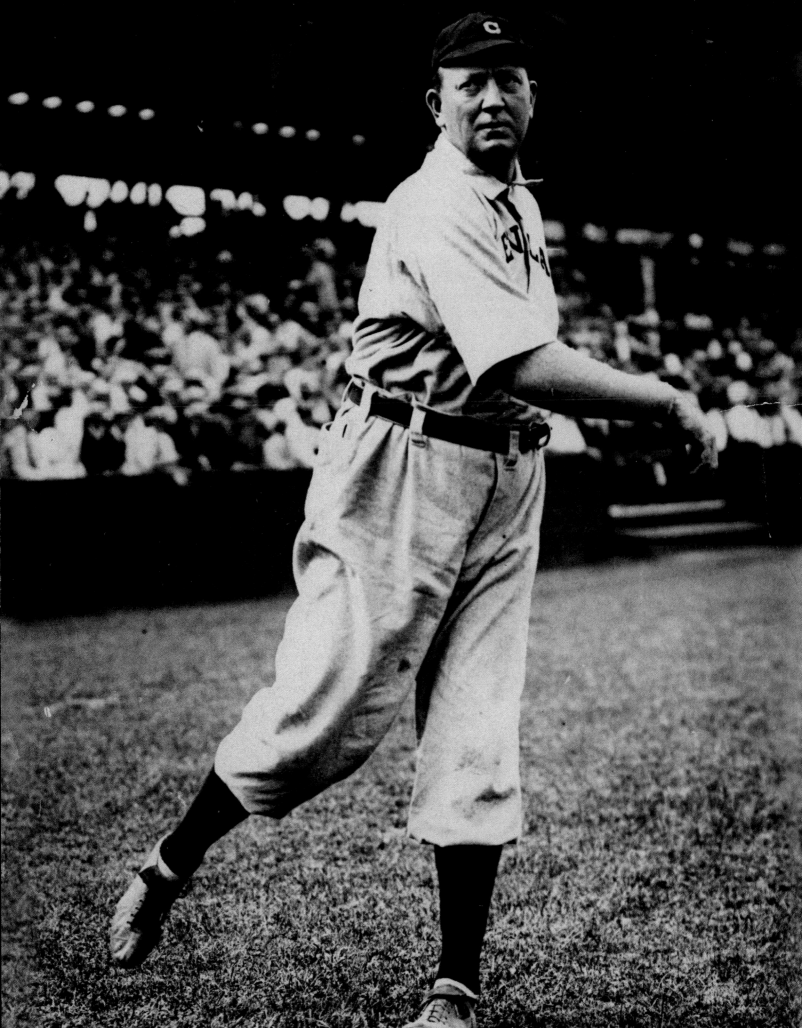

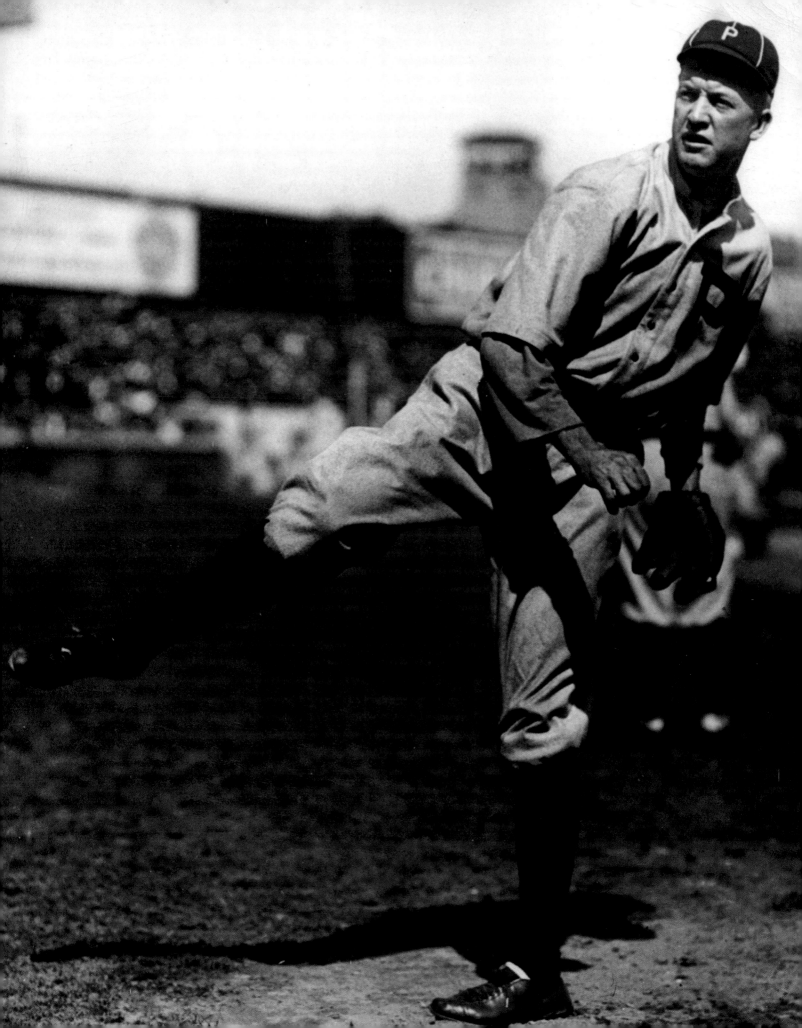

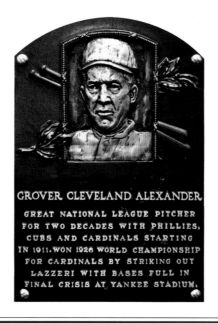

GROVER CLEVELAND ALEXANDER
GREAT NATIONAL LEAGUE PITCHER
FOR TWO DECADES WITH PHILLIES,
CUBS AND CARDINALS STARTING
IN 1911. WON 1926 WORLD CHAMPIONSHIP
FOR CARDINALS BY STRIKING OUT
LAZZERI WITH BASES FULL IN
FINAL CRISIS AT YANKEE STADIUM.

GROVER ALEXANDER

CLASS OF 1938

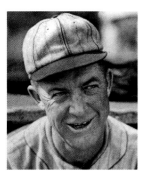

By winning a modern rookie record twenty-eight games, and 373 in all, Grover Cleveland Alexander demonstrated he was one of the greatest pitchers of all time, but when it came to making speeches, his induction speech at the Hall of Fame did not rival the Gettysburg Address.

"I'm not much on talking," the player known as "Ole' Pete" said. "Didn't do much on the farm in Nebraska and then when I got into baseball I couldn't say anything or the umpires would throw me out. I've never had much call to say anything since."

Usually, Alexander's fastball did his speaking for him with the Phillies, Cubs, and Cardinals, but once in a while a question would prompt a soliloquy. He listed some of the toughest hitters he ever faced: "One day in 1915 I was pitching for the Philadelphia Nationals against St. Louis," he said, "and had a shutout going. St. Louis has a new second baseman from Texas and he'd struck out twice. So my catcher comes out and says, 'Let's lay one in and see if the kid can hit.' I laid one in and he rammed it right back out the left line for two bases. His name was Rogers Hornsby. Well, I've pitched behind him, and outside, and inside, and over and under him, and I never did stop him from hitting. He's the worst I've ever faced."

Alexander rated Babe Ruth as the next toughest, even though he saw him only in exhibitions and the World Series. "When he hit that ball, it never came down again," Alexander said. Honus Wagner came in third. "That bowlegged, old Honus Wagner," the right-hander said. "You look at him and it looks like he can't even walk straight, but how he could hit!"

During his career Alexander had problems with alcohol, came back from service in World War I suffering from shell shock and epilepsy, and yet still played for two decades. Former major leaguer and longtime minor league executive George "Specs" Toporcer, who was around the sport for forty years, rated Walter Johnson, Christy Mathewson, and Alexander as his three top pitchers of all time, with Alexander number one. His reasoning came down to one key quality: "The ability of each of them to win ball games, games vital to the team on which they happened to be playing at the moment. From this point of view, I feel Alexander simply cannot be faulted."

Elected to the Hall of Fame in 1938, Alexander said he was curious to hear what his contemporaries would say about him. "Nearly all of them chose as the biggest moment of my career the turning back of the Yankees in that seventh inning of the World Series in 1926," Alexander noted, "when I went out there and shut out the Murderers' Row of Tony Lazzeri, Babe Ruth, Lou Gehrig, and other big bats of the New York American team to win the Series for the Cardinals. But I prize most of all the comment . . . 'Alexander was a true sportsman.'"

—L.F.

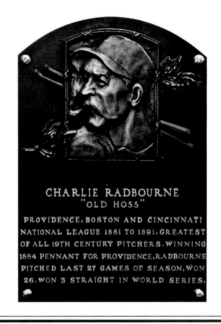

CHARLIE RADBOURNE
"OLD HOSS"
PROVIDENCE, BOSTON AND CINCINNATI
NATIONAL LEAGUE 1881 TO 1891. GREATEST
OF ALL 19TH CENTURY PITCHERS. WINNING
1884 PENNANT FOR PROVIDENCE, RADBOURNE
PITCHED LAST 27 GAMES OF SEASON, WON
26. WON 3 STRAIGHT IN WORLD SERIES.

CHARLES RADBOURN

CLASS OF 1939

Information on the plaque appears as originally cast.

Even by workhorse 1880s standards, Charles Radbourn's 1884 feats were extraordinary and came about because of unique circumstances described by Frank Bancroft, then the manager of the Providence Grays. "We had only two pitchers in those days and played a game every other day," Bancroft said. One pitcher quit the team. Desperately, the idea was advanced that Radbourn pitch 'em all. "I put the proposition up to Radbourn and he said he'd pitch his arm off to win the flag. Put it down in black and white that Old Hoss was to get two men's salary."

The alternative was to disband the team, and hearing that from Bancroft, Radbourn committed: "I'll pitch every day and win the pennant for Providence, even if it costs me my right arm." He won thirty-one games in sixty-five days, including eighteen straight, but suffered excruciating arm pain. He still managed to strike out 441 men and post a 1.38 ERA.

"What pitcher of today is the equal of Rad?" pondered Hughie Jennings when he was managing in the first decades of the twentieth century. He never answered that question.

In 1884 Hoss Radbourn won a major-league-record fifty-nine games in 678⅔ innings, a record that undoubtedly will not be broken in our lifetime. The rules of the day were different, and through 1883 pitchers were throwing underhand. In 1884 "free delivery" was first allowed, and pitchers were able to use an overhand pitch from a mound fifty feet from home, with six balls equaling a walk. Regardless of the rules, Radbourn's feat is no less remarkable.

Given the immense workload Radbourn shouldered, it is no wonder his career lasted only eleven seasons. He hung up his spikes after the 1891 season, in which he posted an 11–13 mark for Cincinnati with a 4.25 ERA in only 218 innings. After deciding that he had retired too young, Radbourn sought to make a comeback, and in 1894 he wrote a letter to the St. Louis Browns asking for a job: "I am in good condition and would like to play ball with you this season. [I] have been in training and feel as if I could play 'out of sight.'" Shortly after penning the note, Radbourn was seriously injured in a hunting accident, and his health went into decline. He never pitched again.

Hall of Famer Clark Griffith recalled, "He was brainy and game to the core; he had curves that were as baffling as any sent plateward. He had a fastball that was a marvel; a slow ball that was about as deceptive as any I have ever seen thrown. And, best of all, Radbourn had control that was absolutely marvelous. He practiced weeks, months and even years to acquire perfect handling of the baseball, and when he finally decided that he had learned his lesson he was able to place the ball in almost any spot he willed."

In his eleven seasons on the mound, Old Hoss's record totaled 309–194, with a 2.68 ERA. He was enshrined in Cooperstown in 1939 by the Old Timers Committee.

—L.F.

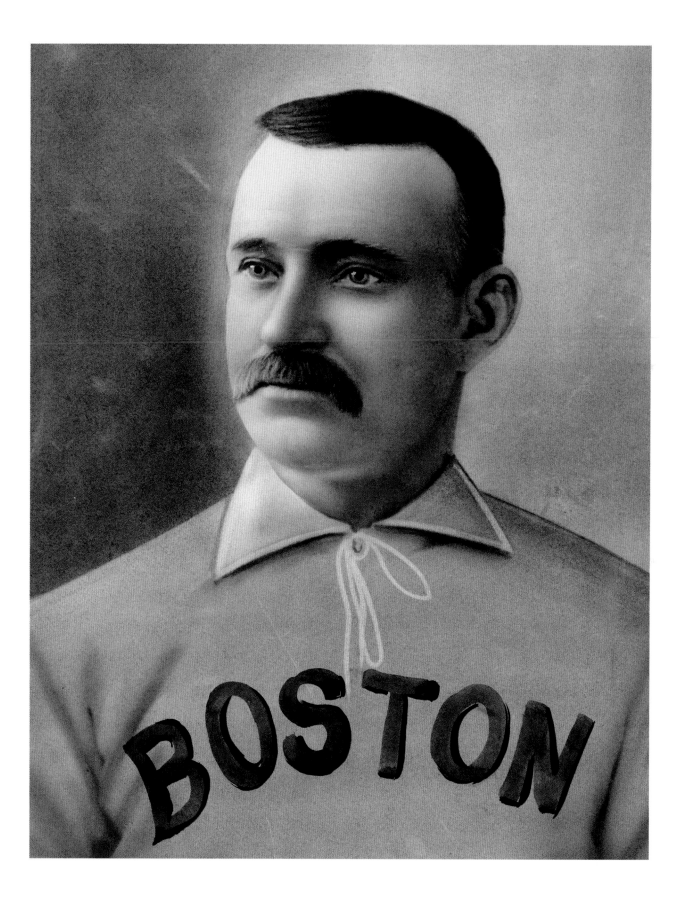

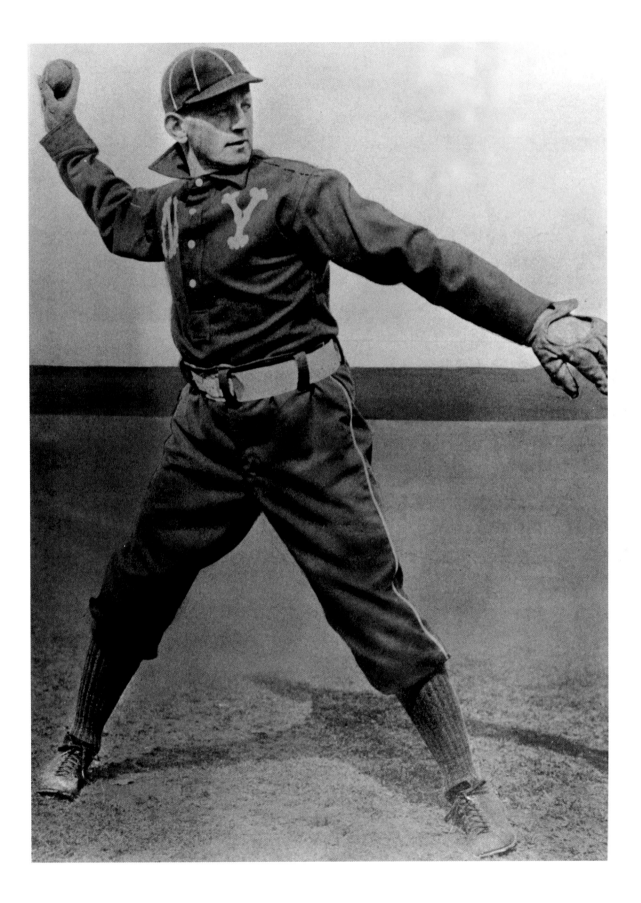

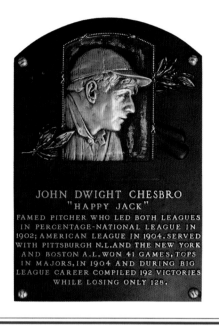

JACK CHESBRO
CLASS OF 1946

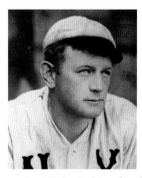

Many Hall of Famers enjoy long, storied careers. Others have brilliant peaks over a shorter time span.

For pitcher Jack Chesbro, his peak featured one of the greatest seasons ever recorded—a season that defined his career but ultimately broke the heart of the right-hander nicknamed "Happy Jack."

In 1904, pitching for the New York Highlanders, Chesbro started fifty-one games and won a modern-era (post-1900) record forty-one of them. Famous for a spitball, which he had begun throwing two seasons before while winning twenty-eight games for Pittsburgh, Chesbro kept New York in the pennant race until the last day of the season.

It was indeed a year for the ages as Chesbro pitched six shutouts, a one-hitter, and a two-hitter, and had a fourteen-game winning streak. But in the ninth inning of a must-win game against the Red Sox, Chesbro's wild pitch allowed the winning run to score. That cost New York the pennant.

"I knew we had to win that game and I was working the spitball over the outside corner," Chesbro said decades later. "The count was 2–2, and I decided to put something extra on the ball. . . . They said it was a wild pitch—I'll let it go at that."

Born in North Adams, Massachusetts, Chesbro is perhaps the only member of the National Baseball Hall of Fame who can actually claim to have played regular-season ball games in Cooperstown, New York. He pitched for a semipro team there in 1896. And that nickname, Happy Jack? Reportedly that came from the positive attitude Chesbro kept up while working in a mental hospital before his pro career took off.

Chesbro went on to become one of the few pitchers to lead both major leagues in win-loss percentage. (He posted an .824 percentage while going 28–6 with Pittsburgh in 1902 and then .774 in that remarkable 41–12 season in New York.) Chesbro claimed he could make his devastating spitball drop anywhere from a few inches to a foot and a half.

"The spitball is worked entirely by the thumb," Chesbro told the *Sporting News* in 1904. "The saliva one puts on the ball does not affect its course in any way. The saliva is put on the ball for the sole purpose of making the fingers slip off the ball first."

After suffering an ankle injury, Chesbro managed just a 10–10 record in 1907 and fell to 14–20 the following season before finishing his career with a handful of games for New York and Boston in 1909.

Major League Baseball would ban the spitball in 1920. But by then Chesbro had retired, after an eleven-year career in which he totaled 198 victories and a 2.68 earned run average.

Clark Griffith, Chesbro's former manager in New York, made him the pitching coach for the Washington Senators. After leaving baseball, he passed away in 1931.

Chesbro was elected to the Hall of Fame in 1946.

—T. Wendel

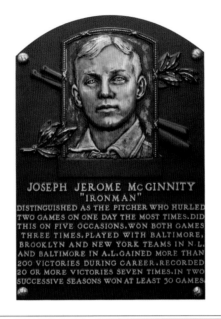

JOSEPH JEROME McGINNITY
"IRONMAN"
DISTINGUISHED AS THE PITCHER WHO HURLED
TWO GAMES ON ONE DAY THE MOST TIMES. DID
THIS ON FIVE OCCASIONS. WON BOTH GAMES
THREE TIMES. PLAYED WITH BALTIMORE,
BROOKLYN AND NEW YORK TEAMS IN N.L.
AND BALTIMORE IN A.L. GAINED MORE THAN
200 VICTORIES DURING CAREER. RECORDED
20 OR MORE VICTORIES SEVEN TIMES. IN TWO
SUCCESSIVE SEASONS WON AT LEAST 30 GAMES.

JOE McGINNITY

CLASS OF 1946

Joe McGinnity was baseball's original "Iron Man." Even though he first gained the nickname from working in a foundry during the offseason, the moniker soon came to describe the way he pitched.

Several times he started both ends of a doubleheader, and in 1903 he pulled off the feat three times in a single month, winning all six games. McGinnity was a key cog in pennant-winning teams with Brooklyn in 1900 and the New York Giants in 1905. Through it all, he never experienced a losing season at the major league level.

After ten years in the majors, playing for Baltimore, Brooklyn, and New York, he pitched in the minors until he was fifty-five, retiring with nearly five hundred wins as a professional. In fact he was still winning both ends of a doubleheader at the age of forty-five, that time around for Butte of the Northwestern League.

It wasn't until McGinnity developed a rising curveball, which he threw with a sidearm, almost underhand delivery, that the right-hander began to make his mark. McGinnity, always one for nicknames, called the pitch "Old Sal."

The Associated Press later reported that McGinnity took to throwing "Old Sal" most of the time—so much so that catchers caught him without using signs. With the pitch a part of his repertoire, McGinnity broke in with the Baltimore Orioles in 1899 at the age of twenty-eight.

The wait was well worth it, as McGinnity won a league-high twenty-eight games, and then was assigned to Brooklyn the following season, again winning a league-high twenty-eight. By 1902 McGinnity was with the New York Giants, where he teamed up with Christy Mathewson to form one of the most effective one-two pitching tandems in baseball history. That season McGinnity won thirty-one games and Mathewson thirty. The following season they combined for sixty-eight victories.

In his ten-year major league career McGinnity won 246 games, had a 2.66 ERA, and completed 314 of 381 starts. Four times he led the league in innings pitched, and in 1903 he threw an astounding 434 innings.

Manager Connie Mack of the rival Athletics simply called him a "magician," while Giants manager John McGraw said McGinnity was "the hardest working pitcher I ever had on my ballclub."

The Giants released McGinnity in early 1909, and he became a minor league team owner and manager in Newark. But he continued to put in major time on the mound, leading the Eastern League in games (55) and innings pitched (422). After winning 246 at the major league level, McGinnity won another 239 in the minors, a professional total surpassed only by Cy Young, according to the Society for American Baseball Research.

"I've pitched for 30 years and I believe I've averaged over 30 games a season," McGinnity said, "and in all my experiences I've never had what I could truthfully call a sore arm."

That's why he will always be remembered as an Iron Man.

—T. Wendel

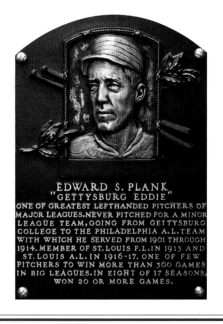

EDWARD S. PLANK
"GETTYSBURG EDDIE"
ONE OF GREATEST LEFTHANDED PITCHERS OF
MAJOR LEAGUES. NEVER PITCHED FOR A MINOR
LEAGUE TEAM, GOING FROM GETTYSBURG
COLLEGE TO THE PHILADELPHIA A.L. TEAM
WITH WHICH HE SERVED FROM 1901 THROUGH
1914. MEMBER OF ST. LOUIS F.L. IN 1915 AND
ST. LOUIS A.L. IN 1916-17. ONE OF FEW
PITCHERS TO WIN MORE THAN 300 GAMES
IN BIG LEAGUES. IN EIGHT OF 17 SEASONS,
WON 20 OR MORE GAMES.

EDDIE PLANK

CLASS OF 1946

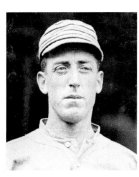

The great southpaw, who was born in Gettysburg just ten years after the end of the Civil War, used to say players teased him by suggesting he was born on the battlefield. "But they exaggerate somewhat," said Plank, the first major league left-hander to win two hundred games and then three hundred. "I admit the 1875 without trying to get away and scalp half a dozen off my age, as some of them do."

Plank, a star of the Philadelphia Athletics' 1911 and 1913 World Series championship teams, got a late start in the sport, however, and might well have been tempted to trim a few years from his true birth date. He said he grew up without any ambition to play ball, or to live anywhere but Gettysburg. "Honestly, I never even read the scores, or knew who played in the big leagues until I was 20 years old," Plank said. "Gettysburg looked big enough to me."

Plank attended Gettysburg Academy, a prep school. He is also on record talking about having pitched for Gettysburg College: "I was 25 when I began pitching for the Gettysburg college team and I was big and strong and fast, and wild and inexperienced, and everything else that goes to make up a college pitcher."

Plank was such a neophyte that, he said, "I simply shut my eyes and cut loose and most of those who didn't strike out got bases on balls, and I have suspected since that a lot of them struck out just to escape from the standing up there at the bat."

In the years before he found his way to the A's, Plank sounds much like a young Randy Johnson or Nolan Ryan.

In the majors, however, there seems to have been more appreciation for his curveball and other slower stuff than for his speed. Plank finally came to an understanding that there was more to pitching than just throwing, and he went right to the majors in 1901 with no minor league toiling.

One distinctive aspect of Plank's career, particularly given the era when he starred, was how long he took between pitches. In the early twentieth century, most pitchers wound up and fired almost as soon as their catcher tossed the ball back to them. Not Plank. He was known as the slowest worker in the American League. A headline that appeared on a story years later in *Baseball Digest,* excerpting a book written by well-known sportswriter Tom Meany, referred to Plank as "The King of Fidgets."

Plank was known to pull at his cap, fool with his belt, and move his feet around as he prepared his delivery. Such shenanigans are commonplace nowadays, but not one hundred years ago. Meany called Plank "one of the great time-consumers of his era." And a sportswriter who was a Plank contemporary said he worked so slowly it affected attendance. "No commuters would come out [if they knew Plank was pitching], because they all knew they would miss their regular trains home," Meany noted in his book.

—L.F.

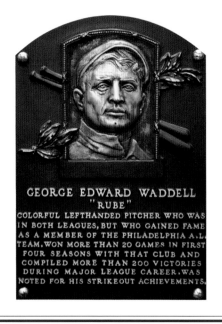

RUBE WADDELL

CLASS OF 1946

Rube Waddell could be overpowering, leading the American League in strikeouts six straight years, including notching a stunning 349 in 1904, but he was also a conversation piece because of sometimes quirky behavior.

In a career of just thirteen years and a life ended too soon at thirty-seven, partly because of alcoholism, Waddell was one of the stingiest pitchers of all time, particularly during his prime years with the Philadelphia Athletics. Waddell recorded a career earned run average of 2.16. Originally from Bradford, Pennsylvania, the fellow born George Edward Waddell picked up the nickname "Rube" because others saw him as a country bumpkin.

Winning as many as twenty-seven games in a season and posting an ERA as low as 1.48, Waddell regularly baffled teammates and manager Connie Mack with zany acts that in later decades made historians wonder if he was afflicted with mental illness, not merely clownlike eccentricities.

Sometimes Waddell sprinted from the dugout in the middle of games to chase fire trucks. Among other lighthearted habits Waddell indulged in were sneaking under the stands to play marbles with kids, occasionally repairing to the stands to sell hot dogs, working as a stand-in for a mannequin in a store window, and performing in vaudeville. There was a running joke in Philadelphia that went like this: "What are the two biggest attractions in the City of Brotherly Love and what do they have in common?" The answer was "The Liberty Bell and Rube Waddell and both are a little cracked."

Waddell was a brilliant pitcher at his best, and Mack loved him for his mound work. But the boss fretted about his popular thrower's behavior the rest of the time.

"I have seen Wild Bill This and Screwy Sam That," Mack said, "but in his heyday the Rube made them all look like amateur night. I never suffered a dull moment as long as he was on my payroll."

Waddell didn't mind returning to the small-town life once in a while, and when he visited home, he also stopped in nearby drinking establishments where he was well known. He loved the theater, springing for a batch of tickets for friends to go to the show with him. At intermission Waddell had a routine. He'd yell, "Who's the best ballplayer in the world?" The gang shouted back that Rube was the man.

Whenever Waddell was away from a ballpark, he was game to try anything suggested. Once at spring training in Florida he rode an ostrich, though it might as well have been a tricycle beneath him. Once, when he was riding in a canoe in swamp water, his hand was bitten by an alligator—not his pitching hand. A drunk Waddell once did major damage to a hotel in Detroit, and when Mack ruled he was to be fined $100 for the hotel escapade, Waddell replied, "Mack, there ain't no Hotel Escapade in Detroit."

—L.F.

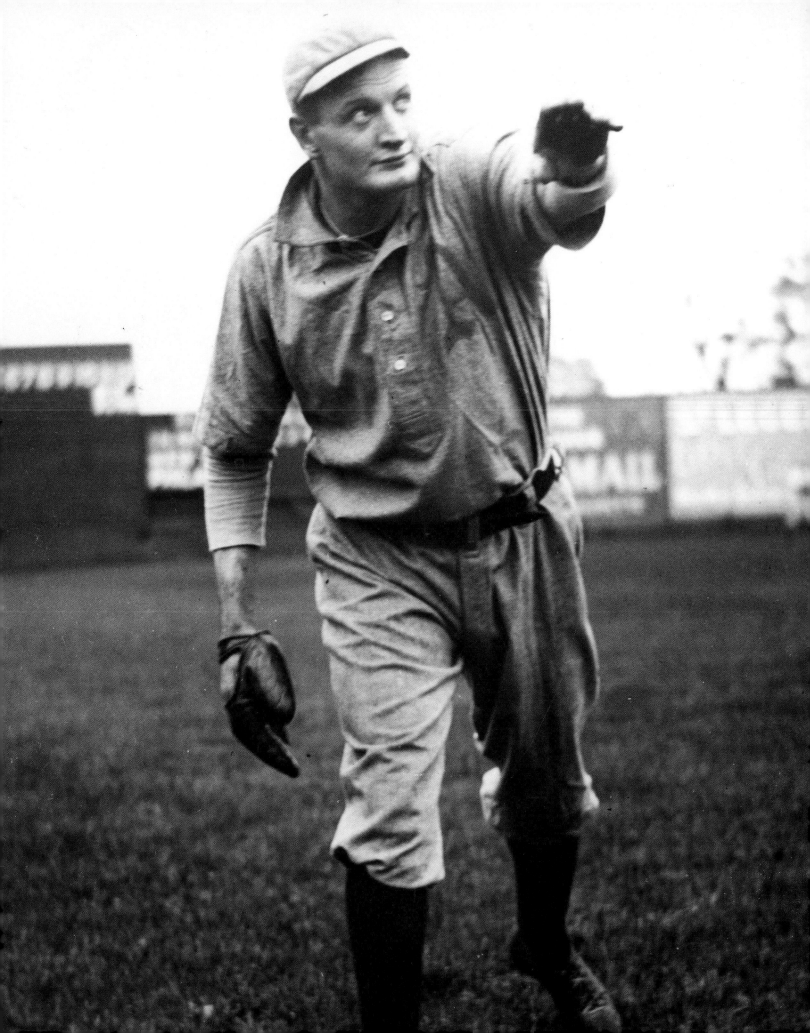

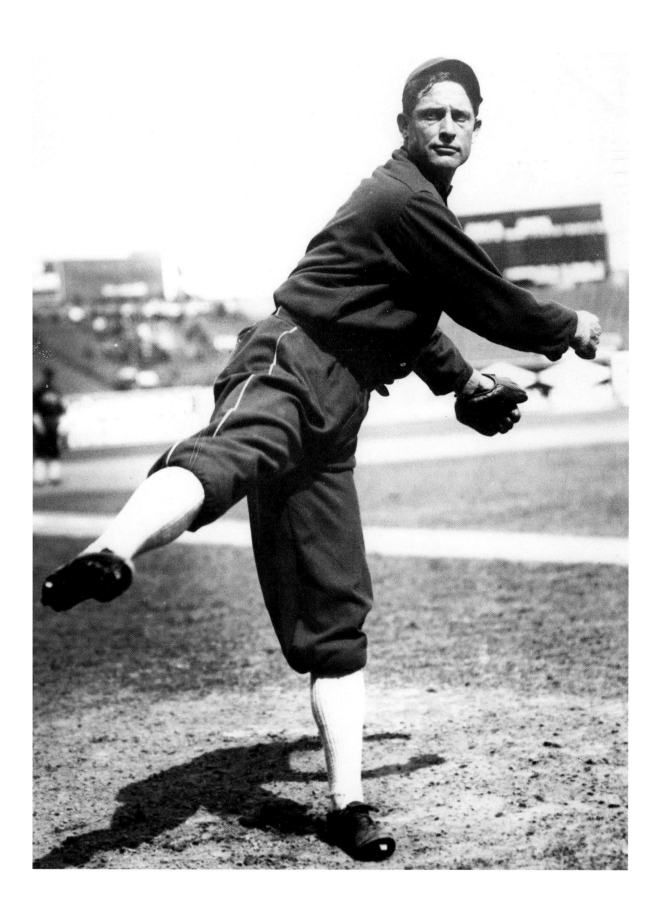

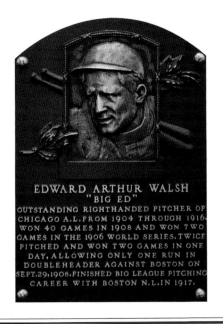

EDWARD ARTHUR WALSH
"BIG ED"
OUTSTANDING RIGHTHANDED PITCHER OF
CHICAGO A.L. FROM 1904 THROUGH 1916.
WON 40 GAMES IN 1908 AND WON TWO
GAMES IN THE 1906 WORLD SERIES. TWICE
PITCHED AND WON TWO GAMES IN ONE
DAY, ALLOWING ONLY ONE RUN IN
DOUBLEHEADER AGAINST BOSTON ON
SEPT.29,1908. FINISHED BIG LEAGUE PITCHING
CAREER WITH BOSTON N.L. IN 1917.

ED WALSH

CLASS OF 1946

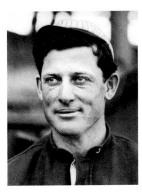

Given that Big Ed Walsh won forty games during the 1908 season by relying heavily on a ball slathered with saliva, it should have been no surprise that the former White Sox hurler defended the spitball later in life on behalf of his fellow pitchers. He thought the powers that be in baseball tilted the playing field too much in favor of batters.

"Everything else in the game favors the hitter," Walsh said. "Livelier baseballs, smaller ball parks. They've practically got the poor pitchers working in straight jackets. Those guys have a right to make a living, too. They say removing the spitter helps cut down on hit batsmen. Bah! They still allow the knuckleball and that's three times as hard to control as the spitter. They say the spitter wrecked pitchers' arms. Curveballs do that, not spitters."

The all-time earned run average leader at 1.82, Walsh usually prevailed in his one-on-one encounters with even the best hitters, but he admired some of them. "I never had any trouble with Ty [Cobb]," Walsh said. "He'd hit me. I'd stop him. He was the greatest. [Babe] Ruth was a great pitcher when he was in it. Hitting the home runs, he had it. But the greatest was Mister Ty Cobb. That's Mister Baseball for me."

Despite achievements including throwing a no-hitter, Walsh said his most special moment on the mound came in a White Sox game against the Philadelphia Athletics when he struck out Stuffy McInnis, Eddie Collins, and Frank "Home Run" Baker on nine straight pitches. "Not a foul," Walsh said. "I went in to relieve with the bases filled and none out in the ninth. Came off the bench. They didn't even get a foul off me."

Ed Walsh produced pitcher Ed Walsh Jr., too. "I want him to have a college education," father Ed said. "He's a good boy and he's entitled to the best that I can give him. He has the makings of a fine pitcher, I know that. I've taught him all I know and he'll make good." Ed Jr. played for Notre Dame, won eleven games in the majors, and died at thirty-two from a heart problem.

After he stopped pitching, Walsh, who estimated that he'd signed 1.5 million autographs during his lifetime, saw his baseball career take a very peculiar turn. American League president Ban Johnson hired Walsh as an umpire. "I have health and strength and ambition," Walsh said. "I know the game and it will be through no fault of mine if I do not justify Ban Johnson's confidence in me."

Walsh was elected to the Hall of Fame in 1946, but after being overlooked in prior elections, he developed an opinion about how voters should compare the field of candidates. "Don't judge a pitcher against an outfielder or a shortstop," Walsh said. "If I am worthy of being admitted to the Hall of Fame I think I should be judged alongside Rube Waddell, Christy Mathewson and Grover Alexander, not against Ty Cobb, Babe Ruth, or Hans Wagner."

—L.F.

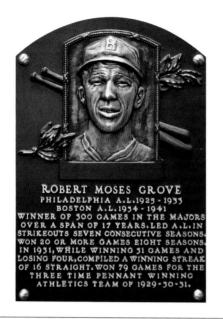

> **ROBERT MOSES GROVE**
> PHILADELPHIA A.L. 1925 - 1933
> BOSTON A.L. 1934 - 1941
> WINNER OF 300 GAMES IN THE MAJORS
> OVER A SPAN OF 17 YEARS. LED A.L. IN
> STRIKEOUTS SEVEN CONSECUTIVE SEASONS.
> WON 20 OR MORE GAMES EIGHT SEASONS.
> IN 1931, WHILE WINNING 31 GAMES AND
> LOSING FOUR, COMPILED A WINNING STREAK
> OF 16 STRAIGHT. WON 79 GAMES FOR THE
> THREE TIME PENNANT WINNING
> ATHLETICS TEAM OF 1929-30-31.

LEFTY GROVE

CLASS OF 1947

Robert Moses "Lefty" Grove is considered by many the best southpaw pitcher in baseball history. Blessed with an exceptional fastball, he dominated from the mound beginning in the late 1920s and throughout the 1930s like no other hurler in the game.

In a major league career that spanned seventeen years between the Philadelphia Athletics and the Boston Red Sox, Grove amassed exactly three hundred wins and seven consecutive strikeout crowns, while his nine ERA titles are easily the most in the sport's history.

"Lefty had a control problem early in his career," said Joe Cronin, his former teammate and manager with the Red Sox. "But even after he mastered his pitches, most hitters were plate-shy. Just to see that big guy [he was six foot three] glaring down at you from the mound was enough to frighten the daylights out of you."

Grove caught the attention of the then minor league Baltimore Orioles' owner Jack Dunn and joined his organization in 1920. Dunn refused multiple offers for Grove until 1925—after the pitcher had compiled a 108–36 career record during five seasons with the Orioles, the Athletics offered an unprecedented amount for the young left-hander.

"I couldn't believe it, either," Grove said. "But Dunn wouldn't let me go and that was it. I couldn't do anything about it. You know, when I finally reached the majors, I was 25. I should have been up at least three years earlier. I could have won 400 games."

Grove would go on to spend nine remarkable seasons with the Athletics, helping the team win three straight American League Pennants from 1929 to 1931, while compiling an astonishing 195–79 record over that span. He also earned two pitching Triple Crowns in 1930 and 1931, the latter season being named the American League's Most Valuable Player when he led the Junior Circuit in wins (31), ERA (2.06), and strikeouts (175). Grove also won sixteen straight games in 1931, tying the American League record.

"Lefty Grove didn't have a curve. All he had was a fastball," said teammate Doc Cramer. "Everybody knew what they were going to hit at, but they still couldn't hit him. He was fabulous."

At the height of the Great Depression, following the 1933 season, the thirty-three-year-old Grove was sent to the Red Sox, along with two teammates, for two players and $125,000. There he would win 105 games over the next eight seasons. Connie Mack, part owner and manager of the Athletics, would later be quoted as saying, "Grove was a thrower until we sold him to Boston and he hurt his arm. Then he learned to pitch."

In 1941, Grove's final season in the majors, he won his three-hundredth game, becoming only the twelfth player in history to accomplish such a feat.

Known as a terrible-tempered perfectionist throughout his pitching career, Grove would later admit it was a defense mechanism.

"I was suspicious of everybody," he said. "And I guess I was scared of the big cities. My attitude was the best defense I could muster. I figured that if I scared people away, they wouldn't bother me."

—N.P.

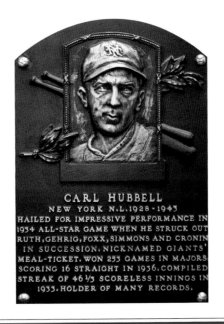

CARL HUBBELL

CLASS OF 1947

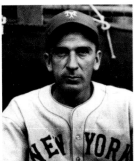

Nicknames sometimes tell us a great deal about a ballplayer. That's certainly the case with Carl Hubbell, who was nicknamed "King Carl" and "The Meal Ticket."

Born in Missouri, Hubbell began a winding journey by moving with his family to Meeker, Oklahoma. While pitching for Oklahoma City, he drew interest from the Detroit Tigers. When Hubbell reported to spring training, manager Ty Cobb refused to let him throw his trademark screwball. Hubbell was sent to the minors, where he floundered without his out-pitch.

On the surface, Hubbell did not look like an impressive specimen. With his floppy ears and frail build, he hardly had the appearance of a prospect. At one point he contemplated giving up baseball and entering the oil business in Oklahoma. Then he caught the attention of an influential Giants scout. Watching him pitch for Beaumont in the Texas League in 1928, the scout came away impressed with the young left-hander and encouraged manager John McGraw to acquire him.

McGraw gave Hubbell permission to use his best pitch. "Hub had a screwball and a good one, the best I ever saw," Hall of Famer Lefty Gomez told the Associated Press. "Before Hubbell came along, they called it a fadeaway. It was Christy Mathewson's out-pitch. His broke away from left-handed hitters. Hubbell's broke away from right-handed hitters."

As a rookie call-up in midseason, Hubbell won ten of sixteen decisions. In 1929 he earned nationwide attention when he hurled a no-hitter against the Pittsburgh Pirates. His masterpiece would portend future greatness. The 1934 Midsummer Classic produced the signature moment of his career. Facing a group of the greatest hitters ever, he struck out five consecutive legends, including Babe Ruth and Lou Gehrig. "It wasn't that much of a fluke," All-Star second baseman Billy Herman told sportswriter Brad Phelps. "[Hubbell] was an unusual pitcher. If you didn't know what he threw, it was almost impossible to hit him."

A durable pitcher who threw more than three hundred innings for four straight years, Hubbell was arguably the greatest National League pitcher of the 1930s. From 1933 to 1937 he led the league in ERA three times; he also led in wins three times. Beginning in July 1936, he strung together a record twenty-four-game winning streak that stretched into the following summer.

Led by Hubbell, the Giants made it to three World Series. The Meal Ticket pitched brilliantly in each Series, winning four of six decisions while posting an ERA of 1.79. He was particularly phenomenal in the 1933 Classic, as he fired twenty shutout innings to lead the Giants to victory.

After his retirement in 1943, the Giants made Hubbell their director of minor league operations. Moving with the Giants to San Francisco in 1958, he remained in the position until 1977, when a stroke forced him to cut back his duties and he become a scout.

Hubbell was a lifelong Giant in more ways than one. And when it came to throwing the screwball, no one was more of a master than King Carl.

—B.M.

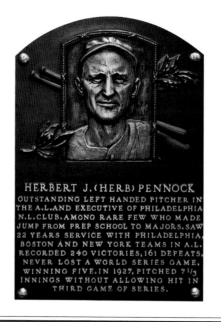

HERBERT J. (HERB) PENNOCK
OUTSTANDING LEFT HANDED PITCHER IN
THE A.L. AND EXECUTIVE OF PHILADELPHIA
N.L. CLUB. AMONG RARE FEW WHO MADE
JUMP FROM PREP SCHOOL TO MAJORS. SAW
22 YEARS SERVICE WITH PHILADELPHIA,
BOSTON AND NEW YORK TEAMS IN A.L.
RECORDED 240 VICTORIES, 161 DEFEATS.
NEVER LOST A WORLD SERIES GAME,
WINNING FIVE. IN 1927, PITCHED 7 1/3
INNINGS WITHOUT ALLOWING HIT IN
THIRD GAME OF SERIES.

HERB PENNOCK

CLASS OF 1948

Although he became a Hall of Famer, left-hander Herb Pennock did not own an outsized ego. After retirement, when referring to his years in the big leagues between 1912 and 1934, he said he thought there were two south-paws far and away better than the others. He named Lefty Grove and Carl Hubbell. When someone suggested that a guy named Pennock might appropriately be added to the list, Pennock said, "I don't know. You see, I never saw him pitch."

Pennock pitched for three New York Yankees World Series winners between 1923 and 1932 after being traded from the Red Sox. It was the same path Babe Ruth followed, but the Ruth deal overshadowed his. He won 241 major league games, but Pennock never had difficulty picking out his biggest thrill—the July 4, 1925, contest versus the Philadelphia Athletics and Grove was an epic, ending 1–0.

"It was a 15-inning duel," Pennock said. "It was a great battle, and both of us, mowing down the opposition, were waiting for a break. It came first for the Athletics in the 15th inning, and then for us in the last half of the same session. I weakened a bit in that inning. Grove, too, weakened in the 15th and Steve O'Neill drove in the winning run. It was some ball game."

Pennock's first major league club was the A's. He was signed at eighteen by Connie Mack, who decried his own impatience with the lad after sending him to Boston. "That was my biggest blunder," Mack said. "I got the impression Pennock was nonchalant, that he lacked ambition." Pennock, Mack added, "made me rue the day."

One time, Pennock came down with a sore arm. Treatment was none too sophisticated then, with some medical folks open to suggestions from all sources, reliable or not. Pennock's big ache flared up during the 1928 season, and a friend, who thereafter may be referred to as a "friend," said he could cure Pennock's arm if the lefty followed his instructions.

The plan called for honeybees to be placed on Pennock's left arm one at a time and permitted to enjoy the habitat until each bee stung him. "Then they brushed off the bees and removed the stingers with a pair of pliers," Pennock reported. What was the result? "Nothing. All I got out of it was an arm that was both lame and sore."

The incident had nothing to do with the fact that when Pennock passed away, only seven months before Ruth, the Babe described him as "a honey." He meant as a quality pitcher, not a beekeeper.

One aspect of Pennock's style that stood out was his easy motion and delivery. It came across as so smooth that it sometimes didn't even look as if he was trying. That was until hitters faced him and he punched them out. "He looks easy to hit from where they stand," said teammate Benny Bengough. "But it ain't."

—L.F.

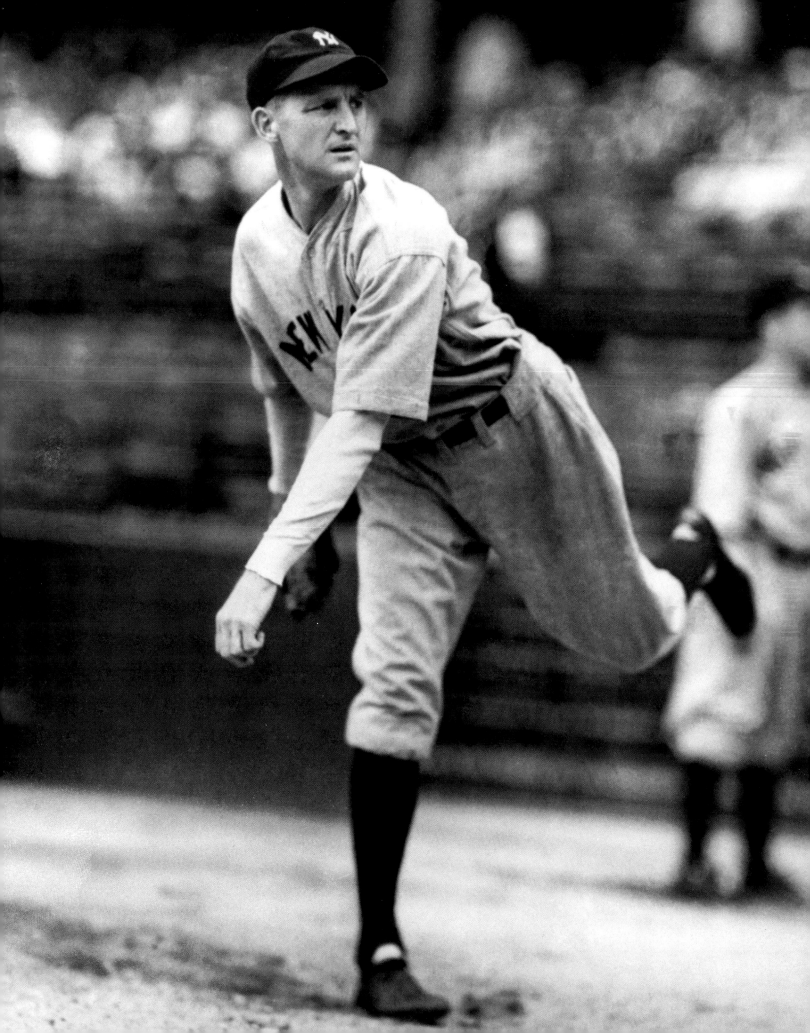

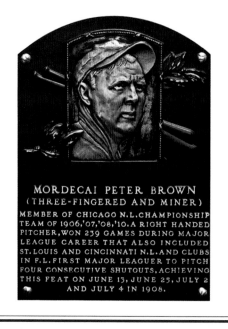

MORDECAI PETER BROWN
(THREE-FINGERED AND MINER)
MEMBER OF CHICAGO N.L.CHAMPIONSHIP
TEAM OF 1906,'07,'08,'10. A RIGHT HANDED
PITCHER, WON 239 GAMES DURING MAJOR
LEAGUE CAREER THAT ALSO INCLUDED
ST. LOUIS AND CINCINNATI N.L. AND CLUBS
IN F.L. FIRST MAJOR LEAGUER TO PITCH
FOUR CONSECUTIVE SHUTOUTS, ACHIEVING
THIS FEAT ON JUNE 13, JUNE 25, JULY 2
AND JULY 4 IN 1908.

MORDECAI BROWN

CLASS OF 1949

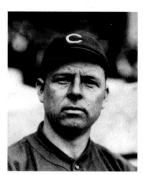

When it came to throwing the curveball, the fabulous Chicago Cubs pitcher Mordecai Brown could have presided over a graduate school class. It was his bread and butter pitch, though partially because Brown turned a disability into a plus. The boy who suffered damage to and the loss of some of his fingers in a corn shredder on his uncle's farm became a hurler known as "Three Finger" Brown.

Rather than view his mangled hand as an insurmountable obstacle to his goal of becoming a professional ballplayer, Brown made his injury work for him. The remaining fingers enhanced the spin on the balls he heaved to the plate. Brown adapted so well he became a Hall of Famer.

Brown was raised in a mining town in Indiana, where one of the mine employees was Legs O'Connell, a former minor leaguer. He tutored Brown. "If it hadn't been for Legs I would never have been anything more than a water boy or a mascot for a ball club," Brown said. "He was a hard teacher, but he taught me how to overcome the handicap of my fingers and even to put them to great advantage."

As one might expect from someone who endured such difficulties, Brown possessed a hard-core, determined attitude.

"There are two classes of pitchers," Brown once wrote in a lesson plan he drew up, called *How to Pitch Curves,* "winners and losers. I believe there is something in the makeup of a player that makes him a winner or a loser in baseball, something in his character. Luck may enter into the winning of a ball game, but luck, in my dictionary, begins with the letter 'P.' It's spelled P-L-U-C-K. And it favors the man who works hardest and does the best he can under all circumstances."

Winners, to Brown's mind, were those who "from the minute they enter the box they are on the job. And it's their very doggedness and determination to win that brings them victory."

During the first years of the twentieth century, Brown, whose 2.06 earned run average was the sixth best ever, and the Giants' Christy Mathewson, played out one of the finest pitching rivalries of all time. They met twenty-four times, with Brown winning twelve, Mathewson eleven, and one no-decision. The two greats brought out the best in each other. Still, whatever Brown accomplished brought up a discussion about his hand. He said there was more to that issue than most ever knew.

"Much has been written about the part my deformed fingers played in my career," Brown said later. "Undoubtedly, they did have much to do with curves. I couldn't throw any other kind of ball. Yet those fingers were a terrific handicap. Few know the excruciating pain I suffered when I had to grip the ball in certain ways. I always felt if I had had a normal hand I would have been a greater pitcher. It took me several years to finally perfect my best ball, the down-curve."

—L.F.

Chas. Nichols.

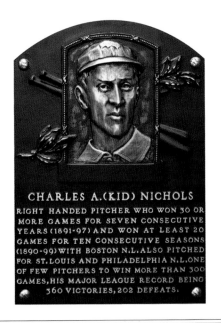

KID NICHOLS

CLASS OF 1949

Few in baseball have been so good so soon as Charles "Kid" Nichols. The right-hander made his professional debut before his eighteenth birthday, when he took the mound for Kansas City of the Western League in 1887. Nichols joined Boston's National League team in 1890. He was only twenty years old. From there, he became one of the best pitchers in the game, reaching the twenty-five-victory plateau in his first nine consecutive seasons.

All that winning didn't make him look any older, though, and he was nicknamed "Kid" by a team photographer early in his fifteen-year big league career.

With Nichols on the staff, Boston enjoyed a decade of success, winning five pennants. From 1891 to 1898 he won a record thirty or more games seven times, averaging thirty-one victories a season for the old Beaneaters. In addition, he proved to be remarkably durable. Nichols started 562 games during his career and went the distance in 532 of them.

He ended up winning 361 games, against 208 losses, and nobody younger had ever reached the three-hundred-victory mark. Nichols was just nine months and twenty-three days past his thirtieth birthday when he accomplished this. Later in life, Nichols said he didn't like the direction baseball was headed in when it came to handling young pitchers. He recalled that back in his time, he threw every three days "just as easy as can be."

"Once in a while I would get a kink in my arm," he added, "but I'd just go out in the sun and work it out. These pitchers nowadays try too much fancy stuff and ruin their arms. If they'd stick to a plain overhand motion, they'd be better off."

Consistency was the key with Nichols, as he didn't vary his approach much, even with men on base.

"There is nothing very peculiar about his delivery," Charlie Bennett, Nichols's longtime catcher, once said. "He has wonderful control over the ball and every one is right around the plate. They don't get many bases on balls with him. Most of the balls which Nichols throws are either fast or slow straight balls. His delivery for both fast or slow ball is so nearly alike that only a man who catches him right along or watches him constantly can tell what he is going to throw."

Nichols moved on to St. Louis in 1904 as player-manager. Besides guiding the Cardinals to seventy-five victories that year, the Kid won twenty-one games and struck out fourteen Brooklyn batters in a seventeen-inning game on August 11. After being let go by St. Louis, Nichols finished his playing days with Philadelphia at the age of thirty-six.

When baseball was over, Nichols went into real estate and the film industry, and he became an accomplished bowler as well. He won bowling championships well into his sixties and managed one of the largest bowling alleys in Missouri. For several summers, he ran a youth team called the Kid Nichols Kids in the Inter City League in Kansas City. One of its members was a young Casey Stengel.

—T. Wendel

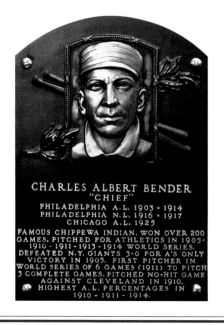

CHARLES ALBERT BENDER
"CHIEF"
PHILADELPHIA A.L. 1903 - 1914
PHILADELPHIA N.L. 1916 - 1917
CHICAGO A.L. 1925
FAMOUS CHIPPEWA INDIAN. WON OVER 200
GAMES. PITCHED FOR ATHLETICS IN 1905 -
1910 - 1911 - 1913 - 1914 WORLD SERIES.
DEFEATED N.Y. GIANTS 3-0 FOR A'S ONLY
VICTORY IN 1905. FIRST PITCHER IN
WORLD SERIES OF 6 GAMES (1911) TO PITCH
3 COMPLETE GAMES. PITCHED NO-HIT GAME
AGAINST CLEVELAND IN 1910.
HIGHEST A.L. PERCENTAGES IN
1910 - 1911 - 1914.

CHARLES BENDER

CLASS OF 1953

One of the kings of the mound for the Philadelphia Athletics under Connie Mack before World War I, the pitcher born Charles Albert Bender was called "Chief" because he was part Chippewa Indian. Bender, though, was a chief of a different sort when hurling, usually in charge and victorious whenever he took his turn.

"If everything depended on one game," Mack said, "I just used Albert, the greatest money pitcher of all time. I'd tell Albert when I planned to use him in a crucial series. That would be several days before the game. Then I relaxed. He never let me down." Mack also called Bender "one of the greatest competitors who ever lived."

Bender was a 212-game winner for five-time pennant-winning A's clubs, and one reason Mack counted on him so much was that he stayed cool under pressure. In the 1911 World Series, Bender shook up two of his infield teammates, Stuffy McInnis and Eddie Collins, with his attempted pickoff throws, or his throws on groundouts. They seemed perturbed about his tosses. "Do you know why?" Bender asked with a laugh. "I'd throw them curveballs in making a putout. They were both so tense and jittery that I merely wanted to demonstrate this was just another ball game. I think my idea went over."

Bender's success was basically dependent on a fastball and a curve. When he gave the spitter a whirl, he didn't like it. "The spitball, I feel confident, has done me harm," he said. "I have made a resolution to give it up and will depend hereafter on speed, control and change of pace."

For recreation during his playing days, Bender indulged in trapshooting and golf, both of which he excelled at, and was once photographed on the links in Atlantic City playing golf with fellow A's pitcher Jack Coombs and other top-notch golfers. He also once won a trapshooting competition against other ballplayers, the field including pitcher Christy Mathewson.

"Naturally, I like all outdoor games," Bender said, "but golf and trap-shooting are my favorites after baseball. I am not going to choose between these two, for I expect to continue to play golf and I don't want to create hard feelings."

A century ago, when prices were lower and salaries were, too, Bender was preparing to represent Philadelphia in the 1913 World Series. Mack, the owner and manager of the A's, called Bender into his office and provided a bonus incentive for him to win a key game against the New York Giants. "I'm banking on you to win the Series," Mack said. "By the way, how much mortgage do you carry on your home?" Bender didn't want to tell Mack at first, but then admitted it was about $2,500. After the A's defeated the Giants four games to one, Mack summoned Bender to his office once more—and handed him a check for $2,500.

—L.F.

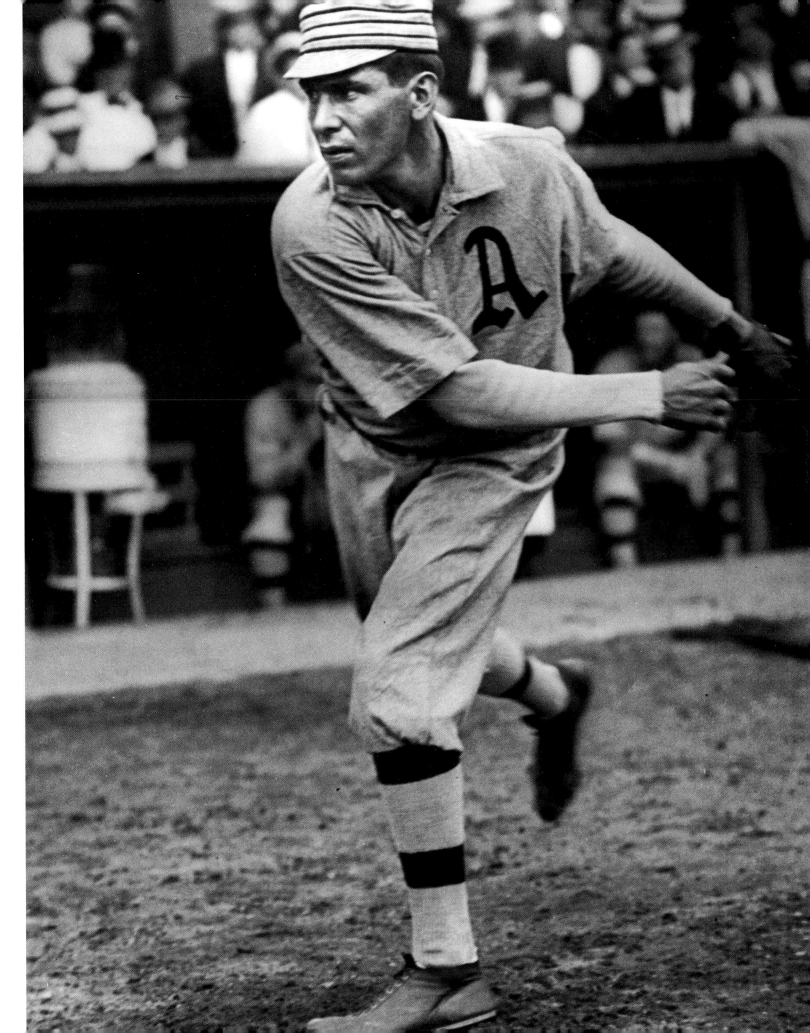

DIZZY DEAN

CLASS OF 1953

Dizzy Dean reveled in his hillbilly image, poking fun at his supposed lack of intelligence. In reality, Dean was far wiser than he let on, and one of the game's most dominant and entertaining pitchers of the 1930s.

Overcoming a difficult youth that included life as the son of a share-cropper and a stint in the Army, Dean signed with the St. Louis Cardinals organization in 1929. Dean pitched so well in the minor leagues that he earned a late-season call-up to St. Louis in 1930.

As a pitcher, Dean tried to keep his job simple. "The dumber a pitcher is, the better," he told *Baseball Digest*. "When he gets smart and begins to experiment with a lot of different pitches, he's in trouble. All I ever had was a fastball, a curve and a changeup and I did pretty good."

In 1933 he led the National League in appearances, complete games, and strikeouts. Then came his famous boast of 1934. He predicted that he and his younger brother, Paul, would combine to win forty-five games. Dizzy proceeded to win thirty games while his brother posted nineteen victories. That gave the brothers forty-nine wins.

Dean continued to excel in 1935 and 1936. The latter season, he won twenty-four games and led the big leagues in saves (although saves did not become an official statistic until 1969), an incredible combination.

Dean provided fun off the field, too. Along with Pepper Martin, Dean became one of the leading members of the famed "Gashouse Gang," a group of rough-and-tumble Cardinals players. Dean pulled off numerous pranks, providing entertainment in hotel lobbies and ballparks. After a 1936 rainout, Dean and some of his Gashouse Gang brethren returned to the team hotel. Donning workmen's overalls, they carried tools and ladders into the grand banquet room during a formal luncheon. Dean climbed a ladder and began hammering on the ceiling while other players rearranged furniture. Some of the banquet guests became upset, only to realize moments later the true identities of the "workers." Delighted, the banquet organizers invited Dean and his mates to dine with them.

In 1937 an injury derailed Dean's career. Pitching in the 1937 All-Star Game, he was hit in the left foot by an Earl Averill line drive. Dean had to modify his delivery so as to put more weight on his right foot. The change in his motion resulted in hip pain, and eventually an injury to his shoulder.

With his career as a pitcher at an end, Dean turned his color-ful, outgoing personality into a broadcasting career. He joined the Cardinals' announcing team and delighted fans with the way he played havoc with the English language.

At his Hall of Fame induction in 1953, Dean retained his ever-present qualities of self-deprecation and humor. "The good Lord was good to me," Dean told the gathering in Cooperstown. "He gave me a strong body, a good right arm, and a weak mind."

At a time when he could have basked in his success, Dizzy Dean felt, as always, that it was better to be humble and funny.

—B.M.

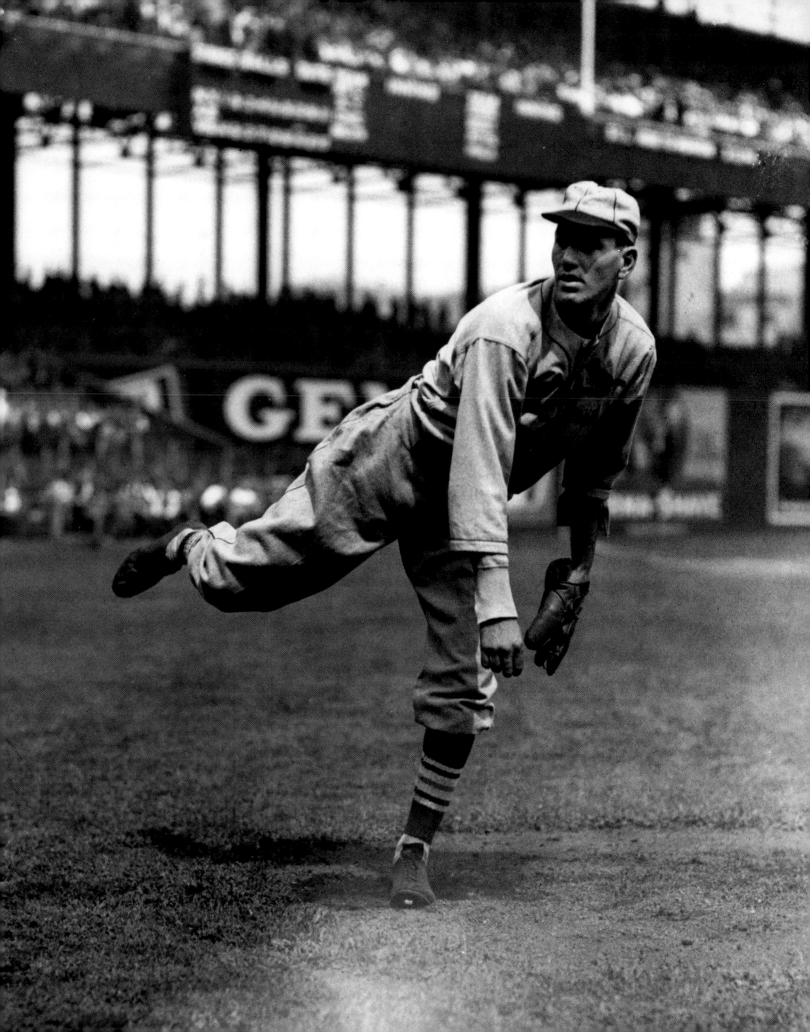

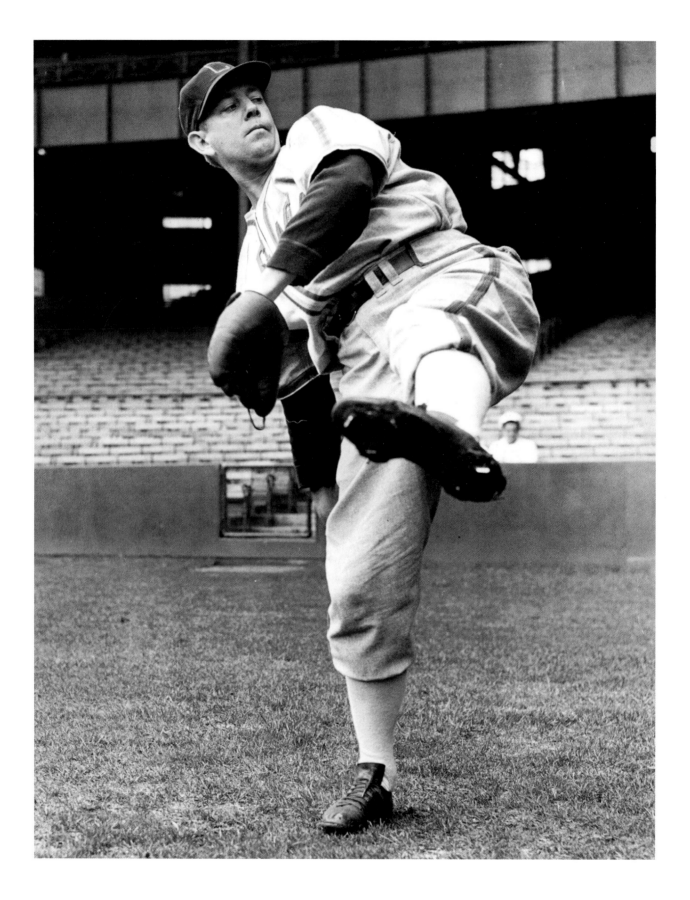

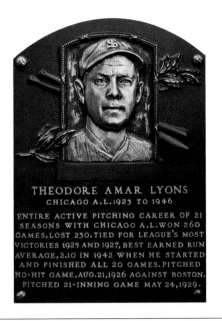

THEODORE AMAR LYONS
CHICAGO A.L. 1923 TO 1946

ENTIRE ACTIVE PITCHING CAREER OF 21
SEASONS WITH CHICAGO A.L. WON 260
GAMES, LOST 230. TIED FOR LEAGUE'S MOST
VICTORIES 1925 AND 1927. BEST EARNED RUN
AVERAGE, 2.10 IN 1942 WHEN HE STARTED
AND FINISHED ALL 20 GAMES. PITCHED
NO-HIT GAME, AUG. 21, 1926 AGAINST BOSTON.
PITCHED 21-INNING GAME MAY 24, 1929.

TED LYONS

CLASS OF 1955

The Chicago White Sox found Ted Lyons without even trying. In 1923 the squad paused for a day in Waco, Texas, on the way to its official spring training camp. Sox catcher Ray Schalk agreed to pose for a publicity picture with some thrower for the Baylor University team.

This college hurler tossed four pitches, and Schalk decided he was no average amateur and should suit up for the Sox. Lyons was signed and spent twenty-one years in a White Sox uniform, winning 260 games, which was a phenomenal accomplishment during that or any era.

Lyons became the mainstay of the staff immediately after the "Black Sox Scandal." Commissioner Kenesaw Mountain Landis banned eight players for life, stripping the team of much of its talent, and the Sox struggled for two decades, coinciding with Lyons's career. It was tough work for a pitcher whose hitters rarely hit for him. The *New York Times* referred to Lyons's mates as "a gosh-awful collection of humpty-dumpties."

Lyons won a team record number of games, but also took a team record number of losses with 230, a reflection of how weak the White Sox were in the 1920s and 1930s. Shortstop Luke Appling, another Hall of Famer, and the star of the batting order, lived through much of the same grief.

"I never heard Ted complain," Appling said. "What a grand person he was. He had a heart as big as the Stone Mountain."

American League players on other teams recognized Lyons's tenacity and skill and didn't relish facing him. Star outfielder Tris Speaker was once asked whom he would want on the mound if he were a manager facing a must-win game for the pennant.

"If I were managing a team in an important game on which the pennant hinged and could pick any pitcher in baseball to pitch it, my choice would be Lyons," Speaker said. "He can be as tough as anybody I know."

A right-handed thrower who was not especially big at five foot eleven and two hundred pounds, Lyons was proud of his ability to swing a bat, too. But he had to earn the trust of White Sox skippers. Lyons was a genial sort who liked to kid around and tell stories. One of his favorites was his account of playing an exhibition game at the state penitentiary in Joliet. It enabled him to spin a yarn and brag about his hitting.

"They've got a short left field there," Lyons said of the prison wall. "After I slammed four doubles against the bricks the warden asked me not to come back—seems he was afraid I'd knock the wall down and there'd be a break."

Lyons acquired the nickname "Professor" because he attended college, but it wasn't as if he viewed baseball as a temporary vocation. He never wanted to retire. The hurler who did not pitch his final major league game until he was forty-five took note when his birthday carried him into a new decade. "Life begins at 40," Lyons said.

—L.F.

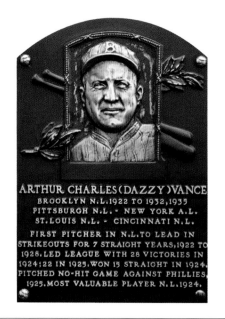

ARTHUR CHARLES (DAZZY) VANCE
BROOKLYN N.L.1922 TO 1932,1935
PITTSBURGH N.L. • NEW YORK A.L.
ST.LOUIS N.L. • CINCINNATI N.L.
FIRST PITCHER IN N.L.TO LEAD IN
STRIKEOUTS FOR 7 STRAIGHT YEARS,1922 TO
1928.LED LEAGUE WITH 28 VICTORIES IN
1924:22 IN 1925.WON 15 STRAIGHT IN 1924.
PITCHED NO-HIT GAME AGAINST PHILLIES,
1925.MOST VALUABLE PLAYER N.L.1924.

DAZZY VANCE

CLASS OF 1955

The best of the Brooklyn Dodgers pitchers during his era, Dazzy Vance had a career that progressed backward. When he was young, Vance had limited velocity and no control. The older he got, the better he got, winning almost two hundred games after his thirtieth birthday.

Born in 1891—not 1893, as he let baseball scouts believe—Vance had a dead arm when he plodded through the minors in 1915. In cameos with the Pittsburgh Pirates and New York Yankees over a couple of seasons in his twenties, he couldn't win a game, his arm letting him down there and in minor league stops.

"Somewhere in-between my stay with St. Joe and my early experience with the Yankees something went wrong with my right arm," Vance recalled. "I no longer could throw hard and it hurt like the dickens every time I threw. It was an odd thing. My arm came back just as quickly as it went sore on me in 1915. I awoke one morning and learned I could throw hard again."

The blessing of a second chance came Vance's way, but it wasn't easy to come by. The righty had been released by minor league teams, and the majors thought he was twenty-nine and too old. (He was actually thirty-one as a rookie in 1922.) When the arm was in full flower, Vance was a flamethrower who led the National League in strikeouts seven straight seasons. He developed a special-delivery way to get his message across that hitters shouldn't stand too close to the plate—a pitch at the shins.

"I make 'em skip rope," Vance said. "They don't like it. It keeps them loose up there. Don't take a toehold on Ol' Daz boys, and you won't get hurt."

Like most boys growing up at the time, Vance spent his playtime outdoors.

"My brother Fred and I lived on our father's farm near Hastings, Nebraska," Vance said, "and as we were the only boys in the neighborhood, we figured out a two-man baseball game. We built a backstop out of chicken wire and marked off the foul lines. I was a better pitcher than Fred, but he was the best hitter, so the scores were fairly even."

Vance liked to think he could hit despite a lifetime average of .150. "Along with my other admirable qualifications," Vance once joked, "I was also an exceptionally fine hitter." Near the end of his career he smacked a long homer into a strong wind that would have won the game, 1–0. He imagined the headline in the next day's paper, "Vance's Homer Wins for Cards," and said he was sure it would be in "the biggest and boldest type any newspaper has used since the sinking of the *Lusitania*."

Only, Vance faltered in the ninth, revising downward, he said, "the number of copies of the newspapers I had originally intended to buy." He was removed for a reliever, and his team lost, 2–1.

—L.F.

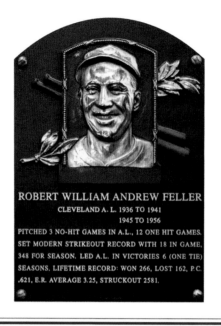

ROBERT WILLIAM ANDREW FELLER
CLEVELAND A. L. 1936 TO 1941
1945 TO 1956
PITCHED 3 NO-HIT GAMES IN A.L., 12 ONE HIT GAMES.
SET MODERN STRIKEOUT RECORD WITH 18 IN GAME,
348 FOR SEASON. LED A.L. IN VICTORIES 6 (ONE TIE)
SEASONS. LIFETIME RECORD: WON 266, LOST 162, P.C.
.621, E.R. AVERAGE 3.25, STRUCKOUT 2581.

BOB FELLER

CLASS OF 1962

No one loved being a Hall of Famer more than Bob Feller. Whether it was through visits in winter storms, perfect attendance at induction ceremonies, or his often professed love of Cooperstown, Feller showed that he considered the Hall of Fame a major part of his life. His presence there was just reward for one of the most storied lives in baseball history.

Feller credited much of his success to growing up on an Iowa farm, where the physically exacting work of farming chores honed his body for a career in pitching. While throwing five no-hitters for Van Meter High School, the blazing right-hander drew the attention of Cleveland Indians scout and general manager Cy Slapnicka. Feller signed as a seventeen-year-old and made the stunning transition straight from high school to major league ball. He actually pitched for the Indians while still in school; after his rookie season, he returned for his senior year.

Once he graduated, Feller concentrated fully on his pitching and became a star. In 1938 he made his first All-Star team and led the American League in strikeouts. He continued his domination over the next three years, winning seventy-six games, including an Opening Day no-hitter in 1940.

Feller left an impression on the league's best hitters, including a rival with the New York Yankees. "I don't think anyone is ever going to throw a ball faster than he does," Joe DiMaggio told a reporter during the 1941 season. "And his curveball isn't human."

Feller's life changed during the winter of 1941, but for reasons having nothing to do with baseball. Just one day after the bombing of Pearl Harbor, Feller became the first major leaguer to enlist to fight in World War II, forgoing a deferment as his family's sole support. Serving aboard the battleship *Alabama*, he earned eight battle stars and five campaign ribbons.

Courageously serving in the Navy, Feller missed all of three seasons and part of a fourth. Yet he never complained of time lost, and never wanted to be draped in glory. "Heroes don't return from war," Feller told *USA Today*. "It's a roll of the dice. If a bullet has your name on it, you're a hero. If you hear a bullet go by, you're a survivor. There are millions of survivors."

Feller returned to the major leagues in the late stages of the 1945 campaign. After a strong nine-game comeback, he proceeded to lead the league in wins, innings, and strikeouts each of the next two years. In 1948 he added another nineteen victories during Cleveland's pennant-winning season.

Off the field, Feller showed concern for the welfare of other players. As the first president of the Players Association, Feller understood baseball as a business and believed that players deserved their fair share of ballpark revenue. He also organized a number of successful wintertime barnstorming tours, which gave him and other star players a chance to earn extra money.

"Feller was the best pitcher I ever saw," Hall of Famer Ralph Kiner told *New York Newsday*. Few who saw Feller firsthand would argue with that assessment.

—B.M.

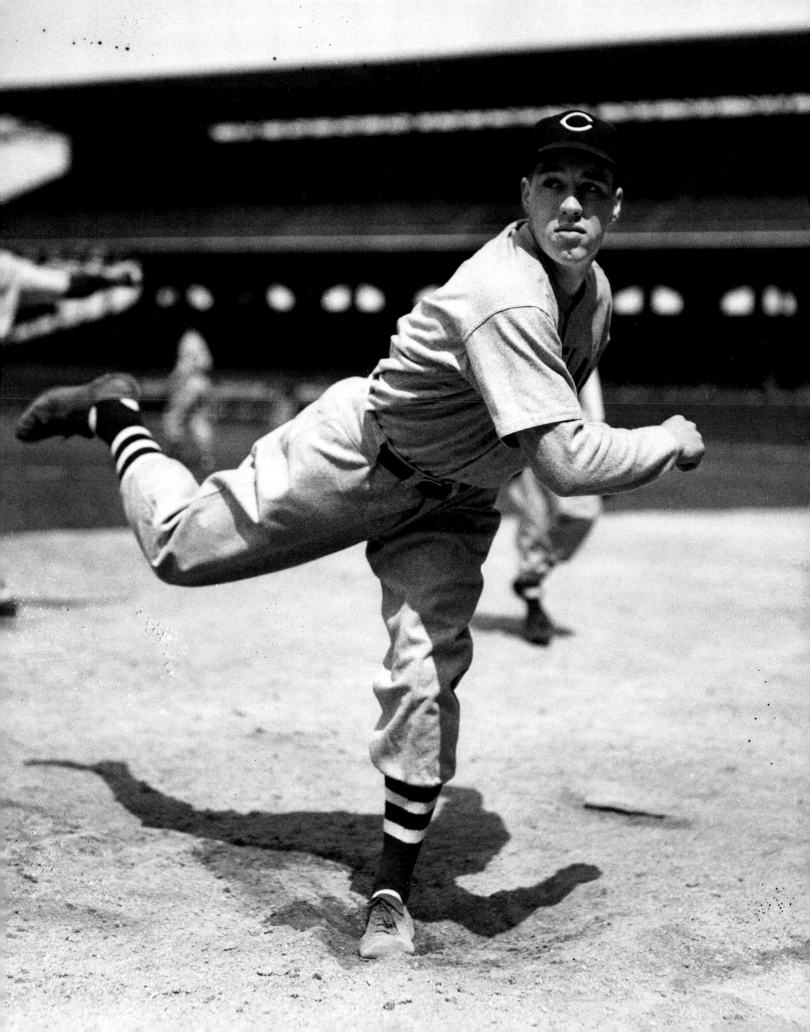

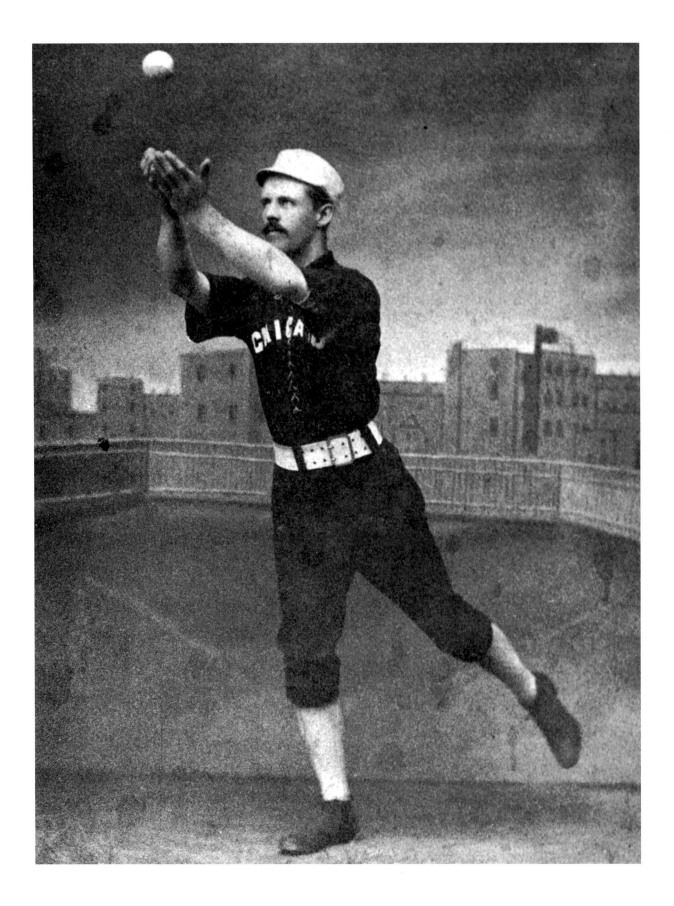

JOHN GIBSON CLARKSON
WORCESTER, N.L. 1882
CHICAGO, N.L. 1884-87
BOSTON, N.L. 1888-92
CLEVELAND, N.L. 1892-94
PITCHED 4 TO 0 NO-HIT GAME AGAINST
PROVIDENCE IN 1885. WON 328 LOST 175
PCT. 652 LED LEAGUE WITH 53 VICTORIES
IN 1885 (INCLUDING 10 SHUTOUTS) 38 IN
1887, 49 IN 1888 AND 49 IN 1889. HAD
2013 STRIKEOUTS IN 4514 INNINGS.

JOHN CLARKSON

CLASS OF 1963

Winning three-hundred-plus games at the big league level? That draws attention even if the pitcher accomplished the feat more than a century ago. But John Clarkson's career featured much more than can be described in one number.

After struggling early in his career, the right-hander put together some of the most amazing win-loss totals in baseball's early days. In 1885, in only his second season with Chicago in the National League, Clarkson started seventy games and won fifty-three of them. During that same season, he won a record fifteen games in June. In 1887 he won thirty-eight games, and two years later Clarkson started seventy-two games, pitched sixty-eight complete games, and won forty-nine.

"Clarkson was one of the greatest pitchers of all time," said Adrian "Cap" Anson, his manager in Chicago.

Ironically for a guy who put up pitching lines for the ages, Clarkson often suffered from a lack of confidence. Anson said that his star right-hander needed plenty of encouragement. "Scold him, find fault with him and he could not pitch at all," Anson said. "Praise him and he was unbeatable."

Perhaps this temperament had to do with Clarkson's rocky start in the game. He came close to never playing at the big league level, let alone becoming a star. He developed a sore shoulder and appeared in only three games. The following season, his friend Art Whitney took over the East Saginaw, Michigan, squad in the Northwestern League. The new manager brought in Clarkson, who was still honing his craft as a pitcher. So Clarkson took an occasional turn on the field, where he struggled as an outfielder.

But late in the 1883 season Clarkson found himself back in the rotation, where he delivered twenty-six scoreless innings. He joined the Chicago ball club the next year, starting thirteen games and winning ten of them. He soon impressed his new teammates with his pinpoint accuracy.

"I have stood behind him day in and day out and watched his magnificent control," said Chicago second baseman Fred Pfeffer. "I believe he could put a ball where he wanted it nine times out of 10."

Following the 1887 season, Clarkson was sold to Boston for $10,000, which was an astronomical sum at the time. He won thirty-three games for Boston in 1888, then captured the pitching Triple Crown in 1889 by leading the National League in wins (49), earned run average (2.73), and strikeouts (284).

Clarkson, who was born in Cambridge, Massachusetts, played in Boston until midway through the 1892 season, when he was released and signed by Cleveland. After going 16–17 in 1893 and 8–10 the following season, Clarkson retired.

He finished with a career record of 328–178—good for a winning percentage of .648, the fourth-best figure for any pitcher with at least three hundred wins.

Clarkson passed away in 1909 and was elected to the Hall of Fame in 1963.

—T. Wendel

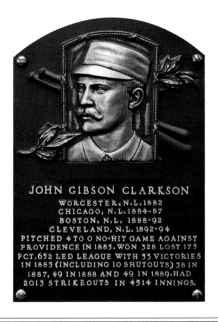

JOHN GIBSON CLARKSON
WORCESTER, N.L. 1882
CHICAGO, N.L. 1884-87
BOSTON, N.L. 1888-92
CLEVELAND, N.L. 1892-94
PITCHED 4 TO 0 NO-HIT GAME AGAINST
PROVIDENCE IN 1885. WON 328 LOST 175
PCT. 652 LED LEAGUE WITH 53 VICTORIES
IN 1885 (INCLUDING 10 SHUTOUTS) 38 IN
1887, 49 IN 1888 AND 49 IN 1889. HAD
2013 STRIKEOUTS IN 4514 INNINGS.

JOHN CLARKSON

CLASS OF 1963

Winning three-hundred-plus games at the big league level? That draws attention even if the pitcher accomplished the feat more than a century ago. But John Clarkson's career featured much more than can be described in one number.

After struggling early in his career, the right-hander put together some of the most amazing win-loss totals in baseball's early days. In 1885, in only his second season with Chicago in the National League, Clarkson started seventy games and won fifty-three of them. During that same season, he won a record fifteen games in June. In 1887 he won thirty-eight games, and two years later Clarkson started seventy-two games, pitched sixty-eight complete games, and won forty-nine.

"Clarkson was one of the greatest pitchers of all time," said Adrian "Cap" Anson, his manager in Chicago.

Ironically for a guy who put up pitching lines for the ages, Clarkson often suffered from a lack of confidence. Anson said that his star right-hander needed plenty of encouragement. "Scold him, find fault with him and he could not pitch at all," Anson said. "Praise him and he was unbeatable."

Perhaps this temperament had to do with Clarkson's rocky start in the game. He came close to never playing at the big league level, let alone becoming a star. He developed a sore shoulder and appeared in only three games. The following season, his friend Art Whitney took over the East Saginaw, Michigan, squad in the Northwestern League. The new manager brought in Clarkson, who was still honing his craft as a pitcher. So Clarkson took an occasional turn on the field, where he struggled as an outfielder.

But late in the 1883 season Clarkson found himself back in the rotation, where he delivered twenty-six scoreless innings. He joined the Chicago ball club the next year, starting thirteen games and winning ten of them. He soon impressed his new teammates with his pinpoint accuracy.

"I have stood behind him day in and day out and watched his magnificent control," said Chicago second baseman Fred Pfeffer. "I believe he could put a ball where he wanted it nine times out of 10."

Following the 1887 season, Clarkson was sold to Boston for $10,000, which was an astronomical sum at the time. He won thirty-three games for Boston in 1888, then captured the pitching Triple Crown in 1889 by leading the National League in wins (49), earned run average (2.73), and strikeouts (284).

Clarkson, who was born in Cambridge, Massachusetts, played in Boston until midway through the 1892 season, when he was released and signed by Cleveland. After going 16–17 in 1893 and 8–10 the following season, Clarkson retired.

He finished with a career record of 328–178—good for a winning percentage of .648, the fourth-best figure for any pitcher with at least three hundred wins.

Clarkson passed away in 1909 and was elected to the Hall of Fame in 1963.

—T. Wendel

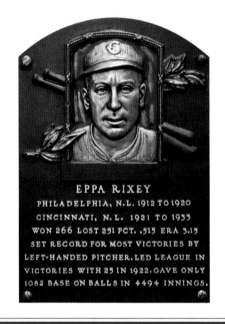

EPPA RIXEY
PHILADELPHIA, N.L. 1912 TO 1920
CINCINNATI, N.L. 1921 TO 1933
WON 266 LOST 251 PCT. .515 ERA 3.15
SET RECORD FOR MOST VICTORIES BY
LEFT-HANDED PITCHER. LED LEAGUE IN
VICTORIES WITH 25 IN 1922. GAVE ONLY
1082 BASE ON BALLS IN 4494 INNINGS.

EPPA RIXEY

CLASS OF 1963

At one time or another, southpaw Eppa Rixey held the National League record for wins by a left-hander with 266, losses by a left-hander, and years pitched by a left-hander. He may also have led the majors in self-deprecating humor. When elected to the Hall of Fame in 1963 by the Veterans Committee, Rixey said, "They're really scraping the bottom of the barrel, aren't they?"

Alas, Rixey did not experience his actual induction into the Hall because he died of a heart attack a month after his selection.

A four-time twenty-game winner, Rixey was not upset when Warren Spahn surpassed him for most National League victories by a lefty in 1959, lifting the record he'd held since 1933. "No one knew I had it," Rixey said. "I'm glad Warren did it. If he hadn't broken my record no one would have known I'd set it." No fanfare was made about the mark when he retired, Rixey said. "It didn't rate national headlines."

Rixey grew up in Virginia and got a late start in professional baseball in 1912 because he was busy earning a degree at the University of Virginia. He also added a master's degree in 1914 after he began playing. One way Rixey made up for lost time was by skipping the minors altogether and jumping right onto the roster of the Philadelphia Phillies.

The young pitcher was very nervous when tabbed for his first start but somehow made it through the game without anything going haywire. "I was scared to death, but I just chucked the ball where Horace Fogel, the manager [sic], signaled, and we won by shutout," Rixey said.

Missing the 1918 season because he was serving in the Army as a lieutenant during World War I, Rixey returned to Virginia, where he was challenged by the university president about being a college graduate wasting his life playing sports. One more year, he told the president, who replied, "Oh, Eppa." Rixey played for fifteen more years and said later in life he would have done it all over again.

Rixey did everything on the slow side. His pitching strength was not his fastball but an assortment of junk. He was also not a fast runner; he stole two bases in his entire career. One of those came on a double steal with teammate Bubbles Hargrave. "I think Bubbles and I were the slowest men in baseball," Rixey said. "We stole on [the Cubs Hall of Famer] Gabby Hartnett [sic], who had the best throwing arm of any catcher in baseball. Gabby was so surprised he forgot to throw."

Despite his love of a good joke, Rixey was not always easygoing. When he lost a game and it rubbed him the wrong way, he could go a little crazy in the locker room. "He was one of a kind," said Clyde Sukeforth, who was a teammate of Rixey's with the Cincinnati Reds for six years. "He would break chairs in the clubhouse when he lost and you wouldn't see him for a few days."

—L.F.

URBAN CLARENCE FABER
CHICAGO A. L. 1914-1933
DURABLE RIGHTHANDER WHO WON 253,
LOST 211, E.R.A. 3.13 GAMES IN TWO DECADES
WITH WHITE SOX. VICTOR IN 3 GAMES
OF 1917 WORLD'S SERIES AGAINST GIANTS.
WON 20 OR MORE GAMES IN SEASON
FOUR TIMES, THREE IN SUCCESSION.

RED FABER

CLASS OF 1964

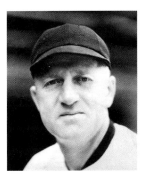

Urban "Red" Faber was among the last of the legal spitball pitchers grandfathered in when Major League Baseball banned the pitch. A star for the Chicago White Sox during a time when they were generally a weak team, he later suggested the spitter be brought back into vogue.

"I don't see any harm in bringing it back, if they think they need it," Faber said in 1964, forty-four years after the spitter became illegal. "You didn't mar the surface of the ball. You don't have to wet the ball, just your fingers. Even if they brought it back, not many pitchers would be able to use it effectively. Remember, only a few of us used it consistently and effectively in my day. Some clubs in the American League didn't have anybody who could throw it."

Ray Schalk, the Hall of Fame catcher, said his batterymate was more of an all-around pitcher than just a spitball thrower anyway. "Mostly all you heard about Red was his spitter," Schalk said, "but he could work on you with a lot of other things. I always said, you know, that his fastball was his best pitch. He used the spitter a lot as a deception. He wanted you to think he was going to throw it, then he'd fire a fastball."

Faber made it sound as if Schalk had a glove that featured near-magical properties to psych out hitters. "Ray had a mitt that popped real loud," Faber said. "It made a pitcher feel real good."

The White Sox won the World Series in 1917 and then made their way back in 1919. That was the year of the "Black Sox Scandal," when several Sox players were accused of throwing the Series in exchange for money from gamblers. Faber was injured and didn't pitch at all after winning eleven in the regular season. Schalk said that if Faber had been healthy and taken his regular turn, there never would have been a scandal.

"If Red Faber had been able to work I feel that no [scandal] situation could have come up," Schalk said. "I did not know what was going on at the time and I never cared to know. I never talked about it and I never will." In fact Schalk felt that if Faber had been added to the pitching rotation, the White Sox would have won. "Red was our mainstay in defeating McGraw's Giants in the 1917 Series. He pitched three starts and one relief job in six games, and won three, lost once."

John McGraw was always a fan of Faber's talents—just not when they were applied against his team. He saw quite a bit of Faber during the 1913–14 world tour both clubs took, and when Sox owner Charles Comiskey considered sending Faber to the minors, McGraw dissuaded him. "That fellow has a lot of stuff, Charley," McGraw said. "He's got the best drop curve I've ever seen along the line for some time and his spitter is a pippin too."

—L.F.

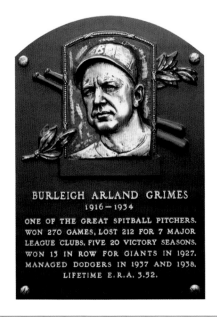

BURLEIGH ARLAND GRIMES
1916—1934
ONE OF THE GREAT SPITBALL PITCHERS.
WON 270 GAMES, LOST 212 FOR 7 MAJOR
LEAGUE CLUBS. FIVE 20 VICTORY SEASONS.
WON 13 IN ROW FOR GIANTS IN 1927.
MANAGED DODGERS IN 1937 AND 1938.
LIFETIME E.R.A. 3.52.

BURLEIGH GRIMES

CLASS OF 1964

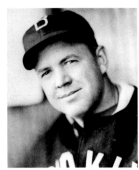

Many people thought Burleigh Grimes didn't like anybody during his nineteen years pitching in the majors, but it was mostly hitters he held grudges against.

"The only time I was ever scared in my life," said Hall of Fame second baseman Frankie Frisch, "was one time when Burleigh threw at me on a 3-and-0 count."

Called "Ol' Stubblebeard," a nickname he earned by not shaving for two days before a game, the right-handed pitcher was also a notorious spitballer.

"I used to chew slippery elm—the bark, right off the tree. Come spring the bark would get nice and loose and you could slice it free without any trouble," Grimes said. "What I checked was the fiber from inside, and that's what I put on the ball. That's what they called the foreign substance. The ball would break like hell, away from right-handed hitters and in on lefties."

At the height of Grimes's career in the early 1920s, big league baseball banned the spitball but allowed Grimes and sixteen other pitchers to continue utilizing the pitch.

"The idea was to keep it on the hitter's mind," Grimes said of the spitter. "That was the psychological advantage. If he was thinking spitter he couldn't concentrate on hitting the pitch."

Grimes would win 270 games during a big league career spent with seven different teams, mostly with Brooklyn. The five-time twenty-game winner would gain a reputation over the years for bearing down on hitters at all times.

"Grimes showed no mercy to anyone," said former teammate Charlie Grimm. "I think he'd have been the same against his own mother in a close game."

Once Grimes had his game face on, it didn't come off easily. He did not always agree that it was time for him to vacate the pitching mound when the manager came out to yank him. His most dramatic confrontation occurred while pitching for Brooklyn when Wilbert Robinson was the manager. Grimes surrendered a triple and could hear the phone ring in the dugout, knowing orders from owner Charles Ebbets to take him out were being delivered.

"Uncle Robbie then came out to get me to leave," Grimes said. "I refused, however. I figured I still had a chance to win. Robbie finally convinced me, but before I left I wound up and threw the ball over the grandstand. That was the most expensive pitch of my career—it cost me $1,500! You see, I was to get a $1,000 bonus if I gave the club 'my very best.' Throwing that ball over the stands was not interpreted as 'my very best.' I was also fined $500."

Proving he had a sense of humor when it came to his fiery reputation, Grimes recalled that once, after being thrown out of a game, he picked up a bucket of water and tossed it in the air, hoping it would land on the umpire's head. "But after I was revived, I learned that the pail had knocked me out," he said. "I had poor control that night."

—B.F.

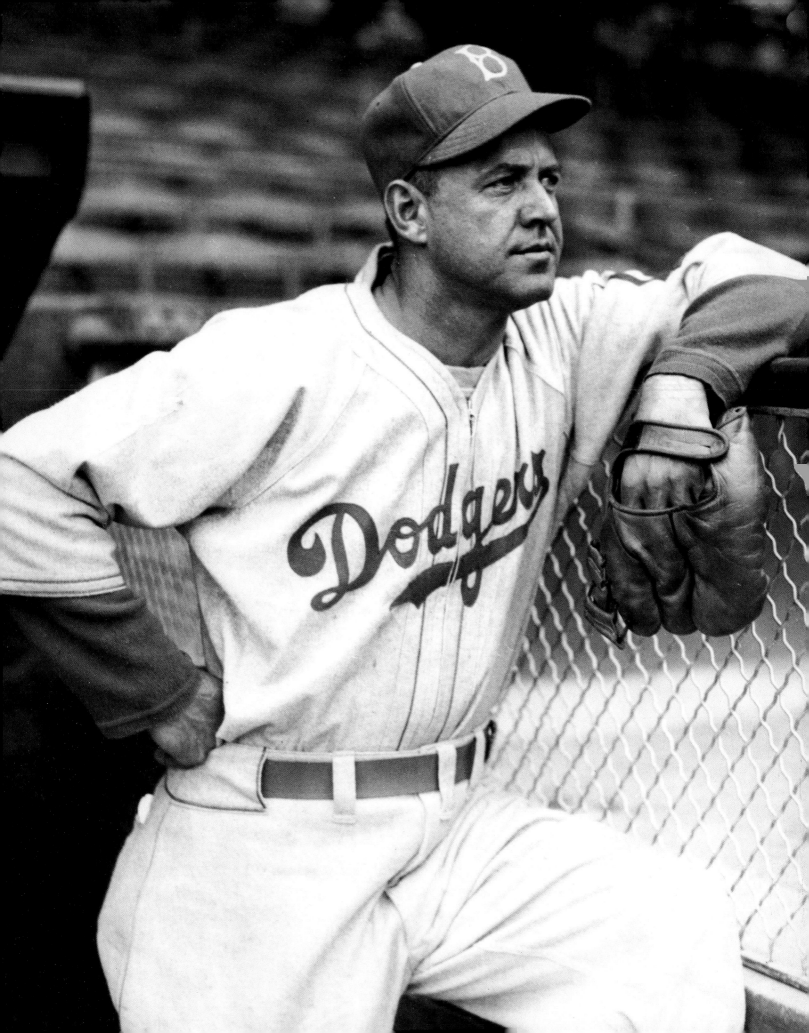

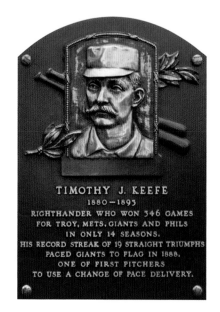

TIMOTHY J. KEEFE
1880—1893
RIGHTHANDER WHO WON 346 GAMES
FOR TROY, METS, GIANTS AND PHILS
IN ONLY 14 SEASONS.
HIS RECORD STREAK OF 19 STRAIGHT TRIUMPHS
PACED GIANTS TO FLAG IN 1888.
ONE OF FIRST PITCHERS
TO USE A CHANGE OF PACE DELIVERY.

TIM KEEFE

CLASS OF 1964

"Keefe is said to be one of the most scientific pitchers in the country—that is, he uses his head as well as his hands while in the box," reported the *Boston Globe* in 1885.

Tim Keefe pitched for five major league teams in fourteen seasons from 1880 to 1893, averaging more than twenty-four wins a season, en route to 342 career victories, second only to Pud Galvin at his retirement. When he left the game, Keefe, a master of guile and deception, was also the career strikeout leader, with 2,564.

"Throughout the 1880s, Keefe successfully adapted to continual rule changes that modified how and from where pitchers could throw the ball, lowered the number of balls a batter needed for a walk, and elongated season schedules," noted baseball historian Charlie Bevis. Keefe repeatedly adapted to ever-lengthening pitching distances.

"I never saw a better pitcher. True, he did his best work from 50 feet, but he still would have had no superior at 60 feet, six inches," said longtime teammate "Smiling Mickey" Welch. Keefe shared half a nickname with Welch, as he was often called "Smiling Tim."

Keefe and Welch first teamed up with the Troy, New York, Trojans of the National League from 1880 to 1882 as a two-man smiling Irish rotation. When the Troy club was dissolved after 1882, Keefe ended up with the New York Metropolitans, where his career blossomed.

Keefe's rookie year coincided with the first year of baseball's reserve clause, which perpetually bound a player to work only for the team he had worked for in the previous year, a fate that Keefe would battle with a series of holdouts throughout his career.

In 1883 Keefe went 41–27, leading the league with sixty-eight complete games and 619 innings pitched. The following year, the Mets won the American Association Pennant as Keefe chipped in another thirty-seven wins.

Keefe moved to the New York Giants in 1885, a loaded team featuring six future Hall of Famers, including Roger Connor, Buck Ewing, Jim O'Rourke, John Montgomery Ward, and Mickey Welch. They finished second to the Chicago White Stockings, though Keefe won thirty-two games and led the league with a 1.58 ERA.

That offseason, Keefe and Ward formed the Brotherhood of Professional Base Ball Players, the game's first players' union. Five years later, the group would form the Players' League, a one-year experiment in player control of the game.

Keefe and the Giants had a fantastic year in 1888, winning the pennant and the World Series over the American Association's St. Louis Browns. Keefe won four of the ten World Series games. In the regular season, he led the league with thirty-five wins and 335 strikeouts, despite holding out until May 1. He also established a record with nineteen consecutive wins from late June to mid-August.

—T. Wendel

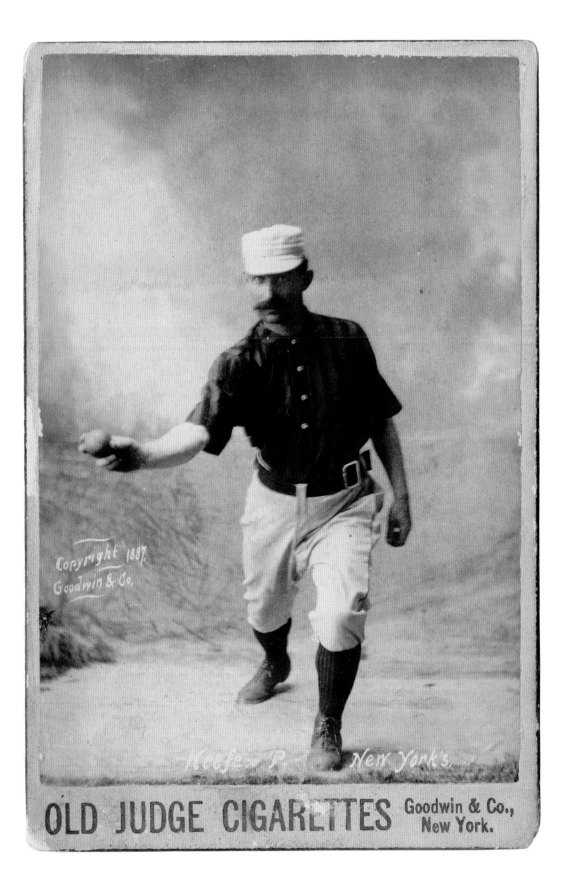

Copyright 1887.
Goodwin & Co.

Keefe, P. New York's.

OLD JUDGE CIGARETTES Goodwin & Co.,
New York.

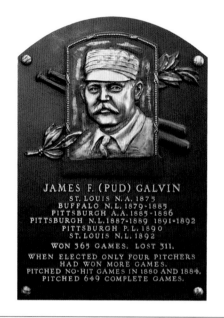

JAMES F. (PUD) GALVIN
ST. LOUIS N.A. 1875
BUFFALO N.L. 1879-1885
PITTSBURGH A.A. 1885-1886
PITTSBURGH N.L. 1887-1889 1891-1892
PITTSBURGH P.L. 1890
ST. LOUIS N.L. 1892
WON 365 GAMES, LOST 311.
WHEN ELECTED ONLY FOUR PITCHERS
HAD WON MORE GAMES.
PITCHED NO-HIT GAMES IN 1880 AND 1884.
PITCHED 649 COMPLETE GAMES.

PUD GALVIN

CLASS OF 1965

At first glance, James Galvin didn't appear to be much of an athlete, let alone a Hall of Famer. Yet few ever threw the ball with more velocity or purpose.

At five foot eight and a robust 190 pounds, Galvin was nicknamed "The Little Steam Engine" and "Pud," supposedly because his offerings turned opposing batters to pudding. He pitched an astounding 646 complete games during his fifteen-year career, which took place before the start of the last century.

"He must have been an iron man," said Lefty Grove, another Hall of Famer who could bring the heat. "My 300 [*sic*] complete games appear insignificant compared with that figure."

Born on Christmas Day 1856, Galvin grew up in the "Kerry Patch" section of St. Louis. Populated by Irish immigrants, the neighborhood was an early hotbed of baseball.

From those early days, Galvin's approach was to pitch fast and faster, and he further exploited sheer velocity when it came to opposing base runners. He once walked three men in an inning and then proceeded to pick each of them off first base in turn.

"If I had Galvin to catch, no one would ever steal a base on me," Hall of Fame catcher Buck Ewing once said. "That fellow keeps them glued to the bag. You notice that funny false motion of his that can't really be called a balk. He fooled me so badly one day that I never attempted to get back to first base. And he certainly also has the best control of any pitcher in this league."

Galvin began his professional career with St. Louis (National Association) in 1875 and put together several impressive seasons in western New York. He won thirty-seven games in 1879 and forty-six games twice, in 1883 and 1884, for a ball club that never finished better than third place. One of the best fastball pitchers ever, Galvin bridged the gap between the game's early days of the underarm delivery and today's overhand style.

"In Galvin, Buffalo has the speediest pitcher in his profession," the *Syracuse Courier* declared. "The celebrity of his pitches is a marvel to behold and it is a wonder he can find catchers to hold him."

During the 1885 season, Galvin left Buffalo and joined Pittsburgh of the American Association. He remained there until the team moved from the American Association to the National League two years later, and he won the first two games in the team's history. In his first four years in Pittsburgh, not counting the partial season of 1885, Galvin averaged nearly twenty-six victories a season. He was selected to the National Baseball Hall of Fame in 1965.

"Galvin goes back so far into baseball antiquity that his last batterymate at Pittsburgh was Connie Mack," wrote Bob Broeg of the *St. Louis Post-Dispatch*. "Galvin labored throughout his career without the benefit of pennant-winning publicity, as a further example of why he faded into baseball's memory. Most of the time, he was saddled with the handicap of trying to win for a second-division ballclub."

—T. Wendel

Copyright 1887.
Goodwin & Co.

~Galvin. P. Pittsburg.

RED RUFFING

CLASS OF 1967

Charles "Red" Ruffing overcame a youth filled with adversity to forge a notable and successful career. Merely reaching the major leagues would have been impressive, but Ruffing took his success to remarkable levels.

Raised in Illinois, Ruffing worked in a coal mine as a teenager. A horrifying accident, in which his left foot was caught between two coal cars, resulted in the loss of four toes. He had to give up playing the outfield and switch to pitching.

Yet Ruffing did not allow serious injury to derail his plan of playing professional ball. Traded by a minor league team to the Boston Red Sox, he made his big league debut at age nineteen, though he was not ready. Struggling badly in eight appearances, he would flounder for the doormat Red Sox that season. While over his first six seasons he had some success, Ruffing did not post a winning record until he was twenty-five.

Success didn't come Ruffing's way till after the Sox traded him to the New York Yankees for backup outfielder Cedric Durst and $50,000. The transaction would rank as one of the most productive in Yankees history. At first bolstered by better run support, Ruffing became a frontline starter by his third season in New York. He posted a hugely improved 3.09 ERA, won eighteen games, and led the league in strikeouts.

Ruffing's 1932 campaign marked the start of a wonderful run of eleven seasons. During that stretch, he won 188 games against only 101 losses. He routinely pitched 230 or more innings, despite constant pain in his left foot.

Just as Ruffing improved his pitching upon being traded to the Yankees, he continued to make adjustments in later years. "Charlie came up with a helluva curve in '36," Hall of Fame catcher Bill Dickey informed the *Saturday Evening Post*. "Until then he had just a slight ripple with no snap. Now that dipsy-dew really breaks off. I don't know more than three, four curves in the league better. The way the guy suddenly developed as a smart pitcher was a revelation."

Two years after refining his curve, Ruffing led the league with twenty-one wins.

He remained effective until 1942, when he was inducted into the Air Force during World War II. He missed the equivalent of 2½ seasons before making a comeback in mid-1945.

After one of his starts in 1946, Dickey marveled at Ruffing's mastery of the art of pitching. "Catching Ruffing is a tremendous kick," Dickey told sportswriter Dan Daniel. "The way that bird operates on the hitters is something that ought to be put in a pitching text book."

Ruffing also knew something about hitting. Regarded by some as the greatest-hitting pitcher in the big leagues, he clubbed thirty-six home runs in twenty-two seasons. Ruffing was so dangerous with a bat that his managers often summoned him to pinch-hit.

As a young man, Red Ruffing could have given up the game completely. Instead, he dedicated himself fully, overcame intense pain, and became one of the most well-rounded pitchers of the twentieth century.

—B.M.

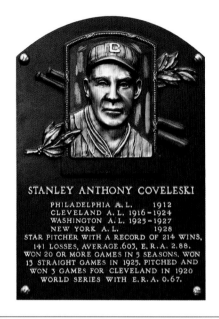

STANLEY ANTHONY COVELESKI
PHILADELPHIA A.L. 1912
CLEVELAND A.L. 1916-1924
WASHINGTON A.L. 1925-1927
NEW YORK A.L. 1928
STAR PITCHER WITH A RECORD OF 214 WINS,
141 LOSSES, AVERAGE .603, E.R.A. 2.88.
WON 20 OR MORE GAMES IN 5 SEASONS. WON
13 STRAIGHT GAMES IN 1925. PITCHED AND
WON 3 GAMES FOR CLEVELAND IN 1920
WORLD SERIES WITH E.R.A. 0.67.

STAN COVELESKI

CLASS OF 1969

Things were a lot less structured in the baseball world when Stan Coveleski was growing up in the late nineteenth century in Shamokin, Pennsylvania. He played a little amateur baseball but mostly developed his strong right arm throwing rocks.

"See, I worked in the mines, coal mines, when I was 12 years old," said Coveleski, who was also influenced to take up baseball by brother Harry, another major league pitcher, three years older. "I worked from seven in the morning to seven at night for $3.75 a week. I had a habit of throwing stones, see. After working I'd put a can on a log, or tie it to a tree and throw and throw and throw at it."

Coveleski felt that pitching in a real game was easier than trying to hit the tin can at fifty feet because home plate was much bigger.

Coveleski got noticed by the Lancaster Red Roses of the Tri-State League. After a while, watching pitchers in other leagues, Coveleski became intrigued by the spitter. "I saw them throwing the spitball and I said to myself, 'By gosh I'm going to try to throw that,'" Coveleski said. "I started working on that spitball and I could make it do practically anything I wanted it to do."

When Coveleski reached the majors in 1912 with the Philadelphia Athletics, the spitter became his out-pitch. "I could throw my spitball as a fastball and the knuckleball as the slow ball," he said. "Just wet them two fingers. Then I'd hold it back with my thumb and slip it over."

The biggest thrill of Coveleski's career was winning three games in the 1920 World Series to gift wrap the title for the Cleveland Indians. Coveleski, who lived to be ninety-four, got a late-in-life thrill when he was inducted into the Hall of Fame in 1969, as he approached his eightieth birthday.

Covelseki did not possess intimidating speed. His goal was to fool the batter, not overpower him. Although he did lead the American League in strikeouts once, that achievement was a by-product of his daily work. "I never tried for a strikeout unless I really needed one," Coveleski said.

Control and location were what Coveleski stressed. He studied the holes in hitters' swings and noted what they couldn't reach because of their stances.

"Babe Ruth?" Coveleski recalled. "Outside and low where he couldn't get ahold of it. I wouldn't pitch inside to Babe. He'd kill it. It was the guys who crowded the plate and choked up on the bat who gave me problems. They could reach the ball wherever it was thrown."

For Coveleski, the spitter was a dual weapon. He used it for real to baffle hitters, but he counted on their knowing he had it in his repertoire to throw them off balance mentally. "I went to the mouth every pitch," Coveleski said. "I wouldn't maybe throw all spitballs. I'd go maybe two or three innings without throwing a spitter, but I'd always have them looking for it."

—L.F.

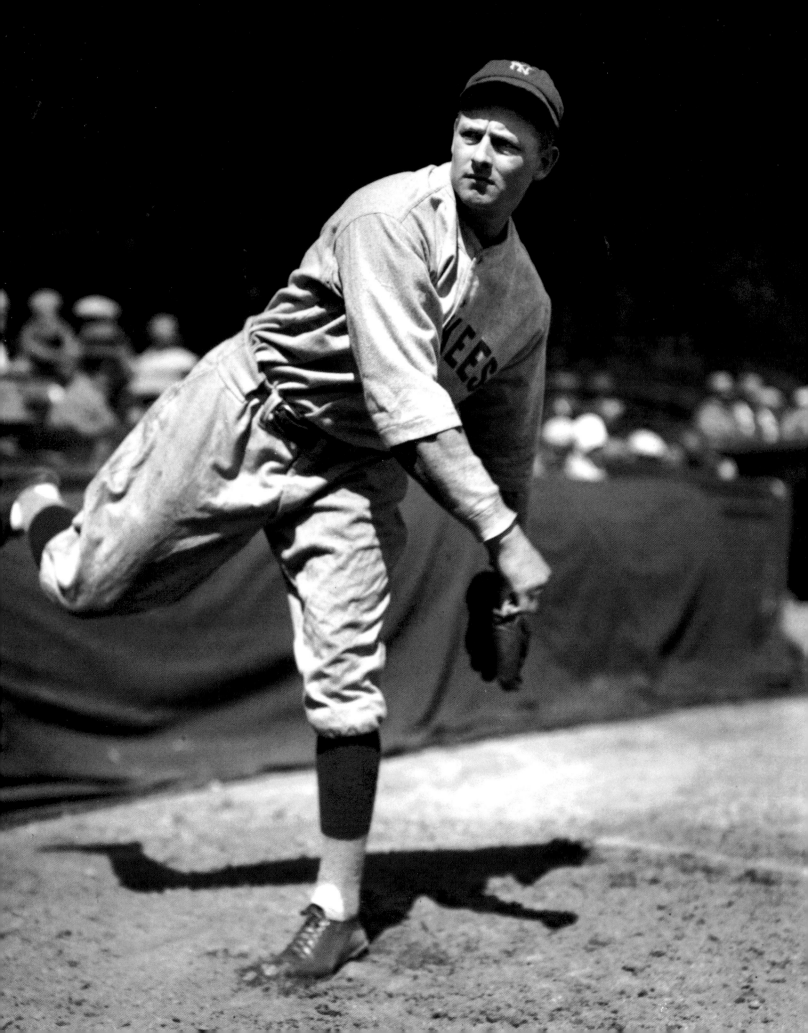

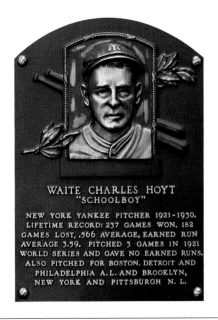

WAITE HOYT

CLASS OF 1969

It was only one game, but Waite Hoyt made his major league debut at age eighteen in 1918 for the New York Giants after being signed as a fifteen-year-old. Mingling with older men, Hoyt was labeled "The Schoolboy Wonder." He stuck around the majors long enough—twenty-one years—that he went from being among the youngest players in the sport to being the oldest and most respected.

Being the youngest ever to sign at that time inundated Hoyt with public attention. "I became something of a national oddity," he said, "and a hero among my peers. The publicity and projection were nationwide and the thrill was traumatic and overpowering."

Indications are that during his remarkable career, which later included twenty-four seasons broadcasting Cincinnati Reds games, Hoyt had a good time every minute, and if he couldn't pitch a baseball, the other things he enjoyed the most were watching baseball and talking about baseball.

Hoyt wanted to be a Yankees broadcaster but couldn't get hired after his retirement in 1938 because it was felt that ballplayers were not articulate enough for the booth. Often cited as an example of Hoyt's linguistic capabilities was an argument he had with umpire George Moriarty. "You're out of your element," Hoyt shouted when he believed that the arbiter had blown a call. "You should be a traffic cop so you could stand in the middle of the street with a badge on your chest and insult people with impunity." Hoyt also performed in vaudeville with Jack Benny, George Burns, and others, and that required fast talking.

A member of the 1927 Yankees, Hoyt pitched in seven World Series. That Murderers' Row club was not only talented, he believed, but also highly focused on the game. "Our bench was like a second grade school room," Hoyt said. "If you talked, you talked baseball. The manager maintained discipline like we were in the second grade and had our hands clasped behind our backs."

Hoyt changed teams nine times (including playing for two teams twice), but when it was noted how famous he was, he demurred, saying, "The secret of success in pitching lies in getting a job with the Yankees." Hoyt represented the Yankees in six World Series.

World Series time was always so exciting for him that Hoyt couldn't understand the country boys he played with who fled the big city for their farms almost the moment the season ended. "They wouldn't stay around for the World Series if you gave them tickets," Hoyt said, "and they missed the best part of the year."

Hoyt was on a golf course in 1969 when he received the telephone call informing him of his selection to the Hall of Fame. He was overcome. "The impact was so great it shook my nervous system to the point I could not continue to answer the questions of the caller," he said. "I had to tell him I was shaking all over, and crying at the same time, which embarrassed me."

—L.F.

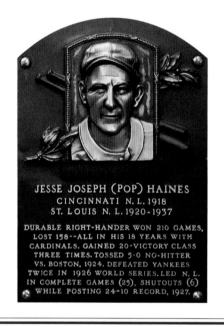

JESSE JOSEPH (POP) HAINES
CINCINNATI N.L. 1918
ST. LOUIS N.L. 1920-1937

DURABLE RIGHT-HANDER WON 210 GAMES,
LOST 158--ALL IN HIS 18 YEARS WITH
CARDINALS. GAINED 20-VICTORY CLASS
THREE TIMES. TOSSED 5-0 NO-HITTER
VS. BOSTON, 1924. DEFEATED YANKEES
TWICE IN 1926 WORLD SERIES. LED N. L.
IN COMPLETE GAMES (25), SHUTOUTS (6)
WHILE POSTING 24-10 RECORD, 1927.

JESSE HAINES

CLASS OF 1970

The knuckleball became right-hander Jesse Haines's best friend when he realized he didn't have enough stuff otherwise to make it as a big league winner. Haines was so reliant on the knuckler that his fingers often bled in his starts.

"When I came to the Cards," Haines said of his rookie season in 1920, after having been the property of the Cincinnati Reds, "I had a fastball and a curve. But it was not much of a curve. I soon found I would have to have something else if I stuck around long, so began at once to work on a knuckleball. I worked on that ball for years. Thought I had it in 1925, but it eluded me the next year. Not until mid-summer of 1926 did the mystery of it come back to stay. And then I started to throw a slow ball. That helped me almost as much as the knuckler. The longer a man lives, the more he learns."

Haines actually pitched in one game for the Reds in 1918, but manager Christy Mathewson sent him down for seasoning in Tulsa in 1919. The pitcher did not respond to the change of climate, and his Tulsa manager dumped Haines "for a song and a silk handkerchief" to Kansas City. He began winning. His old Tulsa manager took it personally, as if Haines hadn't tried for him. When the Cardinals obtained him, Haines said, the Tulsa manager "bet a suit of clothes with [longtime baseball manager] Pants Rowland that I would not stick in the big leagues until

June 1," adding, "Well, that was a long time ago and I am still sticking 'round. I have often wondered since whether or not Rowland collected his suit of clothes."

Haines remained in the majors until he was forty-four, eventually gaining the nickname "Pop."

One of Haines's trademarks was working fast on the mound. As soon as the catcher threw the ball back to him, he was raring to go. He was a regular in the World Series for the Cardinals, and two of his complete-game starts took just one hour, forty-one minutes to play. Haines compared his swift delivery habits to those of a later Cardinals pitcher. "I pitched a lot like Bob [Gibson]," Haines said. "He doesn't fool around out there; I didn't either."

When Haines was pitching, between 1918 and 1937, there was no dawdling permitted. "Umpire Bill Klem would keep yelling to us pitchers," said Haines. "'Hustle it up, hustle it up, that's what the people are paying their good money for.'"

Haines was seventy-seven when inducted into the Hall of Fame in Cooperstown, and not in perfect health. But the day of the ceremony felt perfect to him.

"Friends of this great old game," Haines said in his induction speech, "they called on me first today and maybe there's a reason. I just got out of the hospital and maybe they thought I wouldn't last. But I am here for what has to be the greatest of all my thrills."

—L.F.

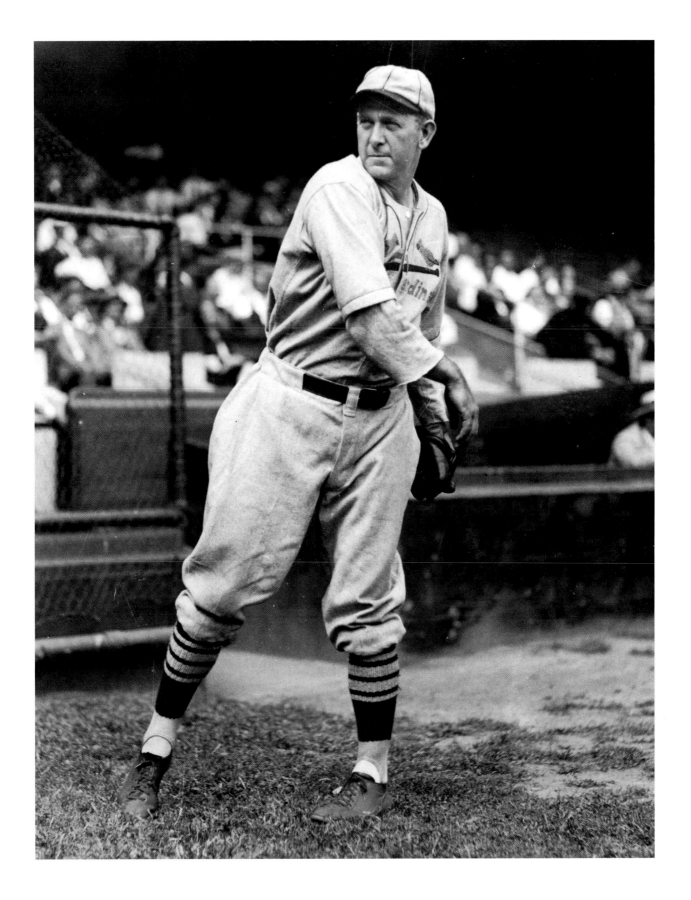

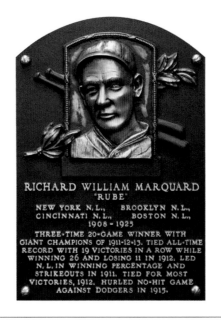

RICHARD WILLIAM MARQUARD
"RUBE"
NEW YORK N. L., BROOKLYN N. L.,
CINCINNATI N. L., BOSTON N. L.,
1908 - 1925
THREE-TIME 20-GAME WINNER WITH
GIANT CHAMPIONS OF 1911-12-13. TIED ALL-TIME
RECORD WITH 19 VICTORIES IN A ROW WHILE
WINNING 26 AND LOSING 11 IN 1912. LED
N. L. IN WINNING PERCENTAGE AND
STRIKEOUTS IN 1911. TIED FOR MOST
VICTORIES, 1912. HURLED NO-HIT GAME
AGAINST DODGERS IN 1915.

RUBE MARQUARD

CLASS OF 1971

Pitcher Rube Marquard, famed for winning a record nineteen games in a row, was born Richard, even if nobody called him that. The nickname "Rube" implied that he was a bit on the flaky side, and he didn't deny that, emphasizing the image by joining the vaudeville circuit and marrying his partner, Blossom Seeley.

A southpaw from Cleveland, Marquard joked that everyone thought he was a country boy because of the nickname, but while he was in the minors, a sportswriter compared him to Rube Waddell, and that was the origin of the moniker. The New York Giants paid a reported $11,000 to pluck him out of the minors in 1908, and he believed his services were well worth the price.

When Marquard was in high school, his dad wanted him to bear down on his studies and go to college to make something of himself. Marquard replied, "I already have a job." His father didn't even believe that baseball players made money. "Yes, they get paid," Marquard argued. Not very much money then; Marquard collected $200 for his first minor league assignment.

Only a few years passed before Marquard showed his dad and everyone in the game that he was a top hurler, and later, to demonstrate his know-how, he wrote a book called *How to Pitch: Ten Great Lessons for the Boy.* His author credit referred to him as "The Master Southpaw."

Marquard proceeded to reveal many of his mound secrets. "From my experience of 25 years in baseball," the Master Southpaw wrote, "I have learned that control is fully 90 percent of successful pitching. If a pitcher has control, he has everything. The entire importance of pitching lies in the ability to pitch to a 'spot' and put the ball where you want it."

Affirming his credentials as an expert was the fact that Marquard won 201 games in his career, though more attention was focused on his nineteen-game winning streak of 1912. Marquard counted on the impeccable reputation of his Giants manager John McGraw for an endorsement to get fans to buy the book. McGraw's blurb sounds lukewarm a century later, but advertising was not terribly sophisticated then. "I consider Rube Marquard thoroughly capable of writing a book telling the youngsters how to pitch," McGraw declared, his words emblazoned on the cover of the tome.

While that single paragraph about control may have given the impression that it pretty much covered all the important elements of pitching according to Marquard, he did have a lot more to say in the volume aimed at aspiring young twirlers. "If you are seriously interested in a career as a successful baseball pitcher, you must begin at once to build a strong constitution," Marquard wrote. "The stronger you are, the better are your chances of succeeding. Remember that your pitching days are numbered by the strength that lies in your arm and your body. Regardless of how much natural ability you may possess you will never get far unless you apply your mind as well."

—L.F.

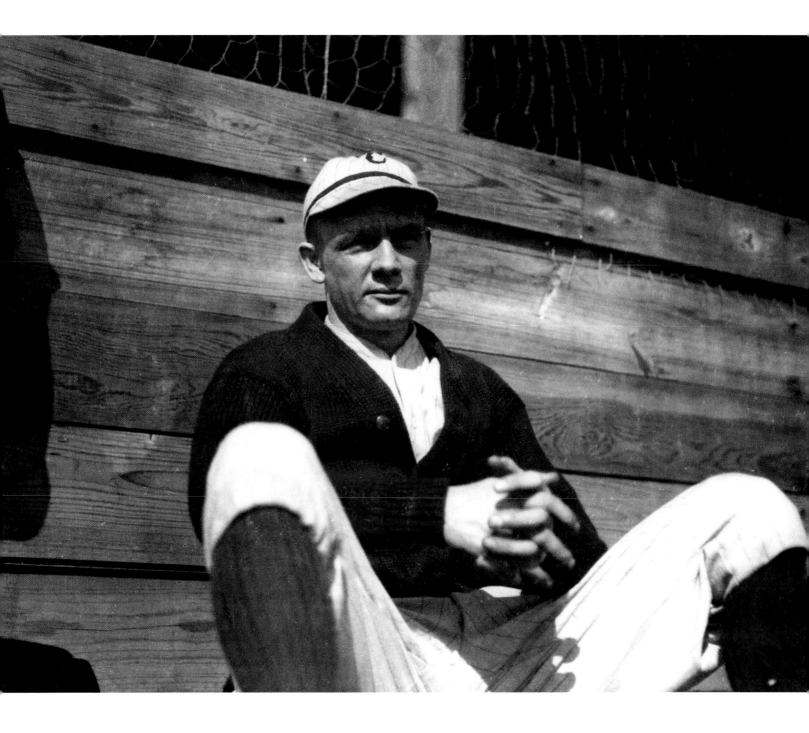

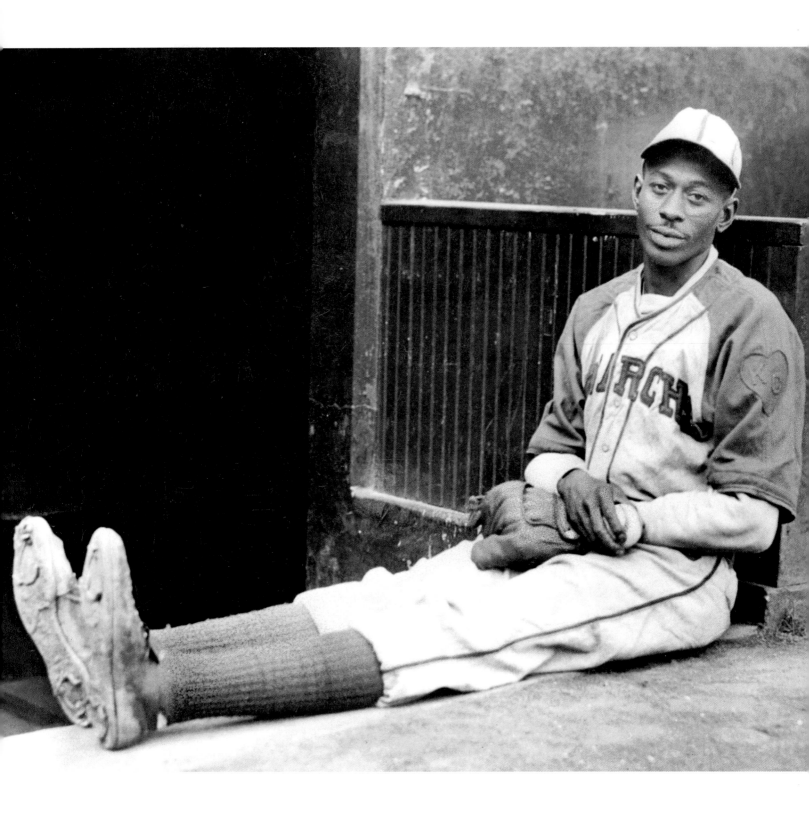

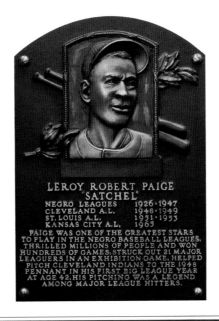

LEROY ROBERT PAIGE
"SATCHEL"
NEGRO LEAGUES 1926·1947
CLEVELAND A.L. 1948·1949
ST. LOUIS A.L. 1951·1953
KANSAS CITY A.L. 1965
PAIGE WAS ONE OF THE GREATEST STARS
TO PLAY IN THE NEGRO BASEBALL LEAGUES.
THRILLED MILLIONS OF PEOPLE AND WON
HUNDREDS OF GAMES. STRUCK OUT 21 MAJOR
LEAGUERS IN AN EXHIBITION GAME. HELPED
PITCH CLEVELAND INDIANS TO THE 1948
PENNANT IN HIS FIRST BIG LEAGUE YEAR
AT AGE 42. HIS PITCHING WAS A LEGEND
AMONG MAJOR LEAGUE HITTERS.

SATCHEL PAIGE

CLASS OF 1971

Joe DiMaggio called Satchel Paige simply "the best and fastest pitcher I've ever faced."

Because of the color barrier that existed in big league baseball until 1947, when Jackie Robinson broke in with the Brooklyn Dodgers, few major league fans saw Paige at his best.

"Through no fault of his own, Satchel never got a chance to show what he could do," legendary team owner Bill Veeck once said. "He would have broken every pitching record in the book. . . . Satchel was a showman, one of very few in baseball. Babe Ruth was in the same class, but Ted Williams and Willie Mays were to a lesser degree.

"You may have been a good hitter with impressive statistics, but that didn't faze Satchel. He wasn't a braggart, but he had utmost confidence in himself."

At the height of his career, from 1927 to 1947, Paige was restricted to playing in the Negro Leagues and was matched up against the big leagues' best hurlers, such as Bob Feller and Dizzy Dean, only in exhibition games. But anybody who went against him soon proclaimed his prowess.

In a discussion of the best pitchers ever to play the game, Dean told the *New York Daily News* that Paige was the best he ever saw. "I have pitched 31 games against that Satchel Paige," Dean said, "and that guy really has something."

Born in Mobile, Alabama, in 1906, Paige was the seventh of

eleven children, and from an early age, baseball was his ticket to the bright lights and big city. With a wide array of pitches, including two fastballs, the trouble ball, and the bee ball (so called because it buzzed past the batter), Paige dazzled hitters at every level.

Hack Wilson once described Paige's fastball as a pitch that started out "like a baseball and when it gets to the plate, it looks like a marble."

Pitching almost any day it didn't rain, Paige hired out to teams on both coasts, as well as the top ball clubs in Puerto Rico, the Dominican Republic, Cuba, and Mexico. It wasn't until 1948, a year after Robinson's debut, that Paige finally got an opportunity to pitch in the majors. When Veeck signed him to a contact with the Cleveland Indians, Paige wasn't bothered by the pressure despite reportedly being forty-two years old. "Plate's the same size, ain't it?" he said.

During his first season in the majors, Paige drew big crowds—home and away—and helped lead the Indians to the American League Pennant and World Series title. He would be inducted into the National Baseball Hall of Fame in 1971.

"I'm told we see the light of stars down here on earth long after they've burned out," his longtime friend and teammate Buck O'Neil wrote in *Reader's Digest*, "and that's the way I feel about Satchel."

At Paige's funeral, O'Neil said, "It's a lovely thing to live with courage and die leaving an everlasting flame. In a sense, Satchel did have a lovely life, and he left all of us who were lucky enough to know him the brighter for his light."

—T. Wendel

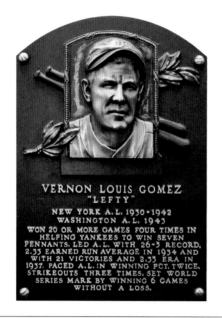

VERNON LOUIS GOMEZ
"LEFTY"
NEW YORK A.L. 1930-1942
WASHINGTON A.L. 1943
WON 20 OR MORE GAMES FOUR TIMES IN
HELPING YANKEES TO WIN SEVEN
PENNANTS. LED A.L. WITH 26-5 RECORD,
2.33 EARNED RUN AVERAGE IN 1934 AND
WITH 21 VICTORIES AND 2.33 ERA IN
1937. PACED A.L. IN WINNING PCT. TWICE,
STRIKEOUTS THREE TIMES. SET WORLD
SERIES MARK BY WINNING 6 GAMES
WITHOUT A LOSS.

LEFTY GOMEZ

CLASS OF 1972

There is no baseball rule that says one cannot be colorful and offbeat while also excelling at the game. If there was, Lefty Gomez would never have existed.

Born to a Spanish father and raised on a California dairy farm, Gomez made his debut for the New York Yankees in 1930. He struggled as a rookie, but learned from the experience, and bounced back as a twenty-one-game winner. In 1934 he won the pitching Triple Crown with league-leading marks in wins, ERA, and strikeouts.

As the Yankees' left-handed ace of the 1930s, Gomez stood in contrast to his businesslike teammates. Unlike quiet stars like Joe DiMaggio, Gomez had an outgoing nature with a comic touch that would have rivaled that of any professional comedian. "He was funnier than Bob Hope," Phil Rizzuto told the *New York Post*, "considering he didn't have a script."

Gomez even dared to venture where no other Yankee would go by needling the great DiMaggio. "Joe D." allowed the older Gomez to include him in the clubhouse fun, partly because he looked to him as a father figure but also because he considered his teammate to be genuinely funny.

To people inside the game, Gomez was known as "Goofy." That nickname fit his delightfully oddball behavior. During a World Series game at the Polo Grounds, he stopped pitching just to watch a plane fly overhead. He also once bragged about a new invention he had come up with: a revolving bowl for tired goldfish.

Gomez brought a nervous energy to the Yankees, a characteristic noted by manager Joe McCarthy. "He wants to pitch all the time," McCarthy told the *Brooklyn Eagle*. "If he isn't working, he gives me the fidgets in a tight game. He wanders from one end of the dugout to the other."

Gomez's antics sometimes put McCarthy on edge, but they kept the Yankees clubhouse loose, which contributed to a winning atmosphere. Gomez pitched his best in World Series play, where he put up a sparkling 2.86 ERA and went 6–0. He also thrived in All-Star Games, starting five and winning three.

Tall and gangly, Gomez could appear clumsy, but that impression masked his talent. He threw with an extremely high leg kick, which added an element of deception, and he finished off hitters with a blazing fastball.

Ever modest, Gomez liked to poke fun at himself, in particular his struggles as a hitter. He showed his humility at his 1972 induction. "I want to thank . . . my teammates who scored so many runs and helped me," Gomez said in Cooperstown, "and Joe DiMaggio, who ran down all my mistakes, and certainly . . . [reliever] Johnny Murphy. . . . If it wasn't for John, I wouldn't be here either, believe me."

As always with Gomez, he had no desire to brag or boast. He was far more interested in giving credit to his teammates, making jokes at his own expense, and having as much fun as possible.

—B.M.

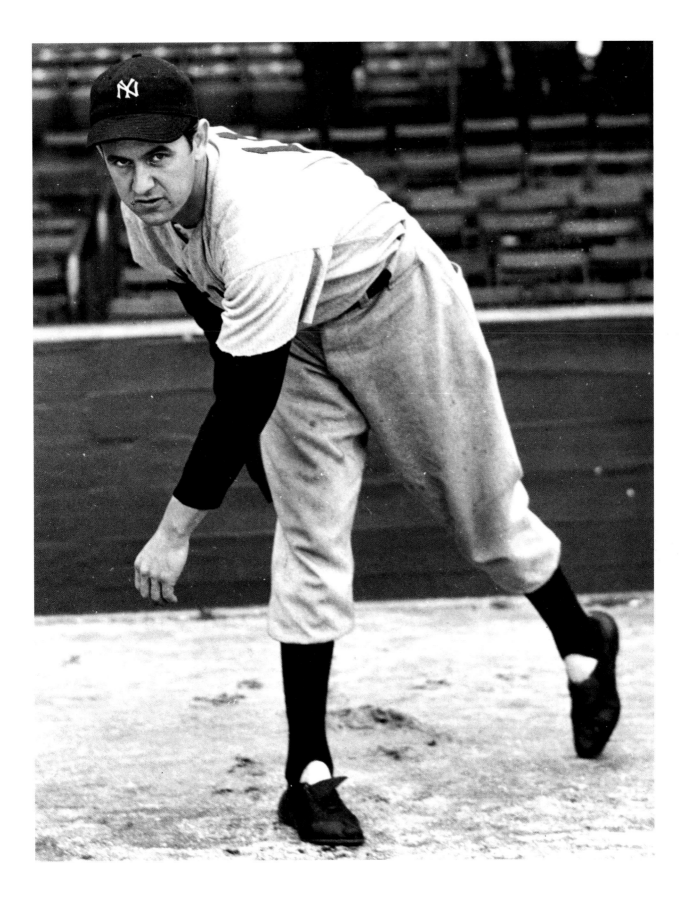

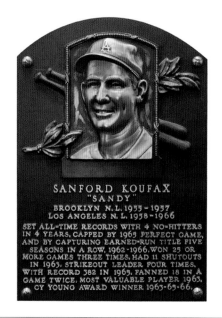

SANFORD KOUFAX
"SANDY"
BROOKLYN N.L. 1955-1957
LOS ANGELES N.L. 1958-1966
SET ALL-TIME RECORDS WITH 4 NO-HITTERS
IN 4 YEARS, CAPPED BY 1965 PERFECT GAME,
AND BY CAPTURING EARNED-RUN TITLE FIVE
SEASONS IN A ROW, 1962-1966. WON 25 OR
MORE GAMES THREE TIMES, HAD 11 SHUTOUTS
IN 1963. STRIKEOUT LEADER FOUR TIMES,
WITH RECORD 382 IN 1965. FANNED 18 IN A
GAME TWICE, MOST VALUABLE PLAYER 1963,
CY YOUNG AWARD WINNER 1963-65-66.

SANDY KOUFAX

CLASS OF 1972

Sandy Koufax actually had two careers in one. For roughly the first half of his twelve-year major league career, he was known more for his potential than for his results. But after an impromptu session one spring, he turned himself into one of the top pitchers of all time.

During a spring training game in 1961, Koufax walked the bases full in the first inning. That's when catcher Norm Sherry suggested he take a little bit off his fastball, try for some control rather than pure velocity. Koufax got out of the inning, with a valuable lesson learned.

"Of course, this was well before radar guns," Sherry recalled decades later. "But Sandy easily threw above 100 miles an hour. The key for him, you could say his career really, was him realizing that he didn't have to throw all that hard to be effective."

After 1960 Koufax never had a losing record again and led the National League in victories in 1963, 1965, and 1966. In addition, he paced the league in earned run average in five seasons, and complete games and innings pitched in two years.

"People who write about spring training not being necessary have never tried to throw a baseball," Koufax later said.

After turning around his career, the dominating left-hander pitched no-hitters in four consecutive seasons, culminating with his memorable perfect game in 1965. Koufax also posted a 0.95 ERA in four World Series matchups, leading the Dodgers to three championships.

"Trying to hit him was like trying to drink coffee with a fork," said Pittsburgh's Willie Stargell.

"He throws a 'radio ball,'" added manager Gene Mauch, "a pitch you hear, but you don't see."

Many opposing batters agreed that getting a foul ball off Koufax in his prime was a moral victory.

"With any of these great pitchers, the questions become, 'Can they harness their stuff? Can they pull together what's been given to them sufficiently to become great?'" said Jeff Torborg, who caught Koufax's perfect game in September 1965. "That's not an easy thing to do. . . . But Sandy certainly delivered."

Later that season, when Game 1 of the World Series fell on Yom Kippur, Koufax made headlines by refusing to play. A well-known Jewish athlete, he went to synagogue rather than take the mound that day. Even though Koufax lost the following day, he defeated the Minnesota Twins in Games 5 and 7 as Los Angeles took the championship.

Because of an arthritic arm, Koufax was forced to retire after the 1966 season, when he went 27–9, with a 1.73 ERA, and won his third Cy Young Award. "I don't regret for one minute the 12 years I've spent in baseball," he said, "but I could regret one season too many."

Koufax finished with a lifetime record of 165–87, a 2.76 ERA, and 2,396 strikeouts in 2,324⅓ innings. He was only thirty-six years old when he was voted into the Hall of Fame.

—T. Wendel

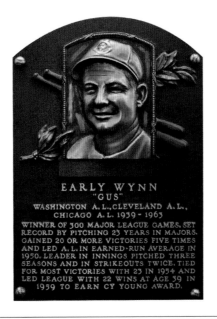

EARLY WYNN
"GUS"
WASHINGTON A.L., CLEVELAND A.L.,
CHICAGO A.L. 1939 - 1963
WINNER OF 300 MAJOR LEAGUE GAMES. SET
RECORD BY PITCHING 23 YEARS IN MAJORS.
GAINED 20 OR MORE VICTORIES FIVE TIMES
AND LED A.L. IN EARNED-RUN AVERAGE IN
1950. LEADER IN INNINGS PITCHED THREE
SEASONS AND IN STRIKEOUTS TWICE. TIED
FOR MOST VICTORIES WITH 23 IN 1954 AND
LED LEAGUE WITH 22 WINS AT AGE 39 IN
1959 TO EARN CY YOUNG AWARD.

EARLY WYNN

CLASS OF 1972

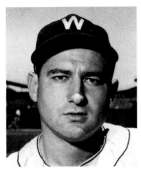

Early Wynn did not pitch with a smile. He approached every game as if it were a life-and-death experience. So he brought to the mound a fiery tenacity that helped him become a three-hundred-game winner.

Wynn's trek to the major leagues involved an unusual route. He attended a Washington Senators tryout camp, where he pitched well enough to receive a professional contract. After a cup of coffee in 1939, he arrived for good two years later.

Relying too heavily on his fastball, Wynn struggled for much of the 1940s. So in 1948 the Senators traded him, along with Mickey Vernon, to the Cleveland Indians for three lesser players. It was a stroke of genius on the part of Indians owner Bill Veeck.

The trade enabled Wynn to work with pitching coach Mel Harder, who rather remarkably taught the raw right-hander four pitches: a curveball, a change, a slider, and a knuckleball. In 1950, Wynn blossomed. With his league-best ERA, he joined forces with Bob Feller, Bob Lemon, and Mike Garcia to form the league's best quartet of starting pitchers.

In 1954 Wynn won twenty-three of the Indians' record-setting 111 victories. He would not endure his first losing season with Cleveland until 1957.

Wynn pitched as if he hated hitters. He stalked the mound with a grim scowl. He treated the pitcher's mound as his office, a place of serious business. Just as he disliked hitters, Wynn also

hated being taken out of a game. Indians manager Al Lopez said that most of his hurlers simply handed over the ball when he pulled them from the game. "I usually stick out my hand and hope [the pitcher] puts the ball in it," Lopez told *Baseball Digest.* "Except the one time I went out to take Early Wynn out. I stuck out my hand and he hit me right in the stomach with the ball."

Off the field, Wynn behaved very differently. He had an easygoing demeanor and enjoyed playing practical jokes, making him popular with teammates.

After the 1957 season, the Indians traded him to the Chicago White Sox as part of a deal for Minnie Miñoso. With the Sox, Wynn remained a dominating pitcher, even as he struggled with a painful ailment. "I've had gout for around eight, nine years," Wynn told *Sports Illustrated* in 1962. "I get it in the arm, right around the elbow. My elbow becomes aggravated and swollen. In the spring, when I do a lot of running, I get it around the heels because the shoes rub there so much."

Overcoming the pain, Wynn remained an effective pitcher even at an advanced age. In 1959, as the elder statesman of the White Sox staff at thirty-nine, Wynn claimed the Cy Young Award, propelling the Sox to an elusive pennant.

Rough and rugged, Wynn left a distinct mark on those batters who opposed him. "Early Wynn was the toughest pitcher I ever faced," Ted Williams told Arthur Daley of the *New York Times.* It would be hard to find higher praise than that.

—B.M.

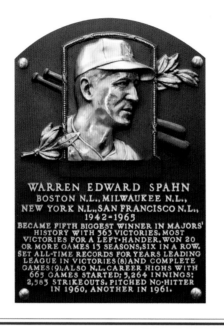

WARREN EDWARD SPAHN
BOSTON N.L., MILWAUKEE N.L.,
NEW YORK N.L., SAN FRANCISCO N.L.,
1942-1965
BECAME FIFTH BIGGEST WINNER IN MAJORS'
HISTORY WITH 363 VICTORIES. MOST
VICTORIES FOR A LEFT-HANDER. WON 20
OR MORE GAMES 13 SEASONS, SIX IN A ROW.
SET ALL-TIME RECORDS FOR YEARS LEADING
LEAGUE IN VICTORIES (8) AND COMPLETE
GAMES (9). ALSO N.L. CAREER HIGHS WITH
665 GAMES STARTED; 5,264 INNINGS;
2,583 STRIKEOUTS. PITCHED NO-HITTER
IN 1960, ANOTHER IN 1961.

WARREN SPAHN

CLASS OF 1973

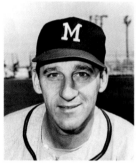

A late start to a major league career does not preclude a Hall of Fame induction. There may not be a better example of such a phenomenon than Warren Spahn.

Spahn always credited his father with teaching him the proper mechanics, which gave him a foundation for pitching. "He taught me how to follow through with my shoulder and body, how to throw without any strain, how to get the most out of my pitch and out of my weight even when I was a skinny kid," Spahn told famed sportswriter Bob Broeg. "He taught me how to roll a curveball, how to let it go off my fingers at the last moment. He taught me how to pass my knee by my right elbow."

"I thought it was a lot of drudgery. It was lots more fun just to pick up the ball and throw, but Dad wouldn't let me play catch unless I did it correctly."

Developing a deceptive high-kicking delivery, Spahn made his way to the Boston Braves in 1942, arriving at the age of twenty. Almost immediately, he saw his career halted by World War II. On active duty in the U.S. Army, Spahn gained acclaim as a war hero. Experiencing the horrors of war firsthand, he fought at the Battle of the Bulge and earned the Purple Heart and the Bronze Star for his courageous efforts.

Losing three seasons to the war, Spahn did not return to the major leagues until 1946, and did not put in his first full season until 1947. He quickly made up for lost time. Spahn would win twenty or more games thirteen times. He would capture the Cy Young Award in 1957. He also authored two no-hitters during his career.

By the 1960s, Spahn had to make concessions to advancing age. Unlike many hurlers, he made the successful transition from power pitcher to crafty left-hander. "I'm smarter now than when I had the big fastball," he told *Time* magazine in 1960. "Sometimes I get behind hitters on purpose. That makes them hungry hitters. They start looking for fat pitches. I make my living off hungry hitters."

A young catcher who moved into the Milwaukee Braves' starting lineup in 1961 immediately gained an appreciation of his much older teammate. "Warren Spahn was a fighter and a winner," Joe Torre told the Associated Press. "He made catching in the big leagues a lot easier for me because he took me under his wing along with Lew Burdette. One of my biggest thrills to this day was catching his 300th victory in 1961."

As if his pitching wasn't sufficient, Spahn was also regarded as one of the better-hitting pitchers of his era. He clubbed thirty-five home runs, the most for a pitcher in the history of the National League.

Continuing to pitch through his forty-fourth birthday, the durable Spahn won more games than any other southpaw in history, compiling a lofty total of 363 victories. It is a record that becomes all the more impressive given his sacrifice for his country and his deserving status as a full-fledged American hero.

—B.M.

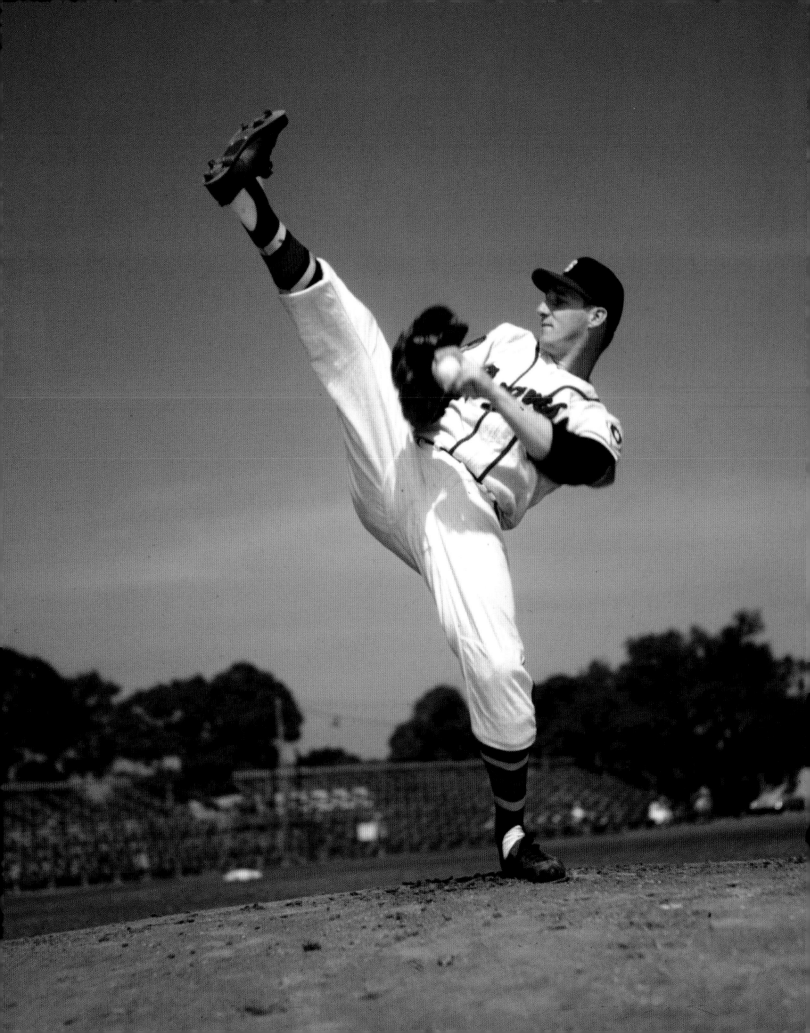

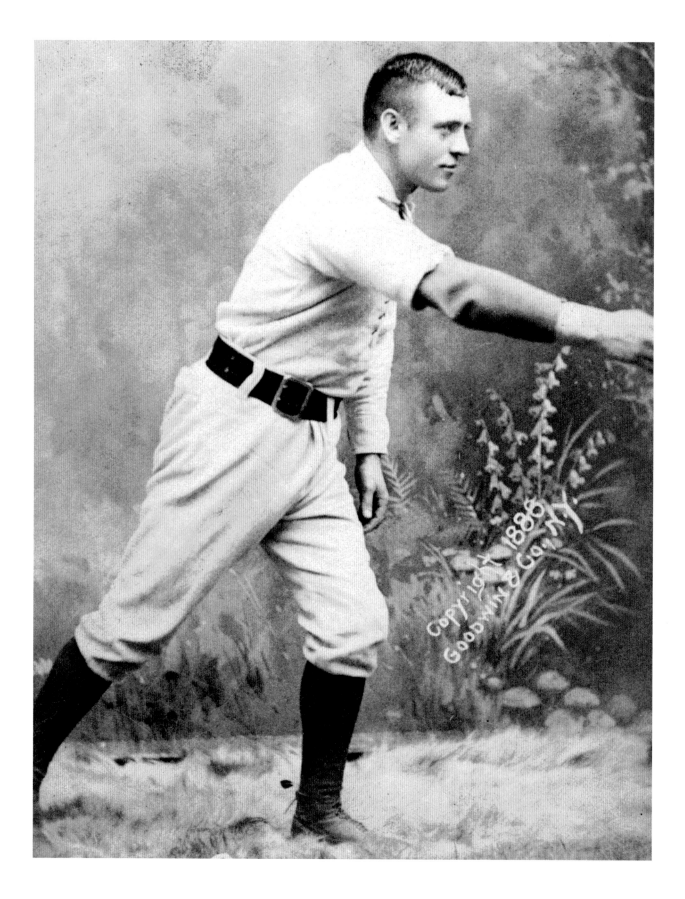

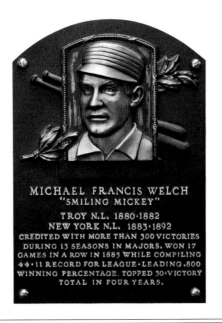

MICHAEL FRANCIS WELCH
"SMILING MICKEY"
TROY N.L. 1880·1882
NEW YORK N.L. 1883·1892
CREDITED WITH MORE THAN 300 VICTORIES
DURING 13 SEASONS IN MAJORS. WON 17
GAMES IN A ROW IN 1885 WHILE COMPILING
44·11 RECORD FOR LEAGUE·LEADING .800
WINNING PERCENTAGE. TOPPED 30·VICTORY
TOTAL IN FOUR YEARS.

MICKEY WELCH

CLASS OF 1973

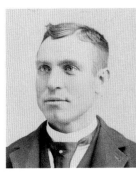

The third pitcher in baseball history to win at least three hundred games, Mickey Welch topped the mark in a hurling career that was completed by 1892. His right arm was so durable he once had to have a clause inserted in his contract with the New York Giants forbidding managers from starting him more often than every other day.

Welch was busy enough, and in 1885 he posted one of the most mind-boggling seasons by any pitcher, going 44–11 with a 1.66 earned run average. Welch was more crafty than overpowering and once won seventeen straight games. "It was just a slow curve that broke down and in on a right-handed hitter and I got a lot of good results with it in the years I pitched for the Giants," he said of his best pitch.

Welch was on the mound for the first game the Giants, then known as the Gothams, played at the original Polo Grounds in 1883.

Although a big leaguer for just thirteen seasons, Welch made his mark not just with his victories but with his personality. His nickname was "Smiling Mickey" because that's what he did all the time. Unlike most of his teammates, Welch eschewed a handlebar mustache and sideburns, and it was known that he didn't drink, smoke, or curse. At a time when baseball players were viewed as ruffians, this was an unusual combination.

Many of Welch's positive results were recorded when the distance from the mound to home plate was shorter than the sixty-feet, six-inch rule that was eventually adopted. Perhaps it made sense for a pitcher who relied on guile over sheer speed to adopt Welch's philosophy of the game.

"I've seen 'em come and go and I want to tell you that in picking an all-time All-Star team most experts make a mistake," said Welch, who died in 1941. "They ignore brains and go for brawn. Believe me, I could put a dream team on the field, smart fighters, who'd beat any team you could assemble. They'd fight at the drop of a hat, but they'd score runs for you."

Welch, selected for the Hall of Fame by the Veterans Committee in 1973, thirty-two years after his death, did name a personal all-time team, and it included such pitchers as Christy Mathewson, John Clarkson, Tim Keefe, and Carl Hubbell and such position players as Ty Cobb, Frank Frisch, Willie Keeler, and Hugh Duffy.

Approaching his eightieth birthday when he made his selections public in 1939, Welch took some criticism for skipping Babe Ruth and overlooking Lou Gehrig in favor of Jack Doyle at first base. "Gehrig could hit, but couldn't field," Welch said. "Jack Doyle could do everything and do it well."

Probably Welch's favorite player—and he showed some bias—was his own old catcher Buck Ewing.

"He was the greatest," Welch said. "He could hit, run and throw. Buck typified this team I picked. He used to sit up all night thinking about ways to upset and beat his rivals of the next day."

—L.F.

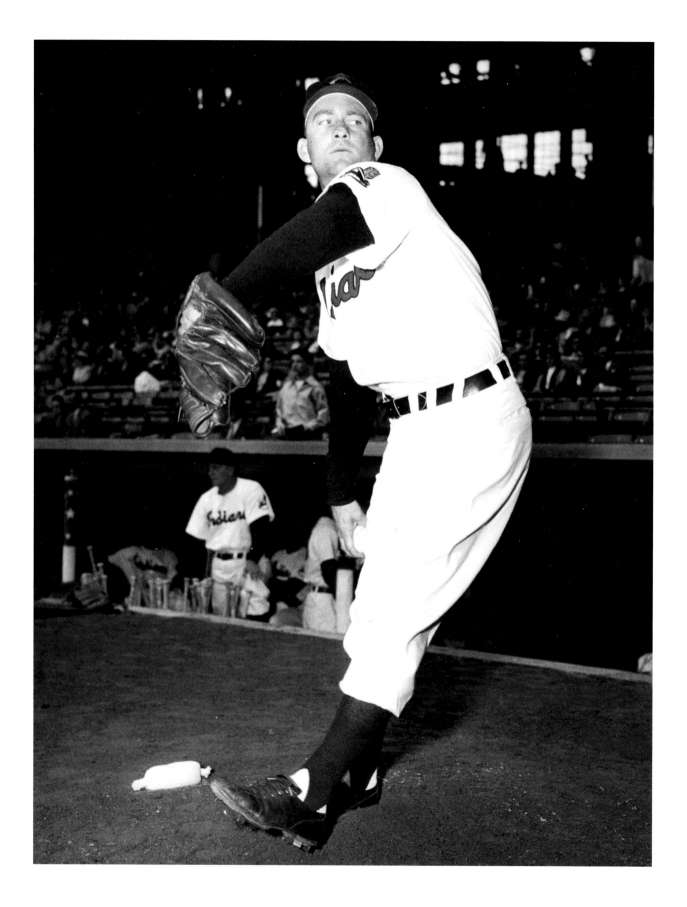

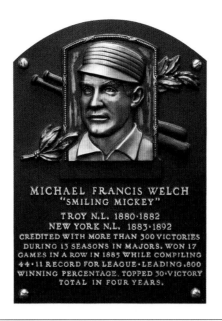

MICHAEL FRANCIS WELCH
"SMILING MICKEY"
TROY N.L. 1880·1882
NEW YORK N.L. 1883·1892
CREDITED WITH MORE THAN 300 VICTORIES
DURING 13 SEASONS IN MAJORS. WON 17
GAMES IN A ROW IN 1885 WHILE COMPILING
44·11 RECORD FOR LEAGUE·LEADING .800
WINNING PERCENTAGE. TOPPED 30·VICTORY
TOTAL IN FOUR YEARS.

MICKEY WELCH

CLASS OF 1973

The third pitcher in baseball history to win at least three hundred games, Mickey Welch topped the mark in a hurling career that was completed by 1892. His right arm was so durable he once had to have a clause inserted in his contract with the New York Giants forbidding managers from starting him more often than every other day.

Welch was busy enough, and in 1885 he posted one of the most mind-boggling seasons by any pitcher, going 44–11 with a 1.66 earned run average. Welch was more crafty than overpowering and once won seventeen straight games. "It was just a slow curve that broke down and in on a right-handed hitter and I got a lot of good results with it in the years I pitched for the Giants," he said of his best pitch.

Welch was on the mound for the first game the Giants, then known as the Gothams, played at the original Polo Grounds in 1883.

Although a big leaguer for just thirteen seasons, Welch made his mark not just with his victories but with his personality. His nickname was "Smiling Mickey" because that's what he did all the time. Unlike most of his teammates, Welch eschewed a handlebar mustache and sideburns, and it was known that he didn't drink, smoke, or curse. At a time when baseball players were viewed as ruffians, this was an unusual combination.

Many of Welch's positive results were recorded when the distance from the mound to home plate was shorter than the sixty-feet, six-inch rule that was eventually adopted. Perhaps it made sense for a pitcher who relied on guile over sheer speed to adopt Welch's philosophy of the game.

"I've seen 'em come and go and I want to tell you that in picking an all-time All-Star team most experts make a mistake," said Welch, who died in 1941. "They ignore brains and go for brawn. Believe me, I could put a dream team on the field, smart fighters, who'd beat any team you could assemble. They'd fight at the drop of a hat, but they'd score runs for you."

Welch, selected for the Hall of Fame by the Veterans Committee in 1973, thirty-two years after his death, did name a personal all-time team, and it included such pitchers as Christy Mathewson, John Clarkson, Tim Keefe, and Carl Hubbell and such position players as Ty Cobb, Frank Frisch, Willie Keeler, and Hugh Duffy.

Approaching his eightieth birthday when he made his selections public in 1939, Welch took some criticism for skipping Babe Ruth and overlooking Lou Gehrig in favor of Jack Doyle at first base. "Gehrig could hit, but couldn't field," Welch said. "Jack Doyle could do everything and do it well."

Probably Welch's favorite player—and he showed some bias—was his own old catcher Buck Ewing.

"He was the greatest," Welch said. "He could hit, run and throw. Buck typified this team I picked. He used to sit up all night thinking about ways to upset and beat his rivals of the next day."

—L.F.

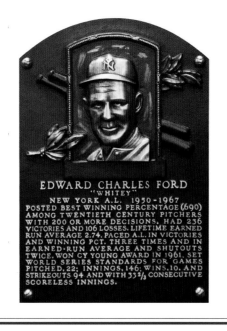

EDWARD CHARLES FORD
"WHITEY"
NEW YORK A.L. 1950-1967
POSTED BEST WINNING PERCENTAGE (.690)
AMONG TWENTIETH CENTURY PITCHERS
WITH 200 OR MORE DECISIONS. HAD 236
VICTORIES AND 106 LOSSES. LIFETIME EARNED
RUN AVERAGE 2.74. PACED A.L. IN VICTORIES
AND WINNING PCT. THREE TIMES AND IN
EARNED-RUN AVERAGE AND SHUTOUTS
TWICE. WON CY YOUNG AWARD IN 1961. SET
WORLD SERIES STANDARDS FOR GAMES
PITCHED, 22: INNINGS, 146: WINS, 10, AND
STRIKEOUTS 94 AND WITH 33⅔ CONSECUTIVE
SCORELESS INNINGS.

WHITEY FORD

CLASS OF 1974

Sometimes a nickname tells us volumes about a player. In the case of Whitey Ford, he was known as both "The Chairman of the Board" and "Slick." The first nickname encapsulated his corporate efficiency and command on the mound; the second nickname bore witness to his cool demeanor and confident attitude.

A native of New York City, Ford was a natural fit to sign with the Yankees. Called up in the middle of the 1950 season, the left-hander made a pronounced impression by winning nine of ten decisions and spinning an ERA of 2.81 to finish second in the American League Rookie of the Year balloting.

From the start, Ford showed his manager that he could pitch with precision and deception. "I never saw a kid with such good control for his age," Yankees manager Casey Stengel told sportswriter Milton Richman. "He had a pack of nerve and excellent judgment. You don't find pitchers like him every day—and if you do, please lemme know where they are."

In reality, there weren't many pitchers like Ford. Unfortunately, the Korean War wrecked Stengel's continuing plans for Ford, who missed all of 1951 and 1952 while serving in the U.S. Army.

When Ford finally returned in 1953, he pitched as if he had not missed a single start. Logging 207 innings, he won eighteen of twenty-four decisions and emerged as the ace of Stengel's staff.

In 1954 Ford lowered his ERA to 2.82. That marked the start of a stretch of five seasons in which his ERA fell below 3.00, highlighted by a pair of ERA titles. Unlike many dominant pitchers, Ford did not overpower hitters with a fastball in the mid-nineties. "The most important thing that makes Ford a helluva good pitcher is that he doesn't give you the same pitch all the time when he's behind you [in the count]," Hall of Fame right-hander Early Wynn told *Sport* magazine. "Ford, when he's behind you, can go to a fastball or a curve or a slider or a change."

Ford's excellence carried over to the postseason. With the Yankees almost perennially winning pennants, Ford became a mainstay of the Fall Classic. He set a record for the most consecutive World Series innings without allowing a run, breaking the long-standing mark held by Babe Ruth.

When Ralph Houk replaced Stengel after 1960, Ford fully blossomed. In contrast to Stengel, who often gave Ford extra rest, Houk pitched his ace every fourth day. In 1961 Ford threw a career-high 283 innings, winning a league-best twenty-five games. Two years later, Ford hurled 269⅓ innings and led the league with twenty-four wins.

Maintaining a full workload through 1965, Ford encountered arm troubles that limited him in 1966 and 1967. Though he remained effective, a severe circulatory problem in his arm forced him to retire.

The great Yankees teams of the 1950s and 1960s were known for their offense. But they wouldn't have been nearly as successful without a legitimate ace, a certified number one starter. Whitey Ford filled that role to near perfection.

—B.M.

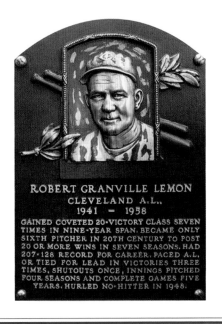

ROBERT GRANVILLE LEMON
CLEVELAND A.L.,
1941 — 1958
GAINED COVETED 20-VICTORY CLASS SEVEN
TIMES IN NINE-YEAR SPAN. BECAME ONLY
SIXTH PITCHER IN 20TH CENTURY TO POST
20 OR MORE WINS IN SEVEN SEASONS. HAD
207-128 RECORD FOR CAREER. PACED A.L.
OR TIED FOR LEAD IN VICTORIES THREE
TIMES, SHUTOUTS ONCE, INNINGS PITCHED
FOUR SEASONS AND COMPLETE GAMES FIVE
YEARS. HURLED NO-HITTER IN 1948.

BOB LEMON

CLASS OF 1976

Bob Lemon had one of the most unusual career paths of any Hall of Famer. He started his professional career as an infielder, became a center fielder, and then agreed to let the Cleveland Indians convert him to pitching. Lemon made that decision look like pure genius.

A minor league third baseman, Lemon hit with little power. Ever attentive, the Indians noticed that his throws from the hot corner had a natural sink to them. Hence, they eventually moved him to the mound.

Even before he emerged as a major league pitcher, Lemon saw his career delayed by World War II. He spent all of 1943, 1944, and 1945 in military service, sacrificing time that he would otherwise have used in advancing his playing career.

Pitching mostly in relief as a rookie, Lemon showed he belonged. "He didn't just fall off a turnip truck when he started pitching," teammate Bob Feller told the *Cleveland Plain Dealer*. "He'd pitched very good ball in the Navy during World War II before Lou Boudreau put him on the mound in 1946. He had a good sinker and was a very good fielder and athlete."

In addition to a superb sinker, Lemon featured an excellent curveball. Those pitches helped him make the transition to starting in 1947. The following year he became a twenty-game winner. That season also saw him launch a stretch of seven consecutive All-Star Game selections.

Lemon became one of the American League's best pitchers of the postwar era. He also teamed with three other right-handers—Feller, Early Wynn, and Mike Garcia—to form one of the game's most devastating rotations. He reached his peak in 1954, when he put up his best season, going 23–7 and helping the Indians to a 111-win season.

Even after his pitching days, Lemon wasn't done. He decided to turn to managing, influenced in large part by his former skipper, Hall of Famer Al Lopez. "Lopez always handled his players like I'd want to be handled," Lemon told the Associated Press. "He treated men like men. He made them feel relaxed.

"That's the only way to play this game . . . by being relaxed. You can't be worried about the manager getting on you. All the time I was at Cleveland, I saw Lopez get mad only twice. He never showed anybody up. I don't do it either."

Lemon also became known for his patience. "I keep players in a slump in the game," Lemon explained to the AP. "They can't come out of it sitting on the bench.

"I remember how much patience they had with me when I was a player. Patience is something that comes easy with me."

Lemon did his finest work during the second half of 1978. Replacing Billy Martin in midsummer, Lemon restored calm to a turbulent clubhouse, helping the New York Yankees overcome a monumental fourteen-game deficit to win their division on the way to a world championship.

In so doing, Lemon accomplished something relatively few have done—winning titles as both a player and a manager. He did so with patience, with class, and with perseverance.

—B.M.

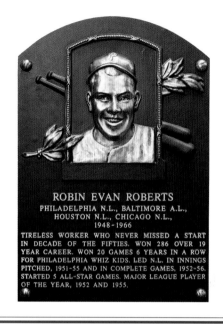

ROBIN EVAN ROBERTS
PHILADELPHIA N.L., BALTIMORE A.L.,
HOUSTON N.L., CHICAGO N.L.,
1948-1966
TIRELESS WORKER WHO NEVER MISSED A START
IN DECADE OF THE FIFTIES. WON 286 OVER 19
YEAR CAREER. WON 20 GAMES 6 YEARS IN A ROW
FOR PHILADELPHIA WHIZ KIDS. LED N.L. IN INNINGS
PITCHED, 1951-55 AND IN COMPLETE GAMES, 1952-56.
STARTED 5 ALL-STAR GAMES. MAJOR LEAGUE PLAYER
OF THE YEAR, 1952 AND 1955.

ROBIN ROBERTS

CLASS OF 1976

Great ballplayers can be intimidating to common fans, who become awed in their presence. Robin Roberts had a way of disarming strangers. Kind and affable, he made fans feel as if they had been his teammates. It became easy to forget how dominant a pitcher he had once been.

Born to a Welsh immigrant coal miner, Roberts grew up in Springfield, Illinois. After a standout career at Michigan State, he drew interest from several teams, including the Philadelphia Phillies, who brought him up in 1948.

He pitched well in his first two seasons, but gave his first indication of stardom in 1950. Working 304⅓ innings, he led the National League with five shutouts. On the season's final day, he won his twentieth game to give the famed "Whiz Kids" the pennant.

The 1950 season also marked the start of the workhorse phase of Roberts's career. For six straight seasons he pitched at least three hundred innings while also leading the league in starts. With his smooth motion, Roberts could throw all day long.

Roberts was not just durable. He was a ferocious competitor who delivered quality, with ERAs consistently below 3.00 during a stretch that included a twenty-eight-win season. He was unquestionably the Phillies' ace, a masterful right-hander who combined high speed with an ability to throw strikes. "Probably the best fastball I ever saw was Robin Roberts's," Ralph Kiner told the Associated Press. "His ball would rise around six or eight

inches, and with plenty on it. And he had great control, which made him very difficult to hit."

Roberts's powerful right arm eventually gave out, a product of having pitched so many innings. Suffering from shoulder problems that struck in 1956, he endured a difficult stretch, prompting the Phillies to sell him to the New York Yankees following the 1961 season. Roberts never made an appearance in a Yankees uniform. He sat idly on the sidelines before drawing his release in May 1962; that very same day, the Baltimore Orioles signed him.

Roberts resurrected his career in Baltimore, learning to become a finesse pitcher. For the next three and a half seasons he pitched effectively for the Birds, becoming a veteran mainstay in a rotation that featured mostly youngsters. He then closed out his career with the Houston Astros and Chicago Cubs.

Whereas early in his career Roberts had leaned on a power fastball, he became more reliant on changing speeds and throwing breaking balls. The latter-day version of Roberts still made an impression. "He looks like the kind of pitcher you can't wait to swing at," slugger Willie Stargell once said, "but you swing and the ball isn't where you thought it was."

Success never changed Roberts's personality. After his Hall of Fame election, he showcased an ever-present ability to communicate with all generations. "I have never met a kinder, nicer, more genuine person in my life," said George Brett, whose career began seven years after Roberts's retirement, in an interview with *USA Today*. "He had that knack of being able to embrace you and become your friend, regardless of age."

—B.M.

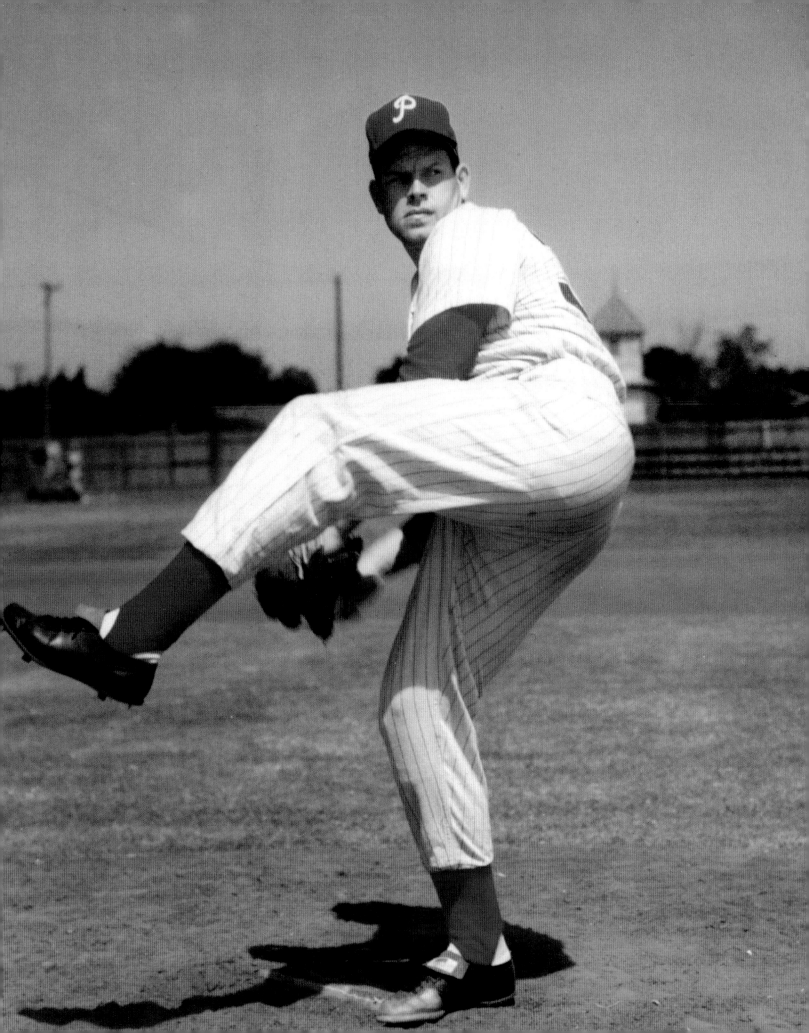

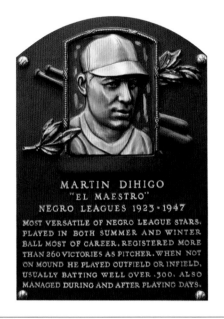

MARTIN DIHIGO
"EL MAESTRO"
NEGRO LEAGUES 1923-1947
MOST VERSATILE OF NEGRO LEAGUE STARS.
PLAYED IN BOTH SUMMER AND WINTER
BALL MOST OF CAREER. REGISTERED MORE
THAN 260 VICTORIES AS PITCHER. WHEN NOT
ON MOUND HE PLAYED OUTFIELD OR INFIELD,
USUALLY BATTING WELL OVER .300. ALSO
MANAGED DURING AND AFTER PLAYING DAYS.

MARTÍN DIHIGO

CLASS OF 1977

Martín Dihigo "could run, hit, throw, think, pitch and manage. You can take your Ruths, Cobbs and DiMaggios. Give me Dihigo. I bet I would beat you every time. He was the best ballplayer of all time, black or white," said Hall of Fame Negro League player Buck Leonard.

In 1923 a teenage second baseman, tall, thin, graceful, and light-hitting, made his debut for the Cuban Stars of the Eastern Colored League. As he filled out and grew as a player, he would also play shortstop, third base, and the outfield, where he took delight in cutting down runners at the plate. Eventually his great arm would lead him to the mound as well. He also excelled there. And the light-hitting tag would utterly disappear.

Martín Dihigo, simply called "El Maestro," might well be the greatest all-around player of all time. He certainly belongs in any such discussion. Imagine if Roberto Clemente or Willie Mays had also been able to pitch with the best in the game.

"Dihigo once let me carry his shoes and glove and that's how I got into the ballpark down there when I was a kid. He was a big man, all muscle with not an ounce of fat on him. He helped me by teaching me how to play properly. But it is difficult to explain what a great hero he was in Cuba. Everywhere he went he was recognized and mobbed for autographs. I'd have to say he was most responsible for me getting to the major leagues. He was a big man, but he was big in all ways, as a player, as a manager, as a teacher, as a man." So said another of Cuba's greatest players, Orestes "Minnie" Miñoso.

Dihigo played in the U.S. Negro Leagues for the New York Cubans, the Philadelphia Hilldale Giants, and the Homestead Grays. Besides Leonard and Miñoso, Willie Wells, Vic Harris, and George Scales all reported that Dihigo was the best ballplayer they ever saw.

In addition to playing in the States, Dihigo was a legendary success in several Latin American countries. By the late 1930s he was one of the finest pitchers in the Mexican League, notching the first no-hitter in that country, hitting well over .300, and leading the league in categories such as earned run average and strikeouts.

Hall of Famer Johnny Mize was on a team in the Dominican Republic with Dihigo in 1943, when El Maestro was thirty-eight years old. Even at that age, he was better than any other ballplayer Mize had ever seen. At age forty-one, Dihigo returned to his homeland, where he was now known by an even greater nickname, "El Inmortal," or "The Immortal."

While American fame was denied Dihigo due to the color of his skin, he was elected to the National Baseball Hall of Fame in 1977. Dihigo is the only man to have been elected to four National Baseball Halls of Fame: in Cuba, Mexico, the United States, and Venezuela.

—T. Wendel

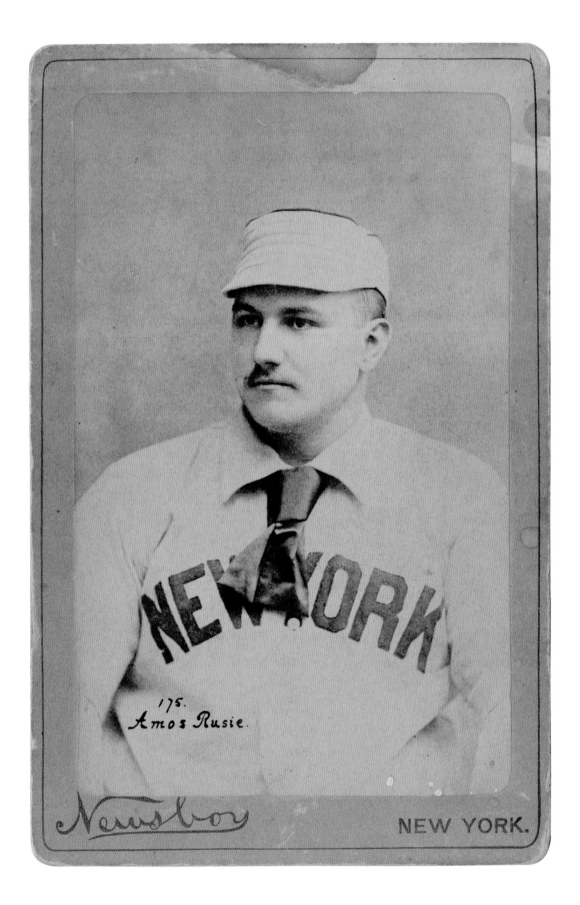

175.
Amos Rusie.

Newsboy

NEW YORK.

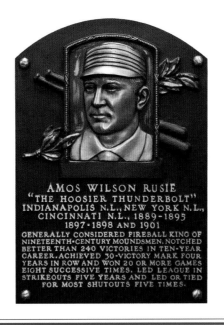

AMOS WILSON RUSIE
"THE HOOSIER THUNDERBOLT"
INDIANAPOLIS N.L., NEW YORK N.L.,
CINCINNATI N.L., 1889-1895
1897-1898 AND 1901
GENERALLY CONSIDERED FIREBALL KING OF
NINETEENTH-CENTURY MOUNDSMEN, NOTCHED
BETTER THAN 240 VICTORIES IN TEN-YEAR
CAREER. ACHIEVED 30-VICTORY MARK FOUR
YEARS IN ROW AND WON 20 OR MORE GAMES
EIGHT SUCCESSIVE TIMES. LED LEAGUE IN
STRIKEOUTS FIVE YEARS AND LED OR TIED
FOR MOST SHUTOUTS FIVE TIMES.

AMOS RUSIE

CLASS OF 1977

Before Walter "Big Train" Johnson and Smoky Joe Wood, long before Bob Feller and Nolan Ryan, Amos Rusie was considered by many to be the fastest pitcher ever to throw a baseball.

Nicknamed "The Hoosier Thunderbolt," Rusie pitched for several teams, notably the New York Giants, until an arm injury ended his career. He was named to the Hall of Fame in 1977.

The legendary Cy Young was once asked to name the top fastball pitchers ever, and his short list was simply "Amos Rusie, Bob Feller and me."

At the height of his career, Rusie was the toast of New York. So much so that a cocktail was named in his honor, vaudeville teams worked up skits about his prowess, and a pamphlet titled "Secrets of Amos Rusie: The World's Greatest Pitcher, How He Obtains His Incredible Speed on the Ball" was a big seller with young fans.

Lou Criger, who caught Young, said Rusie "was the greatest pitcher that ever stepped in the box and I never expected to see a better one."

Owing to Rusie's blazing fastball, along with a few others, in 1893 the game's very rules were changed, with the distance from the mound to home plate increased by ten and a half feet to the current sixty feet, six inches. Rusie, a solidly built redhead, shrugged off such rule changes, thanks in part to an effective curveball, too.

"A curve to most fastball pitchers was just a change of pace," Robert Smith wrote in *Heroes of Baseball,* "if they even bothered to use it. To Rusie, it was another type of fastball, one that snapped its tail sharply in the batter's face, after nearly scaring his breeches off. As for the fastball, well, not enough people even saw that to tell accurately about it. [The pitch] was just a sudden streak and a noise in the catcher's glove."

In fact, Duke Farrell, who sometimes caught Rusie, said that if "any other pitcher hit a man, the man swore, limped a moment and went to first base. If Rusie hit a man, the man retired from the game and sometimes went to the hospital."

Legendary manager John McGraw said of Rusie's fastball, "You can't hit what you can't see."

Despite being one of the game's top stars at the turn of the last century, Rusie had a sudden fall from grace. In a bizarre twist, he was traded for Christy Mathewson, who would soon become his successor with the Giants. Suffering from a sore arm, Rusie pitched only three games for Cincinnati in 1901 and was soon out of baseball. In ten years in the major leagues, he went 246–174 and led the league in strikeouts five times and shutouts four times.

Unfortunately Rusie squandered his success, ending up broke and without a job until McGraw bought him back as a ticket taker at the old Polo Grounds. "It's like climbing out of the grave," Rusie said, "and going to a dance."

—T. Wendel

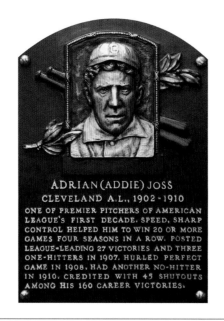

ADRIAN (ADDIE) JOSS
CLEVELAND A.L., 1902-1910
ONE OF PREMIER PITCHERS OF AMERICAN
LEAGUE'S FIRST DECADE. SPEED, SHARP
CONTROL HELPED HIM TO WIN 20 OR MORE
GAMES FOUR SEASONS IN A ROW. POSTED
LEAGUE-LEADING 27 VICTORIES AND THREE
ONE-HITTERS IN 1907. HURLED PERFECT
GAME IN 1908. HAD ANOTHER NO-HITTER
IN 1910. CREDITED WITH 45 SHUTOUTS
AMONG HIS 160 CAREER VICTORIES.

ADDIE JOSS

CLASS OF 1978

Given that hurler Addie Joss, popular and talented, died just two days after his thirty-first birthday from tubercular meningitis in 1911, it is remarkable that he accomplished as much as he did. The sudden demise of the best pitcher for the Cleveland Naps (later the Indians) stunned the baseball universe.

"Big, manly, kindly 'Addie' Joss is dead," read one assessment. "Many thousands of baseball fans will mourn the untimely passing of a clean, hard-working athlete, who was a high type of the product of the great American sport. In many places today men and women will say a good word and a regretful word for the big pitcher."

Joss, from rural Wisconsin, pitched no-hitters, one-hitters, and one of the earliest perfect games, compiled a minuscule earned run average of 1.89, and won 160 times. He was the victor in one of the finest-pitched games in baseball history, an epic 1–0 encounter with Big Ed Walsh of the Chicago White Sox in 1908. Joss hurled a perfect game and Walsh a four-hitter with fifteen strikeouts.

"No one on the bench had said a word," Joss reported, noting a superstition that has remained in place. "If anyone had peeped he would have been chased to the clubhouse. When I thought about it I touched wood. I guess it helped. I did not try for a record. I was seeking to beat the Sox and Ed Walsh had the same

purpose in view. Ed was pitching the game of his life. I never saw him when he had so much stuff."

Walsh said if he had to lose such a game, at least it had taken perfection to beat him. "Yes, I pitched a fairly good game myself, but he pitched better. I am sorry we lost, of course, but seeing that we did have to lose I am glad that Addie took down a record that goes to so few."

Joss, thinking of long-term security for his family, has to have been one of the few professional athletes who aspired to a full-time sportswriting career after retirement. He was already writing offseason columns for big-city Ohio newspapers and had such a following that a special telephone was installed for the public to call him.

When he passed out at the park during a spring training game, Joss was hospitalized. He then returned home to Toledo and two weeks later passed away. Among the many baseball mourners seen in tears at Joss's funeral was Cy Young. Billy Sunday, a major leaguer–turned–evangelist, said, "He was a great player, and above all, a gentleman."

After Joss's death, Cleveland players and an All-Star team engaged in a benefit game for his family, raising $13,000. Years later, when the Hall of Fame was established, Joss was initially excluded because he had not played the requisite ten years. In 1978 the rule was waived and he was chosen. At the time, St. Louis sportswriter Bob Broeg called Joss "the American League's answer to the National League's Christy Mathewson."

—L.F.

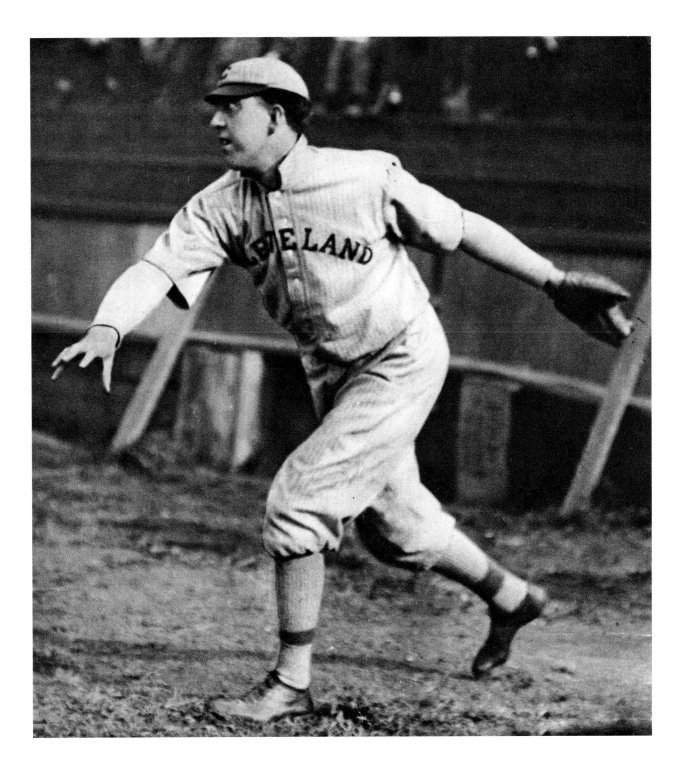

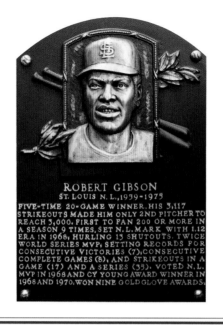

ROBERT GIBSON
ST. LOUIS N.L., 1959-1975
FIVE-TIME 20-GAME WINNER. HIS 3,117
STRIKEOUTS MADE HIM ONLY 2ND PITCHER TO
REACH 3,000. FIRST TO FAN 200 OR MORE IN
A SEASON 9 TIMES, SET N.L. MARK WITH 1.12
ERA IN 1968, HURLING 13 SHUTOUTS. TWICE
WORLD SERIES MVP, SETTING RECORDS FOR
CONSECUTIVE VICTORIES (7), CONSECUTIVE
COMPLETE GAMES (8), AND STRIKEOUTS IN A
GAME (17) AND A SERIES (35). VOTED N.L.
MVP IN 1968 AND CY YOUNG AWARD WINNER IN
1968 AND 1970. WON NINE GOLD GLOVE AWARDS.

BOB GIBSON

CLASS OF 1981

Few athletes are as focused or as successful as Bob Gibson was. In Game 1 of the 1968 World Series, for example, the right-hander broke Sandy Koufax's single-game strikeout record. As the crowd rose to salute the occasion, St. Louis catcher Tim McCarver ran out to the mound to tell Gibson.

Yet the intense pitcher didn't like to be interrupted on the mound. While McCarver tried to inform his teammate what he had accomplished, Gibson kept yelling for the ball. After all, there was a game still to be won. Finally, McCarver got a chance to explain why the crowd was raising such a ruckus.

"All right," Gibson told McCarver. "Now give me the ball."

During his seventeen seasons with the Cardinals, Gibson reached the twenty-win plateau five times and became one of the best big-game pitchers baseball has ever seen. Besides recording seventeen strikeouts in a game, he won seven consecutive postseason games and was named the World Series MVP in 1964 and 1967.

Ironically, he nearly pursued a different sport professionally.

After excelling in basketball as well as baseball in high school, Gibson played hoops at Creighton University and held the school scoring record until Paul Silas, who would go on to play sixteen seasons in the NBA, surpassed it. For a time it appeared that professional basketball would be Gibson's career path. After finishing college in 1957, Gibson signed a pair of $4,000 contracts. One was with the Cardinals' baseball farm team in Omaha. The other was to play basketball for the Harlem Globetrotters, the team he joined after the baseball season was over. At one point Gibson roomed with the legendary Meadowlark Lemon. But it soon became apparent that Gibson needed to focus on one sport. So when St. Louis general manager Bing Devine offered him an additional $4,000 to concentrate on baseball, Gibson quit the Globetrotters.

"It was the best deal I ever made," he said years later. "For the first time, I was headed in one and only one direction."

He certainly was. Gibson broke in with the Cardinals in 1959 and soon established himself as the team's ace. In 1968, the "Year of the Pitcher," he put up a season for the ages, with a league-leading 268 strikeouts, thirteen shutouts, and an amazing 1.12 earned run average.

Bob Gibson is "the luckiest pitcher I ever saw," McCarver said. "He always pitches when the other team doesn't score any runs."

Staring in from the mound, often with a scowl on his face, Gibson was an intimidating sight for any hitter. For they knew he was strictly old school, in that he wasn't afraid to buzz a batter inside to set up the next pitch.

"He couldn't pitch today because they wouldn't let him," said Red Schoendienst, Gibson's former manager in St. Louis. "The way he'd throw inside, he'd be kicked out of the game in the first inning, along with guys like Don Drysdale and Sandy Koufax."

Gibson wouldn't want it any other way.

—T. Wendel

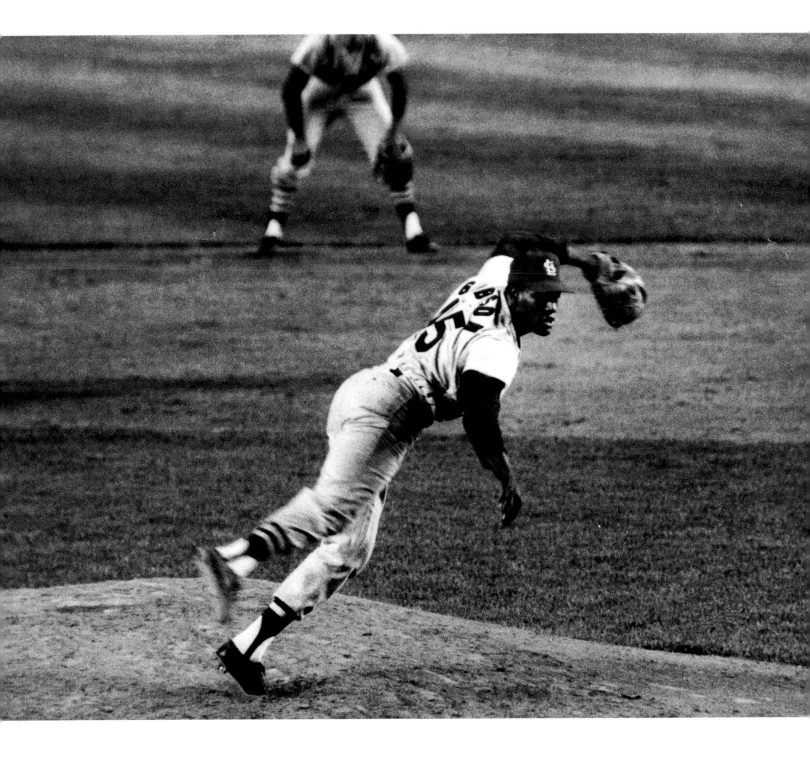

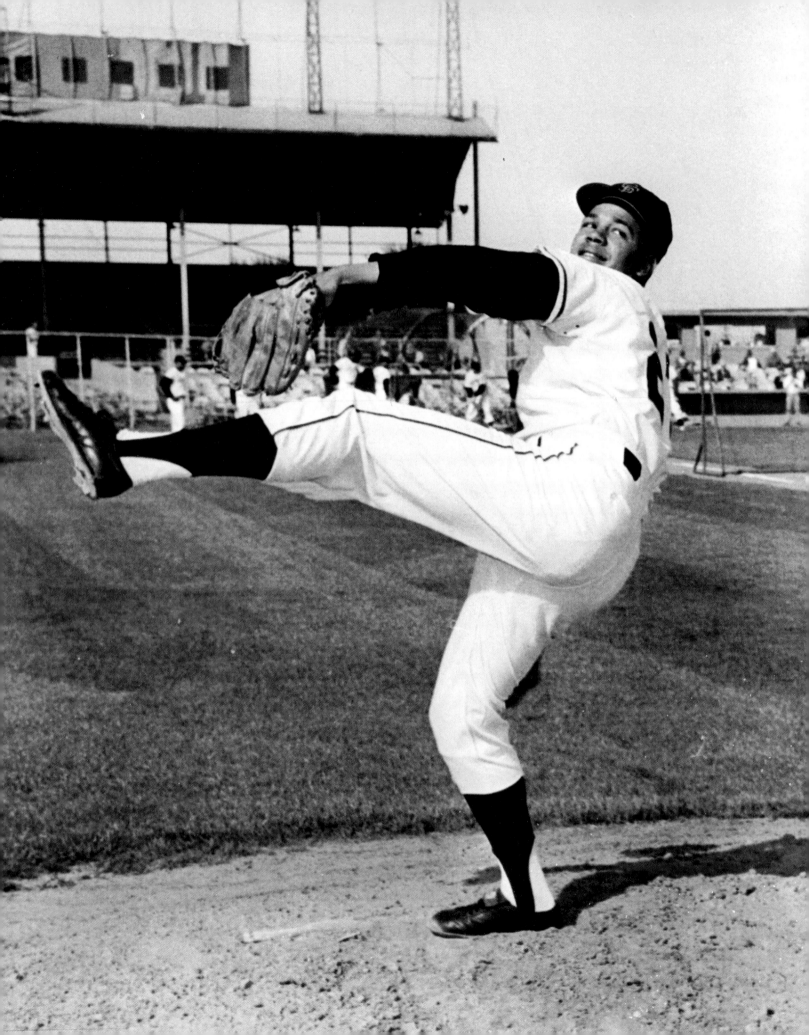

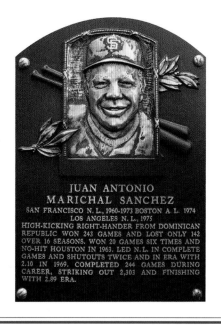

JUAN ANTONIO
MARICHAL SANCHEZ
SAN FRANCISCO N. L., 1960-1973 BOSTON A. L. 1974
LOS ANGELES N. L., 1975
HIGH-KICKING RIGHT-HANDER FROM DOMINICAN
REPUBLIC WON 243 GAMES AND LOST ONLY 142
OVER 16 SEASONS. WON 20 GAMES SIX TIMES AND
NO-HIT HOUSTON IN 1963, LED N.L. IN COMPLETE
GAMES AND SHUTOUTS TWICE AND IN ERA WITH
2.10 IN 1969. COMPLETED 244 GAMES DURING
CAREER, STRIKING OUT 2,303 AND FINISHING
WITH 2.89 ERA.

JUAN MARICHAL

CLASS OF 1983

With his distinctive high leg kick and pinpoint control, Juan Marichal was one of the top arms in the 1960s, a time when major league pitching had never been better. As described by sportswriter Ron Bellamy, "The symbol of his artistry . . . was the windup, with the high, graceful kick that left the San Francisco Giant hurler poised precariously on one leg like a bronzed Nureyev before he swept smoothly forward and propelled the baseball toward the plate."

Born in Laguna Verde in the Dominican Republic, Marichal was part of a wave of Latino stars who arrived in the major leagues during the 1960s. On the Giants, he was teammates with the Alou brothers and Orlando Cepeda. Marichal would be the first Dominican inducted into the National Baseball Hall of Fame, something he never dreamed about when growing up. "[All] I wanted to do was play baseball," he said. "That is what made all of us happy."

Marichal was a shortstop until he saw sidearmer Bombo Ramos pitch. That prompted Marichal's move to the mound. Yet it wasn't until 1959, when Marichal was in Class A, that a coach suggested he pitch overhand. "I was shocked by the question since this was how I'd learned," Marichal told the *New York Times* decades later. "I asked what the benefit would be, and [manager Andy Gilbert] said I'd be much better against left-handers. He took me to the bullpen with a catcher and had me try it. The only

way I could do it was with that leg kick. I had the same control but a little more speed."

With that, one of the most distinctive pitching deliveries ever was born. "If you placed all the pitchers in the history of the game behind a transparent curtain," longtime San Francisco sportswriter Bob Stevens said, "where only a silhouette was visible, Juan's motion would be the easiest to identify. He brought to the mound beauty, individuality and class."

Certainly nobody had a better debut than Marichal. Shortly after being called up to the San Francisco Giants in 1960, he one-hit the Philadelphia Phillies in a 2–0 shutout. Twelve Phillies batters went down on strikes, and Clay Dalrymple's single in the eighth inning was the only hit. Soon all of baseball knew about the new pitching force on the Giants staff.

"It doesn't matter what he throws," Roberto Clemente said. "When he's got it, he beats you."

"I have five pitches," Marichal once said. "Fastball, change, curve, slider, screwball. I don't know any hitters. Catcher, he tells me what to do. I can get any pitch I want over the plate."

Marichal won 243 games and lost only 142 in sixteen big league seasons. He enjoyed six 20-win seasons and was named to nine All-Star teams. "The Dominican Dandy" twice led the National League in complete games and shutouts, finishing 244 contests during his career, while fanning 2,303 and compiling a 2.89 ERA.

When Marichal was named the minister of sport for his native Dominican Republic, one government official said, "This position fits him like a ring on his finger."

—J.G.

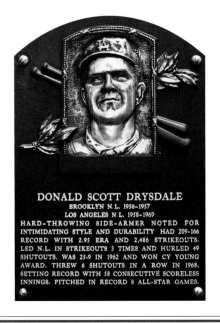

DONALD SCOTT DRYSDALE
BROOKLYN N.L. 1956-1957
LOS ANGELES N.L. 1958-1969
HARD-THROWING SIDE-ARMER NOTED FOR
INTIMIDATING STYLE AND DURABILITY. HAD 209-166
RECORD WITH 2.95 ERA AND 2,486 STRIKEOUTS.
LED N.L. IN STRIKEOUTS 3 TIMES AND HURLED 49
SHUTOUTS. WAS 25-9 IN 1962 AND WON CY YOUNG
AWARD. THREW 6 SHUTOUTS IN A ROW IN 1968,
SETTING RECORD WITH 58 CONSECUTIVE SCORELESS
INNINGS. PITCHED IN RECORD 8 ALL-STAR GAMES.

DON DRYSDALE

CLASS OF 1984

Talent combined with the ability to instill fear can contribute to a Hall of Fame career. One of the clearest examples can be found in the résumé of Don Drysdale.

The hard-throwing right-hander broke in with the Brooklyn Dodgers in 1956, pitching efficiently in a role split between the bullpen and the rotation. He then won seventeen games for the Dodgers during their last year in Brooklyn, but he would become best known for what he did after the franchise relocated to Los Angeles.

In the early 1960s Drysdale teamed with Hall of Famer Sandy Koufax to form one of the most overpowering righty-lefty combinations in history. Tall and strong, Drysdale was one of the most durable pitchers of the decade. Every year from 1962 to 1965 he led the National League in starts. Yet there was far more to him than just quantity. In 1962 he was the league's most dominating pitcher, as he won twenty-five games and struck out 232 batters. The next year he lowered his ERA by .20, from 2.83 to 2.63.

With his sidearm fastball, crackling curveball, and sharp control, Drysdale could dominate hitters on stuff alone. But he also tackled the mental element. "The pitcher has to find out if the hitter is timid," Drysdale told the *New York Times*, "and if he is timid, he has to remind the hitter he's timid."

That reminder often came after the opposing pitcher intentionally threw at one of the Dodgers hitters. For that, the team-oriented Drysdale dispensed his own method of justice. "My own little rule was two for one," Drysdale once said. "If one of my teammates got knocked down, then I knocked down two on the other team." Indeed. Five times he led the National League in hit batsmen.

While the Dodgers struggled to score runs in the mid-1960s, Drysdale enhanced his reputation as one of the game's best-hitting pitchers. In 1965 he hit seven home runs. When the Dodgers played in the World Series that fall, they had only one .300 hitter in the lineup—and that was Drysdale.

As well as Drysdale pitched through the middle of the decade, he saved his most memorable feat for 1968. He set a major league record that year for the most consecutive scoreless innings thrown, which included a run of a half-dozen shutouts.

Retiring at the youthful age of thirty-three, Drysdale continued to turn his Hollywood good looks into frequent appearances on TV, which he had dabbled in during his playing days. He also converted his outgoing personality into a long career as a broadcaster, working in the booths of several teams before returning to the Dodgers as one of their announcers in 1988.

There was a duality to Drysdale. On the mound he was viewed as mean, even nasty, the most intimidating pitcher this side of Bob Gibson. But Drysdale off the field, whether as an actor or as a broadcaster or just as himself, was far different. "On the field, he was as mean as a snake," Hall of Famer Tommy Lasorda told the *Philadelphia Inquirer*. "Off the field, he was as nice a guy as you'd want to meet."

—B.M.

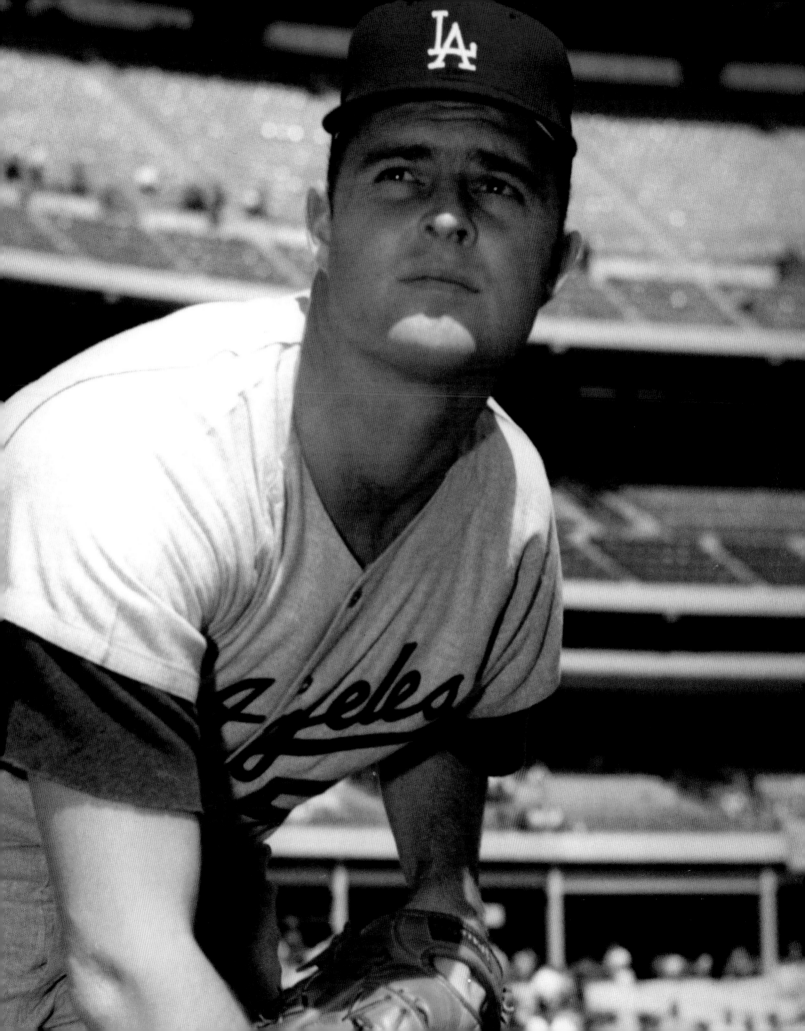

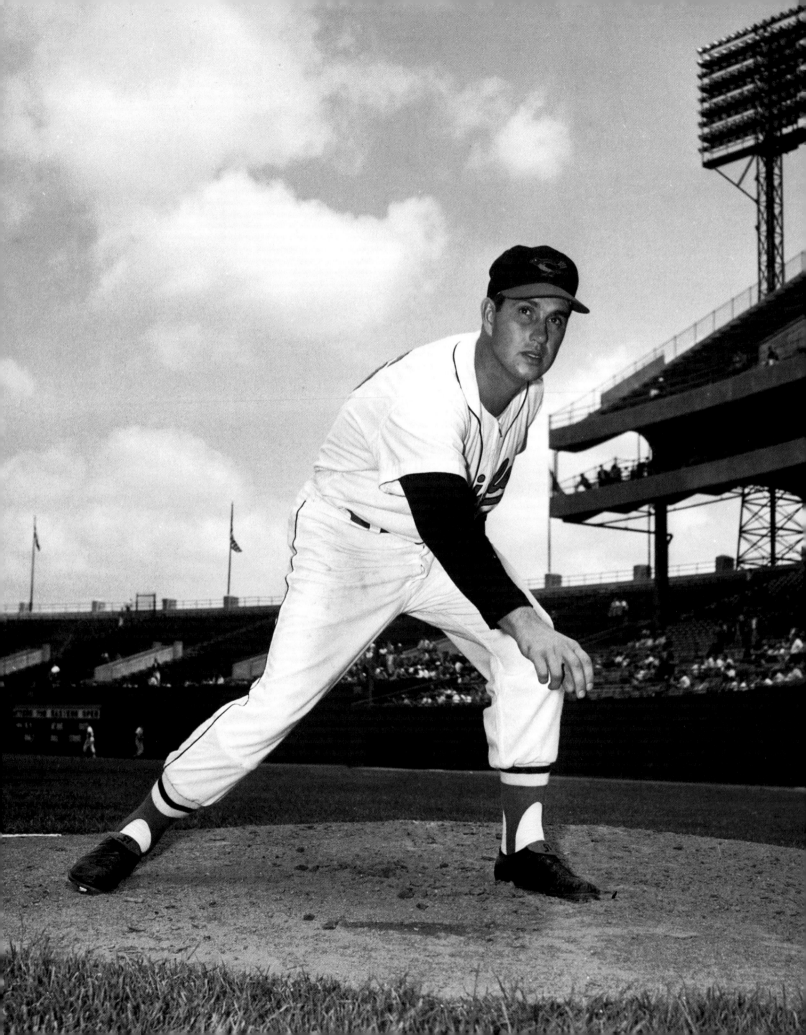

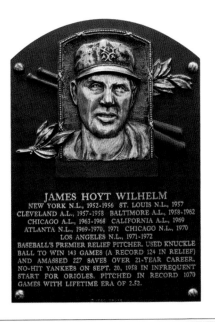

JAMES HOYT WILHELM
NEW YORK N.L., 1952-1956 ST. LOUIS N.L., 1957
CLEVELAND A.L., 1957-1958 BALTIMORE A.L., 1958-1962
CHICAGO A.L., 1963-1968 CALIFORNIA A.L., 1969
ATLANTA N.L., 1969-1970, 1971 CHICAGO N.L., 1970
LOS ANGELES N.L., 1971-1972
BASEBALL'S PREMIER RELIEF PITCHER. USED KNUCKLE
BALL TO WIN 143 GAMES (A RECORD 124 IN RELIEF)
AND AMASSED 227 SAVES OVER 21-YEAR CAREER.
NO-HIT YANKEES ON SEPT. 20, 1958 IN INFREQUENT
START FOR ORIOLES. PITCHED IN RECORD 1070
GAMES WITH LIFETIME ERA OF 2.52.

HOYT WILHELM

CLASS OF 1985

Hoyt Wilhelm was a pioneer on two Hall of Fame fronts. Not only was he the first full-time relief pitcher to earn induction, but also he was the first true knuckleballer to gain entrance to Cooperstown.

Raised on a farm in North Carolina, Wilhelm learned to throw the knuckleball as a boy. "I started fooling with it in high school," Wilhelm told United Press International, "copying the grip used by Dutch Leonard. And I picked it up right away."

Still, Wilhelm did not make an immediate climb to the major leagues. He signed with an independent minor league team and then saw his career postponed by World War II. Drafted into the U.S. Army, Wilhelm served three years and fought in the horrific Battle of the Bulge, earning the Purple Heart for his efforts.

After the war, the New York Giants acquired Wilhelm's contract but kept him in the minors for four seasons. Wilhelm would not make his Giants debut until the age of twenty-nine, a late start, but not too late for the master of the knuckleball.

In one of the most fortunate strokes of Wilhelm's career, Giants manager Leo Durocher made him a reliever. Wilhelm adapted beautifully, winning fifteen of eighteen decisions in 1952 and leading the National League in ERA.

Two years later, Wilhelm helped the Giants sweep the Cleveland Indians in the World Series. Two off years resulted in a trade to St. Louis, followed by a rerouting to Cleveland. Then came a fortuitous deal when Wilhelm was sent to the Baltimore Orioles in the late stages of 1958. Wilhelm made headlines with a September no-hitter, moved to the rotation full-time in 1959, and proceeded to lead the league in ERA.

Baltimore put him back in the bullpen the next year and watched him dominate the late innings for two seasons. With the trademark tilting of his head and neck to one side, he became a familiar sight as he entered games from the sidelines, ready to throw the knuckleball at any time. It was a knuckleball that legendary broadcaster Bob Elson described as a "dancing medicine show."

Wilhelm drew the respect of the Junior Circuit's best hitters. Longtime sportswriter John Steadman once asked Ted Williams where he would rank Wilhelm against the knuckleballers he had faced. "Out in front of all of them," Williams informed Steadman. "He was the best I ever tried to hit. Don't let anybody ever tell you they saw a better knuckleball than Wilhelm's."

Ensuing success with the Chicago White Sox cemented Wilhelm's reputation. In his later years he moved frequently from team to team, taking on a role as an elder statesman who helped younger players adjust to the major leagues. "He was a great teammate," said former Los Angeles Dodgers infielder and future manager Bobby Valentine, who played with Wilhelm in 1972. "He had humor, work ethic, and camaraderie that I will always remember. He was good to the young guys. We really liked that."

They liked it as long as they didn't have to face Wilhelm's knuckleball, which set a high standard for the few knuckleballers who have succeeded him.

—B.M.

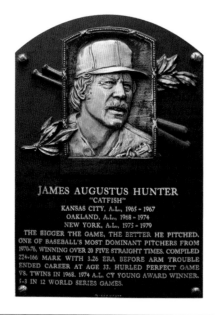

JAMES AUGUSTUS HUNTER
"CATFISH"
KANSAS CITY, A.L., 1965 - 1967
OAKLAND, A.L., 1968 - 1974
NEW YORK, A.L., 1975 - 1979
THE BIGGER THE GAME, THE BETTER HE PITCHED.
ONE OF BASEBALL'S MOST DOMINANT PITCHERS FROM
1970-76, WINNING OVER 20 FIVE STRAIGHT TIMES. COMPILED
224-166 MARK WITH 3.26 ERA BEFORE ARM TROUBLE
ENDED CAREER AT AGE 33. HURLED PERFECT GAME
VS. TWINS IN 1968. 1974 A.L. CY YOUNG AWARD WINNER.
5-3 IN 12 WORLD SERIES GAMES.

CATFISH HUNTER

CLASS OF 1987

In what might be considered the ultimate compliment, some scouts called him a right-handed version of New York Yankees ace Whitey Ford. While there have been pitchers who possessed more impressive repertoires than Jim "Catfish" Hunter, there were few who pitched with more guile, aggression, and tenacity.

Although Hunter did not like being the center of attention, that was where he found himself in 1964, when a horde of scouts raided his home in tiny Hertford, North Carolina. Scouts considered the young Hunter one of the best high school pitchers in the country.

Charlie Finley, owner of the Kansas City A's, succeeded in signing Hunter to his first contract. In 1965, the A's wanted to send the nineteen-year-old to the minor leagues, but his surprising maturity convinced management that he should remain with the big league team.

Hunter quickly impressed the veteran A's players with his demeanor, both on the mound and in the clubhouse. He enjoyed playing practical jokes, which loosened up a clubhouse that was sometimes sidetracked by tension and mistrust.

After the A's moved to Oakland, Hunter emerged as the staff ace. He lacked the imposing arm strength of contemporaries like Nolan Ryan and Tom Seaver, but he made up for the absence of octane with control, a killer slider, and an understanding of baseball's dynamics. "He isn't afraid of giving up a lot of hits," Reggie Jackson told Pat Jordan of *Sport* magazine. "If he's got a big lead

in the eighth, he'll just lay it in there and make them hit it. He doesn't care if he beats you, 11–10, as long as he beats you."

When Hunter defeated the Baltimore Orioles in the final game of a grueling Championship Series in 1973, O's manager Earl Weaver spoke reverently about the man who had beaten him. "He's got his doctorate in pitching," Weaver told reporters at a postgame press conference. "He's had his B.A., he went on and got his master's, and now he's got his doctorate."

After the 1974 World Series, a contract violation by Finley allowed Hunter to leave as a free agent and sign with the Yankees. Hunter's former teammates understood the impact that his loss would have on them. "With Catfish, we were world champions," Jackson told *Sport* magazine. "Without him, we have to struggle to win the division." The A's did win the West, but without the presence of Hunter to pitch in the postseason, Oakland lost the American League Championship Series in three consecutive games.

By the time the Yankees became world champions in 1977, Hunter was no longer an ace, but he remained a valuable secondary contributor during the championship seasons of 1977 and 1978. In so doing, Hunter added to his collection of World Series rings, bringing the total to five.

"Catfish, he's probably the greatest right-handed pitcher I played with," Rollie Fingers said. "When Catfish was on, I didn't even go down to the bullpen—he was that great of a pitcher. He had great control. If you had a game to win, that's who you wanted on the mound when we were playing."

—B.M.

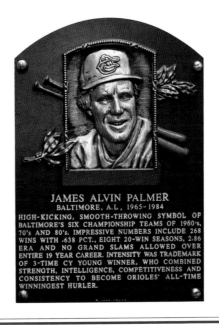

JIM PALMER

CLASS OF 1990

Jim Palmer may have been nicknamed "Cakes" and "Reginald," but few pitchers were tougher with a game on the line than the right-handed fireballer. He had a 4–1 record in Championship Series play and a 4–2 record in the World Series.

In addition, Palmer won twenty or more contests eight times in nine years between 1970 and 1978. The only exception was 1974, when he was sidelined by an injury. In doing so, Palmer became the first American League pitcher to have eight twenty-win seasons since Lefty Grove had his eighth in 1935.

"He won, that's what I remember most," teammate Frank Robinson told the *Baltimore Sun*. "He took the ball, went to the mound knowing what he wanted to do. Then, he did it."

Palmer won the AL Cy Young Award three times and was a six-time member of the All-Star squad. A great fielder, he also won four Gold Glove Awards.

"My first impression [of him] is in 1982, my rookie year," said Cal Ripken Jr., "when we were making a run at Milwaukee and Jim just stood up and took charge. He kept us in every game he pitched.

"He always had so much energy, it seemed like he wasted it by being a pitcher, going out there every four or five days. But the other three or four, he was busy. The rest of the staff just learned from him."

Palmer was a member of some outstanding staffs in Baltimore. In 1971 he, Dave McNally, Mike Cuellar, and Pat Dobson all reached the twenty-win plateau.

"Jimmy was a tremendous competitor," recalled Orioles catcher and then coach Elrod Hendricks. "If he got to the sixth or seventh, you could mail the game in. He was the best finisher I ever saw."

Orioles slugger Boog Powell added, "Give me one game to win and he's my starter. He not only had a great fastball, he knew what he was doing every minute. It wasn't a question of just blowing people away."

Palmer reached the majors in 1965 and posted a shutout in the World Series the following season, making him at twenty the youngest pitcher ever to throw a shutout in the Fall Classic. In 1969 he hurled a no-hitter against Oakland. In total, Palmer pitched for nineteen seasons in Baltimore, becoming a local favorite. (He went on to become an analyst for Orioles broadcasts.) Overall, Palmer compiled a 268–152 record with a 2.86 ERA.

Known to speak his mind, Palmer had a running, often public, feud with Orioles manager Earl Weaver. Of course, the feisty Weaver also didn't mince words. But after Palmer retired, even Weaver told the *Baltimore Sun* that Palmer "was an outstanding pitcher and a pleasure to have on the ballclub. He certainly helped me keep my job all those years in Baltimore. His work habits were excellent and he was a leader. A lot of the success of my [pitching] staffs could be credited to Jim."

—T. Wendel

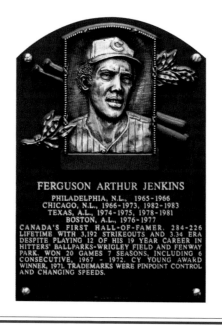

FERGUSON ARTHUR JENKINS
PHILADELPHIA, N.L., 1965-1966
CHICAGO, N.L., 1966-1973, 1982-1983
TEXAS, A.L., 1974-1975, 1978-1981
BOSTON, A.L., 1976-1977
CANADA'S FIRST HALL-OF-FAMER. 284-226
LIFETIME WITH 3,192 STRIKEOUTS AND 3.34 ERA
DESPITE PLAYING 12 OF HIS 19 YEAR CAREER IN
HITTERS' BALLPARKS-WRIGLEY FIELD AND FENWAY
PARK. WON 20 GAMES 7 SEASONS, INCLUDING 6
CONSECUTIVE, 1967 - 1972. CY YOUNG AWARD
WINNER, 1971. TRADEMARKS WERE PINPOINT CONTROL
AND CHANGING SPEEDS.

FERGUSON JENKINS

CLASS OF 1991

Ferguson Jenkins was born with natural athletic talent, his father having been a semipro ballplayer with the Black Panthers prior to Jackie Robinson's breaking baseball's color barrier. It wasn't just baseball that Fergie had a knack for; he also excelled at basketball, hockey, and track.

Jenkins originally signed with the Philadelphia Phillies in 1962 and served in a bullpen role, but didn't find real success until he joined the Chicago Cubs. The Cubs took him out of the bullpen and converted him into a starting pitcher, and the rest, as they say, is history.

A member of the illustrious three-thousand-strikeout club, Jenkins is one of only four players to accomplish the feat while walking fewer than one thousand batters. Former Cubs pitching coach Joe Becker said of him, "His hard slider and his sinker are his best pitches. But your stuff is never good unless you can throw strikes. He can. And he can throw them all day."

"Statistics have always been the sportswriters' measure of a ballplayer," said baseball writer Darl DeVault. "But Jenkins' special talents take him beyond the stats. There was a purity to his pitching, often described as water flowing from a glass. He had pinpoint control of his 90-mph fastball and was always ahead of the count."

Beginning in 1967, under the tutelage of Joe Becker, Jenkins began a string of six straight twenty-win seasons for the Cubbies.

His consistency and domination on the mound eventually led to the Cy Young Award in 1971, a year in which he struck out 263 batters while walking only thirty-seven.

Fergie's manager, Leo Durocher, whose baseball career spanned a half century, called him "one of the best pitchers in baseball, ever."

Jenkins found success in the belief that it was the pitcher's job to get the batter out and not allow walks, and to do that, the pitcher needed to throw strikes. For much of his career, Jenkins had the difficult task of pitching in a notable hitters' ballpark at Wrigley Field for the Cubs, from 1966 to 1973 and then again in 1982 and 1983. Because of these two factors combined, Jenkins is at the top of the Cubs' all-time list for home runs allowed, with 271 in 2,673⅔ innings, and he even noted this during his Hall of Fame induction speech in 1991: "I tried to keep the ball in the ballpark, unfortunately, it didn't always stay in the ballpark. . . . I gave up my share of home runs but with good defense and offense I was able to win some ballgames." And win games he did. Fergie won 284 in his nineteen-year big league career, with a 3.34 earned run average.

Perhaps his single biggest "big-game performance" came in the 1967 All-Star Game. Fergie became one of only four hurlers in big league history to strike out six in a Midsummer Classic when he K'd Harmon Killebrew, Tony Conigliaro, Mickey Mantle, Jim Fregosi, Rod Carew, and Tony Oliva.

—F.B.

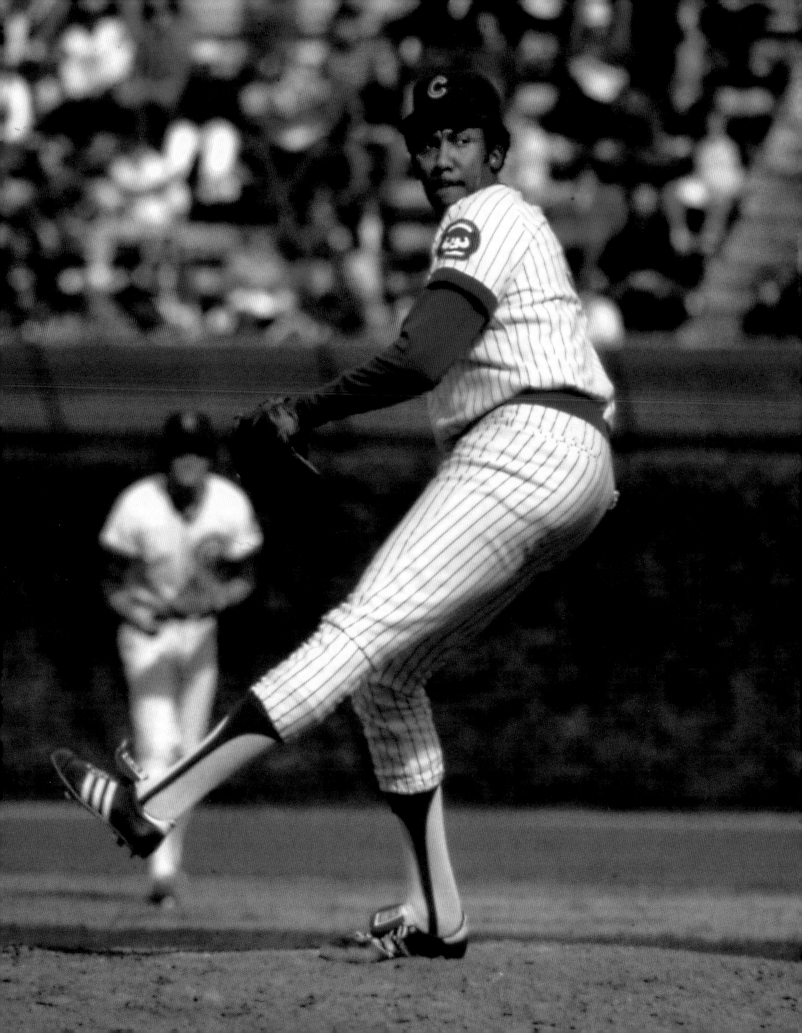

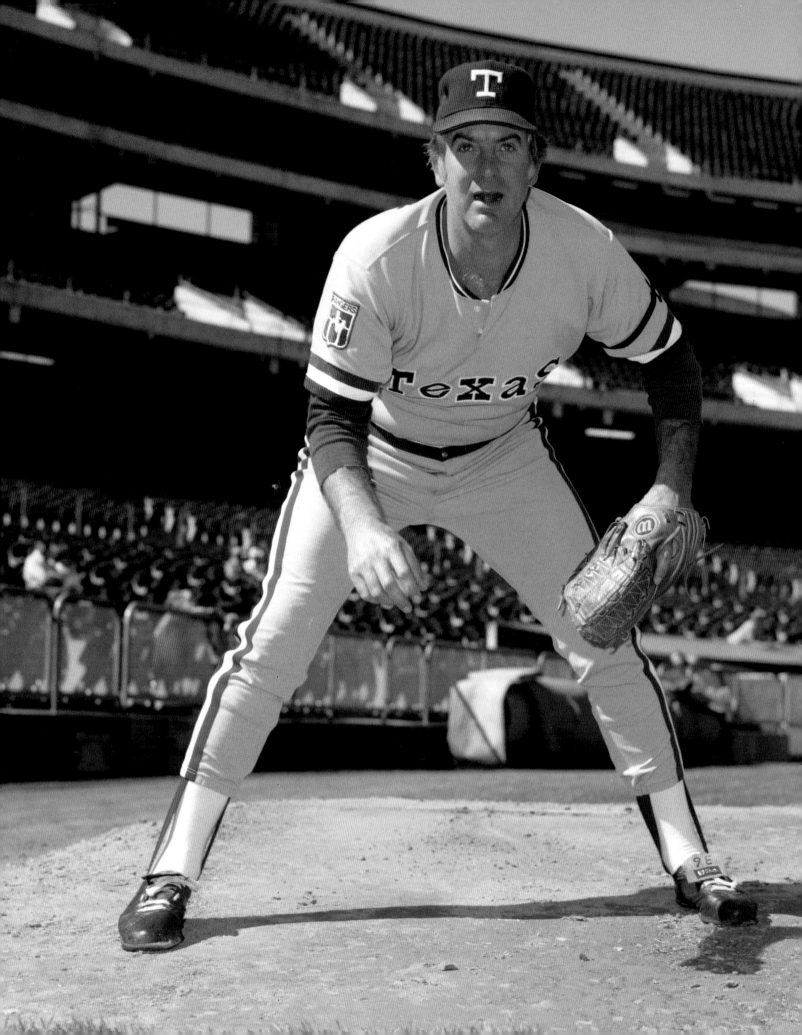

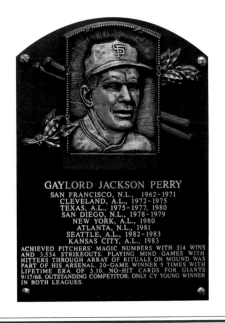

GAYLORD JACKSON PERRY
SAN FRANCISCO, N.L., 1962-1971
CLEVELAND, A.L., 1972-1975
TEXAS, A.L., 1975-1977, 1980
SAN DIEGO, N.L., 1978-1979
NEW YORK, A.L., 1980
ATLANTA, N.L., 1981
SEATTLE, A.L., 1982-1983
KANSAS CITY, A.L., 1983
ACHIEVED PITCHERS' MAGIC NUMBERS WITH 314 WINS
AND 3,534 STRIKEOUTS. PLAYING MIND GAMES WITH
HITTERS THROUGH ARRAY OF RITUALS ON MOUND WAS
PART OF HIS ARSENAL. 20-GAME WINNER 5 TIMES WITH
LIFETIME ERA OF 3.10. NO-HIT CARDS FOR GIANTS
9/17/68. OUTSTANDING COMPETITOR. ONLY CY YOUNG WINNER
IN BOTH LEAGUES.

GAYLORD PERRY

CLASS OF 1991

He was the iron man of the mound, an innings-eating machine who never seemed to tire.

And—oh, yeah—there were those spitball rumors, too.

But as the years pass and Gaylord Perry remains ensconced on baseball's leaderboard, the questions about the legality of Perry's pitches diminish.

What is left are the numbers: 314 victories, five 20-win seasons, and two Cy Young Awards.

Signed by the Giants in 1958, Perry debuted in 1962 at age twenty-three. His first good year occurred in 1966, when he started the season 20–2 and finished 21–8 with a 2.99 ERA while striking out 201 batters, earning his first All-Star Game berth.

Perry was 16–12 in 1971, helping the Giants win their first National League West Division title. But prior to the 1972 season, Perry was dealt to the Indians with infielder Frank Duffy for hard-throwing Sam McDowell. It was a trade the Giants would long regret.

In 1972 Perry won the American League Cy Young Award—the first Indians pitcher to earn the honor. That season, Perry went 24–16 with one save in his forty-one appearances, earning a decision or save in every game he pitched. He worked an incredible 342⅔ innings, the third of six times Perry would top the three-hundred-inning mark.

"In the late 1960s, they started [tracking] pitch counts with the clicker, but they didn't worry about it before that," Perry said. "You went out there and were worried about winning the game."

Midway through his fourth season with the Indians, Perry was traded to the Rangers. Then in 1978, at the age of thirty-nine, Perry joined the San Diego Padres and dazzled the NL en route to a record of 21–6. He was named the NL Cy Young Award winner, becoming the first pitcher to win the award in both leagues.

"Gaylord is a great pitcher; but he is also a great, great competitor," said Ken Aspromonte, who managed Perry with the Indians. "Nobody wants to win more than Gaylord."

Perry bounced back to the Rangers and then to the Yankees and the Braves before landing in Seattle in 1982, where he won his three-hundredth career game on May 6 of that year. He retired after the 1983 season with a record of 314–265, a 3.11 ERA, and 5,350 innings—the sixth-best total of all time.

Perry was often accused of throwing a spitball, and he used those accusations to his competitive advantage by cloaking his delivery in a shroud of ritual, progressing through several hand gestures before every pitch. Yet it was Perry's uncanny control—he averaged fewer than sixty-four walks per season and issued more than one hundred bases on balls only once—that kept him on the mound when most pitchers would have been headed for the showers. Perry also struck out 3,534 batters, which ranks eighth all-time.

Perry led his league in victories three times and was named to five All-Star teams in his twenty-two-year career.

—J.Y./C.M.

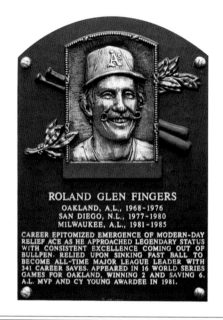

ROLAND GLEN FINGERS
OAKLAND, A.L., 1968-1976
SAN DIEGO, N.L., 1977-1980
MILWAUKEE, A.L., 1981-1985
CAREER EPITOMIZED EMERGENCE OF MODERN-DAY
RELIEF ACE AS HE APPROACHED LEGENDARY STATUS
WITH CONSISTENT EXCELLENCE COMING OUT OF
BULLPEN. RELIED UPON SINKING FAST BALL TO
BECOME ALL-TIME MAJOR LEAGUE LEADER WITH
341 CAREER SAVES. APPEARED IN 16 WORLD SERIES
GAMES FOR OAKLAND, WINNING 2 AND SAVING 6.
A.L. MVP AND CY YOUNG AWARDEE IN 1981.

ROLLIE FINGERS

CLASS OF 1992

Rollie Fingers did not have the luxury of pitching one inning at a time, as is the custom with contemporary closers. In his day, he was expected to pitch several innings in filling the role of a true relief ace.

Fingers first gained national attention for his baseball-playing skills when he was presented the American Legion Player of the Year Award during a ceremony at Cooperstown's historic Doubleday Field in 1964. Soon afterward he signed his first professional contract with the Kansas City Athletics.

The twenty-two-year-old was able to make his big league debut toward the close of the 1968 campaign, during the franchise's first season in Oakland.

Though he was a starting pitcher in the minors, whose repertoire included a hard sinking fastball and knee-buckling slider, Fingers's personality helped him make the successful transition to reliever at the major league level.

"He was one of those kids that was just so nervous," Oakland teammate Joe Rudi said. "If he knew he was going to start, by the time the game started, he had worked himself into such a frenzy that he would almost throw up."

In 1971 Oakland manager Dick Williams moved Fingers to the bullpen and plugged him into the role of "fireman." Veteran hurler Jim "Mudcat" Grant, who had made the switch from starter to reliever, taught Fingers how to attack opposing hitters by mixing his pitches rather than relying on one dominant pitch.

Using the lessons taught to him by Grant, Fingers was able to pitch long stretches during games. "Many, many times," Rudi recalled, "he would come into the game in the sixth inning, get the last out of the sixth, and then pitch the seventh, eighth, and ninth."

"When he came in, you took a deep sigh of relief," said former Oakland teammate Sal Bando. "You knew the game was in control."

The MVP of the 1974 World Series, earning a win and two saves in four games, Fingers, appropriately, was on the mound at the end of two World Series during Oakland's three-year run as world champions from 1972 to 1974.

Like many of his Oakland teammates, Fingers soon opted for free agency, signing after the 1976 season with the San Diego Padres, where he twice led the National League in saves.

"He's the master," said fellow relief pitcher Dan Quisenberry. "Look at his durability and longevity. He always knows how to make the right pitch."

In 1981 Fingers joined the Milwaukee Brewers via a trade and sported a microscopic ERA of 1.04 on his way to winning both the Junior Circuit's MVP and Cy Young Awards. One year later he helped the Brewers to their first-ever World Series appearance.

Fingers finished his career with 114 wins, a then record 341 saves, 1,299 strikeouts, a 2.90 ERA, and 1,701⅓ innings pitched in 944 games.

Throughout much of his career, Fingers's trademark handlebar mustache made him one of the game's most recognizable players. That mustache, along with his vintage slider, was a sight that hitters dreaded seeing whenever he emerged from the bullpen.

—B.F.

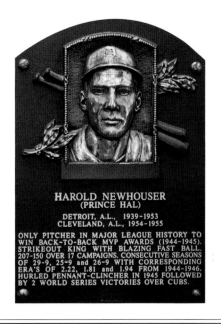

HAROLD NEWHOUSER
(PRINCE HAL)

DETROIT, A.L., 1939-1953
CLEVELAND, A.L., 1954-1955

ONLY PITCHER IN MAJOR LEAGUE HISTORY TO
WIN BACK-TO-BACK MVP AWARDS (1944-1945).
STRIKEOUT KING WITH BLAZING FAST BALL.
207-150 OVER 17 CAMPAIGNS. CONSECUTIVE SEASONS
OF 29-9, 25-9 and 26-9 WITH CORRESPONDING
ERA'S OF 2.22, 1.81 and 1.94 FROM 1944-1946.
HURLED PENNANT-CLINCHER IN 1945 FOLLOWED
BY 2 WORLD SERIES VICTORIES OVER CUBS.

HAL NEWHOUSER

CLASS OF 1992

He was such an intense competitor that his career stalled prior to World War II. But Hal Newhouser eventually found a way to control his temper, clearing a delayed path to Cooperstown.

Newhouser grew up in Detroit, where he excelled as a high school pitcher and drew interest from both the hometown Tigers and the Cleveland Indians. The Tigers barely beat the Indians to the punch.

At age eighteen, Newhouser made his debut for the 1939 Tigers, but he was not ready. He returned in 1940, this time to stay. Newhouser's live left arm inspired awe among scouts, but he struggled to throw strikes. In 1943 he led the American League in walks.

Unlike many ballplayers, Newhouser was deemed ineligible for military service in World War II because of a congenital heart condition. So he kept pitching during the war years, blossoming in 1944. He harnessed his fastball and overhand curve, showing good control of both as he won twenty-nine games.

Newhouser became known for engaging in a memorable series of pitching duels with Bob Feller. Newhouser's rival took note of his determined approach before and during games. "I used to kid him when we'd take those publicity pictures before we'd pitch against each other," Feller told the *Detroit Free Press.* "You know, trying to get him to smile. But he didn't smile too often when he was in uniform. Hal took the game very seriously—in fact, I think it was really more than a game to him."

Ever focused but reining in his temper, Newhouser pitched the Tigers into the 1945 World Series. Facing the Chicago Cubs, he hurled two complete games, including a climactic victory in Game 7.

That October, Newhouser's pitching drew praise from one of the game's great talent evaluators. "He's a very good pitcher," Brooklyn Dodgers president Branch Rickey informed the *New York Post.* "He's got a fastball, a fine curve, and a swell change-of-pace. He's got confidence in himself. Just a great pitcher, that's all." After the season, Newhouser earned his second consecutive AL MVP Award.

Newhouser's greatness continued throughout the decade. In 1948 he faced Feller on the final day of the season. Newhouser won, forcing the Indians to play a tiebreaker against Boston for the pennant. In 1949 "Prince Hal" won eighteen games before persistent shoulder trouble caught up with him the following summer. He signed with the Indians in 1954, pitching his final two seasons as a teammate of Feller's.

Although Newhouser dominated hitters during the war, at a time when many of the game's stars could not play because of military commitments, he was more than just a wartime star. He continued to succeed for several seasons beyond the war. He also drew the approval of his chief rival. "He was very proud of what he did, and he should have been," Feller told the *Detroit Free Press.* "He was a great pitcher. I'm proud to say I played with him and against him."

—B.M.

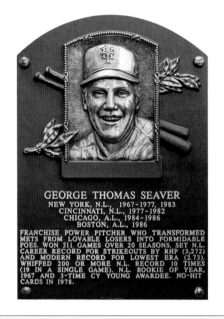

GEORGE THOMAS SEAVER
NEW YORK, N.L., 1967-1977, 1983
CINCINNATI, N.L., 1977-1982
CHICAGO, A.L., 1984-1986
BOSTON, A.L., 1986
FRANCHISE POWER PITCHER WHO TRANSFORMED
METS FROM LOVABLE LOSERS INTO FORMIDABLE
FOES. WON 311 GAMES OVER 20 SEASONS. SET N.L.
CAREER RECORD FOR STRIKEOUTS BY RHP (3,272)
AND MODERN RECORD FOR LOWEST ERA (2.73).
WHIFFED 200 OR MORE N.L. RECORD 10 TIMES
(19 IN A SINGLE GAME). N.L. ROOKIE OF YEAR,
1967 AND 3-TIME CY YOUNG AWARDEE. NO-HIT
CARDS IN 1978.

TOM SEAVER

CLASS OF 1992

Is it possible for one player to lift a franchise out of ineptitude and raise it to the level of a championship contender? Perhaps not, but Tom Seaver came as close to doing so as any player has done with one franchise.

A native Californian, Seaver initially signed with the Atlanta Braves, but Commissioner William Eckert voided the contract because the right-hander's collegiate season was still in progress. Four teams participated in a lottery, with the New York Mets winning the sweepstakes and closing the deal with a $50,000 bonus.

After his 1966 signing, Seaver made his major league debut the following season. As the National League's top rookie, he won sixteen games while posting a tidy 2.76 ERA.

Seaver's Mets lost 101 games, but the situation would change within two years. In 1969 the Mets posted one hundred wins, with Seaver carrying the heaviest load. In capturing his first NL Cy Young Award, "Tom Terrific" won a league-leading twenty-five games, launching the "Miracle Mets" to a stunning world championship.

Over the next four seasons, Seaver used his trademark drop-and-drive delivery, in which he relied heavily on leg strength, to win seventy-eight games and stake claim to three ERA titles. In 1973 he helped the Mets to another division title. He pitched brilliantly that fall, though the Mets lost the World Series in seven games.

No other pitcher dominated the early 1970s like Seaver, whose fastball and curveball highlighted his repertoire. "He was one of the toughest pitchers I ever faced, if not the toughest," Hall of Fame third baseman Mike Schmidt told sportswriter Kevin Horrigan. "He didn't have a pattern. He got me out with whatever he felt like on that night."

In 1977 a dispute with ownership led to a drastic change at the trading deadline. The Mets sent Seaver to the Cincinnati Reds, a move that was hated by New Yorkers. A lasting symbol of the 1969 world championship team, Seaver had become the most popular player in Mets history.

Seaver remained an effective pitcher with Cincinnati; he hurled a no-hitter in 1978 and helped the Reds win the Western Division in 1979.

Surprisingly, Seaver would make a triumphant return to the Mets in 1983. He pitched a workmanlike 231 innings, but his second New York tenure lasted just one season. As part of the compensation system attached to free agency, the Mets lost Seaver to the Chicago White Sox, depriving Mets fans of watching Seaver win his three-hundredth game for New York.

In 1992 Seaver won election to Cooperstown with the highest percentage in voting history. For followers of the Mets, his election carried a special meaning. Seaver became the first player to feature the team's "NY" logo on his bronze plaque. It became a most appropriate legacy for the man known as "The Franchise."

—B.M.

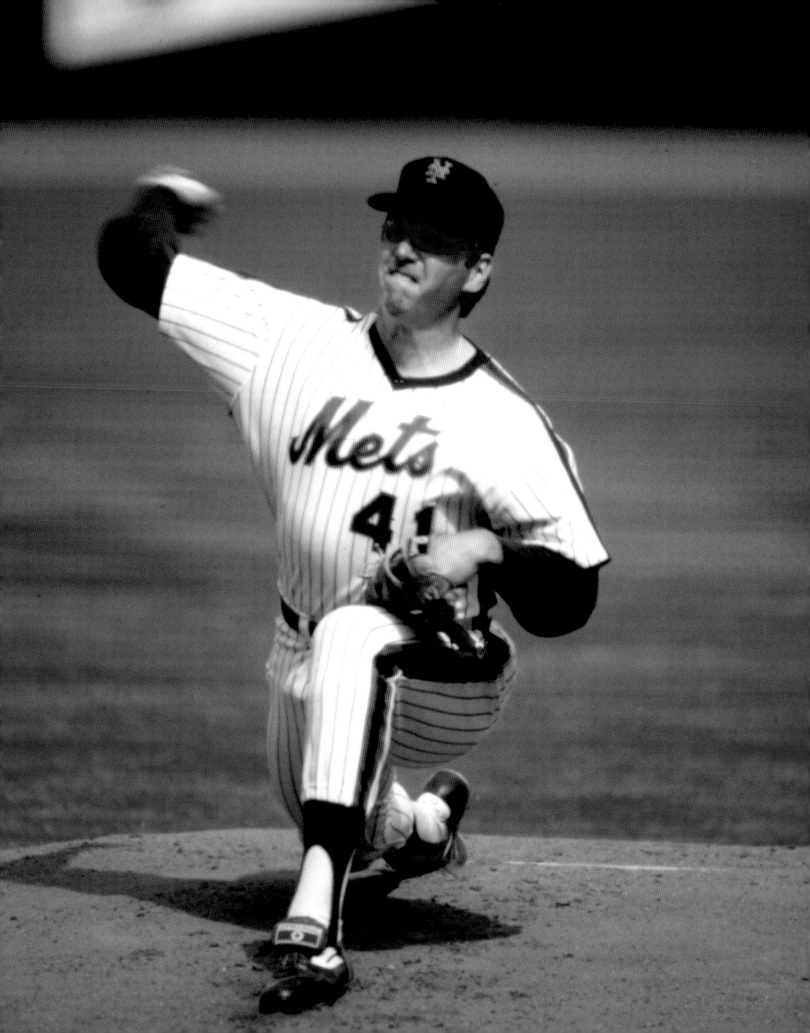

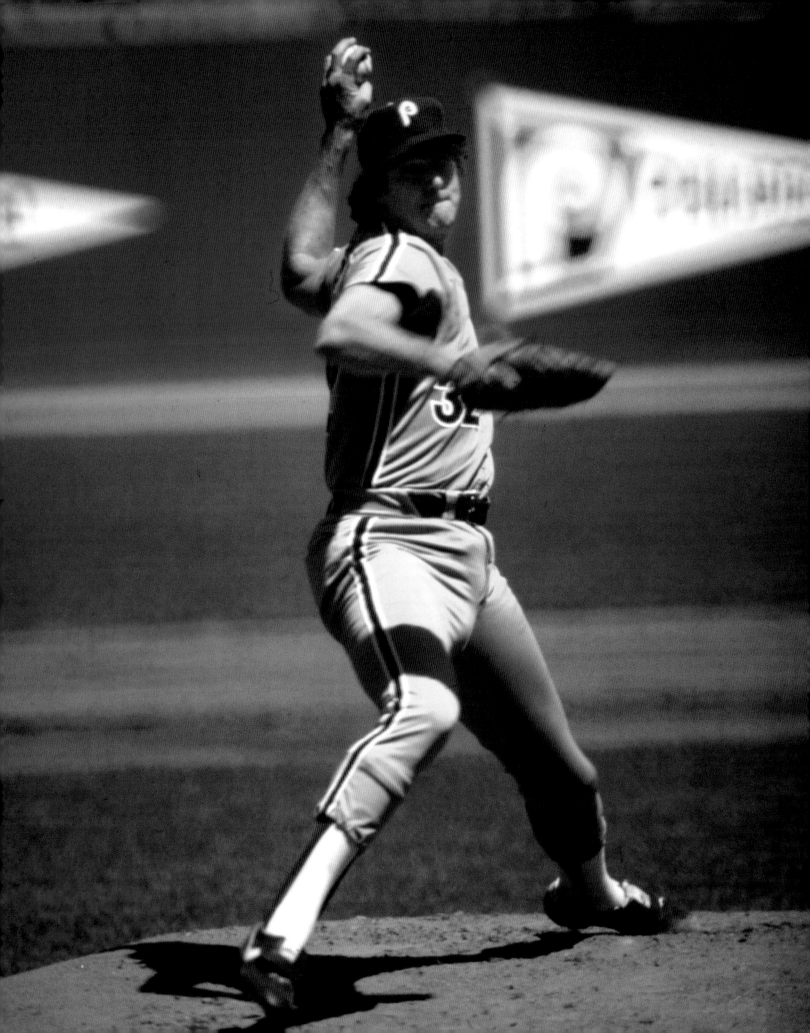

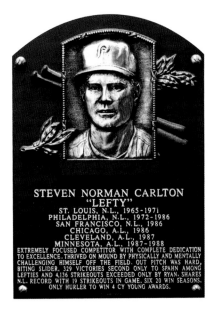

STEVEN NORMAN CARLTON
"LEFTY"
ST. LOUIS, N.L., 1965-1971
PHILADELPHIA, N.L., 1972-1986
SAN FRANCISCO, N.L., 1986
CHICAGO, A.L., 1986
CLEVELAND, A.L., 1987
MINNESOTA, A.L., 1987-1988
EXTREMELY FOCUSED COMPETITOR WITH COMPLETE DEDICATION
TO EXCELLENCE. THRIVED ON MOUND BY PHYSICALLY AND MENTALLY
CHALLENGING HIMSELF OFF THE FIELD. OUT PITCH WAS HARD,
BITING SLIDER. 329 VICTORIES SECOND ONLY TO SPAHN AMONG
LEFTIES AND 4,136 STRIKEOUTS EXCEEDED ONLY BY RYAN. SHARES
N.L. RECORD WITH 19 STRIKEOUTS IN GAME. SIX 20 WIN SEASONS.
ONLY HURLER TO WIN 4 CY YOUNG AWARDS.

STEVE CARLTON

CLASS OF 1994

At his peak, Steve Carlton dominated hitters like few left-handers in history.

Unfortunately for those same hitters, Carlton's peak lasted well beyond the normal career arc of most players. Signing as an amateur free agent with the St. Louis Cardinals in 1963, the six-foot-four Carlton blitzed through the minors before surfacing in the big leagues in 1965. By 1967 Carlton was 14–9 and a member of the Cardinals rotation—helping St. Louis capture the World Series crown that year.

On September 15, 1969, Carlton set a new record (since surpassed) with nineteen strikeouts in a nine-inning game against the Mets. And by 1971, Carlton had notched his first twenty-win season and been named to three All-Star Games. But prior to the 1972 season, a salary dispute resulted in his being traded to the Phillies in exchange for pitcher Rick Wise.

Seven months later, Carlton authored one of the best seasons of the twentieth century, going 27–10 for a Phillies team that won just fifty-nine games all year. Carlton not only garnered nearly half of his team's wins but also led the National League with a 1.97 earned run average and 310 strikeouts while logging 346⅓ innings and thirty complete games.

Carlton was rewarded with his first NL Cy Young Award.

Over the next decade, Carlton remained one of the most feared pitchers in the game. His devastating slider reduced left-handers to a batting average of .233—and also eliminated many from the lineup, as managers would simply sit out their best left-handers against the man known as "Lefty."

Only 19 percent of all plate appearances against Carlton in his twenty-four big league seasons came from left-handed batters. His classic over-the-top delivery made it almost impossible for them to pick up Carlton's pitches.

"I threw all my pitches over the top," Carlton said, "which was important for me because my slider was hard to tell from my fastball at release."

Carlton won his second Cy Young Award in 1977 and followed with his third in 1980, going 24–9 while leading the Phillies to their first-ever World Series title. He won his fourth Cy Young Award (a record at the time) in 1982 while going 23–11 and posting a league-leading nineteen complete games and six shutouts at age thirty-seven.

In 1983 Carlton and Nolan Ryan each passed Walter Johnson's then record 3,508 strikeouts and traded days as the record holder, depending on their turn in the rotation. Carlton held the all-time record as late as September 4, 1984, but the younger Ryan eventually overtook Carlton for the record.

On September 23, 1983, Carlton recorded his three-hundredth career victory, becoming the sixteenth pitcher to reach that milestone.

Carlton ended his career with stints with the Giants, White Sox, Indians, and Twins. When he retired after the 1988 season, he'd totaled 329 wins, a 3.22 ERA, and 4,136 strikeouts to go along with four World Series appearances, two World Series rings, and ten All-Star Game selections.

Carlton was elected to the Hall of Fame in his first year of eligibility in 1994.

—C.M.

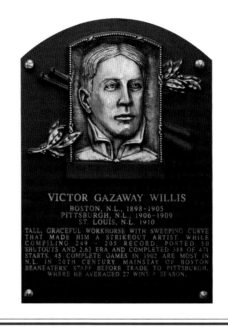

VIC WILLIS

CLASS OF 1995

For a player who already had four 20-win seasons on his résumé, Vic Willis had a tough time renting out his right arm in the early years of the twentieth century. "The Delaware Peach" had hit a little slump and lost more games than he won for a few seasons.

Trying to solidify a new job after a trade and get a raise, he wrote a letter to Pittsburgh Pirates owner Barney Dreyfuss. "Don't believe those tales you hear of me being all-in," Willis said. "Wait until you see me in action for your team and then form your opinion of my worth. I assure you that I am delighted to be a Pirate and that I will do my best to bring another pennant to the Smoky City."

Willis signed for $4,500 and reeled off four straight twenty-win seasons, proving he was not blowing smoke at Dreyfuss. He pitched one season for the St. Louis Cardinals and retired at age thirty-four with 249 wins. For the most part, Willis's history lay dormant for the next eighty-five years until he was elected to the Hall of Fame.

One thing Willis promised Dreyfuss when he joined the team was that he would get another pennant out of the deal, and the Pirates did win the National League title in 1909. Pittsburgh met the Detroit Tigers in the World Series, and Willis was on the mound when Ty Cobb stole home. "That's one thing I'll never forget," Willis said years later, "as long as I live. I didn't think Cobb could beat the throw. I often got razzed for letting Ty get away with that theft, but I don't think anybody could have prevented it."

Ben Decker, grandson of the pitching star, ran a lengthy campaign to get the grandfather he once played catch with in the yard into Cooperstown, and he prevailed in 1995. Decker promised Vic Willis Jr., the pitcher's son, that he would carry the torch for his grandfather after Junior died, and he persistently made the case to the Veterans Committee. Decker remembered his grandfather saying during the years he had those losing marks and the newspapers called him washed-up, "Those outfielders couldn't catch a fly ball with a peach basket."

Willis was born in Maryland but grew up in Newark, Delaware, and retired there. Some believed he still had good years left in his arm, but Willis said he had fulfilled his goals. "When I went into baseball my goal was the purchase of that hotel," he said of the local Washington House, which he'd bought. "So I saved my money and in 1911 when I had $40,000 I acquired it. There never was any more thought of baseball for me after that. Sure, I might have been able to go along for three or four years—with a good team behind me, but I didn't want to gamble on it with all of my money tied up in the hotel."

—L.F.

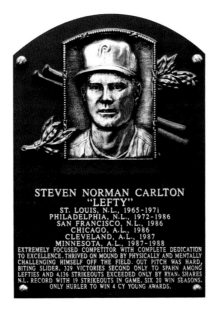

STEVEN NORMAN CARLTON
"LEFTY"
ST. LOUIS, N.L., 1965-1971
PHILADELPHIA, N.L., 1972-1986
SAN FRANCISCO, N.L., 1986
CHICAGO, A.L., 1986
CLEVELAND, A.L., 1987
MINNESOTA, A.L., 1987-1988
EXTREMELY FOCUSED COMPETITOR WITH COMPLETE DEDICATION
TO EXCELLENCE. THRIVED ON MOUND BY PHYSICALLY AND MENTALLY
CHALLENGING HIMSELF OFF THE FIELD. OUT PITCH WAS HARD,
BITING SLIDER. 329 VICTORIES SECOND ONLY TO SPAHN AMONG
LEFTIES AND 4,136 STRIKEOUTS EXCEEDED ONLY BY RYAN. SHARES
N.L. RECORD WITH 19 STRIKEOUTS IN GAME. SIX 20 WIN SEASONS.
ONLY HURLER TO WIN 4 CY YOUNG AWARDS.

STEVE CARLTON

CLASS OF 1994

At his peak, Steve Carlton dominated hitters like few left-handers in history.

Unfortunately for those same hitters, Carlton's peak lasted well beyond the normal career arc of most players. Signing as an amateur free agent with the St. Louis Cardinals in 1963, the six-foot-four Carlton blitzed through the minors before surfacing in the big leagues in 1965. By 1967 Carlton was 14–9 and a member of the Cardinals rotation—helping St. Louis capture the World Series crown that year.

On September 15, 1969, Carlton set a new record (since surpassed) with nineteen strikeouts in a nine-inning game against the Mets. And by 1971, Carlton had notched his first twenty-win season and been named to three All-Star Games. But prior to the 1972 season, a salary dispute resulted in his being traded to the Phillies in exchange for pitcher Rick Wise.

Seven months later, Carlton authored one of the best seasons of the twentieth century, going 27–10 for a Phillies team that won just fifty-nine games all year. Carlton not only garnered nearly half of his team's wins but also led the National League with a 1.97 earned run average and 310 strikeouts while logging 346⅓ innings and thirty complete games.

Carlton was rewarded with his first NL Cy Young Award.

Over the next decade, Carlton remained one of the most feared pitchers in the game. His devastating slider reduced left-handers to a batting average of .233—and also eliminated many from the lineup, as managers would simply sit out their best left-handers against the man known as "Lefty."

Only 19 percent of all plate appearances against Carlton in his twenty-four big league seasons came from left-handed batters. His classic over-the-top delivery made it almost impossible for them to pick up Carlton's pitches.

"I threw all my pitches over the top," Carlton said, "which was important for me because my slider was hard to tell from my fastball at release."

Carlton won his second Cy Young Award in 1977 and followed with his third in 1980, going 24–9 while leading the Phillies to their first-ever World Series title. He won his fourth Cy Young Award (a record at the time) in 1982 while going 23–11 and posting a league-leading nineteen complete games and six shutouts at age thirty-seven.

In 1983 Carlton and Nolan Ryan each passed Walter Johnson's then record 3,508 strikeouts and traded days as the record holder, depending on their turn in the rotation. Carlton held the all-time record as late as September 4, 1984, but the younger Ryan eventually overtook Carlton for the record.

On September 23, 1983, Carlton recorded his three-hundredth career victory, becoming the sixteenth pitcher to reach that milestone.

Carlton ended his career with stints with the Giants, White Sox, Indians, and Twins. When he retired after the 1988 season, he'd totaled 329 wins, a 3.22 ERA, and 4,136 strikeouts to go along with four World Series appearances, two World Series rings, and ten All-Star Game selections.

Carlton was elected to the Hall of Fame in his first year of eligibility in 1994.

—C.M.

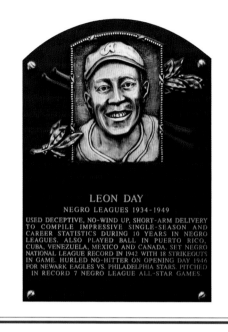

LEON DAY

CLASS OF 1995

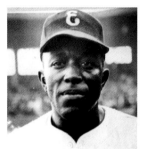

While Satchel Paige and others made headlines in the old Negro Leagues, Leon Day was too often lost in the shadows. But to those who played during those times and later studied that era, nobody was better.

An outstanding strikeout pitcher with a dominating fastball and wicked curve, Day was the mainstay of the Newark Eagles pitching staff in the late 1930s and 1940s. Known for a no-windup delivery, he was regarded as one of the top fireballers ever.

Buck O'Neil called him a "front-line starter" who threw "everything quick."

In a report by the Society for American Baseball Research, Day agreed that "Satchel was more flamboyant. He stood out in a crowd. Me, I just did my job. I didn't open my mouth."

According to Negro Leagues historian Todd Bolton, Day "was never a self promoter. . . . [He] was a humble man and let his record speak for itself."

Former teammate Monte Irvin said that Day was as fast and as competitive as Bob Gibson, adding that Day "was the most complete ballplayer I've ever seen."

A superb contact hitter and fleet base runner, Day was versatile enough to play second base or the outfield when he wasn't pitching.

Day won three of four marquee matchups against Paige and pitched a record seven times in the Negro Leagues' East-West All-Star Game. In 1942, as a member of the Newark Eagles, Day struck out eighteen Baltimore Elite Giants to set a Negro National League record.

"He threw that ball more or less from his hip," Gene Benson, an infielder with the Philadelphia Stars, told SABR. "He didn't rear back and come right over his shoulder. He came right from his thigh, but he would whistle the ball and make it move. He could bring it."

Several times, the *Pittsburgh Courier,* a leading African American newspaper, rated Day higher than Paige, calling him the best Negro League pitcher in 1942 and 1943.

During World War II, Day served in a segregated amphibious unit (helping land supplies after D-Day) and pitched on integrated Army teams. After the war, in his first game back with the Eagles, he tossed a no-hitter against the Philadelphia Stars.

In auditions for the major leagues, with the color barrier at the major league level coming down, Day was still bothered by a bad arm. When he went unsigned, Day headed south, playing in Mexico and Cuba. After retiring from the game, he worked for a time as a bartender in Newark before resettling in Baltimore, where much of his family had moved. There he became a security guard, but he never forgot his heyday in the Negro Leagues, when he ranked among the best ever.

"I was glad to play in the Negro Leagues," he once said. "I wouldn't trade it for anything in the world."

—T. Wendel

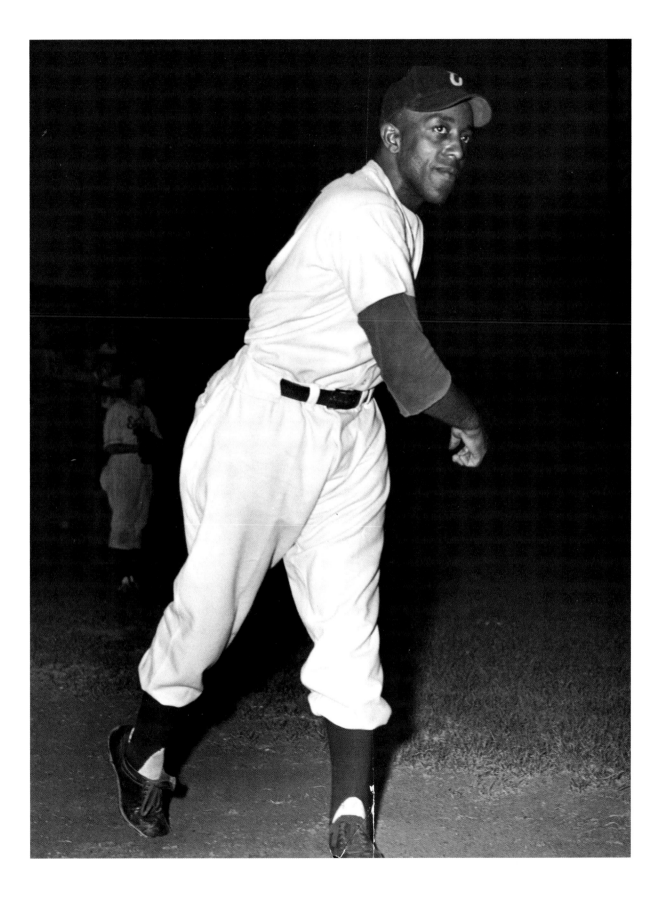

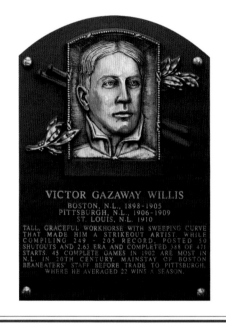

VICTOR GAZAWAY WILLIS
BOSTON, N.L., 1898-1905
PITTSBURGH, N.L., 1906-1909
ST. LOUIS, N.L. 1910
TALL, GRACEFUL WORKHORSE WITH SWEEPING CURVE
THAT MADE HIM A STRIKEOUT ARTIST WHILE
COMPILING 249 - 205 RECORD. POSTED 50
SHUTOUTS AND 2.63 ERA AND COMPLETED 388 OF 471
STARTS. 45 COMPLETE GAMES IN 1902 ARE MOST IN
N.L. IN 20TH CENTURY. MAINSTAY OF BOSTON
BEANEATERS' STAFF BEFORE TRADE TO PITTSBURGH,
WHERE HE AVERAGED 22 WINS A SEASON.

VIC WILLIS

CLASS OF 1995

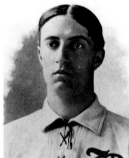

For a player who already had four 20-win seasons on his résumé, Vic Willis had a tough time renting out his right arm in the early years of the twentieth century. "The Delaware Peach" had hit a little slump and lost more games than he won for a few seasons.

Trying to solidify a new job after a trade and get a raise, he wrote a letter to Pittsburgh Pirates owner Barney Dreyfuss. "Don't believe those tales you hear of me being all-in," Willis said. "Wait until you see me in action for your team and then form your opinion of my worth. I assure you that I am delighted to be a Pirate and that I will do my best to bring another pennant to the Smoky City."

Willis signed for $4,500 and reeled off four straight twenty-win seasons, proving he was not blowing smoke at Dreyfuss. He pitched one season for the St. Louis Cardinals and retired at age thirty-four with 249 wins. For the most part, Willis's history lay dormant for the next eighty-five years until he was elected to the Hall of Fame.

One thing Willis promised Dreyfuss when he joined the team was that he would get another pennant out of the deal, and the Pirates did win the National League title in 1909. Pittsburgh met the Detroit Tigers in the World Series, and Willis was on the mound when Ty Cobb stole home. "That's one thing I'll never forget," Willis said years later, "as long as I live. I didn't think Cobb could beat the throw. I often got razzed for letting Ty get away with that theft, but I don't think anybody could have prevented it."

Ben Decker, grandson of the pitching star, ran a lengthy campaign to get the grandfather he once played catch with in the yard into Cooperstown, and he prevailed in 1995. Decker promised Vic Willis Jr., the pitcher's son, that he would carry the torch for his grandfather after Junior died, and he persistently made the case to the Veterans Committee. Decker remembered his grandfather saying during the years he had those losing marks and the newspapers called him washed-up, "Those outfielders couldn't catch a fly ball with a peach basket."

Willis was born in Maryland but grew up in Newark, Delaware, and retired there. Some believed he still had good years left in his arm, but Willis said he had fulfilled his goals. "When I went into baseball my goal was the purchase of that hotel," he said of the local Washington House, which he'd bought. "So I saved my money and in 1911 when I had $40,000 I acquired it. There never was any more thought of baseball for me after that. Sure, I might have been able to go along for three or four years—with a good team behind me, but I didn't want to gamble on it with all of my money tied up in the hotel."

—L.F.

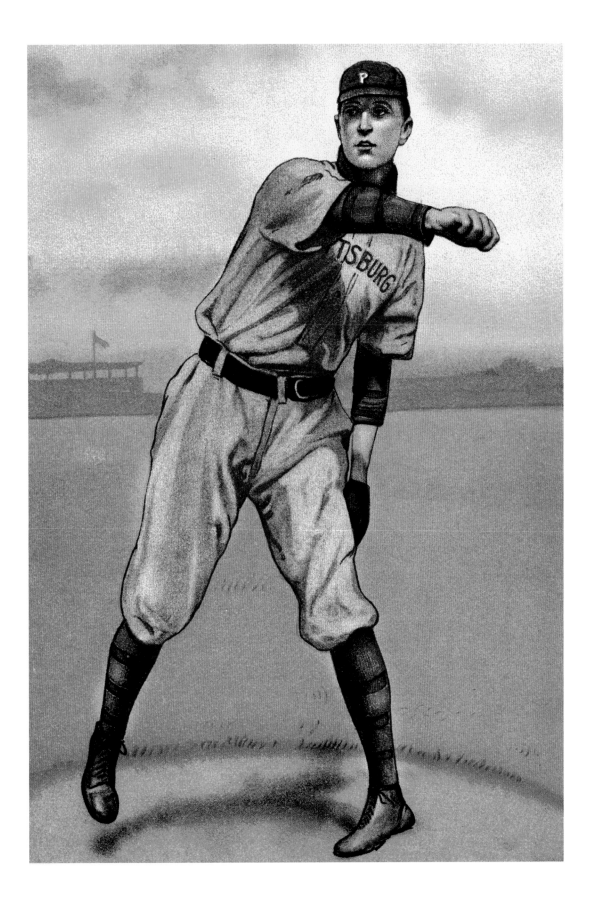

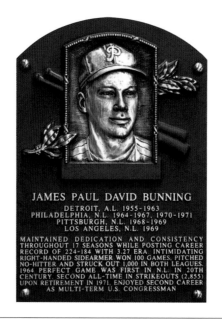

JAMES PAUL DAVID BUNNING
DETROIT, A.L. 1955-1963
PHILADELPHIA, N.L. 1964-1967, 1970-1971
PITTSBURGH, N.L. 1968-1969
LOS ANGELES, N.L. 1969

MAINTAINED DEDICATION AND CONSISTENCY
THROUGHOUT 17 SEASONS WHILE POSTING CAREER
RECORD OF 224-184 WITH 3.27 ERA. INTIMIDATING
RIGHT-HANDED SIDEARMER WON 100 GAMES, PITCHED
NO-HITTER AND STRUCK OUT 1,000 IN BOTH LEAGUES.
1964 PERFECT GAME WAS FIRST IN N.L. IN 20TH
CENTURY. SECOND ALL-TIME IN STRIKEOUTS (2,855).
UPON RETIREMENT IN 1971, ENJOYED SECOND CAREER
AS MULTI-TERM U.S. CONGRESSMAN

JIM BUNNING

CLASS OF 1996

Balancing a baseball career and a college education that kept him from starting his season until after the end of spring classes, Jim Bunning logged nearly one thousand minor league innings before throwing a single pitch at the game's highest level.

Once he reached the major leagues in 1955, Bunning's blend of a sweeping curveball, darting slider, sidearm fastball, and immaculate control would befuddle hitters for the better part of two decades. Bunning posted seventeen or more wins eight times, and with his 2,855 career strikeouts, he ranked second only to Walter Johnson upon his retirement.

Bunning spent the bulk of his career with the Detroit Tigers and Philadelphia Phillies, and he experienced great success with both clubs. As a twenty-five-year-old in his first full season in 1957, he posted a career-best twenty victories for the Tigers.

He started and earned the win in the All-Star Game that season, his first appearance, pitching three perfect innings against the National League stars in St. Louis. Although rules at the time prohibited pitchers from throwing more than three innings, Bunning always wished he could have continued his perfect game effort.

"Maybe it would have been pressing my luck," Bunning told the *New York Times*, "but I still would have liked to keep pitching."

Bunning would amass nine All-Star Game selections in his career.

He spent nine seasons in Detroit. Bunning struck out Boston Red Sox great Ted Williams three times on May 16, 1957, one of only two pitchers to retire Williams on strikes three times in a single game. On August 2, 1959, he became one of the few players in major league history to record a nine-strike, three-strikeout inning, in the ninth inning of a 5–4 loss to the Red Sox.

Following his seasons with the Phillies from 1964 to 1967, Bunning spent time in Pittsburgh and Los Angeles before wrapping up his career in Philadelphia in 1970 and 1971.

The right-hander holds the distinction of being one of only five pitchers to hurl no-hitters in both leagues. Bunning accomplished the feat with the Tigers in 1958 and with the Phillies in 1964—the latter a perfect game against the New York Mets on Father's Day. It was the first perfect game in the National League since 1880, and the New York crowd gave Bunning "one of the biggest ovations ever heard in the Mets' new stadium," reported the *New York Times*.

Bunning played an integral role in the formation of the Players Association and later served several terms in the United States House of Representatives and United States Senate. In 1996 the Veterans Committee elected him to the National Baseball Hall of Fame.

"Jim Bunning is a rare person," wrote biographer Frank Dolson. "Those who know him, above all those who played against him in the big leagues, or played for him in the minor leagues, or sit with him in the House of Representatives, would be hard-pressed to dispute that."

—C.M.

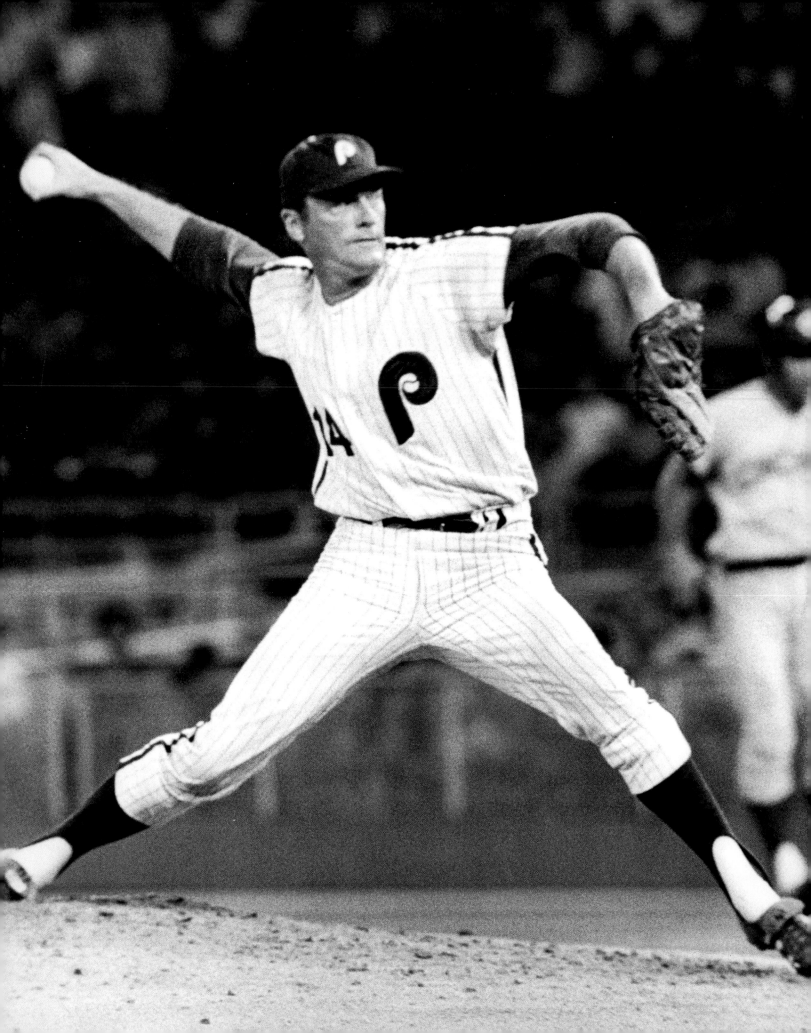

WILLIAM HENDRICK FOSTER
NEGRO LEAGUES, 1923-1937
REGARDED AS ONE OF THE BEST LEFT-HANDED
PITCHERS IN NEGRO LEAGUE HISTORY AND ALSO
MANAGED SEVERAL CLUBS. DEVASTATING SIDEARM
DELIVERY MADE HIM CONSISTENT WINNER
INSTRUMENTAL IN CHICAGO AMERICAN GIANTS' NEGRO
LEAGUE PENNANT AND WORLD SERIES SUCCESS IN
1926, 1927, 1928 AND 1933. WON 26 STRAIGHT IN
1926 AND HAD 32-3 MARK IN 1927. COACHED
BASEBALL AT ALMA MATER, ALCORN A & M COLLEGE
IN MISSISSIPPI, 1960-1978

BILL FOSTER

CLASS OF 1996

Bill Foster's 1926 season was one for the ages. Starring for the Chicago American Giants—run by his older half brother, Hall of Famer Rube Foster—Bill won twenty-six consecutive games, pitching against Negro National League and non-league foes. His league record that season was 16–6. The American Giants won the second-half title and faced the Kansas City Monarchs in the playoffs, needing a double-header sweep on the final day to clinch the pennant. Bill Foster started Game 1 against the ace of the Monarchs, Hall of Famer Bullet Joe Rogan, and beat him, 1–0. Rogan, also the Monarchs' manager, was surprised to see Foster warming up for the second game, and decided to oppose him again. The outcome was similar, as Foster blanked the Monarchs, 5–0, in the nightcap.

As Hall of Famer Buck Leonard once said of Foster, "All the years I played, I never got a hit off him. He threw fire."

The American Giants advanced to the World Series, defeating the Bacharach Giants, while Foster won two games, one a shut-out, threw three complete games, and posted an ERA of 1.27.

For much of that time he was considered the best lefty in the Negro Leagues. According to umpire Jocko Conlan, "Foster had the same perfect delivery of Herb Pennock, but was faster by far, with a sharp curve, and had what all great pitchers have—control."

The great Negro Leagues player and manager Dave Malarcher called him "the greatest exponent of the change-of-pace. He could throw you a fast ball with maybe six or eight changes of speed." Malarcher once stated it even more plainly: "Bill Foster was my star pitcher, the greatest pitcher of our time, not even barring Satchel."

Foster was the winning pitcher in the first East-West All-Star Game in 1933, going the distance against a formidable East lineup that included future Hall of Famers Cool Papa Bell, Oscar Charleston, Biz Mackey, and Jud Wilson. He appeared in the Midsummer Classic again the following year. Foster briefly served as a player-manager in 1931 for the American Giants but resigned in order to concentrate on pitching. He played winter ball in Cuba and California.

Foster played from 1923 to 1937, appearing not just with the American Giants but also with the Memphis Red Sox, Homestead Grays, and Kansas City Monarchs. He notched a .670 career winning percentage in league games, in which he went 128–63. He won eleven of twenty-one head-to-head matchups with Hall of Famer Satchel Paige, and six of seven postseason games against teams composed of white major leaguers. After one such contest in 1929, Hall of Famer Charlie Gehringer told him, "If I could paint you white I could get $150,000 for you right now."

Foster was dean of men and baseball coach at Alcorn State College from 1960 until his death in 1978. He was elected to the Baseball Hall of Fame in 1996. "He gave our best teams fits," said Hall of Famer Cumberland Posey. He was "the hardest man in baseball to beat."

—T. Wiles

To Uncle Claude from
Bill 1928

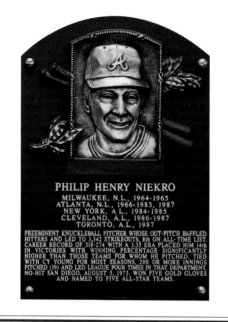

PHILIP HENRY NIEKRO
MILWAUKEE, N.L., 1964-1965
ATLANTA, N.L., 1966-1983, 1987
NEW YORK, A.L., 1984-1985
CLEVELAND, A.L., 1986-1987
TORONTO, A.L., 1987
PREEMINENT KNUCKLEBALL PITCHER WHOSE OUT-PITCH BAFFLED
HITTERS AND LED TO 3,342 STRIKEOUTS, 8th ON ALL-TIME LIST.
CAREER RECORD OF 318-274 WITH A 3.35 ERA PLACED HIM 14th
IN VICTORIES WITH WINNING PERCENTAGE SIGNIFICANTLY
HIGHER THAN THOSE TEAMS FOR WHOM HE PITCHED. TIED
WITH CY YOUNG FOR MOST SEASONS, 200 OR MORE INNINGS
PITCHED (19) AND LED LEAGUE FOUR TIMES IN THAT DEPARTMENT.
NO-HIT SAN DIEGO, AUGUST 5, 1973. WON FIVE GOLD GLOVES
AND NAMED TO FIVE ALL-STAR TEAMS.

PHIL NIEKRO

CLASS OF 1997

Some players are known for moments of glory, others for a long and distinguished career. But right-handed pitcher Phil Niekro is known for both, thanks to his fluttering knuckleball.

The man who was nicknamed "Knucksie" twice led the National League in wins and propelled the Braves to the National League West Division title in 1969, when he recorded twenty-three victories, twenty-one complete games, and a 2.56 ERA.

A five-time All-Star, Niekro no-hit the San Diego Padres in 1973. He later managed the all-women Colorado Silver Bullets baseball team. Niekro also was a five-time Gold Glove Award winner and won 121 games after he turned forty, the most wins by anyone over that age in baseball history.

Besides being a member of the three-hundred-win club, Niekro struck out 3,342 batters, too—many of whom are still grumbling about that elusive knuckler of his.

"Trying to hit him is like trying to eat Jell-O with chopsticks," Bobby Murcer said.

"Trying to hit that thing is a miserable way to make a living," added Pete Rose.

"It giggles as it goes by," said Rick Monday.

For those who tried to catch Niekro's knuckleball, which Ralph Kiner said was "like watching Mario Andretti park a car," Bob Uecker perhaps had the best advice. "Wait until it stops rolling, walk over and pick it up," the former catcher said.

Niekro broke in with Milwaukee in 1964 and led the league with a 1.87 ERA three seasons later with Atlanta. A three-time twenty-game winner, he was the league leader in games started and complete games four times. He retired in 1987, a season that saw him pitch for the Indians and Blue Jays before he ended his career with the Braves.

Looking back on it, he wondered why more pitchers haven't followed his example. Although the knuckleball is difficult to throw, Niekro insisted, "It's a learnable pitch."

Niekro and his younger brother Joe were taught the pitch by their father while growing up in Blaine, Ohio. The brothers went on to win a combined 539 games at the big league level, the most by brothers in baseball history.

Despite such results, Niekro said most major league teams don't really understand the knuckler, let alone embrace it. After R. A. Dickey's success with the New York Mets, Niekro proposed a knuckleball spring training camp in which he, Tim Wakefield, and Charlie Hough could help interested players learn how to throw the pitch.

Niekro told the *New York Times,* "There just aren't many people in organizations that know anything about the knuckleball. I know I'm available. I'd be pleased to help young men learn it if they want to commit to it, because everybody can't throw 90 miles per hour."

The godfather of knucklers wants to spread the wealth? That's the last thing most hitters want to hear.

—T. Wendel

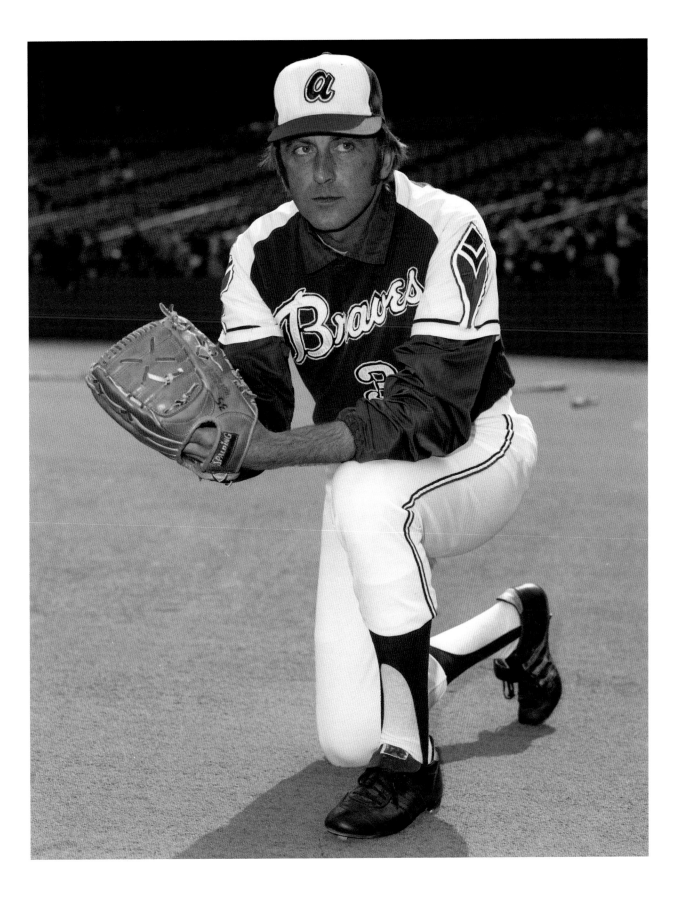

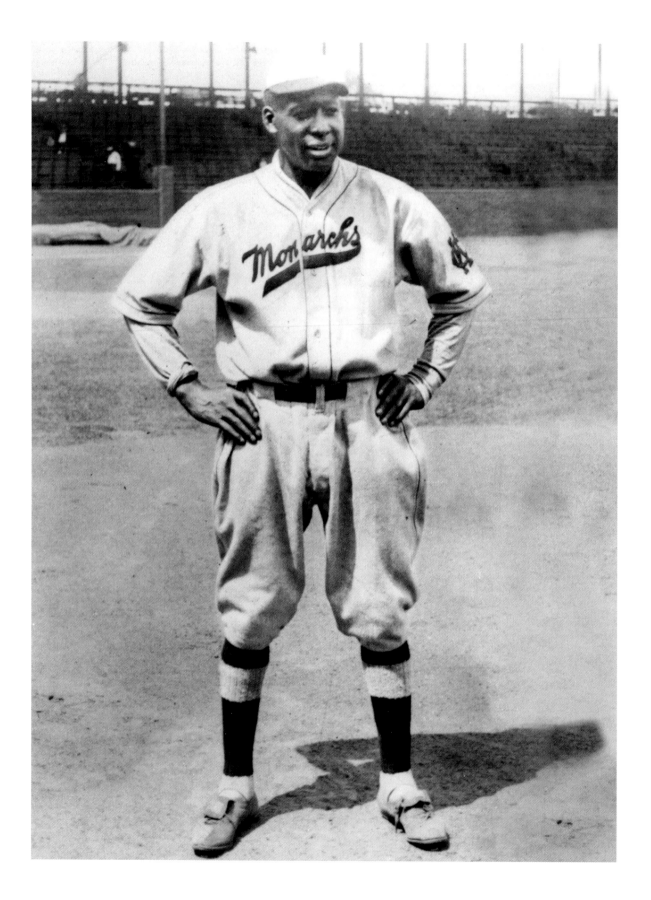

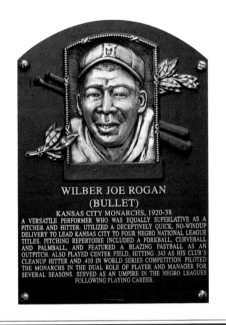

WILBER JOE ROGAN
(BULLET)
KANSAS CITY MONARCHS, 1920-38
A VERSATILE PERFORMER WHO WAS EQUALLY SUPERLATIVE AS A
PITCHER AND HITTER. UTILIZED A DECEPTIVELY QUICK, NO-WINDUP
DELIVERY TO LEAD KANSAS CITY TO FOUR NEGRO NATIONAL LEAGUE
TITLES. PITCHING REPERTOIRE INCLUDED A FORKBALL, CURVEBALL
AND PALMBALL, AND FEATURED A BLAZING FASTBALL AS AN
OUTPITCH. ALSO PLAYED CENTER FIELD, HITTING .343 AS HIS CLUB'S
CLEANUP HITTER AND .410 IN WORLD SERIES COMPETITION PILOTED
THE MONARCHS IN THE DUAL ROLE OF PLAYER AND MANAGER FOR
SEVERAL SEASONS. SERVED AS AN UMPIRE IN THE NEGRO LEAGUES
FOLLOWING PLAYING CAREER.

BULLET JOE ROGAN

CLASS OF 1998

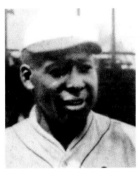

For a pitcher who stood barely five foot seven and was known for a quick no-windup delivery, Charles Wilber "Bullet Joe" Rogan could challenge hitters with a blazing fastball. In fact, Rogan's high heat always draws comparisons with the legendary Satchel Paige and other vintage fireballers.

"Rogan was one of the best pitchers who ever lived," said Negro Leagues veteran Buck O'Neil. "Satchel got all the publicity, but Rogan was just as good.

"And he was very competitive. The better the opposition was, the better he was."

As a frontline pitcher for the Kansas City Monarchs, Rogan posted a 119–50 record.

"Bullet had a little more steam on the ball than Paige, and he had a better-breaking curve," catcher Frank Duncan said. "The batters thought it was a fastball heading for them and they would jump back from the plate and all of a sudden it would break sharply for a strike."

Yet it was Rogan's fastball that Duncan and so many others in the Negro Leagues would never forget. The pitch had such pop that Duncan would buy a pair of steaks whenever he had to catch Rogan. Sliding the steak inside his mitt would help cushion his palm. But even a butcher's best cut wouldn't last past the fifth inning with Rogan on the mound. That's why Duncan always brought two steaks to the game.

"Outside of Bob Feller and Walter Johnson, who I worked behind in an exhibition game, Rogan was the fastest pitcher I've ever seen," said Joe Rue, a former Negro League umpire.

Rogan found his way to the Negro Leagues on Casey Stengel's recommendation. Their respective All-Star teams played against each other in an exhibition in the southern Arizona desert, and "The Old Perfessor" was impressed by Rogan's pitching and all-around play. When Stengel returned to Kansas City, he told Monarchs owner J. L. Wilkinson about Rogan. As a result, the Bullet became a local institution in Kansas City from 1920 to 1938.

Perhaps only Babe Ruth and Martín Dihigo were better all-around players than Rogan. An excellent hitter, Rogan swung a heavy bat and regularly batted cleanup for the Monarchs.

"If you saw Ernie Banks hit in his prime, then you saw Rogan," Buck O'Neil said. "He was the type of guy that stood a long way from the plate."

Rogan was just as accomplished with a glove and could play anywhere in the field. "He is generally regarded as the finest fielding pitcher in Negro baseball history," said Robert Peterson, author of *Only the Ball Was White*. "In one doubleheader, he pitched and played four other positions."

Rogan became player-manager for the Monarchs in 1926 and continued in that capacity until the end of his career in 1938. After retiring, he served as an umpire until 1946.

"I've caught all those great pitchers—Rogan, Smokey Joe Williams, Dizzy Dean, Satchel," Duncan told historian John Holway. "[But] Rogan was such a terrific hitter, I'm telling you. Such an athlete."

—T. Wendel

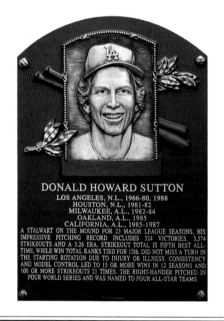

DONALD HOWARD SUTTON
LOS ANGELES, N.L., 1966-80, 1988
HOUSTON, N.L., 1981-82
MILWAUKEE, A.L., 1982-84
OAKLAND, A.L., 1985
CALIFORNIA, A.L., 1985-1987
A STALWART ON THE MOUND FOR 23 MAJOR LEAGUE SEASONS, HIS
IMPRESSIVE PITCHING RECORD INCLUDES 324 VICTORIES, 3,574
STRIKEOUTS AND A 3.26 ERA. STRIKEOUT TOTAL IS FIFTH BEST ALL-
TIME, WHILE WIN TOTAL RANKS TIED FOR 12th. DID NOT MISS A TURN IN
THE STARTING ROTATION DUE TO INJURY OR ILLNESS. CONSISTENCY
AND MODEL CONTROL LED TO 15 OR MORE WINS IN 12 SEASONS AND
100 OR MORE STRIKEOUTS 21 TIMES. THE RIGHT-HANDER PITCHED IN
FOUR WORLD SERIES AND WAS NAMED TO FOUR ALL-STAR TEAMS.

DON SUTTON

CLASS OF 1998

For Don Sutton, consistency was a given—as the man nicknamed "Black & Decker" for his reliability never missed a turn in the rotation at the big league level.

But Sutton was also all about the victories, winning almost 56 percent of his decisions. Little wonder Sutton's teams advanced to the postseason eight times during a career in which he won 324 games.

"For me, it was all about doing your job," Sutton said. "I was just a kid from Florida, and suddenly I'm in the big leagues. I just wanted to stay."

A lightly recruited high school pitcher who grew up in Pensacola, Sutton signed with the Dodgers in 1964 as an amateur free agent. By 1966 Sutton was the number four starter for a Dodgers rotation that featured Sandy Koufax and Don Drysdale. He won the *Sporting News* National League Rookie of the Year Award that season, going 12–12 with a 2.99 earned run average and 209 strikeouts for a Los Angeles team that won the NL Pennant.

Sutton's pinpoint control—he struck out better than 2.6 batters for every one he walked as a rookie and led the league in strike-out-to-walk ratio three times—quickly established him as one of the National League's top young arms.

A four-time All-Star who finished in the top five of the NL Cy Young Award voting five times, Sutton became the backbone of the Dodgers staff following the retirements of Koufax and Drysdale. He led Los Angeles to NL Pennants in 1974, 1977, and 1978. And though his teams never won a World Series title, Sutton was 6–4 with a 3.68 ERA in fifteen postseason appearances.

"When you gave him the ball, you knew one thing: Your pitcher was going to give you everything he had," said Hall of Fame skipper Tommy Lasorda, who managed Sutton from 1976 to 1980.

After spending his first fifteen seasons with the Dodgers, Sutton pitched for the Astros, Brewers, A's, and Angels—often changing teams down the stretch as contending clubs seeking reliable starting pitching traded for him. He finished his career with the Dodgers in 1988, helping Los Angeles prepare for its incredible postseason run before being released on August 10 of that year.

Sutton retired with a record of 324–256, including 3,574 strike-outs (still seventh in MLB history), 756 starts (third all-time), and fifty-eight shutouts (tenth all-time).

As a batter, Sutton has the distinction of being the MLB player with the most at bats without a home run, at 1,354. When he was asked how close he ever came to hitting a home run, Sutton responded, "A triple."

But on the mound, Sutton had few peers. He threw five one-hitters during his career—and on seven occasions threw nine scoreless innings but received a no-decision.

He was elected to the Hall of Fame in 1998.

"Luck," Sutton once said, "is a by-product of busting your fanny."

—J.Y.

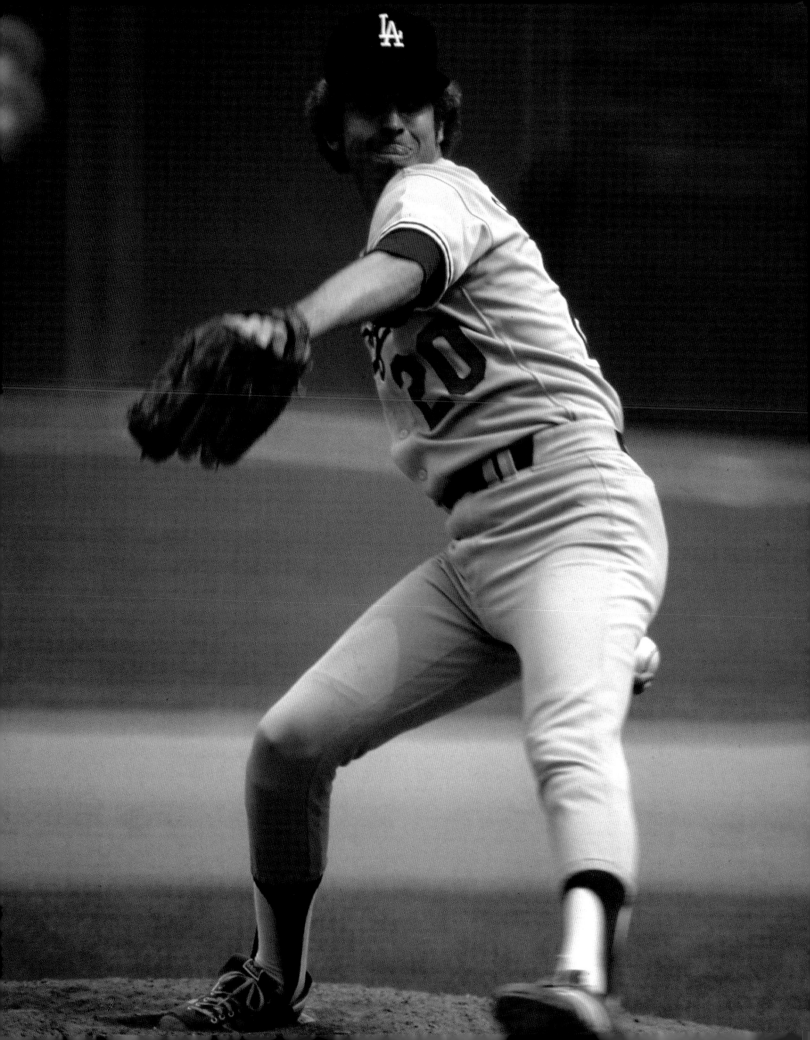

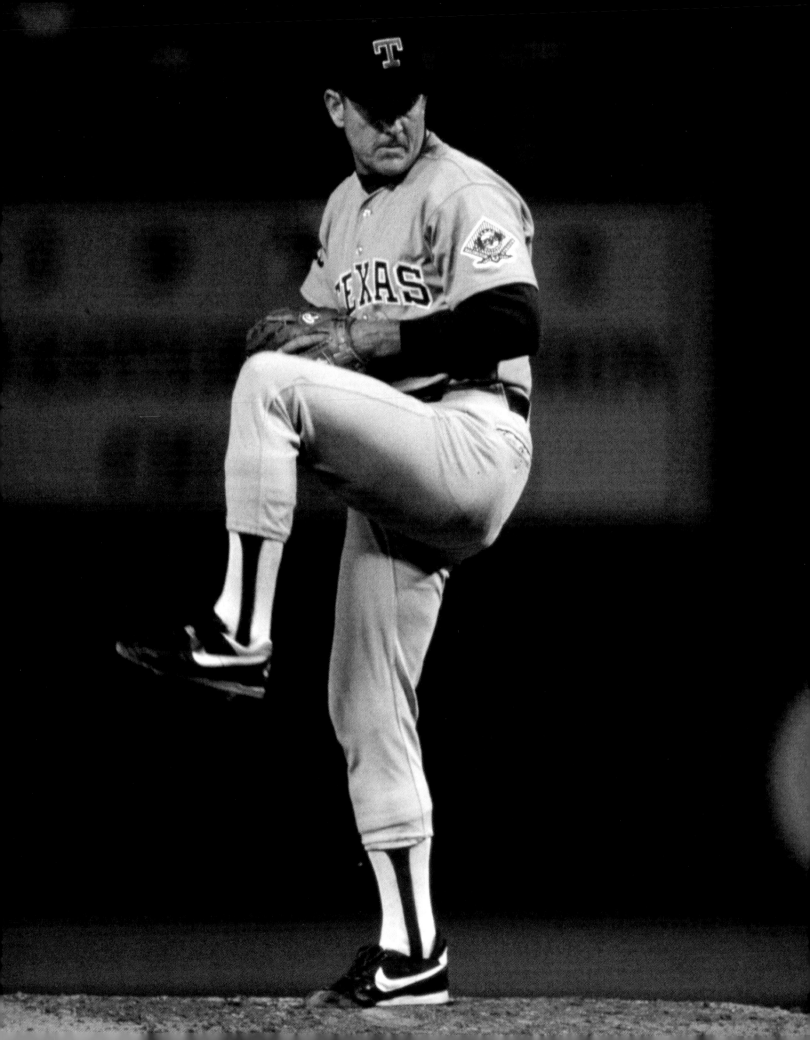

LYNN NOLAN RYAN JR.
NEW YORK, N.L., 1966, 1968 – 1971
CALIFORNIA, A.L., 1972 – 1979
HOUSTON, N.L., 1980 – 1988
TEXAS, A.L., 1989 – 1993

A FIERCE COMPETITOR AND ONE OF BASEBALL'S MOST INTIMIDATING FIGURES ON THE PITCHING MOUND FOR FOUR DECADES. HIS OVERPOWERING FASTBALL AND UNPARALLELED LONGEVITY PRODUCED 324 VICTORIES AND A HOST OF MAJOR LEAGUE RECORDS. LIFETIME BENCHMARKS INCLUDE 5,714 STRIKEOUTS, SEVEN NO-HITTERS AND 12 ONE-HITTERS IN 27 SEASONS PITCHED. LED LEAGUE IN STRIKEOUTS 11 TIMES AND FANNED 300 BATTERS IN A SEASON ON SIX OCCASIONS, INCLUDING A RECORD 383 IN 1973. STRIKEOUT VICTIMS TOTALED 1,176 DIFFERENT PLAYERS. A TEXAS LEGEND WHOSE WIDESPREAD POPULARITY EXTENDED FAR BEYOND HIS NATIVE STATE.

NOLAN RYAN

CLASS OF 1999

For a pitcher who became one of the most dominant in history, it's easy to forget how much Nolan Ryan struggled early in his career. The right-hander went only 29–38 with the New York Mets from 1966 to 1971, but a trade to the California Angels assured him a regular turn in the rotation, and from there "The Express" never looked back.

Over a twenty-seven-year career with four teams (the Mets, Angels, Astros, and Rangers), Ryan took charge with a blazing fastball that approached one hundred miles per hour and a work ethic like none other. He became the all-time strikeout king (5,714 punch-outs) and pitched seven no-hitters and twelve one-hitters. The eight-time All-Star fanned a modern single-season record 383 batters in 1973, and his career strikeouts encompassed 1,176 different players.

"I saw him throw two no-hitters when I was a kid," said Rob Deer of the Detroit Tigers. "Nearly 20 years later, he's getting me out."

Jeff Torborg, who caught Ryan when both of them were with the Angels, remembered an incident when one of The Express's offerings tore a hole in the webbing of his glove and flew to the backstop.

"When you talk velocity, Nolan threw the hardest," Torborg said. "Nolan threw it down the strike zone harder than any human being I ever saw."

"Looking back on it, I've come to believe that if you're blessed with the ability to throw hard, you have to consider all the factors," Ryan said. "It's a gift that you did nothing to earn. It was given to you and what you do with it is up to you."

He started 773 games, reaching the coveted 300-victory plateau with 324. Nobody worked out harder between starts, which led to his amazing durability and a quality fastball even late in his career. At an age when most pitchers needed to turn to more finesse pitches, Ryan was still challenging hitters, getting them out with that epic fastball. It also helped that he could be conveniently wild.

Slugger Reggie Jackson said that Ryan was the only pitcher "who put the fear in me. Not because he could get me out but because he could kill me. Every hitter likes fastballs like everybody likes ice cream. But you don't like it when somebody's stuffing it down you by the gallon.

"That's how you felt when Nolan was throwing fastballs by you. You just hoped to mix in a walk, so you could have a good night."

Respected pitching coach Dave Duncan, who caught in the major leagues, added that what separated Ryan from most pitchers was that he didn't "just get you out. He embarrassed you. There are times when you've won some sort of victory just hitting the ball."

After his playing days, Ryan went on to become principal owner of the Texas Rangers.

—T. Wendel

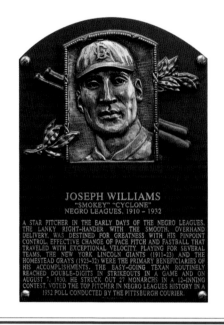

JOSEPH WILLIAMS
"SMOKEY" "CYCLONE"
NEGRO LEAGUES, 1910 - 1932

A STAR PITCHER IN THE EARLY DAYS OF THE NEGRO LEAGUES,
THE LANKY RIGHT-HANDER WITH THE SMOOTH, OVERHAND
DELIVERY, WAS DESTINED FOR GREATNESS WITH HIS PINPOINT
CONTROL, EFFECTIVE CHANGE OF PACE PITCH AND FASTBALL THAT
TRAVELED WITH EXCEPTIONAL VELOCITY. PLAYING FOR SEVERAL
TEAMS, THE NEW YORK LINCOLN GIANTS (1911-23) AND THE
HOMESTEAD GRAYS (1925-32) WERE THE PRIMARY BENEFICIARIES OF
HIS ACCOMPLISHMENTS. THE EASY-GOING TEXAN ROUTINELY
REACHED DOUBLE-DIGITS IN STRIKEOUTS IN A GAME AND ON
AUGUST 7, 1930, HE STRUCK OUT 27 MONARCHS IN A 12-INNING
CONTEST. VOTED THE TOP PITCHER IN NEGRO LEAGUES HISTORY IN A
1952 POLL CONDUCTED BY THE PITTSBURGH COURIER.

SMOKEY JOE WILLIAMS

CLASS OF 1999

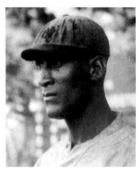

Walter Johnson, Joe Wood, and Christy Mathewson were the pitching stars a century ago, the ones who garnered the headlines. But some experts contend that Smokey Joe Williams was better than all of them.

Born in Seguin, Texas, to an American Indian mother and a black father, Williams was too dark-skinned to play in the major leagues in the years before Jackie Robinson broke the color barrier. But Williams certainly garnered attention pitching in the Negro Leagues and routinely defeating the best white hurlers in exhibition games.

Buck O'Neil, in a scouting report, claimed that Williams had a "great arm" and "could throw the ball by any hitter and he knew it."

Standing six foot four, Williams "was the smoothest pitching machine around," columnist Jackie Reemes of the *Amsterdam News* wrote, "and possessed everything a great pitcher should have: a blinding fastball, a wizard curve, the slow ball or change of pace and oodles of baseball know-how."

Even though Williams was refused access to baseball's biggest stages, he certainly made the most of his opportunities. Williams pitched ten shutouts against white ball clubs, including two against the 1912 National League champion New York Giants and another against the 1915 champion Philadelphia Phillies, according to the *Biographical Dictionary of American Sports*. In a game for the ages, he defeated Walter Johnson, 1–0, and also

defeated such Hall of Famers as Chief Bender, Waite Hoyt, Grover Cleveland Alexander, and Rube Marquard in barnstorming play.

Ty Cobb said that Williams would have been a "sure 30-game winner" if he had been allowed to pitch in the major leagues.

Still, many of Williams's top games came against the top flight of Negro League stars. When he joined the Leland Giants in 1910, owner Frank Leland said, "If you have ever witnessed the speed of a pebble in a storm you have not even see the equal of the speed possessed by this wonderful Texan Giant."

After playing winter ball in the Cuban League, where he would eventually compile a 22–15 lifetime record, Williams joined the New York Lincoln Giants. He would pitch with them through 1923 before moving on to the famed Homestead Grays. In 1919 Williams pitched an Opening Day no-hitter and showed good power at the plate as well.

But arguably Williams's best moments came toward the end of his twenty-two-year career with the Grays. Oscar Charleston, Jud Wilson, and Josh Gibson were in the everyday lineup, with Williams as their staff ace. In 1930, reportedly at the age of fifty, Williams dazzled hitters one last time as he pitched a 1–0 shutout against the Kansas City Monarchs. The game went twelve innings, with Williams fanning twenty-seven hitters.

In 1952 the *Pittsburgh Courier* published a poll asking who was the best pitcher ever in the Negro Leagues. Williams finished one vote ahead of Satchel Paige.

—T. Wendel

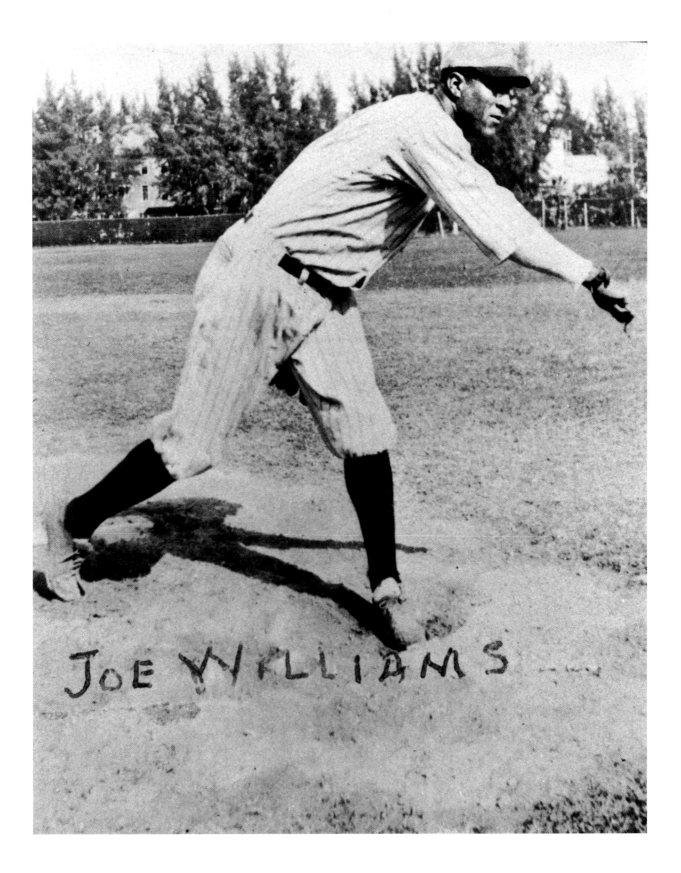

JOE WILLIAMS

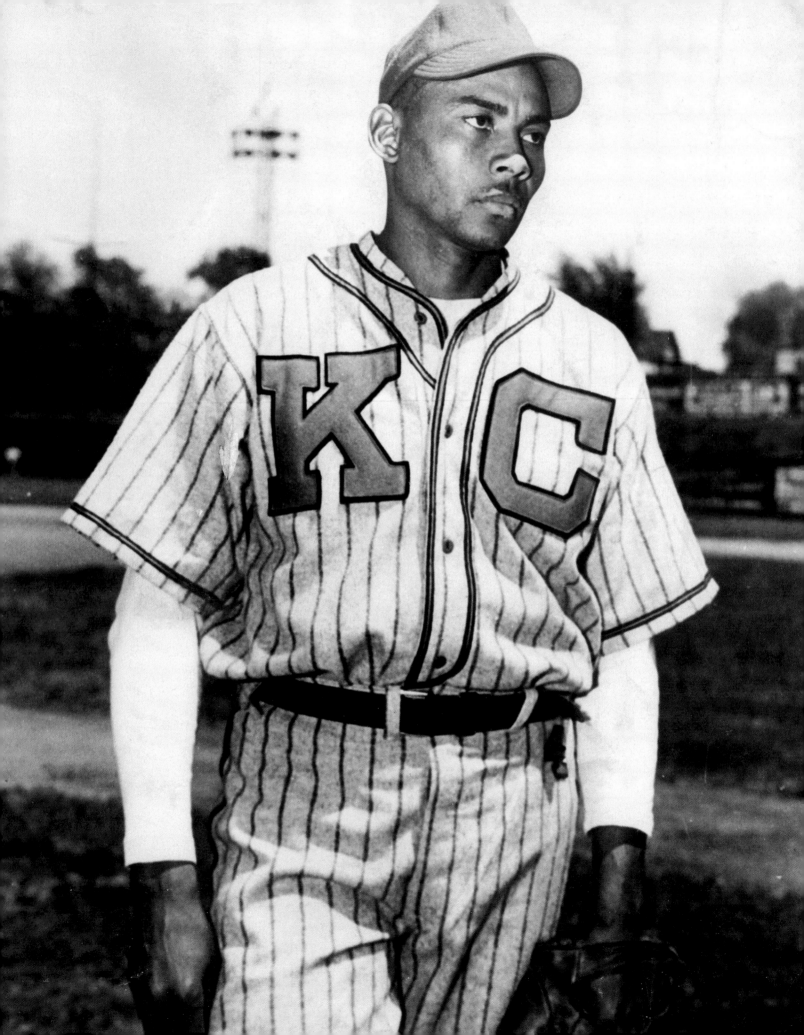

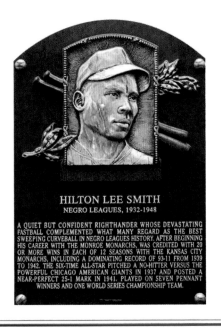

HILTON LEE SMITH
NEGRO LEAGUES, 1932-1948

A QUIET BUT CONFIDENT RIGHTHANDER WHOSE DEVASTATING FASTBALL COMPLEMENTED WHAT MANY REGARD AS THE BEST SWEEPING CURVEBALL IN NEGRO LEAGUES HISTORY. AFTER BEGINNING HIS CAREER WITH THE MONROE MONARCHS, WAS CREDITED WITH 20 OR MORE WINS IN EACH OF 12 SEASONS WITH THE KANSAS CITY MONARCHS, INCLUDING A DOMINATING RECORD OF 93-11 FROM 1939 TO 1942. THE SIX-TIME ALL-STAR PITCHED A NO-HITTER VERSUS THE POWERFUL CHICAGO AMERICAN GIANTS IN 1937 AND POSTED A NEAR-PERFECT 25-1 MARK IN 1941. PLAYED ON SEVEN PENNANT WINNERS AND ONE WORLD SERIES CHAMPIONSHIP TEAM.

HILTON SMITH

CLASS OF 2001

Hilton Smith was called the invisible man of black baseball because he would often relieve the flamboyant Satchel Paige, his Kansas City Monarchs teammate, after the famed hurler tossed a few innings to satisfy the adoring crowds that came to witness his mound majesty. But many in the game considered Smith to be Paige's equal, if not better.

"Hilton Smith had a world of stuff," said Negro Leagues infielder Newt Allen. "Smith was like Satchel when he first came up. He had his stuff on the ball—curveball, fastball. His fastball had a hop on it, his curveball broke. Fast and quick. Up and down. He'd throw overhand and the ball would come up and just do like that, break down. He'd throw a three-quarters curveball, it would come this close to the plate and then break that far out."

The first line of Smith's Hall of Fame plaque may sum up the main reason he is enshrined in Cooperstown: "A quiet but confident righthander whose devastating fastball complemented what many regard as the best sweeping curveball in Negro Leagues history."

As for Paige versus Smith, Negro Leagues historian Bob Kendrick once said of the two, "The old-timers would all say that if you were going to hit anything, you better hit it off Satchel because you weren't going to touch Hilton Smith."

From the mid-1930s until his career came to a close at the end of the 1940s, the six-foot-two, 180-pound Smith, a native of Texas, was a consistent force for the Monarchs. Among his highlights were throwing a no-hitter in 1937 against the Chicago American Giants and being named to six consecutive East-West All-Star Games (1937–1942).

Hall of Fame outfielder Monte Irvin, who played in both the Negro and major leagues, said that Smith "had one of the finest curveballs I ever had the displeasure to try and hit. His curveball fell of the table. Sometimes you knew where it would be coming from, but you still couldn't hit it because it was that sharp. He was just as tough as Satchel was."

According to Negro Leagues veteran Sammy T. Hughes, "Smith had an excellent curveball in addition to his fast one. And I'd rather face Satchel or anybody who throws the ball hard rather than face a curveball. Because then you've got two pitches to think about."

Buck O'Neil may have made the most perceptive point about the famed duo of Paige and Smith when he said that you had to be a true baseball fan to know about Smith, but you didn't have to be a baseball fan to know Paige.

"Hilton Smith was unbeatable there for a spell, from 1938 to 1942. He would have been a 20-game winner in the major leagues with the stuff he had," O'Neil said. "He actually didn't look like a ballplayer, like a Satchel Paige. But he would go out to the mound and pitch like a Satchel—and at times I think he was a little bit better.

"He was a Hall of Famer. No doubt about it."

—J.G.

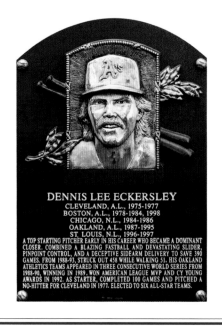

DENNIS LEE ECKERSLEY
CLEVELAND, A.L., 1975-1977
BOSTON, A.L., 1978-1984, 1998
CHICAGO, N.L., 1984-1986
OAKLAND, A.L., 1987-1995
ST. LOUIS, N.L., 1996-1997
A TOP STARTING PITCHER EARLY IN HIS CAREER WHO BECAME A DOMINANT
CLOSER. COMBINED A BLAZING FASTBALL AND DEVASTATING SLIDER,
PINPOINT CONTROL, AND A DECEPTIVE SIDEARM DELIVERY TO SAVE 390
GAMES. FROM 1988-93, STRUCK OUT 458 WHILE WALKING 51. HIS OAKLAND
ATHLETICS TEAMS APPEARED IN THREE CONSECUTIVE WORLD SERIES FROM
1988-90, WINNING IN 1989. WON AMERICAN LEAGUE MVP AND CY YOUNG
AWARDS IN 1992. AS STARTER, COMPLETED 100 GAMES AND PITCHED A
NO-HITTER FOR CLEVELAND IN 1977. ELECTED TO SIX ALL-STAR TEAMS.

DENNIS ECKERSLEY

CLASS OF 2004

Not only did Dennis Eckersley make the transition from successful starting pitcher to dominant closer, but also he made the role of finishing off games something that others would come to emulate. Before John Smoltz, Trevor Hoffman, and Mariano Rivera, there was "The Eck."

But it wasn't as if Eckersley volunteered to move to the bullpen. In fact, he pushed back when Oakland manager Tony LaRussa and pitching coach Dave Duncan made him the A's closer in 1987, when Jay Howell was injured.

"I sure wasn't happy about it," recalled Eckersley, who saved sixteen games that season. "I thought it was a demotion and I hoped it would only be a part-time assignment. When I first came up, the bullpen was pretty much where they put the guys who couldn't start."

Eckersley saved forty-five games the next season, one fewer than Dave Righetti's major league record at the time. In 1988 Eckersley saved all four games in the American League Championship Series against Boston, only to have the Dodgers' Kirk Gibson turn the tables on him with his game-winning homer in the opening game of the World Series.

The right-hander with pinpoint control would go on to save 390 games in his twenty-four-year career and put together some of the best seasons a relief pitcher has ever enjoyed. In 1990 he struck out seventy-three and walked just four in 73⅓ innings,

compiling a 0.61 ERA. Two years later he led the American League with fifty-one saves and became only the ninth pitcher to capture the MVP and Cy Young Awards in the same year.

"He taught me something about fear," LaRussa said. "Eck tells me he spends the whole game being afraid. Fear makes some guys call in sick or be tentative. He uses fear to get him ready for every stinking time he pitches."

But as Eckersley still likes to remind us, he began his career as a starting pitcher, and an impressive one at that. He pitched a no-hitter for Cleveland in 1977 and won at least twelve games in seven of his first eight seasons. That included reaching the twenty-victory plateau in 1978 with the Red Sox. He is the only pitcher with one hundred saves and one hundred complete games.

Interestingly, Eckersley was traded to the Cubs for Bill Buckner in 1984. His final appearance in 1998 was the 1,071st of Eckersley's career, which broke the record held at the time by Hoyt Wilhelm.

Along the way, Eckersley came up with colorful names for pitches, like "cheese," "hair," and "cookie." He's often credited with coining the term "walk-off," as in a walk-off home run, or a similar term he prefers, "bridge job," as in the losing pitcher is tempted to go jump off a bridge after giving up the winning hit.

"My career spanned the era when relievers became so important," Eckersley said. "When I started finishing games and coming off the field shaking hands, it was a beautiful thing. I mean you start seeing you're an important part of the team."

—T. Wendel

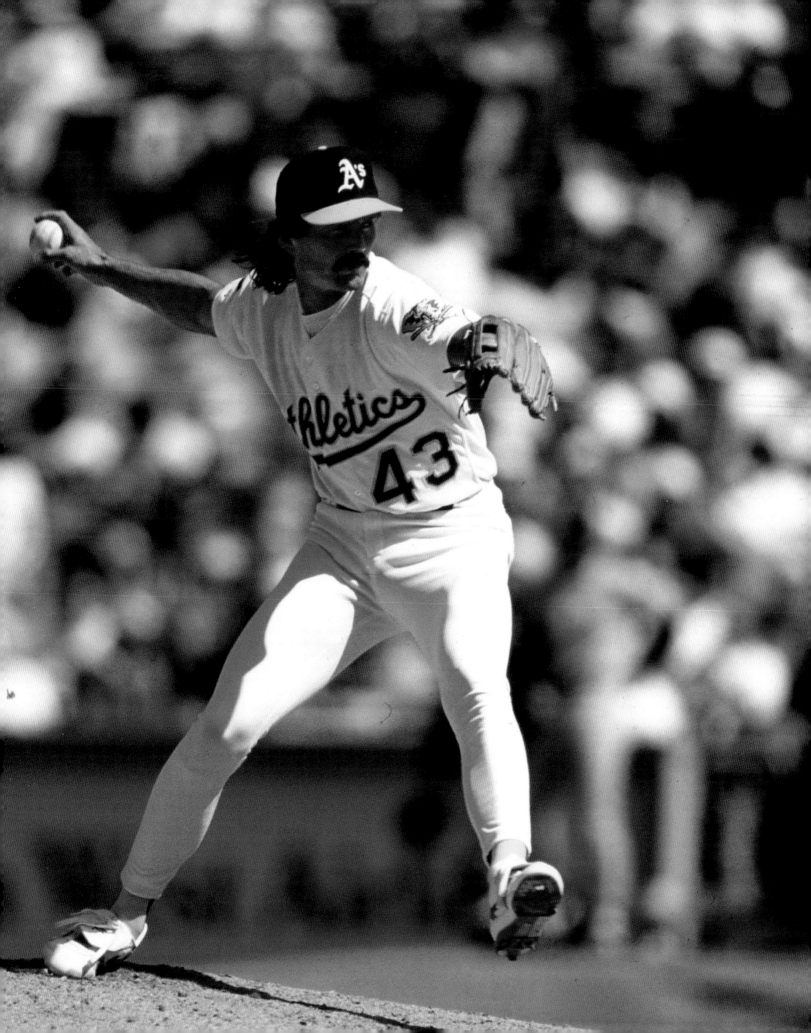

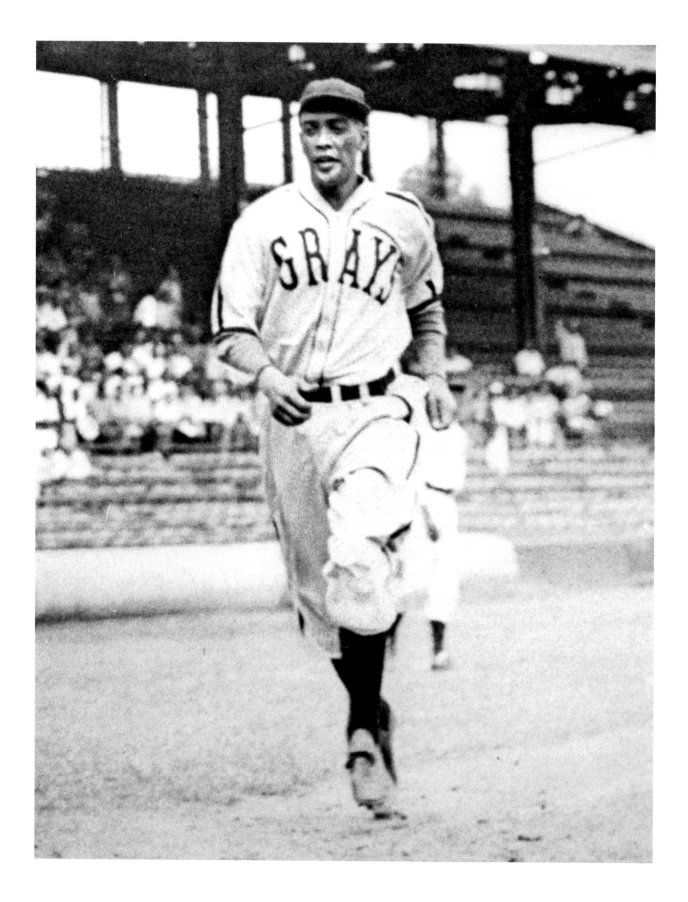

RAYMOND BROWN
"RAY"
NEGRO LEAGUES, 1930-1948

A MAINSTAY OF THE HOMESTEAD GRAYS PITCHING STAFF FOR 14 SEASONS, UTILIZING A VARIETY OF BREAKING BALLS, INCLUDING A DEVASTATING CURVEBALL, TO HELP LEAD THEM TO EIGHT PENNANTS IN NINE YEARS FROM 1937-1945. RANKS AMONG ALL-TIME NEGRO LEAGUES LEADERS IN WINS, WINNING PERCENTAGE AND SHUTOUTS. SELECTED TO THREE EAST-WEST ALL-STAR GAMES. TOSSED ONE-HITTER AGAINST BIRMINGHAM BLACK BARONS IN 1944 NEGRO LEAGUES WORLD SERIES. SPENT SEVERAL STANDOUT SEASONS PITCHING IN CUBA, PUERTO RICO AND MEXICO.

RAYMOND BROWN

CLASS OF 2006

"He was almost unbeatable," said Hall of Famer Monte Irvin, the Negro League and big league star, when recalling the pitching abilities of Raymond Brown.

"Raymond Brown, not only was he a great pitcher, he could hit. He could run and he'd play the outfield when he wasn't pitching."

Brown, elected to the National Baseball Hall of Fame in 2006, was one of the Negro Leagues' most popular attractions, not only filling seats but also putting on a show.

"He's what they called their Sunday Pitcher," said Negro Leagues historian James Riley. "They'd pitch their best on Sunday to draw a crowd, and nobody was better."

In 1938 the *Pittsburgh Courier* newspaper listed Brown as one of five Negro Leagues stars who would certainly have been major leaguers if allowed to play. The others included future Hall of Famers Cool Papa Bell, Josh Gibson, Buck Leonard, and Leroy "Satchel" Paige.

The six-foot-one, 195-pound Brown, born February 23, 1908, in Alger, Ohio, developed a reputation while still an amateur as an all-around star on the diamond. After short stints with the Indianapolis ABCs and the Detroit Wolves in the early 1930s, Brown joined up with Cum Posey's blossoming Negro Leagues powerhouse, the Homestead Grays.

"He was somebody you had to take notice of," said former Negro Leagues pitcher Wilmer Fields, a teammate on the Grays.

"As far as rating him No. 1, 2, 3 or 4, where you might rate him, I don't know. But he was a great pitcher.

"He was the top pitcher on our roster. You could find no greater competitor than he was, I'll tell you that. Yeah, he was something else."

Brown became one of the great stars of African American baseball during his fourteen seasons with the Grays, leading the team to eight pennants in one nine-year span. Though his pitching arsenal included sinkers, sliders, and even knuckleballs, it was his curve that he counted on as his out-pitch.

"So confident was Ray in all of his pitches that he would throw a curve with a 3-and-0 count on the batter," Riley said. "Later in his career he developed an effective knuckleball, and he had good control of all of his pitches."

Brown, who became Posey's son-in-law after marrying Posey's daughter Ethel, threw a one-hitter in the 1944 Negro League World Series—leading the Grays to the title—and pitched a perfect game in 1945.

Brown also starred in winter league play during this era, posting an incredible 21–4 record with Santa Clara of the Cuban Winter League in 1936 while hitting .311 at the plate. He completed twenty-three of his twenty-six starts that season.

In the Negro Leagues, Brown appeared in two East-West All-Star Games, and compiled a 3–2 record in seven Negro League World Series games. He pitched in the Mexican League and the Canadian Provincial League before retiring, following the 1953 season.

—J.G.

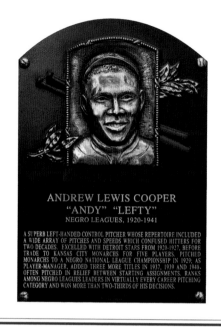

ANDREW LEWIS COOPER
"ANDY" "LEFTY"
NEGRO LEAGUES, 1920-1941

A SUPERB LEFT-HANDED CONTROL PITCHER WHOSE REPERTOIRE INCLUDED A WIDE ARRAY OF PITCHES AND SPEEDS WHICH CONFUSED HITTERS FOR TWO DECADES. EXCELLED WITH DETROIT STARS FROM 1920-1927, BEFORE TRADE TO KANSAS CITY MONARCHS FOR FIVE PLAYERS. PITCHED MONARCHS TO A NEGRO NATIONAL LEAGUE CHAMPIONSHIP IN 1929; AS PLAYER-MANAGER, ADDED THREE MORE TITLES IN 1937, 1939 AND 1940. OFTEN PITCHED IN RELIEF BETWEEN STARTING ASSIGNMENTS. RANKS AMONG NEGRO LEAGUES LEADERS IN VIRTUALLY EVERY CAREER PITCHING CATEGORY AND WON MORE THAN TWO-THIRDS OF HIS DECISIONS.

ANDY COOPER

CLASS OF 2006

Andy Cooper was a stalwart pitcher for more than two decades, his exploits legendary in the segregated base-ball leagues of the 1920s and 1930s. Consistently rated as one of the top southpaw hurlers in Negro Leagues history, he was masterly at changing speeds on the wide variety of pitches in his fabled arsenal.

According to a scouting report prepared by famed Negro Leagues player and manager Buck O'Neil, Cooper, nicknamed "Lefty," had a live arm with a total command of all of his pitches, which included a running fastball, tight curveball, and biting screwball.

The native Texan, born in 1898 and a thick six foot two, 220 pounds, spent the entirety of his nearly two-decade professional diamond career, which spanned the 1920s and 1930s, toiling in black baseball. A durable and consistent left-handed pitcher, he split his career between the Detroit Stars and Kansas City Monarchs, who traded five players to acquire him.

Negro Leagues historian Dick Clark once said of Cooper, "In my estimation, the greatest black pitcher ever to pitch for Detroit—that's for the Stars or the Tigers."

"Andy never possessed the fine assortment of curves held in the supple arms of other pitchers. However, he did have what so many pitchers lack—sterling control," wrote Russ J. Cowans in 1941 in the *Chicago Defender*, one of the top black news-papers of the day. "Cooper could almost put the ball any place he wanted it to go.

"In addition, Cooper had a keen knowledge of batters. He knew the weakness of every batter in the league and would pitch to that weakness when he was on the mound."

Highlights from Cooper's long and illustrious career would include his winning twice as many games as he lost with Detroit and Kansas City, leading Kansas City to the Negro National League Pennant in 1929, compiling a forty-three-inning stretch with the Stars in which he didn't issue a base on balls, taking the mound in the 1936 East-West All-Star Game at the age of thirty-eight, and pitching seventeen innings in a 1937 playoff game against the Chicago American Giants.

Near the end of his playing career, when Cooper would become a valuable relief pitcher, he would also turn to managing, leading the Monarchs to three pennants between 1937 and 1940.

"Cooper was a smart manager and a great, great teacher," said Monarchs pitcher and fellow Hall of Famer Hilton Smith.

Cooper's lone child, Andy Jr., was only eleven years old when his father passed away, but when he attended his dad's Hall of Fame induction in 2006, he shared his memories of a summer spent as the Monarchs' batboy around 1940.

"That was quite a treat, barnstorming with those guys and sleep-ing in the parks," Andy Cooper Jr. said. "I can remember Muskogee, Oklahoma. We got in late at night and we couldn't get any quarters so we slept in the park. Just little things like that I remember.

"That was a treat for me because he'd been gone most of my life. He'd been traveling playing ball because he played ball most of the time. It was a real treat to travel around with him."

—J.G.

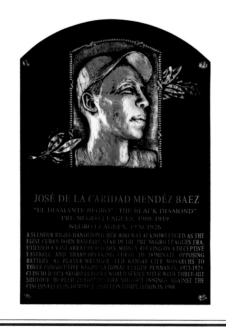

JOSÉ MÉNDEZ

CLASS OF 2006

He was called "The Black Diamond." A Cuban-born hurler with a lean, wiry frame, a deceptively hard fastball, and a sharp curveball, José Méndez would keep hitters off balance using his terrific ability to change speeds.

At one point, Méndez put together an impressive streak of twenty-five scoreless innings of exhibition competition against major league talent when he faced the Cincinnati Reds in 1908 and the Detroit Tigers in 1909.

In her memoirs, Mrs. John McGraw gave her recollections of José Méndez, relating how her husband, the Hall of Fame manager, felt about him: "Without mincing words, John bemoaned the failure of baseball, himself included, to cast aside custom or unwritten law, or whatever it was, and sign a player alone, regardless of race or color."

The apex of Méndez's career came in 1911 while he was pitching for Almendares and competing against the New York Lincoln Giants for the "Colored Championship of the World." In that game, Méndez faced off against Smokey Joe Williams. Two of the greatest hurlers of their era, unofficially banned from Major League Baseball because of their skin color, met in one of the game's greatest pitching duels. The game was knotted at zero for the first nine frames with Williams working on a no-hitter and Méndez on a two-hit shutout. In the first extra frame, Almendares finally broke through and beat the Giants, giving Méndez a 1–0 victory.

Méndez continued his pitching dominance on a tour of Cuba in 1911. At the tour's conclusion, Philadelphia A's catcher Ira Thomas commented on Méndez's chops on the mound: "More than one big leaguer from the states has faced him and left the plate with a wholesome respect for the great Cuban star. It is not alone my opinion but the opinion of many others who have seen Méndez pitch that he ranks with the best in the game."

In 1914 it appeared that Méndez's career had come to a halt as a result of arm trouble, but he proved his mettle and reinvented himself as a shortstop. Méndez's career spanned decades, and he played for a variety of teams, returning from time to time to the place where he got his start—the pitcher's mound.

In 1924, in the Negro League World Series, Méndez's right arm would feature prominently on the mound once again. At the time a player-manager for the Kansas City Monarchs, Méndez went 2–0 with a 1.42 ERA in four games, and in the process led his Monarchs to the Series championship.

While Méndez spent his whole career playing in the Negro Leagues of North America and in Cuba, during his prime he faced major league competition in exhibition games, besting some of the game's best, including Eddie Plank and Christy Mathewson, who would earn their rightful spot in Cooperstown long before The Black Diamond.

Legendary Negro League batsman Pop Lloyd, who faced the Negro League and major league greats of his era, said that he "had never seen a pitcher superior to Méndez."

—F.B.

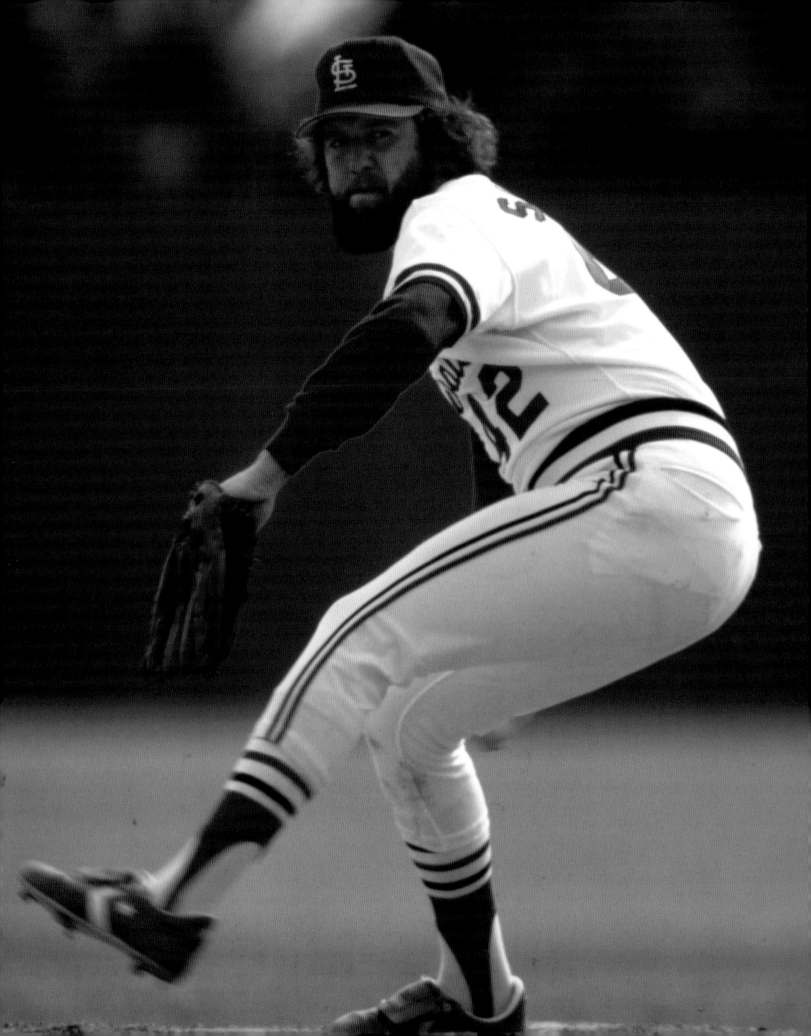

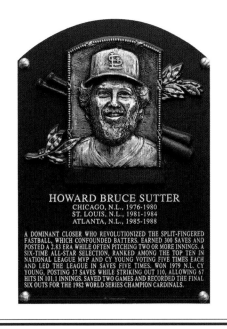

HOWARD BRUCE SUTTER
CHICAGO, N.L., 1976-1980
ST. LOUIS, N.L., 1981-1984
ATLANTA, N.L., 1985-1988

A DOMINANT CLOSER WHO REVOLUTIONIZED THE SPLIT-FINGERED
FASTBALL, WHICH CONFOUNDED BATTERS. EARNED 300 SAVES AND
POSTED A 2.83 ERA WHILE OFTEN PITCHING TWO OR MORE INNINGS. A
SIX-TIME ALL-STAR SELECTION, RANKED AMONG THE TOP TEN IN
NATIONAL LEAGUE MVP AND CY YOUNG VOTING FIVE TIMES EACH
AND LED THE LEAGUE IN SAVES FIVE TIMES. WON 1979 N.L. CY
YOUNG, POSTING 37 SAVES WHILE STRIKING OUT 110, ALLOWING 67
HITS IN 101.1 INNINGS. SAVED TWO GAMES AND RECORDED THE FINAL
SIX OUTS FOR THE 1982 WORLD SERIES CHAMPION CARDINALS.

BRUCE SUTTER

CLASS OF 2006

By adopting and refining one pitch to the point of devastating opposing hitters, Bruce Sutter carved out a path to Cooperstown.

In 1971, he signed with the Chicago Cubs. One year later he hurt his elbow in only his second minor league appearance, putting his livelihood in jeopardy.

When he returned, Sutter decided to come up with another pitch to offset his eighty-five-mile-per-hour fastball. He thought about throwing a curveball, but feared that it might aggravate his surgically repaired elbow. That's when Cubs minor league pitching coach Fred Martin, noticing Sutter's unusually large hands, suggested that he try throwing the split-fingered fastball. Martin's suggestion set the stage for unexpected success.

Even with the splitter, it took Sutter until 1976 to make the Cubs. Along the way, and with some help from Cubs pitching coach Mike Roarke, Sutter made modifications in gripping the splitter, perfecting it so that it became a dominant pitch.

The rookie right-hander soon took a share of the closer's role with veteran Darold Knowles. By 1977 Sutter was in full control of the late innings—and in full control of opposition hitters. "I tried to bunt on him because I can't hit him," Johnny Bench admitted to the *Los Angeles Times*. "He's the best." Posting a microscopic ERA of 1.34, Sutter struck out 129 batters in 107⅓ innings and made his first All-Star team.

By 1979 Sutter had become a headliner. He saved thirty-seven games, tying the National League record established by Clay Carroll and Rollie Fingers. Virtually unhittable in the eighth and ninth innings, the overpowering Sutter earned the NL Cy Young Award.

Thanks to the success he had with the splitter—at a time when no one else was throwing it—Sutter began to popularize the pitch. Other pitchers decided to try the splitter, which "fell off the table" as it reached the front edge of home plate. By the 1980s, the split-fingered fastball had become the fashionable pitch of choice.

In the meantime, Sutter took the splitter with him to St. Louis, as the Cubs traded him to the Cardinals for three players. No less effective with the Cardinals, Sutter saved thirty-six games in 1982, helping St. Louis win the National League East on the way to a world championship.

Enjoying one final hurrah before encountering arm trouble, Sutter notched a career-high forty-five saves in 1984 while accumulating a monstrous 122⅔ innings. "The biggest thing about Bruce is that he's such a competitor," Cardinals manager Whitey Herzog told the *Atlanta Constitution*. "He wants the ball in that tight situation. To me, that is his biggest asset."

Sutter has often said that without the split-fingered fastball, he would have been nothing more than a Double-A pitcher. With it, he became one of the game's great relievers, for parts of two decades a bullpen baron that no hitter enjoyed facing.

—B.M.

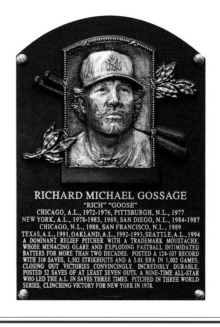

RICHARD MICHAEL GOSSAGE
"RICH" "GOOSE"
CHICAGO, A.L., 1972-1976, PITTSBURGH, N.L., 1977
NEW YORK, A.L., 1978-1983, 1989, SAN DIEGO, N.L., 1984-1987
CHICAGO, N.L., 1988, SAN FRANCISCO, N.L., 1989
TEXAS, A.L., 1991, OAKLAND, A.L., 1992-1993, SEATTLE, A.L., 1994
A DOMINANT RELIEF PITCHER WITH A TRADEMARK MOUSTACHE,
WHOSE MENACING GLARE AND EXPLODING FASTBALL INTIMIDATED
BATTERS FOR MORE THAN TWO DECADES. POSTED A 124-107 RECORD
WITH 310 SAVES, 1,502 STRIKEOUTS AND A 3.01 ERA IN 1,002 GAMES,
CLOSING OUT VICTORIES CONVINCINGLY. INCREDIBLY DURABLE,
POSTED 52 SAVES OF AT LEAST SEVEN OUTS. A NINE-TIME ALL-STAR
WHO LED THE A.L. IN SAVES THREE TIMES. PITCHED IN THREE WORLD
SERIES, CLINCHING VICTORY FOR NEW YORK IN 1978.

GOOSE GOSSAGE

CLASS OF 2008

The game rested on Goose Gossage's right arm, as it had many times during that summer of 1978. But this time, a season also hung in the balance.

Ron Guidry's Cy Young season. Jim Rice's MVP season. The New York Yankees' comeback season.

"I wanted the ball in those situations," said Gossage of the American League East playoff game between the Yankees and the Red Sox. "That was the biggest game I ever pitched in—by far. It seemed like the playoffs and the World Series were anticlimactic after that."

Gossage made it so, recording the final eight outs in a 5–4 win that brought the Yankees all the way back from a midsummer deficit of fourteen games. From there, Gossage recorded two wins and a save in the postseason to give New York its twenty-second World Series title—and put him on the fast track to Cooperstown and the Baseball Hall of Fame.

Gossage made his debut with the White Sox in 1972, but it wasn't until 1975, when manager Chuck Tanner turned Gossage into a full-time reliever, that he found a niche for his blazing fastball.

"Chuck Tanner had the single greatest influence on my career," said Gossage, who had twenty-six saves and a 1.84 ERA in his first season as the closer for the Sox. "I can't fathom having nearly the career I had if I'd been a starting pitcher."

Gossage was part of the 1970s bullpen revolution that saw pitchers like Rollie Fingers and Bruce Sutter step into starring roles. But the transition was not always smooth. After Tanner left the White Sox following the 1975 season, new Chicago manager

Paul Richards moved Gossage into his 1976 rotation—where he went 9–17.

But during that offseason, Tanner became the manager of the Pittsburgh Pirates and engineered a trade that brought Gossage back to the bullpen. He was 11–9 with twenty-six saves that summer in Pittsburgh, then left for New York and free agent riches.

Six years later Gossage fled New York for San Diego—where he proved to be the final piece of the Padres' 1984 National League championship puzzle. San Diego was also the scene of Gossage's most famous failure when he surrendered Kirk Gibson's three-run, eighth-inning homer in Game 5 that iced the World Series for the Detroit Tigers.

"Dick Williams told me to walk Gibson, but then I convinced him to let me pitch to him," said Gossage of his Padres manager and future Hall of Fame teammate. "Well, Dick was right."

Williams, though, never second-guessed his closer's decision.

After four seasons as the Padres' closer, Gossage pitched for six big league teams in his final six seasons, mostly as a set-up man. The final total: a 124–107 record, 310 saves, and 1,002 games pitched.

"I'm probably the only pitcher to span the entire time from the start of closers to what the bullpen is today," said Gossage, whose twenty-two-year career lasted from 1972 to 1994. "But please don't compare me to these modern-day relievers. We pitched two or three innings and came in the game with men on base. We had no room for error.

"You had to want the ball in situations like that. And I wanted the ball."

—C.M.

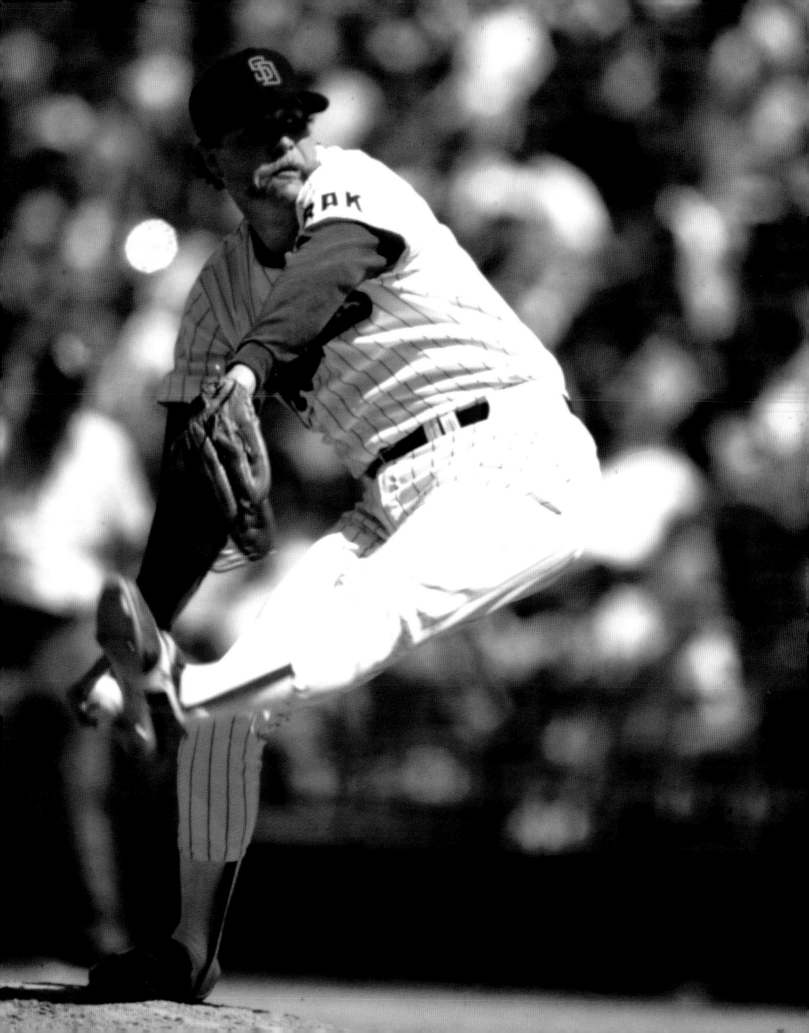

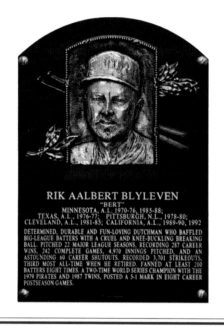

RIK AALBERT BLYLEVEN
"BERT"
MINNESOTA, A.L. 1970-76, 1985-88;
TEXAS, A.L., 1976-77; PITTSBURGH, N.L., 1978-80;
CLEVELAND, A.L., 1981-85; CALIFORNIA, A.L., 1989-90, 1992
DETERMINED, DURABLE AND FUN-LOVING DUTCHMAN WHO BAFFLED
BIG-LEAGUE BATTERS WITH A CRUEL AND KNEE-BUCKLING BREAKING
BALL. PITCHED 22 MAJOR LEAGUE SEASONS, RECORDING 287 CAREER
WINS, 242 COMPLETE GAMES, 4,970 INNINGS PITCHED, AND AN
ASTOUNDING 60 CAREER SHUTOUTS. RECORDED 3,701 STRIKEOUTS,
THIRD MOST ALL-TIME WHEN HE RETIRED. FANNED AT LEAST 200
BATTERS EIGHT TIMES. A TWO-TIME WORLD SERIES CHAMPION WITH THE
1979 PIRATES AND 1987 TWINS, POSTED A 5-1 MARK IN EIGHT CAREER
POSTSEASON GAMES.

BERT BLYLEVEN

CLASS OF 2011

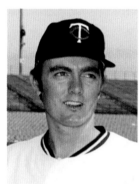

Though the native of Zeist, Holland, was much more than a one-pitch pitcher, it was Bert Blyleven's amazing 12-to-6 curve—one that seemingly went from the top to the bottom of a clock face—that will be his lasting legacy.

"[His curveball] was nasty, I'll tell you that," said Hall of Famer Brooks Robinson. "Enough to make your knees buckle."

Blyleven's family emigrated from Holland to Southern California via Canada when he was six years old, and the wiry right-hander quickly fell in love with the Los Angeles Dodgers and their ace pitcher Sandy Koufax. By the time Koufax retired in 1966, Blyleven had established himself as a pro prospect.

The Minnesota Twins took Blyleven with a third-round pick in the 1969 draft, and a year later he was a member of the Twins starting rotation. With a quick and accurate fastball to set up his physics-defying curve, the durable Blyleven immediately became one of the American League's top young pitchers.

The Twins traded Blyleven to the Rangers midway through the 1976 season, and by 1978 Blyleven found himself with the Pirates. The next season, Blyleven went 12–5 in 237 innings for the Pittsburgh team that won the National League Pennant—Blyleven's curveball caught César Gerónimo looking for the last out of the final game of the NLCS against the Reds—and the World Series.

The Pirates traded Blyleven to the Indians prior to the 1981 season, and after battling an elbow injury in 1982, he went 19–7 in 1984, finishing a career-best third in the AL Cy Young Award voting, an achievement he matched in 1985. That season the Indians traded Blyleven back to the Twins—and by 1987 the thirty-six-year-old Blyleven found himself a veteran leader on a team that shocked the baseball world by winning the World Series just a year after losing ninety-one games.

Blyleven won three games during the 1987 postseason, finishing his career with a 5–1 record and a 2.47 earned run average in the playoffs and World Series.

"Bert's delivery always has been smooth, loose, a lot of leg drive, everything going forward at the same time," said former Twins manager Ray Miller. "It's the type of delivery that allows a guy to hold up year after year."

After three seasons with the Angels at the end of his career, Blyleven retired with a record of 287–250, including 242 complete games, sixty shutouts, and a 3.31 ERA. His 3,701 strikeouts ranked third all-time at the time of his retirement.

His curveball, however, will always remain near the top of the list of the game's greatest pitches.

"One curve I'll always remember was when I was pitching for Pittsburgh," Blyleven said. "Terry Kennedy was a young player with St. Louis. I threw him an 0–2 curve and it snapped. Terry's reaction was to swing straight down, like he was chopping the plate with an axe. I'll have to admit that was a [heck] of a curveball."

—C.M.

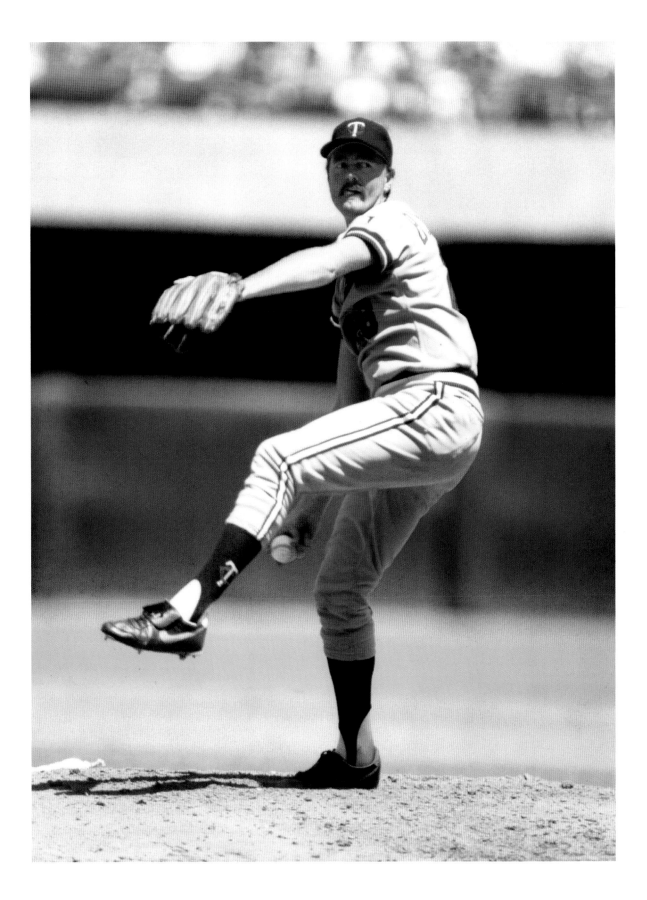

CARLTON FISK

CATCHERS

CATCHERS BY **CARLTON FISK**

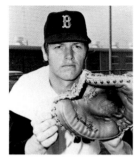

Born and bred in New England, Carlton Fisk originally dreamed of playing for the Boston Celtics. But the man voted the greatest athlete in New Hampshire history wound up becoming a power-hitting catcher instead of a power forward. Splitting his twenty-four-year career between the Boston Red Sox and Chicago White Sox, the determined, durable Fisk was behind the plate until the age of forty-five. Along the way, the eleven-time All-Star helped convince baseball people that it made perfect sense to put a great all-around athlete at catcher.

When I look back on my baseball career, maybe the most amazing thing to me is that I was ever discovered in the first place. See, I grew up in a tiny New Hampshire town, where the weather wasn't conducive to playing a lot of ball. In high school we'd have a twelve-game schedule, and some of those games would get weathered out. So my story definitely was a case of finding a needle in a haystack. Thankfully the scouts wound up finding me.

My hometown of Charlestown, in the western part of the state on the Connecticut River, had a population of about nine hundred people. We had one grocery store, one drugstore, three or four gas stations, and four or five churches. We had stop signs, but no traffic lights. As the old country song says, "I grew up in a town so small, you look both ways and you see it all." That was Charlestown, New Hampshire. We didn't have any community ball fields in town, so we had to carve out our own places to play ball. We actually made our own diamond out of a local cow pasture. There weren't a lot of true hops on that field, but it served its purpose.

Sports were a big part of my youth because that's all we had to do. We had to find some way to amuse ourselves, and sports was it. We'd go swimming in the river and play basketball at my grandfather's barn or baseball in that cow pasture. It was a pretty simple existence, but we had fun.

In my youth, basketball was my game. Baseball was a distant second. It wasn't even close. I loved the Boston Celtics and I dreamed of becoming a power forward for them when I grew up. I loved watching Sam Jones bank his shots off the glass. I loved watching Bill Russell block shots and grab rebounds to start the fast break. And I loved seeing John Havlicek in perpetual motion; the guy never stopped moving from the opening tap to the final buzzer. High school basketball was big in our part of the state. The gymnasiums were small, but the rivalries were big. Those games were like mini Red Sox–Yankees contests. Very, very intense. Lots of bumps and bruises and passion.

I actually wound up earning a basketball scholarship to the University of New Hampshire and discovered real quick that there wasn't a place for a six-foot-two power forward in Division I college basketball, let alone the pros. Heck, I was facing guards six five, so where was I going? My college basketball career lasted just one year.

Like I mentioned, the climate of western New Hampshire wasn't conducive to playing a lot of organized baseball. We'd get a dozen games in during high school baseball season and maybe another fourteen to sixteen during the American Legion season in the summer. Unlike today, you didn't have these showcase tournaments, where kids in the North can go play teams down South. So we were at a distinct disadvantage compared to kids from California or Florida or Texas. I figured out that I probably played just a hundred games my entire amateur career. When I signed

my first pro contract in 1967, I was playing with and against guys who had played 150 games in a single year. I remember talking to Fred Lynn, our center fielder with the Red Sox, and we figured out that between the University of Southern California and summer ball in Alaska, he played more than 230 games during his college career.

I was a pretty good athlete. I could run and jump and throw, and although basketball was my first love, I was good at baseball pretty much from the moment I first picked up a bat and ball. I think the fact I was a big frog in a small pond helped me get discovered. When you're the big frog, you get the write-ups in the paper and people take notice, and I think a bird dog scout must have seen some of the write-ups and decided to take a look. Legion ball helped me get even more exposure. I played on the team in Bellows Falls, Vermont, and we wound up winning the state tournament one year. I believe that's when the interest really started and the bird dog scouts convinced the full-time scouts to give me a look-see, and it kind of took off from there.

In high school I was the biggest guy and threw the hardest, so I pitched a lot. In Legion ball I would pitch once in a while, and I played some shortstop. As time went on, scouts began showing more interest. I remember having a conversation with a scout from the Red Sox, and he said, "You know, Carlton, the quickest way to the big leagues is as a catcher. Have you ever considered giving that position a shot?" My older brother had been a catcher, so I thought, "OK, why not try it." And the rest is history.

I liked the position right away, and I think the thing that appealed to me most is that you are involved in every moment of the game. Every play in the game of baseball is initiated by the catcher and pitcher. You certainly couldn't control the game the way a pitcher could, but you could definitely influence a lot of things that were going on. It forced me to become more of a student of the game. Calling pitches was a huge responsibility and I enjoyed that aspect tremendously. I'd be lying to you if I said I enjoyed the physical beating you took with foul tips and collisions at the plate and all that squatting. But I've always been extremely competitive, and to me the physical toll became another challenge I had to overcome. And that's the way I approached it.

Although I went to UNH on a basketball scholarship, I also played freshman baseball. (Those were the days when freshmen weren't eligible for varsity sports.) I caught some, pitched some, and played a little short and even the outfield. But just like high school, our schedule was very limited; we didn't take any southern trips in the spring like schools do now.

I was only seventeen when I went to college, and I was still pretty immature. I spent more time on the basketball court than in class, so I didn't make it back for a second year. I could have gone back on academic probation, but I decided not to. I hadn't learned how to apply myself in anything but sports. The Red Sox wound up drafting me [in January 1967], and at the same time I received a call to take my physical for active duty. That's when it really hit me right between the eyes. I joined the Army Reserves in Chester, Vermont. My timing ended up being very good because if I had waited two weeks longer, I would have been drafted into active duty and probably would have been sent to Vietnam.

That summer, I reported to Fort Dix, New Jersey, for reserves training. I spent seven months there before reporting to the Red Sox training camp in Sarasota, Florida, to play a few months in the instructional league.

The following year I was assigned to the Red Sox affiliate in Waterloo, Iowa. I still had to fulfill my Army Reserves requirements, which included one week a month and two weeks in the middle of the summer. I continued to do that in 1969, when I played Double-A ball in Pittsfield, Massachusetts; in 1970, when I played Double-A ball in Pawtucket, Rhode Island; and in 1971, when I played Triple-A ball with the Louisville Colonels of the International League. The reserves obligations interrupted your flow—you'd be doing well, and then it would be time to go, and when you returned, it would take time to regain your rhythm, especially at the plate. But I wasn't complaining, because the sacrifices being made by the guys who were on active duty in Vietnam were far, far greater than the ones I was making. Sadly, many of those guys didn't come home alive or came home damaged mentally and physically.

At the end of the 1969 season, I was called up briefly to the Red Sox. That was kind of surreal. I was still basically a kid going through life without a grand plan. I just went along with things, followed other people's directions. I just thought it was a fun experience, but I still wasn't thinking that this was necessarily going to be my longtime career. One of my first at bats in the big leagues was as a pinch hitter against Detroit Tigers star Mickey Lolich. Three swings and three misses later, I was back on the bench. My only other at bats that year resulted in an 0-for-4 performance against Baltimore Orioles ace Mike Cuellar. And that's how my first big league season ended: 0-for-5. I really felt out of place when I joined the Red Sox that season. I didn't feel like I was a part of the team. You had guys like Yaz [Carl Yastrzemski], who had been around forever. I basically felt like a batboy.

After that season I reported to Sarasota for more instructional league ball. It was there that I finally was made to realize that if I wanted to truly pursue baseball as a career, I had better start becoming serious about it. I vividly remember this blistering-hot day, when I was given the assignment of warming up several hotshot pitching prospects. I caught about six or seven sessions in a row—each one lasting about twenty minutes—and none of them were fun. Most of these guys were as wild as can be. They were beating me up pretty good, bouncing balls into the dirt or throwing them way over my head. They couldn't throw a strike to save their lives. When it was over, I was supposed to run. But I was dog tired and angry. "I just spent two-and-a-half bleeping hours catching a bunch of prima donnas who couldn't throw the ball sixty feet, six inches in the air," I screamed at one of the coaches. "I got my bleeping workout in and then some. I'm not running." I'm fuming as I'm storming off toward the clubhouse, when this other coach, a guy by the name of Mace Brown, calmly walks over to me. He listens to me complain for a while, then calmly puts his hand on my shoulder and, in this thick southern accent of his, says, "Carlton, I want to tell you something my daddy told me when I was around your age." I'm still steaming and I say, "What's that, Mace?" even though I firmly believed nothing he said would settle me down. He says, "Son, if you hadn't wanted to work, you oughtn't to hire it out." The words hit me like a ton of bricks. I was speechless. I finally told him, "Mace, that's the most profound statement I've ever heard." It really did open up my eyes and made me realize what a jerk I had just been. It finally dawned on me that baseball, and life, is hard work, full of challenges, and that I needed to have a better attitude and a better approach. From that moment on—continuing through today—whenever I face a challenge, I think about Mace's words: "If you hadn't wanted to work, you oughtn't to hire it out."

I was called up again by the Red Sox at the end of the 1971 season and did much better [a .313 batting average in fourteen games] than I had two years earlier. I reported to spring training the following year, feeling more confident, but I still believed I had a long, long way to go. I knew I had to earn my stripes. That club had Yaz and Rico Petrocelli and Reggie Smith and Luis Tiant. They were veterans and stars. I felt like the new kid on the block, and in order to be accepted, in order to truly be a part of the team, I had to pull my end of the load.

When camp broke, the Sox decided to take three catchers north with them, which was kind of unusual. Duane Josephson was the number one catcher, Bob Montgomery the backup, and me number three. We start the season; soon after, Josephson gets hurt, pulls a groin. And I get excited because I think I'm going to play, completely forgetting that Montgomery is ahead of me. So we go back to Fenway, where we're going to play the Yankees. The Yankees had a fast ball club in those days, and the year before they had run our catchers ragged, stole a bunch of bases. I had a strong arm, so they decided to start me. The problem was that my arm was powerful, but, to be honest, I didn't always know where my throws were going. So I played, and I didn't throw anybody out for about two weeks, but I was getting two hits a game, so they [kept] me in there and I settled down and eventually started throwing people out. And it just took off from there. I played 131 games, and hit 22 homers, drove in 61 runs, and batted .293 to earn American League Rookie of the Year honors. It seemed that once again, fate had intervened on my behalf, just as it had when I was discovered playing ball in a small town and just as it had when we broke camp with me being the number three catcher. Opening Day, I'm the third guy, who might even be shipped out to Triple-A. Five days later, I'm the starting catcher, a job I would hold on to for nearly two decades.

The other interesting thing about my rookie year was that I tied for the league lead with nine triples. (I'm still the answer to the trivia question: Who's the last catcher to lead the league in triples?) I know my number of three-baggers surprised a lot of people, because catchers aren't supposed to be able to run. But I had always moved fairly well around the bases (although after fifteen, twenty years of squatting, I wound up losing much of my speed). There were certain views that baseball people had about catchers back then: namely, that you put the slow, chunky guy behind home plate. Catch the ball. Be a backstop. That's the main thing a catcher should be worrying about. That was the conventional wisdom. And I never understood that philosophy. If catcher is one of the most important positions on the team, why not put the best athlete you can back there? Hopefully, I was among the catchers who helped change the old-school thinking.

I avoided the dreaded sophomore slump in 1973 (26 homers, 71 RBI) and was off to a great start in 1974. Through 52 games, I had 11 homers, 26 RBI, and a .299 average. Everything was coming together for me, and I felt like I was going to have a monster year. But during a game that June, I tore up my knee in a collision at the plate with Leron Lee of the Cleveland Indians. Before I describe what happened, let me just say that one of the dumbest things a catching coach can ever tell a catcher is that he should block the plate in order to stop a guy from scoring. There's never been a run scored in the history of the game that's worth the kind of injury a catcher can suffer in that mismatch. One run is not worth one leg.

Lee was on first base and the batter hit a ball into the alley. Rick Miller, my brother-in-law, is playing center field, and he goes over and picks the ball up after one or two hops off the wall,

delivers a perfect relay to the shortstop, who fires it to me. His throw is a little toward the third-base side of home plate. I try to hold my ground and grab the ball and tag Lee out. Instead of sliding, he sort of jumps and lands right on my leg. I suffered the dreaded Triple Crown of knee injuries—tearing my medial collateral ligament, my medial meniscus, and the anterior cruciate ligament. You have to remember that this is back in the mid-1970s, and sports medicine and rehabilitation programs are still relatively primitive. Heck, we didn't even have an orthopedist as our team physician. We had a urologist. When I got back to Boston, they arranged for me to have surgery with a prominent knee doctor. He had operated on more than two hundred knees, and he told me it was the second-worst knee injury he had seen. He and other doctors who examined it said that my baseball career was through and that I would probably walk with a limp for the rest of my life.

Obviously, I was devastated. Again, there weren't any elaborate physical therapy programs the way there are now, so, after I got over my initial shock and decided I was going to prove that prognosis wrong, I had to pretty much make a go of it on my own. I essentially invented my own rehab exercises on the fly. And that, along with my determination and my wife's encouragement, enabled me to defy the odds. Looking back, the most satisfying achievement of my career was going from that diagnosis to the time when I put that uniform back on again—five days short of a year since my injury. It hurt me every time I took the field for another year, but I could deal with it because I was playing ball again.

I played about half of the 1975 season, and what a special year that was. I hit .331 as we wound up winning the division and making it to the World Series against the Cincinnati Reds. We, of course, lost the Series in seven games, in what many still regard as the greatest Fall Classic of them all. Game 6 produced my signature moment, when I waved that home run fair in the bottom of the twelfth at Fenway to win the contest and send the Series to a seventh game. I joke about that game beginning on October twenty-first and ending on the twenty-second, and that by the time I came to the plate it was way past my bedtime. I was tired and I remember talking to Fred Lynn in the on-deck circle before heading to the plate. I said, "Freddy, I'm going to hit the ball off the wall and I want you to drive me in so we can go home and get some sleep." Just two pitches later, I'm hitting the ball off the foul pole. Why it stayed fair, I don't know. Maybe the ball had eyes and saw me waving it in that direction. If that foul pole is ten feet deeper, then that ball goes foul. Once again, fate had intervened on my behalf.

Years later, the Red Sox honored me by renaming the left-field foul pole the Fisk Foul Pole. That was a tremendous honor. I was well aware that the foul pole down the right-field line had been named the Pesky Pole, after Red Sox legend Johnny Pesky, who, surprisingly, only hit some-thing like seventeen home runs his whole career. It's one of the greatest honors I've ever received. It's pretty awesome to know that you are going to be a part of Fenway Park forever. There's the Green Monster, the Pesky Pole, and the Fisk Pole. Very cool.

I continued to have solid seasons after 1975 as my knee grew stronger and the pain subsided. And it was during that time that the Red Sox–Yankees rivalry really took off. A lot of people talk about it always being the most intense in sports, but I didn't really feel that intensity when I first came up. I think my rivalry with Yankees catcher Thurman Munson kind of lit the fire. I started

competing with him and he started competing with me to see who was the best catcher in the American League. That's where the rivalry started getting rekindled. The fact that Boston and New York had really good ball clubs and were fairly evenly matched up is what made it so compelling. It's not a rivalry when somebody is beating the crap out of somebody else. Rivalries occur when teams are comparable in talent and begin scratching and clawing away at one another. I still contend the rivalry was its most intense when we were locking horns in the 1970s. Every game was a dogfight, and sometimes punches would be exchanged. We didn't like them. They didn't like us. Their fans didn't like our fans. And our fans didn't like their fans. I think the intensity was much greater then than in the late 1990s, early 2000s. It truly was something to be a part of.

Years later, when I was with the Chicago White Sox, there were stories about the Yankees trying to trade for me. When Ken Harrelson became the White Sox general manager, he came to me one night and said he wanted to trade me to New York. You can probably guess what I told him. Fortunately, being a veteran, I could put the kibosh on certain trades, and I did on that one. I respected the Yankees, but there was no way I ever was going to put on their pinstripes.

Looking back on those years with the Red Sox, I'm disappointed that we never won a World Series. I thought we had the best talent in baseball for about a five-year stretch, and should have ended that "Curse of the Bambino" back then instead of having to wait until 2004. But the best teams don't always win. The thing other really good teams had that we didn't was a solid one-through-four rotation and a dominating bullpen. We usually had two starters who could match up with anybody's 1-2 pitchers, but then we would have to fill in with the 3-4 starters, who weren't nearly as dependable. We had a great offense, we had solid defense, and we had some really good pitchers. But we just didn't have a full enough pitching staff to finish the job.

I like to think that those great teams we had really led to a huge growth in popularity of the Red Sox throughout New England. When I first got to Boston, the passion of the fan base really wasn't there. In 1969, I remember playing games in front of just eight thousand people at Fenway. There was hardly anybody in the stands. But I started noticing a change toward the end of the 1972 season, when we went down to the wire with Detroit. We had a bunch of young guys on that team who would become the foundation. I think I saw it grow from there. And now, of course, the Red Sox are such a huge part of the region, with something like eight-hundred-plus straight sellouts.

Like Ted Williams and Yaz, I would have liked to have played my entire career in Boston, but things change. We got to a point where management didn't seem committed to winning, and they let players leave without much effort. Red Sox general manager Haywood Sullivan was two days late in sending me a contract before the 1981 season, thus opening the door for me to become a free agent. He claimed the tardiness was a mistake, but if that were the case, why didn't they immediately make me a contract offer? If they had come right after me and apologized, I would have said, "OK, no problem." But they didn't because, in reality, they had no intention of bringing me back.

I wound up signing a contract with the White Sox, and as fate would have it, the schedule makers had us opening the season in Fenway against my old team. It was a pretty strange and emotional day for me. The fans were great. They gave me a standing ovation. They cheered my

every move. They are smart fans. They knew what was behind me leaving. I wasn't perceived as the villain in this story. I hit a homer that day to beat Boston, 5–3, and I'd be lying to you if I told you that vindication didn't feel sweet.

I spent nearly as many years with the White Sox as I did with Boston, and I enjoyed my time there very much. The number 27 that I had worn in Boston wasn't available, so I inverted the digits and chose 72; 27 eventually became available, but I decide to stick with 72. The White Sox had a talented team and had been close on a few occasions, so I believed I was walking into a good situation. I always felt my handling of a pitching staff was one of my strong suits, and it really pleased me that several of the guys I worked with in Chicago were quite appreciative—especially Jack McDowell, who credited me with helping him win the Cy Young Award. I really studied situations and opposing hitters, so I could take a lot of the burden off our pitchers. I wanted them to trust me in calling the game. I wanted it so they could just concentrate on executing their pitches. We'd go over strategy before, during, and after games. I did my best to boost their confidence. I told them not to worry. Just follow me and we'll get through this.

The longer I played, the more of a toll the game took on me. I dealt with my share of injuries through the years. In addition to the devastating knee injury I suffered in 1975, I had to deal with a broken arm, two broken hands, broken fingers, a torn groin, and a torn elbow. While I was with the White Sox, I hooked up with athletic trainer Phil Claussen to develop a strength and conditioning program that would help me ward off some of the nagging injuries I was dealing with and make me stronger and more durable. For the longest time, baseball people avoided weight training because they believed it would make you muscle-bound and less productive. But we came up with a program that was baseball-specific, that helped me become an even better ballplayer. On top of the weight training, we also began addressing my diet. Nutrition became an important part of my regimen. I started eating a lot better. This stuff is commonplace among athletes and sports teams these days, but it was somewhat revolutionary in baseball back in the 1980s.

I got stronger, especially in my legs, to the point where squatting wasn't as much of a burden as it had been in earlier years. My offseason training program produced immediate results. I felt great from the start in 1985 and wound up having one of the best seasons of my career, with thirty-seven home runs, 107 RBI, and seventeen stolen bases at age thirty-seven. As it turned out, I wound up playing until my mid-forties. Had I not taken steps to get myself into the best shape possible, I never would have played as long as I did. I would have broken down and been forced to retire many seasons short of the twenty-four I logged.

In retrospect, I learned a lot from Carl Yastrzemski in the way he approached the game. I think he influenced everyone he played with in a positive way by the example he set. He came to play every day. I don't know if a lot of people do, but he did. He was certainly an inspiration to me. He taught me just how important hard work was. A lot of people look at the great players and think it's just about talent. But there's so much more to it than that. The great players usually aren't just the most talented; they're also the hardest workers. I hope people perceived me as someone who always respected the game and came to play every single game.

Like I said in the beginning, I'm still kind of surprised about how this all turned out. Just to make it from a small town in New Hampshire to the big leagues was a huge thrill. I still don't know how they found out about me, but I'm glad they did. I'm also proud of coming back from that knee injury when they told me I was done playing baseball forever. And I'm proud that I was willing to put in the work that enabled me to play in four different decades at the most demanding position on the baseball field. Not bad for a guy from a place so small you look both ways and you see it all.

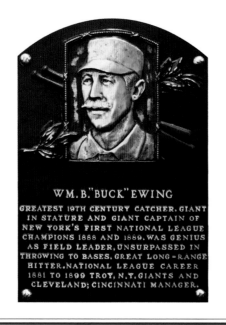

WM. B. "BUCK" EWING

GREATEST 19TH CENTURY CATCHER. GIANT IN STATURE AND GIANT CAPTAIN OF NEW YORK'S FIRST NATIONAL LEAGUE CHAMPIONS 1888 AND 1889. WAS GENIUS AS FIELD LEADER, UNSURPASSED IN THROWING TO BASES. GREAT LONG-RANGE HITTER. NATIONAL LEAGUE CAREER 1881 TO 1899 TROY, N.Y. GIANTS AND CLEVELAND; CINCINNATI MANAGER.

BUCK EWING

CLASS OF 1939

Some credit Buck Ewing with being the first catcher actually to crouch behind home plate. Since Ewing began his major league career back in 1880 with Troy (New York) of the National League, he certainly was in a position to establish such a precedent.

A brilliant fielder who was comfortable playing any position, including pitcher, Ewing was a charter member of the New York ball club in 1883. A real leader in the field, usually directing his team's defensive strategy from behind the plate, Ewing proved that he could swing the bat, too, as he led the NL in home runs in 1883 and triples the following season. He hit better than .300 in eleven of his eighteen major league seasons and finished his career with a .303 batting average.

As the captain of Gotham's first NL championship squad in 1888, Ewing went on to participate in fifteen postseason contests, hitting .290, according to the *Biographical Dictionary of American Sports.*

Time and again, opposing base runners were stopped in their tracks by his impressive throwing arm. "He was the greatest," Hall of Fame pitcher Mickey Welch said of his old batterymate. "He could hit, run and throw. From his haunches, looking innocently at the pitcher and without moving his head, he could throw sidearmed to first base with a rifle-shot pickoff throw."

Welch added that Ewing would often "sit up at night thinking about ways to upset and beat his rivals the next day, like finding out about an opposing pitcher's love life.

"He originated the pre-game clubhouse meeting. He'd do anything to win."

At the turn of the last century, sportswriter Sam Crane compiled a list of the top fifty ballplayers of baseball's early days and he named Ewing number twenty.

"As a thrower to bases Ewing was virtually in a class by himself," Crane wrote. "He was so confident in his ability to head off base runners that even when the speediest of players were on the bases I've seen him very often have passed balls purposely and throw the balls away from him to entice a runner to try for a base."

Like many successful catchers in the game, Ewing moved on to managing after his playing days ended. First as the player-manager and then as a full-time skipper, Ewing compiled an overall managerial record of 489–395 between the New York Giants and Cincinnati Reds. After retiring from the game, Ewing reportedly became a rich man, thanks to his extensive landholdings in the West.

Ewing was born in Hoagland, Ohio, and died in Cincinnati of diabetes in 1906. He was elected to the National Baseball Hall of Fame thirty-three years later.

"No greater catcher ever donned a padded mitt," declared the *Cincinnati Enquirer* upon Ewing's death. "Besides his supreme abilities as backstop and batsman, Buck could fill, in his palmy days, any one of the eight other positions on the field with precision."

—T. Wendel

ROGER BRESNAHAN
BATTERY MATE OF CHRISTY MATHEWSON
WITH THE NEW YORK GIANTS, HE WAS
ONE OF THE GAME'S MOST NATURAL
PLAYERS AND MIGHT HAVE STARRED
AT ANY POSITION. THE "DUKE OF TRALEE"
WAS ONE OF THE FEW MAJOR LEAGUE
CATCHERS FAST ENOUGH TO BE USED
AS A LEADOFF MAN.

ROGER BRESNAHAN

CLASS OF 1945

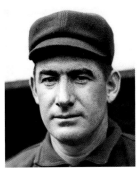

Members of the catching fraternity for-evermore should tithe a percentage of their earnings to Roger Bresnahan, the most innovative of the brethren whose forethought has helped keep them safe from injury.

In 1907 Bresnahan, then employed by the New York Giants, introduced the shin guard to the items of standard protective wear for catchers. He said he was inspired to create the equipment after watching cricket. Modeling the guards, however, took a certain fortitude, since Bresnahan was decried as a wimp. "Boy, they sure called me lots of names when I tried on those shin guards," Bresnahan recalled decades later. "They must have been a good idea at that, though, because they tell me catchers still wear 'em."

For seventeen seasons, between 1897 and 1915, Bresnahan displayed his versatility on the diamond. He started out as a pitcher, played some outfield, and then became a full-fledged catcher. Unusually swift for a catcher, Bresnahan became one of the first to bat leadoff and once stole thirty-four bases in a season. His stance anchored him quite close to the plate, and pitchers took it out on him. To combat their brushbacks, Bresnahan fashioned protection for his head as well. It was a crude model of the first batting helmet.

Some raved about Bresnahan's skill behind the plate, but he believed he might have been exiled if he hadn't hit well enough

for teams to keep him long enough to prove he could catch. "I think if it wasn't for my ability as a batter I never would have stuck to the big show," Bresnahan said. "I tried almost every position, and though I didn't make out so bad, if it hadn't been for my little club I never would have been given the chance to show I had ability as a catcher."

Wherever he played, Bresnahan was regarded as one of the tough guys on the field. A family story passed on through later generations presents a vivid image of a player who could not be intimidated. Recalling the era when teams put on their uniforms in their hotels on the road and then rode to the games, Bresnahan's nephew and namesake said he was told that fans abused the visitors by throwing things at them. "Rog would get up on the seat with the driver," nephew Roger said. "He would catch tomatoes, rocks, or whatever else was thrown, and throw them back at the crowd."

Bresnahan bore the nickname "The Duke of Tralee," but it was based on the misconception that he was born in Ireland. He was actually born in, grew up in, and continued to reside in Toledo, Ohio, and after his playing and managing days ended in the majors, he owned the local Toledo team—the Mud Hens.

The determined catcher adhered to an always-play-hard philosophy. "From the moment you put on your uniform until the game is over," Bresnahan said, "never do anything you wouldn't do in a World Series game."

—L.F.

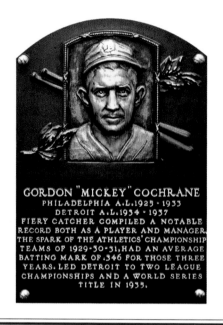

GORDON "MICKEY" COCHRANE
PHILADELPHIA A.L. 1925-1933
DETROIT A.L. 1934-1937
FIERY CATCHER COMPILED A NOTABLE
RECORD BOTH AS A PLAYER AND MANAGER,
THE SPARK OF THE ATHLETICS' CHAMPIONSHIP
TEAMS OF 1929-30-31, HAD AN AVERAGE
BATTING MARK OF .346 FOR THOSE THREE
YEARS. LED DETROIT TO TWO LEAGUE
CHAMPIONSHIPS AND A WORLD SERIES
TITLE IN 1935.

MICKEY COCHRANE

CLASS OF 1947

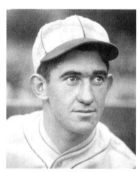

"I always liked football better than baseball," Mickey Cochrane said. "In fact, I couldn't even make the ball club in two of my four years at Boston U. A funny thing, too. I never liked to catch. I'd rather play in the infield or outfield. I even pitched a few games. Anything suited me better than working behind the bat. I carried this distaste for catching into professional baseball."

When Cochrane was in college, he helped support himself by washing dishes. Boston University is located a short distance from Fenway Park, and one day he was looking out the window and saw Babe Ruth, Waite Hoyt, Herb Pennock, and other members of the Yankees taking their leisure.

"See those lucky stiffs on the Brunswick [Hotel] steps?" Cochrane said to a work partner. "Nothing to do but play baseball while I am here washing dishes. Some day I am going to sit over there and look over here and watch other guys washing cups and saucers, knives and forks. Yes, sir. I have made up my mind I am going to be a big leaguer myself."

It turned out the catching line was actually Cochrane's salvation with the Philadelphia Athletics and the Detroit Tigers. The winner of two Most Valuable Player Awards, Cochrane appeared on the cover of *Time* magazine in 1935. Still, catching was initially slow going for him.

"After five days in the Athletics' camp, I wasn't sure he'd even make a relief catcher," manager Connie Mack said. "I nearly put him in the outfield. He was crude at receiving the ball. His stance and crouch were both wrong. And on foul balls he was simply pathetic. Still, he was a natural hitter, putting his whole body and heart into it. 'What can I do with that boy?' I wondered."

Yet Cochrane worked so hard that he became a star. "Player and manager, these 50 years," Mack said, "I've seen hundreds of men, but none of them ever made such a quick and complete job of correcting weaknesses."

Cochrane's career was cut short by a Bump Hadley pitch that smacked him in the head during a 1937 game against the New York Yankees. Rushed to the hospital with a fractured skull, Cochrane nearly died, was hospitalized for seven days, and was ordered by doctors never to play again. The ball had broken downward when Cochrane ducked, essentially following him. New York catcher Bill Dickey, right on the scene, said, "His eyes were rolled up. I could see nothing but the whites of them."

When Cochrane awakened after being rushed to the hospital by ambulance, he said, "I lost sight of the ball when it was three feet from me."

—L.F.

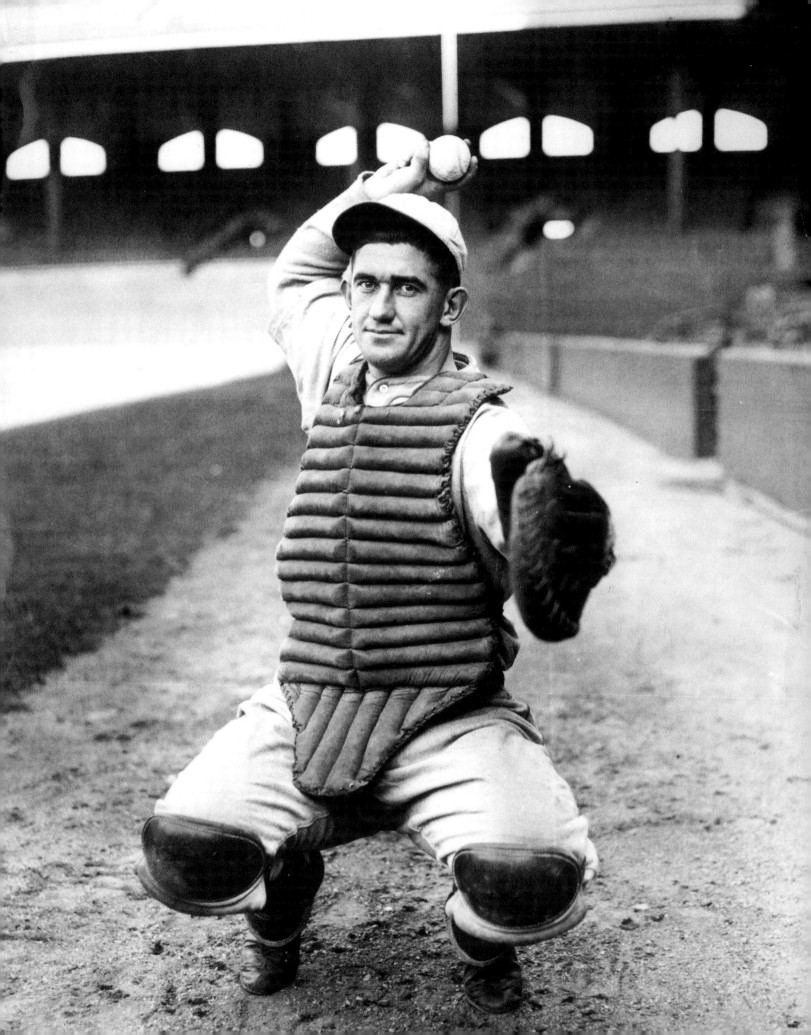

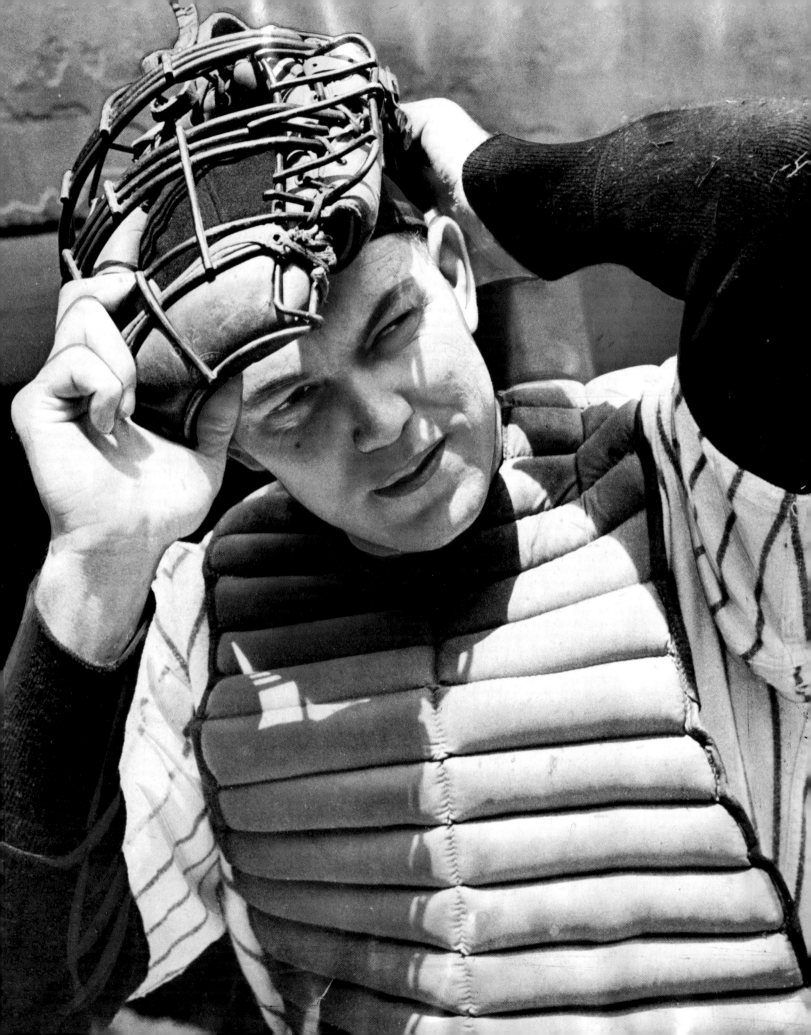

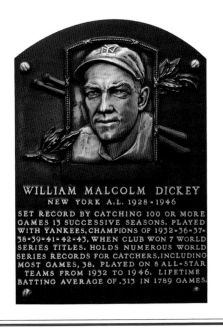

WILLIAM MALCOLM DICKEY
NEW YORK A.L. 1928-1946
SET RECORD BY CATCHING 100 OR MORE
GAMES 13 SUCCESSIVE SEASONS. PLAYED
WITH YANKEES, CHAMPIONS OF 1932-36-37-
38-39-41-42-43, WHEN CLUB WON 7 WORLD
SERIES TITLES. HOLDS NUMEROUS WORLD
SERIES RECORDS FOR CATCHERS, INCLUDING
MOST GAMES, 38. PLAYED ON 8 ALL-STAR
TEAMS FROM 1932 TO 1946. LIFETIME
BATTING AVERAGE OF .313 IN 1789 GAMES.

BILL DICKEY

CLASS OF 1954

"Bill Dickey is the best [catcher] I ever saw," said Hall of Famer Bob Feller. "He was as good as anyone behind the plate, and better with the bat. There are others I'd include right behind Dickey, but he was the best all-around catcher of them all. I believe I could have won 35 games if Bill Dickey was my catcher."

In 1928 Bill Dickey was claimed on waivers from the Class D Jackson Senators of the Cotton States League. "I will quit scouting if this boy does not make good," Yankees scout Johnny Nee told general manager Ed Barrow. Dickey grew up in a baseball family in Arkansas. His father, John, had pitched and caught semipro ball, and his younger brother George would catch in the majors for the White Sox and Red Sox.

Dickey made his debut late in the 1928 season, and the following year became the starting catcher as he hit .324, with thirty doubles, six triples, and ten home runs. As a young, impressionable teammate of Babe Ruth, he tried to hit homers until manager Miller Huggins had a talk with him. "We pay one player here for hitting home runs and that's Babe Ruth. So choke up and drill the ball. That way, you'll be around here longer."

Dickey took Huggins's advice and began a string of six consecutive years hitting above .300, which he would do a total of eleven times en route to a .313 lifetime batting average. He found his power stroke eventually as well, hitting 202 lifetime home runs and averaging twenty-six a year during the Yankees' four consecutive World Series championships from 1936 to 1939. During the same stretch, he averaged 115 RBI.

"I loved to make a great defensive play, I'd rather do that than hit a home run," Dickey once said. Sure-handed and agile, he rarely made physical errors, had a rifle arm, and handled pitchers well while calling a good game. "A catcher must want to catch. He must make up his mind that it isn't the terrible job it is painted, and that he isn't going to say every day, 'Why, oh why with so many other positions in baseball did I take up this one?'"

Yankees pitcher Charlie Devens remarked, "I was lucky to work with Hall of Fame catcher Bill Dickey, who was always one pitch ahead of the batters. He not only called a great game, but had the best arm I'd ever seen."

All business on the field, Dickey was affable and well liked off of it. He was a close friend of Lou Gehrig and was the first player to learn of Gehrig's ALS diagnosis.

Ten times an All-Star up until 1943, Dickey missed the 1944 and 1945 seasons because of military service, returning for an All-Star swan song in 1946. After his career ended, he mentored the next great Yankees backstops, Yogi Berra and Elston Howard. Only Berra would eclipse his seven World Series rings. "He was a great catcher, great hitter, and a great man to have on the ball club," said Yankees manager Joe McCarthy.

—B.M.

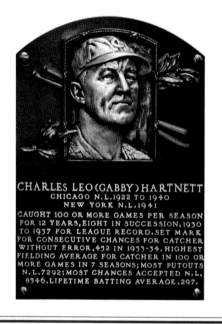

CHARLES LEO (GABBY) HARTNETT
CHICAGO N.L.1922 TO 1940
NEW YORK N.L.1941
CAUGHT 100 OR MORE GAMES PER SEASON
FOR 12 YEARS, EIGHT IN SUCCESSION, 1930
TO 1937 FOR LEAGUE RECORD. SET MARK
FOR CONSECUTIVE CHANCES FOR CATCHER
WITHOUT ERROR, 452 IN 1933-34. HIGHEST
FIELDING AVERAGE FOR CATCHER IN 100 OR
MORE GAMES IN 7 SEASONS; MOST PUTOUTS
N.L.7292; MOST CHANCES ACCEPTED N.L.
8546. LIFETIME BATTING AVERAGE .297.

GABBY HARTNETT

CLASS OF 1955

Born in Woonsocket, Rhode Island, Gabby Hartnett played only one season in the minor leagues before making his debut with the Chicago Cubs in 1922. It was as a rookie, when he was still known as Charles, that he gained his famous nickname. During a long train ride to spring training in California, a writer tried to interview Hartnett. Frustrated over his inability to extract a usable quote from the quiet catcher, the writer sarcastically referred to Hartnett as "the gabbiest guy that ever went to spring training." From then on, the name stuck.

Hartnett got his big break when Bob O'Farrell was injured in 1924. He took full advantage of his opportunity, hitting .299 with sixteen home runs in 111 games and finished fifteenth in the MVP voting. By age twenty-three, Hartnett had established himself as one of the game's best receivers.

Unlike most who don the tools of ignorance, Hartnett, who battled some injuries early on, got more durable as the years progressed. He was also one of the most skilled defenders the game has ever seen. According to Hall of Fame manager Joe McCarthy, "Gabby was the greatest throwing catcher that ever gunned a ball to second base. He threw a ball that had the speed of lightning, but was as light as a feather." In addition to smarts, Hartnett possessed the physical skills that made him an outstanding defensive

catcher. Hall of Famer Al Lopez, a fine fielder in his own right, concurred. Lopez believed that Hartnett had the strongest arm and quickest release of any catcher he ever saw. "He would challenge the runners. . . . He'd yell, 'Go ahead, run!' And when they did, he'd throw them out."

Not only was Hartnett physically gifted, but he also had the brains to back up what his body could do. "I learn something about baseball from every game," Hartnett said. "It's a lifetime study to me. It's the most fascinating thing in the world. I like to watch batters in practice, size them up, see if I can pick up their weaknesses and preferences. I like to size up young pitchers, see what there is to admire or criticize in their pitching stance and form and their delivery."

Hartnett also possessed exceptional skill with the bat. He was one of the best hitters of his era, period, not just one of the best-hitting backstops. In 1935 Hartnett slugged .545 and won the National League Most Valuable Player Award. Three years later, in 1938, when Hartnett was a player-manager nearing the end of his career, his bat provided the signature moment of that career. Hartnett's famed "Homer in the Gloamin'" gave the Cubs their ninth straight win, a key victory over the Pirates with twilight descending, which would ultimately help them beat out Pittsburgh and capture the National League Pennant.

Hartnett was elected to the Hall of Fame in 1955. He died on his seventy-second birthday in 1972.

—B.M.

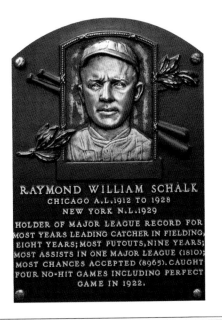

RAY SCHALK

CLASS OF 1955

As Hall of Famer Joe McCarthy remarked, "When you see a little man in a lineup you can know he is extra good, else he would never have been given the chance." It was only through extraordinary effort that Ray Schalk, standing just five foot nine and weighing in at around 165 pounds, was able to make it into the major leagues and eventually the Hall of Fame.

A catcher's value is measured in both his offensive and defensive skills, and the defensive measures are often seen only by those who truly understand the game. Schalk would serve as the workhorse catcher for the Chicago White Sox from 1913 to 1925.

"If I was a good catcher, it was because I learned from the masters," he said. "I caught pitchers of long experience and they hammered the game into me. I had to learn or lose my job. They made me a star."

"The job of catching, in my estimation, is the toughest assignment on the field of play," said Schalk. "It has always been my claim that baseball is played for the benefit of the catcher. By that I mean that he is the one player who has the game squarely in front of him. He faces both the infield and the outfield and also has the base runners in full view. Thus, he is the one player in position to see everything that is going on."

Despite training for it, Ray Schalk found it too tough to break into his field as a linotype operator, so he became a major league baseball player instead. Schalk was clearly the finest defensive practitioner of the skills needed behind the plate during his era, and he introduced innovations such as backing up throws to first base and third base.

"It was always my firm conviction that the catcher and pitcher should have no more than two or three sets of signals and the simpler those signals, the better," Schalk said. "The battery should function as flawlessly as possible, and nothing can prove more costly [than] for the pitcher and catcher to get crossed up in their signs. The catcher can use a glove sign or a knee sign, along with his finger wig-wags.

"Use of the glove or knee in flashing the sign to the pitcher eliminates the maneuver of going into a squatting position and then standing erect, thus saving plenty of energy over a period of years behind the bat."

Schalk espoused some recommendations that are still regarded as common wisdom.

"It is especially important for the battery to work hard to keep the first batter in every inning, particularly when the score is close, from reaching first base," he said. "Work your hardest to get that first batter, even if he is the pitcher, or a supposedly weak hitter. Fully 50 percent of the inning has been completed if you get rid of the first batter."

The catcher was always respected by his opponents. Ty Cobb summed it up best when he said, "When you're up there hitting, you knew that Schalk was always doing something to try to beat you."

—L.F.

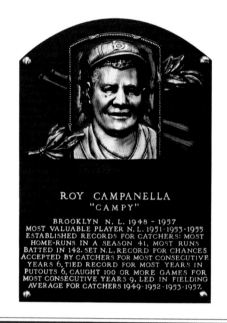

ROY CAMPANELLA
"CAMPY"
BROOKLYN N. L. 1948 - 1957
MOST VALUABLE PLAYER N.L. 1951·1953·1955
ESTABLISHED RECORDS FOR CATCHERS: MOST
HOME-RUNS IN A SEASON 41, MOST RUNS
BATTED IN 142. SET N.L. RECORD FOR CHANCES
ACCEPTED BY CATCHERS FOR MOST CONSECUTIVE
YEARS 6, TIED RECORD FOR MOST YEARS IN
PUTOUTS 6, CAUGHT 100 OR MORE GAMES FOR
MOST CONSECUTIVE YEARS 9, LED IN FIELDING
AVERAGE FOR CATCHERS 1949·1952·1953·1957.

ROY CAMPANELLA

CLASS OF 1969

Racism at the beginning and tragedy at the end bookended his playing days. In spite of those obstacles, Roy Campanella forged a brilliant career that bridged from the Negro Leagues to the Brooklyn Dodgers.

Born in Philadelphia to an African American mother and an Italian American father, Campanella would see his major league career delayed by the unwritten rule that enforced the color line. Still, he wanted to play. At the age of fifteen, he began his professional career with the Negro Leagues' Washington franchise, which later became the Baltimore Elite Giants.

Even though he played against stars many years older than he was, Campanella quickly established himself as one of the smartest players in the Negro Leagues. With his flawless fielding skills and raw power, he became one of black baseball's greatest stars.

Impressing the brass of the Dodgers, Campanella finally received his chance to play in the major leagues in 1948, one year after Jackie Robinson's debut. Campanella avoided the sophomore jinx in 1949, becoming part of the first contingent of African Americans to play in an All-Star Game.

Campanella hit his prime in the 1950s. Emerging as the National League's premier catcher, he won a trio of MVP Awards. His MVP selection in 1955 coincided with the Dodgers' only championship in Brooklyn.

Tragedy struck three years later. On January 28, 1958, Campanella was involved in a horrifying early morning car acci-

dent. He suffered a broken neck and a damaged spinal cord, causing permanent paralysis from his chest down to his legs. The accident ended the career of the eight-time All-Star.

The injuries resulting from the accident may also have prevented Campanella from embarking on a second career. "If it hadn't been for the accident," Duke Snider told the *Philadelphia Inquirer*, "I think Roy would have played another year or two and then been the first black manager. He knew the game and how to get along with people."

The Dodgers, by now transplanted to Los Angeles, did not forget Campanella. In May 1959 they hosted "Roy Campanella Night" at the Los Angeles Coliseum, with proceeds from the game going to cover Campanella's health care costs. The exhibition game drew the largest crowd in big league history: a throng of 93,103 came out to honor the beloved star.

Though limited by health constraints, Campanella regularly took part in Hall of Fame Weekend activities up until his death in 1993. "I remember coming to Brooklyn," Don Drysdale informed the *Chicago Tribune* upon learning of Campanella's passing. "He'd take care of you, made you feel at home, and you knew you were in good hands when Campanella was catching."

Campanella contributed to the Dodgers, but with a far different style from that of the pioneering Robinson. "People always said the difference between Jackie and Roy was that Jackie was more flamboyant and a little more boisterous," said Drysdale, "while Campy was more the fatherly type. That's what made him different.

"He was always just glad to be alive."

—B.M.

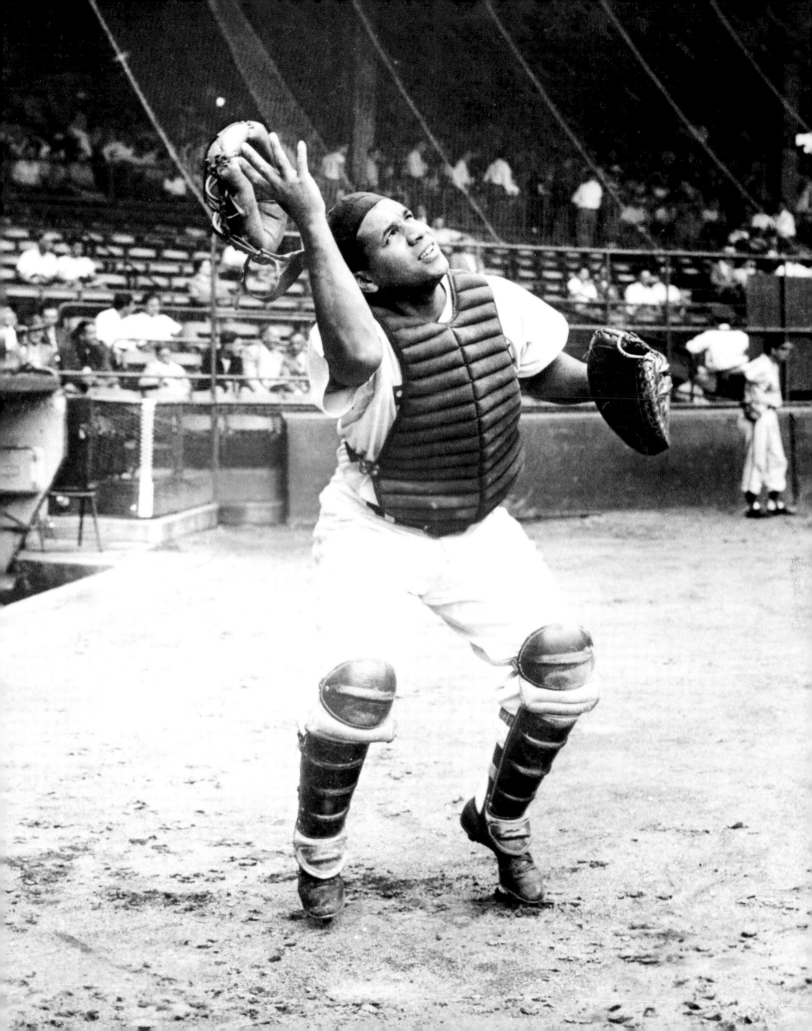

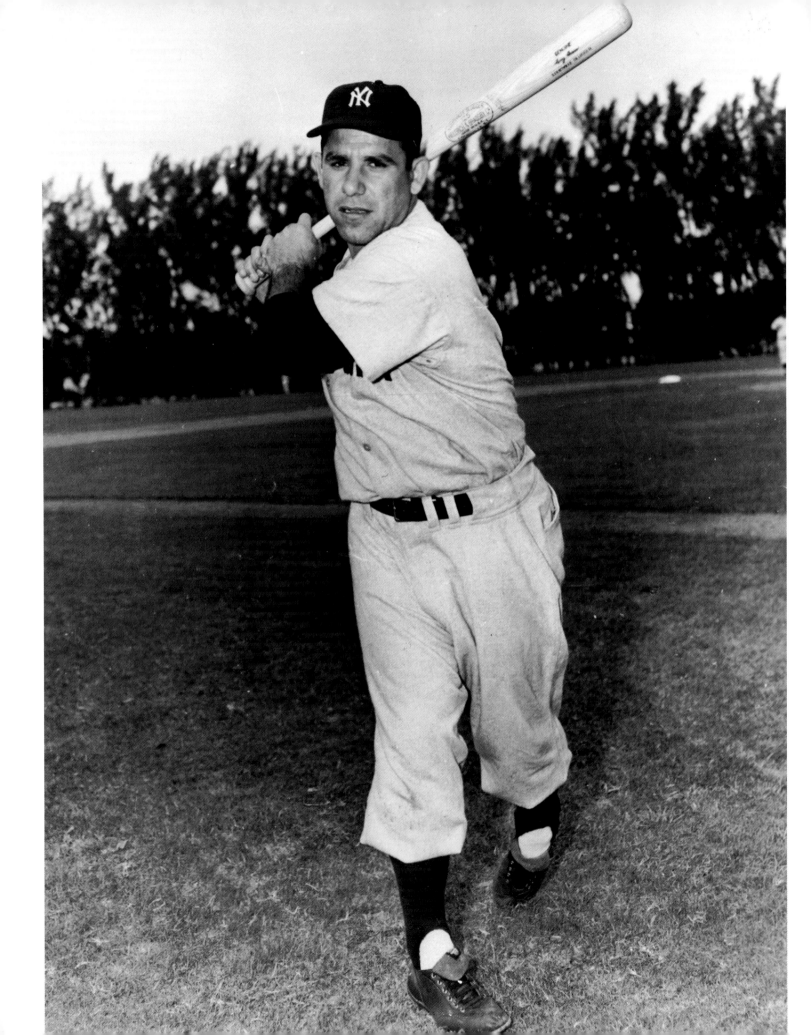

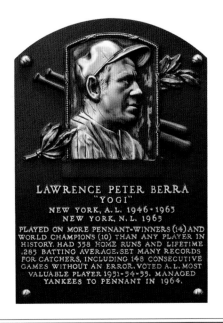

LAWRENCE PETER BERRA
"YOGI"
NEW YORK, A.L. 1946-1963
NEW YORK, N.L. 1965
PLAYED ON MORE PENNANT-WINNERS (14) AND
WORLD CHAMPIONS (10) THAN ANY PLAYER IN
HISTORY. HAD 358 HOME RUNS AND LIFETIME
.285 BATTING AVERAGE. SET MANY RECORDS
FOR CATCHERS, INCLUDING 148 CONSECUTIVE
GAMES WITHOUT AN ERROR. VOTED A.L. MOST
VALUABLE PLAYER 1951-54-55. MANAGED
YANKEES TO PENNANT IN 1964.

YOGI BERRA

CLASS OF 1972

One is tempted to fill a tribute to Yogi Berra with things the all-time great supposedly said. Such Yogi gems as "Baseball is 90 percent mental. The other half is physical." Or "It's like déjà vu all over again." But to do so overlooks how extraordinary a ballplayer Berra was.

He played for eighteen years with the New York Yankees and appeared in an astounding fourteen World Series, hitting .274 with 12 home runs and 39 RBI. New York manager Casey Stengel considered Berra the indispensable member of his often star-studded lineup. "I never play a game without my man," Stengel said.

A brilliant catcher and dominant hitter, Berra was named to the American League All-Star team every year from 1948 to 1962. He topped the one-hundred-RBI mark four years in a row and became a three-time American League MVP in a career that featured fourteen league pennants and ten World Series championships.

Born in St. Louis, he signed with New York in part because the hometown Cardinals considered his boyhood friend Joe Garagiola to be a better prospect. He broke in with the Yankees after serving in World War II and soon made his mark despite being surrounded by such well-known teammates as Joe DiMaggio and then Mickey Mantle. Berra received MVP votes in fifteen consecutive seasons and was behind the plate for Don Larsen's perfect game in the 1956 World Series.

A notorious bad-ball hitter, Berra had more home runs than strikeouts in a season five times and in 1950 struck out just twelve times in 597 at bats.

"Yogi had the fastest bat I ever saw," Héctor López said. "He could hit a ball late—that was already past him, and take it out of the park. The pitchers were afraid of him because he'd hit anything, so they didn't know what to throw."

As a fielder, even though there wasn't much emphasis on the running game during his era, Berra excelled defensively as well as at handling pitchers. He led American League catchers in games caught and chances accepted eight times. In addition, he led the league in double plays a record six times.

"He seemed to be doing everything wrong," Mel Ott said, "yet everything came out right. He stopped everything behind the plate and hit everything in front of it."

Following his playing career, Yogi continued in baseball as a manager and coach for several teams. He did it all with a smile on his face and the habit of saying something puzzling and funny at just the right time.

Perhaps his old mentor Stengel summed it up best.

"They say he's funny," the Yankees manager said. "Well, he has a lovely wife and family, a beautiful home, money in the bank, and he plays golf with millionaires. What's funny about that?"

—T. Wendel

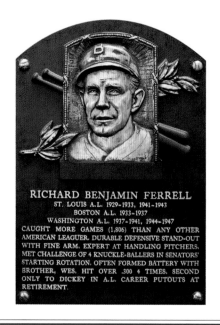

RICHARD BENJAMIN FERRELL
ST. LOUIS A.L. 1929-1933, 1941-1943
BOSTON A.L. 1933-1937
WASHINGTON A.L. 1937-1941, 1944-1947
CAUGHT MORE GAMES (1,806) THAN ANY OTHER
AMERICAN LEAGUER. DURABLE DEFENSIVE STAND-OUT
WITH FINE ARM. EXPERT AT HANDLING PITCHERS.
MET CHALLENGE OF 4 KNUCKLE-BALLERS IN SENATORS'
STARTING ROTATION. OFTEN FORMED BATTERY WITH
BROTHER, WES. HIT OVER .300 4 TIMES. SECOND
ONLY TO DICKEY IN A.L. CAREER PUTOUTS AT
RETIREMENT.

RICK FERRELL

CLASS OF 1984

The defensive subtleties of the catching position sometimes go overlooked by casual fans of the game. Rick Ferrell was a master of those subtleties, making himself a Hall of Famer in the process.

As an amateur, Ferrell showed promise in the boxing ring, but he ultimately made baseball his preferred sport. He grew up with his brother Wes, a talented pitcher who would join Rick in the professional ranks. "We were brothers off the field, but there was no love lost on it," Rick Ferrell said to a reporter about the rivalry between himself and Wes. "We fought like cats and dogs. Wes was always trying to strike me out, and meantime, I was always trying to hit a home run off him."

Rick broke in with the St. Louis Browns, who later traded him to the Boston Red Sox. A year after he joined Boston, the Red Sox acquired Wes, by now an accomplished right-hander. For more than three seasons in Boston, Rick caught his brother. The Red Sox eventually traded the pair to the Washington Senators, where they played together for an additional season.

While with Washington, Ferrell gained the respect of his peers by doing yeoman's work behind the plate; he caught a rotation that featured four knuckleball pitchers. The quartet, which included Dutch Leonard, Mickey Haefner, Johnny Niggeling, and Roger Wolff, came within a game and a half of winning the American League Pennant in 1945. The challenge of catching multiple knuckleballers pushed Ferrell to the limit. "I can't think of a tougher job than catching those four," Ferrell told the *New York Times.* "They were all starters, they all pitched 250 innings."

The knuckleball followed Ferrell throughout his career. "I always marveled—he had knuckleball pitchers over in St. Louis and then over in Washington too," Hall of Fame third baseman George Kell told author Kerrie Ferrell, Rick's daughter, "and he had to catch those guys and he did it so well! It was remarkable to be able to catch those knuckleballers and not get broken fingers. He never did have a problem with too many balls getting by him."

Cool and reserved, Ferrell succeeded not just at containing the knuckler but at all facets of catching. A seven-time All-Star who participated in the first All-Star Game in 1933, he excelled at handling pitchers and had a strong, accurate arm. His durability was another strength. He caught more than a hundred games a season over a span of nine consecutive years.

By the time Ferrell retired, he had set the American League record for the most games played by a catcher. That remained a record until it was surpassed by another Hall of Famer, Carlton Fisk.

After his playing days, Ferrell remained in baseball, serving the Tigers as an executive for forty-two years. He made a lasting impression. "When I was telecasting for the Tigers," George Kell wrote to Kerrie Ferrell in a 2008 note, "everybody wanted to be like Rick Ferrell—so calm, so soft-spoken, a real gentleman."

—B.M.

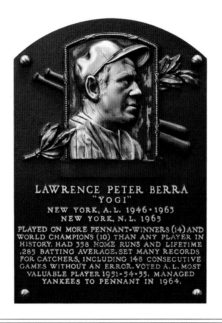

LAWRENCE PETER BERRA
"YOGI"
NEW YORK, A. L. 1946·1963
NEW YORK, N. L. 1965
PLAYED ON MORE PENNANT-WINNERS (14) AND
WORLD CHAMPIONS (10) THAN ANY PLAYER IN
HISTORY. HAD 358 HOME RUNS AND LIFETIME
.285 BATTING AVERAGE. SET MANY RECORDS
FOR CATCHERS, INCLUDING 148 CONSECUTIVE
GAMES WITHOUT AN ERROR. VOTED A.L. MOST
VALUABLE PLAYER 1951·54·55. MANAGED
YANKEES TO PENNANT IN 1964.

YOGI BERRA

CLASS OF 1972

One is tempted to fill a tribute to Yogi Berra with things the all-time great supposedly said. Such Yogi gems as "Baseball is 90 percent mental. The other half is physical." Or "It's like déjà vu all over again." But to do so overlooks how extraordinary a ballplayer Berra was.

He played for eighteen years with the New York Yankees and appeared in an astounding fourteen World Series, hitting .274 with 12 home runs and 39 RBI. New York manager Casey Stengel considered Berra the indispensable member of his often star-studded lineup. "I never play a game without my man," Stengel said.

A brilliant catcher and dominant hitter, Berra was named to the American League All-Star team every year from 1948 to 1962. He topped the one-hundred-RBI mark four years in a row and became a three-time American League MVP in a career that featured fourteen league pennants and ten World Series championships.

Born in St. Louis, he signed with New York in part because the hometown Cardinals considered his boyhood friend Joe Garagiola to be a better prospect. He broke in with the Yankees after serving in World War II and soon made his mark despite being surrounded by such well-known teammates as Joe DiMaggio and then Mickey Mantle. Berra received MVP votes in fifteen consecutive seasons and was behind the plate for Don Larsen's perfect game in the 1956 World Series.

A notorious bad-ball hitter, Berra had more home runs than strikeouts in a season five times and in 1950 struck out just twelve times in 597 at bats.

"Yogi had the fastest bat I ever saw," Héctor López said. "He could hit a ball late—that was already past him, and take it out of the park. The pitchers were afraid of him because he'd hit anything, so they didn't know what to throw."

As a fielder, even though there wasn't much emphasis on the running game during his era, Berra excelled defensively as well as at handling pitchers. He led American League catchers in games caught and chances accepted eight times. In addition, he led the league in double plays a record six times.

"He seemed to be doing everything wrong," Mel Ott said, "yet everything came out right. He stopped everything behind the plate and hit everything in front of it."

Following his playing career, Yogi continued in baseball as a manager and coach for several teams. He did it all with a smile on his face and the habit of saying something puzzling and funny at just the right time.

Perhaps his old mentor Stengel summed it up best.

"They say he's funny," the Yankees manager said. "Well, he has a lovely wife and family, a beautiful home, money in the bank, and he plays golf with millionaires. What's funny about that?"

—T. Wendel

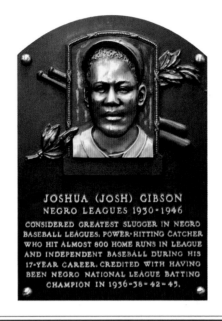

JOSHUA (JOSH) GIBSON
NEGRO LEAGUES 1930-1946
CONSIDERED GREATEST SLUGGER IN NEGRO
BASEBALL LEAGUES. POWER-HITTING CATCHER
WHO HIT ALMOST 800 HOME RUNS IN LEAGUE
AND INDEPENDENT BASEBALL DURING HIS
17-YEAR CAREER. CREDITED WITH HAVING
BEEN NEGRO NATIONAL LEAGUE BATTING
CHAMPION IN 1936-38-42-45.

JOSH GIBSON

CLASS OF 1972

Homestead Grays manager Judy Johnson had to take catcher Buck Ewing out of a game one night in Pittsburgh because of a split-finger injury. Johnson scanned the stands and found eighteen-year-old Josh Gibson, a catcher he'd seen playing on local sand-lots. "I asked him if he wanted to catch and he said 'yes, sir,' so we had to hold up the game while he went and put on Buck Ewing's uniform," Johnson said. "We signed him the next day."

Gibson went on to enjoy one of the greatest careers any baseball player ever had.

"Josh Gibson was, at the minimum, two Yogi Berras," said Bill Veeck, and he wasn't talking about baseball cards. Gibson was, like Berra, the kind of player who defines his position.

He played sixteen seasons for the Homestead Grays and the Pittsburgh Crawfords at the pinnacle of Negro League perfor-mance, both as an individual and as a player on great teams. He also played two seasons for Veracruz in the Mexican League.

He hit for average and power, and possessed a rifle arm. He worked hard at the finer points of catching and was naturally quick, both behind the plate and on the bases. "He had an eye like Ted Williams and the power of Babe Ruth. He hit to all fields," said Monte Irvin.

Gibson batted .350 lifetime in the Negro Leagues, with eleven seasons above 300. He hit .451 in 1936, and .486 in 1943. He posted a .373 average in two Mexican League seasons, a .353 average in his two winter league years in Cuba, a .412 average in exhibition games against major leaguers, and a .479 mark in the Puerto Rican winter league, where he played one season and earned the league's Most Valuable Player Award.

Gibson's power was legendary, though unfortunately statistics in the Negro Leagues were not kept with the same precision as in the major leagues. He hit not just for power but for distance, and there are unconfirmed reports of his hitting a home run out of Yankee Stadium; if true, he would be the only hitter ever to do so. He won twelve home run titles in the Negro Leagues and also led the league in nearly everything else—batting average, dou-bles, triples, slugging percentage, and runs batted in.

His .624 career slugging percentage, if achieved in the majors, would place him fourth all-time behind Babe Ruth, Ted Williams, and Lou Gehrig, and ahead of such luminaries as Jimmie Foxx, Albert Pujols, and Barry Bonds.

Gibson died of a stroke at the age of thirty-five, just three months before Jackie Robinson broke the color barrier in 1947 with the Brooklyn Dodgers.

—T. Wiles

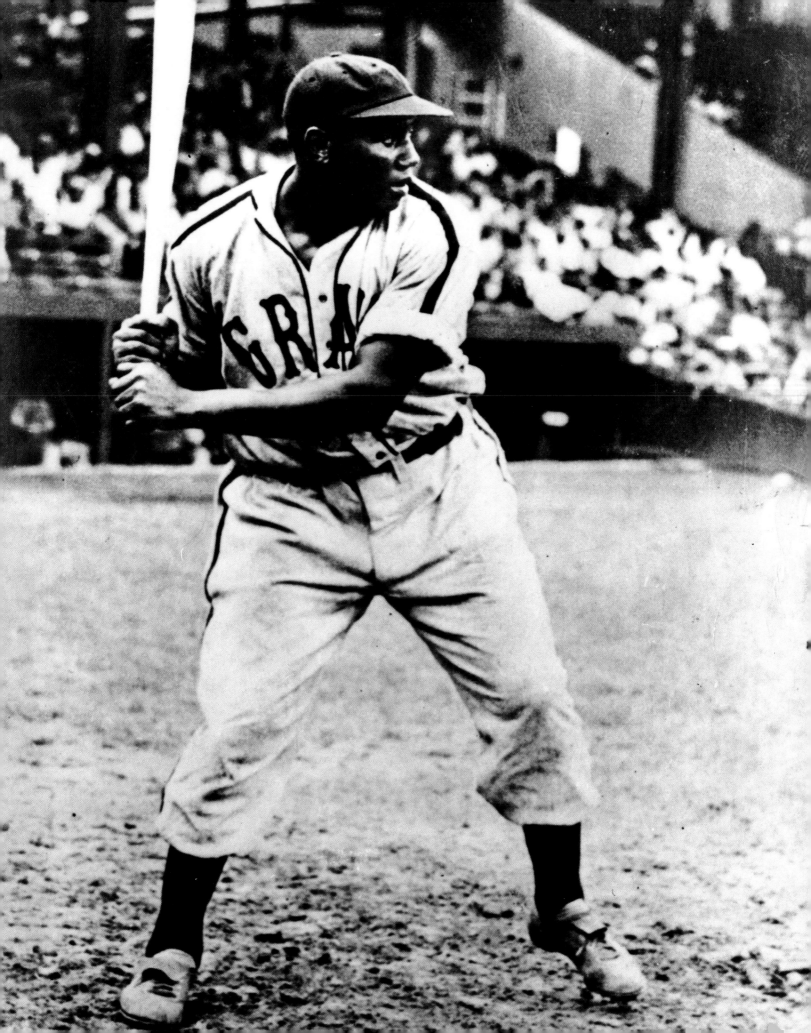

RICHARD BENJAMIN FERRELL
ST. LOUIS A.L. 1929-1933, 1941-1943
BOSTON A.L. 1933-1937
WASHINGTON A.L. 1937-1941, 1944-1947
CAUGHT MORE GAMES (1,806) THAN ANY OTHER
AMERICAN LEAGUER. DURABLE DEFENSIVE STAND-OUT
WITH FINE ARM, EXPERT AT HANDLING PITCHERS,
MET CHALLENGE OF 4 KNUCKLE-BALLERS IN SENATORS'
STARTING ROTATION. OFTEN FORMED BATTERY WITH
BROTHER, WES, HIT OVER .300 4 TIMES, SECOND
ONLY TO DICKEY IN A.L. CAREER PUTOUTS AT
RETIREMENT.

RICK FERRELL

CLASS OF 1984

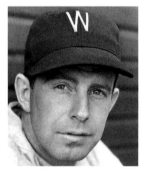

The defensive subtleties of the catching position sometimes go overlooked by casual fans of the game. Rick Ferrell was a master of those subtleties, making himself a Hall of Famer in the process.

As an amateur, Ferrell showed promise in the boxing ring, but he ultimately made baseball his preferred sport. He grew up with his brother Wes, a talented pitcher who would join Rick in the professional ranks. "We were brothers off the field, but there was no love lost on it," Rick Ferrell said to a reporter about the rivalry between himself and Wes. "We fought like cats and dogs. Wes was always trying to strike me out, and meantime, I was always trying to hit a home run off him."

Rick broke in with the St. Louis Browns, who later traded him to the Boston Red Sox. A year after he joined Boston, the Red Sox acquired Wes, by now an accomplished right-hander. For more than three seasons in Boston, Rick caught his brother. The Red Sox eventually traded the pair to the Washington Senators, where they played together for an additional season.

While with Washington, Ferrell gained the respect of his peers by doing yeoman's work behind the plate; he caught a rotation that featured four knuckleball pitchers. The quartet, which included Dutch Leonard, Mickey Haefner, Johnny Niggeling, and Roger Wolff, came within a game and a half of winning the American League Pennant in 1945. The challenge of catching multiple knuckleballers pushed Ferrell to the limit. "I can't think of a tougher job than catching those four," Ferrell told the *New York Times*. "They were all starters, they all pitched 250 innings."

The knuckleball followed Ferrell throughout his career. "I always marveled—he had knuckleball pitchers over in St. Louis and then over in Washington too," Hall of Fame third baseman George Kell told author Kerrie Ferrell, Rick's daughter, "and he had to catch those guys and he did it so well! It was remarkable to be able to catch those knuckleballers and not get broken fingers. He never did have a problem with too many balls getting by him."

Cool and reserved, Ferrell succeeded not just at containing the knuckler but at all facets of catching. A seven-time All-Star who participated in the first All-Star Game in 1933, he excelled at handling pitchers and had a strong, accurate arm. His durability was another strength. He caught more than a hundred games a season over a span of nine consecutive years.

By the time Ferrell retired, he had set the American League record for the most games played by a catcher. That remained a record until it was surpassed by another Hall of Famer, Carlton Fisk.

After his playing days, Ferrell remained in baseball, serving the Tigers as an executive for forty-two years. He made a lasting impression. "When I was telecasting for the Tigers," George Kell wrote to Kerrie Ferrell in a 2008 note, "everybody wanted to be like Rick Ferrell—so calm, so soft-spoken, a real gentleman."

—B.M.

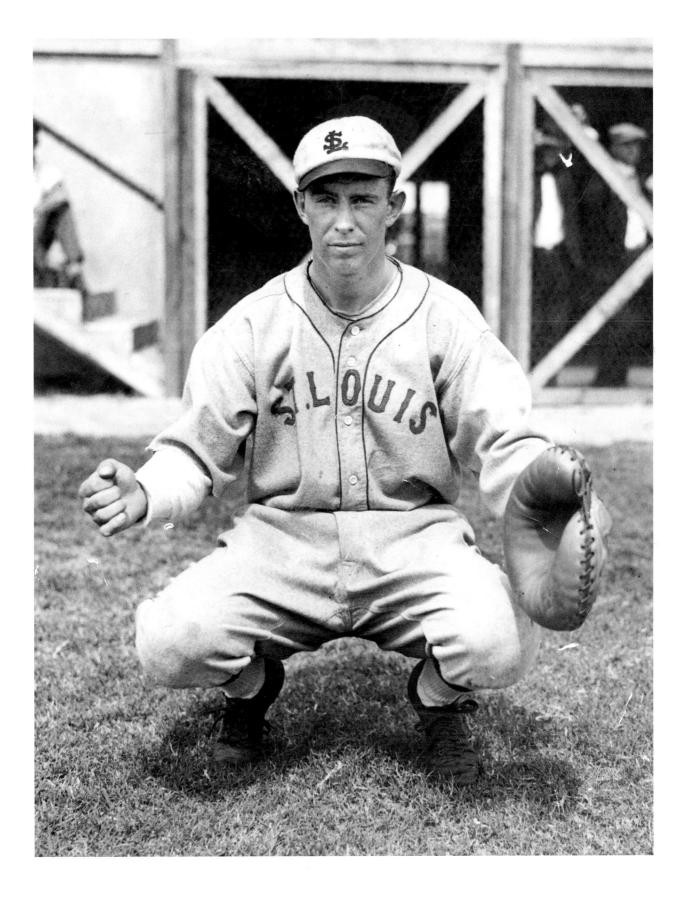

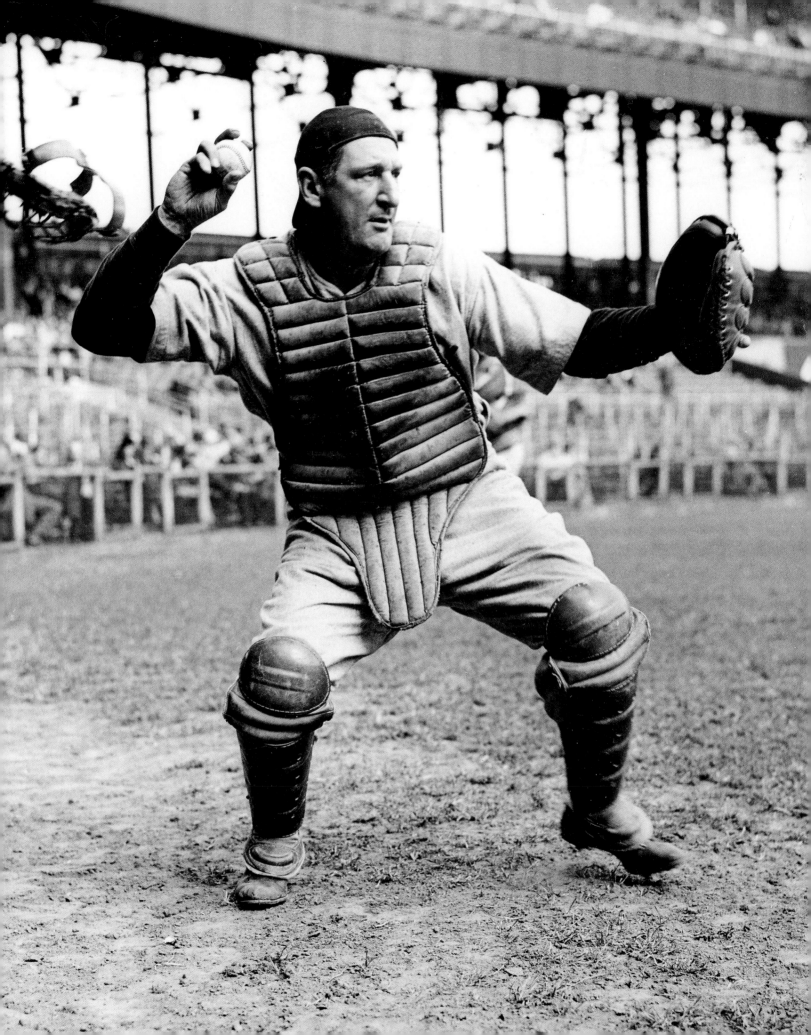

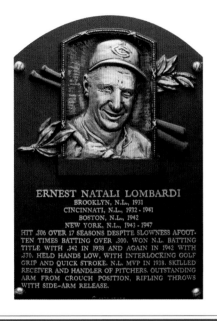

ERNEST NATALI LOMBARDI
BROOKLYN, N.L., 1931
CINCINNATI, N.L., 1932 - 1941
BOSTON, N.L., 1942
NEW YORK, N.L., 1943 - 1947
HIT .306 OVER 17 SEASONS DESPITE SLOWNESS AFOOT.
TEN TIMES BATTING OVER .300. WON N.L. BATTING
TITLE WITH .342 IN 1938 AND AGAIN IN 1942 WITH
.330. HELD HANDS LOW, WITH INTERLOCKING GOLF
GRIP AND QUICK STROKE. N.L. MVP IN 1938. SKILLED
RECEIVER AND HANDLER OF PITCHERS. OUTSTANDING
ARM FROM CROUCH POSITION, RIFLING THROWS
WITH SIDE-ARM RELEASE.

ERNIE LOMBARDI

CLASS OF 1986

He had a nose so long that they called him "Schnozz" and he ran with what some referred to as all the speed of a snail, but Ernie Lombardi defied the stereotype of what makes a great athlete. A phenomenal hitter and a strong-armed defender, Lombardi forged a career as one of the finest catchers in history.

Raised in Oakland, the son of an Italian immigrant grocer, Lombardi excelled at the sport of bocce, but he found his future in the National Pastime, starring as a twelve-year-old for Ravioli's Meat Market. Eventually becoming a long-term standout with the hometown Oakland Oaks, Lombardi was traded by Oakland to the Brooklyn Robins in 1931. That promotion, long overdue, came with a caveat. The Robins already had a fine first-string catcher in young Al Lopez, which meant that Lombardi had to settle for a glorified backup role.

The Robins considered making Lombardi a pitcher, but eased up the catching logjam in a more traditional way by making a trade, sending Schnozz to the Cincinnati Reds as part of a six-player deal. Lombardi would take full advantage of the change in venue, not only becoming Cincinnati's number one catcher but also carving out a ten-year stint as a star with the Reds.

One of the game's biggest catchers, Lombardi couldn't run well, but he plastered line drives across the outfield. Because of his lack of speed, Lombardi rarely enjoyed infield hits. As Arthur Daley once wrote in the *New York Times*, "When you look back

on him and his 17 years in the majors, you almost come to the conclusion that he was the greatest hitter of all time. Every hit he made . . . was an honest one."

From 1936 to 1940 Lombardi made every National League All-Star team. He put up one of his best seasons in 1938, hitting a career-high .342 to win the batting title and slugging an impressive .524. That summer Lombardi also caught both of Johnny Vander Meer's back-to-back no-hitters.

On the heels of his NL MVP Award in 1938, Lombardi helped the Reds to World Series appearances in 1939 and 1940. Injuries limited his opportunities in the latter Series, but he made the most of his chances, picking up a double and a walk in four plate appearances as the Reds claimed the world championship.

After a down season in 1941, the Reds sold him, much to the chagrin of the Cincinnati fans, who loved Lombardi. Joining the Boston Braves, he revived his career. At the age of thirty-four, he won his second batting title while also qualifying for another All-Star Game. One year later he joined the New York Giants, where he finished his career strongly. Even at thirty-nine, an age when most catchers are in full retirement, Lombardi slugged a tidy .436.

With Lombardi, it always came down to the ferocity of his hitting. "When Lom would grasp a bat with that interlocking grip of his, his bat looked like a matchstick," wrote Daley. "And the ball would ricochet off it like a shell leaving a howitzer." In the case of Lombardi, the lack of speed didn't matter much at all.

—B.M.

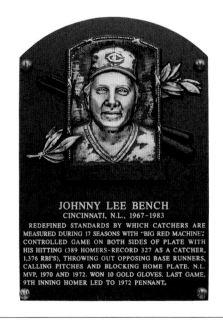

JOHNNY LEE BENCH
CINCINNATI, N.L., 1967-1983
REDEFINED STANDARDS BY WHICH CATCHERS ARE
MEASURED DURING 17 SEASONS WITH "BIG RED MACHINE".
CONTROLLED GAME ON BOTH SIDES OF PLATE WITH
HIS HITTING (389 HOMERS-RECORD 327 AS A CATCHER,
1,376 RBI'S), THROWING OUT OPPOSING BASE RUNNERS,
CALLING PITCHES AND BLOCKING HOME PLATE. N.L.
MVP, 1970 AND 1972. WON 10 GOLD GLOVES. LAST GAME,
9TH INNING HOMER LED TO 1972 PENNANT.

JOHNNY BENCH

CLASS OF 1989

There is some irony to the name "Johnny Bench." It sounds like a put-down moniker for a young player who's not quite good enough to start. Such a nickname would not have fit the actual Johnny Bench, the game's leading catcher for more than a decade and an iconic figure at his position.

A native of Oklahoma City, Bench was taken by the Cincinnati Reds in the second round of the 1965 draft. In 1968 he won the National League's Rookie of the Year Award after catching 154 games.

From the start, Bench established himself as a supreme defensive catcher, capturing the Gold Glove Award as a rookie. Bench earned the nickname "Hands" because his own approached the size of a lion's paws. He could hold eight baseballs in one hand, an attribute that helped him dig balls out of the dirt and keep wild pitches to a minimum. Bench adopted a one-handed catching style; when no runners were on base, he held out only his mitt hand, keeping his bare hand behind his back to protect his fingers from foul tips.

Bench's throwing arm complemented his soft hands. Unquestionably the best-throwing catcher of his era, he pumped cannon shots to second base. Bench's throwing served him well in an era in which the stolen base shared prominence with the home run.

With his 197-pound build Bench looked like a piece of rounded granite, though he was amazingly agile. "Johnny just does things other catchers can't do," his manager Sparky Anderson told *Sports Illustrated*. "He has a way of fielding a bunt in front of the plate so that as he picks it up he is bounding back to throw. And he makes the play at the plate better than anyone. He just takes the plate away from the runner."

By 1970 Bench's offense matched his defense. He led the league with forty-five home runs and 148 RBI, convincingly winning the MVP. Two years later he added another MVP to his collection, as he again paced the league in homers and RBI, and lifted the Reds to their second World Series appearance in three years.

A perennial All-Star, Bench became a fixture behind the plate. From 1968 to 1977 he caught a minimum of 121 games each summer, a stunning level of endurance for a catcher. With Bench often batting fourth or fifth, the Reds captured back-to-back championships in 1975 and 1976.

In four World Series appearances, Bench hit five home runs and slugged .523. He was phenomenal in the 1976 Series, when he hit .533. As much as any other player, he powered the "Big Red Machine," putting up his last big season in 1977, when he hit thirty-one home runs.

By the time Bench retired in 1983, he had long since set the standard for catchers. "We're not going to see another one like him in our lifetime," Anderson told the *Cincinnati Enquirer*. "We're not talking about someone who's [just] good; we're talking about someone in a different category."

—B.M.

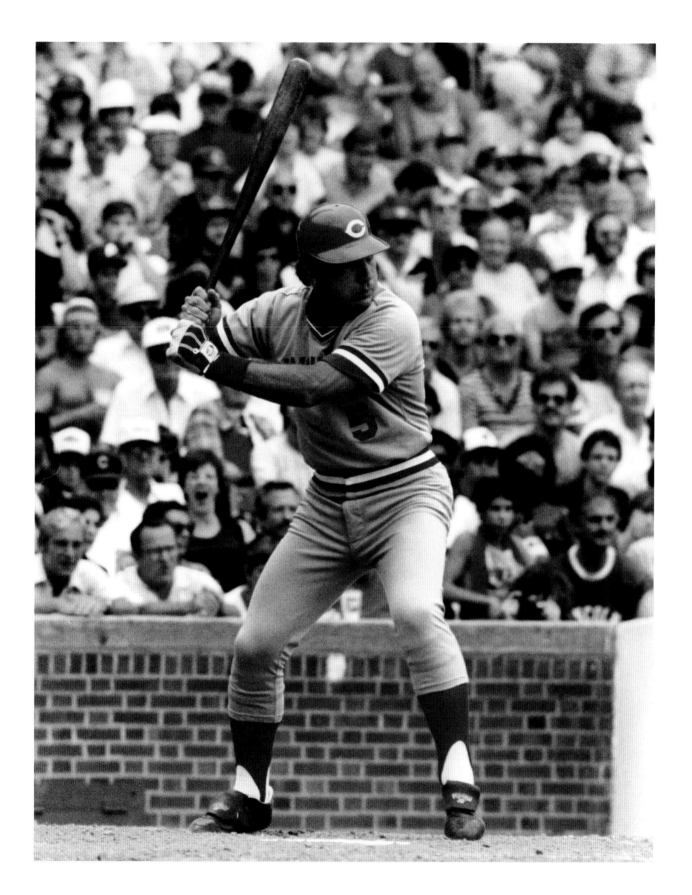

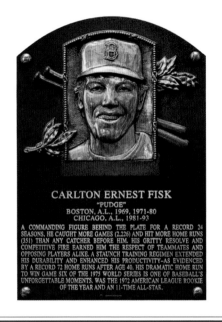

CARLTON ERNEST FISK
"PUDGE"
BOSTON, A.L., 1969, 1971-80
CHICAGO, A.L., 1981-93
A COMMANDING FIGURE BEHIND THE PLATE FOR A RECORD 24
SEASONS, HE CAUGHT MORE GAMES (2,226) AND HIT MORE HOME RUNS
(351) THAN ANY CATCHER BEFORE HIM. HIS GRITTY RESOLVE AND
COMPETITIVE FIRE EARNED HIM THE RESPECT OF TEAMMATES AND
OPPOSING PLAYERS ALIKE. A STAUNCH TRAINING REGIMEN EXTENDED
HIS DURABILITY AND ENHANCED HIS PRODUCTIVITY-AS EVIDENCED
BY A RECORD 72 HOME RUNS AFTER AGE 40. HIS DRAMATIC HOME RUN
TO WIN GAME SIX OF THE 1975 WORLD SERIES IS ONE OF BASEBALL'S
UNFORGETTABLE MOMENTS. WAS THE 1972 AMERICAN LEAGUE ROOKIE
OF THE YEAR AND AN 11-TIME ALL-STAR.

CARLTON FISK

CLASS OF 2000

Carlton Fisk will always be remembered for a single dramatic home run, a game-winning twelfth-inning drive to left field in Game 6 of the 1975 World Series to help his Boston Red Sox defeat the Cincinnati Reds.

"I knew it had the distance and the height," Fisk said. "I just wasn't sure it was going to stay fair."

With the ball hugging the foul line, Fisk waved several times, seemingly willing the ball to stay in play. The image of him waving and then bounding into his home run trot became one of the most iconic and memorable in sports.

"Fisk's home run not only forced a seventh game in one of the greatest World Series ever," Glenn Stout and Richard A. Johnson wrote in *Red Sox Century*, "but came to symbolize the rebirth of the National Pastime itself."

Fisk's career was much more than a lone home run, even if *TV Guide* called that dinger the top televised sports moment of the last century. Though the recently retired Iván Rodriguez currently holds the record for games caught in a career, with 2,427, when Fisk retired in 1993 after twenty-four years behind the plate, he held the mark (2,226). The eleven-time All-Star hit 376 career home runs, including a record-setting 351 as a catcher, since bested by Mike Piazza.

Born in Bellows Falls, Vermont, on December 26, 1947, Fisk attended the University of New Hampshire on a basketball schol-

arship, but switched games when he was taken in the first round of the 1967 amateur draft by the Red Sox.

Fisk broke in with Boston in 1969, was sent down once, in 1970, and then stayed through the 1980 season. He won a Gold Glove Award in 1972, when he was also American League Rookie of the Year, and was a seven-time All-Star with Boston.

After a technicality allowed Fisk to become a free agent, he left for Chicago, a move that baseball commissioner Bart Giamatti later called "the worst moment for Red Sox fans since the team sold Babe Ruth."

In 1983 the White Sox made their first appearance in the postseason in twenty-four years, and Fisk's work with Chicago's inexperienced pitching staff was credited with being a major reason.

"'Pudge' works harder than anyone I know, because he sets goals for himself and then follows through," manager Jim Fregosi said. "I think he's the ultimate professional."

A well-rounded athlete, Fisk also became the first American League catcher to lead the league in triples when he hit nine three-baggers in his rookie season in 1972. In addition, he stole 128 bases in his career.

Fisk finished his career with 2,356 hits, 1,330 RBI, and a .269 batting average—along with three Silver Slugger Awards.

"He played the game the right way," said Red Sox and Hall of Fame teammate Carl Yastrzemski. "Both behind the plate and at the plate."

—T. Wendel

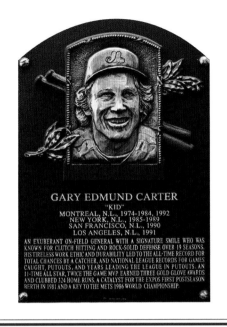

GARY EDMUND CARTER
"KID"
MONTREAL, N.L., 1974-1984, 1992
NEW YORK, N.L., 1985-1989
SAN FRANCISCO, N.L., 1990
LOS ANGELES, N.L., 1991
AN EXUBERANT ON-FIELD GENERAL WITH A SIGNATURE SMILE WHO WAS
KNOWN FOR CLUTCH HITTING AND ROCK-SOLID DEFENSE OVER 19 SEASONS.
HIS TIRELESS WORK ETHIC AND DURABILITY LED TO THE ALL-TIME RECORD FOR
TOTAL CHANCES BY A CATCHER, AND NATIONAL LEAGUE RECORDS FOR GAMES
CAUGHT, PUTOUTS, AND YEARS LEADING THE LEAGUE IN PUTOUTS. AN
11-TIME ALL STAR, TWICE THE GAME MVP, EARNED THREE GOLD GLOVE AWARDS
AND CLUBBED 324 HOME RUNS. A CATALYST FOR THE EXPOS FIRST POSTSEASON
BERTH IN 1981 AND A KEY TO THE METS 1986 WORLD CHAMPIONSHIP.

GARY CARTER

CLASS OF 2003

Gary Carter followed in Johnny Bench's footsteps as the National League's premier catcher. A total of 298 home runs as a catcher, four 100-RBI seasons, and a world championship ring made him a worthy successor.

Growing up in Fullerton, California, Carter excelled as an All-American quarterback. Though he signed a letter of intent to play football at UCLA, he wisely chose baseball after being selected in the 1972 draft.

Quickly working his way up the Montreal Expos' minor league ladder as a catcher, outfielder, and infielder, Carter arrived in Montreal just two years later. As a full-fledged rookie catcher and outfielder in 1975, he was named the *Sporting News* National League Rookie of the Year. In 1977 Carter became Montreal's full-time catcher. Under the tutelage of Expos coach Norm Sherry, he became one of the game's best defensive catchers.

Off the field, Carter won over fans with his friendly nature and boyish enthusiasm. On the field, he displayed a youthful exuberance and an ever-present smile, earning him the nickname "Kid."

As Carter blossomed, so did the fortunes of the Expos. In 1981 he achieved nationwide recognition when he smacked two home runs in the All-Star Game. Carter then led the Expos to their only playoff berth. Hitting safely in all ten postseason games that fall, he posted a .429 batting average.

When the Expos slipped in the standings, they decided to rebuild. Despite a league-leading 106 RBI in 1984, Carter moved on to the New York Mets for a package highlighted by infielder Hubie Brooks. It may have been the best trade the Mets ever made.

Carter joined a team of veterans and rising stars, and helped guide them to a second-place finish in 1985. He hit a career-high thirty-two home runs while handling a talented young pitching staff headlined by Dwight Gooden.

The following season, Carter led the Mets to the division title. In the World Series, his two-out single in the tenth inning of Game 6 sparked a remarkable three-run rally. "I'm standing up there after Wally Backman and Keith Hernandez had made outs, and everybody I think in the stadium thought it was over," Carter stated. "The Boston Red Sox were starting to celebrate—I was told that Dennis 'Oil Can' Boyd had already gone into the clubhouse and . . . opened up a champagne bottle.

"We were a late-inning, rallying type of team. That's the way we played all year. That was the character of our ballclub. I was gonna do whatever I could to reach first base, scratch, claw, whatever it was gonna take to get on first base."

Carter's numbers were impressive, but his passion for the game was even more noteworthy. "Nobody loved the game of baseball more than Gary Carter. Nobody enjoyed playing the game of baseball more than Gary Carter," Hall of Famer Tom Seaver told the *Utica (New York) Observer-Dispatch*. "He wore his heart on his sleeve every inning he played. For a catcher to play with that intensity in every game is special."

—B.M.

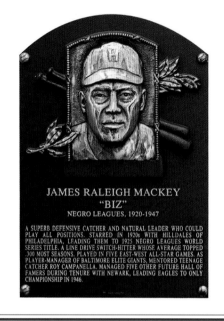

JAMES RALEIGH MACKEY
"BIZ"
NEGRO LEAGUES, 1920-1947

A SUPERB DEFENSIVE CATCHER AND NATURAL LEADER WHO COULD
PLAY ALL POSITIONS. STARRED IN 1920s WITH HILLDALES OF
PHILADELPHIA, LEADING THEM TO 1925 NEGRO LEAGUES WORLD
SERIES TITLE. A LINE DRIVE SWITCH-HITTER WHOSE AVERAGE TOPPED
.300 MOST SEASONS. PLAYED IN FIVE EAST-WEST ALL-STAR GAMES. AS
PLAYER-MANAGER OF BALTIMORE ELITE GIANTS, MENTORED TEENAGE
CATCHER ROY CAMPANELLA. MANAGED FIVE OTHER FUTURE HALL OF
FAMERS DURING TENURE WITH NEWARK, LEADING EAGLES TO ONLY
CHAMPIONSHIP IN 1946.

BIZ MACKEY

CLASS OF 2006

While Josh Gibson and Roy Campanella are highly regarded, and for good reason, James Raleigh "Biz" Mackey may be overshadowed by time but not overlooked when it comes to his peers.

In fact, a poll conducted in 1954 by the *Pittsburgh Courier* had Mackey edging Gibson as the greatest Negro Leagues catcher ever.

Hall of Famer Cum Posey, a longtime Negro Leagues executive, once said, "For combined hitting, thinking, throwing and physical endowment, there has never been another like Biz Mackey. A tremendous hitter, a fierce competitor, although slow afoot he is the standout among catchers who have shown their wares in this nation."

"Actually, as much as I admired Campanella as a catcher, all-around, and Gibson as a hitter," said Hall of Famer James "Cool Papa" Bell, a veteran of the Negro Leagues, "I believe Biz Mackey was the best catcher I ever saw."

A native of Texas, the six-foot, two-hundred-pound Mackey, born in 1897, was an all-around player, but he excelled at catcher, donning the tools of ignorance in a career that spanned nearly three decades, from the late 1910s to the mid-1940s. He proved to be a leader behind the plate and later as a manager.

Mackey has been given credit over the years for furthering the development of a number of Negro Leaguers who would go on to success in the major leagues, such as Roy Campanella, Monte Irvin, and Larry Doby.

"In my opinion, Biz Mackey was the master of defense of all catchers," Campanella said. "When I was a kid in Philadelphia, I saw both Mackey and Mickey Cochrane in their primes, but for real catching skills, I don't think Cochrane was the master of defense that Mackey was.

"When I went under his direction at Baltimore, I was 15 years old. I gathered quite a bit from Mackey, watching how he did things, how he blocked low pitches, how he shifted his feet for an outside pitch, how he threw with a short, quick, accurate throw without drawing back. I got all this from Mackey at a young age."

In a scouting report compiled by Negro Leagues legend Buck O'Neil, the longtime player, manager, coach, and scout wrote of Mackey, "Cat-quick defensively—good hands—strong arm with quick release—could really control a pitching staff—quick bat with pull power . . . good baserunner from 1st to 3rd or 1st to home."

At the plate, the switch-hitting Mackey, with a penchant for hitting line drives, finished his Negro Leagues career with a lifetime batting average well above .300. Behind the plate, the five-time veteran of the East-West All-Star Game proved nimble despite his size, possessing a strong throwing arm and becoming a favorite target for his pitching staff.

"I've pitched to some great catchers, but my goodness, that Mackey was to my idea the best one I pitched to," said Hall of Fame hurler Hilton Smith. "The way he handled you, the way he just built you up, believing in yourself. He was marvelous."

—J.G.

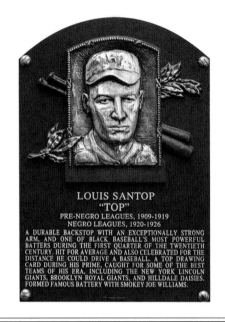

LOUIS SANTOP

CLASS OF 2006

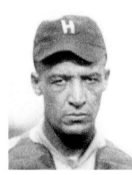

"Now this Santop—you haven't got a man in baseball today like him. Tex hit a ball 999 miles. I never will forget, he hit a ball down in Elizabethport, New Jersey, in 1912, and it went over the fence, and it was 500-some feet away. They put a sign on the fence where he hit it," said teammate Frank Forbes.

Louis Santop was a power hitter, often called "The Black Babe Ruth." Interestingly, Santop resembled Ruth in another way: he had charisma, and a larger-than-life, exuberant personality. He even "called his shot" on several occasions, just as Ruth would later do (or maybe not) in the 1932 World Series. "Santop hit the ball farther than anybody, Beckwith, Mule Suttles, Josh, anybody," said pitcher Jesse Hubbard. Santop has been called "the first of the great Negro League sluggers" and "the first Negro League superstar."

Like Ruth, Santop was a drawing card, earning as much as $500 per month in the teens and twenties. He often gave pre-game throwing exhibitions, crouching and firing repeatedly to each infielder, amazing onlookers with his powerful arm. "He had a better arm than anybody I've ever seen," said pitcher Scrip Lee. "Santop could stand at home plate and throw the ball into the center-field bleachers."

Born in Tyler, Texas, Santop was huge for his day, standing six feet four inches tall and weighing 240. Primarily a catcher, he also played the corner infield and outfield positions. He was nicknamed "Big Bertha," after a piece of German heavy artillery. While he was a gifted slugger who hit mammoth drives in the dead ball era, he also hit for extremely high averages, in the upper three hundreds, and is credited with a .330 lifetime batting average.

He broke in with the Fort Worth Wonders in 1909, and the following season played with the Philadelphia Giants, where he formed the famous "kid battery" with Cannonball Redding. For the next four seasons he caught for the New York Lincoln Giants, where he formed a future Hall of Fame battery with Smokey Joe Williams. In 1914 Santop hit .396 for the Lincoln Giants.

In 1915 he played briefly with the Chicago American Giants, before returning east to play with the Lincoln Giants. The two teams met in the postseason championship and ended up tied at five games each.

He played in the Black World Series for the Hilldale Daisies in 1921, 1924, and 1925, winning in 1921 and 1925. In 1924 Santop hit .349 for the Daisies.

He served in the Navy in 1918–19.

Santop is remembered for having outhit Babe Ruth in an October 1920 postseason series, played at Shibe Park. Santop notched three hits, including a double, while the Babe went hitless. In a 1917 series, Santop recorded six hits in three games against Chief Bender and Joe Bush.

In the mid-1920s Santop was replaced at catcher by another future Hall of Famer, Biz Mackey. After a couple of years of pinch-hitting duty, he retired and formed his own lower-level touring team, the Santop Bronchos. Rube Foster named Santop the catcher on his all-time Negro Leagues team, and Santop joined Foster in the Hall of Fame in 2006.

—T. Wiles

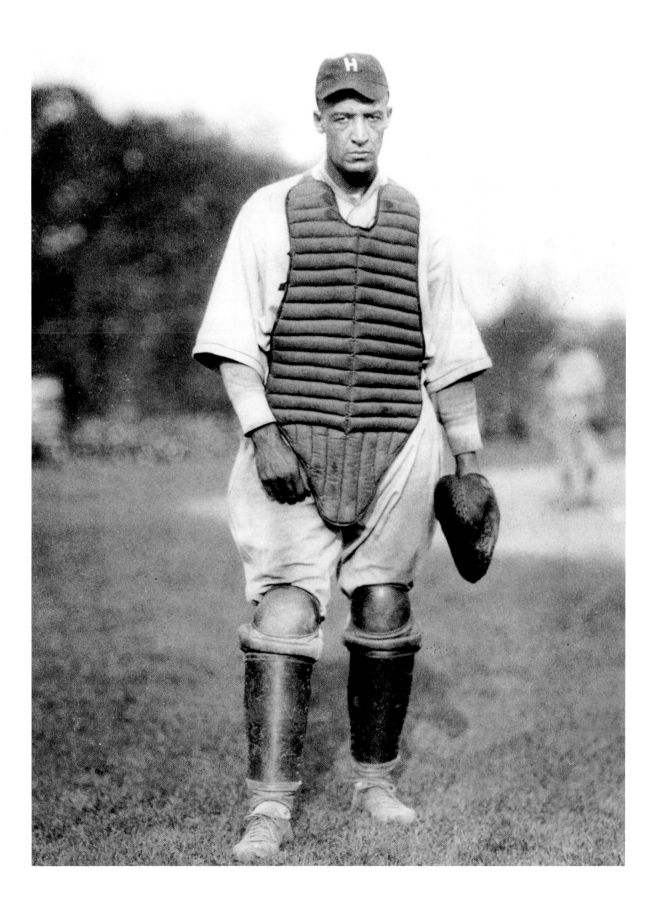

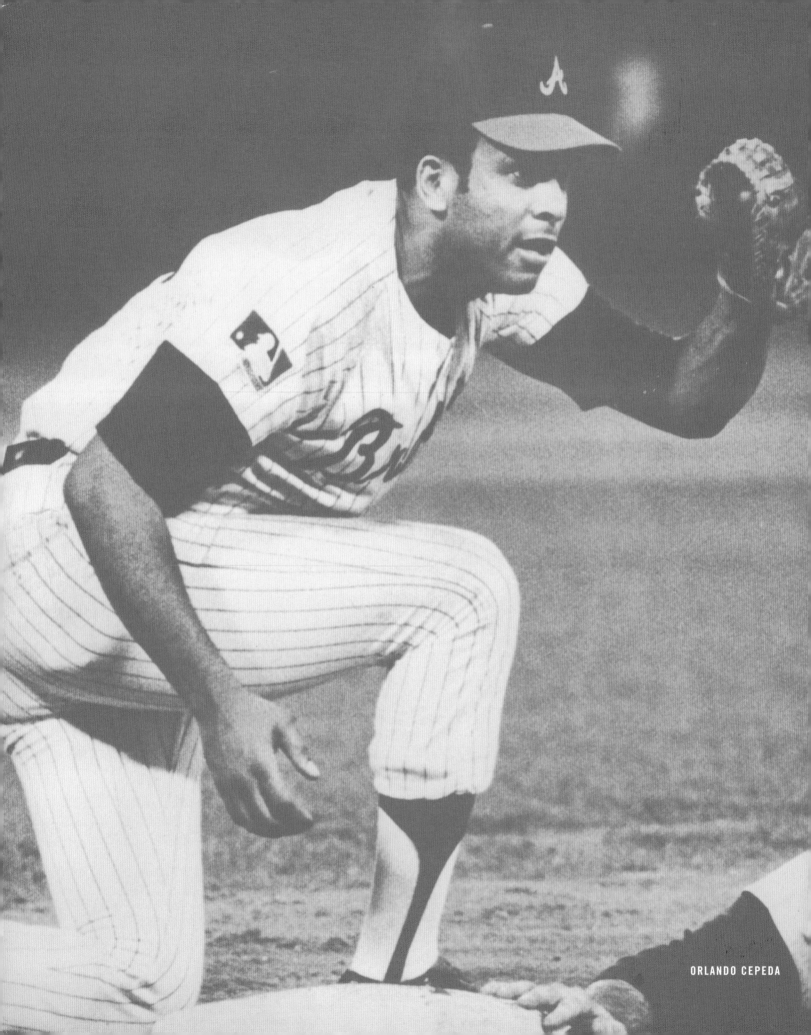

ORLANDO CEPEDA

FIRST BASEMEN

FIRST BASEMEN BY ORLANDO CEPEDA

Orlando Manuel Cepeda Pennes overcame an impoverished childhood in Puerto Rico and several debilitating knee injuries to become one of baseball's most feared sluggers. He was an instant hit with the San Francisco Giants, earning National League Rookie of the Year honors in 1958. Three seasons later, Cepeda became the first Latin American player to lead the league in home runs and RBI. The big first baseman was unanimously voted NL MVP in 1967 while leading the St. Louis Cardinals to the World Series title.

Several years after I was inducted into the Baseball Hall of Fame in the summer of 1999, I had an opportunity to tour the Museum. And when I went to the exhibit that celebrates Latin American baseball, I saw this picture of my dad. Perucho Cepeda had been gone for almost fifty years, but all of a sudden, it was like he was alive in that room. I could feel his spirit. I remember going right away to that team picture that showed him with the great Negro Leagues players Josh Gibson and Satchel Paige and many of the other All-Star players from Puerto Rico and the Dominican Republic and Cuba and Venezuela. And I couldn't stop staring at my father. I was bursting with pride. My dad had been a great, great player in Puerto Rico. Some people called him the Babe Ruth of the Caribbean—that's how good he was.

But like so many others, my dad never got a chance to play in the States because of the color of his skin. And that is such a shame, such an injustice, because there is no doubt he would have been inducted into the Baseball Hall of Fame long before me if he had been allowed to play Major League Baseball. But seeing this exhibit, seeing him with that fierce look on his face in that photograph made me feel really good. I patted my heart and said to myself and to that picture, "Dad, you did make it to Cooperstown after all. People didn't forget you and the others."

When it came time for me to speak at my induction ceremony, I had to fight back the tears. I had so much emotion. It was next to impossible to control. I thanked a lot of people who helped me along the way. I talked about my pride in being the second Puerto Rican, after the great Roberto Clemente, to be inducted. And I was going to tell the crowd about how I felt I wasn't going into the Hall of Fame alone that day, that my dad was going in with me. But I couldn't get the words out. I knew if I said my dad's name, I would have lost it. I would have bawled my eyes out and wouldn't be able to finish. They would have had to help me off the stage. I would have been a wreck. But I know Dad and Mom [Carmen] and Pedro Zorrilla, who got me my tryout with the [New York] Giants, all were looking down from heaven. They all knew that this was their day, too.

Life was not easy for us in Puerto Rico. Even though my dad was a baseball star, there was little money to be made from that. I think the most he ever made was $80 a month. Baseball really was like a second job for Dad. His real job was with the water department. He would put in a long day of work, come home, hop in a car with some other players, and drive an hour, two hours to play a night game, then get back home by one in the morning and get up at six thirty and start

all over again. I remember how tired he looked. But he was doing the best he could do to feed and clothe me, my older brother Pedro, and my mother.

We were poor, but in those days, everyone was poor in Puerto Rico. We had very little. We didn't even have a refrigerator or a telephone in our house when I was growing up. Forget about TV. We didn't get our first television set until 1956, when I came back from the States with one that I bought with some of the money I had made from playing in the minors. Money was always tight, but, looking back, I realize I was rich in other ways.

I remember being out with my dad and seeing how people adored him because he was a baseball legend in my country. People would come up to him and shake his hand. When we were on the bus, people would pay for his and my fare. When we were in a restaurant, people would pick up the check, or the owner would give us the meal on the house. I loved being with my dad because everybody loved my dad. People looked up to him. I looked up to him, too. He was my hero. I wanted to follow in his footsteps. I wanted to be a baseball player.

I was about eight years old the first time I saw Dad play with the Santurce Crabbers in 1945. He was playing second base that night. Josh Gibson was the catcher. Josh and Satchel Paige and the other great Negro League players often would come down and play in Puerto Rico once their seasons were over to pick up some extra money. Josh and Satchel would come over to my house and my mom would cook for them. They loved her cooking. They were always good to me. They took a liking to me and sometimes would give me some money. I have great memories of them.

I started playing ball when I was five. It was fun at first, but it eventually became a burden. Because I was the son of a famous player, people expected too much of me. They wanted impossible things. They expected Perucho's boy to hit a home run every time up, and when I didn't, they were disappointed. By the time I was ten years old, I had enough of people's expectations and quit playing baseball. I decided to take up basketball, another sport that I loved. I played for a few years and wound up hurting my right knee so badly that I needed surgery. I was about fourteen or fifteen when that happened, and the doctor told me not to play sports for several months. I went with a friend to watch him play in a pickup baseball game, and when I got there they said they needed a third baseman. I said, "No, the doctor told me I can't play for a while." But they kept pestering me and I finally said, "OK, I'll give it a try." I had experienced a pretty significant growth spurt around this time and had filled out pretty good. And the size and strength I had gained resulted in me being a much better player than I had been when I gave up the game five years earlier. I wound up hitting the hell out of the ball right away, and I began playing regularly with this team. I didn't tell my father or brother about this at first because of the doctor's orders, but they eventually found out. My father was upset with me, but he got over it quickly after seeing me play. He could tell I wasn't in any pain, and he was really impressed with how hard and far I was hitting the ball. After watching a few of my games, he put his arm around me and said, "Son, you are a baseball player." That really built my confidence. It's funny, but even after I had quit playing ball when I was ten, I never stopped loving the game.

I wound up playing for a team sponsored by City Taxi, and we went on to win the Puerto Rico amateur baseball championship. We then played an All-Star team from the Dominican Republic. Pedro Zorrilla, who owned the Santurce Crabbers, was at that game to scout José Pagán. I wound up having a very good game and he asked our manager, "Who is that kid playing third base for you?" When he told him I was Perucho's boy, he asked my dad to let me come to Santurce to work out with the team. I did, and although I didn't make the team, Pedro asked me to stay on as a batboy. That 1954 season was a great experience for me because it meant I got to take grounders and batting practice every day. And it didn't hurt that, during games, I got to watch two Crabbers—Willie Mays and Roberto Clemente—play ball. I learned a lot just by observing them. They inspired me to want to be like them. Catching Zorrilla's eye was big because he was close to Walter O'Malley of the Brooklyn Dodgers and Horace Stoneham of the New York Giants. The major league teams didn't really have scouts based in Puerto Rico, so they relied on Zorrilla to recommend players.

Around this time, our financial situation at home got worse. Like I said, my dad worked for the government, checking the water in the rivers near our town. One day, while doing his job, he contracted malaria. He got very sick and could no longer work, and my mother had to work odd jobs to help support the family. Pedro was aware of our situation and my baseball talent, so he convinced my parents to let me go to Melbourne, Florida, to take part in a tryout camp in March 1955. He believed I had what it took to make a professional baseball team, and he figured that the money I made would help our situation. It was a gamble, because in those days, not too many black Latinos were given opportunities to play ball in the States. Most teams would only sign white Cubans or white Puerto Ricans. But my family was desperate, and I had confidence that I could play ball there, so I made the trip.

It was a huge, huge tryout camp. There had to be more than a thousand players altogether, and we worked out and played games against each other every day for almost two months. It was very tough on me. I missed my family. I was homesick and used to cry every day. I was in a country where I didn't know anybody and couldn't speak the language. I wanted to go home. I don't think the major league scouts who were there liked the fact that I hit everything to right field. I was a big, strong kid—six foot two and more than two hundred pounds—and they wanted me to pull the ball. Guys kept getting signed while I was there. These were the days when each major league team had about fifteen, twenty minor league teams. I got discouraged because I kept seeing all these guys getting contracts. It wasn't until the end of the camp that someone signed me. I got a $500 contract to go play ball in Salem, Virginia, for an independent team.

I didn't know English, so it took me two days to make it from Melbourne to Salem in a Greyhound bus. I got lost. I didn't know how to tell the driver where I needed to go. I finally got to where I was supposed to be in Salem. In those days the South was segregated, so they put me up with a black family in the black section of town, and then they took me to the ballpark. I was totally exhausted, hadn't slept in two days, but they put me in the lineup that night and I struck out

three times. A day or two later I got word that my father had died from the malaria. I was devastated. I went back to Puerto Rico to bury the man who had been my hero. I didn't want to go back to the States because my mother was alone. My brother was in the Army in Korea at the time. But people convinced me that I had to go back to Salem and play ball because my mother needed that money to make ends meet. So I went back to Virginia, but I was miserable. I was grieving about my dad, worrying about my mom, and feeling all alone in this foreign country. My depression affected me on the field. I was hitting something like .150 after one month in Salem, and they released me. I was going to go back home, but Pedro convinced me not to give up. He arranged for me to go to Kokomo, Indiana, and play for a team in the Mississippi–Ohio Valley League for about $300 a month. It was there that my career turned around completely, thanks to a guy by the name of Walt Dixon. He was the manager of the team, and he and his wife really took care of me.

I'll never forget that first meeting with Walt. He said to me, "You know, Orlando, you have talent; you have potential to play in the big leagues. You are going to be my third baseman. You are going to be in the lineup every day regardless. So don't worry about things. Just relax and let your talent show through." He then took me to his house, and his wife made me a homemade meal. They had me to their house every day we had a home game. They were great people. They really looked after me. They gave me so much love. I can't thank them enough.

The first few games I didn't hit well, but then I settled down and Walt moved me up to the cleanup spot. I wound up having a great year (21 home runs, 91 RBI, a league-leading .393 batting average). After the season, the man who owned the team sold my contract back to the New York Giants, and the next year I was sent to their Class C team in St. Cloud, Minnesota. I had another monster year, winning the Northern League Triple Crown. The next year they were going to send me to Class A Springfield, but I signed that contract on one condition—that they allowed me to go to spring training with their Triple-A team, the Minneapolis Millers. They agreed, and after a slow start I stuck with the Millers and put up good numbers (25 homers, 108 RBI, .309 batting average).

This also was around the time they started to look at me seriously as a first baseman. In the beginning, I struggled a little at the position because I was too aggressive; I tried to charge everything. Whitey Lockman, who was a veteran first baseman with the Giants, took me aside and worked with me. He said, "Orlando, you don't need to charge everything at first because the balls hit to you there are often hit very hard." I adapted to the position quickly after that and came to love first base because it was one of those positions where you are involved in the game on almost every play.

I topped off that good season in Minneapolis with a very good season of winter ball back in Puerto Rico. That convinced the Giants, who had just moved from New York to San Francisco, to invite me to the big league camp in Phoenix in 1958. The Giants organization was loaded with talent back then, particularly at first base. Besides me, they had Bill White and Willie McCovey in their farm system. So it was a real logjam. I had no idea what the Giants planned to do. White was going to miss the first three weeks of camp because he had an Army Reserves obligation. On the

first day of spring training, [manager] Bill Rigney said, "OK, we are going to take infield. Orlando, you go to first base." That boosted my confidence, and I did so well in [White's] absence that when he returned from the reserves, they traded him to St. Louis. And the rest is history.

I felt very comfortable from my first day with the Giants. They made me feel very wanted. Rigney really liked me, really believed in me. He was always very calm with me. When I made a mistake, he didn't yell and scream at me. He'd say, "Don't worry about it, Orlando." And he'd tell me that if this situation came up again, here's how I should handle it. His approach was great with young players. He knew how to get the best out of me. Willie Mays asked the Giants to make me his roommate on the road that season. Willie didn't talk much, but the fact he wanted me, a rookie, as his roommate was a great gesture. Veteran players like Johnny Antonelli took me under their wing the minute I showed up. Johnny's the one who gave me my nickname, "Cha-Cha." He was a great guy; very, very nice to me.

It was a wonderful time in my life. My confidence was soaring. I couldn't wait to get started. My first spring training game, we played the Cleveland Indians, and I wound up going 3-for-4 with a home run and a double. That set the tone, told me I could hit at this level. I did so well in the exhibition games that the *Sporting News* predicted I would win National League Rookie of the Year. I'm glad they wound up being right. I hit 25 home runs, drove in 96 runs, batted .312, and led the league in doubles.

The following year I continued to do well. I was hitting something like .341 in July, and Rigney called me in and said they wanted to bring McCovey up to get another big bat in the lineup. He asked if I would be comfortable if Willie occasionally played some first base. I was a team player and I knew how good Willie was and how that would help our team, so I was all for it. I wound up playing some outfield that year. I was OK with that.

In 1961 I took my game to the next level. I hit 46 home runs, drove in 142 runs, and batted .311. I wound up leading the National League in homers and RBI, making me the first Latin player to lead the league in those categories. That made me so proud and made everyone in Puerto Rico proud. I was in my early twenties and on top of the world. The fans really took to me. Some writers said I was more popular with the fans than Willie Mays. I think part of that was because I was more outgoing than Willie. I would interact with the fans. I loved meeting them in settings outside the ballpark. I enjoyed signing autographs. Willie was more reserved. That was just his personality. I think the fans maybe embraced me more as one of their own because I started my career in San Francisco. They were a little more standoffish with Willie and some of the other star players who had begun their careers in New York. It also helped that I did well on the diamond right from the start. When you are doing well, everybody loves you.

Although I loved the people of San Francisco, I didn't really love Candlestick Park. It was a tough, tough place to play because it was always cold and windy, even in the middle of the summer. And the dimensions were not hitter-friendly. It was 420 feet to dead center and 397 feet to the power alleys. It seemed like the wind was always blowing in. I swear there were seasons

when it cost me between ten and fifteen home runs. I hit so many balls that went out but were blown back in. The wind turned home runs into outs.

The 1962 season wound up being very special because I got to play in my first World Series. We lost to the New York Yankees in seven games, and I wonder if the regular season and the playoff series we were forced to play against the Los Angeles Dodgers took its toll on us. We needed an amazing finish to win the National League Pennant. We trailed the Dodgers by something like four games with a week to go and managed to tie them for first place on the final game of the season. That led to a three-game playoff series. We split the first two games and won the clincher. I tied the game with a sacrifice fly in the top of the ninth and we wound up winning. It was one of the biggest at bats of my career.

That World Series came down to the final out of the seventh game. We were trailing 1–0 and had runners on second and third with two outs. Willie McCovey was at the plate and I was in the on-deck circle. I found out years later that Yankees manager Ralph Houk went out to the mound and asked Ralph Terry if he wanted to walk the left-handed-hitting McCovey and pitch to me. The thinking was that since Terry was a right-handed pitcher, the percentages were better that a righty pitcher could get a righty batter out than a righty pitcher versus a lefty batter. But Terry told him, "I don't want to pitch to Cepeda. I'd rather pitch to McCovey." It's funny, because second baseman Bobby Richardson moved a few steps to his left before Terry delivered his final pitch. Bobby had seen catcher Elston Howard calling for a pitch inside, so Richardson believed there was a greater chance that McCovey would pull the ball.

Well, Willie wound up doing just that. He hit this incredibly hard line drive, and when it left his bat, I immediately headed toward home plate because I was going to motion for Willie Mays, who was on second, to get ready to slide at home plate with the winning run. That's how sure I was that it was going to be a base hit. But instead of going into right field, the ball wound up in Richardson's glove for the final out of the game. I think about that game and I can't help but wonder "What if?" I would have loved to have seen Terry walk McCovey and pitch to me. That is a situation every player dreams about. Bottom of the ninth. World Series. You're up to bat with a chance to become a hero. But Terry knew what he was doing. I had almost gotten him a few times before. He didn't want to face me again. That makes me feel good that he respected me that much. I just wish I had gotten one more at bat that day.

I started having some problems with my knees as the years went on, and I was shocked when the Giants decided to trade me to the St. Louis Cardinals during the 1966 season. The Giants had told people that I was washed-up. That really hurt, because I had grown up in the Giants organization; had given them my all. They didn't want me. But the Cardinals did, and the minute I joined them, guys like Tim McCarver and Curt Flood and Bob Gibson and Lou Brock and Mike Shannon welcomed me with open arms. My attitude changed immediately. I thought, the Giants actually may have done me a favor. I was walking into a great situation. I wound up hitting .303 [for the Cardinals] that season and was named National League Comeback Player of the Year.

My 1967 season was even better. In fact, it wound up being the best year of my career, on and off the field. I got off to a great start. I finished with a .325 average, 21 game-winning hits, and a league-leading 111 RBI. The baseball writers made me the first player since Carl Hubbell [in 1936] to win the National League MVP Award unanimously. But what made the season even better was that we won the World Series in seven games against the Boston Red Sox. That washed away the disappointment of 1962. I think I showed my old team, the Giants, that I was far from being washed-up.

I had a great time playing in St. Louis. The fans embraced me immediately. This is not a put-down of any other place, but to me, St. Louis is the best baseball town in America. It's really a small city, but they still draw 3 million every year. Their fans make going to the ballpark every day a great experience. Those people are so passionate and so knowledgeable about baseball. They love the game with heart and soul. When I look back on my career, I was very fortunate because I played in some great baseball cities—San Francisco, Boston, Oakland, Atlanta, and Kansas City. But none of them can match St. Louis.

I wound up my career in Kansas City in 1974. I was only thirty-seven years old, but my knees were shot. I was in too much pain and I couldn't play the way I was used to playing anymore. So I called it quits. I had some tough, tough times after I was done playing. I made some mistakes, associated with some people I shouldn't have. I eventually had to leave my homeland of Puerto Rico because of those problems. People didn't want me there anymore. They kicked me out. It was tough. Very tough.

I had a friend who introduced me to Buddhism, and that helped me get my life back. I learned to stay away from bad people. I began associating with people who had a greater mental capacity than I had, people who could teach me. I believe if you surround yourself with smart people, you will learn from them. Your life will be better.

There were times when I wondered if I would ever get into the Baseball Hall of Fame. I felt I belonged, but some of the writers weren't in a forgiving mood. But time heals all wounds. As the years went on, people began to forgive; they began to see that I had turned my life around completely, that I was trying to help others and do good things. A lot of people went to bat for me, people like Peter Magowan. After he became owner of the Giants, Peter wrote a letter to the members of the Veterans Committee telling them all the work I was doing in the community and how I belonged in the Hall of Fame. And in 1999 I got the call that I had finally made it. I was so overcome with emotion when I received that call that I had to hand the phone to my wife and let her talk for me. I was crying like a baby. Tears of joy.

I was so proud to be only the second player from Puerto Rico to make it to Cooperstown. The first was Roberto Clemente, who I first met back in 1952 when he was just [seventeen or eighteen] years old and playing for a team managed by my father. I got to play ball with Roberto in Santurce. I became very close to him. I'm still good friends with his wife and his kids and grandkids. He was

a fine, fine human being. To follow in his footsteps is a great honor. To think there are now three players from my small island [Roberto Alomar was inducted in 2011] blows my mind.

When I look back on people who influenced me, I have to mention Minnie Miñoso. Minnie was every Latin ballplayer's hero. He was the Jackie Robinson of Latino baseball players. Like Jackie, he broke down barriers and inspired people like me to follow in his footsteps. The first time I met him was in 1956. I was on my way to spring training and I ran into him at the airport in Miami. I swear I almost fainted. Even today, he remains my hero. There's no doubt in my mind that Minnie Miñoso belongs in the Hall of Fame, not only because he was a great baseball player, but also because of what he meant to all Latino players, then and now.

I can sympathize with what African American ballplayers had to go through in the 1940s, '50s, and '60s because I experienced some of the same challenges. I remember how there were cities where the black American players and I had to eat in our hotel rooms because we weren't allowed to eat in the main dining room with the rest of the team. And that wasn't just in the South. I remember that being the case even in Chicago. In 1958 we were playing a series at Wrigley Field, and Felipe Alou and I were walking back to our hotel, which was in the white section of town, and a police car pulled up and asked us what we were doing in that neighborhood. We told them we were ballplayers and we were going back to the team hotel. They let us continue walking, but they followed us all the way to the hotel, and they even went inside to make sure we really were who we said we were and that we really were staying there. A year later, in Pittsburgh, I met Clemente for lunch at this restaurant, and when we walked in, a guy says, "We already have enough people to wash dishes and we aren't hiring any more dishwashers." We told them we were ballplayers, but the guy said he didn't care who we were, we couldn't eat there; we had to leave. I guess the one advantage I had when I was in the minor leagues is that I didn't understand the language. If they were screaming [racial epithets] at me, they didn't mean anything to me.

That kind of discrimination kept my dad from receiving the opportunities and recognition he deserved. But like I said, I really believe he was being inducted along with me back in '99 because without him and my mom and Pedro Zorrilla, it never would have happened for me.

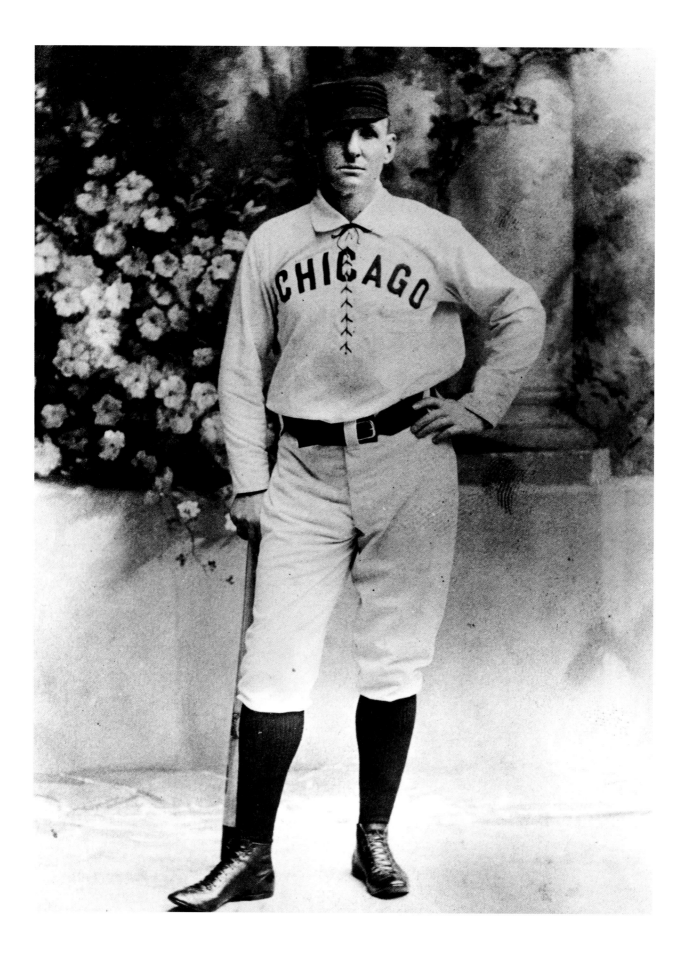

ADRIAN CONSTANTINE ANSON
"CAP"
GREATEST HITTER AND GREATEST
NATIONAL LEAGUE PLAYER-MANAGER
OF 19TH CENTURY. STARTED WITH
CHICAGOS IN NATIONAL LEAGUE'S
FIRST YEAR 1876. CHICAGO MANAGER
FROM 1879 TO 1897. WINNING 5 PENNANTS.
WAS .300 CLASS HITTER 20 YEARS,
BATTING CHAMPION 4 TIMES.

CAP ANSON

CLASS OF 1939

Adrian "Cap" Anson has been called simply the greatest hitter and the best player-manager of the nineteenth century.

A major figure in baseball's early days, Anson played at the major league level for twenty-seven years and batted better than .300 in twenty-four of those seasons. With a lifetime batting average of .334, Anson was the first National League player to surpass three thousand hits, and he won batting titles in 1879, 1881, 1887, and 1888.

One of the few power hitters in a dead ball era, Anson hit ninety-seven home runs and drove in more than two thousand runs. Just as important, he was recognized as one of the game's best managers and a real innovator inside and outside the lines. Spring training, coaching boxes, pitching rotation, and signals are just a few of the things he brought to the game during his time leading the Chicago Colts team, which eventually became the Cubs. He had a .578 career winning percentage as a manager in eighteen full seasons and parts of three others, finishing third or better eleven times. In his first eight seasons as manager, he led Chicago to five NL Pennants.

"Adrian C. Anson was one of the greatest players that ever lived," said A. G. Spalding, "and a man whose word was always good as his bond."

Charles Comiskey called Anson "the greatest batter that ever walked up to hit a baseball thrown by a pitcher."

After his time in baseball ended, Anson remained so popular with the general public that he became a vaudeville star. One of his productions co-starred his daughters, with skits written by George M. Cohan and Ring Lardner. In that closing act, Anson swatted papier-mâché baseballs into the crowd with a silver bat given to him by Notre Dame alumni.

In his later years, Anson's personal stationery bore the inscription "A Better Actor Than Any Ball Player. A Better Ball Player Than Any Actor."

Despite such success away from the diamond, Anson's first love always remained the National Pastime. When he died in April 1922, legendary sports columnist Grantland Rice recalled seeing him at the previous year's World Series, between the Yankees and the Giants. Rice noted that Anson was one of the first in the stands and one of the last to leave the ballpark. Even then, Cap couldn't help but still be enthralled by the game. First as a player and then as a winning manager, Anson will always be remembered as one of the sport's pioneers. He remains part of a select group who ensured that baseball not only gained a following but soon became the National Pastime as well.

"The secret of Anson's greatness was not only due to his great skill and rugged integrity," Rice wrote in Anson's obituary, "but also to the fact that he loved the game with an intensity that the long caravan of years could never weaken."

Anson was named to the National Baseball Hall of Fame in 1939.

—T. Wendel

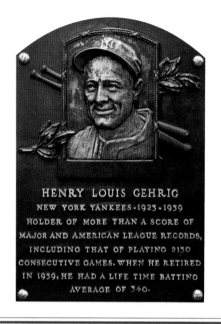

HENRY LOUIS GEHRIG
NEW YORK YANKEES·1923·1939
HOLDER OF MORE THAN A SCORE OF
MAJOR AND AMERICAN LEAGUE RECORDS,
INCLUDING THAT OF PLAYING 2130
CONSECUTIVE GAMES. WHEN HE RETIRED
IN 1939, HE HAD A LIFE TIME BATTING
AVERAGE OF 340.

LOU GEHRIG

CLASS OF 1939

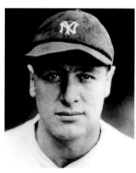

Before his name became a synonym for the fatal disease amyotrophic lateral sclerosis, Lou Gehrig was known as a terrific first baseman and for his iron man record of playing in 2,130 straight games during his seventeen-year career with the New York Yankees. He came to the Yanks from Columbia University, and once he worked his way into the lineup, he never left until he became too sick to play.

The cleanup hitter behind Babe Ruth, Gehrig was overpowering at the plate. "There is the hardest hitter I ever pitched against," said pitcher Andy Coakley gazing toward Gehrig. "He is the greatest young hitter that I've ever seen."

Ruth had the bigger slugging reputation, but with his 184 RBI in one season, Gehrig eclipsed the Bambino on that count. Bucky Harris, the "Boy Wonder" manager, believed that Gehrig was Ruth's equal at the plate. "When that guy came to bat, all you could do was hold your breath," Harris said. "When you consider everything, the number of games he played, the way he hit, his reliability, and his drive, he was for me, the greatest first baseman of all time."

Gehrig famously stepped into the New York lineup one day in 1925 to replace Wally Pipp. "I had no idea I was going to play," Gehrig said. "I had taken a few swings in batting practice and gone back to the clubhouse to lie down for a few minutes."

Manager Miller Huggins sought him out to inform him he was in at first. "I jumped up and grabbed my mitt out of the locker and went out to the field."

It was Gehrig who asked to be taken out of the lineup fourteen years later, ending his streak. Teammates believed he was fading because of age, but they tried to boost his spirits. One day George Selkirk attempted to cajole him onto the field to hit. "Why don't you quit stalling and get out there this afternoon and hit a couple," Selkirk said. Gehrig, who understood those days were gone, said, "I wish I could, George. I wish I could."

Ruth and Gehrig had their tensions during their years as teammates, but Ruth was shocked and saddened when Gehrig passed away. "I can't say how sorry I am over Lou's death," Ruth said. "No one ever lived a cleaner life. He was a great ballplayer and a grand hustler."

Soft-spoken, friendly to fans and teammates, Gehrig was known as a gracious man, but he really didn't know how beloved he was until his skills deteriorated because of illness. Long before he made his famed "luckiest man" farewell speech in Yankee Stadium, he was amazed by the outpouring of appreciation for his work on the diamond.

"I want to tell the fans how grateful I am for the way they've been treating me," Gehrig said. "I hear their applause, and I know they're still pulling for me, and that means everything when you're out there having a tough time getting started."

—L.F.

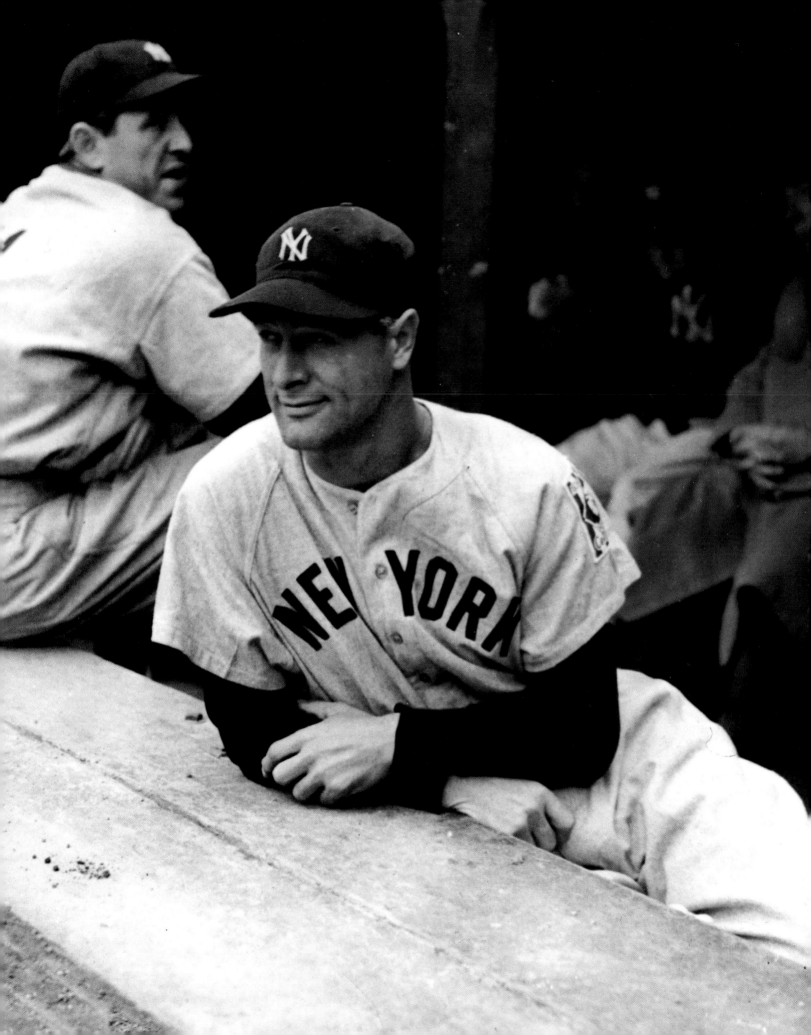

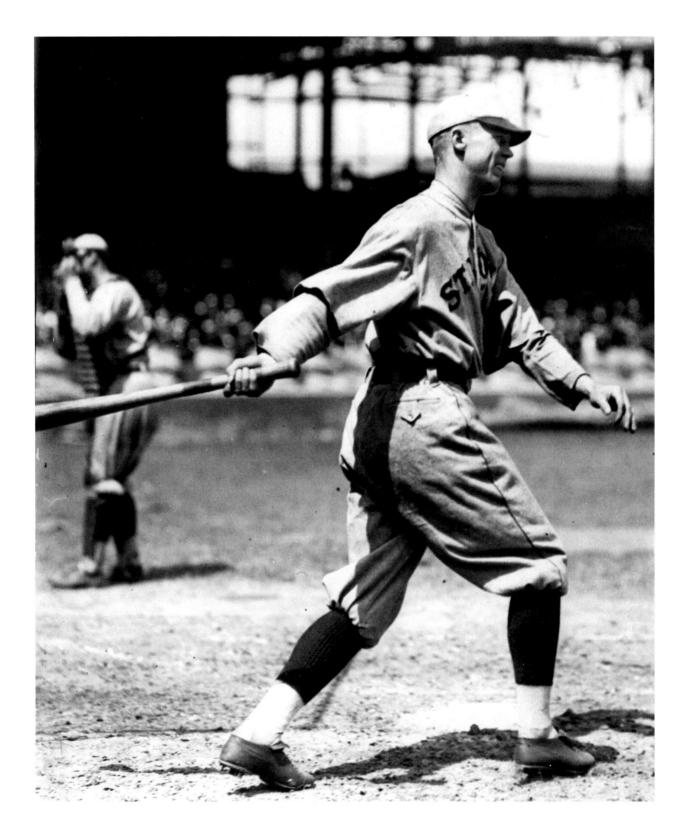

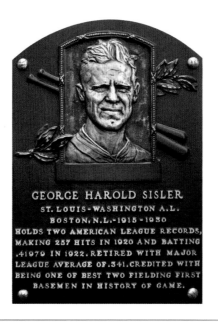

GEORGE HAROLD SISLER
ST. LOUIS-WASHINGTON A.L.
BOSTON, N.L.-1915-1930
HOLDS TWO AMERICAN LEAGUE RECORDS,
MAKING 257 HITS IN 1920 AND BATTING
.41979 IN 1922. RETIRED WITH MAJOR
LEAGUE AVERAGE OF .341. CREDITED WITH
BEING ONE OF BEST TWO FIELDING FIRST
BASEMEN IN HISTORY OF GAME.

GEORGE SISLER

CLASS OF 1939

George Sisler batted .420 one season, fielded first base with the grace of a dancer, was an excellent base runner, and even pitched on occasion, reasons enough to explain why his contemporaries thought so highly of him on the diamond.

"He was poetry in motion," said Hall of Fame second baseman Frankie Frisch, "the perfect player."

After graduating with a mechanical engineering degree from the University of Michigan in 1915, Sisler moved right onto the roster of the St. Louis Browns. Branch Rickey, who coached Sisler at Michigan and then brought him to the Browns when he was named skipper of the big league team, considered Sisler his favorite player.

"George Sisler was the smartest hitter who ever lived," Rickey said. "He never stopped thinking. And in the field he was the picture player, the acme of grace and fluency."

Starting his career as a pitcher, Sisler eventually became a first baseman in order to get his powerful left-handed bat in the everyday lineup.

"I used to stand on the mound myself, study the batter and wonder how I could fool him," Sisler said. "Now when I am at the plate, I can more easily place myself in the pitcher's position and figure what is passing through his mind."

The Washington Senators' Walter Johnson was Sisler's baseball idol, and only a few months into his big league career, on a humid St. Louis afternoon in August 1915, Rickey matched Sisler against Johnson on the mound—and Sisler won, 2–1.

"I looked over as soon as the game ended to see if Johnson was in the dugout," Sisler said. "I had the impulse to say something—maybe even tell him I was sorry—but he was gone."

Peerless defensively at first, Sisler also excelled with his forty-two-ounce bat in hand. In a big league career that lasted fifteen seasons, "Gorgeous George" batted over .300 thirteen times, including league-leading averages of .407 in 1920 and .420 in 1922. His 257 hits during the 1920 campaign remained a modern major league record until Seattle's Ichiro Suzuki broke it in 2004. A skilled base runner as well, he led the league in stolen bases four times.

Baseball great Ty Cobb, an American League rival for many years, once called Sisler "the nearest thing to a perfect ballplayer" he had ever seen.

"Sisler could do everything," Cobb said. "He could hit, run and throw and he wasn't a bad pitcher, either."

Once, Sisler met actor and humorist W. C. Fields, who was known as much for his drinking habits as his one-liners, and the comedian proved to be a fan. "You fascinate me, George," Fields said. "I've admired your artistry very much many times. Have a drink."

Sisler declined, saying he didn't drink. Fields expressed his regrets, saying, "Well, even the perfect ball player can't have everything."

—B.F.

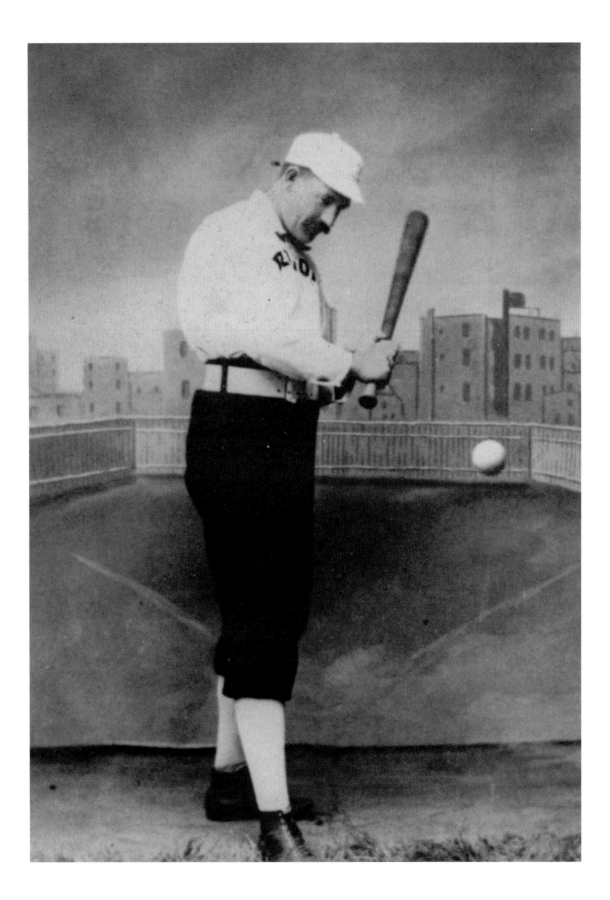

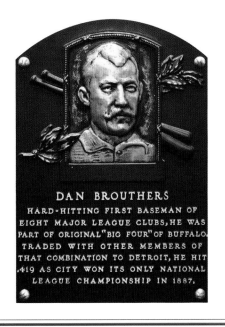

DAN BROUTHERS

HARD-HITTING FIRST BASEMAN OF
EIGHT MAJOR LEAGUE CLUBS, HE WAS
PART OF ORIGINAL "BIG FOUR" OF BUFFALO.
TRADED WITH OTHER MEMBERS OF
THAT COMBINATION TO DETROIT, HE HIT
.419 AS CITY WON ITS ONLY NATIONAL
LEAGUE CHAMPIONSHIP IN 1887.

DAN BROUTHERS

CLASS OF 1945

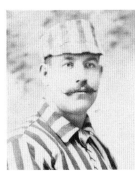

Before Babe Ruth, Dan Brouthers was the hard-hitting slugger who kept pitchers awake at night. Few players were more feared when they stepped up to the plate in baseball's early years. And just like Ruth, Brouthers swung the bat left-handed and began his career as a pitcher.

Brouthers got his start playing baseball in the Hudson Valley and went on to capture five batting titles at the major league level with four different ball clubs (Buffalo of the National League in 1882 and 1883, Boston of the NL in 1889, Boston of the American Association in 1891, and Brooklyn back with the National League in 1892).

The legendary John McGraw recalled that it was Brouthers's arrival in Baltimore, along with that of Wee Willie Keeler in 1894, that laid the foundation for those great Orioles teams. "His build was somewhat similar to that of Babe Ruth," McGraw said, "a big body tapering off to thin legs. And Big Dan, though he had passed his peak when he reached Baltimore, still was a good first baseman, although he had been playing big league ball since the early '80's."

In fact, Brouthers played nineteen years in the majors while posting a .342 lifetime batting average. He had a keen eye, and averaged more than twenty-eight at bats per strikeout. In

September 1886 he hit three home runs in a single game against Chicago. He had a single and a double on that day, too.

Even though the first baseman they called "Big Dan" would finish his career with McGraw's Giants in 1904, Brouthers is perhaps best known for being a part of the "Big Four" in Buffalo in the early 1880s, which included Hardy Richardson, Jack Rowe, and Deacon White. The foursome were sold as a group following the 1885 season to Detroit, where they led the Wolverines to their first pennant in 1887.

In his series on the fifty greatest players in history, Sam Crane claimed that Brouthers "could hit a ball harder and further than any player I ever had the pleasure of playing with or against. Let him get a low ball or one between his waist and knee and then watch the smoke of that clout."

After his playing days were over, Brouthers became a coach and scout, and reportedly discovered such players as Larry Doyle, Buck Herzog, and Fred Merkle for McGraw's Giants. The fiery manager always looked out for his old first baseman, keeping him employed as a night watchman and stadium attendant. Up to his death in 1932, Brouthers also worked the press gate and up in the press box.

"They had more fun playing in those days," McGraw said, "but fun was about all they did have, as the salaries wouldn't satisfy Class B players of the modern era."

—T. Wendel

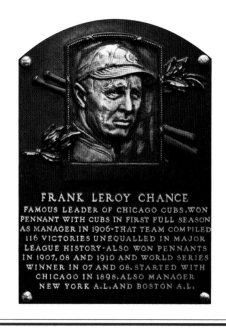

FRANK LEROY CHANCE
FAMOUS LEADER OF CHICAGO CUBS.WON
PENNANT WITH CUBS IN FIRST FULL SEASON
AS MANAGER IN 1906·THAT TEAM COMPILED
116 VICTORIES UNEQUALLED IN MAJOR
LEAGUE HISTORY·ALSO WON PENNANTS
IN 1907,08 AND 1910 AND WORLD SERIES
WINNER IN 07 AND 08.STARTED WITH
CHICAGO IN 1898.ALSO MANAGER
NEW YORK A.L.AND BOSTON A.L.

FRANK CHANCE

CLASS OF 1946

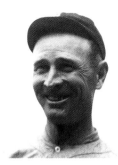

You know you have the respect of people in your sport when your nickname is "The Peerless Leader." That was Frank Chance, who not only played one-third of the role in the Chicago Cubs' double-play combination immortalized in poetry, but managed the team as well.

Chance was of the win-at-all-costs school of baseball and played at a time when fraternization with the other team might amount to a punch in the mouth or a sarcastic remark. He once dismissed the idea of acquiring the Pittsburgh Pirates' Big Chief Wilson because he felt he was too polite. Once, Chance was spiked on a play and was removing his shoe for a look at the wound when Wilson, who was nearby, said, "I hope you are not hurt." Rather than taking that comment as a sign of human concern, Chance believed it showed weakness. "Wilson isn't the kind of man I want," Chance said. "He should have said, 'I hope you lose your leg next time.'"

It seemed that Chance came by his super-aggressiveness naturally. During his offseasons from professional baseball, Chance was an amateur boxer who at least once fought twenty rounds. Some of the best heavyweights, from John L. Sullivan to James J. Corbett, admired Chance's fistic abilities. It's a wonder Chance didn't switch to the sweet science early on, since the first pitcher he faced in the majors was Cy Young.

Chance gained outsized fame because of the enduring nature of the Franklin P. Adams poem about his double-play relationship with Johnny Evers and Joe Tinker, but Evers thinks Chance would have been an even better first baseman if he hadn't also managed. "If Frank Chance had not been a great manager he would have been ranked as one of the greatest first basemen that ever played," Evers said, "possibly the greatest."

One of Chance's philosophies was never to show weakness to an opponent. It harkened back to schoolyard days when, if hit by a pitch or a batted ball, you didn't give your foe the satisfaction of seeing you whimper, so you didn't rub the hurt spot. "Frank Chance was a great builder of the fighting spirit," Evers said. "We were taught in that school to suffer in silence—no alibis, no complaints, no squawking. Later on in my career, when 'don't rub' was the slogan of the team, I once slid into second base and broke a leg. 'Don't rub!' was the call from the bench. If I hadn't been brought up in the Chance school I would have stayed there at second nursing a broken leg. As it was I got up and ran to third. That was Frank Chance's idea of what baseball should be."

Chance brought game results home from the office. One time, his wife tried sympathetically to soothe his sadness after a defeat. Chance did not respond well to her comments when she said that at least he had her. "I would have traded you for a base hit," Chance said.

—L.F.

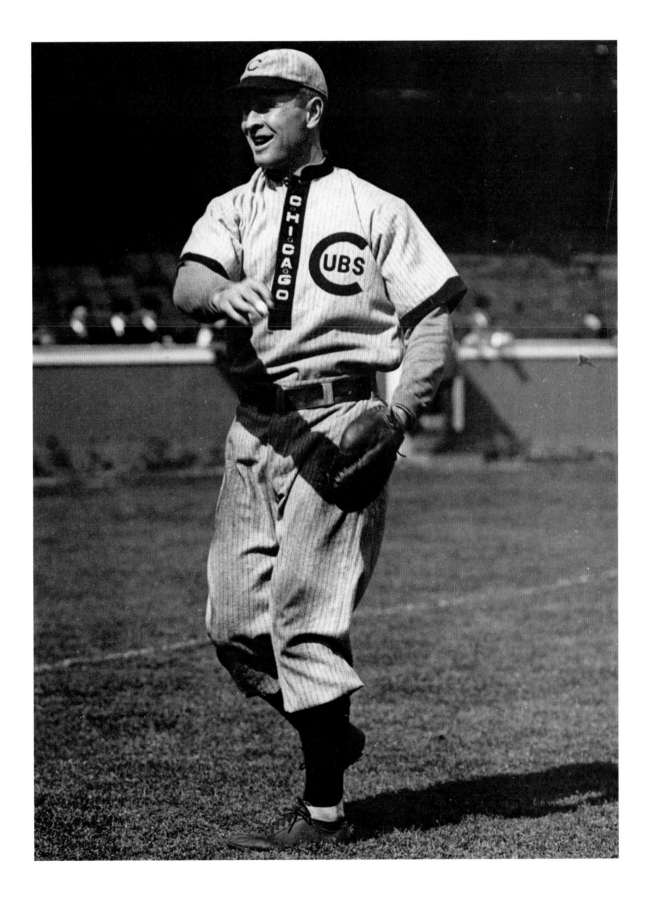

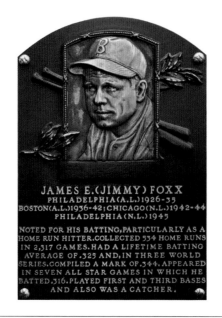

JIMMIE FOXX

CLASS OF 1951

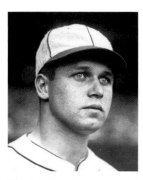

Few hit better from the right side of the plate than Jimmie "Double X" Foxx.

A fearsome power hitter who was also nicknamed "The Beast," he anchored the great Philadelphia Athletics teams of 1929–1931. Those memorable ball clubs went to the World Series three times, winning twice, thanks in large part to Foxx's prowess. That's when he graced the cover of *Time* magazine.

"He had great powerful arms, and he used to wear his sleeves cut off way up," said Chicago White Sox pitcher Ted Lyons, "and when he dug in and raised that bat, his muscles would bulge and ripple."

The second batter in history to top five hundred home runs, Foxx belted thirty or more homers in twelve consecutive seasons and drove in more than one hundred runs in thirteen consecutive years, including a career-best 175 with Boston in 1938. He won back-to-back American League MVP Awards in 1932 and 1933, capturing the Triple Crown in the latter year.

In his twenty-year career, Foxx had 534 home runs, which was the most by a right-handed hitter at the time and second only to Babe Ruth's 714. In addition, Foxx had 1,922 RBI, a .609 slugging percentage, three MVP Awards, two World Series titles, and that Triple Crown (.356, 48 home runs, 163 RBI) in 1933.

With a little luck he could have surpassed Ruth for the single-season home run mark, too. The year before his Triple Crown performance, Foxx homered fifty-eight times and

easily missed out on several more dingers. According to the *Philadelphia Inquirer*, Foxx lost five home runs to rainouts and saw another half-dozen or more big flies get caught in the screens in St. Louis and Cleveland. Those didn't count as round-trippers.

"No matter how hard I throw the ball, he always hits it back harder," pitcher Lefty Gomez said. "When he got good wood on a pitch, it took you 20 minutes to walk to where the ball landed."

Indeed, Foxx hit some of the longest clouts ever in baseball history. He hit one well over the left-center-field bleachers at the old ballpark in Cleveland. And he is credited with hitting the longest homer ever at Philadelphia's old Shibe Park, a blow in 1932 that was estimated to have traveled well over five hundred feet.

Born in Sudlersville, Maryland, on the Eastern Shore, Foxx was originally a catching prospect. But the Athletics already had future Hall of Famer Mickey Cochrane there, so Foxx was placed at first base instead. He left Philadelphia during Connie Mack's fire sale after the 1935 season and went to Boston, where he won his 1938 AL MVP Award with the Red Sox (.349, 50 home runs, 175 RBI).

He played there until 1942, when he was selected off waivers by the Chicago Cubs, and he finished his career with the Philadelphia Phillies in 1945. Foxx also tried his hand at managing, at least in an unconventional sense, as he led the Fort Wayne (Indiana) Daisies of the All-American Girls Professional Baseball League. In doing so, he became the inspiration for Tom Hanks's Jimmy Dugan character in the movie *A League of Their Own*.

　　　　　　　　　　　　　　　　　—T. Wendel

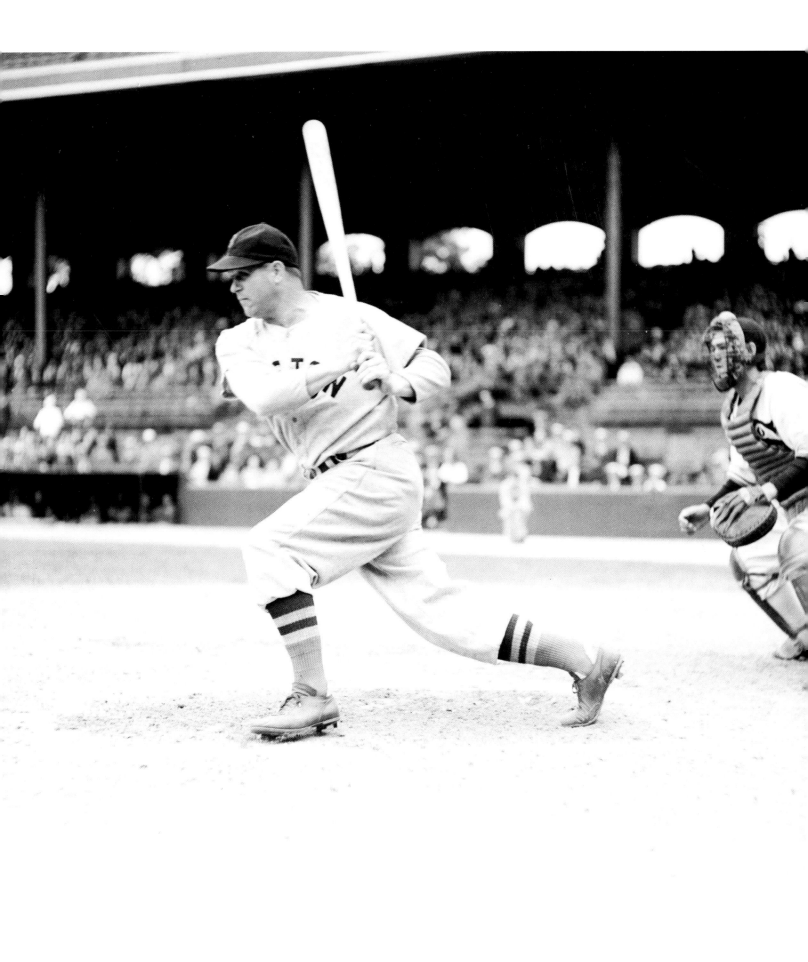

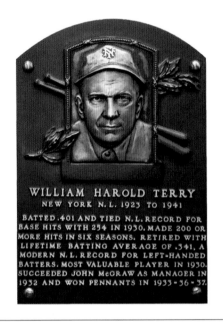

WILLIAM HAROLD TERRY
NEW YORK N. L. 1923 TO 1941

BATTED .401 AND TIED N.L. RECORD FOR
BASE HITS WITH 254 IN 1930. MADE 200 OR
MORE HITS IN SIX SEASONS. RETIRED WITH
LIFETIME BATTING AVERAGE OF .341, A
MODERN N. L. RECORD FOR LEFT-HANDED
BATTERS. MOST VALUABLE PLAYER IN 1930.
SUCCEEDED JOHN McGRAW AS MANAGER IN
1932 AND WON PENNANTS IN 1933-36-37.

BILL TERRY

CLASS OF 1954

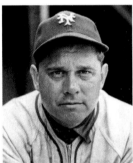

Long before he was known as one of the best hitters in the National League and had his number 3 retired by the Giants, Bill Terry was a teenaged pitching phenom. He was just fifteen years old when seen by a scout and signed for his ability to throw.

"Breaking into baseball was no easy job for me," Terry once said. "I had to do it twice. And the original urge to go into the game came from an unknown scout for the St. Louis Browns. It was at the height of the Federal League excitement. The sports pages every day named fabulous sums in connection with baseball contracts. Players were jumping from the majors to the outlaws for unheard-of salaries. I decided that baseball wasn't so bad after all and that if it was true that I could pitch I would go after some of that soft dough."

Terry spent $11 to buy a new trunk, but before he could get out of the house, the Browns released him. Discouraged, but not completely demoralized, Terry took his left arm to the employ of the Newnan Cowetas of the Georgia-Alabama League and pitched throughout the region. Big bucks did not follow, however, and Terry quit the sport to take a job for an oil company in Memphis.

Kid Elberfeld, the former major leaguer who operated the Little Rock, Arkansas, franchise, tried to change Terry's mind but couldn't, so he turned his rights over to the New York Giants.

When the Giants came through Memphis for an exhibition game, manager John J. McGraw was more persuasive.

"He induced me to come out of retirement," Terry said. "I had to break into baseball a second time, and I did it with Toledo, where I became a first baseman."

A superb one, and Terry proved to be a mainstay of the Giants in the 1920s and 1930s. In 1930 Terry batted .401 and clouted 254 hits, still tied for third all-time. McGraw ran the Giants with an iron fist, and he and his star frequently clashed. When McGraw stepped down as manager after a three-decade reign, it was a shock to many when he named Terry as his player-manager successor for the 1932 season. Terry was one of those who were surprised.

McGraw had suffered from health problems for two years, and when he made his announcement, he did it quietly, posting a note on the bulletin board in the Giants clubhouse. The notice offered his reasoning for the selection of Terry to follow him. "It was my desire that a man be appointed who was thoroughly familiar with my methods and had learned his baseball under me," McGraw wrote.

The pleased Terry said, "Naturally, I'm proud to be picked as the successor to McGraw. I've done practically all of my ball playing under him and admire his ability. If I can come close to being as good a manager as McGraw, it will satisfy me, and it certainly should satisfy everybody else."

—L.F.

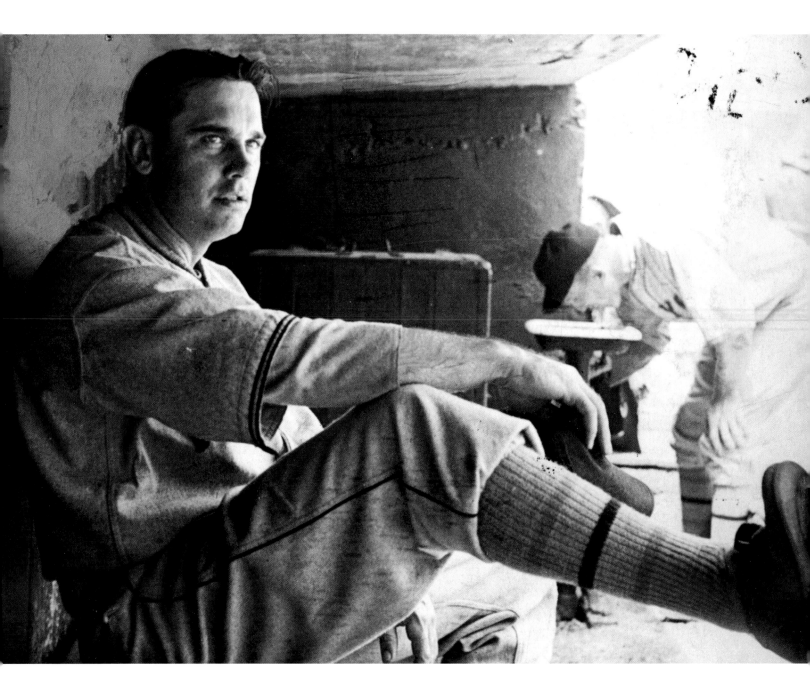

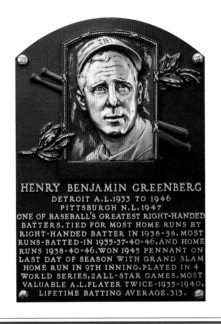

HANK GREENBERG

CLASS OF 1956

Hank Greenberg was more than just a legendary slugger. He overcame early awkwardness, a position change, and bigotry in becoming a heroic figure.

Born to Jewish immigrants in New York City, Greenberg seemed like a natural to sign with a New York team. He attended a New York Giants tryout camp, but manager John McGraw deemed the oversized Greenberg (at six foot three and 210) too clumsy. The New York Yankees made Greenberg an offer, which he turned down because of the presence of Lou Gehrig. So in 1929, the Detroit Tigers took advantage of their good fortune and signed Greenberg.

Working hard at several minor league stops, Greenberg made it to Detroit for good in 1933. He hit .301 with twelve home runs before emerging as a frontline star in 1934. He slugged .600 while leading the American League with sixty-three doubles.

That September, Greenberg faced questions about playing on the High Holy Days. He came up with a compromise, playing on Rosh Hashanah but resting on Yom Kippur. "When Greenberg walked into the synagogue that day, everyone applauded," filmmaker Aviva Kempner said. "I think it was even more of a bold move than Sandy Koufax sitting out the first game of the World Series." The synagogue reaction stood in contrast to the ethnic taunts Greenberg often faced. On one occasion, a group of opposing players hurled insults his way. Greenberg stood his ground, challenging his opponents to "stand up." None did.

In 1935 Greenberg won the MVP by leading the league in home runs, RBI, and total bases. His performance spearheaded the Tigers to a second straight pennant.

Incredibly, the best was yet to come for the sculpted slugger. After a 1936 season shortened by a frightening collision, Greenberg brutalized pitchers for four years. In 1937 he led the league with 183 RBI. The following summer he hit fifty-eight home runs in making a memorable run at Babe Ruth's single-season record. In 1940 he moved to left field to make room for Rudy York at first base. The change in positions did not prevent him from taking home his second MVP.

Greenberg seemed destined for another fine season in 1941, when he was drafted by the Army. He served in World War II until June 1945, receiving a Presidential Unit Citation and four battle stars while missing the equivalent of four seasons.

He did his best to make up for lost time, slugging over .500 during the balance of 1945. He led the league in home runs and RBI in 1946, but a salary dispute led to his departure from Detroit. "Hammerin' Hank" was purchased by the Pittsburgh Pirates, hit twenty-five home runs, and served as a mentor to a young Ralph Kiner before retiring.

Long respected for his intelligence, Greenberg moved on to management. Bill Veeck hired him as general manager of the Cleveland Indians, where he assembled the pennant-winning team of 1954. So accomplished as a player, Greenberg found a way to match that success in the front office.

—B.M.

JACOB PETER BECKLEY
"OLD EAGLE EYE"
1888 - 1907
FAMED NATIONAL LEAGUE SLUGGER
MADE 2,930 HITS FOR LIFETIME .309 BATTING
AVERAGE. HOLDS RECORD IN MAJORS FOR
FIRST BASE: FOR CHANCES ACCEPTED 25,000
MOST PUTOUTS 23,696, MOST GAMES 2,368,
PLAYED 20 SEASONS WITH PITTSBURGH,
NEW YORK, CINCINNATI AND ST. LOUIS.

JAKE BECKLEY

CLASS OF 1971

Some ballplayers are simply fun to watch, and in baseball's early days, nobody caused more delight and disbelief than Jake Beckley. Certainly the big first baseman could hit, as he finished his career with a lifetime batting average of .308 and 244 career triples. When he got really hot at the plate, he often shouted "Chickazoola!"

Because of a weak throwing arm, Beckley almost always played first base, a duty he often turned into part adventure, part comic skit. Once, the Pirates' Tommy Leach put down a bunt, and Beckley had no choice but to field it. Beckley's underhand throw to first base flew up the right-field line and Beckley then hustled to retrieve it. By this point, Leach was well around second base and eyeing home. Rather than risk another throwing error, Beckley sprinted toward the plate and barely tagged Leach out.

Recognized as a master of the hidden ball trick, Beckley tried the ploy on just about every rookie he encountered. He would hide the ball in his clothing, under his arm, even sliding it under a base. That move wasn't without its mishaps, though. One time, Beckley forgot which corner of the base he had hidden the ball under, and the runner easily scored.

Even at the plate, Beckley often embraced the unorthodox. Sometimes he flipped the bat around to bunt the ball with the handle in sacrifice situations. A young Casey Stengel saw him perform the stunt, now illegal, and demonstrated it to his disbelieving players on the New York Yankees a half century later.

"I showed our players," Stengel said, "and they say it's the silliest thing they ever saw, which it probably is but Beckley done it."

A left-handed batter and thrower, Beckley hailed from Hannibal, Missouri, where Mark Twain set the tales of Tom Sawyer and Huckleberry Finn. In his own way, Beckley was as colorful as those literary heroes. After bouncing between several western teams in 1886–87, he caught on with the Pittsburgh Alleghenys and led the team in hitting, earning the nickname "Eagle Eye."

Beckley finished his twenty-year career with the St. Louis Cardinals. When he retired after the 1907 season, Beckley was baseball's all-time leader in triples. He was elected to the National Baseball Hall of Fame in 1971.

"Comedy, desperation, wisdom and valor, all in one package," former Detroit player and manager George Moriarty wrote, "were Beckley's prize contributions for [Lou] Gehrig and [Jim] Bottomley and the best of the modern first basemen to shoot at."

—T. Wendel

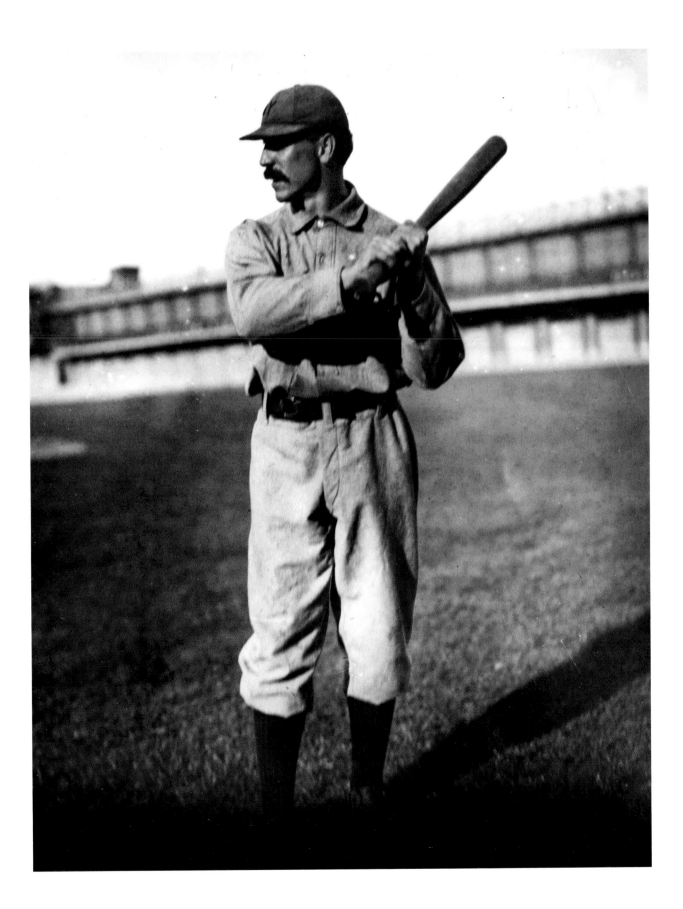

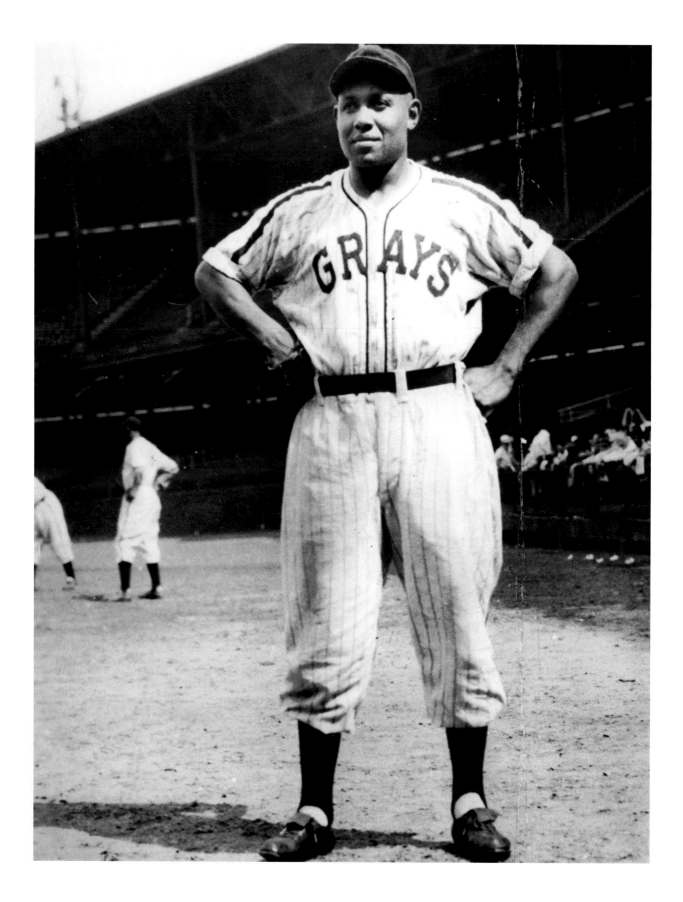

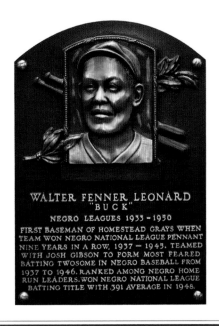

WALTER FENNER LEONARD
"BUCK"
NEGRO LEAGUES 1933-1950
FIRST BASEMAN OF HOMESTEAD GRAYS WHEN
TEAM WON NEGRO NATIONAL LEAGUE PENNANT
NINE YEARS IN A ROW, 1937 — 1945. TEAMED
WITH JOSH GIBSON TO FORM MOST FEARED
BATTING TWOSOME IN NEGRO BASEBALL FROM
1937 TO 1946. RANKED AMONG NEGRO HOME
RUN LEADERS. WON NEGRO NATIONAL LEAGUE
BATTING TITLE WITH .391 AVERAGE IN 1948.

BUCK LEONARD

CLASS OF 1972

It was in 1999 that the old "Bible of Baseball," the *Sporting News*, created its list of the top one hundred baseball players of all time. It was in that ranking that they placed Buck Leonard, one of just five players on the list who spent most, if not all, of their career in the Negro Leagues, at number 47.

In fact, at the age of forty-five, with Jackie Robinson having broken baseball's color barrier, he was offered a major league contract but turned it down, later saying, "In 1952, I knew I was over the hill. . . . I didn't try to fool myself."

Off the field Buck Leonard was even-tempered, modest, and loyal, while on the field he was all business. The left-handed hitter was a model of consistency and one of the best pure hitters ever to play Negro Leagues baseball.

The slugging first baseman spent his entire career, spanning seventeen seasons, with the Homestead Grays, the longest term of service for a player with one team in Negro League history. During that span, Leonard competed in a league-record eleven East-West All-Star Games, from 1937 to 1945, while being part of nine consecutive Negro National League championship teams.

In 1942 he slugged forty-two home runs, and, not so coincidentally, the Grays found themselves in four consecutive Negro League World Series.

Legendary basketball man Eddie Gottlieb, who worked in baseball at the time, recalled, "Buck Leonard was as smooth a first baseman as I ever saw. . . . In those days the first baseman on a team in the Negro Leagues often played the clown. They had a funny way of catching the ball so the fans would laugh, but Leonard was strictly baseball—a great glove, a hell of a hitter, and drove in runs."

Later in life, after his playing days had wound down, Leonard went back to school. He hadn't been able to get a high school diploma as a youth because the high school in Rocky Mount, North Carolina, didn't allow African Americans to attend. At the age of fifty-two, he could finally call himself a high school graduate.

Leonard once recalled, "We in the Negro Leagues felt like we were contributing something to baseball, too, when we were playing. We played with a round ball and we played with a round bat. And we wore baseball uniforms and . . . we loved the game and we liked to play it. But we thought we should have and could have made the Major Leagues, and all of us would have desired to play in the Major Leagues because we felt and we knew that that was the greatest game."

Leonard served as an ambassador for Negro Leagues baseball until his death in 1997.

—F.B.

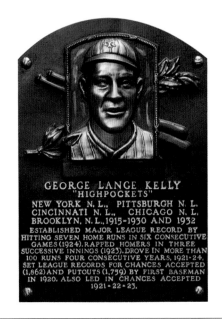

GEORGE LANGE KELLY
"HIGHPOCKETS"
NEW YORK N. L., PITTSBURGH N. L.
CINCINNATI N. L., CHICAGO N. L.
BROOKLYN, N. L.,1915-1930 AND 1932
ESTABLISHED MAJOR LEAGUE RECORD BY
HITTING SEVEN HOME RUNS IN SIX CONSECUTIVE
GAMES (1924). RAPPED HOMERS IN THREE
SUCCESSIVE INNINGS (1923). DROVE IN MORE THAN
100 RUNS FOUR CONSECUTIVE YEARS, 1921-24.
SET LEAGUE RECORDS FOR CHANCES ACCEPTED
(1,862) AND PUTOUTS (1,759) BY FIRST BASEMAN
IN 1920. ALSO LED IN CHANCES ACCEPTED
1921-22-23.

GEORGE KELLY

CLASS OF 1973

The slick first baseman nicknamed "High Pockets" spent sixteen summers in the majors, but that wasn't enough for George Kelly. He continued playing baseball in the minors for several seasons after leaving the National League at age thirty-six, then spent years afterward as a coach and a minor league manager.

After growing up in San Francisco, Kelly was involved in baseball as a profession for four decades. He got his start after his uncle Bill Lange, a big league star in the 1890s, made a phone call pumping up his eighteen-year-old nephew for a minor league tryout.

Kelly had already made a name for himself in his neighborhood.

"I played for the Ideal Billiard Parlor and the Union Iron Works," Kelly said of his teenage years. "The latter team was terrific and we played to crowds of up to 5,000 at Golden Gate Park."

During Kelly's first season in the minors, in Victoria, British Columbia, in 1914, word reached him that the New York Giants had their eye on him. "It was my greatest thrill," Kelly said. "There was one thought in my head: [Giants manager John] McGraw wants *me*."

At first Kelly wasn't so sure he was going to last very long in the majors.

"I didn't get a hit the first 23 times I got up to bat for the Giants and I was getting an awfully hard time from the newspapers," Kelly said. "One guy wrote that he was ready to retire once he saw Kelly get a hit. Somebody else said that I hit some of the prettiest fly balls ever caught."

Kelly spent his prime years with New York, where he became one of baseball's better power hitters of the 1920s, when the Giants won four consecutive pennants. Kelly led the NL with twenty-three home runs in 1921, when the Giants won their first World Series over the Yankees. Kelly won back-to-back rings when the Giants beat the Yankees in five games in the 1922 World Series.

One of a handful of tangible souvenirs from his playing days kept by Kelly was a large bat that practically qualified as a club. It was his weapon of choice on his finest hitting day, a three-homer, one-double, one-single assault on the Cubs at Wrigley Field. "Sure it's heavy," Kelly said. "It had to be. If we swung a 30-ounce bat like these guys do today we'd have been left holding nothing but a handle when we tried to hit one of those balls we used 40 years ago. Even the sound of the bat on the ball is different than what it used to be."

Kelly was elected to the National Baseball Hall of Fame in 1973, some forty years after he retired.

"They called him 'High Pockets,' but George Kelly was more than just a colorful appellation," the Associated Press noted at the time. "To Frankie Frisch, he was one of the finest first basemen who ever lived. To Waite Hoyt, he was a dangerous man in the clutch. And to the people who vote for such things, he is a perfect choice for the Baseball Hall of Fame."

—B.F.

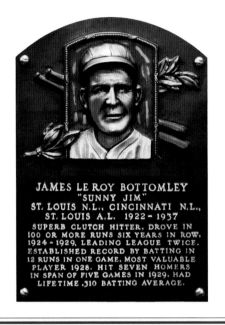

JAMES LE ROY BOTTOMLEY
"SUNNY JIM"
ST. LOUIS N.L., CINCINNATI N.L.,
ST. LOUIS A.L. 1922-1937
SUPERB CLUTCH HITTER. DROVE IN
100 OR MORE RUNS SIX YEARS IN ROW,
1924-1929, LEADING LEAGUE TWICE.
ESTABLISHED RECORD BY BATTING IN
12 RUNS IN ONE GAME. MOST VALUABLE
PLAYER 1928. HIT SEVEN HOMERS
IN SPAN OF FIVE GAMES IN 1929. HAD
LIFETIME .310 BATTING AVERAGE.

JIM BOTTOMLEY

CLASS OF 1974

The sixteen-year first baseman for the St. Louis Cardinals, Cincinnati Reds, and St. Louis Browns was almost always in a good mood, so Jim Bottomley's nickname became "Sunny Jim." And he kept a smile on his face right up until he retired to his 127-acre farm in Missouri.

Before he headed back to the farm, Bottomley served as manager of the Browns in 1937, succeeding one of his old teammates, Rogers Hornsby, something he didn't expect to happen. "I guess it's a swell break for me," Bottomley said, "but then again I feel a bit sad about it all. You know what I mean, stepping into Rog Hornsby's shoes. That's what makes it tough on me."

The whole managing thing was so new to Bottomley that he welcomed a scribe to his table on a train and interrupted the downing of an ear of corn and a steak, which his wife indicated was getting cold. "I can always eat," Bottomley told her. "But I don't think you realize that your hubby has stepped into an important job."

Bottomley could always hit, too. The two-time World Series champion batted .310 but also set one of the most enduring batting marks in baseball history. During one game for the Cardinals, Bottomley stroked two home runs, a double, and three singles for twelve runs batted in. The RBI record, tied once, has stood since 1924.

"He was the best clutch hitter I ever saw," said Hall of Fame second baseman Frankie Frisch of Bottomley. "It was a standing joke with us on the Cardinal bench whenever the fellow in front of Jim was given a walk. Everyone would giggle. Imagine walking someone to get at Bottomley. And Jim loved it. He'd just grin wider and strut up to the plate. Pow!"

Growing up in a rural area and plying his trade with such minor league franchises as the Mitchell Kernels in South Dakota and the Houston Buffaloes, Bottomley was not the most sophisticated player when he first showed up at Sportsman's Park for the Cardinals in 1922. Branch Rickey, future Hall of Fame executive and Cardinals manager at the time, said the only reason Bottomley had taken a taxi to the ballpark was for fear he would get lost on his own in a big city. "His heart was broken when the driver charged him over $4 fare. He wore a pair of shoes that were the largest I ever saw. I give you my word those shoes were number 20, if shoes were numbered that high."

Bottomley showed his innocence in another fashion. When he first approached the bat rack, he wondered about the label on a huge club sticking out taller than all others. "Who's this Mr. Fungo?" he asked.

Bottomley didn't want to retire from baseball when he did, but his body was letting him down. He had been hiding an arthritic condition, had bone spurs growing on his vertebrae, and announced that his wife said they had enough money to retire. "When I'm no longer wanted, I'll slide out gracefully and forget it," Bottomley once said.

—L.F.

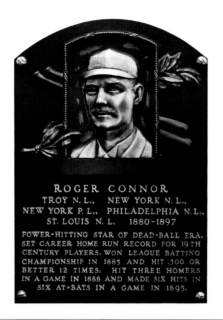

ROGER CONNOR
TROY N. L., NEW YORK N. L.,
NEW YORK P. L., PHILADELPHIA N. L.,
ST. LOUIS N. L. 1880-1897
POWER-HITTING STAR OF DEAD-BALL ERA.
SET CAREER HOME RUN RECORD FOR 19TH
CENTURY PLAYERS. WON LEAGUE BATTING
CHAMPIONSHIP IN 1885 AND HIT .300 OR
BETTER 12 TIMES. HIT THREE HOMERS
IN A GAME IN 1888 AND MADE SIX HITS IN
SIX AT-BATS IN A GAME IN 1895.

ROGER CONNOR

CLASS OF 1976

Many of today's baseball fans recall the excitement and anticipation of watching Hank Aaron slowly approach the most hallowed record in American sports—Babe Ruth's 714 career home runs. Hammerin' Hank finished the 1973 season just one home run short of tying the Babe, and the excitement simmered all winter, leading to many hot stove discussions about home runs. Inevitably, some wondered whose career record Ruth himself had broken.

The name surprised baseball fans, since it wasn't a familiar one. Roger Connor, with his 138 home runs in the nineteenth century, had been unjustly forgotten. When the young Ruth surpassed his career total in 1921, the event went almost unnoticed.

The home run itself was not a revered part of the game when Connor played from 1880 to 1897. Raw power was in short supply relative to today, and the game's strategists preferred "inside baseball," the game of stolen bases and hit-and-run plays.

Yet one gets the sense that Connor could have played in any era. At six foot three and 220 pounds, he'd be just an average-sized player today, but his batting punch would still stand out on the field.

"He is as fine a specimen of physical development as any in the profession, being a few inches over six feet in height, weighing over two hundred pounds, without an ounce of superfluous flesh, and being admirably proportioned.

"Notwithstanding his great size, he is endowed with more than the average amount of activity, and evidently possesses extraordinary powers of endurance," declared the *New York Clipper*.

The left-handed first baseman hit more than ten home runs in a season seven times, a nineteenth-century record. In twelve seasons he hit over .300, leading the National League with a personal-best .371 in 1885. On September 10, 1881, he hit the major leagues' first grand slam home run.

His prodigious power produced a most memorable home run on September 11, 1886. At the original Polo Grounds, at 110th Street and Fifth Avenue, Connor launched a tape-measure home run over the right-field wall that landed on 112th Street. According to the *New York Times*, "He met it squarely and it soared upward with the speed of a carrier pigeon. All eyes were turned on the tiny sphere as it soared over the head of Charlie Buffington in right field."

Members of the New York Stock Exchange in attendance that day were so impressed that they passed a hat and came up with $500, which they used to present him with a gold watch.

Upon his retirement, Connor was the career leader in walks (1,002), triples (233), and home runs, and was runner-up in hits, runs, and runs batted in. His 244 career stolen bases were also of note, as was his career batting average of .316.

His manager Jim Mutrie was so enamored of Connor and fellow stars John Montgomery Ward and Buck Ewing that he called them "my giants," reportedly leading to the franchise name still sported by his old club, now known as the San Francisco Giants.

—T. Wendel

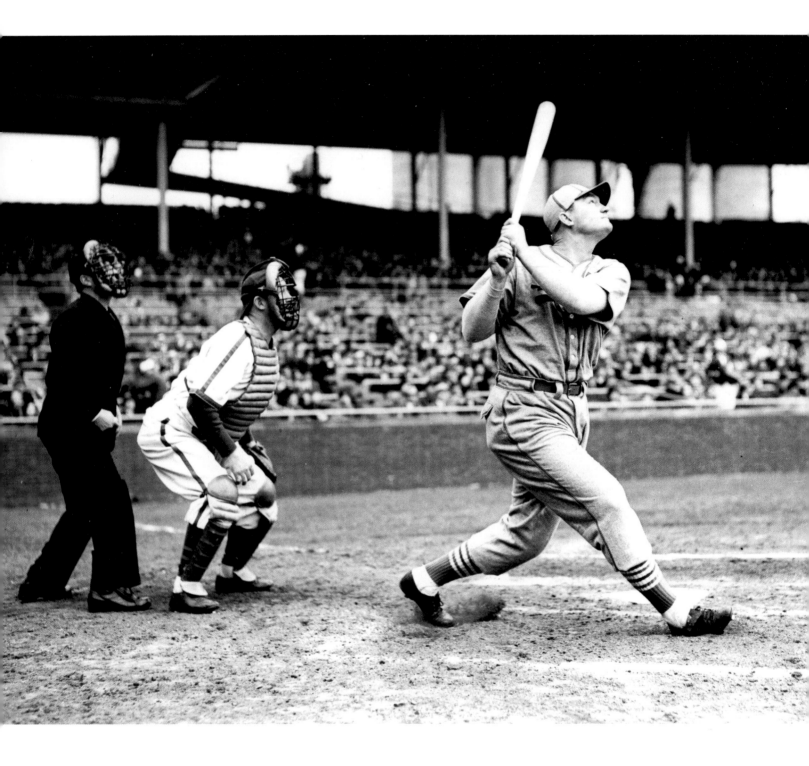

JOHN ROBERT MIZE
"THE BIG CAT"
ST. LOUIS N.L., NEW YORK N.L.,
NEW YORK A.L., 1936-1953
KEEN-EYED SLUGGER SMASHED 359 HOME RUNS
AND BATTED .312 IN 15-YEAR CAREER WHILE
TOPPING .300 MARK NINE SEASONS IN A ROW.
SET MAJOR LOOP RECORDS BY HITTING THREE
HOMERS IN A GAME SIX TIMES AND TRIO IN
SUCCESSION ON FOUR OCCASIONS. WON N.L.
BATTING TITLE ONCE, LED OR SHARED LEAD
IN HOMERS AND SLUGGING PCT. FOUR TIMES,
RUNS BATTED IN AND TOTAL BASES THRICE.

JOHNNY MIZE

CLASS OF 1981

In many ways Johnny Mize was the perfect hitter. He hit for average, batted with power, and drew walks. His sheer size and silky swing instilled a feeling of absolute intimidation in opposing pitchers.

A native of Georgia, Mize signed with the major leagues' southernmost team, the St. Louis Cardinals. He made his debut in 1936 and immediately applied heavy damage to National League pitching. Playing almost exclusively against right-handers, he batted .329 with a .577 slugging percentage.

Mize became an everyday player in 1937, but his rates of production did not suffer. His .427 on-base percentage and .595 slugging percentage made him an offensive terror. Over the next three seasons Mize put up historic numbers, as he won three slugging percentage titles, two home run crowns, and a batting title. He twice finished as runner-up in the league's MVP voting.

Mize also cut a distinctive posture at the plate. Burly and full faced, he would smear mud under his eyes so as to cut down on glare from the sun. He swung with such graceful balance that he became known as "The Big Cat." "Relaxed, Mize dug in his left foot," Hall of Famer Stan Musial wrote in the *Sporting News*. "Like Ted Williams, he would move only the right foot away on pitches up and in, then swing with a smooth, deceptively easy stroke." Unlike many other hitters, Mize did not step out of the batter's box between pitches but remained deadly still as he awaited the next delivery.

He appeared destined for a long period of stardom in St. Louis, but after a slight downturn in 1941, the Redbirds traded him to the New York Giants for three lesser players and $50,000. Cardinals executive Branch Rickey believed in trading players one season too soon, but in Mize's case, he pulled the trigger far too early.

Mize put up a solid season in 1942, as he led the league in RBI. But further returns on the deal were delayed by the realities of World War II. Mize missed the next three seasons while fulfilling a commitment to the Navy. He finally received his discharge in October 1945.

He showed no signs of rust when he returned to the Giants, as he hit home runs at a remarkable rate, but he also suffered a broken hand and a fractured toe, causing him to lose the home run title. There would be no such injuries in 1947, when he reached a career-high fifty-one home runs. A tremendously smart hitter, he struck out only forty-two times that season.

In 1949 Mize expressed some dismay over his playing time, so the Giants sold him to the New York Yankees. No longer an everyday player, Mize became a valuable part-time performer on five consecutive Yankees world championship teams.

Though often overshadowed by the era's other great hitters, Mize was well appreciated by his contemporaries. "I was impressed mostly with that sweet swing and the fact that he was a power hitter who rarely struck out," Musial told sportswriter Bob Broeg. "He had the greatest batting eyes I've ever seen." Coming from someone like "Stan the Man," that was high praise indeed for "The Big Cat."

—B.M.

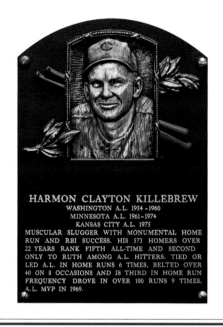

HARMON CLAYTON KILLEBREW
WASHINGTON A.L. 1954–1960
MINNESOTA A.L. 1961–1974
KANSAS CITY A.L. 1975
MUSCULAR SLUGGER WITH MONUMENTAL HOME
RUN AND RBI SUCCESS. HIS 573 HOMERS OVER
22 YEARS RANK FIFTH ALL-TIME AND SECOND
ONLY TO RUTH AMONG A.L. HITTERS. TIED OR
LED A.L. IN HOME RUNS 6 TIMES, BELTED OVER
40 ON 8 OCCASIONS AND IS THIRD IN HOME RUN
FREQUENCY DROVE IN OVER 100 RUNS 9 TIMES.
A.L. MVP IN 1969.

HARMON KILLEBREW

CLASS OF 1984

Two words describe Harmon Killebrew succinctly and accurately: consummate gentleman. Always soft-spoken and considerate with those who approached him, Killebrew would never cast a disparaging remark. His kind and gracious personality belied what he could do with a baseball bat, as he terrorized major league pitchers throughout the 1960s and early 1970s.

A product of Idaho, Killebrew signed as a bonus baby with the old Washington Senators. He began as a second baseman but soon moved to third base, and eventually to first, also playing nearly five hundred games in the outfield. In his first five seasons, he found himself constantly on the shuttle between Washington and the minor leagues. He finally broke through in 1959, his sixth season, as he took a share of the American League lead in home runs.

Yet it was as a member of the transplanted Minnesota Twins that Killebrew made his mark. In 1961, his first year with Minnesota, he walloped forty-six home runs. Focused more on hitting for power than average, he led the American League in round-trippers from 1962 to 1964.

Killebrew attributed his raw power to growing up in Idaho. "When I was 14, and for the next four years, I was lifting and hauling ten-gallon milk cans full of milk," he told the *Washington Post*. "That will put muscles on you even if you're not trying."

With those muscles, he struck a definitive pose on the playing field. He looked so well balanced, so firmly entrenched in the batter's box with his tree-trunk legs, that it would have taken a forklift to move him off the plate.

Arguably, his best season came in 1969; he won the American League MVP and led the Twins to their first division title. He led the league in home runs, on-base percentage, walks, and RBI. He even stole eight bases in ten attempts.

Killebrew's statistical dominance throughout the 1960s becomes even more impressive in light of how often he switched positions. He put in significant time at third base and first base, sometimes appearing at both spots in the same game. Yet he never complained. Instead, he put forth a sense of everlasting calm. Not surprisingly, he was never thrown out of a game during his career. He never even threw his helmet in anger.

For most of his career, Killebrew remained underrated, partly because of his emphasis on hitting home runs and drawing walks over hitting for a high average. Yet there was more to it than that. He was the antithesis of a self-promoter. Completely humble, he was uncomfortable talking about his own accomplishments.

His impact was not lost on his teammates. "Harmon Killebrew was a gem," Twins teammate Rod Carew said in a written statement upon learning of Killebrew's death in 2011. "He was a consummate professional who treated everyone from the brashest of rookies to the groundskeepers to the ushers in the stadium with the utmost of respect. . . . He was a Hall of Famer in every sense of the word."

—B.M.

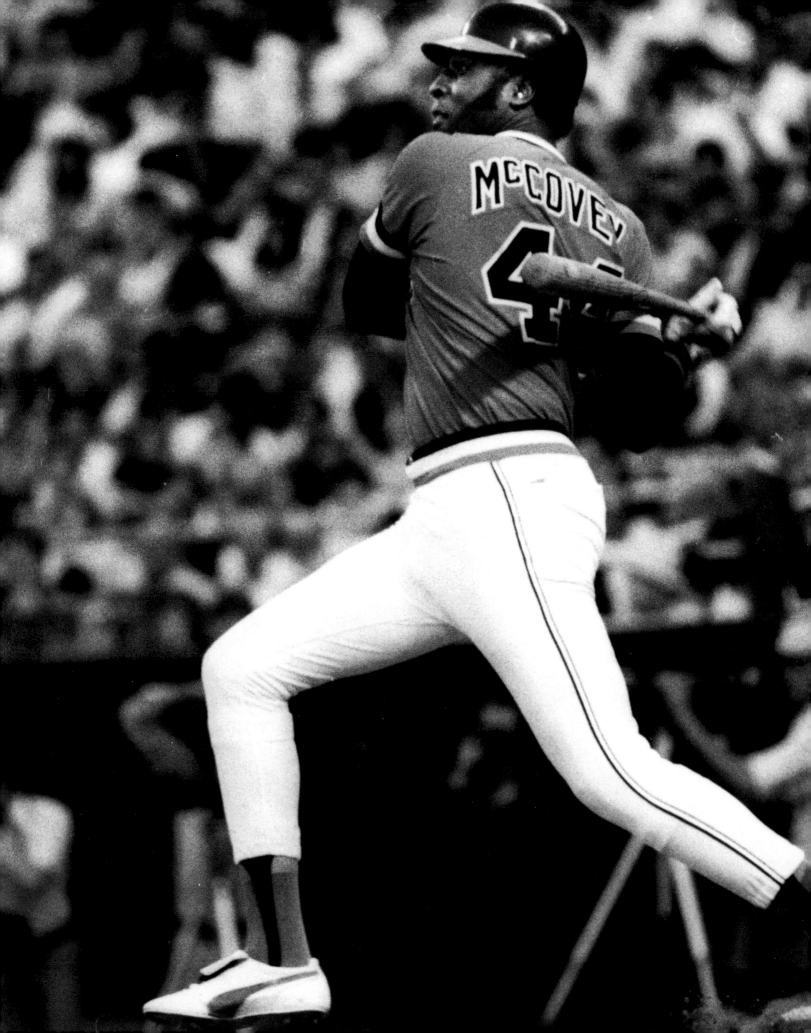

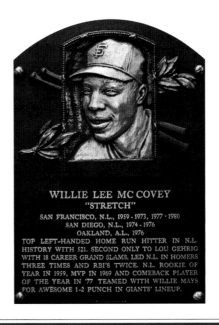

WILLIE LEE MC COVEY
"STRETCH"
SAN FRANCISCO, N.L., 1959 · 1973, 1977 · 1980
SAN DIEGO, N.L., 1974 · 1976
OAKLAND, A.L., 1976
TOP LEFT-HANDED HOME RUN HITTER IN N.L.
HISTORY WITH 521. SECOND ONLY TO LOU GEHRIG
WITH 18 CAREER GRAND SLAMS. LED N.L. IN HOMERS
THREE TIMES AND RBI'S TWICE. N.L. ROOKIE OF
YEAR IN 1959, MVP IN 1969 AND COMEBACK PLAYER
OF THE YEAR IN '77 TEAMED WITH WILLIE MAYS
FOR AWESOME 1-2 PUNCH IN GIANTS' LINEUP.

WILLIE McCOVEY

CLASS OF 1986

In the 1960s, the San Francisco Giants had a roster filled with stars: Willie Mays, Orlando Cepeda, the Alou brothers, and Juan Marichal. But few were more popular in the Bay Area than Willie McCovey.

The ballplayer they called "Stretch" broke into the majors in 1959, and Giants manager Bill Rigney decided to see what McCovey had. So he moved Mays up to second in the batting order and hit the rookie third. McCovey responded by going 4-for-4, including two triples, off veteran hurler Robin Roberts. The newcomer went on to hit .354 and win National League Rookie of the Year honors. "He could hit a ball farther than anyone I ever played with," said Mays.

Soon McCovey became such a force in the National League that New York Mets manager Casey Stengel once asked his pitching staff, "Where do you want us to defense McCovey—in the upper or lower deck?" McCovey played twenty-two years in the majors, collecting 521 home runs, which tied him with Ted Williams on the all-time list.

"There's no telling how many home runs he would have hit if those knees weren't bothering him all the time and if he played in a park other than Candlestick," Hank Aaron told the *Oakland Tribune*.

Longtime outfielder Rusty Staub said, "Willie was a joy to watch at the plate. What I remember most, though, is the way he always handled himself with so much poise. He always seemed to have the right attitude about everything."

While McCovey won admiration from his fellow sluggers, he left a different impression on rival pitchers.

"I can remember those big, long arms and that short bat," former Los Angeles Dodgers pitcher Don Drysdale said in 1986. "As hard as he swung, it's remarkable how often he made good contact."

Drysdale recalled one time when he threw the left-handed-hitting McCovey his best sinker, and the Giants slugger promptly drove it the opposite way, to left field. "I remember saying, 'He belongs in another league,'" Drysdale said. "That was my best stuff and he hit it the other way for a homer."

McCovey often pulled the ball to right—so much so that opposing teams, especially the Cincinnati Reds, deployed a radical shift, with only the left fielder positioned to the left side of second base. Perhaps as a way to cope, McCovey soon gained a reputation for hitting the ball up the middle, too.

"It certainly wasn't too funny when you faced him," St. Louis ace Bob Gibson said. "You didn't want to get the ball over the plate, because he had a tendency of hitting it through the box—hard."

Former pitcher Roger Craig agreed: "He was so strong and he had great bat speed. . . . Willie could hit the ball out of the park quicker than anyone I ever saw."

As a salute to the hitting star, the body of water beyond the right-field pavilion in San Francisco's AT&T Park is known simply as McCovey Cove.

—T. Wendel

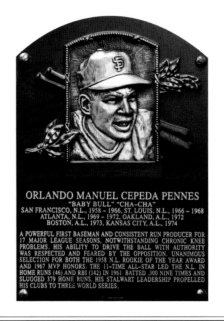

ORLANDO MANUEL CEPEDA PENNES
"BABY BULL" "CHA-CHA"
SAN FRANCISCO, N.L., 1958 – 1966, ST. LOUIS, N.L., 1966 – 1968
ATLANTA, N.L., 1969 – 1972, OAKLAND, A.L., 1972
BOSTON, A.L., 1973, KANSAS CITY, A.L., 1974

A POWERFUL FIRST BASEMAN AND CONSISTENT RUN PRODUCER FOR
17 MAJOR LEAGUE SEASONS, NOTWITHSTANDING CHRONIC KNEE
PROBLEMS. HIS ABILITY TO DRIVE THE BALL WITH AUTHORITY
WAS RESPECTED AND FEARED BY THE OPPOSITION. UNANIMOUS
SELECTION FOR BOTH THE 1958 N.L. ROOKIE OF THE YEAR AWARD
AND 1967 MVP HONORS. THE 11-TIME ALL-STAR LED THE N.L. IN
HOME RUNS (46) AND RBI (142) IN 1961 BATTED .300 NINE TIMES AND
SLUGGED 379 HOME RUNS. HIS STALWART LEADERSHIP PROPELLED
HIS CLUBS TO THREE WORLD SERIES.

ORLANDO CEPEDA

CLASS OF 1999

Orlando Cepeda was born into a world of baseball. By the time his playing career was finished, he had changed that world with his all-around talent.

Cepeda carried on a legacy for his father, Perucho Cepeda, a power-hitting shortstop who was nicknamed "The Babe Ruth of Puerto Rico." During Orlando's preteen years, Perucho refrained from trying to steer his youngest son toward baseball. That changed as Orlando grew bigger and stronger, developing a physique best suited to baseball.

"One day he came down and saw me playing basketball," Cepeda said. "He came home and threw my basketball out of the house. 'Baseball, or nothing,' he said. He was right."

Perucho wanted his son to refine his skills. He repeatedly schooled Orlando in the fundamentals of the game. Perucho was strict, demanding, and unrelenting. "One time we played an important game—the championship of Puerto Rico of amateur ball," Orlando said. "They hit a fly ball, I dropped it, I struck out two times. He came down and said, 'You got two more times [at bat]. If you don't do anything, you don't come home tonight.' He meant it. He meant it."

Improving under his father's discipline, Cepeda signed with the New York Giants in 1955. Unfortunately, Perucho died from malaria before Orlando established himself in the minor leagues; the loss devastated Cepeda, who initially played so poorly that his career nearly ended. But Cepeda resurfaced with a club in

Kokomo, Indiana, where manager Walt Dixon took him under his wing. Recognizing Cepeda's struggles with speaking English and adapting to a new culture, Dixon supported his developing star.

Three years later, Cepeda made his debut with the San Francisco Giants. He emerged as a productive power-hitting first baseman en route to the National League Rookie of the Year Award in 1958. In 1961 "The Baby Bull" put together his best season in San Francisco, with a .311 average and a .609 slugging percentage. The following year, Cepeda and the Giants won the National League Pennant.

Cepeda remained in San Francisco until 1966. With two star first basemen in Cepeda and Willie McCovey, the Giants decided to trade Cepeda to the Cardinals for left-hander Ray Sadecki. The Cardinals reaped the benefits of one of the best trades in franchise history. In 1967 Cepeda emerged as a vocal team leader, was voted the unanimous National League MVP, and helped the club to a world championship.

After leading St. Louis to the NL Pennant again in 1968, Cepeda was shipped to the Atlanta Braves for Joe Torre. Cepeda helped the Braves advance to the postseason, this time by winning the newly formed National League West Division title.

Wherever Cepeda went, he had an impact, but nowhere more so than in St. Louis. "He's always optimistic," Hall of Fame outfielder Lou Brock told *Sport* magazine. "You can get [upset] in this game, you know. But Cepeda is always there, very energetic, full of fire, and it's catching."

—B.M.

ATANASIO PÉREZ RIGAL
"TONY"
CINCINNATI, N.L., 1964-1976, 1984-1986
MONTREAL, N.L., 1977-1979
BOSTON, A.L., 1980-1982
PHILADELPHIA, N.L., 1983

A CLUTCH PERFORMER THROUGHOUT AN ILLUSTRIOUS 23-YEAR
CAREER, HE TORMENTED THE OPPOSITION WITH HIS ABILITY TO
CONSISTENTLY DRIVE IN RUNS. HIS COMPOSURE UNDER PRESSURE LED
TO 379 HOME RUNS, 505 DOUBLES AND 1,652 RBI, INCLUDING SEVEN 100-
RBI SEASONS AND 954 RBI IN THE 1970s. A CATALYST OF CINCINNATI'S
TALENTED BIG RED MACHINE TEAMS DURING THE 1970s, HIS SUBTLE
LEADERSHIP AND TIMELY HITTING HELPED PACE THOSE CLUBS TO
FIVE DIVISION TITLES, FOUR PENNANTS AND TWO WORLD SERIES
CHAMPIONSHIPS.

TONY PÉREZ

CLASS OF 2000

"Tony Pérez was not the best hitter I ever saw," former Reds manager and Hall of Famer Sparky Anderson wrote in his autobiography. "Nobody was better, though, with the game on the line. He did it with concentration as much as with his bat. He was the glue that kept it all stuck together. I never realized until we traded him after the 1976 World Series. It was the biggest mistake the Cincinnati Reds ever made. . . . We would have won at least two more championships with Tony Pérez."

Cincinnati's "Big Red Machine" had many stars—Pete Rose, Joe Morgan, and Johnny Bench, to name a few—but none was more important than Tony Pérez. Pérez was arguably the top run producer of the 1970s. "Pete [Rose] would get his 200 hits, and [Johnny] Bench would do his thing," said former teammate Pat Corrales. "And Tony would get shoved in the background, driving in his 100 runs every year. You'd see it in the notes at the end of the stories in the paper—'Oh, by the way, Pérez hit a three-run homer to win the game.'"

A native of Cuba, Pérez left a job in a Havana sugarcane factory at the age of seventeen to sign with the Reds organization. By 1967 he was the full-time third baseman in Cincinnati and notched the first of seven 100-RBI campaigns. "With men in scoring position and the game on the line," said Willie Stargell,

longtime slugger for the rival Pirates, "Tony's the last guy an opponent wanted to see."

A skilled batsman in the clutch, Pérez competed in five World Series and blasted three home runs in the 1975 Fall Classic against the Boston Red Sox, including a shot off Bill Lee in the Reds' 4–3 victory in Game 7. "Nobody was better with men on base than 'Doggie,'" teammate and fellow Hall of Famer Joe Morgan said. "Some of us may have gotten more attention, but he was the guy who made the 'Big Red Machine' go."

Pérez was a positive influence on those around him and in the clubhouse, especially his Latino teammates. "[Pérez] was a fatherly type in the clubhouse, especially to the Spanish ballplayers," said longtime teammate Pete Rose. "They looked up to him as well as relating to him through his background and language." Another longtime teammate, Johnny Bench, added, "Tony cast a net over the entire team with his attitude. He was always up, always had a sense of humor."

Of the 1,652 RBI Pérez collected over his twenty-three-year big league career, the slugging first baseman and seven-time All-Star totaled 954 in the 1970s, second only to Hall of Famer and former Reds teammate Johnny Bench's 1,013.

Perhaps Sparky Anderson said it best: "If there's a runner on second base, there isn't anybody I'd rather see walk to the plate than Tony Pérez. He turns mean with men on base."

—T. Wendel

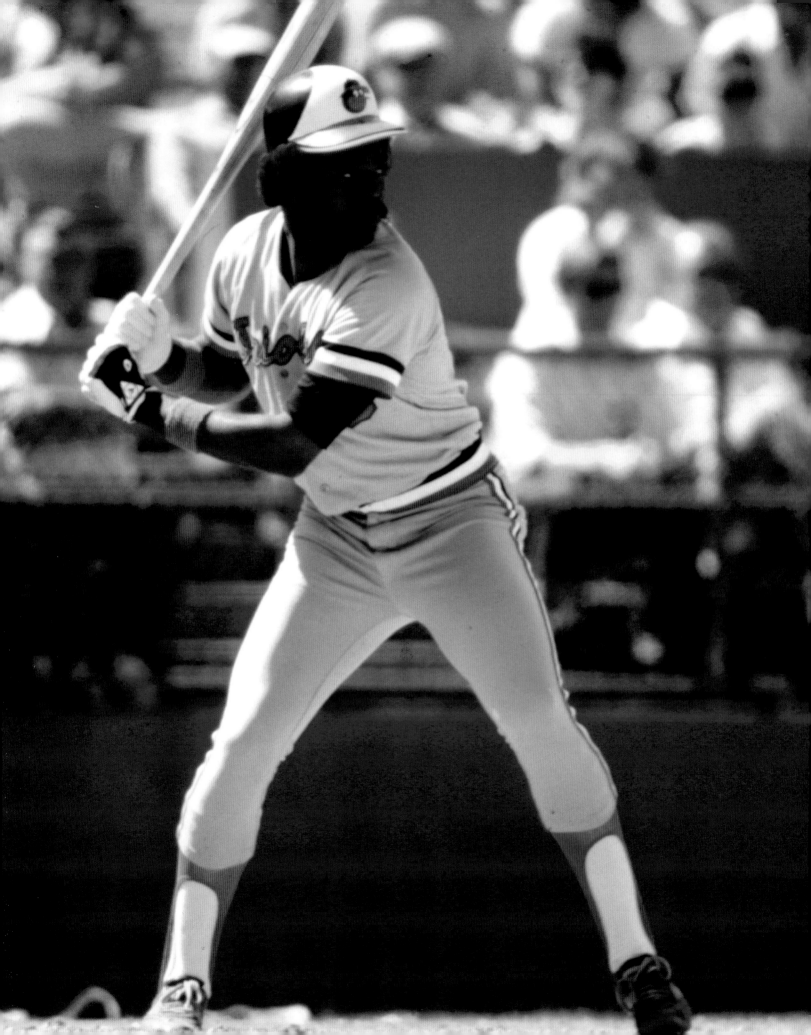

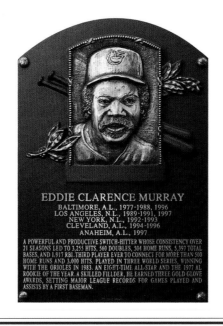

EDDIE CLARENCE MURRAY
BALTIMORE, A.L., 1977-1988, 1996
LOS ANGELES, N.L., 1989-1991, 1997
NEW YORK, N.L., 1992-1993
CLEVELAND, A.L., 1994-1996
ANAHEIM, A.L., 1997

A POWERFUL AND PRODUCTIVE SWITCH-HITTER WHOSE CONSISTENCY OVER
21 SEASONS LED TO 3,255 HITS, 560 DOUBLES, 504 HOME RUNS, 5,397 TOTAL
BASES, AND 1,917 RBI. THIRD PLAYER EVER TO CONNECT FOR MORE THAN 500
HOME RUNS AND 3,000 HITS. PLAYED IN THREE WORLD SERIES, WINNING
WITH THE ORIOLES IN 1983. AN EIGHT-TIME ALL-STAR AND THE 1977 AL
ROOKIE OF THE YEAR. A SKILLED FIELDER, HE EARNED THREE GOLD GLOVE
AWARDS, SETTING MAJOR LEAGUE RECORDS FOR GAMES PLAYED AND
ASSISTS BY A FIRST BASEMAN.

EDDIE MURRAY

CLASS OF 2003

Eddie Murray may have been a man of few words, but he belongs in select company. Murray was only the third player to collect three thousand hits and five hundred home runs. The others were Willie Mays and Hank Aaron.

When Murray retired in 1997, he was the all-time career RBI leader among switch-hitters. A three-time Gold Glove Award winner at first base, Murray was also an eight-time All-Star and a fan favorite in Baltimore, where he played for thirteen seasons with the Orioles and was a major contributor to the franchise's winning the World Series in 1983.

"To this day, Eddie has the biggest heart of any of my friends," Cal Ripken, Murray's teammate in Baltimore, once told the *Washington Post*. "He's always been fun to be around. He's got a great sense of humor. When I was a young player, he loosened me up and helped me be accepted by the team. And he's the best teammate I ever had to go side-by-side into battle."

Kenny Lofton, who played with Murray in Cleveland, appreciated how Murray played the game. "He's a true professional," Lofton once told the *New York Times*, "and cares about the little things. Like the way he gets the extra base, going from first to third. He'll slow up around second to lull the outfielder to sleep, and then puts on a burst of speed and winds up at third."

Always a student of the game, Murray reportedly had seven different batting stances—three from the right side of the plate and four from the left. "I've changed stances three times on three pitches," he once said. No wonder he had at least seventy-five RBI in each of his first twenty seasons in the big leagues.

"He was the best clutch hitter that I saw during the decade that we played together," said Mike Flanagan, another Orioles teammate. "Not only on our team, but in all of baseball."

Murray grew up in Los Angeles, practicing his craft by hitting Crisco can covers because actual baseballs were hard to come by in his neighborhood. He went on to play on a superb team at Locke High School, which included a pair of future major leaguers, pitcher Darrell Jackson and shortstop Ozzie Smith.

Selected by the Orioles in the June 1973 amateur draft, Murray reached the majors in 1977, winning American League Rookie of Year honors after he hit twenty-seven home runs and drove in eighty-eight. The following season he became Baltimore's regular first baseman and continued to put up the numbers that would earn him a place in Cooperstown.

Murray was traded to the Los Angeles Dodgers after the 1988 season and hit a career-high .330 on the West Coast in 1990. By 1994 he was in Cleveland and homered in the 1995 World Series against the Atlanta Braves.

He garnered his three-thousandth hit in June 1995 against the Minnesota Twins (as a member of the Indians) and his five-hundredth home run a season later against the Detroit Tigers (as a member of the Orioles).

—T. Wendel

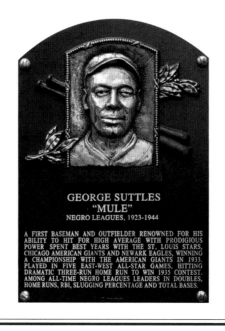

GEORGE SUTTLES
"MULE"
NEGRO LEAGUES, 1923-1944

A FIRST BASEMAN AND OUTFIELDER RENOWNED FOR HIS
ABILITY TO HIT FOR HIGH AVERAGE WITH PRODIGIOUS
POWER. SPENT BEST YEARS WITH THE ST. LOUIS STARS,
CHICAGO AMERICAN GIANTS AND NEWARK EAGLES, WINNING
A CHAMPIONSHIP WITH THE AMERICAN GIANTS IN 1933.
PLAYED IN FIVE EAST-WEST ALL-STAR GAMES, HITTING
DRAMATIC THREE-RUN HOME RUN TO WIN .935 CONTEST.
AMONG ALL-TIME NEGRO LEAGUES LEADERS IN DOUBLES,
HOME RUNS, RBI, SLUGGING PERCENTAGE AND TOTAL BASES.

MULE SUTTLES

CLASS OF 2006

"The longest ball I ever saw anybody hit, I saw Mule hit it out of the old Washington ball park," said fellow Hall of Fame inductee Leon Day. Senators owner Clark Griffith is reported to have said, "It's worth anybody's money to see that man hit." As noted by Kansas City Monarchs infielder Othello Renfroe, "Josh Gibson hit his homers on a line, Suttles's blows were high and hard." According to Braves outfielder Wally Berger, "He hit them like [Babe] Ruth . . . towering smashes."

The slugging first baseman and outfielder had a shining career during the Golden Era of Negro Leagues baseball. He played with some of the great squads of segregated ball, including the Newark Eagles, Chicago American Giants, and Birmingham Black Barons, between 1921 and 1944. He boasted a lifetime batting average of more than .325, and was particularly known for his power.

According to teammate Red Moore, everyone would gather to watch Suttles at batting practice. "They'd come out to see him hit the ball. I can tell you he was a great hitter. He was known for his power. He could really hit the ball a long way. In batting practice he hit some tape-measure balls. He could really hit it for distance."

Suttles had a soft-spoken personality and did not seek out attention. He let his bat do all the talking for him. According to Moore, "He didn't get the ballyhoo that Satchel [Paige] and Josh [Gibson] got. They were the ones who it seemed all the sportswriters put the praise on. Mule Suttles was a powerful hitter. I

can't fathom why he didn't get the publicity they got. He was a laid-back person. He didn't do much talking. He wasn't the boastful type. Sometimes the better players get overlooked."

As noted in a *Tuscaloosa News* article, "He was born at the start of a century that's passed in a town that no longer exists. He played for teams that have long since folded, in leagues that closed up shop more than 50 years ago." Despite his almost being lost to history, Suttles's reputation was sufficient to earn him a place in baseball's pantheon when he was selected to enter the Hall of Fame in 2006.

He was fondly remembered by teammates, who recall his kind nature and willingness to do anything to help win a game. As Red Moore remarked, "He was kind of a genteel person. He was friendly, but when he was on the field he went to play. He was all business." In addition to his baseball skills, Suttles was also known as a good teammate, often serving as a father figure to the younger players. Although he did not develop a reputation as a great manager, he was noted for his patience in working with young players who were still learning the game.

"We always wondered why Uncle George was never mentioned," said his niece Merriett Burley, who accepted his plaque during the Hall of Fame induction ceremony. "They always mentioned Satchel Paige and Josh Gibson and Cool Papa Bell, but they never mentioned Uncle George. We're now saying he's getting his just rewards. For this to come up now, we're all just thrilled to death."

—J.G.

BENJAMIN HARRISON TAYLOR
"BEN" "OLD RELIABLE"
PRE-NEGRO LEAGUES, 1908-1919
NEGRO LEAGUES, 1920-1929
A SOFT-SPOKEN AND MODEST TEAM LEADER WHO TRANSITIONED
FROM SUCCESSFUL PITCHER TO TOP-FLIGHT DEFENSIVE FIRST
BASEMAN AND CLUTCH HITTER. PRODUCTIVE LINE-DRIVE
HITTER WHO BATTED OVER .300 WITH REGULARITY, EXCELLING
FOR NINE SEASONS WITH INDIANAPOLIS ABCs. COMBINATION OF
VAST KNOWLEDGE OF THE GAME, STRONG LEADERSHIP SKILLS
AND TEACHING ABILITIES LED TO MANAGING POSITIONS WITH A
NUMBER OF NEGRO LEAGUES TEAMS. THE YOUNGEST OF FOUR
PROFESSIONAL BASEBALL-PLAYING BROTHERS.

BEN TAYLOR

CLASS OF 2006

Ben Taylor was surrounded by baseball talent as he was growing up in a family that produced four excellent ballplayers for the old Negro Leagues. His career spanned four decades, in which he served as a premier first baseman and as a valued manager. Playing along with his brothers C.I., Steel Arm John, and Candy Jim, Ben Taylor starred for a number of teams in the pre–Negro Leagues era of 1908 to 1919, before they moved to various teams during the Golden Era, from 1920 to 1941.

Primarily a line-drive hitter, Taylor was noted for his ability to hit to all fields. His execution of the hit-and-run was formidable, and he became known as "Old Reliable" for both his clutch hitting and his outstanding defensive play at first base. Much of his playing career involved squads for which there are few reliable statistics, but Taylor is considered to be a lifetime .300 hitter, and a man who maintained a scientific approach to the game. According to a *Chicago Defender* writer in 1935, Ben Taylor was "a man who has inspired, trained and led baseball teams for many years. . . . Ben has one of the keenest minds in all baseball and knows the game from all angles. I do not know of any player, past or present, who is more deserving of a place in Negro baseball than Ben Taylor."

He was soft-spoken and well respected. His reputation as a teacher was made clear by the great Hall of Famer Buck Leonard, who said, "I got most of my learning from Ben Taylor. He helped me when I first broke in with his team. He had been the best first baseman in Negro baseball up until that time, and he was the one who really taught me to play first base."

After his death in 1953, the *Chicago Defender* noted simply, "Ben was recognized as one of the great first basemen in Negro baseball. His name is bracketed with that of other top first sackers of that period. He was an excellent fielder and a cracking good hitter from the left side."

Historian and author Phil Dixon has written, "Highly regarded by his peers, smooth in the field, and with no weakness at the plate, Ben Taylor is well deserving of his niche among the greats of black baseball history." As biographer Todd Bolton noted, Ben Taylor's life can be summed up by the ten words on his gravestone: "A Graceful Player, A Superb Teacher, and A True Gentleman."

—J.G.

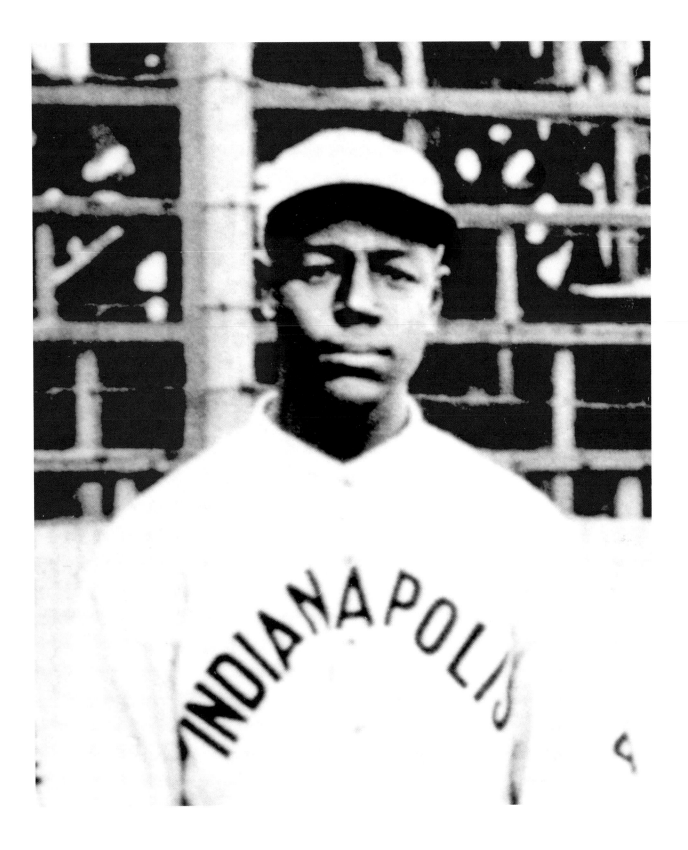

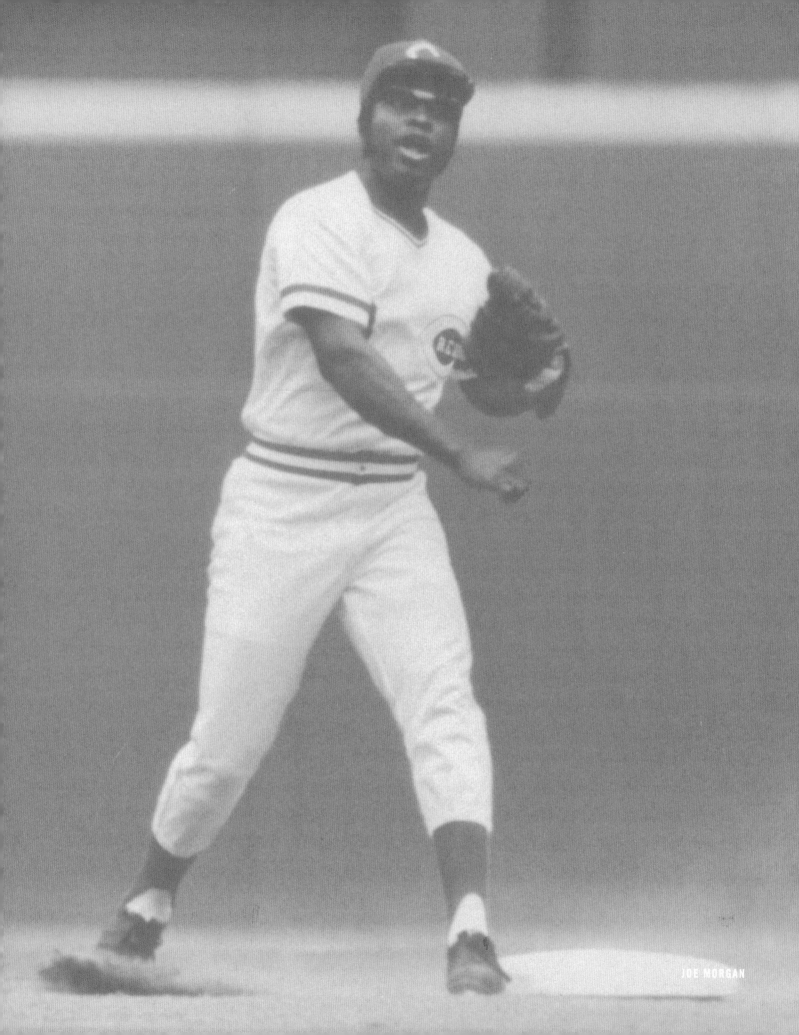

JOE MORGAN

SECOND BASEMEN

SECOND BASEMEN BY **JOE MORGAN**

Joe Morgan stood just five feet seven inches tall, but during the height of the Big Red Machine's dynasty, nobody played bigger than Morgan. In both 1975 and 1976, he was named National League Most Valuable Player on teams that won back-to-back World Series titles. Quite an accomplishment, considering those Cincinnati Reds clubs featured fellow Hall of Fame players Johnny Bench and Tony Pérez and the game's all-time hits leader, Pete Rose. Morgan prided himself on being a complete player. He won five Gold Glove Awards at second base, stole 689 bases, and clubbed 268 home runs in a twenty-two-year career that saw him play for Cincinnati, Houston, San Francisco, Philadelphia, and his hometown team—the Oakland A's.

Hindsight is a great teacher. When I was growing up, I hated the fact that some people questioned my ability on the baseball diamond because I was short. It didn't matter that I was strong for my size and had some pop in my bat. Or that I led every team I played on in home runs and runs batted in. People would still doubt me, still focus on my lack of size rather than my production. And that really bothered me. But I realize now that I was lucky to be the size I was. The fact I was small was what made me work harder; it drove me to become an all-around player; it became my motivation. My mantra throughout my baseball career was always "Work harder. Work harder. Work harder. Prove them wrong. Prove them wrong. Prove them wrong." And I think I definitely succeeded in doing that. As it turned out, my size wound up being an advantage rather than a disadvantage. If I had been four or five inches taller, maybe I wouldn't have been motivated to work as hard as I did to become the player that I became. So the moral of my story is that sometimes things that are perceived as weaknesses are really strengths.

I was introduced to the game of baseball at a very early age. My mom tells the story that not long after I was born in Bonham, Texas, in 1943, my dad put a ball and a bat in my hands. By the time I was just three or four, I became the batboy for the semipro team Dad and my uncles played for. So that's when the seed was planted. I wanted to follow in their footsteps.

We moved to Oakland when I was about seven, and I played a bunch of different sports there. I actually became a pretty good running back and quarterback, but I could tell early on that baseball was going to be the sport where I had a future. Oakland produced a lot of great athletes. I grew up on the east side of town, as did Willie Stargell. On the west side, you had guys like Frank Robinson, Vada Pinson, Curt Flood, Tommy Harper, and basketball great Bill Russell. Those guys were all ahead of me, but it was very inspiring to have so many guys to look up to. A lot of us wound up playing on amateur baseball teams sponsored by Sam Bercovich. He owned a bunch of furniture stores in the Bay Area and was good friends with Raiders owner Al Davis. He was so close to Al that he would sit next to him in the owner's box during games. Like most kids back then, I played ball all day long, every day during the summer.

My heroes growing up were Jackie Robinson—for obvious reasons—and Nellie Fox. Jackie was the hero of every African American kid back then, and I liked Nellie because he was a smallish player who always hustled and did the things that helped win ball games. He just seemed to be the player I envisioned myself becoming someday—a guy who didn't let his height prevent him

from becoming a very good major league player. Later on I would wind up becoming a team-mate of Nellie's, and he would help me correct the problem I had with my swing that turned my career around.

I also had an opportunity to meet Jackie a couple of times. The first meeting was the most memorable. We were playing a game in San Francisco against the Giants, and Jackie was broadcasting the game with NBC. When I found out he was going to be there, I went to the ballpark earlier than normal so I could meet him. The night before, I remember going over in my mind all these questions I was going to ask him. But when I actually got to see him, I could barely get any words out of my mouth because I was so nervous, so in awe. As I shook his hand, the only words I could mouth were "Thank you." He looked at me and smiled and said, "Joe, you are welcome." I settled down a little and we had a short discussion, but I definitely was awestruck. I will always cherish that memory because of what he had to endure in opening the door for me and so many other African Americans. I also remember seeing him at the World Series in 1972. He threw out the first pitch and attended a press conference in which he was asked to assess the game's racial progress. He told the reporters that he hoped baseball would take the next step and he would be able to look in one of these dugouts and see a manager with a black face. I admired him for continuing to be a champion for people of color right up until the end. I believe that was his last public appearance. He died within weeks of that World Series. Years later, I wound up being honored by the Jackie Robinson Foundation and have been on the board for fifteen, twenty years. I remember telling his widow, Rachel, about how nervous I was the first time I met Jackie. She got a big kick out of that.

There wasn't a draft in baseball in the late 1950s, early '60s, so it was up to the scouts from the various teams to find you. And they found me, thanks to the fact that I played in a city that was a hotbed for producing big league players. The three teams that were most interested in me were the New York Yankees, New York Mets, and Houston Colt .45s, who later changed their name to the Astros. I wound up signing with Houston for $3,000 on November 1, 1962, because of their scout, Bill Wight. Unlike scouts from the Yankees and Mets, Bill never once brought up my height. The guys from the Yankees and Mets said to me, "You're a great little player," and really put an emphasis on the word "little." But Bill never once used that word. He told me I had the potential to be a great player in the major leagues. Period. That made me feel like the Houston organization would view me as a player, not as a little player. So I wouldn't have to fight that stigma about being short. And I wouldn't have to battle stereotypes that short players couldn't hit for power. In other words, I could play my game, which was much more than just bunting people over and slapping the ball around.

After signing, I reported to Houston's minor league camp in Florida. They had us play games all day long. You might play twenty innings and wind up getting ten at bats in a single day. It just so happened that Paul Richards, the general manager of the Colt .45s, was there when I had one of my best days. I think I hit two home runs, had a double and a triple, stole a few bases, and made some plays in the field. Up until that point I was kind of an unknown. But that all changed that day. Richards took notice and told his guys that "this kid Morgan is going to be a star player for us." And once he said that, everybody in the organization began looking at me differently. They say timing is everything, and I clearly couldn't have picked a better time to have a great day.

It's funny, but after Richards praised me, Houston's minor league managers began fighting over where I should be assigned. Fortunately, Dave Philley, who managed their team in Modesto, California, was the guy who won the Joe Morgan sweepstakes. And I couldn't have been happier, because Modesto wasn't that far from Oakland, which meant my family and friends were able to see me play and I was able to go home on my off days. I did well in Modesto, but [soon] they shipped me across the country to Durham in the Carolina League. Not only would I be moving three thousand miles away, but I'd also be going to a southern city not known for treating African Americans well. And I would be the only black player on the team. By the time I arrived in Durham, the game already had started, but they still had me suit up. I was sitting on the bench when, in the ninth inning, the manager, Billy Goodman, sent me up to pinch-hit. I hit the first pitch for a home run to either tie or win the game, and the crowd went wild. I was an instant hero in Durham. I wound up having a great season there, and the fans treated me well. They voted me the second-most-popular player on the Bulls, and years later the club retired my jersey.

That's not to say I wasn't exposed to the racism that was prevalent in those days, especially in the Deep South. Although I was not the target of epithets from the home crowd, I heard my share of stuff on the road. And in a strange twist, I heard the epithets that were hurled at African American players from teams that visited our ballpark. Even though it wasn't directed at me, it was very unnerving. During road games, while my white teammates went to the Ritz-Carlton with air-conditioned rooms, I went to stay with black families that didn't have air-conditioning. That part didn't bother me because I actually got to eat better than my teammates did. There was some great food I feasted on in the African American community. You couldn't beat the home cooking.

I was fortunate because my white teammates took care of me and sheltered me from a lot of the really bad stuff. If anybody tried to mess with me, they immediately came to my defense. Walt Matthews, who remains a good friend, was one of my guardian angels. He was a big guy, six two, six three, who had been in Durham for about three years. Everybody respected him, especially the fans, who voted him most popular player, just ahead of me. So the fact that Walt was on my side carried a lot of weight. At times, when I did have to listen to the hatred from fans, I thought about what Jackie had endured. And I remembered the stories that Frank Robinson told me. It was far worse than what I was facing. Frank told me about how he and his African American teammates would have to wait for Ku Klux Klan rallies to end before they could leave their house in black neighborhoods and head safely to the ballpark. I never had anything like that happen. So I realize that as unpleasant as it was, it could have been worse.

Although I had a strong arm and had played shortstop in high school, Houston decided to move me to second base during my first camp. Unfortunately, I developed some bad throwing habits when I initially made the move. Instead of throwing the ball to first, I kind of slung it sidearm, and wound up developing some arm problems. My arm would never be as strong as it had been, and when I look back, that's one of my few regrets, because I'd always prided myself on being a complete ballplayer.

I played a total of 140 games between Modesto and Durham that summer, batting a combined .310 with eighteen homers, five triples, and twenty-five doubles. Richards was so impressed with my season that he called me up to the big club that September and I made my major league debut

just two days after my twentieth birthday. I wound up hitting .240 in eight games with a triple and three runs batted in. I clearly was on the fast track.

I started my second season of pro ball with the Colt .45s' Double-A team in San Antonio, Texas. That was a great experience for me because I had several African American teammates, and laws had been passed so that we could stay in the same hotel as our white teammates. I wound up winning the Texas League's MVP Award after batting .323 with twelve homers, eight triples, forty-two doubles, and ninety RBI. I received another late-season call-up, and although I hit just .189 in ten games, I felt I was ready to take the next step in 1965. And the Houston brass agreed.

I had an excellent exhibition season and broke camp as Houston's starting second baseman. I had a solid rookie year, hitting .271 with fourteen homers and forty RBI. I actually led the National League in walks (97), but the stat I was most proud of was my one hundred runs scored. I did it batting first or second for a team that finished second-to-last in the standings, so I had to manufacture a lot of those runs, which I did by stealing twenty bases and stretching singles into doubles and doubles into triples.

And I did it in a new ballpark that was not hitter-friendly. Houston had changed its name to the Astros that season and had begun playing their games indoors in the brand-new Astrodome. The building was hailed as "The Eighth Wonder of the World," but there wasn't a lot wondrous about it when it came to playing baseball. People forget, but the first year of the Dome, the groundskeepers had attempted to grow a real grass field indoors. But the grass never took, so the infield wound up being an all-dirt diamond, like the skin diamonds I played on as a kid. Only this was the big leagues and these guys were hitting the ball much harder and there wasn't any grass to slow it down. The ball would be on top of you in nothing flat. It was just awful. There were some plays where you didn't have a prayer. I remember having a lot of tough chances that season that resulted in a lot of extra bruises from balls off your chest and forearms and shins. That's not to say the Astrodome was all bad. The heat can get oppressive in Houston in the summertime, so it was nice to be able to play in climate-controlled conditions indoors, and you never had to worry about a rainout.

I mentioned that Nellie Fox had been a player I admired growing up, and it just so happened that he was my teammate on the Astros. He and Eddie Kasko were middle infielders, and they were kind enough to work with me and help me develop into a pretty good defensive second baseman. Each day at about three thirty, about a half hour before batting practice, we'd go out there and I'd take extra grounders. I didn't have great hands at first, but thanks to Nellie and Eddie, I developed soft hands, which are essential for a middle infielder. I wound up winning five consecutive Gold Glove Awards at second base, starting with the 1973 season, and I'm extremely proud of that because I really had to work at that part of my game.

Nellie also played a pivotal role in me becoming a better hitter. I mentioned that the Dome wasn't a hitter-friendly park. It was something like 350 feet down the lines and 390 feet to straight-away right field. Plus, you had to hit it over a wall that was about thirty feet high. It seemed like about once a night I would hit a 389-foot fly ball to right field that would be caught on the warning track. After about a month of doing this, Nellie came up to me and said, "Joe, we got to get that ball out of the air and turn it into a line drive in the gap." We talked about what I was doing

wrong, and we determined that I was dropping my back elbow and that was causing my back shoulder to drop, resulting in fly balls. So Nellie suggested I start flapping my left arm while waiting for the pitch to remind me to keep my elbow away from my body. This way I would drive the ball rather than lift it. It looked funny, but it worked for me, and I used it for the rest of my career.

Over the next six seasons, I put up some solid numbers, but there's no question that playing in the Dome really depressed my power numbers. My home run totals really jumped when I went to Cincinnati, because Riverfront Stadium was a much fairer hitter's ballpark than the Astrodome. The other problem I had playing for the Astros was that I wasn't exactly surrounded by great talent in the lineup. We had a tough time scoring runs, which, again, is why I tried to do as much as I could, taking extra bases or stealing bases. I had three seasons in Houston where I had double-digit figures in triples and three seasons where I stole forty or more bases.

On November 29, 1971—almost two months after completing my seventh full season with the Astros—I was part of a blockbuster trade with Cincinnati. The Reds sent Lee May, Tommy Helms, and Jimmy Stewart in exchange for me, center fielder César Gerónimo, pitcher Jack Billingham, infielder Denis Menke, and minor league outfielder Ed Armbrister. The trade caught me totally by surprise. In fact, I had heard rumors of me going to Philadelphia for Deron Johnson. At the time, the Phillies were as bad as the Astros. We weren't making much money in those days, and I remember my wife and I deciding that it didn't make sense to uproot and go to Philly. I told her I would retire and go back to school and finish my college degree and find a different career. I just had no desire to start all over in some strange place with a bad team. Then, out of the blue, the Reds trade materializes. I wasn't happy, because I didn't want to leave my friends, especially my road roommate, Jimmy Wynn. But going to Cincinnati wasn't like going to Philadelphia. The Reds were loaded with talent. My dad put everything into perspective when he said, "You know, you now have a chance to play in a World Series." That kind of set the tone for me. And when I went to camp the following spring and watched the way Johnny Bench and Pete Rose went about their business, I could tell I was walking into a great situation. In Houston, for too long, the attitude had been about beating the Mets or the Phillies to stay out of last place. With the Reds, I could see immediately that the mind-set was "Let's win the World Series."

I was impressed right away with Sparky Anderson. Sadly, I had developed a reputation in Houston as being a clubhouse lawyer. But the real reason I was outspoken is that we had a racist manager, and I wasn't going to sit back and let him initimidate me the way he had other African American players. As a result, he tried to paint me as a malcontent. Well, when I got to Cincinnati, Sparky put all that stuff to rest. He pulled me aside and said, "Joe, I know and everybody here knows what went on. I also know you work hard and play hard all the time and that's all I want from you." Sparky wound up lockering me next to Pete Rose. And he did so for a reason. He knew that we would push each other every day. Pete was a little different, but I could deal with that. And we formed a bond that remains strong to this day. Sparky also showed faith in me from the start by giving me complete freedom on the bases. He said, "Joe, I'm never going to give you a sign. I'm just going to let you go play. I know you are a smart player and whatever you do is going to be in the best interest of the team." It was the highest compliment a manager can pay a ballplayer, to give him that kind of freedom. But it also came with a tremendous responsibility,

and I never abused it. I always tried to do what was best for the team. I always tried to do what I believed Sparky would want me to do in a specific situation. I only stole a base when it meant something. And I worked out signs and discussed situations with guys like Bench when I was on base and he was at the plate. They'd know when I was going. And they knew when I wasn't, and they had the green light to take their cuts. It worked out really well.

What I discovered quickly was that I had joined not only a tremendously talented team but a very, very smart team. I don't know what our IQs were away from the diamond, but on the diamond we had a bunch of guys who were Phi Beta Kappas in baseball. You look back on those Cincinnati teams and you will see that we went weeks at a time without making a mental mistake. Didn't throw to the wrong base. Didn't squander opportunities to move guys over or get that sac fly. Just a smart, smart group of baseball players. I'm biased, but I will say, without hesitation, that the Big Red Machine was the greatest team in baseball history. Those eight guys that went out there every day could do it all. They could hit, hit with power, hit in the clutch. They could field and throw with the best of them. We had four guys up the middle that were Gold Glove Award winners.

The change of venue wound up having an immediate impact on me. During that 1972 season, my average jumped nearly forty points and I led the league in on-base percentage (.417), runs (122), and walks (115). I also hit sixteen home runs, drove in seventy-three runs, and stole a career-high—up to that point in my career—fifty-eight bases. But best of all, we made it to the World Series. And although we lost to the Oakland A's, who were on their way to becoming just the second club in baseball history to win three consecutive Fall Classics, I could tell we were on the verge of something special. My stats continued to rise the next two seasons, but I felt unfulfilled because we didn't get back to the World Series either year.

Our hunger was growing, and in 1975 and '76 we finally realized our potential and won back-to-back World Series, beating the Red Sox in seven games in what many believe is the best Series of all time and following that with a four-game sweep of the Yankees. And I picked a pretty good time to be at the top of my game, winning back-to-back National League MVP Awards those years. In '75, I hit .327 with 17 homers, 94 RBI, and 67 stolen bases. The following year, I had career years in homers (27) and RBI (111) and scored 113 runs and stole 60 bases. Both seasons I led the league in on-base percentage, and in '76 I also topped the league in slugging percentage (.576). It was the pinnacle for me as a ballplayer. It was special to be MVP on a team that included Johnny Bench, Pete Rose, and Tony Pérez—some of the best players in the history of the game.

Of course, it wouldn't have been nearly as special for me if we hadn't won it all those two years. I got to play a pivotal role in the Red Sox series. The day after Carlton Fisk's dramatic walk-off homer in Game 6, I drove in the winning run to win the Series. Interestingly, I hit a ball that looked like a home run in Game 6, but Dwight Evans made a superb catch. If he didn't come up with that, we likely would have won the Series in six and Fisk never would have gotten the opportunity to win that game in extra innings. One of the other interesting things about the 1975 Reds is that about a month into the season, Sparky came up to me and said he needed me to move from second to third in the order because the guy who was batting third was leaving too many guys on base. I gladly made the switch and almost drove in a hundred runs. There were other times when Sparky even had me bat cleanup. It didn't matter to me. Wherever he needed me, that

was cool. And with that lineup, you were going to get opportunities to score and drive in runs no matter where you batted. I remember one game that year, I had a batting line where I had no at bats but four runs scored. I walked four times, stole a few bases, and was knocked in each time.

I think the 1976 season really underscored just how great the Big Red Machine was. I remember before we were about to play the Phillies in the playoffs, a writer came up to me and asked what I saw unfolding. I said, "I think you are about to see something really special." Now, I wasn't expecting us to do what we did—sweep the Phillies, then the Yankees. But we entered that postseason with everybody healthy, and I believed that when we were healthy, we were unbeatable.

I had another good season in 1977, but the Los Angeles Dodgers beat us out to make it to the World Series, and I could start to see the wheels beginning to come off the Big Red Machine. I had subpar seasons in 1978 and '79, and before the 1980 season I decided to go back to my old team, the Astros. I had experienced the best years of my career in Cincinnati, but leaving wasn't as tough as it might have been, because the Big Red Machine was no more. Pete Rose was gone. Tony Pérez was gone. And Sparky Anderson was gone. So it wasn't the same feeling. Things had changed. When I was traded by Houston nine years earlier, I told reporters that I loved Houston and that maybe someday I would be back there to help the Astros win a championship. It's interesting that I wound up there, because it looked like I might wind up with the Dodgers instead. Tommy Lasorda was recruiting me heavily. He wanted me to come to Los Angeles and play second base. They were going to move Davey Lopes to center field to make room for me. Davey didn't want to make the move. I had always been a team player, and I didn't want to go someplace where there would be a divide—and there certainly would have been one had I forced Lopes to move. Half the team would have welcomed me; the other half would have been clamoring for Lopes to remain at second. So I avoided that potential mess and went back to Houston, in part because I had a great relationship with [general manager] Tal Smith.

Even though I was a newcomer, the guys on that club looked up to me as a leader because I had been on championship teams and they had only knocked on the door. Down the stretch, things got tight, but we got it done, and the Astros qualified for the postseason for the first time in their history. Although we wound up losing to Philadelphia in the best-of-five series, it was a very fulfilling season for me. I'm glad I went back even if it was just for a year. I spent the next two seasons back in the Bay Area, playing for the San Francisco Giants. That was kind of cool for me because I had grown up there rooting for Willie Mays and those guys. My first season there was kind of screwed up because it was interrupted by a strike. It was great to play for Frank Robinson those two seasons, the second of which was more enjoyable, because we were contenders. It was the first time I had played for an African American manager, and it reminded me of what Jackie Robinson had said years before about hoping to see a man of color managing a team. It was a great experience for me, and Frank and I became good friends. I wound up raising my batting average forty-nine points to .289 that season, and won National League Comeback Player of the Year.

In 1983 I headed to Philadelphia, where I was reunited with my old teammates Pete Rose and Tony Pérez. I struggled with a pulled hamstring, and my average plummeted fifty-nine points to .230. But I still managed to hit twenty doubles and sixteen homers and helped us down the stretch by hitting .337 in the month of September. My good finishing kick continued in the postseason,

and we made it to the World Series. I hit a home run in the sixth inning of Game 1, and Garry Maddox homered in the eighth to win it. But the Baltimore Orioles swept the next four. In the fifth and final game, I hit a triple in the eighth inning and asked for the ball. Some were wondering why I would do that, but I wanted that ball because I had decided that was my last at bat. I was going to retire after that game. But Roy Eisenhardt, who owned the Oakland A's, kept on me about spending my final season with the A's. I kept refusing, but he finally got smart and talked to my mom and dad, and they convinced me to close out my career in my hometown. So I played in 116 games that season before officially calling it a career.

I mentioned that one of my goals was to be a complete ballplayer, and I hope that's what I brought to the position of second base. There had been people at the position who had been great hitters, like Rogers Hornsby, who they kind of just stuck there. And there were guys like Bill Mazeroski, who was known for his glove and his ability to turn the double play like nobody ever had. I'd like to think that I brought a lot of offense and some pretty good defense to the position—the complete package. Defensively, I was the first one to perfect the backhanded throw that you see a lot of guys utilizing today. Dave Concepción and I were looking for ways for me to get the ball to him quicker on double plays, especially when he had guys like Dave Parker bearing in on him. So I started practicing the backhanded toss to him. We'd do it from close range, and then I'd move away a little farther and then farther still. And it worked. It got the ball there much quicker and made us an even better double-play combination. The move was considered flashy back then. But it became more accepted over time, and now it's commonplace.

My induction into the Hall of Fame in 1990 was the final validation of my career. I was very proud of what I had accomplished. This five-foot-seven guy from Oakland, California, had proven that height doesn't mean beans. The greatest validation, though, came from my teammates. Pete Rose said I was the smartest player he ever saw. And Johnny Bench said I was the best player he ever played with. It doesn't get any better than that.

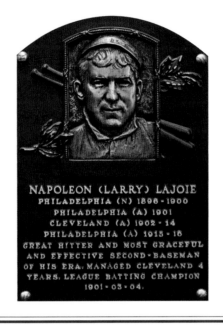

NAPOLEON (LARRY) LAJOIE
PHILADELPHIA (N) 1896-1900
PHILADELPHIA (A) 1901
CLEVELAND (A) 1902-14
PHILADELPHIA (A) 1915-16
GREAT HITTER AND MOST GRACEFUL
AND EFFECTIVE SECOND-BASEMAN
OF HIS ERA. MANAGED CLEVELAND 4
YEARS. LEAGUE BATTING CHAMPION
1901-03-04.

NAPOLEON LAJOIE

CLASS OF 1937

One of the greatest hitters of all time, Napoleon "Larry" Lajoie was so beloved that in the early years of the twentieth century, when he played for the Cleveland team of the American League and managed them, they were called the "Naps" in his honor. Of French Canadian lineage, Lajoie won five batting titles, hit .426 in a season, and was the third player to surpass three thousand hits.

Lajoie could do just about any trick with a bat, but he was a very well grounded person. Lajoie was not flamboyant in speech, and once he was married, he was very much a homebody. One of his closest friends wrote a magazine story about him that included the following description: "Lajoie is of a retiring and modest disposition and seeks quiet rather than publicity, which naturally comes to a man as much in the public eye as he is. I do not know of any hobby he has except that he likes to sit behind a good horse and to play a game of pool."

The great Cy Young was once asked to choose between Lajoie and Eddie Collins as the best among second basemen during his era and he couldn't do it. Lajoie was "one of the most rugged hitters I ever faced," Young said. "He'd take your leg off with a line drive, turn the third baseman around like a swinging door, and powder the hand of the left fielder." Young certainly left the impression that Lajoie hit the ball hard.

Young remembered Lajoie being hugely popular, with kids following him around outside the park the way they later did with Babe Ruth. Lajoie had a deal to plug chewing tobacco, and Young liked to tell a story that even he said might not have been true. "Lajoie endorsed a certain kind of chewin' tobacco, as all ball players did in those days, just like they endorse cigarettes and clothes today. And do you know what happened? The day after the advertisement was in the papers half the kids in the country were sick from chewing."

Although they were not as famous as pitcher Satchel Paige's rules for living, Lajoie issued his own nine rules to follow to become a great hitter. The short version: (1) Select a bat consistent with your size and weight; (2) Go up to the plate determined to hit the ball; (3) Imagine that all pitchers look alike to you. Most pitchers are afraid of you; (4) Never allow a pitcher to tease you out of your position at the plate; (5) Try to judge the pitcher; (6) Observe the positions the fielders have taken from you and try to place the ball in open territory; (7) Be calm and collected; (8) Keep your mind on your task; (9) Practice.

"In my many years in the majors," Lajoie said, "I saw hundreds of good batters. I studied their positions, their methods, and I have come to the conclusion that good batters are born, not made, but nevertheless, batting is an art and can be developed."

—L.F.

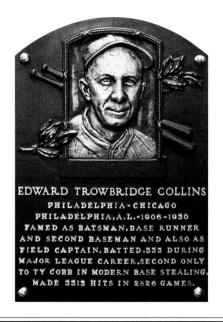

EDWARD TROWBRIDGE COLLINS
PHILADELPHIA-CHICAGO
PHILADELPHIA, A.L.-1906-1930
FAMED AS BATSMAN, BASE RUNNER
AND SECOND BASEMAN AND ALSO AS
FIELD CAPTAIN. BATTED .333 DURING
MAJOR LEAGUE CAREER. SECOND ONLY
TO TY COBB IN MODERN BASE STEALING.
MADE 3313 HITS IN 2826 GAMES.

EDDIE COLLINS

CLASS OF 1939

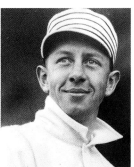

Eddie Collins did so many things so well during his twenty-five-year career with the Philadelphia Athletics and Chicago White Sox, including setting the record of 512 sacrifice hits, that the legendary manager John J. McGraw praised him enough to leave him blushing.

"Eddie Collins is the best ball player I have seen during my career on the diamond," the old New York Giants manager said. "He is the most perfect and most resourceful player in the world. He did more to beat the Giants out of two world's championships than any other member of Connie Mack's team."

While attending Columbia University, Collins initially hoped to become an attorney, but he loved baseball, and those feelings guided him. "It must be great to be a big leaguer," he said in 1905 just before he became one. "I hate to think of studying law." Instead he took up study of the hit-and-run.

The longtime second baseman was a member of six World Series teams, and he ranked very high in a number of hitting categories by the time he retired in 1930. The biggest surprise of Collins's baseball life was being purchased from the A's by the White Sox. There was no inkling such a transfer was in the offing. The phone rang at Collins's home, and his wife answered it and thought the caller was carrying out a prank, because the couple had received some hoax telegrams.

This is how Collins tells the story: "The voice at the other end of the line said, 'This is Ban Johnson [the American League president]. I want to speak to Eddie Collins.' She hung up the phone without further ado. Within a matter of a few minutes the phone rang again and my wife once more answered it. 'This is Charles Comiskey [the White Sox owner],' said the voice at the other end. Convinced now that a practical joker was at work, my wife merely replied, 'Glad to know it,' and once again hung up the phone. Fire literally blazed in her eyes and her words were slightly sulphuric when the phone rang a third time. This time, though, she recognized the voice when it said, 'This is Connie Mack, Mabel, I want to talk to Eddie.' She actually got flustered, turned alternately beet red and a sickly white and called to me, 'Heavens! Do you suppose those other calls were really from Mr. Johnson and Mr. Comiskey?'" Collins met Mack, the A's owner, in his office and was officially notified of the purchase.

With the A's, Collins was a member of the so-called "$100,000 Infield" that starred in the early part of the twentieth century. It consisted of Collins, Stuffy McInnis at first, Frank "Home Run" Baker at third, and Jack Barry at short. When Collins died, McInnis said, "He was the greatest ball player I ever saw around second base—never made any mistakes. He loved all sports, was a brilliant man and could have succeeded in any profession."

—L.F.

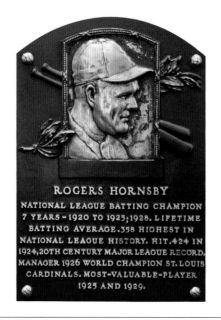

ROGERS HORNSBY
NATIONAL LEAGUE BATTING CHAMPION
7 YEARS - 1920 TO 1925;1928. LIFETIME
BATTING AVERAGE .358 HIGHEST IN
NATIONAL LEAGUE HISTORY. HIT .424 IN
1924,20TH CENTURY MAJOR LEAGUE RECORD.
MANAGER 1926 WORLD CHAMPION ST. LOUIS
CARDINALS. MOST-VALUABLE-PLAYER
1925 AND 1929.

ROGERS HORNSBY

CLASS OF 1942

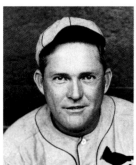

The words that best sum up Rogers Hornsby's life would be baseball, baseball, and baseball. Growing up in a small town in Texas, Hornsby began playing the game so young that he had no memories dating back to before he had a ball in his hand. "I guess I started playing as soon as I could close a fist around a ball," he said.

A remarkable hitter with a lifetime .358 average, Hornsby worked overtime to preserve his eyesight for hitting and skipped going to the movies or reading much so as not to strain his eyes.

Hornsby's exceptional vision was complemented by a textbook stroke. "Look at that swing," said the Cubs' Charlie Grimm one day, gazing at Hornsby in the batter's box. "That rhythm. That balance." He was twice the National League Most Valuable Player and a seven-time batting champion who hit better than .400 three times.

Regarded as possibly the best second baseman of all time, Hornsby lived for hitting in a way that almost no other superstar did besides Ted Williams. "I doubt that a great batter is born," Hornsby said. "In my case, I can say batting ability was accomplished entirely through confidence, constant practice, and a personal desire to excel in a profession that brings rich dividends."

Hornsby hit as high as .424 one year, and was so proficient at batting that one of his contemporaries, the exalted third baseman

Pie Traynor, said Hornsby was underrated in other aspects of the game, especially "as a fielder and as a base runner." Traynor elaborated: "Base running? Hornsby was a right-handed batter. Take Mickey Mantle and Hornsby—when they were in their prime. Have Mantle hit right-handed and Hornsby could beat him getting to first base. Fielding? Hornsby covered an awful lot of ground."

Hornsby managed six teams between 1925 and 1953, with some gaps. Never known to compromise, Hornsby, after a while with one team, was surprised when he *wasn't* fired. "It was a new experience for me," he said, "to have a club owner tell me he didn't want to get rid of me."

Hornsby understood that his opinions got him into trouble with management, but he never stepped back from an argument. "They've always said I had no tact," Hornsby said, "and I suppose they're right. If by having no tact they meant that I wouldn't say 'Yes' when I meant 'No' they're certainly right. When I ask a man a fair question, I like a fair answer, and I always give one when I'm asked. That has gotten me into a lot of trouble and people say I would have been better off if I had been more diplomatic."

If there was one thing that bothered Hornsby about his batting when he left the game, it was his failure to reach 3,000 hits; he managed 2,930. "There won't be any special prizes or more money, but a man likes to feel that he is leaving just a little more behind him when he's through as a player."

—L.F.

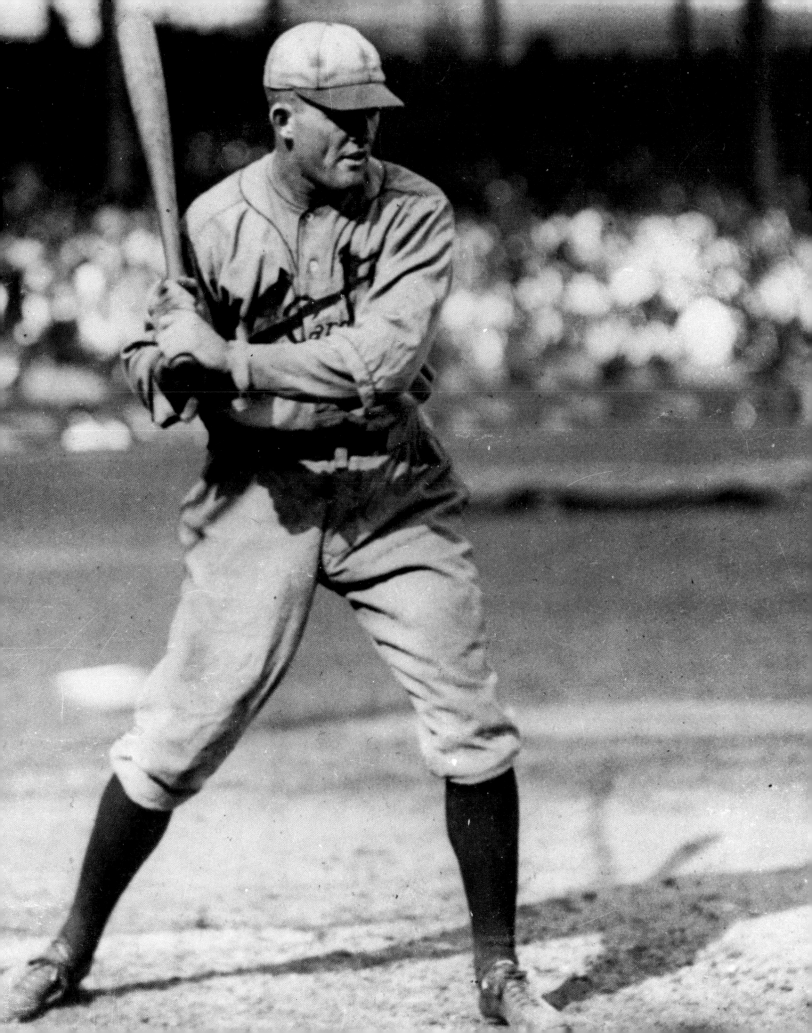

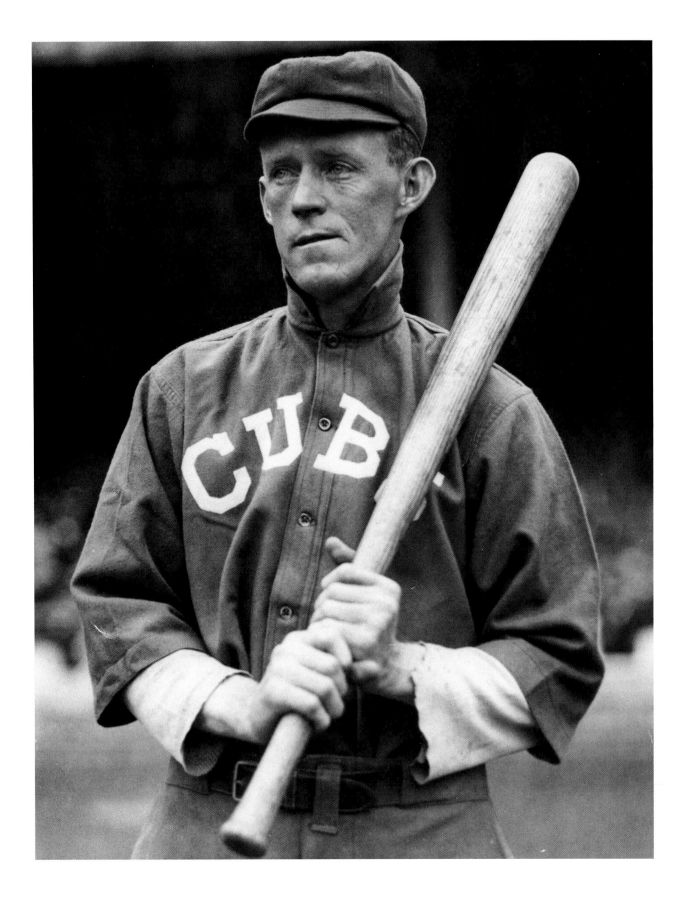

JOHN JOSEPH EVERS
"THE TROJAN"
MIDDLE-MAN OF THE FAMOUS DOUBLE
PLAY COMBINATION OF TINKER TO EVERS
TO CHANCE. WITH THE PENNANT WINNING
CHICAGO CUBS OF 1906, 07-08-10 AND WITH
THE BOSTON BRAVES' MIRACLE TEAM OF
1914. VOTED MOST VALUABLE PLAYER IN N.L.
IN 1914. SERVED AS PLAYER, COACH AND
MANAGER IN BIG LEAGUES AND AS A SCOUT
FROM 1902 THROUGH 1934. SHARES RECORD
FOR MAKING MOST SINGLES IN FOUR
GAME WORLD SERIES.

JOHNNY EVERS

CLASS OF 1946

Known as "The Human Crab" because he was a hard-nosed player and argued for his rights regularly with umpires, Johnny Evers was the second baseman for the Chicago Cubs in the most famous double-play combination of all time. He was joined on the scorecard and in poetry with first baseman Frank Chance and shortstop Joe Tinker.

All three of them made it into the Hall of Fame, and all three of them were immortalized by newspaper columnist Franklin P. Adams's poem "Baseball's Sad Lexicon" in 1910. Although he extolled the threesome's talents in verse, Adams had never met the players. Many years later, John Kieran, a panelist on the *Information Please* radio show, introduced him to Evers. Evers said, "I owe you a debt of gratitude." Adams was puzzled. "For keeping my name before the public all these years," Evers explained. "I'd have been forgotten long ago if it wasn't for 'Baseball's Sad Lexicon.'"

One reason Evers had to play so hard to survive was that he weighed so little, with estimates ranging from 115 to about 130 pounds. His small stature didn't hold him back from fisticuffs, though. "If you'll remember," Evers said, "all my fights were with fellows who weighed from 180 to 200 pounds. Someone always held them. No one ever thought of holding me."

From a distance, everyone assumed that the double-play Cubs must be the best of friends, but Evers and Tinker had a feud going for some time while they shared their diamond duties and didn't speak to each other. According to Evers, they didn't talk at all off the field during the 1907 and 1908 seasons. The Cubs won the World Series both years.

"But in 1909 Joe and I made up, shook hands and called off the war," Evers said. "And that year Pittsburgh beat us out. At the end of the season Frank Chance [by then manager] called us both together. 'You fellows didn't speak in 1907 and 1908 and we won. You made up this year and we lost out. If I catch you speaking to each other next season, I'll break your backs.' Joe and I had another row in 1910, didn't speak, and again won the pennant."

The reason the players originally clammed up, Evers said, was that on one occasion, although he was only ten feet away, Tinker unnecessarily threw a ball at him to catch at super-speed and it broke his finger. Then Tinker laughed about it.

Likely because of his personal experience with Tinker, Evers never believed that players on winning teams had to be pals in order to be winners. "What a guy thinks about another guy on a ball team doesn't mean a thing," Evers said. "That's a personal affair. What a guy thinks about the team as a whole is something else. Tinker and myself hated each other, but we loved the Cubs. We wouldn't fight for each other, but we'd come close to killing people for our team. That was one of the answers to the Cubs' success."

—L.F.

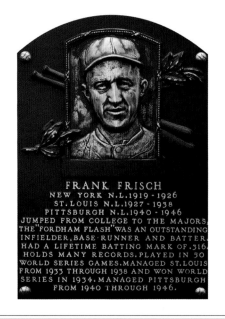

FRANK FRISCH
NEW YORK N.L. 1919-1926
ST. LOUIS N.L. 1927-1938
PITTSBURGH N.L. 1940-1946
JUMPED FROM COLLEGE TO THE MAJORS.
THE "FORDHAM FLASH" WAS AN OUTSTANDING
INFIELDER, BASE-RUNNER AND BATTER.
HAD A LIFETIME BATTING MARK OF .316.
HOLDS MANY RECORDS. PLAYED IN 50
WORLD SERIES GAMES. MANAGED ST. LOUIS
FROM 1933 THROUGH 1938 AND WON WORLD
SERIES IN 1934. MANAGED PITTSBURGH
FROM 1940 THROUGH 1946.

FRANK FRISCH

CLASS OF 1947

When it came to playing hard, from hustling on the bases to digging out bunts and diving for ground balls, few could compare to Frankie Frisch, "The Fordham Flash," who was one of the key figures on the St. Louis Cardinals' Gashouse Gang teams of the 1930s.

"I might have a dirty uniform, but I always wore clean white understockings and shined shoes that were snug and firm," Frisch said. "I always had five pairs of baseball shoes."

The Gashouse Gang that won the 1934 World Series over the Detroit Tigers was regarded as one of the most spirited teams of all time, and while there was tremendous talent on the roster, the Cardinals always paid attention to getting the little things right and outthinking their opponents.

Frisch played in eight World Series, but the most memorable was the 1934 battle with Detroit. "The '34 Series was the roughest, toughest, saltiest in which I ever played," Frisch said, "more for violence on the bases than in knockdown pitching, though there was enough of that, too."

Splitting his Hall of Fame career at second base between the New York Giants (for whom he played in four World Series) and the Cardinals, Frisch collected fifty-eight World Series hits. Frisch's last Series (when he was player-manager) was the 1934 competition, and it went to seven games. The seventh game was in the third inning when the Cardinals broke clear of a 0–0 deadlock with seven runs on the way to an 11–0 final. It was Frisch's three-run double that opened the gates.

"They walked Jack Rothrock to load the bases for the old Flash, but they should have known better," Frisch said. "I must have fouled off a half-dozen curveballs on a 3-and-2 count before I lined one into the right-field corner. I got so excited watching those three runs score that I tripled into a double. If one of my men had stopped at second base the way I did, I'd have fined him."

One of Frisch's adventures while managing was keeping the fabulously talented but aptly named Dizzy Dean, his ace, focused on taking care of business on the mound when it really counted. They used to argue about what Dean should throw. "One game Dizzy Dean used only his fastball," Frisch said, "and afterward he crowed, 'That's showing the Dutchman I don't need to throw the curveball.' Diz didn't realize I was giving the signs."

Frisch, who also managed the Pirates and the Cubs before retiring from the dugout in 1951, always loved to talk about the old days of the game. He rated George Sisler, the .400 hitter for the Browns, and homer king Babe Ruth as the two best players he ever saw. "Great extremes, huh," Frisch said. "A place hitter and a slugger." But when Hall of Fame manager Joe McCarthy was asked once what his composite of the perfect player would be, he responded, "What are you going to all that trouble for? What couldn't Frankie Frisch do?"

—L.F.

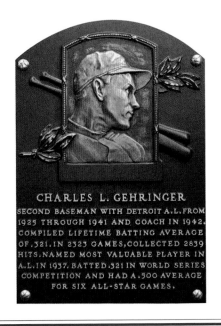

CHARLES L. GEHRINGER
SECOND BASEMAN WITH DETROIT A.L. FROM
1925 THROUGH 1941 AND COACH IN 1942.
COMPILED LIFETIME BATTING AVERAGE
OF .321. IN 2323 GAMES, COLLECTED 2839
HITS. NAMED MOST VALUABLE PLAYER IN
A.L. IN 1937. BATTED .321 IN WORLD SERIES
COMPETITION AND HAD A .500 AVERAGE
FOR SIX ALL-STAR GAMES.

CHARLIE GEHRINGER

CLASS OF 1949

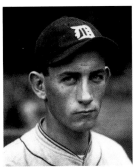

He played the game with such consistency and precision that others compared him to a machine. Robotic and repetitive in his effectiveness, Charlie Gehringer fully earned his nickname, "The Mechanical Man."

Born and bred on a farm in Michigan, Gehringer loved baseball so much that he and his brother carved out a playing field on the farm so they could play every day. Choosing to remain in the state, he played college ball at the University of Michigan. So it was only appropriate that he would sign with the Detroit Tigers and make his debut for them in 1924.

Gehringer moved into the starting lineup two years later for player-manager Ty Cobb. He batted only .277 that summer, but he would credit Cobb with revamping his left-handed swing and transforming him into a .300 hitter.

In 1927 Gehringer batted .317, beginning a stretch in which he would hit better than .300 in thirteen of fourteen seasons. "All I know," Hall of Famer Lefty Gomez once told a reporter about Gehringer, "is that whenever I'm pitching, he's on base." Gehringer enjoyed one of his finest seasons in 1929, when he batted .339 and led the American League in hits, runs, and stolen bases. An exceedingly patient hitter, he typically walked four times as often as he struck out.

In addition to pelting line drives across the expanse of the outfield, Gehringer played the game smartly. A fundamentally sound second baseman, he harbored encyclopedic knowledge about every hitter's tendencies. He always seemed to be in the right position, always knew where to throw the ball. A reporter once asked Hall of Fame teammate Mickey Cochrane if he ever saw Gehringer make the wrong play. "I thought I did once," Cochrane told the *Brooklyn Eagle*, "but on second thought, I decided he had made the right play. That was the only time I even suspected him of doing the wrong thing."

It only made sense that The Mechanical Man did not age like most other players. Gehringer put up his two best offensive seasons in 1936 and 1937, when he was thirty-three and thirty-four years old. In 1936 he racked up a phenomenal total of sixty doubles. In the latter season, he won the batting title with a career-high .371 average and took home MVP honors.

A Tiger for all nineteen seasons of his career, Gehringer was an excellent all-round player who hit, fielded, and ran the bases well but didn't like to talk much about himself. Quiet and reserved in the extreme, he preferred simply to play the game on the field and enjoy his time afterward reading books and doing crossword puzzles.

"He's the epitome of one of the great, outstanding players in the history of the game," former Tigers ace Hal Newhouser told the Associated Press. "He was the type of fellow [who], when he played, you didn't even know he was around. Everything was done with precision."

—B.M.

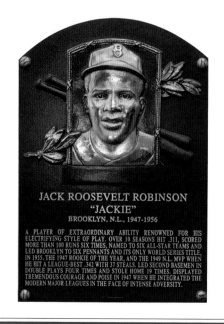

JACKIE ROBINSON

CLASS OF 1962

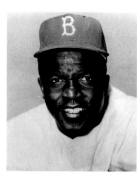

As a symbol of progress in the United States, Jackie Robinson has been cited as the second-most-important African American of the twentieth century, behind Martin Luther King Jr. When he broke baseball's color barrier with the Brooklyn Dodgers in 1947, his courage in the face of being despised by narrow thinkers and taking abuse from the ignorant made him an enduring hero.

He was also a good actor, rarely revealing his true feelings. "I was nervous as the devil," Robinson told confidants after being portrayed in newspapers as cool.

Only Robinson, among all of baseball's great players, has been honored by having his uniform number retired by every club. He made that number so famous and familiar that the 2013 movie about Robinson's baseball breakthrough was simply called 42.

Robinson's pioneering career opened doors for blacks and opened minds for whites. Born into a sharecopping family in Cairo, Georgia, he gained baseball seasoning with the Negro Leagues' Kansas City Monarchs, and he gained life seasoning in the U.S. Army. All of his experience was hard-earned in a nation slow to accept integration of the races.

Robinson was a genius on the bases, a great batsman, and a versatile enough player to man several different positions throughout his career, including second base, third base, first base, the outfield, and shortstop. When he arrived in the National League, he seemed to be playing at least ten miles per hour faster than others. When someone asked, "Who taught him to do things like that?" Branch Rickey, the Brooklyn general manager who signed Robinson, replied, "Primarily God."

Robinson batted .311, was a six-time All-Star, and won the National League Most Valuable Player Award in 1949. He led a solemn life, under pressure in the public eye, and he did not joke around much in public forums even though he became more comfortable with his teammates while playing in Dodgers card games.

The rest of baseball was neither as welcoming nor as committed to Rickey's self-described great experiment, and Robinson needed nerves of steel and uncommon patience to withstand the taunts hurled his way. He was able to answer only through the demonstration of his skills, while restraining his natural inclination to fight back with his fists and his words.

Robinson did not live a long life. His hair turned prematurely white, and the effects of diabetes ravaged his body, leading to his death at fifty-three in 1972. But he lived long enough to witness and participate in the 1960s civil rights movement, legislative changes in the United States, and the breakdown of many societal barriers for African Americans.

"I honestly believe that baseball did set the stage for many things that are happening today," Robinson said shortly before he passed away, "and I'm proud to have played a part in it."

—L.F.

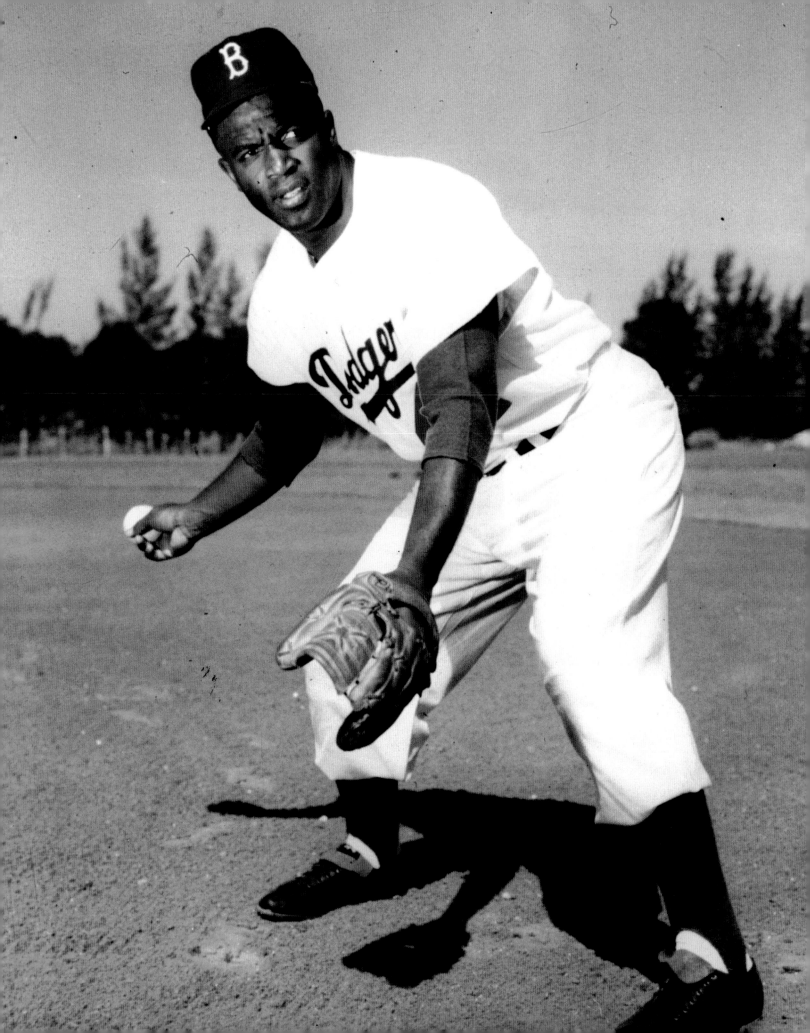

WILLIAM JENNINGS HERMAN
CHICAGO, N. L. BROOKLYN, N. L.
BOSTON, N. L. PITTSBURGH, N. L.
1931 – 1947
MASTER OF HIT-AND-RUN PLAY OWNED .304
LIFETIME BATTING AVERAGE. MADE 200 OR
MORE HITS IN SEASON THREE TIMES. LED
LEAGUE IN HITS (227) AND DOUBLES (57)
IN 1935. SET MAJOR LEAGUE RECORD FOR
SECOND BASEMEN WITH FIVE SEASONS OF
HANDLING 900 OR MORE CHANCES AND N.L.
MARK OF 466 PUTOUTS IN 1933. LED LOOP
KEYSTONERS IN PUTOUTS SEVEN TIMES.

BILLY HERMAN

CLASS OF 1975

Billy Herman provided certainty throughout the 1930s. Almost every year, he made the All-Star team, hit .300, and contributed excellent defense while playing the pivot.

The native of Indiana played four minor league seasons before finally attracting the attention of the Chicago Cubs. Purchasing Herman for $50,000, the Cubs brought him to the big leagues in August 1931. He played brilliantly down the stretch, hitting .327.

In 1932 Herman played every game for the pennant-winning Cubs, hit .314, and placed ninth in the MVP race. After an "off year," even though he did get 173 hits, he would resume his march toward stardom in 1934. He hit .303, marking the start of a four-year stretch in which he hit better than .300. He also made the All-Star team, kicking off an eight-year run of Midsummer Classic selections.

A smart player, Herman made adjustments in his career. "His first two years in the league, he couldn't get a hit off me," Hall of Fame left-hander Carl Hubbell told writer Tim Cohane. "But he set out scientifically to figure me out and he succeeded. From 1933 on, I couldn't get him out."

Herman was an ideal number two hitter, the perfect practitioner of the hit-and-run. He reached his peak in 1935, when he led the National League with 227 hits and achieved a career-best .341 bat-

ting average. Those numbers took on greater meaning as the Cubs advanced to the World Series, where Herman drove in six runs.

Early in 1941, the Cubs dealt him to the Brooklyn Dodgers for two lesser players and $65,000, allegedly because manager Jimmie Wilson considered Herman a threat to replace him. Herman would help the Dodgers win the pennant.

Still an elite ballplayer, Herman put up two standout seasons in Brooklyn, including a one-hundred-RBI campaign in 1943, before being called up for service in World War II. He missed the 1944 and 1945 seasons.

Herman came back from the war in 1946 and hit .288 over the first two months of the season, but advancing age made him trade bait. The Dodgers shipped him to the Boston Braves, where he played a half season before finishing out his career as player-manager for Pittsburgh.

Although Herman was a solid line-drive hitter who scored more than one hundred runs five times, it was in the field where his play sparkled. A smooth fielder with blanketing range and a knack for positioning himself against hitters, Herman led the league in assists three times. Playing in a 1933 doubleheader, he tied a major league mark by recording sixteen putouts.

When it came to playing second base, few could compare with Herman. Though he was often overlooked, those pennant-winning teams in Chicago and Brooklyn would not have made it without him.

—B.M.

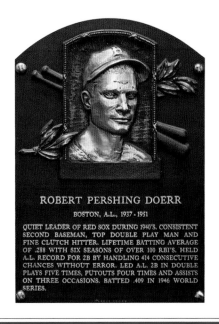

ROBERT PERSHING DOERR

BOSTON, A.L., 1937-1951

QUIET LEADER OF RED SOX DURING 1940'S. CONSISTENT
SECOND BASEMAN, TOP DOUBLE PLAY MAN AND
FINE CLUTCH HITTER. LIFETIME BATTING AVERAGE
OF .288 WITH SIX SEASONS OF OVER 100 RBI'S. HELD
A.L. RECORD FOR 2B BY HANDLING 414 CONSECUTIVE
CHANCES WITHOUT ERROR. LED A.L. 2B IN DOUBLE
PLAYS FIVE TIMES, PUTOUTS FOUR TIMES AND ASSISTS
ON THREE OCCASIONS. BATTED .409 IN 1946 WORLD
SERIES.

BOBBY DOERR

CLASS OF 1986

He was all of five foot eleven and 175 pounds, but he hit the ball with the ferocity of a much larger man. He was also overshadowed by his teammate, the legendary Ted Williams, but he constituted another vital part of the great Boston Red Sox clubs of the 1940s.

A native of Los Angeles, Bobby Doerr was originally signed by fellow second-base legend Eddie Collins, who saw him on the same scouting trip that netted Williams for Boston. Soft-spoken and hardworking, "Bashful Bobby" made his major league debut in 1937. He was only nineteen and not quite ready, but he attained a level of comfort in his sophomore season. By his third year, he showed the makings of stardom, as he batted .318, hit twelve home runs, and fielded with flawless precision.

In 1940 Doerr began to take advantage of the cozy left-field wall at Fenway Park. He hit twenty-two home runs and slugged nearly .500, impressive numbers for a middle infielder. National recognition followed in 1941, when he was named to his first All-Star team. Scouts considered him the successor to Charlie Gehringer as the American League's best second baseman.

Another rival second baseman had plenty of respect for Doerr. "What makes Doerr so good is his steadiness," Hall of Famer Joe Gordon told sportswriter Harold Kaese. "He's in there every day. He's good in the pinches. He hits the long ball. He does everything the way it should be done."

Doerr reached his peak in 1944, when he batted .325 and led the American League with a .528 slugging percentage. Just as the twenty-six-year-old Doerr reached superstardom, the realities of World War II suddenly hit home. Called into military service, he missed all of the 1945 season.

When Doerr returned to action in 1946, he wasn't quite the same player, but he was still awfully good—and extremely valuable to Boston. Doerr hit eighteen home runs, drove in 116 runs, and placed third in the AL MVP race. With Doerr, Williams, and Rudy York anchoring the lineup, Boston claimed the pennant. Doerr then clubbed St. Louis Cardinals pitching by slugging .591, though the Red Sox lost the World Series in seven tough games.

After two more fine seasons, Doerr and the Red Sox nearly returned to postseason play in 1949. Doerr hit .309 as Boston lost out to New York during the season's final days.

In 1951 injuries limited Doerr to 106 games, but he still hit well in limited play. Though he was only thirty-three, he decided to retire because of a bad back. Fittingly, he qualified for another All-Star team in his final go-round.

"Bobby Doerr was an absolutely outstanding player," Ted Williams told the *New York Times*. "He was an exceptional second baseman; he rarely booted ground balls; he was a good clutch hitter and a good all-round hitter who could bat third, fourth, or fifth in a lineup of good hitters." His hitting ability, his quiet class, and his gentlemanly demeanor make Doerr one of the most beloved members of Red Sox Nation.

—B.M.

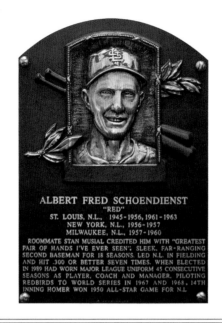

ALBERT FRED SCHOENDIENST
"RED"
ST. LOUIS, N.L., 1945-1956, 1961-1963
NEW YORK, N.L., 1956-1957
MILWAUKEE, N.L., 1957-1960
ROOMMATE STAN MUSIAL CREDITED HIM WITH "GREATEST
PAIR OF HANDS I'VE EVER SEEN". SLEEK, FAR-RANGING
SECOND BASEMAN FOR 18 SEASONS. LED N.L. IN FIELDING
AND HIT .300 OR BETTER SEVEN TIMES. WHEN ELECTED
IN 1989 HAD WORN MAJOR LEAGUE UNIFORM 45 CONSECUTIVE
SEASONS AS PLAYER, COACH AND MANAGER, PILOTING
REDBIRDS TO WORLD SERIES IN 1967 AND 1968. 14TH
INNING HOMER WON 1950 ALL-STAR GAME FOR N.L.

RED SCHOENDIENST

CLASS OF 1989

When promising athlete Albert Schoendienst suffered an eye injury as a teenager, he trained himself to bat left-handed so he could better see right-handed pitching. As a result, he later became one of the most durable switch-hitters in baseball history. Having worn a major league uniform in parts of six decades with three franchises—the Cardinals, the Giants, and the Braves—Schoendienst was a catalyst in St. Louis and Milwaukee for a combined five world championships as a player, coach, and manager. It was his feats as a player, however, that earned him election to the Hall of Fame by the Veterans Committee in 1989.

Schoendienst began his career with the Cardinals in 1945 as a fleet-footed left fielder but made the transition to second base in 1946. That move helped St. Louis to its third World Series championship of the 1940s, establishing him as one of the game's steadiest middle infielders. Fellow Hall of Famer Stan Musial, his roommate for ten years with the Cardinals, once said Schoendienst had "the greatest hands I've ever seen and he was as good a fundamental player as you ever wanted to see."

Schoendienst, known as "Red" for his ruddy hair and fair complexion, was a ten-time All-Star and twice finished among the top four in voting for the annual National League Most Valuable Player Award. In 1948 he stroked a record eight doubles in a three-game span, and his fourteenth-inning home run won the 1950 All-Star Game for the NL. Twice he led the Senior Circuit in

at bats and had two hundred hits in 1957, which he split between the Giants and the Braves.

While his .289 lifetime batting average was more than respectable, in defensive prowess he had few rivals. Schoendienst topped National League second basemen in fielding percentage for six seasons and was a perennial leader at his position in games played, assists, putouts, and double plays turned from 1946 to 1958. In 1949 and 1950 Schoendienst had separate streaks of 285 and 323 chances without an error or misplay, covering spans of forty-four and fifty-seven games, respectively.

Schoendienst was an aggressive but good-natured competitor on the field; the greatest challenge he faced in his career was physical, when a severe bout of tuberculosis jeopardized his health and sidelined him for almost all of Milwaukee's 1959 schedule. He eventually rebounded and returned to St. Louis, where he batted .300 in 1961 and .301 in 1962, but he decided to retire as a player at the 1963 All-Star break. It was the beginning of another transition, this time to the dugout as a coach, manager, and special assistant, where he would witness several more Cardinals pennants and World Series championships over the next five decades.

On and off the field, Schoendienst's bequest to generations of baseball stars was his leadership and experience. His teammate in Milwaukee, Hall of Famer Hank Aaron, said of Schoendienst, "He was just a tremendous ballplayer. He and I dressed side-by-side and I'll never forget how much he taught me about the game. He was a terrific leader."

—J.A.

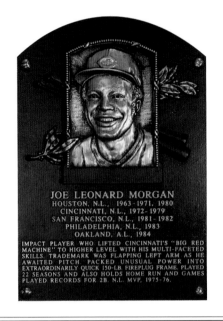

JOE LEONARD MORGAN
HOUSTON, N.L., 1963-1971, 1980
CINCINNATI, N.L., 1972-1979
SAN FRANCISCO, N.L., 1981-1982
PHILADELPHIA, N.L., 1983
OAKLAND, A.L., 1984
IMPACT PLAYER WHO LIFTED CINCINNATI'S "BIG RED
MACHINE" TO HIGHER LEVEL WITH HIS MULTI-FACETED
SKILLS. TRADEMARK WAS FLAPPING LEFT ARM AS HE
AWAITED PITCH. PACKED UNUSUAL POWER INTO
EXTRAORDINARILY QUICK 150-LB. FIREPLUG FRAME. PLAYED
22 SEASONS AND ALSO HOLDS HOME RUN AND GAMES
PLAYED RECORDS FOR 2B. N.L. MVP, 1975-76.

JOE MORGAN

CLASS OF 1990

"When he's healthy, he's the finest ball-player I ever played with," said Hall of Fame catcher Johnny Bench of Joe Morgan, his longtime teammate with the Cincinnati Reds. "He could win ball-games in more ways than anybody."

Morgan, whose multifaceted skills set him apart from his contemporaries, spent twenty-two seasons (1963–1984) as a big league second baseman, mainly with Houston and Cincinnati. A ten-time All-Star, five-time Gold Glove Award recipient, and winner of two National League MVP Awards (1975 and 1976), Morgan was a terror on the bases, swiping 689. Despite a small frame (five foot seven, 160 pounds), he cracked 449 doubles and 268 home runs, a record for his position at the time he retired.

"We've always thought he was the most vital man on the ball-club because he does so many things. He's not only a power hit-ter, but he's a good base stealer, a good defensive man. It's pretty tough to say where his shortcomings are; he really doesn't have too many," said coach Ted Kluszewski.

Born in Bonham, Texas, in September 1943, Morgan grew up in Oakland but returned to Texas as a professional, signing with the expansion Houston Colt .45s in 1962. He spent nine seasons with Houston but didn't develop into a future Hall of Famer until after being traded in November 1971 to the Reds (in an eight-player deal). Perfectly suited to the artificial surface game of the 1970s, he emerged from relative obscurity to become one of the

key cogs in Cincinnati's Big Red Machine. Morgan was arguably the best player on one of the sport's best-ever teams, helping the Reds capture back-to-back World Series championships in 1975 and 1976.

Pete Rose, a famed member of the Big Red Machine, said of Morgan, "We all know that Joe's a great ballplayer. I think what Joe does that many ballplayers don't do is that throughout the years he's created good habits in the way he practices and the way he plays baseball. In a baseball season when you play 162 games a year, year after year after year, there's so much repeti-tion, and Joe just does the right things instinctively. That's why he's such a good player."

After leaving the Reds as a free agent in 1980, Morgan remained a contributor on winning teams, playing regularly for Houston's division champions in 1980, serving two produc-tive seasons in San Francisco, and then belting sixteen homers for Philadelphia's pennant-winning "Wheeze Kids" in 1983. He played his final season back home in Oakland in 1984 before embarking on a long career as a color analyst with ESPN.

Not surprisingly, Morgan was elected to the National Baseball Hall of Fame in his first year of eligibility in 1990. Upon receiving the joyous news he said, "I take my vote as a salute to the little guy, the one who doesn't hit 500 home runs. I was one of the guys that did all they could to win. I'm proud of all my stats, but I don't think I ever got one for Joe Morgan. If I stole a base, it was to help us win a game, and I like to think that's what made me a little special."

—J.Y.

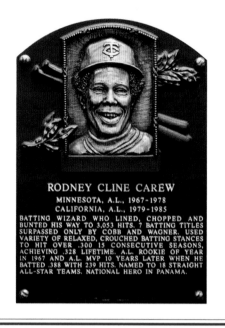

RODNEY CLINE CAREW
MINNESOTA, A.L., 1967-1978
CALIFORNIA, A.L., 1979-1985
BATTING WIZARD WHO LINED, CHOPPED AND
BUNTED HIS WAY TO 3,053 HITS. 7 BATTING TITLES
SURPASSED ONLY BY COBB AND WAGNER. USED
VARIETY OF RELAXED, CROUCHED BATTING STANCES
TO HIT OVER .300 15 CONSECUTIVE SEASONS,
ACHIEVING .328 LIFETIME. A.L. ROOKIE OF YEAR
IN 1967 AND A.L. MVP 10 YEARS LATER WHEN HE
BATTED .388 WITH 239 HITS. NAMED TO 18 STRAIGHT
ALL-STAR TEAMS. NATIONAL HERO IN PANAMA.

ROD CAREW

CLASS OF 1991

Rod Carew was a hitter of many stances. So much so that rival manager Dick Williams once said that going against the legendary hitter was like "pitching to five different guys every night."

Carew approached hitting in his own distinctive way, and it took Ted Williams, whose legacy he eventually chased, to come to his defense. Williams once told *Sports Illustrated*, "He's so smooth he seems to be doing it without trying. Some guys—Pete Rose is one, and I put myself in that category—have to snort and fume to get everything going. Carew doesn't."

With seven batting titles, Carew is surpassed only by Ty Cobb, Tony Gwynn, and Honus Wagner, and equaled only by Rogers Hornsby and Stan Musial. He hit better than .300 in fifteen consecutive seasons with the Twins and Angels, achieving a .328 lifetime average. The American League Rookie of the Year in 1967, he went on to win the league MVP ten years later and was named to eighteen straight All-Star teams.

"He has an uncanny ability to move the ball around as if the bat were some kind of magic wand," pitcher Ken Holtzman once said.

In fact, in 1977 Carew took a run at Williams's legacy. Of course, "The Splendid Splinter" was the last to hit better than .400 in a season when he averaged .406 in 1941. Thirty-six years later,

Carew hit .388 for the season, coming up roughly seven hits shy of the .400 plateau.

That said, Carew's .388 average for the season was fifty points higher than the next-best batting average in the majors that year.

In 1985 Carew became the second Latino player, after Roberto Clemente, to collect his three-thousandth hit. Despite the accomplishment, the quiet-spoken Carew was reluctant to hold a press conference afterward.

Carew was born on a train in Panama as his mother was trying to get to a hospital forty miles away from their home. He was named after the doctor who came in from the white section of the train to help deliver him. From such poor beginnings, Carew became a national hero in his native country.

"The astonishing thing about Carew is that he hits everybody," said Jim Frey, a former hitting coach with the Baltimore Orioles. "You think you spot a weakness in him, and it may work for three or four at-bats, but then he catches on and it's bang-bang-bang all over again."

In his prime, Carew was also lights-out on the base paths. He stole 353 bases in his nineteen-year career, including seven steals of home in 1969—a single-season total surpassed only by Ty Cobb.

"I taught him how to steal home," Billy Martin said. "That's all I ever taught him. As for hitting, he knew how to do that all by himself."

—T. Wendel

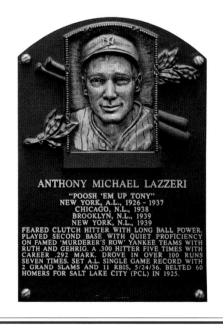

ANTHONY MICHAEL LAZZERI
"POOSH 'EM UP TONY"
NEW YORK, A.L., 1926 - 1937
CHICAGO, N.L., 1938
BROOKLYN, N.L., 1939
NEW YORK, N.L., 1939
FEARED CLUTCH HITTER WITH LONG BALL POWER,
PLAYED SECOND BASE WITH QUIET PROFICIENCY
ON FAMED 'MURDERER'S ROW' YANKEE TEAMS WITH
RUTH AND GEHRIG. A .300 HITTER FIVE TIMES WITH
CAREER .292 MARK. DROVE IN OVER 100 RUNS
SEVEN TIMES. SET A.L. SINGLE GAME RECORD WITH
2 GRAND SLAMS AND 11 RBIS, 5/24/36. BELTED 60
HOMERS FOR SALT LAKE CITY (PCL) IN 1925.

TONY LAZZERI

CLASS OF 1991

For some, the test of greatness comes through an ability to overcome adversity. In the case of Tony Lazzeri, that test was epilepsy, which could not prevent him from becoming an integral part of a New York Yankees dynasty.

He was born in San Francisco, one of the cities in the league in which Lazzeri first made a name for himself. As a rookie for Salt Lake City in the Pacific Coast League, Lazzeri was struggling badly. A local restaurant owner, Cesare Rinetti, befriended him and provided him with Italian dinners for three straight nights. Lazzeri acquired his nickname from Rinetti, who'd sit in the stands and cheer for him to "Poosh 'Em Up," or hit the ball out of the park. Lazzeri would eventually become a hero to Italian American fans.

Playing for Salt Lake City in 1925, he put up one of the most stunning seasons in minor league history. He batted .355 and piled up 222 RBI, statistics that, though aided by a long schedule and thin air, were still eye-popping. Those outlandish numbers drew the attention of the Yankees, who brought him up the following summer.

As a twenty-two-year-old rookie, Lazzeri led the American League in strikeouts, but he also produced eighteen home runs, sixteen stolen bases, and 117 RBI. The next year, he made the leap to stardom, his improvement coinciding with the birth of the "Murderers' Row" Yankees. He batted .309 and slugged .482, elite numbers for a middle infielder.

"I guess he didn't weigh more than 175 pounds," Yankees shortstop Frank Crosetti told *New York Newsday*. "But he was big through the shoulders. As a kid, he worked as a boilermaker and he had arms of steel. . . . What a hitter he was with men on base."

In four of his first five seasons, he drove in more than one hundred runs, reaching a high of 121 RBI in 1930. He also put up batting averages like .332, .354, and .303.

Yet Lazzeri was more than just a hitter. A steady and durable second baseman, he fielded his position with sharp instincts and athleticism, combining good range with soft hands. Highly respected, he provided leadership in the clubhouse. He was often called the smartest player on the Yankees.

Lazzeri took World Series play especially seriously. He participated in seven Fall Classics, five ending with the Yankees as champions. He excelled in the 1932 Series, hitting two home runs, and in the 1937 Fall Classic, when he batted an even .400.

His accomplishments look all the more impressive considering that he played his entire career with an epileptic condition. Remarkably, he never suffered an on-field seizure during his twelve years with the Yankees—or in his entire fourteen-year career.

Nor did he complain about his condition. "He was a leader. He was like a manager on the field," Crosetti told a sportswriter. "He not only was a great ballplayer, he was a great man."

—B.M.

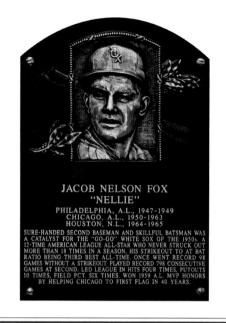

JACOB NELSON FOX
"NELLIE"
PHILADELPHIA, A.L., 1947-1949
CHICAGO, A.L., 1950-1963
HOUSTON, N.L., 1964-1965
SURE-HANDED SECOND BASEMAN AND SKILLFUL BATSMAN WAS
A CATALYST FOR THE "GO-GO" WHITE SOX OF THE 1950s. A
12-TIME AMERICAN LEAGUE ALL-STAR WHO NEVER STRUCK OUT
MORE THAN 18 TIMES IN A SEASON. HIS STRIKEOUT TO AT BAT
RATIO BEING THIRD BEST ALL-TIME. ONCE WENT RECORD 98
GAMES WITHOUT A STRIKEOUT. PLAYED RECORD 798 CONSECUTIVE
GAMES AT SECOND. LED LEAGUE IN HITS FOUR TIMES, PUTOUTS
10 TIMES, FIELD PCT. SIX TIMES. WON 1959 A.L. MVP HONORS
BY HELPING CHICAGO TO FIRST FLAG IN 40 YEARS.

NELLIE FOX

CLASS OF 1997

In contrast to sports like football and basketball, baseball does not necessarily favor those who are taller or bigger. At five feet ten inches and 160 pounds, Nellie Fox had sufficient height and weight for baseball—enough to forge a career as one of the game's great second basemen.

Fox broke into the major leagues with the Philadelphia A's in 1947, his career delayed by military service in World War II. After playing parts of three nondescript seasons in Philadelphia, Fox received a nudge in the form of a trade to the Chicago White Sox. Taking over as the full-time second baseman, Fox struggled in his first season with Chicago before breaking out into stardom. He batted .313 in 1951, marking the start of an eleven-year stretch in which he made the All-Star team every summer.

Fox became a fixture at Comiskey Park, where he emerged as a fan favorite because of his diminutive stature, his distinctive bottle bat, and his almost psychic ability to make contact with the ball. Fox drew his share of walks, but he almost never struck out. Remarkably, he totaled only 216 strikeouts in nineteen seasons.

With his ability to reach base, slap the ball to all fields, and nimbly handle the defensive chores at second base, Fox became a pest to opponents. "That little feller, he ain't so big, but he's all fire," New York Yankees manager Casey Stengel told the *New York Times*. "He's caused me more grief than any other player on the White Sox."

Fox was never more important to the Sox than in 1959. He batted .306, won a Gold Glove Award, and captured MVP honors, his spirited play driving the Sox to the pennant. Slashing line drives against an intimidating Los Angeles Dodgers pitching staff, Fox batted .375 in the World Series.

Because of his lack of size, Fox became an easy candidate for injuries, especially on takeout slides at second base. Yet he rarely missed games. On five occasions he led the American League in games played; he appeared in 150 or more games six other times.

Fox was willing to play hurt. "Fox is what you'd call a manager's ballplayer. He does his job expertly and he does it every day," said Hall of Fame skipper Al Lopez. "He's the type of player you can count on. He's an old pro. A great many times, he is hurting pretty badly from the dumpings he's taken on the field, but he's always ready to play."

He continued to play for Lopez through the 1963 season. Faced with rebuilding, the White Sox sent Fox to the expansion Houston Colt .45s for two younger players. Making a new home in Houston, Fox had a profound influence on the next generation of Hall of Famers.

"I played with him, and I wouldn't be standing here today if it wasn't for what I learned from him," said Joe Morgan, who had glowing words of praise for Fox at his own Hall of Fame induction. "Above all, Nellie impressed upon me the importance of going to the park every day bringing something to help the team. . . . Nellie Fox was my idol."

—B.M.

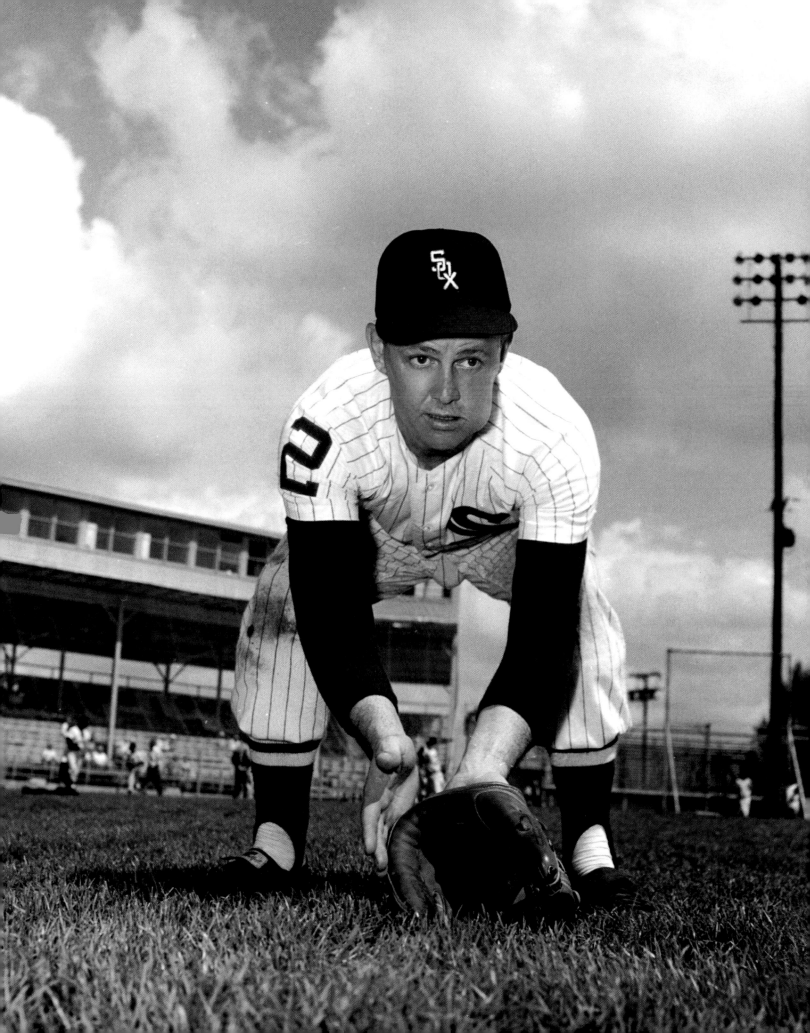

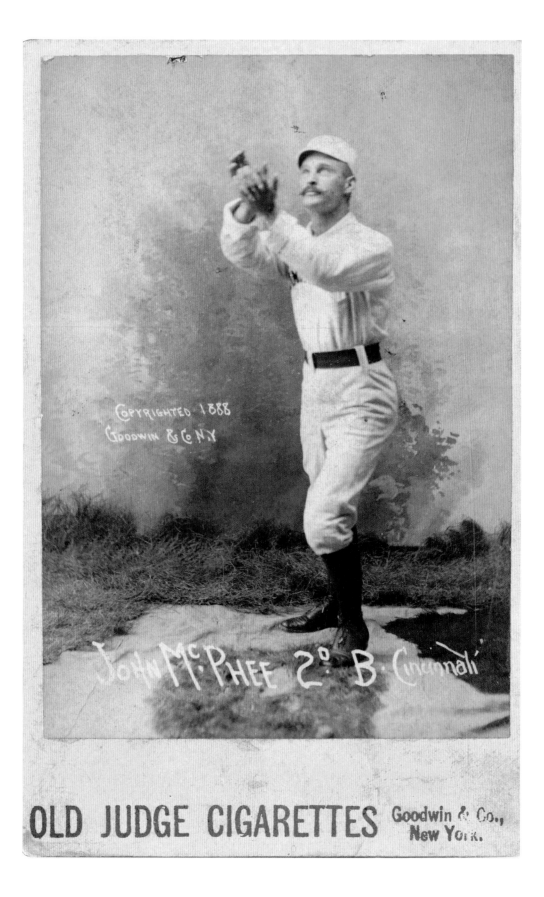

COPYRIGHTED 1888
Goodwin & Co N.Y.

John McPhee 2° B Cincinnati

OLD JUDGE CIGARETTES Goodwin & Co.,
New York.

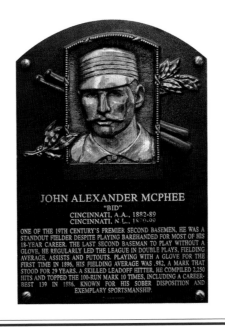

JOHN ALEXANDER MCPHEE
"BID"
CINCINNATI, A.A., 1882-89
CINCINNATI, N.L., 1890-99
ONE OF THE 19TH CENTURY'S PREMIER SECOND BASEMEN, HE WAS A STANDOUT FIELDER DESPITE PLAYING BAREHANDED FOR MOST OF HIS 18-YEAR CAREER. THE LAST SECOND BASEMAN TO PLAY WITHOUT A GLOVE, HE REGULARLY LED THE LEAGUE IN DOUBLE PLAYS, FIELDING AVERAGE, ASSISTS AND PUTOUTS. PLAYING WITH A GLOVE FOR THE FIRST TIME IN 1896, HIS FIELDING AVERAGE WAS .982, A MARK THAT STOOD FOR 29 YEARS. A SKILLED LEADOFF HITTER, HE COMPILED 2,250 HITS AND TOPPED THE 100-RUN MARK 10 TIMES, INCLUDING A CAREER-BEST 139 IN 1886. KNOWN FOR HIS SOBER DISPOSITION AND EXEMPLARY SPORTSMANSHIP.

BID McPHEE

CLASS OF 2000

He may have been the finest second baseman of the nineteenth century. That he played almost exclusively without the benefit of a fielder's glove speaks to the magnificence of Bid McPhee.

Born in the upstate New York town of Massena, McPhee would make his name in the Midwest. Though he was only five feet eight inches tall and weighed 150 pounds, his fast feet and reliable hands caught the attention of the Cincinnati Red Stockings.

He joined Cincinnati in 1882, contributing to a first-place finish, but generally struggled over his first two seasons. It wasn't until 1886 that he emerged as a star. Flashing a combination of power and speed, he stole forty bases and surprisingly led the American Association with eight home runs.

With his serious nature, intelligence, and quiet toughness, McPhee became a favorite of Cincinnati fans. Even as the Red Stockings moved to the National League and became known as the Reds, McPhee remained an effective player: a fast contact-hitting leadoff man. In 1887 he stole a career-high ninety-five bases and led the league in triples.

Yet it was his fielding that made him a brand-name player. He gobbled up grounders with the softest hands, rarely making errors, and routinely leading the league in fielding percentage. He did all of this without the benefit of a fielder's glove. Gloves did not become commonly used until the mid-1880s, and even then, McPhee held out. "I have never seen the necessity of wearing one," McPhee told the *Cincinnati Enquirer*, "and besides, I cannot hold a thrown ball if there is anything on my hands. This glove business has gone a little too far. . . . True, hot-hit balls do sting a little at the opening of the season, but after you get used to it there is no trouble on that score."

Strident in his belief, McPhee was the last second baseman to take the field without a glove. He finally gave in to the temptation in 1896, when a sore on his left hand did not heal properly. Putting on a glove, he posted a record fielding percentage for second basemen.

McPhee played the final four seasons of his career using the glove full-time. Maintaining himself in top condition, he continued to man second base regularly. Although he apparently retained sufficient skill to keep playing, he decided to retire in the spring of 1900. He told his manager, Bob Allen, that his throwing arm was too sore to allow him to earn his salary.

Allen grudgingly accepted his retirement. "In the 18 years he has played professional ball, he was never anything but an honorable man," Allen told the *Cincinnati Enquirer*. "His retirement shows his caliber. He could draw a big salary as long as he wore a uniform, whether he played or not, but he would not listen to it. And he retires as the honorable man that he is."

Not only was Bid McPhee honorable; he may also have been as tough as any man to play the game.

—B.M.

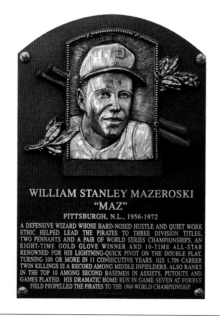

WILLIAM STANLEY MAZEROSKI
"MAZ"
PITTSBURGH, N.L., 1956-1972

A DEFENSIVE WIZARD WHOSE HARD-NOSED HUSTLE AND QUIET WORK
ETHIC HELPED LEAD THE PIRATES TO THREE DIVISION TITLES,
TWO PENNANTS AND A PAIR OF WORLD SERIES CHAMPIONSHIPS. AN
EIGHT-TIME GOLD GLOVE WINNER AND 10-TIME ALL-STAR
RENOWNED FOR HIS LIGHTNING-QUICK PIVOT ON THE DOUBLE PLAY,
TURNING 100 OR MORE IN 11 CONSECUTIVE YEARS. HIS 1,706 CAREER
TWIN KILLINGS IS A RECORD AMONG MIDDLE INFIELDERS. ALSO RANKS
IN THE TOP 10 AMONG SECOND BASEMEN IN ASSISTS, PUTOUTS AND
GAMES PLAYED. HIS DRAMATIC HOME RUN IN GAME SEVEN AT FORBES
FIELD PROPELLED THE PIRATES TO THE 1960 WORLD CHAMPIONSHIP.

BILL MAZEROSKI

CLASS OF 2001

He set the standard for playing second base. Whether it came to ranging far to his backhand side, nestling ground balls in his soft hands, or turning double plays with unprecedented quickness, Bill Mazeroski became the master of the keystone position.

A native of Wheeling, West Virginia, Mazeroski broke through as the Pittsburgh Pirates' starting second baseman in 1956, when he was only nineteen. By his third season, Mazeroski made the All-Star team and won a Gold Glove Award. But it was the 1960 World Series that put him in the national spotlight. With the score tied in the ninth inning of Game 7, Maz stepped to the plate, swung at a high fastball from Ralph Terry, and lofted it high toward left-center field.

The Terry-to-Mazeroski delivery cleared the 406-foot mark, landing in a grove of maple trees. "By the time I reached the dugout," Mazeroski told sportswriter Scott Pitoniak, "my legs felt like rubber and my body was battered and bruised." Mazeroski became the first player to end the World Series with a home run, in what some observers called the most exciting game ever.

Mazeroski's home run represents a singular moment, but it was his marvelous defensive play that made the game's purists hyperventilate. "Show me a better second baseman than Mazeroski, a second baseman who could field his position better than Mazeroski," Hank Aaron told the *Albany Times Union.* "Red

Schoendienst was the only second baseman I saw who was comparable. Mazeroski truly was a most gifted athlete."

Maz displayed good range and soft hands, and he owned an exceedingly fast trigger on the double-play pivot, so quick that he was given the nickname of "No-Touch." He barely held the ball in his glove before making an instantaneous transfer to his bare hand and firing to first base. "Maz may not have hit 400 home runs or driven in 2,000 runs, but look how many runs he saved," teammate Willie Stargell told sportswriter Dan Castellano. "Fielding his position, he was perfection."

Even as he grew older, scouts marveled at Mazeroski's knowledge of opposing hitters and his instinctive ability to position himself accordingly.

Mazeroski's durability was just as impressive as his fielding. He twice led the National League in games played, and often appeared in more than 150 games a season.

By 1969 an aging Maz took it upon himself to teach his successor, Dave Cash, the subtleties of playing second base. Replacing a popular legend could have been nightmarish. But "it really wasn't that difficult," Cash said, "because I got a lot of help from Maz. As a matter of fact, I learned how to play second base; a lot of it came from his knowledge. . . . I didn't realize the ballplayer I was replacing until I started reading some of his stats."

Those statistics, particularly the ones involving the art of fielding, are lasting tributes to an exemplary career. Yet they tell only part of the story. Those who saw Bill Mazeroski play second base saw something that the numbers can never describe.

—B.M.

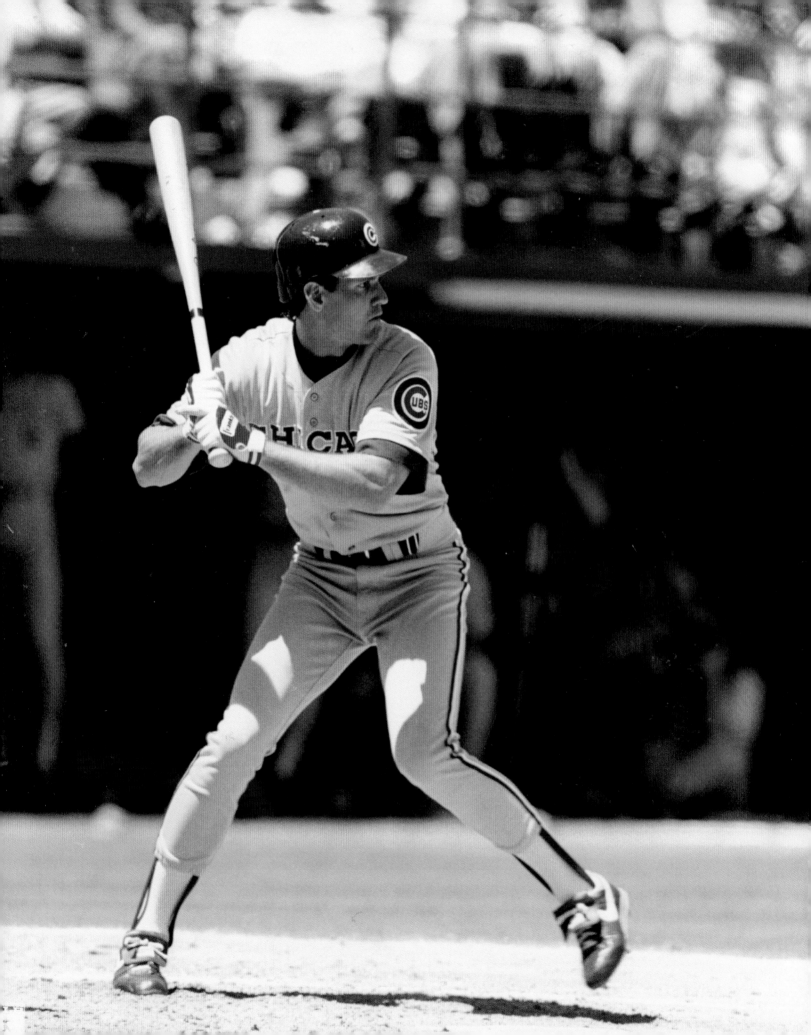

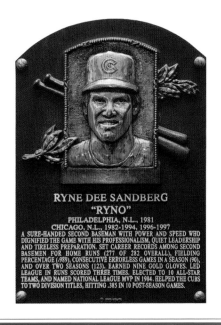

RYNE DEE SANDBERG
"RYNO"
PHILADELPHIA, N.L., 1981
CHICAGO, N.L., 1982-1994, 1996-1997
A SURE-HANDED SECOND BASEMAN WITH POWER AND SPEED WHO
DIGNIFIED THE GAME WITH HIS PROFESSIONALISM, QUIET LEADERSHIP
AND TIRELESS PREPARATION. SET CAREER RECORDS AMONG SECOND
BASEMEN FOR HOME RUNS (277 OF 282 OVERALL), FIELDING
PERCENTAGE (.989), CONSECUTIVE ERRORLESS GAMES IN A SEASON (90),
AND OVER TWO SEASONS (123). EARNED NINE GOLD GLOVES, LED
LEAGUE IN RUNS SCORED THREE TIMES. ELECTED TO 10 ALL-STAR
TEAMS, AND NAMED NATIONAL LEAGUE MVP IN 1984. HELPED THE CUBS
TO TWO DIVISION TITLES, HITTING .385 IN 10 POST-SEASON GAMES.

RYNE SANDBERG

CLASS OF 2005

Whether it was deceptive speed, surprising power from a lean body, or masterly fielding at a most demanding position, Ryne Sandberg played the game with refined elegance. That elegance translated into seven seasons with more than one hundred runs scored and a home run total greater than that of any previous second baseman in history at the time of his retirement.

Sandberg's connection to baseball began in the weeks leading up to his birth in Spokane, Washington. Struggling to agree on a name for their son, his parents watched hard-throwing reliever Ryne Duren make his way to the mound in a televised game. Ryne it would be.

Drafted in the twentieth round by the Philadelphia Phillies, Sandberg played in the minor leagues as a shortstop. He impressed the Phillies, but the organization projected him as a third baseman in the major leagues. That was not a position that needed filling, given the presence of Mike Schmidt. In 1982, one year after Sandberg made his Philadelphia debut, the Phillies relieved the logjam—by trading Sandberg and veteran shortstop Larry Bowa to the Chicago Cubs for shortstop Ivan DeJesus. The trade would become one of the best in the history of the Cubs.

After starting his rookie season in a 1-for-31 slump, Sandberg rebounded to finish with a respectable .271 average and thirty-two stolen bases. When the Cubs traded for Ron Cey, they moved Sandberg to second base for his sophomore season. Working hard at learning the double-play pivot, Sandberg played the position as if he had been there for years. Sure hands and considerable range led to his first Gold Glove Award.

Sandberg's offensive skills soon caught up with his fielding. He credited a supportive manager, Jim Frey, with changing his career. In the spring of 1984, Frey encouraged Sandberg to drive the ball, to pull it with power. Sandberg did exactly that, slugged .520, and led the Cubs to their first National League East title. Not surprisingly, he won the MVP, the first Cub to take the honor since Ernie Banks in 1959.

Taking advantage of the friendly winds at Wrigley Field, Sandberg led the league with a career-high forty home runs in 1990. After a brief retirement in 1994, he returned to the Cubs two years later and played the game as if he had never stopped, hitting twenty-five home runs while committing only six errors.

By the time Sandberg retired for good, he had set a standard for his position. "He was a great ballplayer and holds a ton of records for second basemen, offense and defense," Hall of Famer Ralph Kiner told sportswriter Jerome Holtzman. "Those are pretty good qualifications. He's the best second baseman of his era."

Sandberg also impressed teammates with his quiet class and grace. "He's the type of individual who, every time you heard people talk about him," former Cubs great Andre Dawson told the *Chicago Tribune*, "they wanted their kid to grow up like Ryne Sandberg."

—B.M.

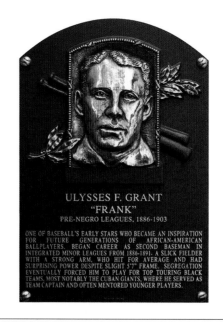

ULYSSES F. GRANT
"FRANK"
PRE-NEGRO LEAGUES, 1886-1903

ONE OF BASEBALL'S EARLY STARS WHO BECAME AN INSPIRATION FOR FUTURE GENERATIONS OF AFRICAN-AMERICAN BALLPLAYERS. BEGAN CAREER AS SECOND BASEMAN IN INTEGRATED MINOR LEAGUES FROM 1886-1891. A SLICK FIELDER WITH A STRONG ARM, WHO HIT FOR AVERAGE AND HAD SURPRISING POWER DESPITE SLIGHT 5'7" FRAME. SEGREGATION EVENTUALLY FORCED HIM TO PLAY FOR TOP TOURING BLACK TEAMS, MOST NOTABLY THE CUBAN GIANTS, WHERE HE SERVED AS TEAM CAPTAIN AND OFTEN MENTORED YOUNGER PLAYERS.

FRANK GRANT

CLASS OF 2006

Before the Negro National League was formed in 1920, well before Jackie Robinson broke the color barrier in 1947, Ulysses Franklin "Frank" Grant demonstrated that people of color could excel at playing the game of baseball.

Grant, a quick, agile, skilled second baseman, was perhaps the best of the African American players who played in white organized baseball in the 1880s, before the color line was drawn.

"Were it not for the fact that he is a colored man," read a press account during Grant's playing days, "he would without a doubt be at the top notch of the records among the finest teams in the country."

After playing with local semipro teams in his native Pittsfield, Massachusetts, and in Plattsburgh, New York, Grant joined Meriden (Connecticut) in the Eastern League in 1886, leading the team with a batting average of .316. When the Meriden team folded that July, he reported to the Buffalo Bisons of the International League, where Grant led the team with a .344 batting average and drew strong press throughout the league for his play in the field.

In 1888 Grant, who was just twenty-two at the time, hit eleven home runs, with thirty-six extra-base hits, and had twenty-three stolen bases for Buffalo. And because he also wowed the crowds with his slick fielding, he was nicknamed "The Black Dunlap" after Fred Dunlap, the majors' best second baseman at the time. Bisons manager John "Jack" Chapman compared Grant favorably with King Kelly, a star with the National League Boston Beaneaters during this period.

But some, even Grant's teammates, couldn't look past his skin color. While the Bisons tried to pass him off as a "Spaniard" who had headed north from somewhere in the Caribbean to play professional baseball, Grant found it increasingly difficult to maintain his spot on the team. Even though he fashioned wooden shin guards to protect himself from the spikes-high slides of opposition base runners, he never totally won over his own dugout. Some of Grant's teammates refused to sit for team portraits if he was in attendance.

The 1887 season was pivotal for African American players in organized baseball, for at midseason, the International League banned teams from signing new contracts with black players.

Grant left Buffalo after the 1888 season, relenting to the changing environment and the pressure coming from his teammates, fans, and the media, and switched to the Cuban Giants, one of the leading all-black clubs at the time. The Cuban Giants played against white professional teams, though, and so Grant faced continued antagonism, especially when he and a black teammate played for Harrisburg, a white team, in 1890 and 1891. Other stops along the way would include such leading black teams as the Page Fence Giants, the Cuban X-Giants, and the Philadelphia Giants.

Hall of Famer Sol White, a player, manager, and writer on the early years of black baseball, said, "In those days, Frank Grant was the baseball marvel. His playing was a revelation to his fellow teammates, as well as the spectators. In hitting he ranked with the best and his fielding bordered on the impossible. Grant was a born ballplayer."

—B.F.

JOSEPH LOWELL GORDON
"JOE" "FLASH"
NEW YORK, A.L., 1938-1943, 1946
CLEVELAND, A.L., 1947-1950

AN ACROBATIC SECOND BASEMAN WITH TREMENDOUS POWER WHO
HELPED LEAD HIS TEAMS TO SIX PENNANTS IN 11 SEASONS, WINNING
FIVE WORLD SERIES TITLES. RENOWNED FOR SUPERB DEFENSIVE
RANGE, THE NINE-TIME ALL-STAR AND 1942 A.L. MVP LED THE
LEAGUE IN ASSISTS FOUR TIMES AND DOUBLE PLAYS THREE TIMES.
SET CAREER A.L. HOME RUN RECORD FOR SECOND BASEMEN. DROVE
IN MORE THAN 100 RUNS FOUR TIMES AND HIT 20 OR MORE HOME
RUNS SEVEN TIMES. ALSO MANAGED PARTS OF FIVE SEASONS WITH
CLEVELAND, DETROIT AND KANSAS CITY ATHLETICS AND ROYALS.

JOE GORDON

CLASS OF 2009

The best testament to Joe Gordon's career can be found in the records of the teams for which he played. His teams always finished above .500, and many of them contended for league titles. As one of his teams' stars, Gordon contributed mightily to those winning seasons.

Born in Los Angeles, "Flash" Gordon enjoyed much of his success on the East Coast. Originally signed by the New York Yankees as an amateur free agent in 1936, he fought his way onto the roster only two years later. A worthy successor to Tony Lazzeri, Gordon immediately showed that he belonged, hitting twenty-five home runs, slugging .502, and playing an agile and athletic second base. The right-handed slugger played even better in his second season, as he increased his home run and RBI totals, despite having to deal with the difficult dimensions of Yankee Stadium.

A remarkably consistent player, Gordon continued to put up fine seasons through 1943. His offensive game reached a peak in 1942, when he batted a career-high .322 and reached base over 40 percent of the time, while winning the American League MVP Award.

In the early 1940s, Yankees manager Joe McCarthy offered up the highest of praise for Gordon. "The greatest all-around ball-player I ever saw," McCarthy said to a reporter, "and I don't bar any of them, is Joe Gordon."

Only twenty-eight years old at the end of the 1943 season, Gordon was clearly still near his peak level of performance. Then came the reality of war. He missed all of 1944 and 1945 while serving in the Army during World War II. Those two years fell right in the prime of his career.

Returning in the middle of the 1946 season, Gordon was affected by the layoff and struggled to return to prior form. Concerned that he was suddenly over the hill, the Yankees traded him to the Cleveland Indians for right-handed ace Allie Reynolds. Gordon shook off the rust and proceeded to post two spectacular seasons followed by a pair of good ones. "He was a wild swinger at the plate, a free swinger with power," Indians teammate Bob Feller told ESPN. "He was an acrobat around the bag; he was all over the place in the field."

Gordon wrapped up his major league career in 1950. He remained a helpful player who sported good power, as evidenced by nineteen home runs in his final season.

Although Gordon's career was relatively short, he did lose two and a half seasons to World War II. Given appropriate war "credit," his career would have spanned thirteen seasons. Of the eleven actual campaigns in which he played, nine were highly productive, including four seasons in which he slugged over .500. And he did most of it within the context of pennant-contending clubs: six of his teams advanced to the World Series, and three others finished third. None of his teams ever finished in the second division.

For Joe Gordon, it was all about winning. He was a high-quality player on numerous championship-caliber teams. In other words, he achieved one of the most basic definitions of a Hall of Famer.

—B.M.

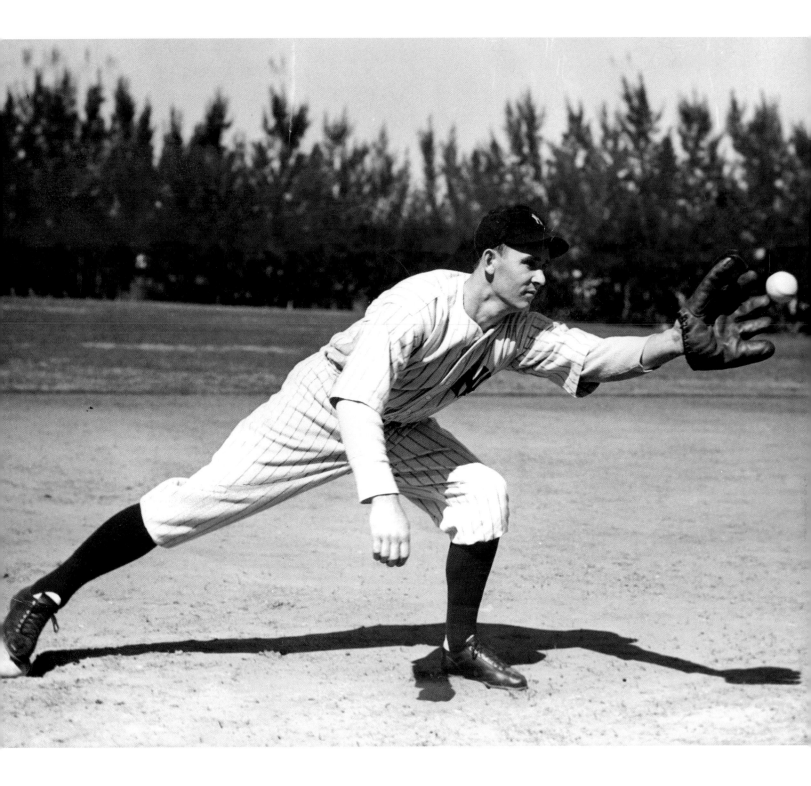

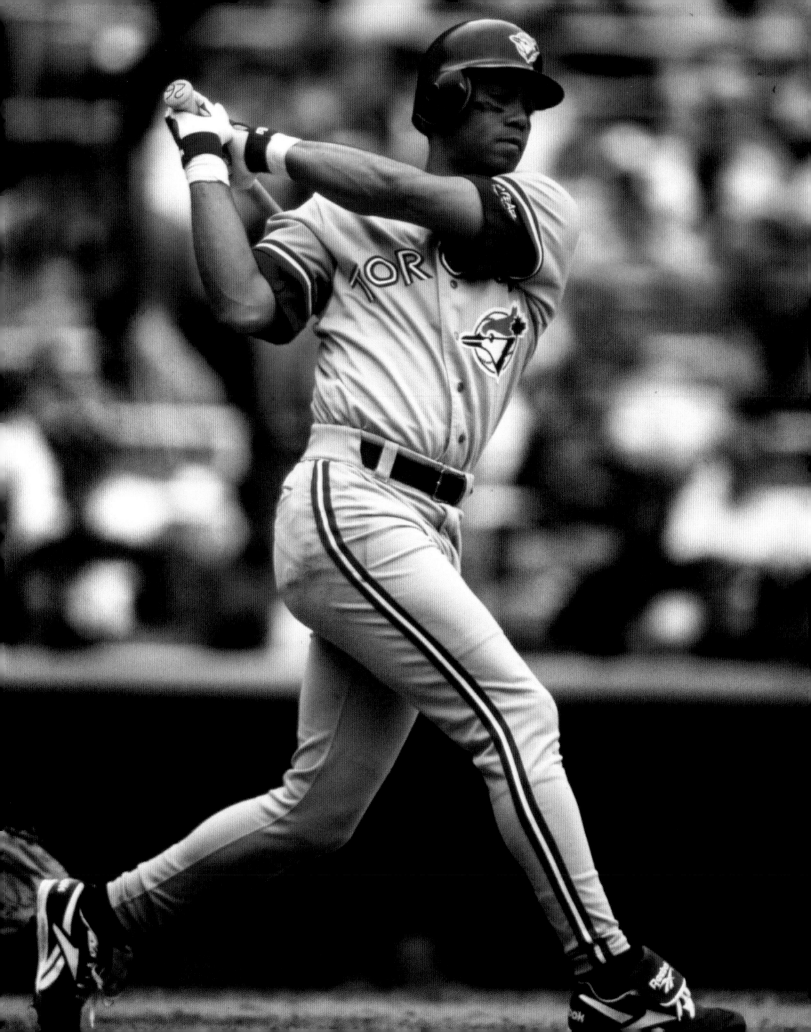

ROBERTO ALOMAR VELAZQUEZ
"ROBBIE"
SAN DIEGO, N.L., 1988-90; TORONTO, A.L., 1991-95;
BALTIMORE, A.L., 1996-98; CLEVELAND, A.L., 1999-2001;
NEW YORK, N.L., 2002-03; CHICAGO, A.L., 2003-04;
ARIZONA, N.L., 2004
SET THE STANDARD FOR A GENERATION OF SECOND BASEMEN WITH A QUICK,
POWERFUL BAT, A SMOOTH, STEADY GLOVE AND SEEMINGLY ENDLESS RANGE.
MEMBER OF A PUERTO RICAN FAMILY OF BASEBALL STARS, HIS GRACE,
TIRELESS PREPARATION AND POISED PRESENCE RESULTED IN A .300 BATTING
AVERAGE, 2,724 HITS, 210 HOME RUNS, 474 STOLEN BASES, AND 12 ALL-STAR
GAME APPEARANCES. HIS 10 GOLD GLOVE AWARDS ARE A POSITION RECORD. A
MODEL OF CONSISTENCY, HIT .300 OR BETTER NINE TIMES, SPURRED BLUE
JAYS TO CONSECUTIVE WORLD SERIES TITLES IN 1992-1993.

ROBERTO ALOMAR

CLASS OF 2011

Roberto Alomar was destined to be a great ballplayer.

His father, Sandy Alomar Sr., remembered a St. Louis Cardinals scout watching his son play pepper when he was just six years old and wanting to sign him.

"He was determined to be a player," the senior Alomar, a major leaguer himself, once told *Sports Illustrated*. "He always told me, 'I'm going to be better than you.'"

In his first spring training camp, Roberto turned heads by lugging a bag of balls out to a far diamond and hitting off a tee for an hour. By the age of twenty he was the starting second baseman for San Diego, and an All-Star two years later. When he was traded to Toronto, along with outfielder Joe Carter, in December 1990 for first baseman Fred McGriff and shortstop Tony Fernandez, baseball insiders realized what a prize the Blue Jays had landed. In five years in Toronto, Alomar hit .307 and won five Gold Glove Awards, along with two World Series rings. He later became the first Hall of Famer to be inducted as a Blue Jay.

According to Joe Morgan, another Hall of Fame second baseman, Alomar redefined the position with his range, arm, and bat. Able to go deep in the hole between first and second base, Alomar would often slide and then pop back to his feet, throwing to get the runner. *Sports Illustrated* ranked him as the third best of all time at the position, behind only Bill Mazeroski and Eddie Collins. Alomar also has been called the best ballplayer to hail from Puerto Rico since Roberto Clemente.

"I'm not only a player of the game," Alomar said. "I'm a student of the game. I watch and learn."

He proved that in garnering twelve consecutive All-Star selections. The switch-hitter batted .300 for his career and stole at least thirty bases in eight seasons. His ten Gold Glove Awards are the most ever at his position. Alomar played for seven teams over a seventeen-year big league career, including the 1992 and 1993 Blue Jays, winners of back-to-back World Series.

The Blue Jays had come up short three previous times in the American League Championship Series. But in 1992 Alomar made sure they finally reached the Fall Classic as he homered in a pivotal at bat off Oakland's Dennis Eckersley. "I don't think we'd have ever gone to the World Series in '92 if he didn't hit that home run," Toronto general manager Pat Gillick later said.

A year later, Alomar hit .326 and stole fifty-five bases as the Blue Jays repeated as World Series champions.

Prior to the 1996 season, Alomar signed with the Baltimore Orioles and formed a future Hall of Fame double-play combination with Cal Ripken Jr. The pair led the O's to the playoffs in back-to-back seasons.

From there Alomar went on to Cleveland, where he teamed up with another slick-fielding shortstop—Omar Vizquel. They would win three consecutive Gold Glove Awards together, becoming one of a handful of second baseman–shortstop combinations to do so.

—T. Wendel

GEORGE BRETT

THIRD BASEMEN

THIRD BASEMEN BY **GEORGE BRETT**

The shadow cast by his older brothers proved a daunting challenge for George Brett, but the greatest player in Kansas City Royals history wound up not only emerging from their shadow but also casting an enormous one of his own. A sweet-swinging left-handed-batting disciple of Charlie Lau, Brett became the only player in baseball history to win batting titles in three different decades. He flirted with a .400 season in 1980 before finishing with a robust .390 average. Brett also worked hard at becoming a solid third baseman, winning a Gold Glove Award for his defense in 1985.

My oldest brother, John, had captained the baseball team and played football at El Segundo High School, just south of Los Angeles International Airport. He was a tough, tough, tough individual, who wound up playing a year and a half in the Boston Red Sox organization. John didn't take guff from anyone, and the story goes that he wound up getting into a fight in the minors with Carlton Fisk and the next day he was released. The moral of that story is: Don't get into a fight with the team's number one draft pick if you aren't a number one draft pick yourself.

Next in the pecking order was Ken—we all called him Kenner. All these decades later, he's still regarded as one of the best athletes ever to come out of Southern California. He was a tremendous football player and an excellent guard in basketball. But baseball was where he really excelled. He was the fourth player taken in the 1966 draft, and the following year, as a nineteen-year-old with the Red Sox, he became the youngest player ever to pitch in a World Series. He developed arm trouble not long after that, and even though it prevented him from fulfilling his potential, he wound up spending fourteen years in the big leagues with ten different teams. The third Brett boy—Bobby—was a good baseball player and an all-league basketball player who wound up going to Cal Poly–Pomona. He spent one year in the Kansas City Royals organization before deciding to go in a different direction.

And then I came along.

Not surprisingly, I was constantly being compared to my older brothers—and not always in a kind way. I'd hear things like "Well, George doesn't hit as well as his brother Ken." Or "George is not as tough as his brother John." Or "Bobby is so much faster than George, it's unbelievable." And yadda, yadda, yadda. It was so bad that even when I went to the beach near us just to unwind, I'd have to hear that I wasn't as good a surfer as my brothers. I wasn't really the black sheep of the family, but that's how I started to feel. I guess, in retrospect, it kept me striving because I yearned for someone to finally say, once, just once, "Hey, George, you're pretty good," instead of "George, you're not as good as your brothers." That's not to say I wasn't proud of John, Kenner, and Bobby; I was. It's just that you reach a point where you want to be judged on your own merits, not somebody else's.

It's funny, but when I was eight or nine I wasn't into sports the way my brothers were. I was kind of lazy and more interested in hanging out at the beach. But my brothers would push me to work harder at times. I remember my brother John hanging a tarp off the rafters inside our garage and hitting balls off a batting tee. He'd drag me out there and he'd have me pick up all the balls

he hit, put them in a basket so he could hit again. Then, when he was done, he would let me hit a few off the tee.

But the person who pushed me the most and never stopped pushing until the day he died was my dad. Jack Brett was one demanding cookie. He refused to accept mediocrity. He expected us to toe the line and work hard at all times. He wanted us to excel. To be honest, I was very afraid of my dad. But what you have to remember is that this was the late 1950s, early '60s, and parents parented differently then. I think a lot of kids were scared of their parents back then. We didn't have a woodshed in the backyard, but we might as well have had one. If he saw me or my brothers hit a grounder or a pop-up and not run full speed, we'd get an earful.

Even when I made it to the big leagues, I heard it from him. And he was still comparing me to my brothers. I remember in 1974 I was really struggling, hitting about .200 at the All-Star break, and my brother Ken was having a really good year with the Pirates. I called home [one Sunday], which I always did during the season, and the next thing you know, I'm crying and throwing the phone against the wall of my apartment and shattering a mirror. My dad had just gone on about how Ken was a better ballplayer than me and how he was hitting home runs [Ken hit ten career big league home runs, including two in 1974, a year when he hit .310 overall], and I couldn't even get the ball out of the infield. My roommate at the time was Buck Martinez. He could see what my dad's criticism was doing to me and he wound up talking to him one day. He said, "Jack, let me give you some advice. Leave him alone. He's going to be good." After that he lightened up a bit. But just a bit. I really appreciated Buck doing that, and I was even more appreciative that he thought I was going to be good, because I didn't hear that much from people for the longest time.

There's a funny story my mother tells about how one night she and Dad were dining alone at our house. I was in high school and my three brothers were living somewhere else, and my dad looked at Mom and said, "Poor George, he's probably going to live with us till he's forty years old. He's not a very good player and he's not very good in school." We all got a kick out of that one later on, when I began enjoying quite a bit of success in the big leagues.

I was fortunate to play on some great, great high school baseball teams at El Segundo. We didn't have those *USA Today* national rankings back then, but if we had, we probably would have been rated at or near the top of the polls. My junior year we were 38–2, and my senior year we were 39–1. I think we had six guys drafted my senior year. And the year after that, one of our pitchers, Scotty McGregor, was chosen first overall by the Yankees. That gives you an idea of the caliber of talent we had.

I was an all-state shortstop my junior and senior seasons, and my coach fully expected me to be drafted in the first round in 1971. But the first round came and went and I hadn't been chosen. Finally, Kansas City picked me near the top of the second round. Although nobody knew much about the Royals in SoCal—they had just joined the American League as an expansion team two years earlier—I was just thrilled to be chosen and excited that I was about to start my professional baseball career. But in addition to being excited, I was scared. I'll never forget bawling my eyes out as I prepared to board that airplane for Billings, Montana, the Royals' rookie league team,

where I'd been assigned. You can get a good education in college and you can get a good education living on your own at eighteen. And that's the education I got.

I was playing shortstop in Billings, and one game I wound up getting spiked in the knee. It took sixteen stitches to sew up the gash, and I missed four or five games. I never fancied myself playing shortstop in the major leagues, so when I returned, I wasn't disappointed when they put me at third base. They figured initially it would be better for me to play there because there wouldn't be as much stress on my knee. After the season ended, I went to the instructional league in Florida and played third base exclusively. And that was fine with me.

Things went well for me in the minors. I made the All-Star teams all three seasons and progressed from Billings to San Jose to Triple-A Omaha before getting a call-up to the Royals on August 2, 1973. I was used in spot duty and hit just a buck twenty-five [5-for-40], but it was a good experience, and the next spring I was invited to big league camp and wound up winning the third-base job. I didn't exactly set the world on fire my first full season with the Royals. In fact, I struggled to stay above the .200 mark, and by the All-Star break my confidence was shot.

When I first got to the big leagues, our hitting instructor, Charlie Lau, wasn't that familiar with me. During the first few months of the 1974 season he didn't really instruct me; he just observed me. Oh, he was cordial. He'd ask how I was doing and tell me, "Let's go get 'em today." But that was that. By the All-Star break, he'd watched me for about two hundred at bats, so he had a body of work to analyze. He had noticed that I never made an adjustment. I just kept doing the same swing, over and over and over again. One day he finally said to me, "You know, George, I love your enthusiasm. I really think you can play, but you got to make some changes. If you are willing to do what I say, I'll work with you. But I'm not going to waste my time. You can't just work for two weeks and then go back to your old ways if it doesn't work out. This is going to be a long, drawn-out process. We're going to take a lot of extra batting practice. It's going to take a real commitment on your part." I told him I was all in, and we got to work.

Looking back, I know he got me at a perfect time, because I was desperate. I had hit rock bottom and I needed to try something different. I would show up to the ballpark at about one o'clock, about three hours before regular batting practice, and we spent part of the time talking about hitting mechanics and strategy and looking at both still photographs and films. We started experimenting the first day during the All-Star break. We took a lot of extra batting practice those three days, then our team flew to Baltimore to resume the season, and we continued the extra sessions before those road games. We worked on finding a comfortable place to put my hands. And we finally found it. We hit extra every day for the remainder of the season, and we set a goal of .250. I said, "Holy cow, that's going to be impossible."

Well, about a month later I was at .250. I remember coming into the dugout after the hit that elevated me to that mark and he had a smile on his face. I said, "Charlie, we did it. We reached our goal." And he said, "B.S. we did. We now have a new goal—.260." And then when we reached that mark, he raised the bar to .270, and so on and so on. I got it up to .292 with four games to go in the season, and they wound up demoting Charlie to the minors. I ended up going 0-for-11 to finish the season at .282. In midseason 1975, the Royals fired manager Jack McKeon and hired Whitey Herzog. And he immediately promoted Lau back to his former position. No one was hap-

pier than me. During that season, Charlie and I developed a very close relationship. It was almost like father and son. After games, we'd go to dinner together. We'd play cards together in the clubhouse. And we'd talk hitting all the time. We really took an interest in each other. I will always be indebted to him for saving my career. A lot of it had to do with the corrections he made to my swing and my hand positioning and my strategy at the plate against particular pitchers. But a lot of it had to do with his belief in me. Like my old roommate Buck Martinez, Charlie thought I could be a good player.

Another guy who believed in me was Al Zeek, the Royals' longtime equipment manager. When I first arrived in the big leagues, they gave me number 25. I had always worn number 5 in honor of my favorite player, Brooks Robinson. But Richie Scheinblum already was wearing number 5 for the Royals. No big deal. Well, after the 1974 season I got a call from Al saying Scheinblum had been sold and 5 was available. I said, "Zeek, it really doesn't matter." And he said, "No, I think you are going to be around for a long time and you should wear number 5." And I said fine. That meant a lot that he felt that way about me.

In 1975 I hit over .300 for the first time, and in 1976 I won my first batting title by a sliver. The race came down to the final day of the season, and it just so happened that the three other guys in contention for the title—teammate Hal McRae and Rod Carew and Lyman Bostock of the Minnesota Twins—were involved in that final game. I actually won the title on a flukish inside-the-park home run. To this day, I haven't seen a replay of it. All I remember is that I swung at a two-strike pitch and didn't hit the ball well. I was just trying to put the ball into play, and after I hit it, I put my head down and tore out of the box. I saw the first-base coach immediately wave me toward second, and that's when I saw the ball was bouncing toward the wall. So I just kept busting my tail and our third-base coach waved me home. I'm told the ball dropped in front of the left fielder and took a funny high bounce off the turf and over his head. I think it was my third hit of the day. Hal ended up getting two hits and Carew and Bostock had one or two hits apiece. It was so close that I think they had to carry it out to five digits. It might have been .33333 compared to .33206.

I'm obviously happy I won the title, but if I hadn't won it, I would have wanted Hal to. Like me, Hal was a Charlie Lau disciple. And he and Charlie and I would spend a lot of time talking hitting. I really admired the way Hal played the game, and I wound up patterning my approach after his. Hal was always hustling. He loved to take guys out at second base on double plays and he loved to try to stretch singles into doubles and doubles into triples. If I had to single out a favorite teammate, it would have to be Hal because he taught me so much about the game. After games, most guys shower and leave, but Hal and I would hang around, have a few beers, and talk about the game for forty-five minutes to an hour. Charlie often would join us, and we'd re-create our at bats and talk about what the pitcher was trying to do and so forth. I learned an awful lot of baseball after games, not just during them.

I didn't spend much time celebrating my batting title because we had a playoff series to worry about. The Oakland A's had dominated the division and baseball, winning World Series titles in 1972–1974. But we finally had broken their stranglehold, and people in Kansas City were going bonkers because after so many down years with the old Kansas City Athletics and then the expansion Royals, they finally had a team to root for in the postseason. That American League

Championship Series between the small-market Royals and the big-city Yankees will forever be remembered for Chris Chambliss's dramatic walk-off homer that catapulted the Bronx Bombers into the World Series. I had a good series against the Yankees, and I hit a three-run homer in the eighth inning of the final game off Grant Jackson to tie the score. I credit Charlie for giving me a tip just before I headed to the on-deck circle. He reminded me that Jackson usually had a tough time getting the ball away to left-handed hitters; he often came inside to them. So Charlie suggested that I move up a few inches in the box and be ready for an inside fastball. Sure enough, that's the pitch I saw, and I was able to hit a fly ball down the right-field line for a home run. Unfortunately, it was all for naught because of Chambliss's homer. That really was the start of the rivalry between us and the Yankees. And what a rivalry it would become.

Although we were very disappointed with the loss, we also were very proud of what we had accomplished. The Royals had never won anything before, and all of a sudden we had won our division and then took the mighty Yankees to five games before losing. But after being there once, the next time you go, you'd better win. We came up short in 1977, came up short in 1978, missed the playoffs by two games in '79, then in 1980 put together a great season and finally beat the Yankees to reach the World Series. It was like the ultimate to vanquish the Yankees. Not to take anything away from the Philadelphia Phillies—they had some unbelievable players—but I think we were emotionally shot after our series with the Yankees. We wound up winning the ALCS in New York and then sat around the Big Apple for three days waiting for the NLCS to end so we could find out if we would be flying to Philly or Houston.

Nineteen eighty was also the season I flirted with becoming the first major league player to hit .400 since the great Ted Williams in 1941. I finished at .390, which is not too shabby. The way I started that season gave no indication of how I would finish. I was only hitting about .250, .260 by the end of April. But slow starts were kind of customary for me. Back then, I didn't work out much in the offseason. I never picked up a baseball or a bat and rarely exercised. I figured that's what the six weeks of spring training were for—to get into baseball shape. It wasn't until the winter of 1984 that I changed my approach and spent the entire offseason working out. Not that it made any difference with regard to how my season started. I still hit about .250 in April in '84. I think the slow starts had more to do with the fact I was a Southern California kid who was used to playing in warm weather. When I was with the Royals, we played a lot of April games in Kansas City and in places like Detroit, Chicago, and New York, where it was borderline winter sometimes the first month of the season. So I think it just took me a while to warm up. Usually my hitting would start heating up around my birthday [May 15].

That was certainly the case in 1980. I hit something like .472 that June before tearing a bunch of ligaments in my ankle sliding into second base. That cost me about six weeks. Then, in September, I missed about ten games when the bone chip in my wrist began acting up. I had broken my wrist horsing around in the gym my freshman year of high school. Through the years, it would act up on me. And that September was one of those times, so I needed a couple of cortisone shots to calm it down.

As a result of those injuries, I played in only 117 games that season. I think back often to what might have happened had I been healthy the entire year. I was hitting .407 in late August,

so maybe I could have given it a better run. The interesting thing is that both times I returned to the lineup after my injuries, I immediately started hitting. Usually you're rusty, and it takes ten to twenty at bats versus live pitching to get your timing back. But not that season. I think I had three hits in my first game back after the ankle injury. It was just one of those magical years where my swing was dead-on and I was seeing the ball incredibly well.

As I mentioned, I patterned my game after Hal McRae's, which meant all out, all the time. And that aggressive style of play isn't always conducive to staying healthy. I certainly had my share of "hustle" injuries during my career. I had five knee injuries, the torn ankle ligaments, a broken shoulder, and several occasions when my wrist flared up. Somebody told me once that I lost about two seasons' worth of games because of injuries. So that probably cost me another 350 to 400 hits, which would have put me a lot higher on some of those all-time lists. Then again, if I hadn't taken the aggressive approach I had, maybe I wouldn't have accomplished nearly as much as I did. I just loved that style of ball. I remember being on first and almost welcoming the chance to barrel into that shortstop or second baseman to break up a double play. I took a lot of pride in that stuff.

Speaking of aggressive plays, one of the things I'll be most remembered for was the way I came sprinting out of the visitors dugout at Yankee Stadium during a July 24, 1983, game after umpire Tim McClelland took away my home run because I had used too much pine tar on my bat. The tape of me running toward McClelland like a raging bull has been replayed about a billion times. What can I say? I was angry beyond belief. Fortunately, American League president Lee MacPhail agreed with our appeal and the home run was restored and we resumed the game later that season. I credit our GM at the time, John Schuerholz, for writing the reasoned letter that swayed MacPhail to rule that the umpires had the right to take the bat away, but not the home run.

I hit that dinger off Goose Gossage, who was one of the most fearsome relievers of that time and all time. I had faced Goose enough in my career to know that this was going to be power-on-power, no finesse. Goose knew how to throw only one speed—one hundred miles per hour—so he wasn't going to try to outsmart me with a changeup. He was going to try to blow me away. His first pitch was a fastball up and away, and I hit a long foul ball down the left-field line that missed being a home run by about five feet. His next pitch was a fastball up and in, and I just turned on it and tomahawked it into the right-field seats. (Goose and I have talked about that pitch often, and he always jokes, "I was trying to hit you in the neck." Then again, maybe he wasn't joking.)

After taking my home run trot, I'm sitting in the dugout and I'm feeling pretty good about myself. And then I see Billy Martin out there, holding my bat and talking to McClelland. I'm totally confused. Are they thinking I corked my bat? The pine tar limit isn't even on my mind. Our second baseman, Frank White, comes over and says, "You know what? I think they are going to call you out because you have pine tar all the way up to the label." I said, "Frank, if they call me out for using too much pine tar, I'm going to go out there and kill him." As soon as I said that, McClelland, who's about six foot five, 250 pounds, points the bat at me and calls me out. I storm out of the dugout as if I've been shot out of a cannon. It looks like I'm going to hit him, but that wasn't my intention. I did intend to give him a piece of my mind and let him know that I was upset beyond belief. The thing that makes the footage look worse than it actually was is the scene of umpire Joe Brinkman getting me in a chokehold. I'm trying with all my might to get free of

that hold. To be honest, I didn't know who had me by the neck. I didn't know if it was one of my teammates, one of the Yankees, or a New York City cop. Brinkman finally lets me go, and by then I've calmed down some, but I'm still giving McClelland an earful.

There's a funny story behind this story. Gaylord Perry, who I loved, was on that Royals team. Gaylord was kind of a memorabilia nut, and he realized instantly that my bat was going to be in the news and in great demand among collectors. So what does he do? Amid the chaos, he goes out there and gets the bat from McClelland and he starts running to the dugout with it. He gives it to our batboy, who starts running up the tunnel toward our clubhouse. Well, the Yankees security people get on their walkie-talkies and start monitoring his progress. It's like a scene from a comedy. They finally apprehend him and confiscate the bat. After the game ends, our manager, Dick Howser, comes in and starts screaming at me for having too much pine tar on my bat. I said, "Dick, why are you screaming at me? I didn't even know there was a rule for that." Looking back, it was all pretty funny. Of course, it wouldn't have been so humorous if MacPhail hadn't reversed McClelland's call and I had lost that homer and we had lost that game. The thing is, I've always had good relationships with the umpires from my playing days. I became friends with a bunch of them, including McClelland and Brinkman. Every time I run into them they bring up that memorable day and we all have a good laugh.

In 1985 I had one of my best seasons. I hit thirty home runs, drove in 112 runs, batted .335, and won a Gold Glove Award. But when I look back on that year, I don't think of individual accomplishments. I think of how we finally made it to the top of the mountain and won the World Series. We had some great young players on that team, including our ace, Bret Saberhagen, who wound up being named MVP of the Series after pitching two complete-game victories against St. Louis, including a shutout in Game 7. But I believe the championship meant a lot more to me than it did to the young guys like Saberhagen, Mark Gubicza, and Danny Jackson, because they had just started their big league careers. They didn't have to suffer through all the disappointments and close calls I and some of the other veterans had the previous eleven years. I think the setbacks made it all the more special for me. The thing I enjoyed most is how that title electrified the people of Kansas City. I was absolutely blown away by the victory parade. Hundreds of thousands lined the streets.

In 1990 I got off to a terrible start that extended beyond my usual bad April. It was so bad, in fact, that I even contemplated retirement. Fortunately, my former teammate John Wathan, who was then managing the Royals, talked me out of it. I kept grinding away, and around July things started clicking for me again. I hit .386 down the stretch, and in September I caught Rickey Henderson to take the lead in the batting race. Just like in 1976, it came down to the final day of the season. I wound up winning the crown with a .329 average.

Two years later I achieved another major milestone when I got my three-thousandth hit. I went 4-for-5 to get there, but there were some uncertain moments leading up to it. We were playing in Minnesota, and I swung at a ball up and away and struck out. I felt a twinge in my shoulder on the swing, but I didn't think much of it. We flew out to California to play the Angels after the game, and on the flight my shoulder really started throbbing. By the time I got to the hotel it was killing me, and the next morning our trainer took me to see the Angels' team doctor. He told me

I had a slight tear in my shoulder and gave me a cortisone shot. My wife and about twenty to twenty-five people had come from Kansas City in hopes of seeing me get the four hits I needed for three thousand. My mom also was there (my dad had passed away the year before). And my brother Ken was broadcasting Angels games, so there was a great deal of anticipation building. But the first night I'm in too much pain to play, so I sit out. I test it again in batting practice the next night, and it's still hurting, and I sit out again. Now, the people who came in from Kansas City are starting to get a little ticked. They obviously didn't fly out there to see me sit on the bench. But what could I do?

The third night I take batting practice and I'm about 70 percent and I tell our manager, Hal McRae, that I'm about 70 percent and I think I can go. He put me in at DH. My first time up, I hit a double, then when I get back into the dugout, I ice it. My second time up, I hit a single, then more ice. Third time, same thing. As I head to the batting circle before my fourth at bat, my heart starts racing; I'm nervous as can be. Fortunately, when I stepped into the box, I began to calm down. The umpire and the catcher told me good luck, and I line the first pitch into right field for number three thousand. They stop the game and my teammates come over to congratulate me. Rod Carew, who was the Angels hitting coach, walked to the top of the dugout and gave me the thumbs-up. Angels first baseman Gary Gaetti is laughing and telling me, "George, this is so much fun." And I'm as giddy as can be. Finally, the game resumes and I take my lead off first. [Fortugno throws over] and Gaetti tags me out. I just laughed as I trotted off the field. I had another claim to fame: I'm the only member of the three-thousand-hit club to get picked off after reaching the milestone.

Although I spent the last couple of seasons of my career at first base and designated hitter, I'm proud that I spent the lion's share at third base. Even when I was playing shortstop in high school and my first year of professional ball, I never saw short as my natural position. It's funny, but ever since I was a little kid playing Wiffle ball in the neighborhood, I liked third base, the hot corner. And that's why Brooks Robinson became my idol, because I loved the way he played third base. Of all the positions represented in the Hall of Fame, the one with the fewest members is third base. It's always going to be looked on as an offensive position first, a position that calls for you to be a run producer. Of course, there are some Hall of Fame third basemen, such as Brooks and Mike Schmidt, who could flash the leather and save you runs. I never considered myself a great-fielding third baseman. In fact, there was a time in my career when some of my Royals teammates joked that I was destined to become the first player with three thousand hits and three thousand errors. I worked hard at becoming a good fielder, and I'm very proud that I was able to win a Gold Glove Award. Of course, that didn't happen until Brooks and Graig Nettles and Buddy Bell retired, but, hey, I'll take it.

JAMES COLLINS

CONSIDERED BY MANY THE GAME'S
GREATEST THIRD BASEMAN. HE
REVOLUTIONIZED STYLE OF PLAY AT THAT
BAG. LED BOSTON RED SOX TO FIRST
WORLD CHAMPIONSHIP IN 1903. A
CONSISTENT BATTER. HIS DEFENSIVE PLAY
THRILLED FANS OF BOTH MAJOR LEAGUES.

JIMMY COLLINS

CLASS OF 1945

It is one thing to star at a particular position, even become a Hall of Famer. It can be quite another to revolutionize how a position is played, but that is precisely what Jimmy Collins did.

Back in 1895, his Louisville ball club was trying to hang with the great Baltimore team, which included Willie Keeler and John McGraw. Time and again the Orioles bunted their way on base, prompting Louisville third baseman Walter Preston into several errors. That's when Louisville manager John McCloskey was told that Collins had played some third while becoming a sandlot star in Buffalo.

Collins was brought in from his outfield spot, and the Orioles even pledged to stop bunting so much. But Collins told them, "Go ahead and bunt. I'll show you something." And indeed he did, throwing out four consecutive Baltimore bunters before the Orioles decided to change their approach.

"A third baseman had to give himself a chance to get those fast guys," Collins explained decades later. "Once around the circuit, you knew who would bunt and who wouldn't. You knew McGraw and Keeler were bunters. So I played them at the edge of the grass."

Clark Griffith said Collins "was a cat on bunts."

Sportswriter Grantland Rice declared that nobody was better at charging slow rollers up the third-base line or racing back to catch pop-ups. "Collins had no superior," Rice said. "A wonderful fielder, a sure, hard hitter and ballplayer with the ease and grace of a hawk."

Another noted writer of the era, Tim Murnane, considered Collins "a model for all third basemen, the king of the trappers and footworkers."

Besides defining how third base was played forever after, Collins could be a standout at the plate, too. In 1898, with the Boston Beaneaters, he led the league in home runs with fifteen. That doesn't sound like a lot today, but remember this was the dead ball era. In addition, Collins hit better than .300 in five of his fourteen big league seasons and was a career .294 batter.

"Those were the days when you were batting against the spitball and the shineball and emeryball," Griffith said, "and the pitchers had a big edge on the hitter."

Red Sox fans remember Collins as the manager of Boston's first championship team in 1903. In fact, Collins had jumped to the Boston Americans two years before as the team's player-manager. That move helped give the American League credibility and led to an increase in player salaries. Collins's value as a player and manager was further highlighted when Boston defeated Pittsburgh, five games to three, in the first modern World Series.

After managing stints in Minneapolis and Providence, Collins returned home to western New York, where he became a street inspector. More important, for twenty-two years, Collins directed the Buffalo Municipal League, then one of the country's top amateur programs.

—T. Wendel

Horner
Photo

·BOSTON·

HAROLD J. (PIE) TRAYNOR
RATED AMONG THE GREAT THIRD BASEMEN
OF ALL TIME, BECAME A REGULAR WITH
THE PITTSBURGH N.L. TEAM IN 1922 AND
CONTINUED AS A PLAYER UNTIL CONCLUSION
OF 1937 SEASON. MANAGED THE PIRATES
FROM JUNE, 1934, THROUGH SEPT. 1939. HOLDS
SEVERAL FIELDING RECORDS AND COMPILED
A LIFETIME BATTING MARK OF .320. ONE OF
FEW PLAYERS EVER TO MAKE 200 OR MORE
HITS DURING A SEASON, COLLECTING
208 IN 1923.

PIE TRAYNOR

CLASS OF 1948

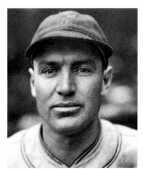

There are several versions of the story explaining how Harold Traynor, growing up in a community near Boston, obtained the nickname "Pie," but whether it was because he was rewarded for good play with the treat or because he frequented a grocery store where he always bought pies, the appellation stuck.

Traynor became a lifetime Pittsburgh Pirate, earning the description of the best third baseman of all time during his playing days before becoming a radio broadcaster.

Although a tryout had been arranged with the Boston Braves, manager George Stallings hadn't been informed, and he yelled at Traynor as if he were an interloper off the streets. "Get out of there!" shouted Stallings. "Isn't it bad enough to be saddled with a ball club like this without having a clown like you tearing up the infield before a game?"

Traynor's reception was warmer with the Pirates, and he went on to bat .320 for Pittsburgh over seventeen seasons. While hitters of the more scientific persuasion could be picky about their equipment, one trademark of Traynor's career was that he didn't care what war club he carried into the batter's box. In fact, many of them didn't even belong to the third sacker.

"Any I could pick up that pleased my fancy" was how Traynor described the selection. "I stole most of them. You know how the clubs lay out the bats in front of the dugouts. Well, I'd just stroll around and pick them up and try them. If I came across one I liked I'd take it. I wouldn't exactly steal it. I'd tell the manager or somebody else on the club that I was taking it. I liked to get old ones, with the lumber well seasoned."

Although the gloves during Traynor's day covered much less acreage than modern gloves, he was regarded as a whiz around the third-base bag. "You must have speed, a good arm and be a quick thinker," Traynor said. "You must have cat in you. You must be able to start after a ball in a split second, gather up that ball, and fire it to first base or second." Traynor claimed that a "topped" ball was the hardest to field. "The third baseman must run in and take that ball between hops."

Traynor became a player-manager in 1934, but eased out of the lineup and didn't play a game in 1936. Then he briefly returned to the field in 1937 and was teased about being a rookie. "I'm as nervous as a bride," he admitted. "I'm a little scared." Traynor played just five games that season and quit for good when he realized that he didn't resemble *the* old Pie Traynor as much as he did *an* old Pie Traynor.

As a true rookie, Traynor was paid $4,000 in 1920, plus a $2,200 bonus, and he topped out at $16,500 during his career. "It was enough," he said. "I was making a lot more than a lot of my friends back home who were working for the Works Progress Administration."

—L.F.

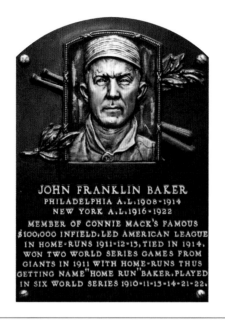

JOHN FRANKLIN BAKER
PHILADELPHIA A.L.1908-1914
NEW YORK A.L.1916-1922
MEMBER OF CONNIE MACK'S FAMOUS
$100,000 INFIELD. LED AMERICAN LEAGUE
IN HOME-RUNS 1911-12-13, TIED IN 1914.
WON TWO WORLD SERIES GAMES FROM
GIANTS IN 1911 WITH HOME-RUNS THUS
GETTING NAME "HOME RUN" BAKER. PLAYED
IN SIX WORLD SERIES 1910-11-13-14-21-22.

FRANK BAKER

CLASS OF 1955

The irony behind Frank "Home Run" Baker's famous nickname is that he played during baseball's dead ball era, when few home runs were hit. Baker locked up the nickname before Babe Ruth, Hank Aaron, and other big-time swatters entered the sport.

Although Baker won four American League home run titles, he never hit more than twelve in a season. He was christened with the nickname after the 1911 World Series, when he crushed two game-turning blows against the New York Giants for the winning Philadelphia Athletics.

Baker's first four-bagger came off of Rube Marquard in the second game, played at home in Philadelphia, and he was thrilled by the accomplishment. "Thousands of fans on their feet," Baker said of the blow that cleared the fence at Shibe Park, "hands waving, hats in the air and shouting as you rounded second base is something a man never forgets."

Hal Chase, player-manager of the New York Highlanders, was a witness to the soaring smash. "I don't think a ball could be hit any harder than that was," Chase said.

The shot off of Christy Mathewson in the third game of the Series occurred in the ninth inning and tied the contest. This was a straight line drive that landed in the seats beyond the right-field fence. The famed Giants hurler was disconsolate over yielding the homer, and Marquard, who'd been victimized the game before, asked Mathewson what mistake he'd made. "The same thing you did, Rube," Mathewson told him. "I gave Baker a high, fast one. I have been in the business a long time and have no excuse."

There was a suggestion that those hitting ahead of Baker in the order were helpful to him by setting the table, but Eddie Collins, the second baseman, figured that Baker would have done just fine on his own. "When it came to hitting, Baker needed help like Andrew Carnegie needed money," Collins said.

Baker was injured in the third game when the Giants' Fred Snodgrass slid into him at third, spikes gleaming. Baker was cut and needed treatment afterward. He thought the play was no accident. "Yes, I believe Snodgrass spiked me intentionally," Baker told sportswriters. "He jumped across the bag to get me. I was in my right position." Athletics manager Connie Mack also felt that Snodgrass had cut Baker on purpose. "Snodgrass went out of his path to sink his spikes in Baker," Mack said. "It was a dirty, contemptible trick."

A member of three world championship teams, Baker was also greatly admired for his .307 lifetime average and fine fielding at third base. Baker was a member of the Athletics' so-called "$100,000 Infield," which included Stuffy McInnis, Collins, and Jack Barry. These days, those infielders would probably be valued at $50 million.

When it came to public acclaim, however, Baker thrust himself into the American consciousness with his consecutive-game World Series homers. Fans sent him hundreds of telegrams cheering his performance. "I never saw in all my life a ballplayer grow so popular overnight," Chase said.

—L.F.

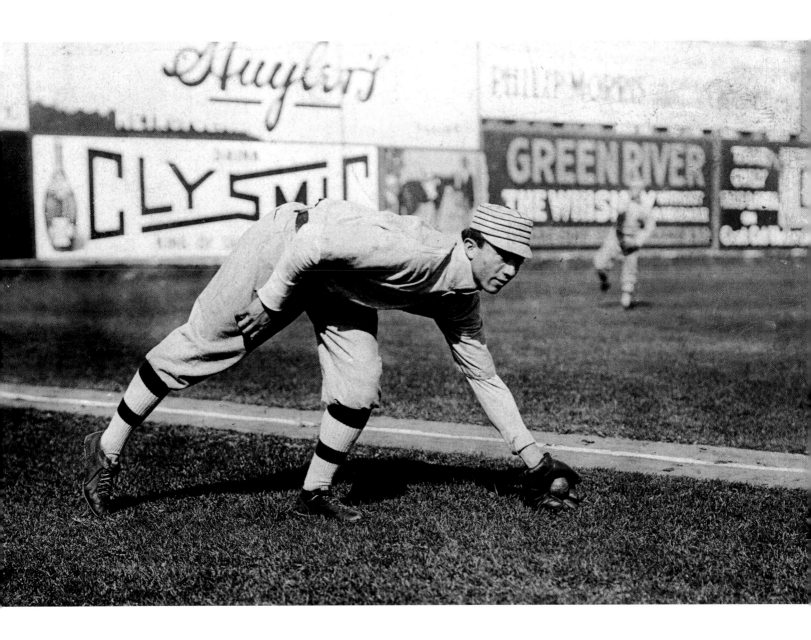

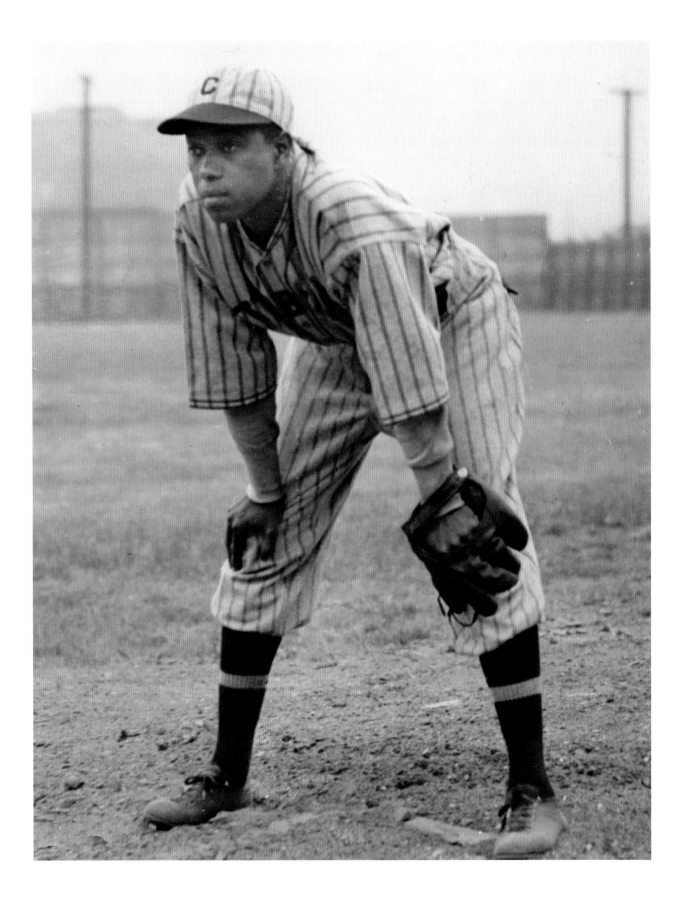

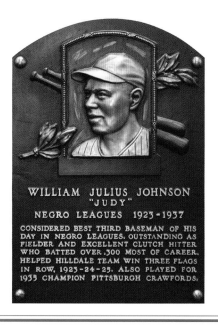

WILLIAM JULIUS JOHNSON
"JUDY"
NEGRO LEAGUES 1923-1937
CONSIDERED BEST THIRD BASEMAN OF HIS
DAY IN NEGRO LEAGUES. OUTSTANDING AS
FIELDER AND EXCELLENT CLUTCH HITTER
WHO BATTED OVER .300 MOST OF CAREER.
HELPED HILLDALE TEAM WIN THREE FLAGS
IN ROW, 1923-24-25. ALSO PLAYED FOR
1935 CHAMPION PITTSBURGH CRAWFORDS.

JUDY JOHNSON

CLASS OF 1975

"Judy Johnson was the smartest third baseman I ever came across. A scientific ball player, he did everything right, more than anybody I ever saw. And I saw Brooks Robinson, Mike Schmidt and even Pie Traynor," said Ted Page, Johnson's teammate with the Pittsburgh Crawfords.

One of the Negro Leagues' best third basemen, William "Judy" Johnson was a slick-fielding, spray-hitting clutch performer, and later a manager, scout, and coach. Johnson hit right-handed to all fields, with punch but not much power.

At age eighteen he began playing semipro baseball for five dollars a game. He quickly moved up to the Hilldale Stars, joining the club full-time in 1921. It was there that he acquired his nickname, after a Chicago American Giants player named "Judy" Gans. His mentor as a young player was Hall of Famer John Henry "Pop" Lloyd.

"He's the man I give the credit for polishing me; he taught me how to play third base," said Johnson. In an interesting twist, Johnson is said to have called Lloyd "The Black Pie Traynor," a nickname later applied to Johnson.

Johnson was a smart player with an eye for talent. One night, Homestead catcher Buck Ewing hurt his hand and had to leave the game. In the stands, Johnson spotted an eighteen-year-old catcher he'd seen on local sandlots and brought him into the game. His name was Josh Gibson. Johnson served as Gibson's mentor throughout his career.

Johnson led the Hilldales to three pennants in a row, from 1923 to 1925, hitting .290, .342, and .389 in those years. He played in the first Negro League World Series in 1924, hitting .341 with five doubles, a triple, and a home run. Though the Hilldales lost that series, they beat the Monarchs the following year.

In 1929 Johnson was named the Negro Leagues' Most Valuable Player by the *Chicago Defender* and the *Pittsburgh Courier*, two of the leading black newspapers. The following season he became player-manager of the Homestead Grays.

In 1932 he and most of his teammates jumped to the Pittsburgh Crawfords. He was captain of the 1935 club, which featured five future Hall of Famers: Johnson himself, Cool Papa Bell, Oscar Charleston, Josh Gibson, and Satchel Paige. He played winter ball in Cuba, where he hit .334 over six seasons, and also in Florida. He retired as a player in 1937.

In 1951 Johnson scouted for the Philadelphia Athletics, later scouting for the Braves, Phillies, and Dodgers. He signed Richie Allen and Bill Bruton, and could have signed Hank Aaron for the A's, though they reportedly balked at the price. In 1954 he was hired as a spring training coach for the A's, responsible for working with African American players.

From 1971 to 1974, Johnson served on the Hall of Fame's Committee on the Negro Baseball Leagues. After stepping down from the committee, he was elected to the Hall in 1975.

Cool Papa Bell said of Johnson, "No matter how much the pressure, no matter how important the play or the throw or the hit, Judy could do it when it counted."

—T. Wiles

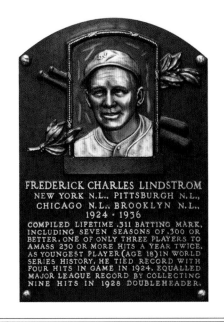

FREDERICK CHARLES LINDSTROM
NEW YORK N.L., PITTSBURGH N.L.,
CHICAGO N.L., BROOKLYN N.L.
1924 · 1936
COMPILED LIFETIME .311 BATTING MARK,
INCLUDING SEVEN SEASONS OF .300 OR
BETTER. ONE OF ONLY THREE PLAYERS TO
AMASS 230 OR MORE HITS A YEAR TWICE.
AS YOUNGEST PLAYER (AGE 18) IN WORLD
SERIES HISTORY, HE TIED RECORD WITH
FOUR HITS IN GAME IN 1924. EQUALLED
MAJOR LEAGUE RECORD BY COLLECTING
NINE HITS IN 1928 DOUBLEHEADER.

FREDDIE LINDSTROM

CLASS OF 1976

If it hadn't been for a chronically bad back and a broken leg, Freddie Lindstrom—a Hall of Famer all the same—might have been considered the best third baseman of all time. He had brilliant hands in the field and hit as high as .379 at the plate, but the debilitating physical ailments took a toll in the latter part of his career and provoked a move to the outfield.

Lindstrom was from Chicago, and by the time he was sixteen, he was looking for tryouts from major league clubs. In his later years, when asked how he acquired his gray hair, Lindstrom liked to joke, "Playing for McGraw." Lindstrom was actually at his happiest playing for the Giants and John J. McGraw, but he'd tried to catch on with the Cubs first.

Lindstrom was the shortstop for Wilmette's Loyola Academy when he wangled a tryout for Chicago. "I've often wondered what would have happened if Bill Killefer hadn't been playing cards that day," he said. "I thought I'd done a good job, but then discovered that Killefer, the Cubs manager, hadn't even seen the workout. He was in the clubhouse playing cards."

Not much more than a month later, a Giants scout spotted Lindstrom, signed him, and sent him to the minor league team in Toledo. Former catcher Roger Bresnahan, who was the team president, didn't see much value in having a sixteen-year-old kid around, so he let Lindstrom work out only in the mornings and then sat him in the stands during games. The team was flopping, however, and manager George Whitted, looking for personnel help, demanded that Lindstrom be given a try.

The way Lindstrom remembered the scene, Whitted approached Bresnahan and said, "That kid's doing us no good in the bleachers. Whether you like it or not, I'm gonna stick him on third base." Lindstrom added, "He did and two years later I was on the Giants." Actually, when he was older he realized that many other fine players had had to pay their dues in longer minor league apprenticeships. "Breaking into the big time happened to be very easy for me," Lindstrom said. "When I look back on it at all now I am amazed it was so easy."

Although Lindstrom admired McGraw, he was not scared of the man who often ruled his clubhouse by intimidation. Once, Lindstrom broke his leg sliding into third base, and his teammates visited him in the hospital to offer sympathy. When McGraw showed up, he was growling. "I always said you never learned how to slide," McGraw said. Lindstrom grew angry. "Do you think this is fun?" he retorted. "I hope you break your leg, too. Then you'll find out what it's like."

They were not bantering lightly but were serious. McGraw stormed out of the hospital and stepped right in front of a taxicab and broke his leg. When Lindstrom went to visit the skipper, he told him, "Breaking your leg? I always said you didn't know where you were going."

—L.F.

EDWIN LEE MATHEWS
BOSTON N.L., MILWAUKEE N.L.,
ATLANTA N.L., HOUSTON N.L.,
DETROIT A.L., 1952-1968
BECAME SEVENTH PLAYER IN MAJOR LEAGUE
HISTORY TO HIT 500 HOME RUNS. FINISHED
CAREER WITH 512. HIT 30 OR MORE HOMERS
NINE YEARS IN ROW, 1953-1961. REACHING
40 MARK FOUR TIMES. ESTABLISHED RECORD
FOR HOMERS IN SEASON BY THIRD BASEMAN
WITH 47 IN 1953. LED N.L. IN HOME RUNS
TWICE AND IN WALKS FOUR TIMES. HAD FIVE
SEASONS OF 100 OR MORE RUNS BATTED IN.

EDDIE MATHEWS

CLASS OF 1978

One of the most underrated of great ballplayers, Eddie Mathews did not like to talk about his accomplishments. No one could have blamed him for bragging. After all, he was a prodigious power hitter who drove in 1,453 runs over seventeen seasons. Teaming with Hank Aaron, Mathews helped form one of the most devastating hitting duos of all time.

Mathews's path to the major leagues began in his family's backyard, where his parents played a leading role. "[My father] played catch with me every day," Mathews told *Sports Illustrated*. "He made me exercise to build myself up. He and my mother and I would go over to the field in the evenings. My mother would pitch and I'd hit and my father would shag the balls in the outfield. But then I clipped my mother with a couple of line drives, so my father had to pitch and my mother shagged balls. My father didn't coach me at all. He just gave me a chance to play all the time."

Mathews brought along the requisite work ethic. He broke in with the Boston Braves, but made a name for himself after the franchise moved to Milwaukee. In 1953 he led the league in home runs, breaking Ralph Kiner's seven-year stranglehold on the crown. One year later Mathews made history when he appeared on the cover of the inaugural edition of *Sports Illustrated*.

A patient power hitter, he would lead the league in home runs once more and would draw more than one hundred walks five times. Also a capable third baseman, Mathews manned the position regularly through 1966, the Braves' first year in Atlanta. In so doing, he became the only man to play for all three incarnations of the Braves franchise.

Mathews tended to be overlooked by the media, perhaps because of the presence of Aaron. But National League opponents knew how tough, competitive, and exceptional Mathews was. "By no means was Eddie ever an afterthought," his rival Frank Robinson told Claire Smith of the *Philadelphia Inquirer*. "I know [that] Henry knows that Eddie wasn't an afterthought. Eddie Mathews was a reason why Henry was getting all those pitches to hit."

After a brief stint with the Houston Astros, Mathews finished his career as a backup infielder and pinch hitter, but he did it for a world championship team, the 1968 Detroit Tigers. "He was a bear-down, no-nonsense type guy," Tigers Hall of Famer Al Kaline told the *Sporting News*. "And he couldn't stand anyone who didn't give 100 percent. He'd get on the guys and no one would talk back to him. He didn't play a lot in '68, but he was a big factor in our winning."

Mathews later became the manager of the Braves, serving his final season in 1974, when his old friend Aaron broke Babe Ruth's home run record.

In many ways, Mathews redefined the third-base position. Prior to him, most third basemen had been known as line-drive contact hitters. Very few third basemen made the Hall of Fame with those credentials. Mathews re-created the hot corner, making it a position of both power and defensive excellence.

—B.M.

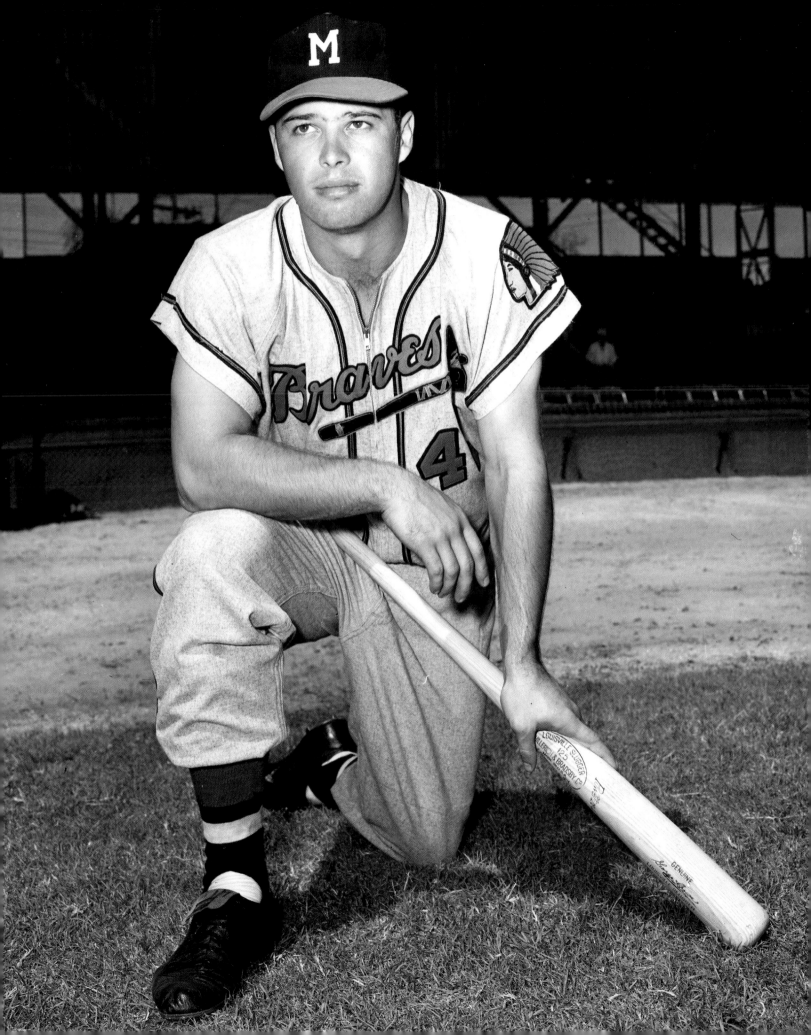

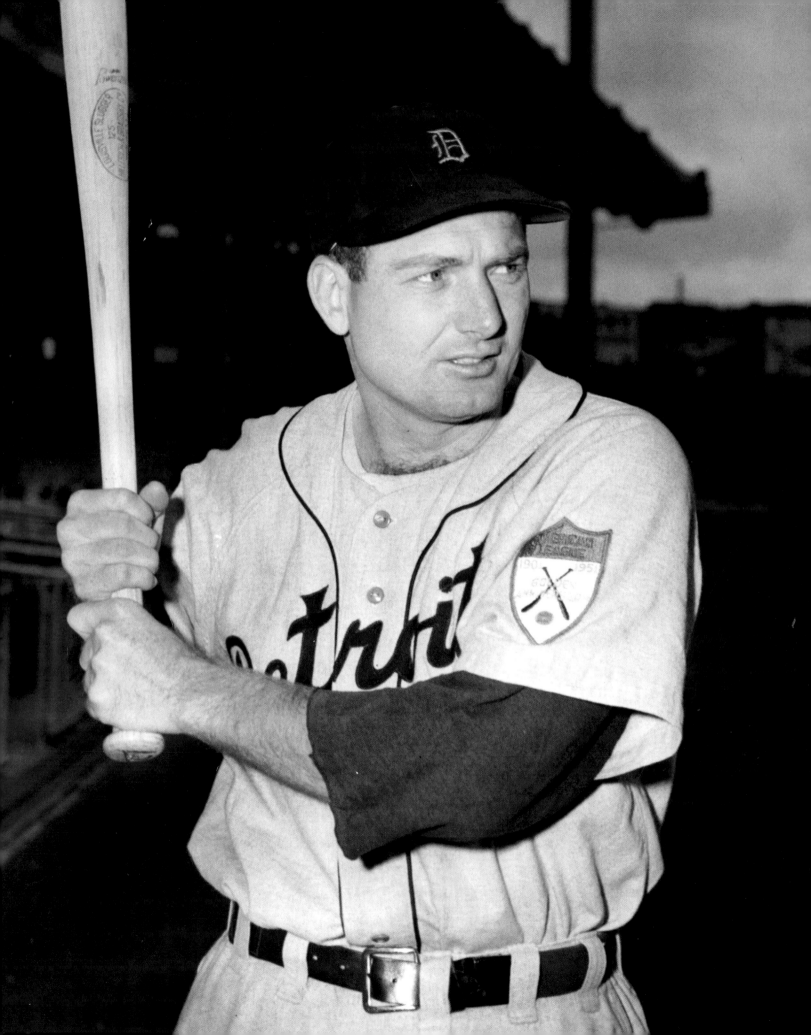

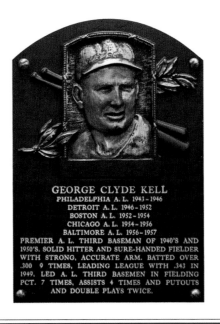

GEORGE CLYDE KELL
PHILADELPHIA A. L. 1943-1946
DETROIT A. L. 1946-1952
BOSTON A. L. 1952-1954
CHICAGO A. L. 1954-1956
BALTIMORE A. L. 1956-1957
PREMIER A. L. THIRD BASEMAN OF 1940'S AND
1950'S. SOLID HITTER AND SURE-HANDED FIELDER
WITH STRONG, ACCURATE ARM. BATTED OVER
.300 9 TIMES, LEADING LEAGUE WITH .343 IN
1949, LED A. L. THIRD BASEMEN IN FIELDING
PCT. 7 TIMES, ASSISTS 4 TIMES AND PUTOUTS
AND DOUBLE PLAYS TWICE.

GEORGE KELL

CLASS OF 1983

Kept from military service by cartilage damage in both knees, George Kell became one of the greatest baseball players to emerge during World War II. Kell's keen hitting eye and sure-handed fielding abilities cemented his place among the game's all-time greats.

Although Kell's career got off to an inauspicious start—the Brooklyn Dodgers cut him during spring training in 1942—he earned a major league opportunity with the Philadelphia Athletics in 1943 and blossomed into a star after being traded to the Detroit Tigers in 1946.

He excelled at putting the ball into play, cracking the .300 mark nine times while never striking out more than thirty-seven times in a single season during a fifteen-year career. Never a power hitter, the stocky right-hander instead used a combination of quick hands and a light bat to spray baseballs across the diamond.

Kell, who had been hitting .299 through twenty-six games before being traded to the Tigers in 1946, caught fire immediately after arriving in Detroit. Batting .327 over the remainder of the season, he finished the year with a .322 average. It was the first of eight straight .300 seasons for the Swifton, Arkansas, native.

He edged out Ted Williams for his only batting title in 1949, denying the Boston slugger a third Triple Crown. With the Tigers facing Cleveland in the final game of the season, Kell tagged a first-inning double and a third-inning single off Indians starter Bob Lemon en route to finishing the game 2-for-3. Williams,

meanwhile, went hitless in two at bats against the New York Yankees, handing Kell the batting crown by the narrowest of margins, .34291 to .34276.

An all-around player, Kell led American League third basemen in fielding percentage seven times, his glove honed by tireless practice and repetition.

"I always could hit, but fielding I had to work at," Kell told the authors of the 1994 book *We Played the Game*. "I took as much pride in fielding as hitting. I became a complete ballplayer."

Traded to the Red Sox in 1952, he spent parts of three seasons in Boston before being dealt to the Chicago White Sox early in the 1954 season. Despite his ailing knees, Kell batted .312 and led the White Sox with eighty-one RBI during the 1955 campaign.

The White Sox shipped Kell to the Baltimore Orioles in 1956, and in his final season, 1957, he batted a respectable .297 in ninety-nine games. As a member of the Orioles, he mentored future Hall of Famer and fellow Arkansas native Brooks Robinson.

Kell and Robinson would meet again in Cooperstown nearly thirty years later, when the third basemen were both inducted into the National Baseball Hall of Fame as part of the Class of 1983.

"I still find it, Brooks, almost unbelievable that we have traveled the same path for so long with the same goals in mind and we wind up here in Cooperstown in the Hall of Fame on the same day," Kell said, addressing his former protégé, in his induction speech.

—C.E.

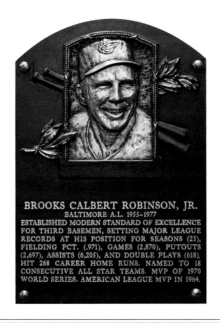

BROOKS CALBERT ROBINSON, JR.
BALTIMORE A.L. 1955-1977
ESTABLISHED MODERN STANDARD OF EXCELLENCE
FOR THIRD BASEMEN, SETTING MAJOR LEAGUE
RECORDS AT HIS POSITION FOR SEASONS (23),
FIELDING PCT. (.971), GAMES (2,870), PUTOUTS
(2,697), ASSISTS (6,205), AND DOUBLE PLAYS (618).
HIT 268 CAREER HOME RUNS. NAMED TO 18
CONSECUTIVE ALL STAR TEAMS. MVP OF 1970
WORLD SERIES. AMERICAN LEAGUE MVP IN 1964.

BROOKS ROBINSON

CLASS OF 1983

There were third basemen who were better athletes than Brooks Robinson and had a stronger arm, but none who had the same lightning-quick first step, vacuum-like hands, and shortstop-like range. He turned the position of third base into an ever-evolving highlight reel of game-changing defensive plays.

Groomed as the replacement for George Kell, Robinson found his career stagnating in a series of fits and starts. He finally turned a corner in 1960, when he hit .294 with eighty-eight RBI. He also made the All-Star team while winning a Gold Glove Award, which would become a nearly annual occurrence during his career.

Robinson's power numbers fell in 1961, but he bounced back with a flourish in 1962. Batting better than .300 for the first time, he also clubbed twenty-three home runs.

In 1964 Robinson put his offensive talents to full use. He achieved career highs in batting average (.317), home runs (28), and RBI (118), the last figure leading the league. With a .521 slugging percentage, Robinson raised his power hitting to the same level as his defense. The baseball writers rewarded him by naming him the league's MVP.

In 1966 Robinson hit twenty-three home runs and drove in one hundred. Placing second in the American League MVP race, he added a home run in the World Series, which the Orioles swept in four games.

Four years later, Robinson put on a one-man fielding extravaganza in the World Series against Cincinnati. Already known as "The Human Vacuum Cleaner" for his ability to gobble up ground balls as if his hands were suction cups, Robinson took his defensive reputation to unprecedented heights. The Reds referred to him as "Hoover," a reference to the well-known vacuum manufacturer. In an effort that could be described as superhuman, Robinson robbed seemingly all of Cincinnati's right-handed hitters of extra-base hits.

Robinson's exploits proved to be too much for Reds manager Sparky Anderson. "I'm beginning to see Brooks in my sleep," Anderson told reporters during the Series. "If I dropped this paper plate, he'd pick it up on one hop and throw me out at first." Incredibly, Robinson added a pair of home runs against the Reds.

Even as Robinson's power began to decline after 1971, he continued to play brilliantly at third base. Headed by the acrobatic Robinson, the Orioles' defense remained an elite force throughout the early 1970s.

By the time Robinson ended his long career, he had played twenty-three seasons, all with Baltimore. "He could rise to the occasion better, both offensively and defensively, than any other player I have ever had on my club," manager Earl Weaver told sportswriter Charles McGeehan. "The tighter the situation, the better [the] ballplayer Brooks was."

Robinson's ability in the clutch, coupled with his genuinely kind and affable nature, made him an Orioles icon. It would be difficult to find anyone more beloved in Baltimore than "Brooksie."

—B.M.

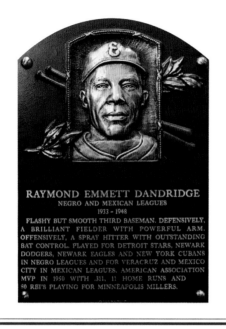

RAY DANDRIDGE

CLASS OF 1987

Ray Dandridge met San Francisco Giants owner Horace Stoneham in the 1970s and said, "You know, I really don't like you, because if I could have played in just one game in the majors, my career would have been complete."

"Yeah," said Stoneham, "I made a mistake."

When he met Stoneham, Dandridge was referring to the Giants' failure to promote him between 1949 and 1952, when the aging third baseman hit .362, .311, .324, and .291 (at age thirty-nine) for the Minneapolis Millers, their top farm team. It would have been interesting to see what a difference the high-average hitter and slick-fielding third baseman would have made for the Giants, who finished third in 1950, lost the World Series in 1951, and finished second in 1952. A look at Dandridge's batting averages over the previous twenty years in the Negro Leagues, routinely around the .350 mark, makes one wonder.

Ironically, one of the men Dandridge was not given the chance to unseat was fellow former Negro Leaguer Hank Thompson. Neither Thompson nor Sid Gordon nor Bobby Thomson hit .300 playing third base for the Giants during that stretch, though they all came close. "Dandridge didn't get the chance to play in the majors, but he had major league talent. He was a superstar," said Hall of Fame former teammate Monte Irvin.

Dandridge broke into baseball with the Detroit Stars in 1933 at age nineteen. He was a contact hitter who could hit to all fields,

and a fancy fielder at third base who could also play anywhere outside the battery. At a 1988 old-timers' game, he commented to teammate Billy Williams, "Ozzie's the onliest guy I've seen who's got my style," referring to the acrobatic Ozzie Smith.

Dandridge became a star when he moved to the Newark Dodgers (later Eagles) in 1934. He hit .403 that year, .372 in 1937, and .340 in 1938. Along with Hall of Famers Mule Suttles and Willie Wells, Dandridge and second baseman Dick Seay formed Newark's "Million Dollar Infield."

In 1939 he began playing in Latin America, leading Caracas of the Venezuelan League to a championship. When the season ended more than a month before the Mexican League season, he zipped north to Veracruz, where he was a key player in that club's league championship. He finished up an extraordinary baseball journey by hitting .310 for Cienfuegos in Cuba that October. He played in the Mexican League for most of the 1940s, taking the 1944 season off to return to Newark—where he hit .370 and led the league in hits, runs, and total bases in his final Negro League season.

Bill Veeck invited him to join the Cleveland Indians in 1947, but Dandridge was doing too well in Mexico, both on the field and financially, and would not take the chance. "I thought I would be jeopardizing a whole lot, so I refused," he recalled.

Another Negro Leagues Hall of Famer, Cumberland Posey, for whom Dandridge played in 1937, said, "There never was a smoother-functioning master at third base than Dandridge, and he can hit that apple too."

—T. Wiles

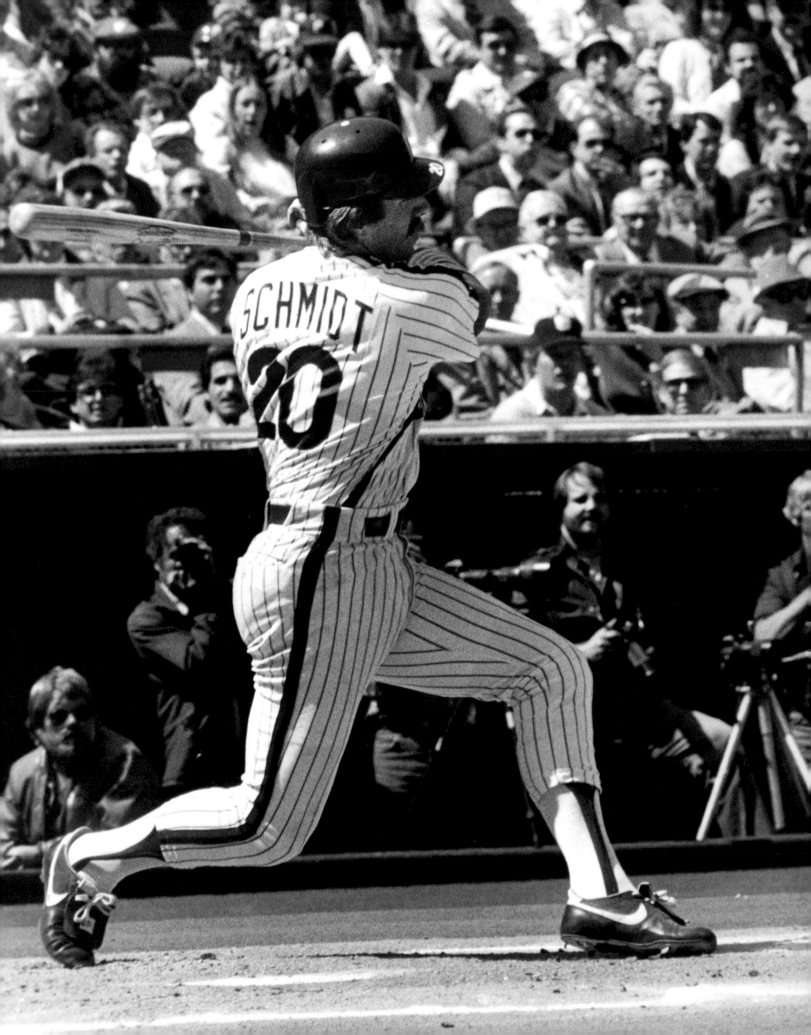

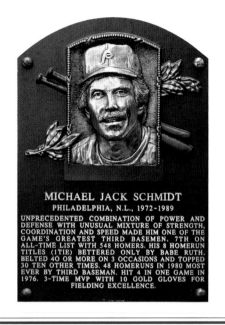

MICHAEL JACK SCHMIDT
PHILADELPHIA, N.L., 1972-1989
UNPRECEDENTED COMBINATION OF POWER AND
DEFENSE WITH UNUSUAL MIXTURE OF STRENGTH,
COORDINATION AND SPEED MADE HIM ONE OF THE
GAME'S GREATEST THIRD BASEMEN. 77TH ON
ALL-TIME LIST WITH 548 HOMERS. HIS 8 HOMERUN
TITLES (1TIE) BETTERED ONLY BY BABE RUTH.
BELTED 40 OR MORE ON 3 OCCASIONS AND TOPPED
30 TEN OTHER TIMES. 48 HOMERUNS IN 1980 MOST
EVER BY THIRD BASEMAN. HIT 4 IN ONE GAME IN
1976. 3-TIME MVP WITH 10 GOLD GLOVES FOR
FIELDING EXCELLENCE.

MIKE SCHMIDT

CLASS OF 1995

If a general manager were to create a template for what he ideally wanted in a major league third baseman, he might begin by attempting to replicate Mike Schmidt. With literally no weakness in his game, Schmidt offered the ideal mix of power, base running, hitting ability, and fielding acumen.

Raised in Ohio, Schmidt signed with the Phillies organization in 1971. One year later he made his way to Philadelphia for a thirteen-game look.

Schmidt opened the eyes of Hall of Famer Eddie Mathews, who was managing Atlanta at the time. "He was a good-looking prospect. Big and strong, but real fluid. . . . The ball came off his bat like a rocket," Mathews recalled for the *Philadelphia Daily News*. "I thought he was a kid with a helluva lot of tools and a chance to be something special."

That came to pass in 1974, when Schmidt began to make adjustments to his swing and stance. He ripped a walk-off home run on Opening Day, signaling the start of a drastic turnaround. He would hit a respectable .282 while bursting out in the power department. Leading the National League with 36 home runs and a .546 slugging percentage, he also stole 23 bases and played his position with smoothness and grace.

Schmidt's 1974 breakout marked the first of three straight home run crowns. He also exhibited patience at the plate, drawing one hundred or more walks each season. The only flaw in his game was his tendency to strike out, but he would begin to curb that problem in 1977.

As Schmidt improved, so did the Phillies, who won three consecutive Eastern Division crowns. With his strikeout totals declining, Schmidt lifted his on-base percentage and home run totals. From 1979 to 1981, he reached new levels for a third baseman. He hit forty-five home runs in 1979, and the following year came within two of hitting fifty, pushing his slugging percentage over .600.

Fittingly, Schmidt's career-best season, 1980, coincided with the Phillies' greatest success. With Schmidt anchoring the middle of the lineup and the infield defense, the Phillies advanced to the World Series. Schmidt's hitting highlighted the Fall Classic; he batted .381 with two home runs to lead Philadelphia to its first world championship.

Continuing to play at a high level, Schmidt had to overcome a major change in 1985, when the Phillies moved him to first base. He returned to third in 1986, and proceeded to lead the league in home runs and RBI. At age thirty-seven, Schmidt took home his third NL MVP Award.

Long before his retirement, it was evident that Schmidt had created a new threshold for third basemen. "I put Schmidt in the category of a true superstar," Willie Mays told the *Philadelphia Daily News*. "He's one of the best all-around players I've seen, and I've seen quite a few."

—B.M.

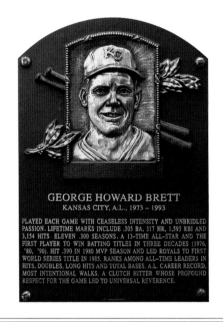

GEORGE HOWARD BRETT
KANSAS CITY, A.L., 1973 – 1993

PLAYED EACH GAME WITH CEASELESS INTENSITY AND UNBRIDLED
PASSION. LIFETIME MARKS INCLUDE .305 BA, 317 HR, 1,595 RBI AND
3,154 HITS. ELEVEN .300 SEASONS. A 13-TIME ALL-STAR AND THE
FIRST PLAYER TO WIN BATTING TITLES IN THREE DECADES (1976,
'80, '90). HIT .390 IN 1980 MVP SEASON AND LED ROYALS TO FIRST
WORLD SERIES TITLE IN 1985. RANKS AMONG ALL-TIME LEADERS IN
HITS, DOUBLES, LONG HITS AND TOTAL BASES. A.L. CAREER RECORD,
MOST INTENTIONAL WALKS. A CLUTCH HITTER WHOSE PROFOUND
RESPECT FOR THE GAME LED TO UNIVERSAL REVERENCE.

GEORGE BRETT

CLASS OF 1999

Nobody was more intense or had more fun playing the game than George Brett. Perhaps that's because he played his entire twenty-one-year career with one team, the Kansas City Royals.

Brett is the only player in history to accumulate three thousand hits, three hundred home runs, six hundred doubles, one hundred triples, fifteen hundred RBI, and two hundred stolen bases. The thirteen-time All-Star also won the American League's Most Valuable Player Award, a Gold Glove Award, and three batting titles, and had a lifetime batting average of .305.

But when he was asked about his professional achievements, which included a pair of World Series appearances, Brett often returned to his long tenure with the Royals. He kept a box of his player cards in his locker and often pulled one out to show visitors.

"That's what I'm the most proud of," he said, "to be a part of one organization for my entire career. You won't see that too much in the future."

"If there was one player I ever wanted to be like," said Robin Yount, "it was George Brett."

What also turned heads was Brett's run at becoming the first hitter to finish .400 or better in a season since Ted Williams. Even though Brett fell short, his .390 average in 1980 was the highest since "The Splendid Splinter" hit .406 in 1941.

Still, Brett was the first player in Major League Baseball history to win a batting title in three different decades.

"George Brett could fall out of bed on Christmas morning," former Kansas City Royals general manager John Schuerholz said, "and hit a line drive."

Born in Glen Dale, West Virginia, Brett grew up in a sports-minded family. His older brother Ken pitched in the 1967 World Series at the age of nineteen.

Despite the awards and accolades, Brett's competitive nature was perhaps best illustrated by what became known as the "Pine Tar Incident." On July 24, 1983, Brett hit a two-run homer against the New York Yankees. After he crossed the plate, Yankees manager Billy Martin pointed out that the pine tar on Brett's bat extended more than eighteen inches from the knob, a violation of the rule book.

When home plate umpire Tim McClelland sided with Martin, an enraged Brett charged out of the dugout. No matter that the home run was later upheld by American League president Lee MacPhail and that the game was resumed several weeks later. What many would remember was Brett furiously protesting the original call.

A few weeks later the evidence was returned to Brett, and Gaylord Perry, then his teammate on the Royals, reminded the slugger that his was a historic bat.

"I said, 'You know, you're probably right,'" Brett later told the *New York Times*. "So I put it in the bat bag, and now it's in the Hall of Fame."

As is the hitting machine named George Brett.

—T. Wendel

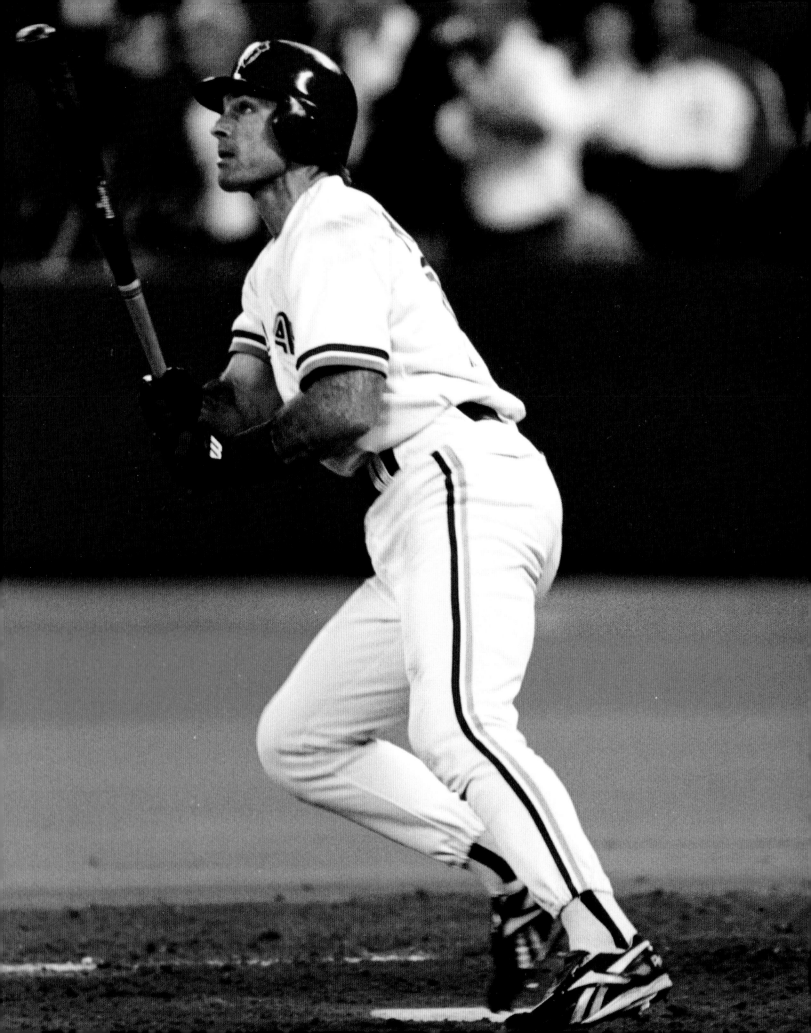

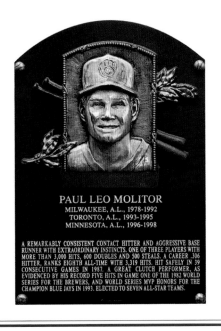

PAUL LEO MOLITOR
MILWAUKEE, A.L., 1978-1992
TORONTO, A.L., 1993-1995
MINNESOTA, A.L., 1996-1998

A REMARKABLY CONSISTENT CONTACT HITTER AND AGGRESSIVE BASE
RUNNER WITH EXTRAORDINARY INSTINCTS. ONE OF THREE PLAYERS WITH
MORE THAN 3,000 HITS, 600 DOUBLES AND 500 STEALS. A CAREER .306
HITTER, RANKS EIGHTH ALL-TIME WITH 3,319 HITS. HIT SAFELY IN 39
CONSECUTIVE GAMES IN 1987. A GREAT CLUTCH PERFORMER, AS
EVIDENCED BY HIS RECORD FIVE HITS IN GAME ONE OF THE 1982 WORLD
SERIES FOR THE BREWERS, AND WORLD SERIES MVP HONORS FOR THE
CHAMPION BLUE JAYS IN 1993. ELECTED TO SEVEN ALL-STAR TEAMS.

PAUL MOLITOR

CLASS OF 2004

Despite being plagued by injuries throughout his career, Paul Molitor was one of the few ballplayers who got better with time. And in doing so, he earned designated hitters a measure of respect, too.

Certainly Molitor could play other positions, putting in nearly eight hundred games at third base, another four hundred at second, and almost two hundred at first base. Still, over his twenty-one-year career, Molitor had his best years as a DH. He hit better than .300 in nine of his final twelve seasons and batted .341 at the age of forty, when he returned home to play for the Minnesota Twins. Molitor helped the Milwaukee Brewers to their first World Series appearance in 1982 (when he became the first man to collect five hits in a Fall Classic game) and led the Toronto Blue Jays to the World Series title in 1993.

For his career, Molitor had 3,319 hits, and his three thousandth was certainly memorable. It came on September 16, 1996, three years to day after fellow St. Paul native Dave Winfield reached that plateau. Molitor tripled on a drive to right-center field in Kansas City, becoming the first major leaguer to join that elite club with a three-bagger. Future Hall of Famers Robin Yount and George Brett were among those in attendance.

As a member of the Brewers, Blue Jays, and Twins, the seven-time All-Star batted over .300 in a dozen seasons, stole over five hundred bases, and fashioned a thirty-nine-game hitting streak in 1987. His five-hundredth career stolen base came when he was forty-one.

"I think he's one of the best base-runners—not for speed but for instinct—in the game ever," Tom Trebelhorn, one of his former managers, once told the *Sporting News.*

Too often, though, injuries kept Molitor on the sidelines. He rarely came close to playing a full season. "Without all that downtime," teammate Yount once told *Sports Illustrated,* "his numbers would have been in the top one percent. But nobody has more bad breaks than he had."

Yet when Molitor had a chance to shine, he usually came through. In five postseason series he batted .368, which prompted Hall of Fame manager Sparky Anderson to say, "If you gave him a chance, he could always beat you. He's what I call a winning player, like Joe Morgan. They're just winners."

Never was that more apparent than in the 1993 World Series, between Toronto and the Philadelphia Phillies. In the six-game showdown, Molitor had twelve hits in twenty-four at bats, including two doubles, two triples, and two home runs. He scored ten runs and drove in eight in being named that Series' Most Valuable Player.

When baseball was rocked by a bitter labor dispute the following season, which saw the cancellation of the World Series, Molitor was also an active player representative.

Molitor retired after the 1998 season with 953 extra-base hits. He went on to coach with the Twins and then the Seattle Mariners.

—T. Wendel

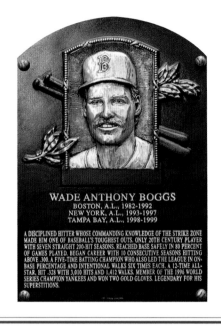

WADE ANTHONY BOGGS
BOSTON, A.L., 1982-1992
NEW YORK, A.L., 1993-1997
TAMPA BAY, A.L., 1998-1999

A DISCIPLINED HITTER WHOSE COMMANDING KNOWLEDGE OF THE STRIKE ZONE MADE HIM ONE OF BASEBALL'S TOUGHEST OUTS. ONLY 20TH CENTURY PLAYER WITH SEVEN STRAIGHT 200-HIT SEASONS. REACHED BASE SAFELY IN 80 PERCENT OF GAMES PLAYED. BEGAN CAREER WITH 10 CONSECUTIVE SEASONS HITTING ABOVE .300. A FIVE-TIME BATTING CHAMPION WHO ALSO LED THE LEAGUE IN ON-BASE PERCENTAGE AND INTENTIONAL WALKS SIX TIMES EACH. A 12-TIME ALL-STAR, HIT .328 WITH 3,010 HITS AND 1,412 WALKS. MEMBER OF THE 1996 WORLD SERIES CHAMPION YANKEES AND WON TWO GOLD GLOVES. LEGENDARY FOR HIS SUPERSTITIONS.

WADE BOGGS

CLASS OF 2005

If the experts are to be believed, Wade Boggs shouldn't have been a major leaguer, let alone a Hall of Famer. But the left-handed hitter not only became a regular with two of the most storied franchises in the game, the Boston Red Sox and New York Yankees, but earned a place in Cooperstown, too.

Even though Boggs didn't get a chance to play every day in the big leagues until the age of twenty-four, he reached the three-thousand-hit plateau and retired with a lofty .328 batting average. Once he was in the lineup, Boggs became known for a keen eye and great bat control, as he won five batting titles, strung together seven consecutive seasons of two hundred or more hits, and earned one hundred walks in four straight seasons. With his knack for getting on base, Boggs often batted leadoff and scored at least one hundred runs every season from 1983 to 1989.

"I used to tell my pitchers I could get them two strikes on Boggs easy, but from then on they were on their own," said rival manager Rene Lachemann. "There's no doubt in my mind that he is the best two-strike hitter in history."

Hitting coach Walt Hriniak agreed, stating, "No one can compare with him in regard to putting the bat on the ball."

Longtime New York Yankees owner George Steinbrenner called Boggs "one of the greatest hitters I have ever seen."

Still, coming out of high school, Boggs wasn't selected until the seventh round in the June 1976 draft, owing to his lack of power and defensive liabilities. He was taken only because one scout, George Digby of the Red Sox, believed in him.

"Most of the scouts didn't like his makeup," Digby later told the *Chicago Tribune*. "But I liked his bat. I scout bats."

After playing in the minor leagues for six seasons, Boggs finally made Boston's roster in 1982. When Carney Lansford, the team's regular third baseman, twisted an ankle, Boggs hit .410 over the next month as his replacement. He finished his rookie year with a .349 average and would have captured the batting title in the American League if he'd had enough at bats.

After 1982, the Red Sox traded Lansford to Oakland and Boggs became Boston's everyday third baseman. Boggs's league-leading .361 average in 1983 was the best by a Boston hitter since Ted Williams's .388 in 1957.

Boggs was a mainstay in Boston until 1993, when he joined the Yankees. In Gotham he was a member of the 1996 World Series champions.

The son of an Air Force sergeant, Boggs embraced routine, and it worked wonders for him. Stepping into the batter's box, he had his own ritual, which involved scratching the Hebrew character *chai,* meaning "life," in the dirt for good luck. And of course there was his chicken diet. Boggs began eating chicken before games in the minors, and, being superstitious, he kept it up throughout his storied career.

—T. Wendel

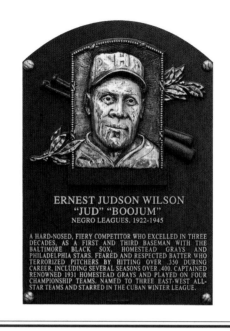

ERNEST JUDSON WILSON
"JUD" "BOOJUM"
NEGRO LEAGUES, 1922-1945

A HARD-NOSED, FIERY COMPETITOR WHO EXCELLED IN THREE
DECADES, AS A FIRST AND THIRD BASEMAN WITH THE
BALTIMORE BLACK SOX, HOMESTEAD GRAYS AND
PHILADELPHIA STARS. FEARED AND RESPECTED BATTER WHO
TERRORIZED PITCHERS BY HITTING OVER .350 DURING
CAREER, INCLUDING SEVERAL SEASONS OVER .400. CAPTAINED
RENOWNED 1931 HOMESTEAD GRAYS AND PLAYED ON FOUR
CHAMPIONSHIP TEAMS. NAMED TO THREE EAST-WEST ALL-
STAR TEAMS AND STARRED IN THE CUBAN WINTER LEAGUE.

JUD WILSON

CLASS OF 2006

Absolutely fearless and with an ill temper to match, Ernest Judson Wilson came out of the Foggy Bottom section of Washington, D.C., to terrorize pitchers for more than twenty years. Wilson earned the nickname "Boojum" from Satchel Paige for the sound his vicious hits made, and he is considered to be among the most dangerous batters in the history of Negro Leagues baseball.

Paige listed Wilson among the top hitters he ever faced, with Boojum noting, "He just tried to blur that ball by you. I timed his blinding stuff and just raked him for base hits." As for any thoughts of respect for the great pitchers, Wilson retorted, "Pitchers all look the same to me."

A veteran of Army service during World War I, Boojum came out of the military to star for some of the greatest teams in black baseball history, including the Baltimore Black Sox, Homestead Grays, Pittsburgh Crawfords, and Philadelphia Stars, between 1922 and 1945. He regularly batted over .320 and was always noted for his strength and power. According to outfielder Ted Page, "Wilson was strong enough to go bear-huntin' with a switch."

Wilson had limited defensive skills at third base, using his chest to stop hard-hit balls, and at bat he would crowd the plate, thereby ensuring that he was often playing hurt. There are stories told by his teammates that his body was frequently covered with bruises earned on the field of play, but Wilson seldom let these keep him out of the lineup. According to the *Biographical Dictionary of American Sports,* Wilson had "an unyielding desire to win," and this "earned him a reputation for being a mean, nasty, talented competitor." This reputation also served to inspire his teammates to work harder.

Despite his weakness as a fielder, his hitting served to cement his reputation as a great ballplayer. Josh Gibson called Wilson the greatest hitter he had ever seen. There were few pitchers who wanted to face him. Having played against all the great black pitchers, and many of the white stars in exhibition games, Wilson made it perfectly clear: he just did not like pitchers, regardless of their color.

He remained in the Washington, D.C., area after his playing days until his death in June 1963. Wilson is buried at the Arlington National Cemetery in Virginia. He was elected to the National Baseball Hall of Fame in 2006, more than four decades after his death, ensuring that his name will forever be listed among the greats of the game.

—J.G.

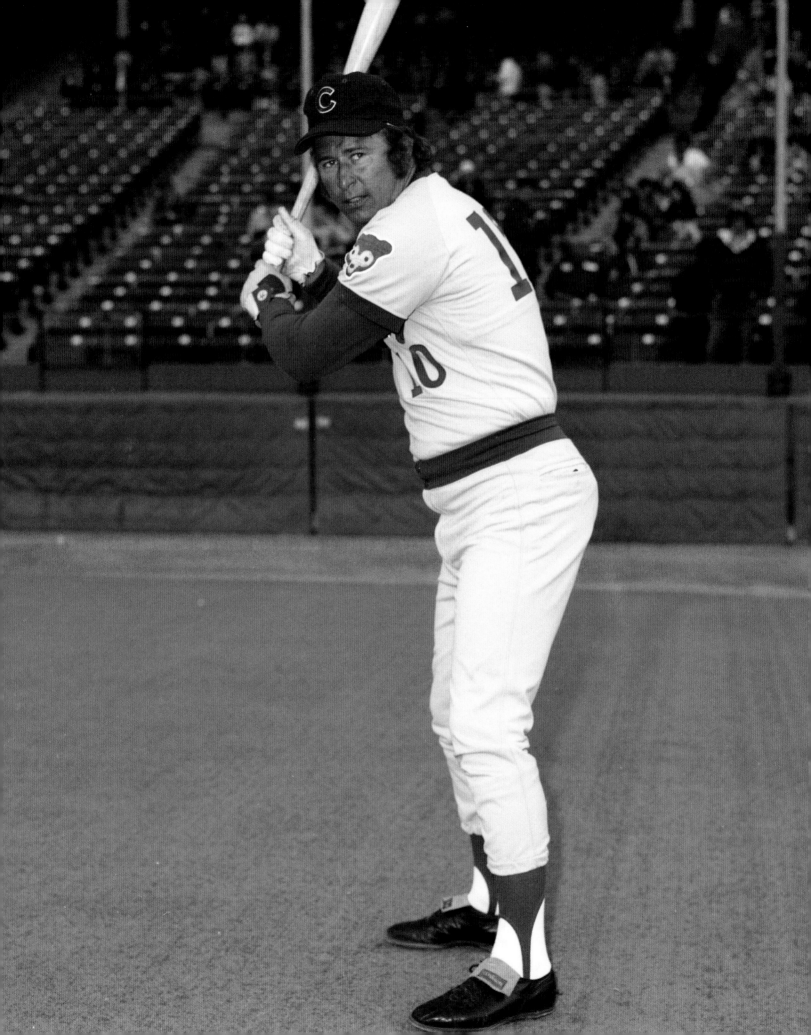

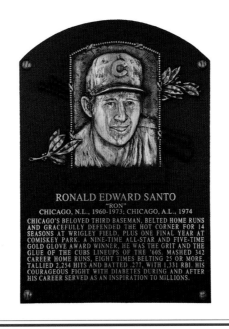

RONALD EDWARD SANTO
"RON"
CHICAGO, N.L., 1960-1973; CHICAGO, A.L., 1974
CHICAGO'S BELOVED THIRD BASEMAN, BELTED HOME RUNS
AND GRACEFULLY DEFENDED THE HOT CORNER FOR 14
SEASONS AT WRIGLEY FIELD, PLUS ONE FINAL YEAR AT
COMISKEY PARK. A NINE-TIME ALL-STAR AND FIVE-TIME
GOLD GLOVE AWARD WINNER, HE WAS THE GRIT AND THE
GLUE OF THE CUBS LINEUPS OF THE '60S. MASHED 342
CAREER HOME RUNS, EIGHT TIMES BELTING 25 OR MORE.
TALLIED 2,254 HITS AND BATTED .277, WITH 1,331 RBI. HIS
COURAGEOUS FIGHT WITH DIABETES DURING AND AFTER
HIS CAREER SERVED AS AN INSPIRATION TO MILLIONS.

RON SANTO

CLASS OF 2012

For most of his major league tenure, Ron Santo gave Chicago fans everything they could have wanted from a third baseman. That he did so while playing with a debilitating condition like diabetes only made his accomplishments all the more stunning.

A product of Seattle, Washington, Santo learned of his condition at age eighteen. He kept his diagnosis private and did not complain, instead working hard to overcome the effects of the disease in climbing his way to the major leagues. He signed with the Chicago Cubs, who brought him up in 1960 at the age of twenty. In spite of his youth, he put up respectable numbers as a rookie before developing into a top-notch player in his second season.

After an off year in 1962, Santo became a fixture of excellence at the hot corner. A patient hitter with a keen eye, he led the National League in walks four times. He also paced the league in on-base percentage twice. As a Cub, he hit 337 home runs, despite playing most of his career in an era in which pitchers held a clear advantage over hitters.

Remarkably consistent, Santo was not a one-dimensional player. He was an excellent fielder who led the National League in assists seven times. He had excellent range, soft hands, and an ability to start double plays quickly.

Despite having to deal with diabetic symptoms such as low blood pressure and persistent fatigue, Santo missed only twelve games over a ten-year span in the 1960s. Other Cubs took notice. "He was a tough player, he wanted to play and contribute every day, and he never let any obstacles stand in his way," Hall of Famer Ferguson Jenkins told ESPN. "Ronnie was one of the leaders on our team. [Manager] Leo Durocher made him the captain, and he took that role very seriously."

Santo brought with him an unusual level of emotion. He took defeats especially hard, sometimes behaving abruptly with members of the media. When the Cubs won, he was gleeful. During the second half of the 1969 season, he celebrated Cubs victories at Wrigley Field by clicking his heels on his way to the home clubhouse.

For his era, Santo set a standard among National League third basemen. Regarded by some as the Senior Circuit's counterpart to Brooks Robinson, Santo reached base with regularity, hit with enormous power, and defended his position with flair. In other words, he fulfilled the definition of a Hall of Fame third baseman.

After his retirement, Santo only magnified his acclaim throughout Chicago as a popular Cubs broadcaster; he became a revered figure to fans who already loved him for his playing performance.

Similarly, Santo ranked high in terms of what he delivered as a teammate. "Ronnie was always there for you, and through his struggles, he was always upbeat, positive and caring," Hall of Fame teammate Ernie Banks told *USA Today*. "I learned a lot about what it means to be a caring, decent human being from Ron Santo."

—B.M.

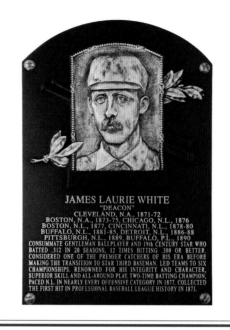

JAMES LAURIE WHITE
"DEACON"
CLEVELAND, N.A., 1871-72
BOSTON, N.A., 1873-75, CHICAGO, N.L., 1876
BOSTON, N.L., 1877, CINCINNATI, N.L., 1878-80
BUFFALO, N.L., 1881-85, DETROIT, N.L., 1886-88
PITTSBURGH, N.L., 1889, BUFFALO, P.L., 1890
CONSUMMATE GENTLEMAN BALLPLAYER AND 19th CENTURY STAR WHO
BATTED .312 IN 20 SEASONS, 12 TIMES HITTING .300 OR BETTER.
CONSIDERED ONE OF THE PREMIER CATCHERS OF HIS ERA BEFORE
MAKING THE TRANSITION TO STAR THIRD BASEMAN. LED TEAMS TO SIX
CHAMPIONSHIPS. RENOWNED FOR HIS INTEGRITY AND CHARACTER,
SUPERIOR SKILL AND ALL-AROUND PLAY. TWO-TIME BATTING CHAMPION,
PACED N.L. IN NEARLY EVERY OFFENSIVE CATEGORY IN 1877. COLLECTED
THE FIRST HIT IN PROFESSIONAL BASEBALL LEAGUE HISTORY IN 1871.

DEACON WHITE

CLASS OF 2013

James "Deacon" White stopped playing big league ball before the dawn of the twentieth century. But his accomplishments still shine brightly enough to splash his name across the baseball world more than 120 years later.

White, a catcher and third baseman who played from 1871 to 1890, literally witnessed the birth of Major League Baseball. He was the first batter in the first National Association game on May 4, 1871. The National Association, which existed from 1871 to 1875, is considered by many historians to be the first major league.

White doubled in that first at bat for Cleveland's Forest City ball club, launching a career in which he would become known as the finest bare-handed catcher of his generation.

Born December 7, 1847, White played for Forest City of Cleveland (1871–72), the Red Stockings of Boston (1873–1875, 1877), the Chicago White Stockings (1876), Cincinnati Reds (1878–1880), Buffalo Bisons (1881–1885, 1890), Detroit Wolverines (1886–1888), and Pittsburgh Alleghenys (1889).

At one time in White's professional career he played all nine positions on the field, including two pitching appearances. He moved to third base for the second half of his career.

White was a standout catcher in an era when catchers were especially important. Catchers did not use any equipment and

were positioned much farther back from the pitcher than in modern baseball. Just being able to catch the ball was considered an advantage, but White could catch and throw runners out.

"You can talk all you want about the great catchers; but the best who ever worked behind the plate was Jim White," said Hall of Fame pitcher Pud Galvin. "I have seen them all, but I place him first."

White was forty-two during his last season and had been the oldest player in the league for his last four seasons. He was also the first player to win a team "most valuable player award," earning the honor in 1875, when his Red Stockings went 71–8.

"What was most admired about him was his quiet and effective way of doing his work," said future Hall of Famer Henry Chadwick of White. "Kicking [complaining] is unknown to him. And let us say there is one thing in White stands pre-eminent, and that is in the integrity of his character. Not even a whisper of suspicion has ever been heard about Jim White. Herein lay as much of his value to his team as his great skill as a catcher."

At his retirement, White had a career batting average of .312, 2,067 hits, and 988 RBI in just 1,560 games.

"If anyone should be in the Hall of Fame," said Hall of Fame manager Connie Mack, who was a player contemporary of the Deacon, "it should be James White."

White passed away on July 7, 1939.

—C.M.

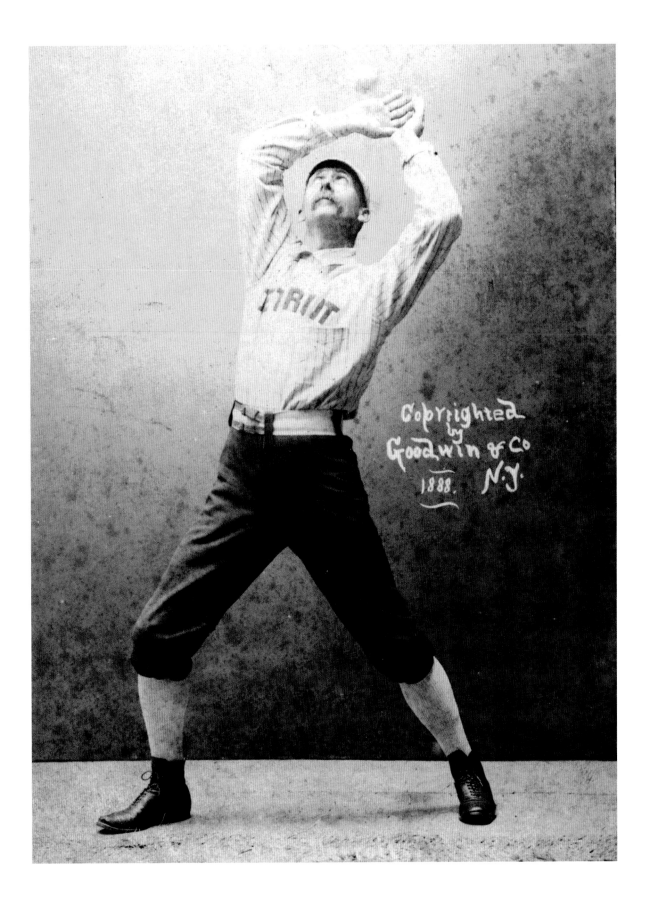

Copyrighted
by
Goodwin & Co
1888. N.Y.

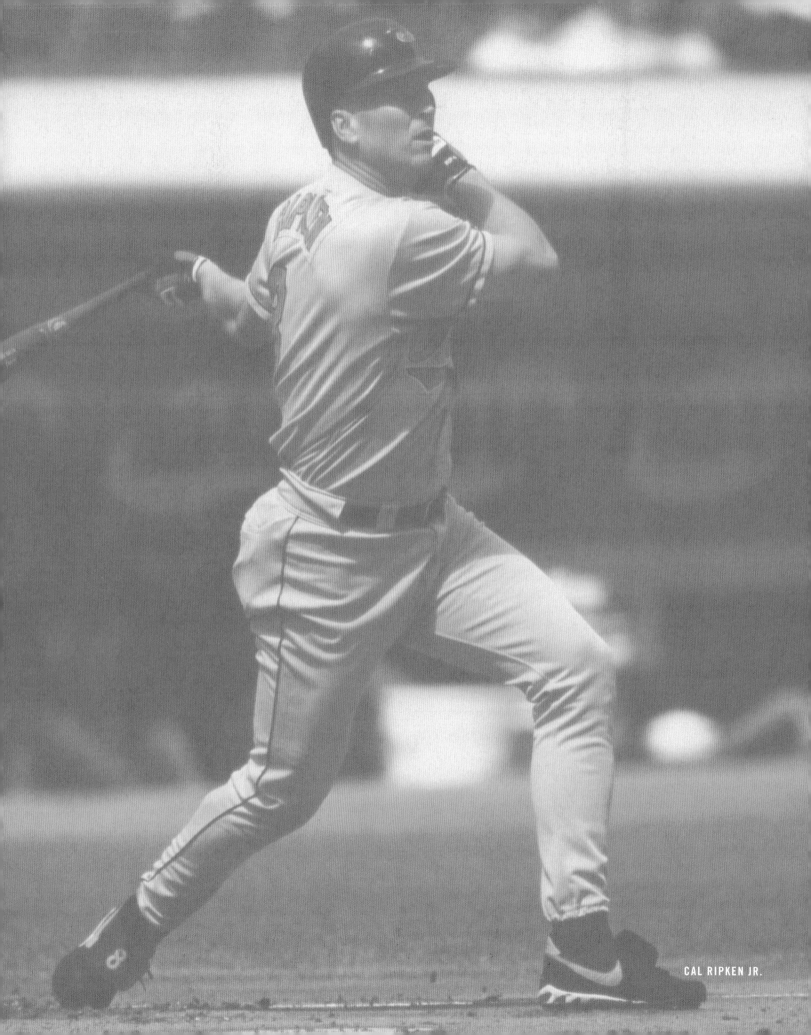

CAL RIPKEN JR.

SHORTSTOPS

SHORTSTOPS BY **CAL RIPKEN JR.**

During his stellar twenty-one-year big league career with the Baltimore Orioles, Cal Ripken Jr. accumulated 3,184 hits, 431 home runs, 1,695 RBI, an American League Rookie of the Year Award, and two MVP Awards. But the number he'll forever be associated with is 2,632—the number of consecutive games he played, shattering Lou Gehrig's iron man streak. Ripken, who was inducted into the Hall of Fame in 2007, will also be remembered for becoming one of the game's most beloved goodwill ambassadors and for proving that shortstops need not be short.

I obviously wound up making a name for myself as a guy who played every day, every season, season after season. But people forget that many teams originally were more interested in drafting me as a pitcher instead of an everyday player. I'd had considerable success on the mound at Aberdeen [Maryland] High School, outside of Baltimore. My senior year I went 7–2 with a 0.70 earned run average and something like one hundred strikeouts in just sixty innings. I think what really grabbed the scouts' attention was my final high school game, when I pitched a two-hitter and struck out seventeen to help us win the Class A state championship.

When the Baltimore Orioles drafted me in the second round back in 1978, I know that's the direction they were thinking, even though I had a pretty good year at the plate, with an above-.400 batting average and twenty-nine RBI in just twenty games. They saw this tall, lanky kid who could throw the ball hard and they were thinking, "Maybe this kid can be the next Jim Palmer."

Not long after they chose me, I met with them to discuss my baseball future. O's manager Earl Weaver was there, as were general manager Hank Peters and Tom Giordano, Baltimore's director of scouting. My dad, who was an Orioles coach, also was there, but he kind of stayed in the background, played the role of a diplomat. I could tell that the majority of the people in that room wanted me to start my pro career as a pitcher. But Earl had a different idea. He saw me as an everyday shortstop. He said, "I've watched him play a bit. He has great hands, is a strong hitter. I think we'd be foolish not to start him out as a position player." Like I said, my dad played the role of a diplomat. When it came his turn to speak, he didn't come on strong and say, "I agree with Earl. My boy should be a position player." Instead he said, "During the many years I managed in the minor leagues, whenever we had a situation like this where we weren't sure if a kid should be an everyday player or a pitcher, it's been better to start him as a position player because it's easier to then try to convert him to pitching than the other way around. At least, that's been my experience." The guys in that room went back and forth about this for a while, and Hank finally looked at me and asked, "Cal, what do you want to do?" And I said, "Well, the way I look at it is that pitchers get to play one out of every five games, or a little more if you are a reliever, and I want to play every day." So Hank and Tom finally said, "OK, let's start out that way and see what happens."

So they sent me to their Class A team in Bluefield, West Virginia, as a shortstop. I was happy about that, but in the back of my mind I had this feeling that the Orioles brass really wanted me to pitch and that if I struggled early on, they wouldn't wait long to make the switch. Well, wouldn't you know it, I go to Bluefield and I get off to a terrible start. I wound up making thirty-three errors in just sixty-two games that season. I really struggled in the beginning with my accuracy on

my throws and adjusting to the speed of the game. Giordano swung through early in the season when I was really having problems in the field and at the plate, and I could almost read his mind. He had to be thinking, "I told him he should have pitched." I kept waiting for him or someone else to tap me on the shoulder and say, "OK, Cal, we've tried this long enough and it isn't working, so let's try you as a pitcher." Fortunately, that didn't happen. They gave me a longer leash than I thought they would. They let me push through my struggles, and eventually it all worked out.

Once in a blue moon I'll think back to my decision and wonder what would have happened had I started out pitching. We'll obviously never know, but it is fun to think about. I did have a really powerful arm and I was still growing at that time. I grew about another two to two and a half inches after high school, and I kept filling out until I hit about 225 pounds. So my arm strength and accuracy continued to improve as I went on. But I wasn't just a big kid who threw hard. I really got into the cerebral part of pitching early on. I realized that you might be able to blow it by high school hitters, but unless you were blessed with a Nolan Ryan heater, you weren't going to succeed past high school by being a one-trick pony. So I actually had developed four pitches that I had a pretty good command of. And spending a lot of time at ballparks with my dad when he managed at various levels of the Orioles farm system clearly had helped me learn about the mental side of pitching. I was able to pick the brains of professional pitchers, and I think that gave me a real edge. Again, it's always interesting to ponder the "what-ifs" in life. I obviously have no complaints with the path I chose.

When I look back, I realize how blessed I was to have a father whose office was the ballpark. From a relatively early age, I got to accompany him to work during the summers when the team he was managing was home. It was an absolute blast. I never, ever remember being bored, because there was always something to do there. And what a learning experience it was, watching him impart his vast knowledge of the game to his players, and being able to seek the advice of those players, many of whom took me under their wings. You talk about a baseball education. I received a great one and at an early age. I was like a sponge at the ballpark. I had a thirst for baseball knowledge and I absorbed everything I could. I listened with rapt attention when Dad was instructing players. In those days [late 1960s and early 1970s], minor league managers did it all. Dad didn't have a special pitching coach or hitting instructor or fielding coach. He had to wear all those hats himself. He would throw batting practice, hit fungoes, and talk pitching with the pitchers. He had been a catcher in his playing days, so he had a pretty good knowledge in a lot of areas. I would be privy to those teaching moments he had with his players. And on our drive to and from the ballpark, I would be able to ask Dad a ton of questions. *Dad, during batting practice, why did you tell so-and-so that he should be hitting that pitch to right field?* Or *Dad, why should so-and-so be taking the relay in that situation? Shouldn't that be such-and-such's play?* It was a great classroom for me, and Dad was the best baseball teacher I ever had.

I remember him allowing me to put on a Red Wings uniform and go to the outfield to shag balls during batting practice at old Silver Stadium in Rochester, New York. I was something like nine or ten years old at the time. I recall having conversations about pitching with guys like Jesse Jefferson, a right-handed pitching prospect for the Orioles with a pretty good curveball. He would talk to me in the outfield a lot. And Doug DeCinces, the third-base prospect who had the unenvi-

able task of following in the legendary footsteps of Brooks Robinson in Baltimore, took an interest in me. He would play catch and pepper with me and give me hitting and fielding tips.

And I would take what I learned from them and Dad and incorporate it into my organized games, from Little League right up through high school. There's no question, being around the game the way I was gave me a great advantage. I think it also helped that I was a curious kid. I was always asking questions. From an early age I loved the mental challenge of the game almost as much I enjoyed the physical challenge. Baseball may seem like a simple game to the outsider, but it really is a cerebral game. There is a ton of stuff going on, and it requires great concentration to succeed.

The other thing I learned from observing my dad was the importance of loving what you do. Even though he liked to say he was putting on his work clothes whenever he got into his uniform, I don't think he ever thought of baseball as work. It was his passion. And it became my passion, too.

As I said, my professional baseball career didn't get off to a great start. When I first reported to Bluefield, there was a guy by the name of Bobby Bonner already there, and he was twenty-one or twenty-two years old and fresh off the campus of Texas A&M. When we started taking grounders at shortstop, I could see how much more advanced he was than me. He was so smooth, had a great arm, and was making all the plays with ease. I said to myself, "I'm never going to get a chance to play with this guy here." Fortunately, about three, four days later, they sent him straight to Double-A, where he belonged. In one of our first exhibition games, I hit a ball through the light tower for a home run. It was a shot. But I wound up suffering through a major power outage after that. I didn't hit a single home run that regular season. But I did eventually settle down and start hitting for average. And in the coming seasons, as I filled out and got stronger and gained knowledge and confidence, I became a decent power hitter.

One of the other pressures I felt early on was the pressure that comes when you are in the same organization as your dad. At times when I struggled, I would hear rumblings that I was being shown favoritism because of him. I even heard extreme things, like, if it weren't for him, I wouldn't have been drafted in the first place. I knew that wasn't true, because every other team had been watching me in high school and talking to my coach. I learned to avoid it and block it out. It was just noise.

My second year of pro ball with Miami of the Class A Florida State League, something clicked for me. I had received a wrong shipment of bats, ones with a thinner handle than I was used to. I had no other choice but to try them, and I wound up hitting my first professional home run to win a game in the twelfth inning. I kind of liked the buggy-whip action I got with those thin handles, so I stuck with the new bats. I got called up to Double-A Charlotte during the year. The following season my power numbers began to soar, and I hit twenty-five homers and drove in seventy-eight runs. When I got to Rochester the next season [1981], my confidence was really high. I was facing pitchers who were up and down from the big leagues, so when I got off to a really good start with the Red Wings, I felt I was ready. There was even some talk that I would get called up early because Earl Weaver wanted me up there instead of Bonner, but that was a year when the season was interrupted by a strike, so they decided to keep me in Rochester and let me keep playing and

progressing. I wound up winning International League Rookie of the Year, and in August, after the strike ended, I did get the call-up.

I reported to spring training in 1982 as a third baseman. That season, Bonner and Lenn Sakata were splitting time at short, but Earl wasn't thrilled with either of them. I had started the season at third. I went 3-for-5 on Opening Day, then proceeded to go 8-for-my-next-63. Once I finally started to get my hitting going, Earl moved me to shortstop. I joke now that it was supposed to be a temporary move to bolster the lineup with more offense. But that temporary move lasted fifteen years.

Earl clearly was bucking conventional baseball wisdom by moving me there. I was six foot four, 220 pounds, built more like a third or first baseman. But I moved well for a guy my size. I had a late growth spurt. Before it, I was built more like traditional shortstops. I was a little taller than most, but I hadn't filled out. Looking back, I don't see myself as transforming the position. I just think that the success I enjoyed there might have changed the mind-set a bit. It might have forced some baseball people to open up their thinking. Maybe it shouldn't be a foregone conclusion; once a guy gets bigger, he doesn't necessarily have to go to the corner. Maybe you can get offense and defense out of that position. I had been fortunate to have a guy like Orioles shortstop Mark Belanger as one of my mentors. I remember talking to him about the nuances of the position when I was sixteen years old. Some of the stuff helped me right away, while other stuff clicked in after I had been playing the position in the big leagues for a while. I was in somewhat uncharted territory because of my size. I couldn't do everything the way little guys could. I had to figure out what best suited my build and skills. There were some advantages I had because of my size. My height enabled me to rob some hits by leaping or really stretching out on dives. I also had a stronger arm than many of the little guys playing the position, so that enabled me to play a little bit deeper, and that extra depth enhanced my range.

I think the time I had spent at third also helped me develop some accuracy with my throws and taught me how to charge balls and make bare-handed plays. I grew up in the Baltimore area, so I guess it wasn't surprising that I would idolize Orioles third baseman Brooks Robinson. My dad was in Baltimore's minor league system during most of Brooks's career, so I didn't have a great number of encounters with Brooks, but I had a few. And he was always nice to me, always seemed to take an interest in me. I'll never forget that when I made my major league debut at third base in old Memorial Stadium, I could feel Brooks's presence out there. Just standing on the same ground that he had stood on was really kind of a sacred moment for me. I think my parents were happy that I had chosen Brooks as my favorite player growing up because he was such a great role model as a player and as a person.

I learned a lot just by watching Brooks from a distance. And I also learned a lot by watching my Orioles teammate Eddie Murray up close. Eddie didn't say a lot, but his actions spoke volumes. He really taught me how to go about my job in a professional manner every day. I also learned from him the importance of being in the lineup every day even when you might be slumping at the plate. There are some things in baseball that can't be easily measured. And lineup presence is one of those things. Eddie was one of those guys who impacted the team in a positive way even when he was struggling at bat. He was always a feared hitter, so he would ensure that people

batting in front of him would get more strikes to hit because pitchers didn't want to risk walking guys and having to face Eddie with runners on base. He also impacted pitching changes late in the game because he was a switch-hitter. His influence clearly went beyond his numbers.

I mentioned how I got off to a rough start in 1982 after my three-hit Opening Day performance. But I settled down and really got into a groove, finishing with 28 homers, 93 RBI, and a .264 average to win the American League Rookie of the Year. The next season was even better—for me and our team. Joe Altobelli had replaced Earl Weaver, who had retired, and we had a team that was loaded with talent. I followed up my rookie year with improved stats overall. I had one less homer, but drove in nine more runs and batted .318. I also led the league in doubles (47), hits (211), and runs scored (121) to earn the Most Valuable Player Award. However, that's not what I remember most when I look back on that season, because that was the year we beat the Chicago White Sox in the AL Championship Series and then won four of five against the Philadelphia Phillies to capture the World Series title. I hit only a buck sixty-seven in that Fall Classic, but that didn't matter because my teammates, especially our pitchers, really picked me up. I wound up catching a soft liner for the final out. I made hundreds of tougher catches in my life, but none as meaningful as that one.

In the years that followed, I kept striving to put up consistent numbers, and my managers kept writing my name on that lineup card each game. To be honest with you, it wasn't until I was closing in on a thousand games that I started becoming aware of the streak, and that was only because it was a nice round number, and reporters started asking me and others about it. I think Eddie Murray and Brooks had a couple of streaks that were four hundred, five hundred games long. A lot of people—especially some reporters—mistakenly believed I became obsessed with it as it grew, but that just wasn't true. My parents had ingrained in me the importance of a good work ethic. I just believed that whether you were a ballplayer or factory worker or newspaper reporter, you had an obligation to show up to work each and every day and give it your best. It wasn't about the streak. It was about honor and responsibility to your job, and being a good teammate.

As the seasons passed and the streak grew, it obviously became a bigger topic of conversation. I did my best to block out the noise, but some of the criticism hurt, particularly the accusations that I was being selfish and hurting my team by not taking some time off. In retrospect, I think it was a case of being selfless rather than selfish. If I was really selfish, I think I would have taken time off, like the guys who came up with mysterious ailments such as Randy Johnson–itis when they didn't want to face a tough pitcher who might hurt their averages. I know I probably could have had better individual numbers if I had taken ten days off a year. I could have missed the games against pitchers I had trouble hitting. But I believed that even if I was struggling at the plate, I could do other things to help my team win. And I thought, "What kind of example am I setting for my teammates if I'm begging out of the lineup against Roger Clemens in a day game following a night game where we've just played fifteen innings?" They're going to drag themselves out there and try to beat Clemens even though they're beat-up and dog tired, and I'm going to take the easy way out? To me that would have been selfish; that would have shown them I thought I was a star, that I thought I was entitled and didn't have to grind it out and go to battle with them.

After the streak, I remember Frank Robinson telling me that there were times when he was the Orioles manager when he seriously considered sitting me down, giving me a game off. He said he would go into his office and say, "OK, today's the day." Then he'd start looking at the lineup and thinking about all the things I'd do during the course of a game, and he'd say, "I don't want to be without those things. Those are things that give this ballclub the best chance to win. It's too big of a hole to fill." Frank realized there also were intangibles involved and that this really was about the team and not just me. That was great validation from one of the greatest players of all time, and it meant the world to me when he told me that.

This is not to say that the streak didn't eventually become a goal of mine, because it did. It was a motivation and an incentive, but it was never an obsession. By the time the big night arrived, on September 6, 1995, and my 2,131st game became official, breaking the tie with the great Lou Gehrig, I was admittedly exhausted—physically, mentally, and emotionally. That season, from the very beginning, there was great anticipation and celebration. Even those who had been critical of my pursuit had changed their tune and saw it as something good. I knew everywhere I went, from the moment I showed up at spring training that February, people were going to want to talk about it. I knew I had to give in to the process, not fight it, but I needed to keep it under as much control as I could so it wouldn't affect my play. I was very uncomfortable when it got down to the record-breaking game because I would have preferred it to unfold in the thick of a pennant race. I was hoping these games with the California Angels were going to have playoff ramifications, and the focus was going to be on that. But as we fell out of the race, the focus fell more on me, individually.

I felt a tremendous sense of relief when the streak-breaking game became official. They stopped the game and I emerged from the dugout a couple of times to doff my cap to the crowd at Camden Yards. I kept waving my cap and mouthing, "Thank you, thank you," but they wouldn't stop applauding. I appreciated the standing ovation, but I also felt a little embarrassed. I wanted to get the game restarted out of respect for my opponents, especially their pitcher. But it just wouldn't stop. It felt kind of surreal. Then, Raffy [Rafael Palmeiro] and Bobby Bo [Bobby Bonilla] pushed me out of the dugout toward the right-field line. My first inclination was "OK, let's try this; let's see if this works. I'll go around the ballpark really fast and we'll get the game started." But then as I started to shake hands and see the looks on people's faces, the impact of the moment became much more emotional and meaningful for me—and the fans. And by the time I reached the left-field line, all those worries about having to get the game started went away. It was a tremendous emotional release for me. It gave me a chance to reflect and feel good. Maybe I felt like it was a confirmation of my persistence and perseverance and my trying to do the right thing. By the time I got back to the dugout and my family, I couldn't care less if we started the game.

I think the streak really resonated with people because they wanted so badly to be able to fall back in love with the game. It had been a bad stretch for baseball. The strike and the cancellation of the 1994 World Series had really turned off a lot of people. I think there was a yearning to find something good about the game again, to stop obsessing about the ugly business of baseball, to connect with it once more as America's National Pastime. The streak linked the game all the way back to Lou Gehrig's days, to a happier time. I've always contended, and I still contend, that ulti-

mately, the streak wasn't so much about me as it was about finding something good about base-ball once more.

I also think many people could relate to Gehrig's work ethic and my work ethic, that there was something noble about going to your job every day, about going to school every day, about taking pride in what you were doing. So the streak wound up touching people in different ways—all good.

That connection to Gehrig was very special to me. I would love to be able to have a conversation with him because, if anyone could relate to the rigors of the streak, he could. I would imagine that his streak happened for the same reasons that mine had. He had a great work ethic, and it was important to him to be in the lineup every day for the good of his team. My connection to him became even stronger when I went for my Hall of Fame orientation in Cooperstown several months before my induction in 2007. I was curious about the size of the bat he swung and his first baseman's mitt. They had really small gloves in those days, and I wondered how in the world he could be as effective a fielder as he was without the big hinged, scooped mitts first basemen have today. It just made me appreciate him all the more. Just to be mentioned in the same sentence as Lou is such an honor because he was one of the greatest players in the history of the game, maybe one of those guys whose greatness wasn't fully appreciated because he played in the shadow of and on the same team as Babe Ruth. So that was another positive about the streak. It brought out the story of Lou Gehrig to another generation of fans.

I'm flattered when current stars like Derek Jeter and Alex Rodriguez give me props for opening the door for bigger players to be able to play shortstop. But as I mentioned before, I really don't take credit for transforming the position. My success there might have changed the mind-set a bit, might have caused people to be more open-minded to the talented players out there who could play short and second base in spite of their size. But let's be real. Derek and Alex were so gifted that they would have wound up at shortstop even if I hadn't preceded them. I joke with them about that. I tell them, I appreciate your paying tribute to me, but it wasn't me who gave you the opportunity to play short, it was you who gave yourself that opportunity because you're so talented.

When I look back at the changing attitudes toward the position, I kind of liken it to Magic Johnson playing point guard at six foot nine. Before Magic, the thinking was that your point guard had to be a smaller, quicker guy. But Magic showed people that his height, coupled with his great vision and ball-handling skills, was an advantage, not a disadvantage. I mentioned about how my height and length enabled me to get to some balls smaller guys might not have reached, and my arm strength allowed me to play deeper, therefore giving me even more range. It also helped me around the bag on double plays. Being as big as I was, I was able to hang in on the double play a little bit better. Guys were reluctant to come barreling into me with takeout slides because there was a risk they could get hurt if a 225-pound guy landed on them.

I think the shortstop position, like all positions on the diamond, will continue to evolve as the ballplayers of each generation become bigger, faster, stronger, and more creative, and the equipment continues to improve. Things you see today from shortstops, like throwing from one knee, flipping the ball with their glove, flipping the ball through their legs, a lot of that stuff was deemed fancy and high risk when I played. But they're now becoming commonplace, more accepted,

because they're more efficient. Backhanded flips were considered hotdog plays when I played. Now they are considered a huge weapon because you can get the ball to the bag quicker.

We're seeing guys use their size and their athleticism to push the game to higher levels. Look at the outfielders climbing the walls, timing their jumps to steal home runs. It's become another weapon. And it's immensely entertaining to watch. It's all forcing longtime baseball people to rethink things, and that's good because like any endeavor in life, it's important to take new approaches and think outside the box on occasion. Everything evolves. Including baseball. Fortunately for me, I had people like Earl Weaver, who went against the conventional wisdom about the size of shortstops. By not being contrained by the old norms, he opened the door for me and guys like Derek Jeter and Alex Rodriguez.

Thanks to Earl, I was able to play my natural position—shortstop—even after I experienced a growth spurt that supposedly made me too big to be there. And thanks to him, I also got a chance to prove myself as an everyday player rather than as a pitcher. I think things wound up working out pretty well in that regard.

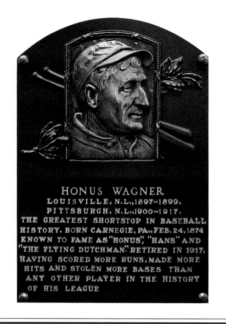

HONUS WAGNER

CLASS OF 1936

Honus Wagner was referred to by Hall of Fame skipper John McGraw as "the nearest thing to a perfect player no matter where his manager chose to play him." Playing primarily at shortstop with his hometown Pittsburgh Pirates, "The Flying Dutchman," as he was known, could do it all on the baseball diamond. During his major league career Wagner played every position on the field except catcher, but he could probably have done that, too.

Wagner had a bit of an awkward look about him; he stood five foot eleven and weighed two hundred pounds, had huge hands, long arms, a barrel chest, and was bowlegged, but looks can be deceiving. He held the bat with his hands inches apart and could drive the ball the other way on outside pitches or slide his hands back down the barrel of the bat to pull inside pitches. A sharp gamesman, Wagner could adjust to meet any situation. Burleigh Grimes, once a teammate of Wagner's, recalled, "One day he was batting against a young pitcher who had just come into the league. The catcher was a kid, too. A rookie battery. The pitcher threw Honus a curveball, and he swung at it and missed and fell down on one knee. Looked helpless as a robin. I was kind of surprised, but the guy sitting next to me on the bench poked me in the ribs and said, 'Watch this next one.' Those kids figured they had the old man's weaknesses, you see, and served him up the same dish—as he knew they would. Well, Honus hit a line drive so hard the fence in left field went back and forth for five minutes."

Wagner considered his biggest thrill in the game to be winning the 1909 National League Pennant and the World Series. He said, "We had an iron man pitching staff in Howard Camnitz, Vic Willis, and Lefty Leifield. Camnitz won 25 games, Willis 22, and Leifield 19, yet none of those men won a game for us in the World Series. The hero of the Series for us was Babe Adams, a 20-year-old right-hander. He had won 12 out of 15 games during the season and won three in the Series from the Tigers."

Acknowledged as two of the game's best, Wagner and Ty Cobb first met on the diamond in that 1909 Series. Cobb reached first and yelled to Wagner about his plan to steal second: "Hey, Krauthead, I'm comin' down on the next pitch." Cobb took off and raised his spikes to try to topple Wagner. He was surprised when the Pirates fielder eluded him and tagged him by jamming the ball in his mouth. Cobb needed stitches to close the wound. He later said, "That . . . Dutchman is the only man in the game I can't scare."

Upon retirement, Wagner continued to be involved with the game, coaching for thirty-nine years. Pittsburgh erected a statue of him in tribute, and in 2000 the U.S. Postal Service produced a Wagner stamp. Well into his senior-citizen years with the club, Wagner engaged listeners with his baseball stories. If someone asked if a tale was true, Wagner replied, "Son, I may stretch a point or two, but I'll never tell you a story you can't repeat at the family dinner table."

—F.B.

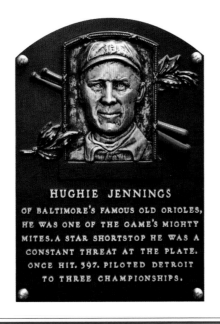

HUGHIE JENNINGS
OF BALTIMORE'S FAMOUS OLD ORIOLES,
HE WAS ONE OF THE GAME'S MIGHTY
MITES. A STAR SHORTSTOP HE WAS A
CONSTANT THREAT AT THE PLATE.
ONCE HIT .397. PILOTED DETROIT
TO THREE CHAMPIONSHIPS.

HUGHIE JENNINGS

CLASS OF 1945

Baseball wasn't meant to be a cerebral game for Hughie Jennings. Though he was a great strategist, both as a player and then later as a manager, Jennings also believed that the sport deserved to be celebrated. How else to explain the way he would stamp the ground, claw at the grass with his hands, and yell his trademark "Ee-yah"?

Jennings grew up in the hardscrabble coal country near Scranton, Pennsylvania. Even though he first gained attention as a catcher, he caught on as a shortstop and eventually became one of the mainstays of the Baltimore Orioles in the National League in 1893. This ball club represents one of the best from the game's early days. Managed by Ned Hanlon, that vintage Orioles team included John McGraw, Wilbert Robinson, Joe Kelley, and Willie Keeler. Jennings was their captain and was known for finding any way to get on base and being adept at stealing bases, too. The Orioles captured three consecutive NL Pennants from 1894 to 1896, with Jennings stealing a total of 160 bases during that period.

When Hanlon became manager and part owner in Brooklyn after 1898, he took Jennings, Keeler, and Kelley with him, and another baseball juggernaut was formed. After Jennings hurt his arm during this time, he simply moved over to first base, where he played during Brooklyn's 1899–1900 championship run.

An aggressive, fiery player, Jennings wasn't afraid to get hit by the ball and often crowded the plate. He was hit fifty-one times in the 1896 season alone, but the approach almost cost him dearly when he was later hit in the head by Amos Rusie, one of the top fireballers ever in the game. Jennings suffered a skull fracture and was reportedly unconscious for several days. Despite the time on the sidelines, he returned to the game as feisty as ever.

By 1903 Jennings's playing career was winding down, and he eventually signed on as the player-manager in Detroit. Unlike many star ballplayers, Jennings proved to be a successful manager as well. His Tiger teams, with such stars as Ty Cobb and Sam Crawford, won three consecutive American League Pennants (1907–1909).

From the coaching box, Jennings delighted the crowd with his antics, which often included a series of war whoops, with Jennings shouting "Ee-yah" and "Attaboy" to urge his ball club on to victory.

"Manager Jennings executed a sailor's hornpipe, a Highland Fling and wound up with an Indian rain dance," a New York writer once recorded.

Jennings managed the Tigers through 1920. After a brief stint as the New York Giants' manager when McGraw became ill, Jennings was out of baseball, but not soon forgotten.

"There was no quicker thinker ever played the game, and he acted as he thought," Sam Crane wrote. "[Jennings] was a grand base runner and a fine hitter. The teamwork displayed by the Orioles [in 1894–1896] . . . both in fielding and batting was the amazement of baseballdom."

—T. Wendel

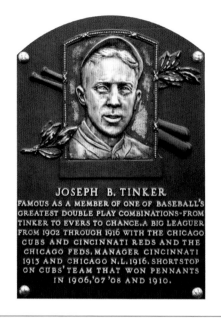

JOSEPH B. TINKER
FAMOUS AS A MEMBER OF ONE OF BASEBALL'S
GREATEST DOUBLE PLAY COMBINATIONS-FROM
TINKER TO EVERS TO CHANCE. A BIG LEAGUER
FROM 1902 THROUGH 1916 WITH THE CHICAGO
CUBS AND CINCINNATI REDS AND THE
CHICAGO FEDS. MANAGER CINCINNATI
1913 AND CHICAGO N.L. 1916. SHORTSTOP
ON CUBS' TEAM THAT WON PENNANTS
IN 1906,'07 '08 AND 1910.

JOE TINKER

CLASS OF 1946

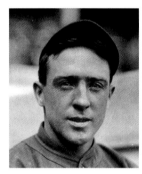

Joe Tinker was the man who scooped up those grounders to start the double plays that helped immortalize the Chicago Cubs' infield crew of more than a century past. Over to Johnny Evers at second and on to Frank Chance at first—double play. They became famous together.

Tinker was more renowned for his fielding than hitting, and unlike many old-time ballplayers, he thought that later generations were better.

"Sure I'm proud of my record and of the fellows who played with me, yet I think they were not quite on a par with the lads of today," Tinker said in 1939. "The boys today take baseball as a business. When the game is over they forget it until the next day, just as a clever businessman does. In my time we thought so much about the game that we'd fight with our wives and children after a bad day."

Yet Tinker didn't think that the players who came along after him worked hard enough. "These kids in a big league camp, and even the veterans, for that matter, don't know what hard work is nowadays," Tinker said. "When I was with the Cubs it was work, work, work, from the time we first got to camp. Now if a club has two drills a day the boys feel a little annoyed."

One year during a late-season contest when the pennant had been decided, the Cubs were weary of a drag-out fourteen-inning game against the Boston Braves. Tinker grumbled, "If the ball comes to me I'll get this blankety-blank game over." Sure enough, a grounder was hit to Tinker. He grabbed it and threw to Frank Chance at first. Only the ball sailed ten feet over the first baseman's head. The ball hit the wall in front of the seats and bounced back to Chance. He threw home to catcher Johnny Kling to get the lead runner at the plate. Kling, playing heads-up, fired the ball to third and gunned down the runner who'd initiated the play for a game-ending double play. Not one of the famous Tinker-to-Evers-to-Chance double plays by any means.

Tinker batted only .262, but there was one contemporary superstar he had no difficulty with. "I could hit [Christy] Mathewson," Tinker said, and because he could—he had a lifetime average of .357 against him—Tinker was a key reason the Cubs won the 1908 National League Pennant.

Once, a grouchy Dick Egan of Cincinnati challenged Tinker to a postgame fight. Tinker didn't take him seriously. He showered, dressed, and dashed out of the clubhouse to meet a crowd of friends. Only, Egan was waiting on the field, and fisticuffs commenced. Manager Chance was in the shower when he got word. He pulled on an undershirt and ran onto the field to break it up, provoking screams from the women and hilarity from Tinker because Chance was otherwise unclothed. "I had to laugh at the sight of the big fellow's naked legs as he sprinted for us," Tinker said.

—L.F.

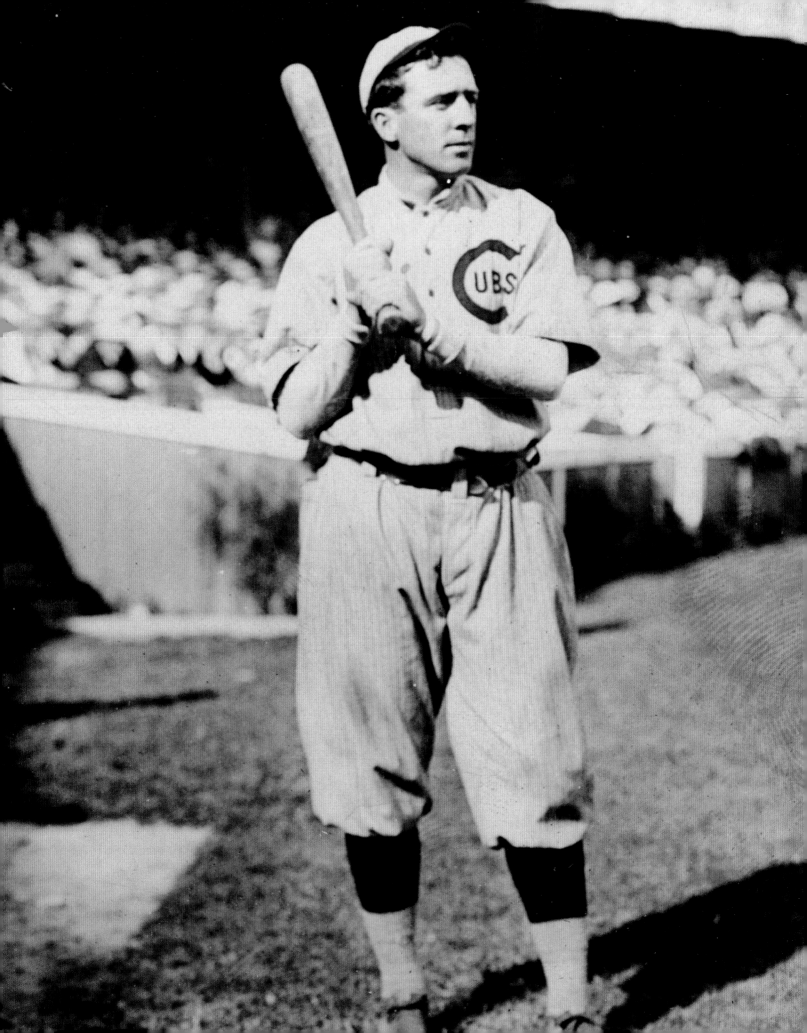

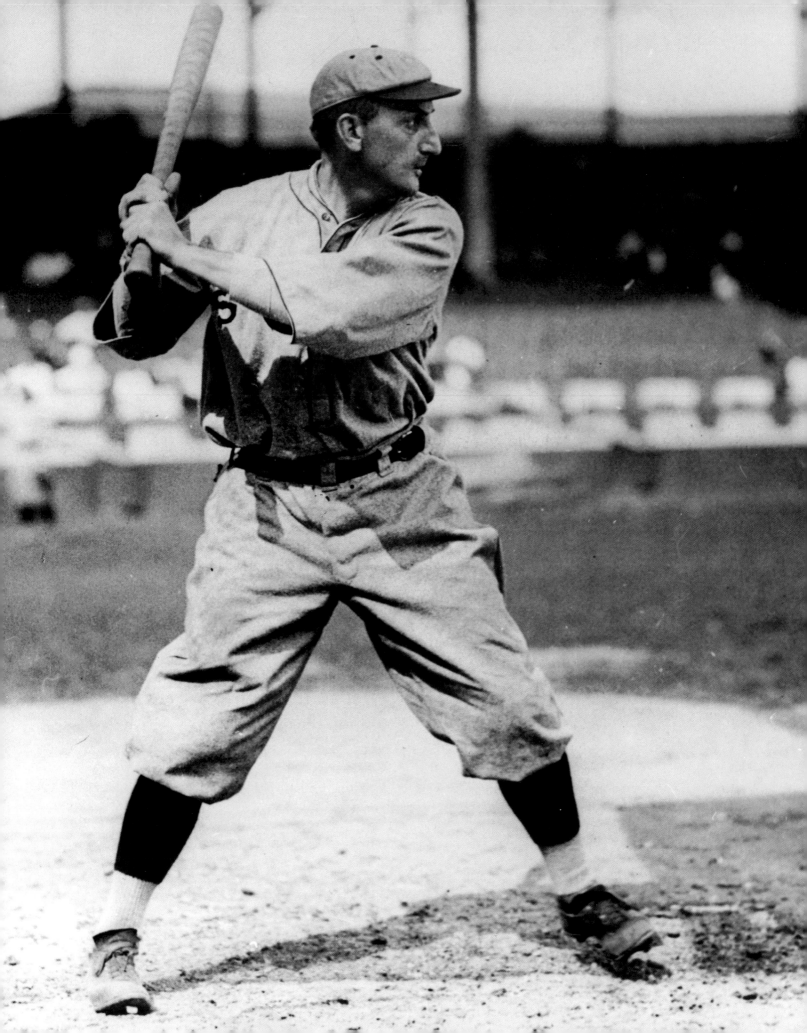

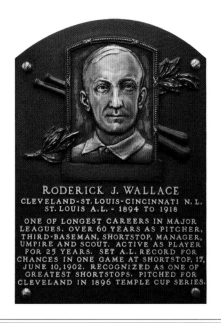

RODERICK J. WALLACE
CLEVELAND-ST. LOUIS-CINCINNATI N. L.
ST. LOUIS A.L. - 1894 TO 1918
ONE OF LONGEST CAREERS IN MAJOR
LEAGUES. OVER 60 YEARS AS PITCHER,
THIRD-BASEMAN, SHORTSTOP, MANAGER,
UMPIRE AND SCOUT. ACTIVE AS PLAYER
FOR 25 YEARS. SET A.L. RECORD FOR
CHANCES IN ONE GAME AT SHORTSTOP, 17,
JUNE 10,1902. RECOGNIZED AS ONE OF
GREATEST SHORTSTOPS. PITCHED FOR
CLEVELAND IN 1896 TEMPLE CUP SERIES.

BOBBY WALLACE

CLASS OF 1953

When it comes to baseball longevity, it's hard to top Bobby Wallace. He began as a player in the 1890s, managed, switched to umpiring, and then scouted practically forever. That multifaceted career kept him linked to the game for sixty-three years.

In 1954, when Wallace was just shy of his eightieth birthday, he said, "I've loved every minute of it."

Roderick John Wallace, who was born in Pittsburgh in 1873, made his major league debut in 1894 as a pitcher for the Cleveland Spiders. After three seasons, with a best record of 10–7 in 1896, Wallace moved to the infield and from 1899 on spent his time in St. Louis.

Wallace played some third base, but by the last year of the nineteenth century he had tried short. "Right off the bat, I knew I found my dish," Wallace said.

There were some rough times if you were a visiting player in the old days, as Wallace remembered well. "We used to believe that even the drivers of our horse-drawn busses which hauled us to the park were in cahoots with the enemy," Wallace said. "On some occasions they managed to take us back to our hotel by routes which guaranteed a maximum of over-ripe eggs, rocks, and spoiled vegetables fired point blank along the way."

Long after he concluded his time as a player, Wallace remained in the American League top ten in several fielding cate-gories, including chances, overall assists, putouts, and assists per game for a shortstop. In one 1902 contest Wallace handled seventeen chances in a nine-inning game. He was elected to the Hall of Fame by the Veterans Committee in 1953.

Known for covering ground, Wallace got his glove on just about anything hit to his neighborhood and surprised some of his contemporaries with his range. Wallace said that fielders used to take more time throwing, but runners got faster dashing to first. "It was plain the stop and toss had to be combined into a continuous movement," he said. "When you really were in a special delivery rush you had to learn to throw from the ankle and off either foot, as well." Some credit Wallace with being the first middle infielder to scoop throws underhand to bases.

Never a dominant hitter (his lifetime average was .268), Wallace collected his share of runs and RBI and was a stolen base threat. Wallace played until he was forty-four, and it took most of a century for him to be eclipsed as the oldest man to play a game at short, when Omar Vizquel surpassed him.

Wallace saw the best players up close for decades, including Ty Cobb. "Well, with Ty, baseball was more than a mental and physical test," Wallace said. "It was an affair of the spirit, and in the early days, when the Georgia Peach was burning up the league, so intense was his desire to win that in the heat of battle there were times, I believe, when he would have laid down his life for victory."

—L.F.

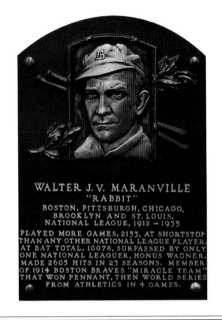

RABBIT MARANVILLE

CLASS OF 1954

Walter J. Maranville, who acquired the nickname "Rabbit" because he was as fast as one and was the possessor of large ears as well, had a sense of humor about as highly publicized as his prowess in fielding grounders at shortstop during a twenty-three-year major league career spent entirely in the National League.

Marvanville could laugh with the best of them, the men that were playing a little boys' game for money, even when he was the butt of the joke. Maranville was heaved out of one game by the famed, less jolly umpire Bill Klem, but instead of retreating to the clubhouse, Maranville, still in uniform, greeted fans as they left Ebbets Field. He hawked newspapers to them, announcing the "headline." "Extra! Extra!" shouted Maranville. "Read all about Maranville and that big baboon Klem!"

Playing for half of the National League during the years when it was an eight-team circuit, Maranville earned his paychecks with acrobatic fielding, but he could have been a full-time vaudeville actor, since his personality so suited the role. The five-foot-five infielder had the gift of pantomime and always was on the lookout for a situation to exploit for a chuckle. One game, a batter for the opposing team shrugged off being hit in the hand by a pitch that drew a bit of blood, stemming the flow with a handker-chief. Maranville came to bat the next inning with a large towel wrapped around his hand—and fans cackled loudly.

The Chicago Cubs got the crazy notion to make Maranville manager near the end of the 1925 season, and to say that he was miscast was one of the great understatements of American life during the first half of the twentieth century. Upon his appointment, Maranville roamed through the railroad car carrying the team and dumped ice water on sleeping players. "No sleeping after midnight under Maranville's management," he declared as he woke them.

Maranville quickly saw that the assignment was not for him. "When I resigned my temporary position as manager of the Chicago National League club on September 3, 1925," he said, "it was because I realized that the job had put me on the spot. I couldn't assume the role of a martinet now that I was in command when I had been the wildest of players as a private in the ranks."

The Rabbit was one of those players who never wanted to retire and was willing to give up space on an active roster only if his uniform was torn off. "Even at the age of 42 they had to break my leg to get me out of there," he said. "That happened in 1934. I was still on crutches when that season ended—but when the 1935 season opened it was old Rabbit Maranville, in his 43rd year, and on a gimpy leg, who was the regular second baseman of the Boston National League club. But the leg wouldn't hold up under the strain of playing every day."

—L.F.

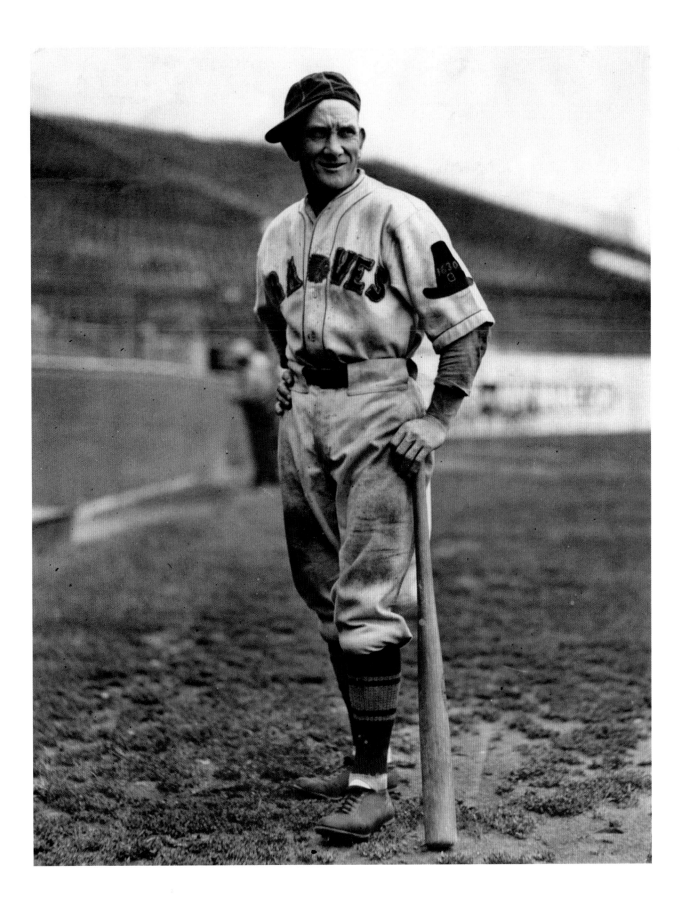

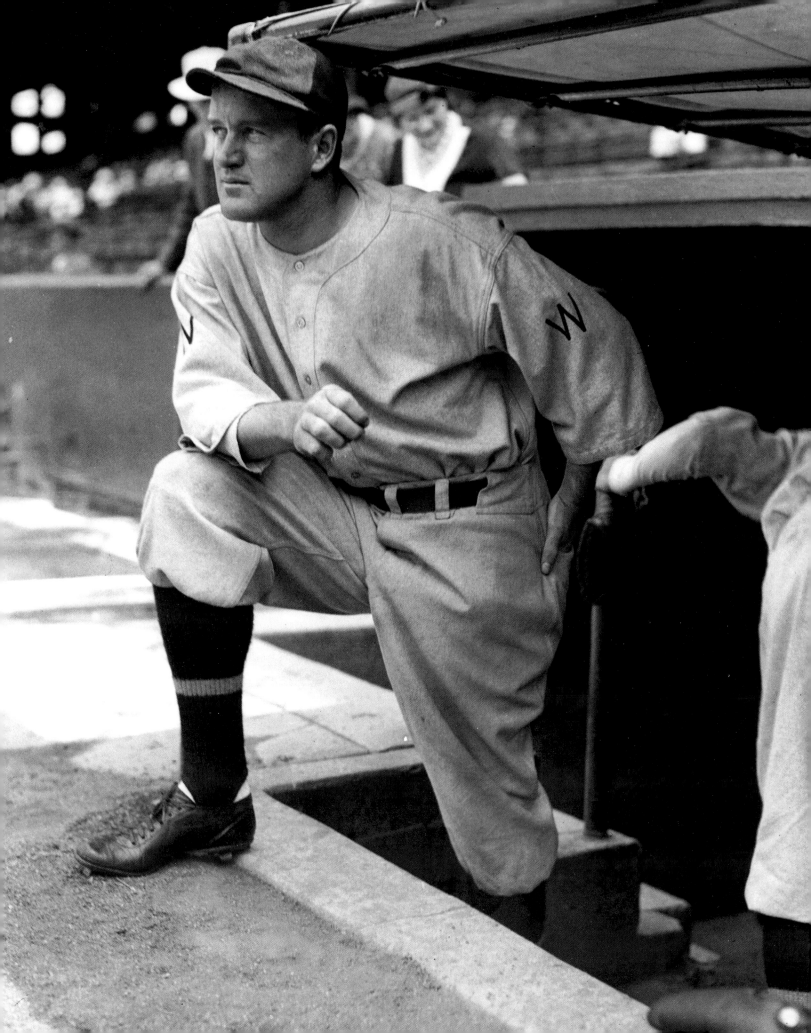

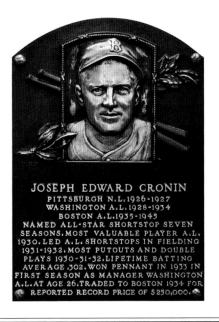

JOSEPH EDWARD CRONIN
PITTSBURGH N.L.1926-1927
WASHINGTON A.L.1928-1934
BOSTON A.L.1935-1945
NAMED ALL-STAR SHORTSTOP SEVEN
SEASONS.MOST VALUABLE PLAYER A.L.
1930.LED A.L.SHORTSTOPS IN FIELDING
1931-1932.MOST PUTOUTS AND DOUBLE
PLAYS 1930-31-32.LIFETIME BATTING
AVERAGE .302.WON PENNANT IN 1933 IN
FIRST SEASON AS MANAGER WASHINGTON
A.L.AT AGE 26.TRADED TO BOSTON 1934 FOR
REPORTED RECORD PRICE OF $250,000.

JOE CRONIN

CLASS OF 1956

"Joe Cronin was a great player, a great manager, a wonderful father. No one respects you more than I do, Joe. I love you. In my book you're a great man," said Ted Williams upon the retirement of Cronin's uniform number 4 by the Red Sox in 1984.

Baseball's traditional five tools don't really begin to describe Joe Cronin, a standout as a player, manager, team executive, American League president, and member of the Hall of Fame's board of directors and Veterans Committee.

A fine-fielding shortstop who hit for power and average, he broke in with the Pittsburgh Pirates at age nineteen in 1926. The Washington Senators purchased his contract in 1928 for $7,500, a tremendous figure at the time. The following year he became their starting shortstop. In 1933 he became player-manager, winning the pennant in his first season at the helm.

If the $7,500 paid for Cronin six years earlier had been a surprising sum, imagine the shock to the baseball world in October 1934, when the Red Sox shipped shortstop Lyn Lary, and almost a quarter of a million dollars, to Washington in order to acquire Cronin.

Taking over immediately as player-manager, Cronin played for the Red Sox until 1945, and managed them until 1947. In 1942 Cronin took himself out of the everyday lineup to make way for the young Johnny Pesky. Cronin played sparingly after that, but developed a reputation as a very fine pinch hitter. In 1943 he set an American League record with five pinch-hit home runs, and a major league record with twenty-five pinch-hit RBI. On June 17 of that year, he became the first major league player to hit two pinch-hit home runs in a doubleheader.

Cronin hit over .300 for the Red Sox six times, and managed the team to the 1946 pennant, losing to the St. Louis Cardinals in the World Series. His career managerial winning percentage was .540.

Cronin posted a batting average of .301 over twenty seasons, recording 2,285 hits, driving in 1,424 runs, and scoring 1,233 runs. He had punch to go with his average, hitting 515 doubles, 118 triples, and 170 home runs.

In the field, Cronin led the league in putouts and assists three times each, and twice in fielding percentage. Though the All-Star Game wasn't established until his eighth season in the league, he was a seven-time All-Star and finished in the top ten in American League Most Valuable Player voting five times.

Beginning in 1948, Cronin served in the Red Sox front office for eleven years, as treasurer, general manager, and vice president. In 1959 he became the first former player to be named American League president, a position he held until 1973.

Though he had one of the most accomplished all-around careers in baseball, Cronin once reflected, "Every day I put on a uniform was a thrill. Just to be a part of the show was a real thrill for me. Every day could have been my first big league game."

—T. Wiles

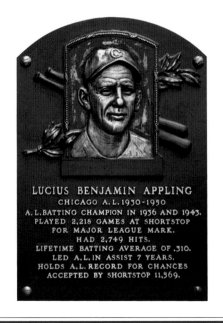

LUCIUS BENJAMIN APPLING
CHICAGO A.L. 1930-1950
A.L. BATTING CHAMPION IN 1936 AND 1943.
PLAYED 2,218 GAMES AT SHORTSTOP
FOR MAJOR LEAGUE MARK.
HAD 2,749 HITS.
LIFETIME BATTING AVERAGE OF .310.
LED A.L. IN ASSIST 7 YEARS.
HOLDS A.L. RECORD FOR CHANCES
ACCEPTED BY SHORTSTOP 11,569.

LUKE APPLING

CLASS OF 1964

He was called "Old Aches and Pains," but most of the hurt was felt by opposing pitchers, who had to deal with the line drives he produced. Luke Appling handled the bat like a Stradivarius, seemingly directing the ball wherever he wanted.

Appling grew up with baseball in High Point, North Carolina. "Ever since I was knee-high to a duck, I played ball," Appling told *Sports Illustrated*. "In pastures and vacant lots. We had a farm in Douglas County, Georgia, and I chopped wood with a double-edged ax and plowed the fields behind a mule. That's how my arms got so strong. I played football secretly for Oglethorpe College before my father read my name in the papers and made me quit. I played 104 games in A-ball and came up to the majors as a home run hitter. As soon as I got to Comiskey Park I realized I'd have to change. It took me three years to learn to hit to right."

After enjoying a cup of coffee with the Chicago White Sox in 1930, the young shortstop struggled in his first full season in the major leagues. It wasn't until 1933 that he emerged as a star. A shortstop with good range, he became better known for his hitting, as he sprayed the ball to all fields and batted .322. By 1936 he elevated himself to a supreme level; he led the American League in hitting with a .388 batting mark and finished second in the MVP voting.

Appling developed the habit of fouling off pitch after pitch until he finally saw a delivery that he could smash. This tendency reached its height in a game in 1940. "I remember when Luke ran Charlie [Red] Ruffing of the Yankees right out of the game," Hall of Famer Ted Lyons told the *New York Times*. "It was a steaming hot day, and when Appling was up in the first inning with two out and two on, Charlie got three balls and two strikes on him. Then Luke stood there and fouled off 14 pitches in a row. Finally he walked and the next batter hit one out for a homer. It wasn't long before Ruffing was taken out." Ruffing cursed Appling as he walked to the dugout.

There's a story about how Appling gained his colorful nickname. Teammates and opponents called him Old Aches and Pains because he spent so much time with White Sox trainer Al Schacht, who often gave him pregame rubdowns. Appling frequently complained of minor ailments, much to the amusement of his teammates. Unlike most athletes, Appling felt that injuries sometimes gave him an edge. "Any good athlete plays better when he's a little injured because he concentrates harder," Appling told the *New York Times*.

As leadoff batters go, few played better than Appling. Nine times in his career he compiled an on-base percentage of better than .400. On three occasions he exceeded one hundred walks.

How good a hitter was Luke Appling? In 1982 he hit a home run against Warren Spahn in an old-timers' game—at the age of seventy-five.

—B.M.

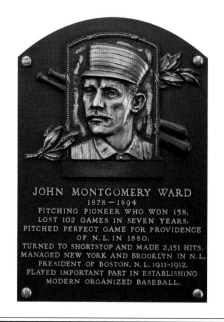

JOHN MONTGOMERY WARD
1878 — 1894
PITCHING PIONEER WHO WON 158,
LOST 102 GAMES IN SEVEN YEARS.
PITCHED PERFECT GAME FOR PROVIDENCE
OF N.L. IN 1880.
TURNED TO SHORTSTOP AND MADE 2,151 HITS.
MANAGED NEW YORK AND BROOKLYN IN N.L.
PRESIDENT OF BOSTON, N.L. 1911-1912.
PLAYED IMPORTANT PART IN ESTABLISHING
MODERN ORGANIZED BASEBALL.

JOHN WARD

CLASS OF 1964

During baseball's rough-and-tumble beginnings, John Montgomery Ward stood out not only for his success on the diamond but for his vision for the game as well.

He was a star pitcher and topflight shortstop during his seventeen-year major league career. In 1879 he led the Providence Grays to the pennant with a league-leading forty-seven victories, and in 1880 authored the second perfect game in big league history. As the star shortstop for the New York Giants, Ward helped the club capture its first two pennants, in 1888 and 1889.

Ward is perhaps best remembered for his efforts off the field. As a strong opponent of the game's reserve clause, he organized the Players' Brotherhood, baseball's first union.

Ward's resiliency was tested early on. He was born in Bellefonte, Pennsylvania. When his parents died, he was forced to quit school. After failing to earn a living as a traveling sales-man, he turned to baseball. At first he played in semipro leagues and worked odd jobs. His first big break came when he began to pitch for the Providence Grays. He pitched shutouts in his first two starts and never looked back.

In his second season (1879) he won forty-seven games, striking out 239, pitching in 587 innings. He threw 595 innings the following year, with thirty-nine victories and a league-leading eight shutouts. In his perfect game, he bested Pud Galvin, another Hall of Famer.

In 1882 he shut out Detroit, 1–0, in eighteen innings, which many consider the longest complete-game shutout in baseball history.

By 1883, though, Ward's arm was wearing down, and he was traded to the New York Giants. There he became a shortstop. Even though he struggled at the plate early on, averaging only .226 in 1885, he was batting .338 two seasons later.

Off the field, Ward earned a law degree from Columbia University and soon became an outspoken opponent of the reserve clause. "Players have been bought, sold and exchanged as though they were sheep instead of American citizens," he said.

He and other players formed the Brotherhood of Professional Base Ball Players, with Ward as its president. After making some progress on the labor front, Ward joined a group of All-Star players on a world tour. That's when the owners struck back. They created a player classification system and traded Ward to Washington.

Ward came home early and soon created the Players' League, which took the field in 1890. Ward was the player-manager for Brooklyn, but when the new league folded the following season, he stayed in Brooklyn with the National League franchise.

Historian John Thorn notes that "Ward was also a sturdy writer with a historical bent." Indeed, Ward's book about the game's origins helped baseball catch on in the early days.

"No player before or after his day on the diamond ever did more to bring the sport to its present high standing and popularity," wrote Sam Crane of the *New York Journal*. "He was considered the model ballplayer of the century."

—T. Wendel

587.

Newsboy NEW YORK.

LOUIS BOUDREAU
CLEVELAND A.L. 1938-1950
BOSTON A.L. 1951-1952

LED A.L. SHORTSTOPS IN FIELDING EIGHT
SEASONS. SET MAJOR LOOP MARK FOR DOUBLE
PLAYS BY SHORTSTOP (134) AND WON BATTING
TITLE, 1944. PACED A.L. IN DOUBLES THREE
TIMES. MOST VALUABLE PLAYER, 1948, WHEN
HE BATTED .355 TO LEAD INDIANS TO PENNANT
AS PLAYER-PILOT. LIFETIME BATTING
AVERAGE .295

LOU BOUDREAU

CLASS OF 1970

Lou Boudreau's baseball career took him from the diamond to the dugout to the broadcast booth—and finally all the way to Cooperstown.

At each stop, Boudreau demonstrated that there was little he could not do.

Raised by his divorced father in the Midwest, Boudreau made his major league debut in 1938. Earlier that spring, he had failed to make a favorable first impression with some of his teammates. "When Lou first came to spring training in 1938 in New Orleans . . . he didn't look like much," Hall of Famer Bob Feller told the *Los Angeles Times*. "Then I found out the guy who signed him also signed me and a few others. I figured Lou must have some ability there. He developed fast and he was the best shortstop I ever saw."

Feller's reestimation of Boudreau turned out to be accurate. In 1940 Boudreau made his first All-Star team and placed fifth in the American League MVP voting, while hitting .295 with 101 RBI.

A major change came Boudreau's way in 1942. Though he was only twenty-four, he applied for the Indians' manager job. The Indians surprisingly hired Boudreau, prompting the press to label him "The Boy Manager." The additional burden of managing seemed to affect his play at first, but by 1944 the precocious star had emerged as a batting champion. Four years later he won the AL MVP, leading the Indians to the pennant before guiding them to the World Series title over the Boston Braves.

"He was afraid of nobody," Feller told the *Cleveland Plain Dealer*. "He did it all in 1948. Nobody ever had a greater season under pressure." Boudreau also played hurt. In August of that season Boudreau delivered a game-winning single while playing on a badly injured ankle.

As a manager, Boudreau was innovative. He guided the transition of future Hall of Famer Bob Lemon from third base to pitcher. He also devised the trendsetting "Williams Shift," an unusual defensive alignment that attempted to combat the pull-hitting tendencies of Boston Red Sox star Ted Williams. Boudreau estimated that the shift reduced Williams's hitting efficiency by more than 35 percent.

After the 1950 season the Indians released Boudreau from his contract. Now a free agent, Boudreau signed with the Red Sox as a shortstop. One year later, he added the Red Sox managing job to his résumé.

Having already made the move from playing to managing, Boudreau made a smooth transition to the broadcast booth. Popular with the fans in Chicago, Boudreau worked Cubs broadcasts on WGN with Jack Brickhouse before retiring in 1990.

Boudreau left behind a legacy as a baseball Renaissance man. Talented on the field, he was a gentleman to his teammates. "He was a great manager, teammate, and friend," Feller told the *Chicago Tribune*. "Just a great man. There is not a more gracious man than Lou Boudreau, and there have not been many better all-around players."

—C.M.

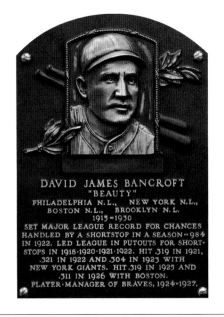

DAVID JAMES BANCROFT
"BEAUTY"
PHILADELPHIA N.L., NEW YORK N.L.,
BOSTON N.L., BROOKLYN N.L.
1915-1930
SET MAJOR LEAGUE RECORD FOR CHANCES
HANDLED BY A SHORTSTOP IN A SEASON · 984
IN 1922. LED LEAGUE IN PUTOUTS FOR SHORT-
STOPS IN 1918·1920·1921·1922. HIT .319 IN 1921,
.321 IN 1922 AND .304 IN 1923 WITH
NEW YORK GIANTS. HIT .319 IN 1925 AND
.311 IN 1926 WITH BOSTON.
PLAYER-MANAGER OF BRAVES, 1924-1927.

DAVE BANCROFT

CLASS OF 1971

It's hard to imagine how Dave Bancroft would react to the modern baseball world, where starting pitchers rarely throw complete games and relief pitchers parade out of the bullpen one after the other. That's because the sixteen-season National League shortstop (starting in 1915) and Boston Braves manager was already complaining in 1927 about hurlers' reasoning in not finishing games as they had in the past.

"The average athlete is just as strong now as he was 20 years ago," Bancroft said. "Therefore there's no reason in the world why a baseball pitcher shouldn't do just as effective work as the old fellows did, except that he has got the notion in his head and we can't get it out."

Bancroft, who often had opinions on developments in the sport, was a player-manager in 1926 when the introduction of the resin bag to the mound as a tool for pitchers was made legal. There was considerable hullabaloo about this addition, but Bancroft said he didn't see that it would make all that much difference. "There seems to be a widespread impression that the use of the rosin bag will revolutionize baseball," he said. "As a matter of fact, the use of the rosin bag may be of only small importance. It was a very wise thing to permit the use of rosin, as some pitchers undeniably find that it helps them to control the ball."

Bancroft reached the majors during the dead ball era and made those observations from the perspective of a man watching the transformation of the game to a reliance on more home runs. "Those in control seem to have realized that hitting isn't everything in baseball," Bancroft said. "They suspect that the mad orgy of slugging, backed by only little finer baseball, is palling on the baseball public."

Long after he retired from the playing field, Bancroft continued to work as a minor league manager or coach, and then when the All-American Girls Professional Baseball League was founded, he managed three of the clubs over a four-year period—the Battle Creek Belles, the Chicago Colleens, and the South Bend Blue Sox. When he was a player, Bancroft picked up the nickname "Beauty" because he referred to sharp pitches as "beauties." Handling teams in the women's league may have changed his outlook on what was beautiful, as stories about his squads referred to players being cute or just coming from the beauty parlor.

"It's fun here," Bancroft said while managing Chicago, "mixed with the usual headaches of a second-division skipper. It pays better than the minors and it sure comes under the head of a new experience, and even at 57, and as gray-haired as I am, I can be attracted by novelty. This girls' baseball is more than a novelty because it is good, brisk baseball and we give the customers a fast show."

Bancroft was just shy of his eightieth birthday when he became a Hall of Famer. "I was more surprised by my election than anything that ever happened to me," he said.

—L.F.

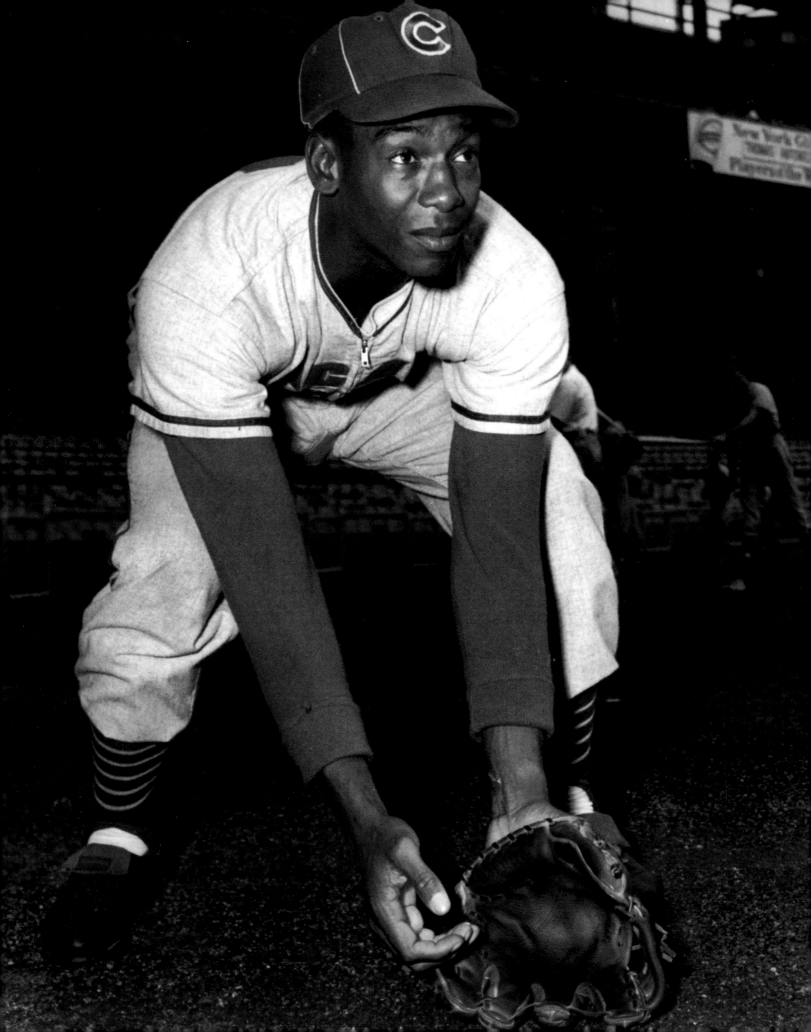

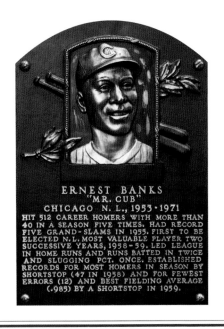

ERNEST BANKS
"MR. CUB"
CHICAGO N. L., 1953-1971
HIT 512 CAREER HOMERS WITH MORE THAN
40 IN A SEASON FIVE TIMES. HAD RECORD
FIVE GRAND-SLAMS IN 1955. FIRST TO BE
ELECTED N.L. MOST VALUABLE PLAYER TWO
SUCCESSIVE YEARS, 1958-59. LED LEAGUE
IN HOME RUNS AND RUNS BATTED IN TWICE
AND SLUGGING PCT. ONCE. ESTABLISHED
RECORDS FOR MOST HOMERS IN SEASON BY
SHORTSTOP (47 IN 1958) AND FOR FEWEST
ERRORS (12) AND BEST FIELDING AVERAGE
(.985) BY A SHORTSTOP IN 1959.

ERNIE BANKS

CLASS OF 1977

For two years during the late 1950s, Ernie Banks was arguably the best player in baseball.

But for Banks, the 1958 and 1959 seasons—when he was named the National League's Most Valuable Player—were just a snapshot of an outstanding nineteen-year career that ended with a plaque in Cooperstown.

Born January 31, 1931, in Dallas, Ernest Banks—a decorated high school athlete—signed to play with the Kansas City Monarchs of the Negro American League in 1950 before joining the Chicago Cubs as a free agent late in the 1953 season. By 1954 Banks was the Cubs' starting shortstop, appearing in all 154 games and hitting nineteen home runs, a prodigious number in an era when shortstop was regarded as a "defense first" position.

But Banks was just getting started.

From 1955 to 1960, Banks averaged better than forty-one home runs per season and led the league in games played in all but one of those years.

In 1958 Banks posted National League–leading numbers in home runs (47) and RBI (129). Those stats, combined with a .313 batting average and a lofty .614 slugging percentage, earned "Mr. Cub" his first NL MVP crown.

The following year proved to be just as good. In 155 games, he drove in 143 runs, hit 45 homers, and posted a .304 batting average. When he picked up his second NL MVP title at the con-

clusion of the season, he became just the fifth man to win the award in consecutive years.

"Without him, the Cubs would finish in Albuquerque," former big league manager Jimmy Dykes once said.

And while the Cubs never made it to the postseason in Banks's major league career, his positive attitude and love for the game made him a favorite of teammates, opponents, and fans.

"It's a beautiful day for a ballgame," Banks would famously remark. "Let's play two."

Banks holds the Cubs' career record for extra-base hits and has the most home runs by a National League shortstop.

Banks began the switch from shortstop to first baseman in the 1961 season and continued his offensive dominance. When he retired in 1971, he had 512 career home runs, 1,636 RBI, and 2,583 hits.

By the end of his career, Banks had played in more games at first base (1,259) than at shortstop (1,125). But his glory days in the middle of the infield—including his two MVP seasons—left a legacy that marks him as one of the game's greatest shortstops.

In 1977 the fourteen-time All-Star was elected to the National Baseball Hall of Fame in his first year of eligibility—becoming just the thirteenth player to earn election in his first year on the ballot.

"He rejoices merely in living," wrote journalist Arthur Daley. "And baseball is a marvelous extra that makes his existence so much more pleasurable."

—C.M.

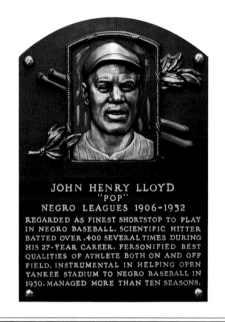

JOHN HENRY LLOYD
"POP"
NEGRO LEAGUES 1906-1932
REGARDED AS FINEST SHORTSTOP TO PLAY
IN NEGRO BASEBALL. SCIENTIFIC HITTER
BATTED OVER .400 SEVERAL TIMES DURING
HIS 27-YEAR CAREER. PERSONIFIED BEST
QUALITIES OF ATHLETE BOTH ON AND OFF
FIELD. INSTRUMENTAL IN HELPING OPEN
YANKEE STADIUM TO NEGRO BASEBALL IN
1930. MANAGED MORE THAN TEN SEASONS.

POP LLOYD

CLASS OF 1977

Pop Lloyd's baseball career spanned parts of four decades beginning in the early 1900s. A slick-fielding shortstop, Lloyd earned the nickname "The Black Wagner." Honus Wagner later said, "I am honored to have John Lloyd called the black Wagner. It is a privilege to have been compared to him."

A member of multiple championship teams in the Negro Leagues, Lloyd also spent time playing ball in Latin America. In Cuba he earned the nickname "El Cuchara," which translates to "The Tablespoon" or "The Shovel," because of how he characteristically scooped up a gloveful of dirt from the ground every time he fielded a ball, similar in style to Honus Wagner.

Lloyd was generally considered the finest shortstop ever to set foot on the diamond in the Negro Leagues. At a time when pitchers dominated the game, Lloyd always found a way to get on base and score runs. He possessed a great batter's eye and had terrific control. A line-drive hitter, Lloyd was known to drop down a bunt from time to time to keep infielders on their toes.

While not the fastest man ever to play the game, he was a smart ballplayer and a good base runner, which led to a fair number of stolen bases. Lloyd was really a four-tool player. He never hit for power, but he could hit for average and steal bases, and was a terrific fielder with a fine arm at one of baseball's premium defensive positions.

The consummate gentleman off the field, Lloyd was an aggressive, fearless player on the field. This translated into the easygoing Lloyd's becoming a player-manager, and being given the affectionate nickname "Pop" by the young players he mentored.

"Pop Lloyd was the greatest player, the greatest manager, the greatest teacher," said Bill Yancey, a rookie shortstop who played with Lloyd. "He had the ability and knowledge and, above all, patience. I did not know what baseball was until I played under him."

Being the terrific defensive player that he was, Lloyd would at times play other positions when his teams were in a pinch. In one instance he caught a game while wearing a wire wastepaper basket to protect his face because his team could not afford to buy a real catcher's mask.

Like all the others who played Negro Leagues baseball in his era, Pop never got a shot at Major League Baseball. He did, however, get to play exhibition games against major league competition—exhibitions in which he excelled. Pop was a dominant force in the Negro Leagues, but the fact that he wasn't allowed into Major League Baseball never got him down. "I don't consider that I was born at the wrong time," he said in later years, after the color barrier had come down. "I feel it was at the right time. I had a chance to prove the ability of our race in this sport and because many of us did our best for the game, we've given the Negro a greater opportunity now to be accepted into the major leagues with other Americans."

—F.B.

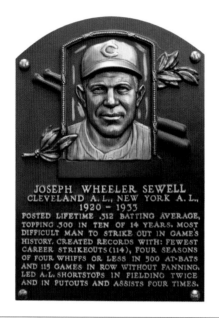

JOSEPH WHEELER SEWELL
CLEVELAND A. L., NEW YORK A. L.,
1920 - 1933
POSTED LIFETIME .312 BATTING AVERAGE,
TOPPING .300 IN TEN OF 14 YEARS. MOST
DIFFICULT MAN TO STRIKE OUT IN GAME'S
HISTORY. CREATED RECORDS WITH: FEWEST
CAREER STRIKEOUTS (114), FOUR SEASONS
OF FOUR WHIFFS OR LESS IN 500 AT-BATS
AND 115 GAMES IN ROW WITHOUT FANNING.
LED A. L. SHORTSTOPS IN FIELDING TWICE
AND IN PUTOUTS AND ASSISTS FOUR TIMES.

JOE SEWELL

CLASS OF 1977

The hardest man in baseball history for pitchers to strike out could thank his best girl, Black Betsy, for some of his success. Infielder Joe Sewell, who struck out twice in a game just once in a fourteen-year career, babied that bat, and the bat took care of him, too.

"I boned it every day," said Sewell, who later donated the stick to his alma mater, the University of Alabama, where he later coached the baseball team.

Sewell, a .312 lifetime hitter, was enshrined in 1977, forty-four years after he retired. "I feel like putting on my old uniform, putting Black Betsy on my shoulder, and walking up and down the street," Sewell said when informed he had been elected. "I might take Mrs. Sewell out to dinner and get her a hamburger or something to celebrate."

Born in Titus, Alabama, Sewell was used to rural living, having grown up in the early years of the twentieth century, when baseball still permeated the daily routine.

"Baseball has been my life," Sewell said. "We were 15 miles from the railroad. We didn't have a car. We didn't have a radio. We didn't have a basketball or any other sport. But we had baseball. I can't remember a time when I wasn't playing baseball. And if I couldn't play, then I would take a stick and a rock or a

piece of coal and throw that rock into the air and hit it. I'd walk a quarter of a mile to school in Titus and it would take me an hour because I'd be hitting a pocketful of rocks."

Sewell played baseball for the Crimson Tide before turning professional, and he was in the minors in New Orleans when Cleveland Indians shortstop Ray Chapman was fatally injured by a pitched ball in a 1920 game. The Indians turned to Sewell.

"Now I wasn't down there [in the minors] very long when Cleveland, which was trying to win a pennant, called me right in," Sewell said. "[Backup shortstop Harry Lunte] couldn't do the job on a pennant winner. So they called me in and I stayed for 11 years."

The Indians won the pennant and the World Series. Sewell, just twenty-one, played twenty-two regular-season games and batted .329. Typically, throughout his career, Sewell hit for average but not for power. He cracked just forty-nine home runs in 8,333 plate appearances, but one time, after he was traded to the New York Yankees, Sewell recorded a perfect hitting day (5-for-5), including a homer, against Philadelphia.

"[The fans] had come to see [Babe] Ruth and Lou Gehrig hit that ball," Sewell said. "Lefty Grove was pitching for the Athletics. I got five hits in five times at bat and the last one was a home run into the right-field stands. When I hit it, Grove threw his glove into the air and followed me around the bases talking to me."

—L.F.

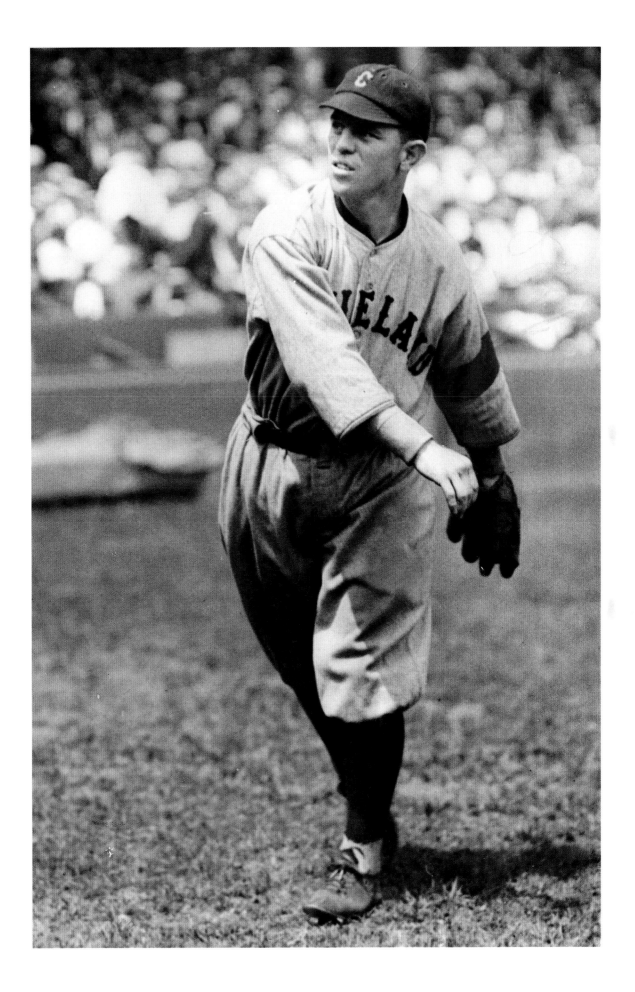

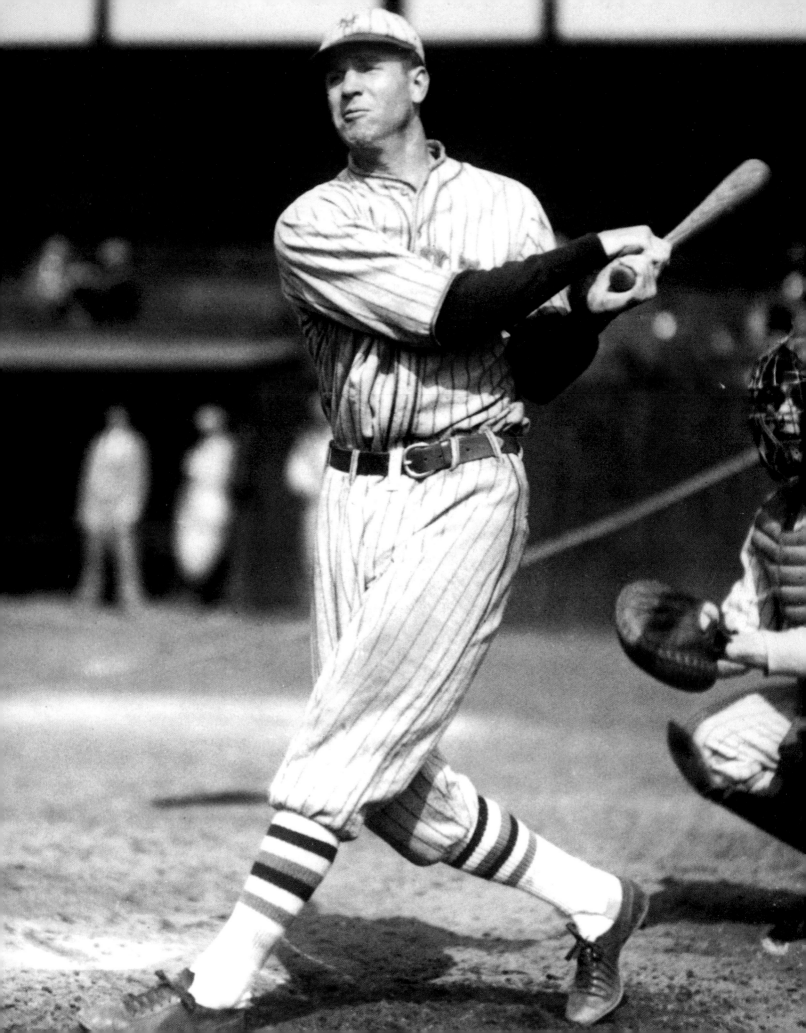

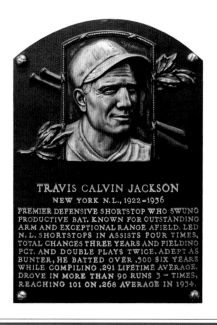

TRAVIS CALVIN JACKSON
NEW YORK N.L., 1922-1936
PREMIER DEFENSIVE SHORTSTOP WHO SWUNG
PRODUCTIVE BAT. KNOWN FOR OUTSTANDING
ARM AND EXCEPTIONAL RANGE AFIELD. LED
N.L. SHORTSTOPS IN ASSISTS FOUR TIMES,
TOTAL CHANCES THREE YEARS AND FIELDING
PCT. AND DOUBLE PLAYS TWICE. ADEPT AS
BUNTER, HE BATTED OVER .300 SIX YEARS
WHILE COMPILING .291 LIFETIME AVERAGE.
DROVE IN MORE THAN 90 RUNS 3 - TIMES,
REACHING 101 ON .268 AVERAGE IN 1934.

TRAVIS JACKSON

CLASS OF 1982

Travis Jackson, named for Colonel William B. Travis, who served at the Alamo, got his first look-see as a ballplayer when he was fourteen years old because his uncle knew Kid Elberfeld, a former major leaguer and then a minor league executive with the Little Rock Travelers. He told Jackson to come back when he wanted to turn pro.

Jackson's dad started him out playing catch when he was three, and Jackson said his only ambition in life was to become a baseball player. "Other kids around Waldo, Arkansas, wanted to be generals and firemen and cops and the like," Jackson said. "I had heard and read about Ty Cobb of Georgia and I believed that to be a great baseball star was about the last word in fame and success."

For a player who would ultimately become a Hall of Fame infielder, Jackson was rough around the edges in Little Rock, making seventy-three errors at shortstop in 1922. "I guess I set a world record for errors," Jackson said. "At least a league record. I had a pretty good arm, see, but I didn't have much control. The people in the first base and right field bleachers knew me. When the ball was hit to me, they scattered. 'Watch out! He's got it again!'"

That same season Jackson suffered a serious injury that could have ended his career.

"During the forepart of the season I had an accident that almost cost me my life," Jackson said. "Elmer Leifer, the center fielder for the Travelers, and myself started after a short fly in a game at Atlanta. We were both trying to get it—and we tied. Our heads hit. His skull was fractured, the optical nerve of his left eye was severed and he lost the sight of it. My nose was broken, my skull fractured, and my left eye cut open. I was in the hospital for a long time."

Even after all of that, John J. McGraw, manager of the New York Giants, sought him out.

Jackson was long retired when he was selected for the Hall of Fame by the Veterans Committee in 1982, and it was a beautiful bonus for him. "The longer you're out, the more time they have to forget," he said, "and I've been out a long time. I was really surprised and happy. Anybody who ever played ball wants to go to the Hall of Fame. Don't let any of them ever kid you."

During the weekend of his induction ceremony, Jackson said he was constantly asked about his biggest thrill in the game. Everyone expected he would pick the World Series, his one All-Star appearance, or his selection to the Hall. But Jackson fooled them. Simply stepping onto the field for Little Rock in 1921 for his first professional game was his choice. "I was in awe," Jackson said. "It held 4,500 people or so and I never saw a park that big. And I was holding my pants up with a cotton rope."

—L.F.

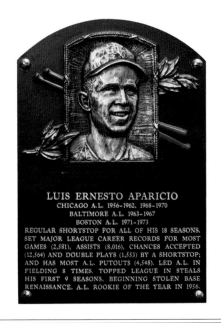

LUIS ERNESTO APARICIO
CHICAGO A.L. 1956-1962, 1968-1970
BALTIMORE A.L. 1963-1967
BOSTON A.L. 1971-1973
REGULAR SHORTSTOP FOR ALL OF HIS 18 SEASONS.
SET MAJOR LEAGUE CAREER RECORDS FOR MOST
GAMES (2,581), ASSISTS (8,016), CHANCES ACCEPTED
(12,564) AND DOUBLE PLAYS (1,553) BY A SHORTSTOP;
AND HAS MOST A.L. PUTOUTS (4,548). LED A.L. IN
FIELDING 8 TIMES. TOPPED LEAGUE IN STEALS
HIS FIRST 9 SEASONS. BEGINNING STOLEN BASE
RENAISSANCE. A.L. ROOKIE OF THE YEAR IN 1956.

LUIS APARICIO

CLASS OF 1984

Luis Aparicio, who made his major league debut in 1956, helped redefine how the position of shortstop was played. With his great range and arm, he regularly robbed hitters of base hits. At the plate and especially on the base paths, he demonstrated that a shortstop could also be an offensive force.

Born in Maracaibo, Venezuela, Aparicio signed with the Chicago White Sox on the recommendation of his countryman, the legendary shortstop Chico Carrasquel. After a short stint in the minors, Aparicio soon became a key player for the White Sox. He won Rookie of the Year honors in 1956 and was instrumental to Chicago's American League Pennant–winning squad three years later, the "Go-Go" White Sox. That season he placed second in the AL MVP balloting to his double-play partner, Nellie Fox. The two were also close off the field, as Aparicio named his son after Fox.

"What is the top requirement for a second baseman? A fine shortstop," Fox once said. "I am fortunate in having the greatest shortstop in baseball, Luis Aparicio."

Aparicio went on to garner nine Gold Glove Awards, led the American League in stolen bases in nine seasons, and was named to the All-Star squad thirteen times.

"Luis Aparicio is the only guy that I ever saw go behind second base, make the turn and throw Mickey Mantle out," Phil Rizzuto said. "He was as sure-handed as anyone."

"He's the best I've ever seen," declared Bill Veeck. "He makes plays which I know can't possibly be made, yet he makes them almost every day."

After a salary dispute, Aparicio was traded to Baltimore, where he won a World Series and teamed up with Orioles second baseman Jerry Adair and third baseman Brooks Robinson to form one of the best infields of that era.

After the 1967 season, Aparicio returned to the White Sox and broke Luke Appling's team record for games played at shortstop (2,219). He finished out his career with Boston, and when Aparicio retired in 1973, he held the career record for shortstops for games played, double plays, and assists. Also, during his eighteen-year major league career, Aparicio never played a single big league inning at any position other than shortstop. He was so good at the position that no manager dared move him to another spot on the diamond.

"That little guy is just about the greatest shortstop I've ever seen," New York Yankees manager Ralph Houk said. "I can't imagine how anybody could possibly be any better, no matter how far back you go."

Fellow Venezuelans Ozzie Guillén and Omar Vizquel were among those to follow. Aparicio returned home to manage in the Venezuelan Winter League and also became a television commentator. In fact, he reportedly heard about his selection to the National Baseball Hall of Fame while working with Radio Caracas Television.

"He was my idol growing up," Omar Vizquel said. "He showed many of us the way."

—T. Wendel

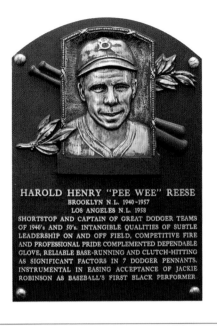

HAROLD HENRY "PEE WEE" REESE
BROOKLYN N.L. 1940-1957
LOS ANGELES N.L. 1958
SHORTSTOP AND CAPTAIN OF GREAT DODGER TEAMS
OF 1940's AND 50's. INTANGIBLE QUALITIES OF SUBTLE
LEADERSHIP ON AND OFF FIELD, COMPETITIVE FIRE
AND PROFESSIONAL PRIDE COMPLEMENTED DEPENDABLE
GLOVE, RELIABLE BASE-RUNNING AND CLUTCH-HITTING
AS SIGNIFICANT FACTORS IN 7 DODGER PENNANTS.
INSTRUMENTAL IN EASING ACCEPTANCE OF JACKIE
ROBINSON AS BASEBALL'S FIRST BLACK PERFORMER.

PEE WEE REESE

CLASS OF 1984

Harold "Pee Wee" Reese was more than just a standout shortstop on great teams of the 1950s. He was a man of character, a player who deserved to be called "The Captain."

Born in the segregated state of Kentucky, Reese originally signed with the Pittsburgh Pirates, who sent him to the Boston Red Sox as part of a minor league working agreement. But Reese never saw time in Boston; the Sox traded him to the Brooklyn Dodgers for $35,000, three players, and a player to be named later.

Reese's rookie season of 1940 ended early because of injury, but he had such an impact that he earned consideration for MVP. He slumped at the plate the next two seasons but played shortstop reliably, convincing the Dodgers that he could play every day.

Unfortunately, World War II delayed Reese's development, as he missed three full seasons. More mature when he resumed his career in 1946, he was ready to contribute as a hitter. He batted .284 in each of his first two postwar seasons, showed some power, and led the league with 104 walks in 1947.

The 1947 season also saw the arrival of Jackie Robinson. Some of the Dodgers resented the presence of a black teammate, but Reese refused to sign a petition that threatened a player walkout if Robinson was allowed to play. The Dodgers family took note of Reese's principled stance. "I thought it was a very supportive gesture, and very instinctive on Pee Wee's part," Robinson's widow, Rachel Robinson, told *Jet* magazine. "When Jack first entered, there were still a lot of people who didn't know if it was the right thing to do. Pee Wee used all of his leadership skills and sensitivity to bring the team together. . . . Pee Wee was more than a friend. Pee Wee was a good man."

At Crosley Field, some Cincinnati Reds fans heaped such verbal abuse on Robinson that they left him slumped in dejection. Walking over from shortstop, Reese reportedly put his arm around Robinson's shoulder and whispered words of encouragement. The gesture inspired Robinson; he and Reese eventually formed one of the game's best double-play combinations.

As Dodgers captain, Reese served as a role model, but he also contributed in more tangible ways. "He was one of the best bunters. . . . He was a hit-and-run man. He could steal bases," Roy Campanella told the *Louisville Times*. "I had so much confidence in Pee Wee in the field, hitting behind the runner, calming down players in the dugouts, straightening out umpires."

Reese remained a stalwart through the championship season of 1955, as he hit .296 in Brooklyn's World Series triumph. Three years later, after the Dodgers' first season in Los Angeles, Reese called it a career.

Reese left behind a clear and discernible legacy as a Dodger. "If you asked anyone on the ballclub how Pee Wee Reese helped them, they would say not only in baseball, but in their lives," Duke Snider told the *New York Post*. "Without his help, I never would have been a Hall of Fame player. He is the finest person I think I've ever met."

—B.M.

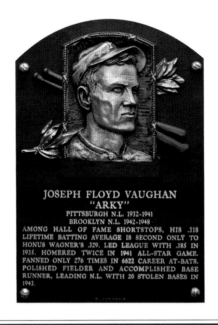

JOSEPH FLOYD VAUGHAN
"ARKY"
PITTSBURGH N.L. 1932-1941
BROOKLYN N.L. 1942-1948
AMONG HALL OF FAME SHORTSTOPS, HIS .318
LIFETIME BATTING AVERAGE IS SECOND ONLY TO
HONUS WAGNER'S .329. LED LEAGUE WITH .385 IN
1935. HOMERED TWICE IN 1941 ALL-STAR GAME.
FANNED ONLY 276 TIMES IN 6622 CAREER AT-BATS.
POLISHED FIELDER AND ACCOMPLISHED BASE
RUNNER, LEADING N.L. WITH 20 STOLEN BASES IN
1943.

ARKY VAUGHAN

CLASS OF 1985

According to an old axiom in baseball, left-handed-hitting shortstops are hard to find. Great ones are nearly impossible to uncover. Arky Vaughan proved an exception to both of those supposed rules.

He was born in Arkansas, the state that provided the reasoning behind his nickname. Obtained by the Pirates in 1932, Vaughan played only one season in the Western League before convincing scouts that he belonged in Pittsburgh. The Pirates brought up the twenty-year-old the next spring and watched him hit .318 as the starting shortstop.

By his third season, Vaughan reached a level of offensive superstardom. In 1934 he led the National League in walks and on-base percentage. In 1935 he added a batting title and a slugging percentage title to his collection; those crowns allowed him to win the *Sporting News* NL MVP Award.

Vaughan quickly established himself as the Pirates' best shortstop since Honus Wagner. Not coincidentally, it was Wagner who guided a young Vaughan as one of the Pirates' coaches. "I get a great kick out of watching the kid," Wagner told famed sportswriter F. C. Lane. "We room together. He doesn't say much, but he listens a lot, and that's what I like in a young fellow."

Reserved and respectful, Vaughan accepted Wagner's advice. He especially needed to improve his fielding after committing forty-six errors in each of his first two seasons. A defensive upgrade came in 1935, when he cut his error total to thirty-five.

The Pirates also appreciated his tremendous range to either side; he covered the left side of the infield better than any other Pirates shortstop since Wagner himself.

For his all-around play, Vaughan received a full endorsement from Wagner. "He's one of the sweetest hitters I ever saw," Wagner enthusiastically told Lane. "And fast! They don't make 'em any faster."

He stayed with the Pirates through 1941, an injury-plagued season that prompted a trade to Brooklyn for a package of four players. No longer a star, he remained an effective player at third base and then shortstop, leading the league in runs in 1943.

Vaughan would sacrifice a good portion of his career to a conflict with manager Leo Durocher. He missed three full seasons. Rather remarkably, he returned at the age of thirty-five in 1947 and proceeded to hit .325. Adapting beautifully to a new role as a part-time outfielder and third baseman, Vaughan participated in his first World Series that fall.

After his playing days, Vaughan became a hero, albeit a tragic one. During a fishing trip at Lost Lake in California, the boat carrying him and a friend capsized. Vaughan tried to rescue his friend, who had difficulty swimming. Both men drowned in the deep, freezing water.

Vaughan's death at the age of forty brought widespread reaction, none more stirring than a tribute from a former Brooklyn teammate. "He was one of the fellows who went out of his way to be nice to me when I came in as a rookie," a saddened Jackie Robinson told the United Press. "Believe me, I needed it. He was a fine fellow."

—B.M.

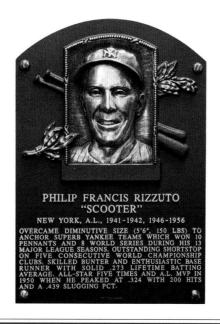

PHILIP FRANCIS RIZZUTO
"SCOOTER"
NEW YORK, A.L., 1941-1942, 1946-1956
OVERCAME DIMINUTIVE SIZE (5'6", 150 LBS) TO
ANCHOR SUPERB YANKEE TEAMS WHICH WON 10
PENNANTS AND 8 WORLD SERIES DURING HIS 13
MAJOR LEAGUE SEASONS. OUTSTANDING SHORTSTOP
ON FIVE CONSECUTIVE WORLD CHAMPIONSHIP
CLUBS. SKILLED BUNTER AND ENTHUSIASTIC BASE
RUNNER WITH SOLID .273 LIFETIME BATTING
AVERAGE. ALL-STAR FIVE TIMES AND A.L. MVP IN
1950 WHEN HE PEAKED AT .324 WITH 200 HITS
AND A .439 SLUGGING PCT.

PHIL RIZZUTO

CLASS OF 1994

Phil Rizzuto touched multiple genera-tions of fans. As a player in the 1940s and 1950s, he proved to be one of the linchpins of the New York Yankees dynasty. After giving up the game and taking up a role in the broadcast booth, Rizzuto entertained fans for another forty years.

Born in Brooklyn, Rizzuto ended up signing with the Dodgers' rivals. He spent four highly produc-tive years in New York's farm system, during which time he was nicknamed "Scooter" for the way he pursued ground balls, before the Yankees promoted him in 1941. Hitting for high averages and fielding everything in sight, Rizzuto played so well that he earned MVP consideration in his first two seasons.

Then came World War II. Joining the Navy in October 1942, Rizzuto served for three full years. As a result, he missed three prime seasons in his mid-twenties.

A slick fielder and a master at bunting, Rizzuto provided sta-bility to the infield and at the top of the batting order. "He was a Yankee all the way," Hall of Fame pitcher Bob Feller told *Sports Illustrated*. "He knew the fundamentals of the game and he got 100 percent out of his ability. He played it hard and he played it fair." With Rizzuto, the Yankees won seven World Series—covering a span from 1941 to 1953.

Rizzuto was at his best in 1950. Combining contact hitting with patience at the plate, he collected thirty-six doubles and drew niney-two walks in earning the MVP Award. Reaching base almost 42 percent of the time, he was a constant pest to opposing pitchers.

Aging better than most players, Rizzuto continued to produce good numbers through 1953, when he was thirty-five. Three years later he was heartbroken to learn that he was being released, but he soon found his way in another line of work.

After his retirement, the Scooter became a Yankees institution as a broadcaster. Anchoring WPIX-TV and radio broadcasts for four decades, the charismatic Rizzuto emerged as the centerpiece in broadcast coverage of the Yankees, complete with his trade-mark catchphrases like "Huckleberry" and "Holy cow!"

Rizzuto broke almost all of the rules of broadcasting. He often failed to follow the play, gave premature home run calls, inter-spersed his broadcasts with "Happy Birthdays," and occasionally failed to take note that a no-hitter was in progress. "He didn't try to act like an announcer," Hall of Fame teammate Whitey Ford explained to *Sports Illustrated*. "He just said what he thought. It added fun to the game."

In bringing comic and boyish elements to the broadcast, Rizzuto was so personable, so charming, so entertaining that most Yankees fans loved listening to him regardless of whether their team was winning or being blown out. Because of Rizzuto, Yankees broadcasts became a mix of situation comedy, talk show, and a little baseball.

He helped the Yankees win championships, and then he helped describe them.

—B.M.

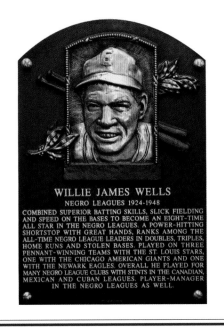

WILLIE JAMES WELLS
NEGRO LEAGUES 1924-1948
COMBINED SUPERIOR BATTING SKILLS, SLICK FIELDING
AND SPEED ON THE BASES TO BECOME AN EIGHT-TIME
ALL STAR IN THE NEGRO LEAGUES. A POWER-HITTING
SHORTSTOP WITH GREAT HANDS, RANKS AMONG THE
ALL-TIME NEGRO LEAGUE LEADERS IN DOUBLES, TRIPLES,
HOME RUNS AND STOLEN BASES. PLAYED ON THREE
PENNANT-WINNING TEAMS WITH THE ST. LOUIS STARS,
ONE WITH THE CHICAGO AMERICAN GIANTS AND ONE
WITH THE NEWARK EAGLES. OVERALL HE PLAYED FOR
MANY NEGRO LEAGUE CLUBS WITH STINTS IN THE CANADIAN,
MEXICAN AND CUBAN LEAGUES. PLAYER-MANAGER
IN THE NEGRO LEAGUES AS WELL.

WILLIE WELLS

CLASS OF 1997

Willie Wells said, "I didn't want to do anything but play baseball. That was my life and it was good to me. Baseball is still nothing but hit the ball and catch the ball." And that is all he did—play baseball. Hit the ball. Catch the ball. Willie Wells was the consummate ballplayer.

Unfortunately for Wells, he played in an era when he was kept out of Major League Baseball simply because of the color of his skin. Wells still had a fine career and was successful wherever he went—Canada, Cuba, Mexico, and the Negro Leagues in the United States—even playing against major league competition in exhibition games held in Cuba.

It was during his time in Mexico that he was given the monicker "El Diablo." Because of his astonishing play at the shortstop position, players in the Mexican League began to say, "Don't hit it to shortstop because 'El Diablo' plays there." Hall of Famer Cool Papa Bell once said, "The shortstops I've seen, Wells could cover ground better than any of them. Willie Wells was the greatest shortstop in the world." The only woman elected to the National Baseball Hall of Fame, Effa Manley, called Willie Wells "the finest shortstop, black or white."

Wells played more than twenty years on the diamond and was the quintessential "five-tool player." He could hit for average and power, could run, and was a tremendous defensive shortstop with a very accurate arm. Hall of Fame second baseman Charlie Gehringer called Wells "the kind of player you always wanted on your team," adding, "He played the way all great players play—with everything he had."

Wells was selected to play in the annual East-West All-Star Game eight times in his career, despite the fact that the contest didn't begin until 1933, when Wells had already played nine full seasons of professional baseball. In addition to leading the Chicago American Giants to back-to-back pennants in two different leagues, capturing the Negro Southern League title in 1932 and then the inaugural pennant of the new Negro National League the following season, he was also part of the Newark Eagles' famed "Million Dollar Infield" in the late 1930s alongside future Hall of Famers Mule Suttles and Ray Dandridge.

In his later years, Wells served as a mentor to younger players including Jackie Robinson and Monte Irvin. Irvin recalled, "Wells showed me everything he knew. We talked about hitting—he was a really good curve ball hitter—about moving around on different pitchers, especially left-handers, moving up in the box, moving back, trying to throw the pitcher off, trying to take a peek back to see how the catcher is holding his target in a close game."

Shortly before his death in 1989 Wells remarked, "I just wanted to be the best. I never wanted to lose." Wells was formally recognized as one of the game's best when he was inducted into the Hall of Fame by the Veterans Committee in 1997.

—F.B.

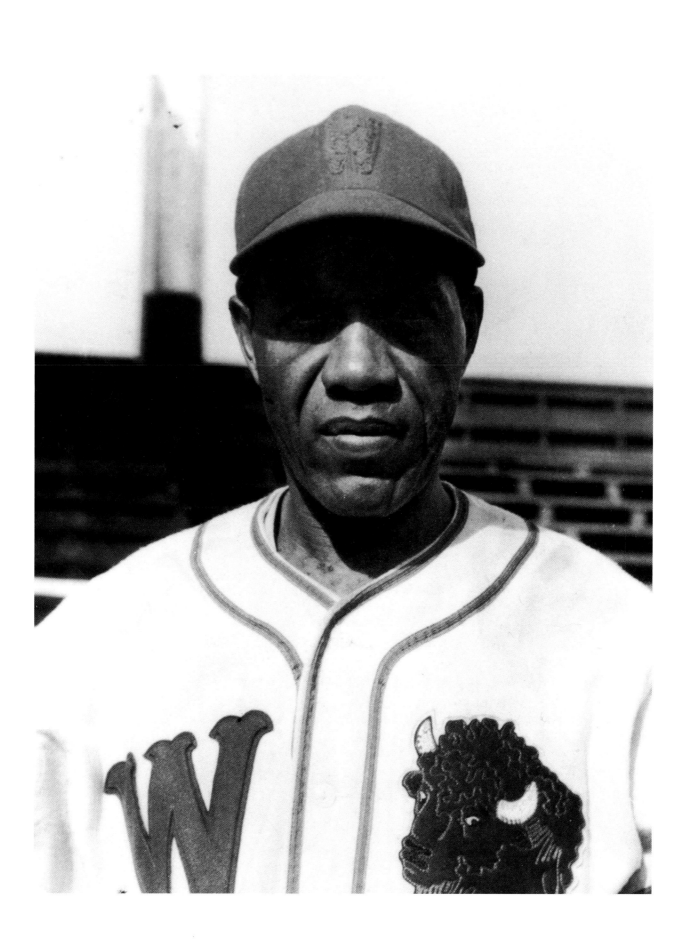

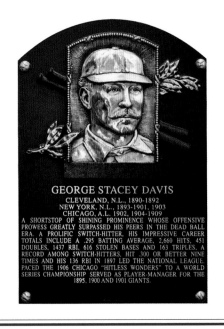

GEORGE STACEY DAVIS
CLEVELAND, N.L., 1890-1892
NEW YORK, N.L., 1893-1901, 1903
CHICAGO, A.L. 1902, 1904-1909
A SHORTSTOP OF SHINING PROMINENCE WHOSE OFFENSIVE
PROWESS GREATLY SURPASSED HIS PEERS IN THE DEAD BALL
ERA. A PROLIFIC SWITCH-HITTER, HIS IMPRESSIVE CAREER
TOTALS INCLUDE A .295 BATTING AVERAGE, 2,660 HITS, 451
DOUBLES, 1437 RBI, 616 STOLEN BASES AND 163 TRIPLES, A
RECORD AMONG SWITCH-HITTERS, HIT .300 OR BETTER NINE
TIMES AND HIS 136 RBI IN 1897 LED THE NATIONAL LEAGUE.
PACED THE 1906 CHICAGO "HITLESS WONDERS" TO A WORLD
SERIES CHAMPIONSHIP SERVED AS PLAYER-MANAGER FOR THE
1895, 1900 AND 1901 GIANTS.

GEORGE DAVIS

CLASS OF 1998

Underrated as a ballplayer, George Davis took on heroic dimensions off the field. In both regards, he easily fulfilled the requirements of a Hall of Famer.

Born in the small New York city of Cohoes, Davis played semiprofessional ball before joining the Cleveland Spiders in 1890, but did not fully develop his talents until joining the New York Giants. In his Giants debut, he hit eleven home runs (a good total for the time), stole thirty-seven bases, and batted .355.

A strong switch-hitter with far more power than most shortstops of his era, he almost perennially led the Giants in batting. At the same time, he deftly handled the demands of the shortstop position.

One of Davis's best seasons came in 1897. He led the National League with 135 RBI, compiled a .410 on-base percentage, and stole 65 bases.

Although his accomplishments were obscured by time, historians came to appreciate Davis's true value. Biographer Bill Lamb placed Davis into proper perspective. "You could put Honus Wagner to one side and compare the two and make a serious case that George Davis is the second-best shortstop who ever played," Lamb told the *Oneonta (New York) Daily Star*.

Prior to the 1902 season, Davis jumped from the Giants to the Chicago White Sox. He then jumped back to the Giants in 1903, appeared in a few games, and then had to sit down because of a dispute as to who owned his contractual rights. Eventually

the White Sox were declared the winners; Davis returned to the Windy City for 1904.

The assignment to Chicago turned out to be fortunate. The light-hitting White Sox won the 1906 pennant before upsetting the rival Cubs in the World Series. Playing in his first Series, Davis batted .308 with six RBI.

Yet the numbers tell only a fraction of Davis's story. Away from the ballpark, he emerged as a legitimate hero. While playing for the Giants in 1900, Davis and teammates Kid Gleason and Mike Grady were making their way to the Polo Grounds when they noticed a raging fire in a Harlem apartment building. With more than two hundred people believed to be in the building at the time, the situation had the makings of a major tragedy.

Davis and his teammates sprang into action. They ran into the building and began extracting residents from the blaze. At one point, Davis noticed a woman on the top floor. He climbed up a ladder and carried her to safety.

The *New York World* proclaimed Davis a hero, but he maintained his modesty. "Oh, I didn't do much," Davis told a reporter. "Once I thought I was going to be cut off by flames and be prevented from reaching a child that was holding out its arms to me. But I got through to the little one and reached the ground. . . . I didn't do half as much as Grady and Gleason."

That last statement is debatable. What is not debatable is Davis's standing as one of the finest shortstops ever. In any century, nineteenth or twentieth, Davis was one of the all-time greats.

—B.M.

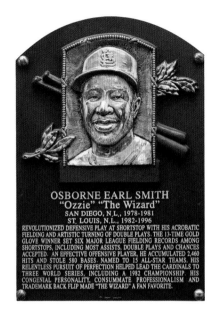

OSBORNE EARL SMITH
"Ozzie" "The Wizard"
SAN DIEGO, N.L., 1978-1981
ST. LOUIS, N.L., 1982-1996
REVOLUTIONIZED DEFENSIVE PLAY AT SHORTSTOP WITH HIS ACROBATIC
FIELDING AND ARTISTIC TURNING OF DOUBLE PLAYS. THE 13-TIME GOLD
GLOVE WINNER SET SIX MAJOR LEAGUE FIELDING RECORDS AMONG
SHORTSTOPS, INCLUDING MOST ASSISTS, DOUBLE PLAYS AND CHANCES
ACCEPTED. AN EFFECTIVE OFFENSIVE PLAYER, HE ACCUMULATED 2,460
HITS AND STOLE 580 BASES. NAMED TO 15 ALL-STAR TEAMS. HIS
RELENTLESS PURSUIT OF PERFECTION HELPED LEAD THE CARDINALS TO
THREE WORLD SERIES, INCLUDING A 1982 CHAMPIONSHIP. HIS
CONGENIAL PERSONALITY, CONSUMMATE PROFESSIONALISM AND
TRADEMARK BACK FLIP MADE "THE WIZARD" A FAN FAVORITE.

OZZIE SMITH

CLASS OF 2002

Certain players set a standard by which others are measured. When it came to playing shortstop, Ozzie Smith set the standards mountain-high. He did so with athletic talent, diligent work, and an ability to adapt as he aged.

Born in Alabama, Smith attended Cal Poly–San Luis Obispo before the San Diego Padres drafted him in 1977. He played only sixty-eight minor league games before moving up, immediately establishing himself as a defensive stalwart and a dangerous base runner. Stealing forty bases, Smith finished second in the 1978 National League Rookie of the Year voting.

Smith's rookie season was highlighted by one of the most remarkable plays ever. Atlanta Braves slugger Jeff Burroughs hit a hard ground ball, forcing Smith to move to his left. He dove for the ball, which suddenly took a terrible hop and bounded to Smith's right, above his hip. Sticking out his bare hand, Smith somehow snared the ball before throwing to first. In 1980 Smith set a record for the most assists by a shortstop in a season (621). Smith's defensive brilliance amazed observers, but his inconsistent hitting concerned the Padres, who traded him to St. Louis for Garry Templeton after the 1981 season.

The young switch-hitter was a perfect fit for Cardinals manager Whitey Herzog, who emphasized speed and defense. The Cardinals played home games at Busch Stadium, where the fast artificial turf provided a special stage for Smith. "He's changed fielding for shortstops . . . ," Hall of Famer Lou Boudreau informed *Sports Illustrated*. "In my day, the only time you would throw on the run was when the ball got by the pitcher. He does it on all normal ground balls."

With his patented diving stops to either side, the rangy "Wizard of Oz" became the anchor of the Cardinals defense, arguably the best in the league. Smith proved to be the linchpin of the club's 1982 world championship.

As the decade progressed, so did Smith's hitting. In 1985 he hit .276, his best mark to date. In 1987 he hit a high-water mark of .303 while drawing a career-high eighty-nine walks. "Ozzie's been a hell of an offensive player, even before this year," Herzog told *Sports Illustrated*. "He does a lot of things with the bat—moving runners along, hitting and running—that go unnoticed." In Game 5 of the 1985 NL Championship Series, Smith belted a game-winning home run from the left side. The home run, a walk-off blast, was the first left-handed home run of his major league career.

Even as Smith moved into his thirties, he remained an All-Star, playing with a rotator cuff injury from 1985 to 1996. Instead of having surgery, Smith improvised by strengthening his shoulder with weight training and was able to play until he was forty-one.

Smith's fielding exploits coincided with the explosion of baseball's television era, allowing fans nationwide to witness his defensive brilliance personally. Those highlights captured Smith's knack for the spectacular play, maintaining it for future generations. Without them, those fans might not believe what they will hear about Ozzie Smith.

—B.M.

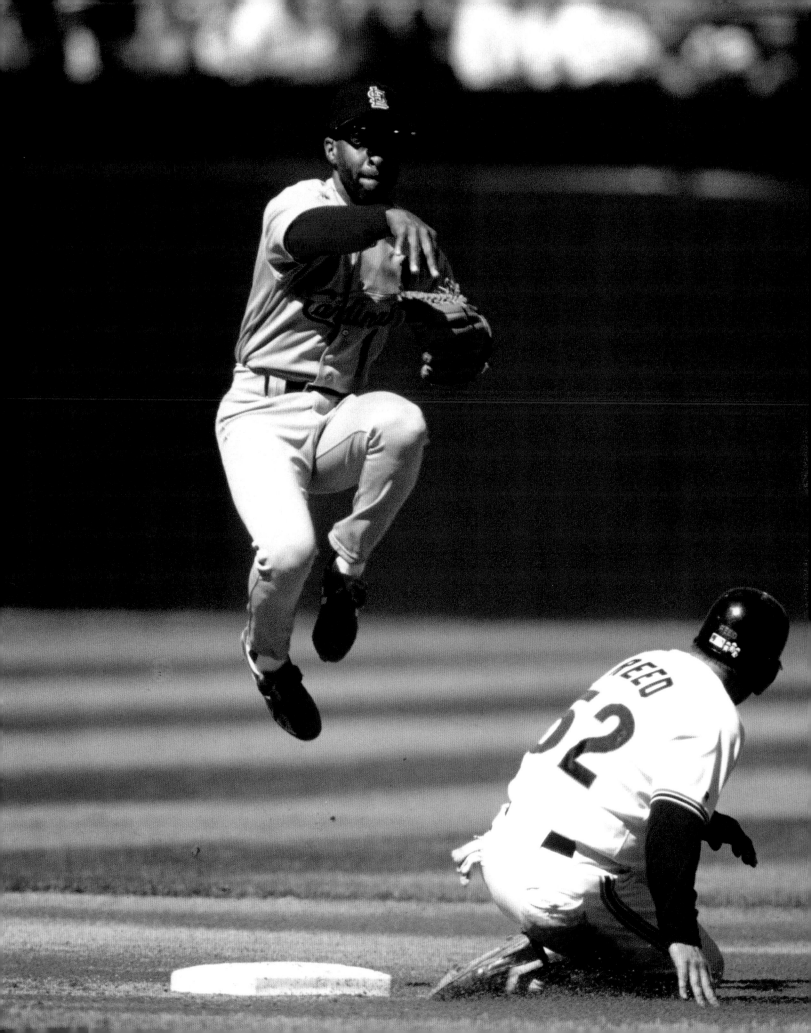

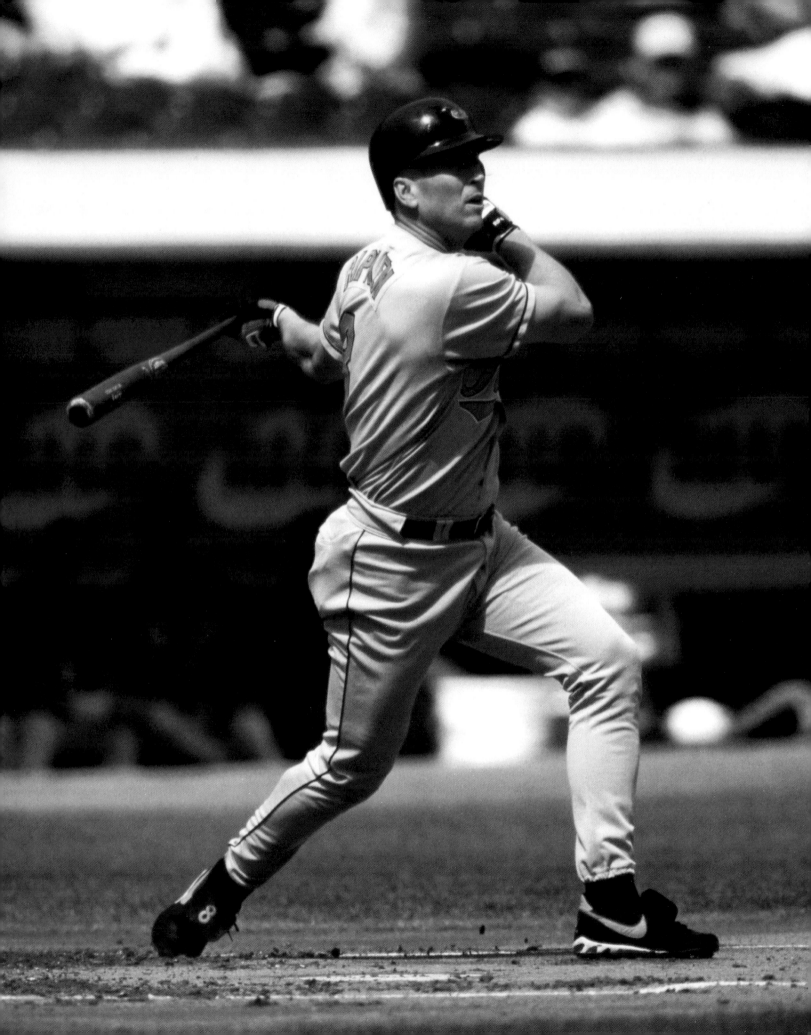

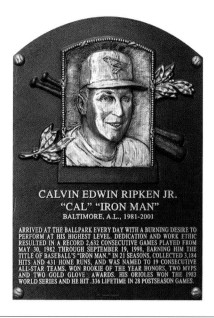

CALVIN EDWIN RIPKEN JR.
"CAL" "IRON MAN"
BALTIMORE, A.L., 1981-2001

ARRIVED AT THE BALLPARK EVERY DAY WITH A BURNING DESIRE TO
PERFORM AT HIS HIGHEST LEVEL. DEDICATION AND WORK ETHIC
RESULTED IN A RECORD 2,632 CONSECUTIVE GAMES PLAYED FROM
MAY 30, 1982 THROUGH SEPTEMBER 19, 1998, EARNING HIM THE
TITLE OF BASEBALL'S "IRON MAN." IN 21 SEASONS, COLLECTED 3,184
HITS AND 431 HOME RUNS, AND WAS NAMED TO 19 CONSECUTIVE
ALL-STAR TEAMS. WON ROOKIE OF THE YEAR HONORS, TWO MVPS
AND TWO GOLD GLOVE AWARDS. HIS ORIOLES WON THE 1983
WORLD SERIES AND HE HIT .336 LIFETIME IN 28 POSTSEASON GAMES.

CAL RIPKEN JR.

CLASS OF 2007

Of all the great moments in baseball, few have warranted a special wire services bulletin. But such was the case on September 6, 1995, when an Associated Press alert read, "Cal Ripken broke Lou Gehrig's unbreakable record Wednesday night when he played his 2,131st consecutive game."

On that memorable night in Baltimore, the Orioles great shattered a record that many thought would never be broken. In doing so, Ripken ensured that his name would become synonymous with durability and a tremendous work ethic. "Somewhere along [the way] I got used to the fact that the streak is my identity," Ripken said. "I don't say that in a positive or negative manner, it's just the way it is. I've accomplished other things. I played in the World Series. I've hit some home runs, but the streak is who I am."

Ripken was drafted out of Aberdeen (Maryland) High School with the forty-eighth pick in the June 1978 draft. He was called up to the majors for good in 1981 and spent his entire twenty-one-year career in Baltimore. By the time he retired after the 2001 season, he had earned the respect of teammates and the opposition alike.

"He is a bridge, maybe the last bridge, back to the way the game was played," Yankees manager Joe Torre said. "Hitting home runs and all that other good stuff is not enough. It's how you handle yourself in all the good times and bad times that mat-

ters. That's what Cal showed us. Being a star is not enough. He showed us how to be more."

Rafael Palmeiro, who was the Orioles' starting first baseman the night Ripken broke Gehrig's mark, said that Ripken "was the one player I enjoyed playing with and learned more from than just about any player. Just the way he approached the game, especially during times he was under stress with the streak. The way he handled that and prepared for each game even with all the ups and downs you go through. You watch a player like that and you can't help but admire him."

Ripken came from a baseball family. His father, Cal Senior, managed throughout the Orioles organization, including the parent club, while Ripken's brother Bill also played in the major leagues, and on the same team as Cal.

Ripken won a World Series with Baltimore in 1983, was a member of Major League Baseball's All-Century Team in 1999, twice was named the Most Valuable Player in the All-Star Game, and was on the All-Star roster nineteen times. In addition, he became only the seventh player to hit four hundred home runs and reach the three-thousand-hit plateau. During his career, he averaged .276 at the plate and collected 1,695 RBI. In 1996 he shifted from shortstop (where he once played a record ninety-five consecutive games without an error) to third base and never missed a beat.

"There was nothing to keep him from being a star in the major leagues," said Earl Weaver, who managed Ripken in Baltimore. "That was inevitable."

—T. Wendel

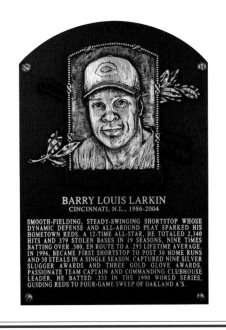

BARRY LOUIS LARKIN
CINCINNATI, N.L., 1986-2004

SMOOTH-FIELDING, STEADY-SWINGING SHORTSTOP WHOSE
DYNAMIC DEFENSE AND ALL-AROUND PLAY SPARKED HIS
HOMETOWN REDS. A 12-TIME ALL-STAR, HE TOTALED 2,340
HITS AND 379 STOLEN BASES IN 19 SEASONS, NINE TIMES
BATTING OVER .300, EN ROUTE TO A .295 LIFETIME AVERAGE.
IN 1996, BECAME FIRST SHORTSTOP TO POST 30 HOME RUNS
AND 30 STEALS IN A SINGLE SEASON. CAPTURED NINE SILVER
SLUGGER AWARDS AND THREE GOLD GLOVE AWARDS.
PASSIONATE TEAM CAPTAIN AND COMMANDING CLUBHOUSE
LEADER, HE BATTED .353 IN THE 1990 WORLD SERIES,
GUIDING REDS TO FOUR-GAME SWEEP OF OAKLAND A'S.

BARRY LARKIN

CLASS OF 2012

His career path took him from leadoff hitter to RBI man, with stops up and down the lineup in between.

Along the way, Barry Larkin was selected to twelve All-Star Games in nineteen seasons. It doesn't get much better than that for any shortstop.

Born April 28, 1964, in Cincinnati, Larkin was an honor student and athletic star at Cincinnati's Moeller High School and enrolled at the University of Michigan with the idea of playing both baseball and football.

But when legendary Michigan football coach Bo Schembechler advised Larkin to redshirt his freshman year, Larkin's path to Cooperstown opened up.

"The best decision Bo Schembechler ever made, in my opinion," Larkin said. "It allowed me to focus on only one sport [baseball] for the first time."

After earning a spot on the 1984 U.S. Olympic baseball team, Larkin was taken by the Reds with the fourth overall pick in the 1985 MLB draft.

Larkin finished seventh in the National League Rookie of the Year voting in 1986 despite playing just forty-one games. The next season, he won the Reds' starting shortstop job, and by 1988 Larkin was a first-time All-Star with a .296 average, 91 runs scored, 32 doubles, and 40 stolen bases.

In 1990 Larkin finished seventh in the NL MVP voting after hitting .301 with 30 steals and 67 RBI. The Reds went wire-to-wire in winning the NL West that year, then dispatched the Pirates and the A's in the postseason to win the World Series.

In the four-game sweep over Oakland in the Fall Classic, Larkin hit .353 and scored three runs.

Larkin began to develop power in 1991, when he hit twenty homers, and his all-around play continued to improve. He won the first of three consecutive Gold Glove Awards in 1994, was named the NL MVP in 1995 after hitting .319 en route to the Reds' NL Central title and trip to the NLCS, and became the first shortstop—and just the second Reds player—to post a thirty-homer/thirty-steal season in 1996.

"I'm not a home run hitter," said Larkin, who hit five home runs in two consecutive days in 1991—another first for a shortstop. "I'm a line drive hitter. [In 1996] I hit [thirty-three] line drives that went over the fence."

Larkin was also a role model off the field, winning the Roberto Clemente Award in 1993 and the Lou Gehrig Award in 1994.

Larkin retired after the 2004 season—he was named an All-Star in his final year in the big leagues—with a .295 career average, 2,340 hits, 1,329 runs scored, and 379 stolen bases. Larkin scored at least eighty runs in a season seven times, hit thirty-plus doubles in six seasons, and stole thirty or more bases five times. He won his three Gold Glove Awards at shortstop en route to a career fielding percentage of .975, and won nine Silver Slugger Awards.

He played every one of his nineteen big league seasons with the Reds.

—C.M.

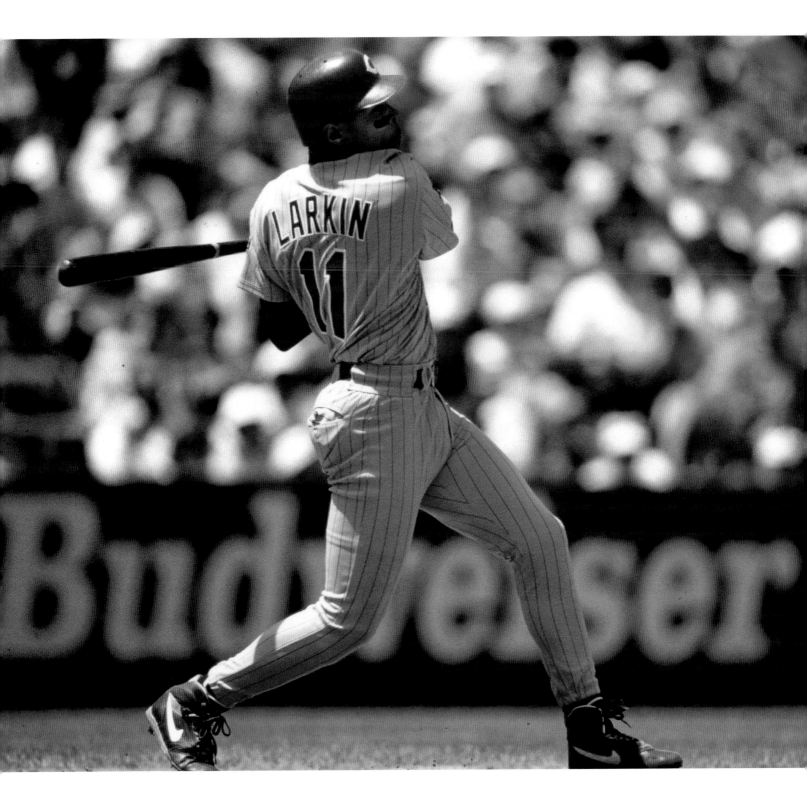

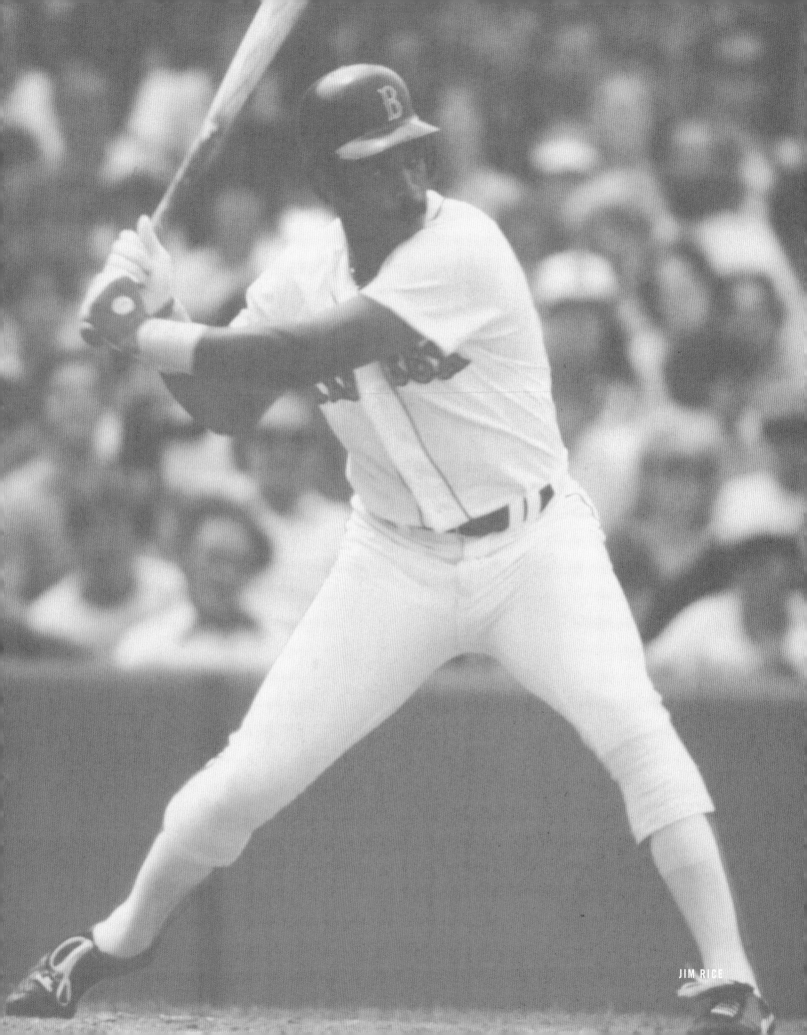

JIM RICE

LEFT FIELDERS

LEFT FIELDERS BY **JIM RICE**

Boston is a city steeped in history and tradition, and during his sixteen-year big league career, Jim Rice ensured that the tradition of great Red Sox left fielders continued. An eight-time American League All-Star and 1978 Most Valuable Player Award winner, Rice proved a worthy successor to his predecessors Carl Yastrzemski and Ted Williams, while patrolling the hallowed real estate in front of Fenway Park's iconic Green Monster. The Anderson, South Carolina, native established himself as one of the game's most feared sluggers in the 1970s and 1980s, leading the league in home runs three times and driving in one hundred or more runs eight times. In 2009 Rice was inducted into the Hall of Fame and his uniform number 14 was retired by the Red Sox.

Before the start of my rookie season in 1975, Carl Yastrzemski and I walked out to the Green Monster in Fenway Park. Yaz had just made the decision to turn left field over to me, and when we got out there that day, he just looked at that big old wall and said, "Jim, you've got to learn as much as you can about this crazy wall. And the only way you're going to do that is to work on it." And that's what we did. Every day for an hour or two before batting practice during home games, Johnny Pesky and I headed out to the Green Monster, and Johnny would hit ball after ball to me so that I got to know the Monster like the back of my hand. The toughest thing about playing left field in Fenway is that you have to learn how to play the angles. The ball takes a lot of funny bounces off of different parts of that wall. There is a ladder going up the wall. And a door and a scoreboard along the warning track. There were dead spots in the wall, where the ball would hit and drop straight down. And hard spots where the ball would ricochet back toward the infield or out toward center field. There wasn't much foul territory out there. And sometimes the wind above the wall would do funny things to the ball. So it could make you look like a fool if you weren't fully prepared to deal with it.

I owe Johnny a lot of credit, because he knew where to hit those fungoes. I swear he was like a magician out there. He hit 'em off the ladder and the scoreboard and the top of the wall and the middle of the wall and the bottom of the wall. At first I felt like I was in the middle of a pinball machine, because the balls were shooting off in a hundred different directions. But after about three or four weeks of this, I got a decent feel for it. I learned what the ball would do in all types of situations. Our center fielder Freddy Lynn and I also worked together well as a team out there. If he was going back to the wall to try to catch the ball, I would line myself up in case he couldn't get to it and it caromed hard off the wall. And he would do the same with me. If I was going for the catch, he would line up for the ricochet. It helped that we had played together in the minors. We knew how much ground each of us could cover and we knew how to position ourselves to help the other guy out.

I understood that it wasn't going to be easy taming the Monster. I also knew there would be lots of pressure on me because Boston fans had high expectations and I would be measured against my famous left-field predecessors—Yaz and Ted Williams. But I had never been afraid of hard work, and I wasn't one of those guys who was reluctant to work on his weaknesses. I was hell-bent on becoming a good defensive player. I was determined to turn my weakness into

a strength, and I think the fans appreciated how hard I was working on it. Red Sox fans aren't unreasonable people. They're only going to get on you if you aren't giving an honest effort, if you are cheating them. Then they're going to be all over you and hold you accountable. And that's the way it should be. I think they saw me out there busting my tail before games. They saw me working on the fundamentals, and I think they appreciated that.

I mentioned how our coach, Johnny Pesky, had put in a lot of extra time with me. But it wasn't just with my defense. He also spent plenty of time working with me on my hitting. I can't tell you how many times we went out to that dusty old batting cage beneath the center-field bleachers and he threw BP to me. It didn't matter how hot or cold it was; if I wanted to hit, he'd be there for me. We'd actually start showing up at Fenway in January, about a month before we were to report to spring training, and when we got to Florida, Johnny often would be there at six in the morning so I could get my work in without any distractions.

That's why I was so thrilled that when the Red Sox held a ceremony back in 2009 to retire my jersey, Johnny was the one who hoisted my number 14 at Fenway. I told people that night that Johnny wasn't raising that number for me; he was raising that number for us. I really meant that, because Johnny was like a father figure to me. He became such a great mentor and friend.

I was a very focused, disciplined ballplayer throughout my sixteen years with the Red Sox, and I believe that work ethic was ingrained in me by my dad and several of my coaches back in my hometown of Anderson, South Carolina. Anderson was a small city of about thirty thousand back in the day. The cotton mills were our main industry. My dad worked for the city recreation department, so we had access to a lot of sports equipment, and that was great because sports was a big part of my life from the start. My dad—Roger Rice—was a thickly muscled man, built along the lines of [former Detroit Tigers slugger] Willie Horton. I was one of nine kids, and Dad ran a tight ship. None of us kids ever dared get out of line or else we'd have to answer to him. And believe me, you didn't want to have to answer to Roger Rice. There also were other adults in the neighborhood who kept you on the straight and narrow. Everybody looked out for one another. You learned to respect your elders, and I think that was a good thing—maybe something that's lacking in many parts of our society today.

I played a bunch of sports in high school. I was blessed to be good at most every sport I tried. I was big for my age and could palm and dunk a basketball fairly early on, and I made my varsity team as a seventh-grader. Coach played me at guard and forward, too, because I could really jump. Looking back, basketball might have been my best overall sport. I also was a good sprinter in track—I did the one hundred [yard dash] in 9.9 seconds and won a state championship. I played running back in football. The brand of high school football in Anderson was very good. Stanley Morgan, who became a great receiver with the New England Patriots, and Chicago Bears nose tackle William "Refrigerator" Perry came from my area. So that gives you an idea of the quality. I was good enough to receive a scholarship from the University of Nebraska. This was back in 1971, when Johnny Rodgers was starring for them and the Cornhuskers were national champions. But I wound up reneging on my scholarship. The more I thought about it, the more I realized that most running backs had short careers in the NFL. I'm not saying I would have made the NFL. I was just trying to think ahead.

Fairly early on it became apparent that baseball was my best option. I could hit the ball a long, long way, and starting in the ninth grade, the scouts began showing up at my high school and American Legion games. I owe a lot of credit to my Legion coach, Olin Saylor. He came by my house every day and picked me up. There were times when I didn't really want to play ball, but Olin was very determined to make me play baseball for American Legion Post 14. I think he saw that I had some special talents that I might not have seen in myself with regard to baseball. He was one of the first to believe that I might be able to make a career out of it. Another guy who pushed me in that direction was my high school coach, John Moore. He was a disciplinarian, just like my dad, and he taught me a valuable lesson when I was a sophomore. I was sick and didn't go to school one week, but I didn't bother telling Coach Moore or anybody else. When I came back to school, he said, "Jim, where have you been?" I said, "I was sick, Coach." He then asked, "Well, did you bother telling anybody here that you were sick?" And when I told him I hadn't, he said, "Jim, that was very irresponsible of you. You're off the team." I thought he was fooling, but he wasn't. It was a tough lesson, but a good one. That forced me to grow up and learn how to become a responsible adult.

Coach Moore and Coach Saylor taught me and my teammates the importance of putting the team ahead of ourselves. We were taught how to hit the ball the other way to move runners over. And we were penalized if we couldn't hit the ball to the opposite field. I think that ability to go with the pitch and not become strictly a dead pull hitter like most sluggers enabled me to hit for a good average in the big leagues. The thing was, I was fortunate because I was strong enough to drive the ball out of the park even when I was going with an outside pitch to the opposite field. I might have hit more homers if I had become nothing but a pull hitter, but I believe my batting average would have been a lot lower. I'm proud of the fact that I hit over .300 seven times in my career. And I think that ability to use the entire park also enabled me to hit a lot of triples—including fifteen in both the '77 and '78 seasons. Not too many people who played this game can say they led the league in homers and triples in the same season, but I was able to do that in '78.

Like I said, the scouts had begun paying attention to me in the ninth grade, and after my senior year in 1971, the Red Sox—on the recommendation of Mace Brown and Sam Mele—drafted me in the first round and signed me to a $46,000 bonus contract, which was more money than I ever knew existed. They assigned me to their New York–Penn League team in Williamsport, Pennsylvania, and to be honest with you, I really didn't suffer any great bouts of homesickness. Maybe it had something to do with the fact I came from a family of nine kids and I was looking forward to being out on my own with a little room to breathe.

Our manager was Dick Berardino, and he was a great guy and a great teacher of the game. He's still in the organization, and I still see him every spring training and on occasion during the season. Dick knew how to relate to the players and handle a bunch of guys who were away from home for the first time in their lives. The funny thing about Dick is that he tried to make everybody on the ball club Italian because he was Italian. Every city we played in, he managed to find an Italian restaurant. Fortunately, I grew to love Italian food.

Because I had a really strong arm, I had played right field in high school. And that's where I spent my first two years of pro ball. But the Red Sox switched me over to left at the start of my

third season because they had this top prospect named Dwight Evans in right field. He was just starting out with the big club and they were really high on him because he had a great arm and was a great fielder. So they thought it would be better if they started grooming me to play left, with the thought that I would eventually be able to succeed Yaz.

I had a decent year in 1971 with Williamsport, batting .256 with nine doubles, five triples, five homers, and twenty-seven runs batted in during sixty games. Following the season I played winter ball in the Florida Instructional League, and that really helped. Things really started to kick in for me the next year with Winter Haven in the Florida State League. I hit 17 homers, drove in 87 runs, and batted .291. I again followed the season with more games in the instructional league, and in 1973, at Double-A Bristol in the Eastern League, I elevated my game a little more, hitting .317 with 27 homers and 93 RBI. At the end of that season, I was promoted to the Red Sox Triple-A team in Pawtucket, Rhode Island. I was there for only ten regular-season games and the playoffs, but I was able to make an impression with four homers, ten RBI, and a .378 batting average. I capped my brief stay with the PawSox by hitting a three-run homer against the Tulsa Oilers of the American Association to help us win the Junior World Series.

After that big win, I played in the instructional league once more and headed to spring training in 1974, confident that I might be able to make the big club. I came close, but they figured I'd be better off playing every day in Triple-A instead of playing occasionally in Boston, so they sent me back to Pawtucket. I was definitely determined to show them I was ready to be in the big leagues, and I wound up taking it out on International League pitchers that summer. I led the league in homers (25), RBI (93), and batting average (.337) to win the Triple Crown and earn IL Rookie of the Year and MVP honors as well as being named the Minor League Player of the Year. It also earned me a late-season call-up to the Red Sox. I played twenty-four games and did OK, with two doubles, a triple, a homer, thirteen RBI, and a .269 batting average.

I felt I was definitely ready to stick with the big club heading into spring training in 1975, but I was concerned about getting an opportunity, because Yaz was still a very productive left fielder and there didn't appear to be any positions available. I really didn't want to return to the minors, because there was nothing left for me to prove at that level. And I wasn't looking forward to riding the bench and being used off and on in the big leagues. I was twenty-two years old and I was anxious to play every day. There had been some rumors about me possibly being traded, but I didn't believe them, because I knew the Red Sox were high on me. Fortunately, that's when Yaz opened the door for me in left field.

Nineteen seventy-five wound up being a great year for me and the Red Sox. With Dwight in right, Freddy in center, and me in left, it was like the dawn of a new era in Boston. I batted .309 with 22 homers and 102 RBI, and was just nudged out for American League Rookie of the Year and MVP honors by Fred. The only downside to that year was the way it ended for me and my team. Toward the end of the regular season, I was hit by a pitch and broke the pinkie finger on my left hand and injured my wrist. That forced me to miss both the playoffs and the World Series. I tried to convince our manager, Darrell Johnson, to let me play, but he told me I had a great future in this game and they didn't want to jeopardize that by putting me out there and risking a permanent injury. It was really disappointing, but what are you going to do? That's life.

That was the year, of course, that the Red Sox and Cincinnati Reds staged one of the best World Series of all time. Went seven games. Down to the wire. I've run into Joe Morgan and Johnny Bench and Tony Pérez from the Reds through the years and each of them told me that if I had been able to play, they would have liked Boston's chances. But we'll never know, and it doesn't do any good anguishing about it because you can't change the past.

I healed completely and turned in another solid season in 1976 (25 homers, 85 RBI, .282 batting average). The next year I started coming into my own, as I led the league in home runs for the first time with 39, to go along with 114 RBI and a .320 average. I think the average was the thing I was really proud about because I wanted people to think of me not merely as a slugger but as a good all-around hitter.

In 1978 I was able to put together the best season of my career and one of the best offensive seasons anyone had put up in quite some time. I led the league in home runs (46), RBI (139), hits (213), and triples (15), while batting .315. I was twenty-five years old at the time, and I think I had become a much more knowledgeable and confident hitter, thanks in large part to all that extra work I had done with Johnny Pesky. I took extra BP almost every day that season. I would ask Johnny, "What do I have to do?" And he said, "Keep it simple, Jim. Hit the ball where it's pitched." And that's what I did, which is why I was able to hit a lot of triples. People have this misconception that Fenway is a bandbox because the Green Monster is relatively close. But in reality, its dimensions are a lot bigger than many parks'. There's a lot of space in center field and right field—it's not easy to hit it out there. And although the wall in left might be close, it's very high. I relied on what Johnny preached and what my high school and Legion coaches had preached—hit the ball where it's pitched, gap-to-gap, alley-to-alley.

I definitely benefited from being in such a potent lineup. You don't drive in 139 runs and score 121 runs unless you are surrounded by good hitters, and I really was. I wouldn't have wanted to have been a pitcher facing a lineup that included Carlton Fisk and Freddy Lynn and Yaz and Dwight Evans and me. We could put up a bunch of runs on you. That was a fun lineup to be a part of because it seemed like every time I came to bat that season, somebody was in scoring position. And whenever I was on base, in scoring position, it seemed like somebody was there ready to knock me in. I loved being a part of that team. It was a lot of fun.

Of course, that season always will be remembered for how we squandered a big lead in September and the Yankees caught us, forcing that memorable one-game play-in. That was the height of the Yankees–Red Sox rivalry. A lot has been made about the players from each team hating one another, but I think that stuff gets overblown. Yeah, we wanted to beat them, but we wanted to beat everybody and get back to the World Series. I really think the rivalry is more of a rivalry between the cities and their fans than between the players. The fans from those two teams didn't like one another, and that was apparent to me whether we were playing New York at Fenway or at Yankee Stadium.

The Yankees obviously won that playoff game in 1978, and everybody remembers Bucky Dent's improbable home run into the screen. But when I look back, I think the biggest play of the game was made by Yankees right fielder Lou Piniella. We were trailing by a run with one out and one on in the bottom of the ninth. Jerry Remy hits a ball to right field, and Piniella is blinded

by the sun, but he pounds his glove as if he is going to catch the ball easily. That causes Rick Burleson, who's on first, to hold his ground instead of taking off and making it all the way to third. The ball drops in for a hit, but Rick has to hold at second. I come up and hit a deep fly ball that would have easily scored Rick from third had he been there. Yaz then popped out, and the Yankees won the game. I have to tip my cap to Lou. That was a shrewd, shrewd play on his part, and it prevented Rick from taking the extra base. I felt really bad for Yaz, because he was nearing the end of his career and his chances of getting back to the World Series were diminishing. Being just twenty-five and being with a good club, I felt I had a shot at several more World Series, but it doesn't always work out that way.

Some people blame Don Zimmer for us squandering the big lead we had in the standings that season, but I think that's so unfair. Number one, it falls upon us players, not the manager. Don wasn't throwing pitches or swinging the bat. We were. Number two, the Yankees had a pretty darn good club, too, with Ron Guidry winning twenty-five games and guys like Reggie Jackson and Thurman Munson and Graig Nettles driving in plenty of runs for them. Sometimes the breaks just go the other way. Nothing you can do about that. I really liked playing for Zim. He was great to Freddy and me. I was a right-handed batter and Freddy was a lefty, and Zim would alternate us between third and cleanup, depending on whether we were facing a righty or a southpaw. If there was a left-hander pitching, I would bat third and Freddy fourth. And if there was a right-hander, Zim would flip-flop us. He also told us as young players not to worry. He said, "You guys are playing every day, regardless. The only way you are coming out of the lineup is if you come to me and tell me you are hurt." That just gave each of us so much confidence, knowing that he believed in us.

I loved listening to Zim and Johnny Pesky and other old-timers, like Bobby Doerr, Dominic DiMaggio, and, of course, Ted Williams, tell stories from their playing days. I was like a sponge when they started spinning those tales or doling out advice. My dad and others had taught me about respecting my elders and becoming a good listener. Guys like Zim had seen and experienced so much more than I had, and I just loved sitting there listening to them and taking it all in.

Another guy I learned an awful lot from was Yaz. He wasn't a vocal leader by any means. He definitely led by example. Johnny told me early on, "Jim, if you are going to learn from someone, you need to learn from someone who's been successful over a long period of time." And that certainly was Yaz. Nobody worked harder than that guy. He really was the first one to the ballpark and the last one to leave. If we were supposed to report to the field at ten, Yaz was always there fifteen minutes early. He showed me you don't have to necessarily be a rah-rah guy to be a leader.

His style of leadership fit me best because I was always more of a doer than a talker. I figured, why should I be doing a bunch of talking? That's why you have managers. That's why you have general managers and owners. I wasn't making out the lineup. I wasn't signing the paychecks. I figured my job was to work hard and play the game hard. And because I was intense, some people thought I didn't have fun playing, but I really did. I loved playing baseball. When I put on that big league uniform, it always took me back to being a kid when I was playing ball from sunup to sundown in Anderson, breaking only for food and water. I was getting paid to play a kids' game. I never forgot that.

I strove for consistency, and I think if you look back on my career, you'll see I was able to put up solid numbers, year after year, throughout the majority of my career. I had a stretch from 1983 through 1986 when I drove in more than a hundred runs each year, including '83, when I led the American League with 126 RBI. I prided myself on being in the lineup every day, somebody you could count on, and there were ten years when I had more than six hundred plate appearances.

Perhaps the most memorable moment of my career had nothing to do with me swinging a bat or throwing or catching a ball. It had to do with making a save, but not the kind that shows up in a box score. We were playing a game in Fenway on August 7, 1982, when a young boy named Jonathan Keane was struck by a line drive off the bat of Dave Stapleton. I had heard the crowd groan and I jumped up from the dugout to see what had happened. It's strange, because everybody was just standing there, in panic, looking at the kid and doing nothing. So I just hightailed it into the stands, picked Jonathan up, and carried him quickly into our clubhouse. I didn't think anything of it. I just reacted. But afterward our team trainer and team doctor told me that my quick response had been crucial. Jonathan's dad said I probably saved his son's life. Before I was inducted into the Hall of Fame in 2009, Jonathan and his dad came to Fenway and we chatted for a long time. Jonathan told me that he had graduated from Duke University with honors and thanked me for saving his life. I was very touched by his words and I was so glad to hear what he had gone on to do with his life. Looking back, I don't believe I did anything heroic. I really don't. Sometimes, in those situations, where there's blood flowing and something awful happens, people start to panic and don't know what to do. It's almost like they become paralyzed. I just reacted the way I would have if it had been my own kid.

In 1986 I had my last big statistical year, batting .324 with 20 homers and 110 RBI. That was my first trip back to the World Series, and sadly we lost in seven games again, this time to the New York Mets. That will forever be remembered as the Series when Bill Buckner let Mookie Wilson's roller go through his legs, enabling the Mets to win Game 6. I really felt for Bill. Yes, if he catches it and touches first, we still have a chance to win Game 6. But even with the loss, we still had a seventh game the next day, and we didn't get it done then either. It's a tough thing to be remembered for, and the fans were extremely hard on him after that, to the point [where] he had to leave Boston. That was too bad, because the guy did have an outstanding career, and, sadly, people seem to forget that.

It's been well documented that it took until my last year on the ballot for me to be voted into the Hall of Fame. But that doesn't bother me. Ultimately, nobody cares when you get in, but rather if you are in. I'm in, and I couldn't be more honored and humbled. I remember being at that banquet in Cooperstown during my induction weekend, sitting there with all those Hall of Famers, and feeling so fortunate. I thought about the beginning of my pro career, being back in rookie ball with sixty players. A lot of those guys were really talented players. And yet, I was the only one fortunate enough to be able to make it to the big leagues. One guy out of sixty. That's amazing. It takes a lot of hard work and perseverance, but you have to have a little luck, too. I feel blessed.

Looking back, I'm extremely proud to have spent my entire career with an organization like the Red Sox. I played with some great players who really put the team ahead of themselves. I also had some fine coaches and managers and a great owner in Tom Yawkey, who really created a family atmosphere. I'm so honored that I was able to carry on that Red Sox tradition in left field. I worked really hard at becoming a good left fielder. I took a lot of pride in playing the ball off the Monster and throwing someone out who was trying to stretch a single into a double. I wasn't trying to be the next Ted Williams or Carl Yastrzemski. I was just trying to be me and keep the tradition going, and I'd like to think I succeeded.

FRED CLARKE
THE FIRST OF THE SUCCESSFUL
"BOY MANAGERS," AT TWENTY-FOUR HE
PILOTED LOUISVILLE'S COLONELS IN
THE NATIONAL LEAGUE. WON 4 PENNANTS
FOR PITTSBURGH AND A WORLD
CHAMPIONSHIP IN 1909. STARRED AS
AN OUTFIELDER FOR 22 SEASONS.

FRED CLARKE

CLASS OF 1945

Adventures began early for Pittsburgh Pirates star Fred Clarke, and they continued at a full-blown pace as long as he lived. As a child, Clarke, who was born in Iowa, traveled west to Kansas with his family in a caravan of covered wagons. As a ballplayer, he got his first break when he impersonated another hopeful, going to a tryout on his friend's train ticket. He became a player-manager at twenty-four, and late in life he survived an accidental shooting while quail hunting and a home gas furnace explosion.

Owner of a thirty-five-game hitting streak and a .312 lifetime batting average, Clarke played on four Pittsburgh pennant winners and always maintained his sense of humor. Once, Clarke surprised legendary umpire Bill Klem by patting him on the back and telling him, "You were a model umpire today." Klem gave Clarke a smile, since he took the comment as a compliment. Clarke told him to go home and look up the meaning of the word. The next time, Clarke said, "with practically no reason, Klem kicked me out of the game." There was more than one dictionary definition of the word. "He learned that model meant a small imitation of the real thing," Clarke said.

In later decades Clarke felt that players had got softer compared to his turn-of-the-twentieth-century contemporaries. He never understood the fuss about pitchers who threw inside, either hitting batters or making them hit the dirt. "How come all this talk about the bean ball?" Clarke asked. "Why, in my day we used to invite them to throw at us. That was a good way to get on base. And if you got hit they didn't rush out the ambulance and play under protest."

As a big league outfielder, first with the Louisville Colonels and then with Pittsburgh, Clarke was regarded as an exceptional fielder, but he didn't start out that way. To get noticed, Clarke inserted an ad in the *Sporting News* telling the world he was available. The Hastings, Nebraska, club signed him for $40 a month. "I still wonder why they kept me," Clarke said. "They stuck me in the outfield, then a new position for me, and I was lucky to catch half of the drives they hit to me. An old-timer told me I could improve my fielding with practice, so I went out to the ballpark at 8 o'clock in the morning and practiced until game time. Eventually, I reached a point where I could catch fly balls pretty well."

Early on in his career, Clarke, who was regarded as a great bunter, was a night owl and carouser, but Pirates owner Barney Dreyfuss warned him that he was going to ruin his game and be forced to retire young. Thereafter, when Clarke entered a saloon and was asked what he wanted, it was written, he replied, "A toothpick." Clarke became an inveterate toothpick chewer. It was estimated that he destroyed a cord of wood annually with his teeth.

—L.F.

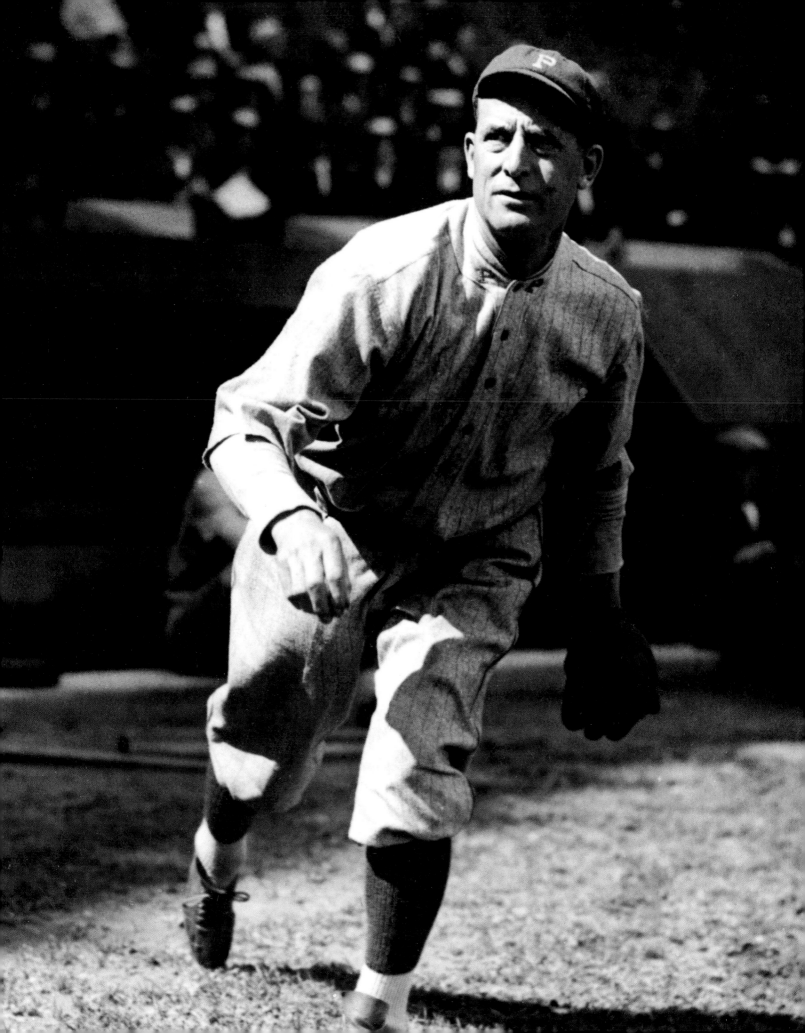

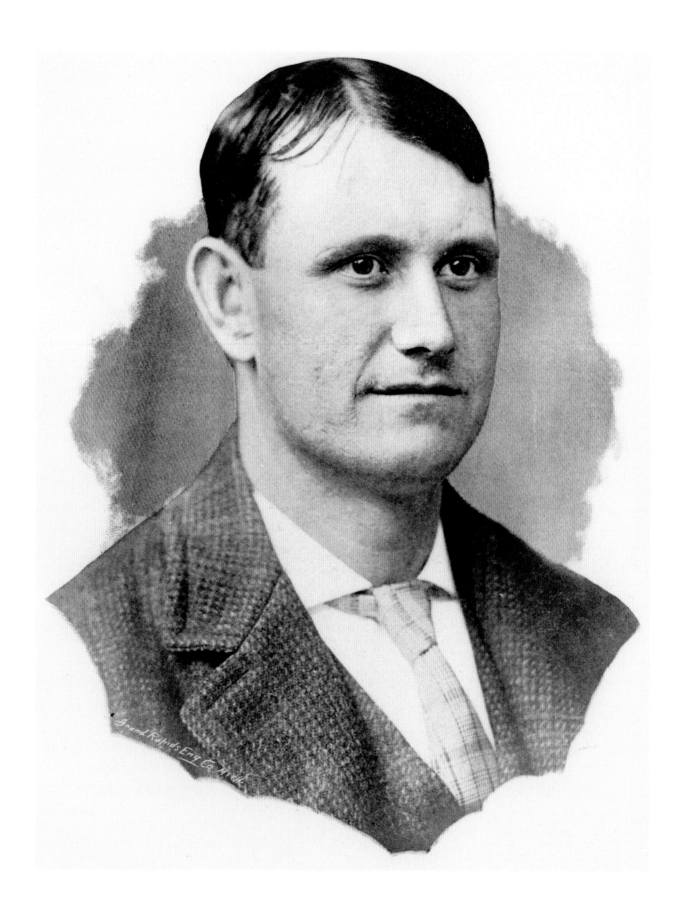

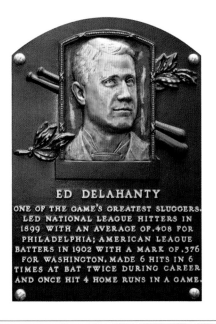

ED DELAHANTY
ONE OF THE GAME'S GREATEST SLUGGERS. LED NATIONAL LEAGUE HITTERS IN 1899 WITH AN AVERAGE OF .408 FOR PHILADELPHIA; AMERICAN LEAGUE BATTERS IN 1902 WITH A MARK OF .376 FOR WASHINGTON. MADE 6 HITS IN 6 TIMES AT BAT TWICE DURING CAREER AND ONCE HIT 4 HOME RUNS IN A GAME.

ED DELAHANTY

CLASS OF 1945

Ed Delahanty was "the best right-handed hitter I ever saw, really a great hitter. It's hard to choose between him and Honus [Wagner]," said Hall of Famer Sam Crawford.

"We lived in an Irish neighborhood in Cleveland, and the Delahantys lived nearby," recalled outfielder Tommy Leach in *The Glory of Their Times.* "There were six brothers, Ed, Tommy, Joe, Jim, Frank, and Willie. All of them except Willie eventually made the big leagues." In fact, among the five boys, the Delahantys played a total of forty-one seasons of big league baseball. Youngest brother William played in the minors.

Ed Delahanty was the eldest of the brothers and had the longest career, playing sixteen years in the majors between 1888 and 1903, with the Phillies, the Senators, and the Cleveland Infants of the 1890 Players' League.

Delahanty, an outfielder and sometime first and second baseman, was a five-tool player: he could hit for average and power, field, throw, and run. Reds hurler Philip "Red" Ehret said that Delahanty was "the hardest man in the league for pitchers to puzzle." If the outfielders played deep, he would drop one in front of them; if at normal depth, he would swing away and put one over their heads.

A lifetime .346 hitter, Delahanty hit .300 or better for twelve consecutive seasons, and three times topped the .400 mark. He led the league in doubles five times, triples once, and home runs twice. He also led the league in RBI three times and hits once,

and led the league in on-base percentage twice and slugging percentage five times.

Twice, Big Ed went 6-for-6 in a game, and he once went 9-for-9 in a doubleheader. He had a four-double game and a four-homer game, and once collected hits in ten consecutive at bats. "If Del had a weakness at the bat I never could discover it," noted veteran catcher Jack O'Connor.

"Delahanty is an awfully even, well balanced player all around. . . . You look at his batting and say well, that chap is valuable if he couldn't catch the measles, and then you look at his fielding and conclude that it wouldn't pay to let him go if he couldn't hit a bat bag," declared the *Sporting Life*, a prominent baseball paper of the day.

Delahanty had 455 career stolen bases and led the league with 58 in 1898.

His incredible career was cut short by his tragic death at age thirty-five. After an erratic period when he gave away valuable possessions, drank heavily, and took out a life insurance policy on himself, Delahanty boarded a train from Detroit to New York. He may have been hoping to "jump" from the Senators to the Giants—as he had done twice before.

The erratic and disruptive behavior continued on the train, and the conductor put him off when the train stopped near the 3,600-foot International Railway Bridge over the Niagara River outside Buffalo. A scuffle with a bridge patrolman ensued, and Delahanty stumbled—or perhaps jumped—off the bridge. His body was found seven days later at the base of the Canadian falls.

—T. Wendel

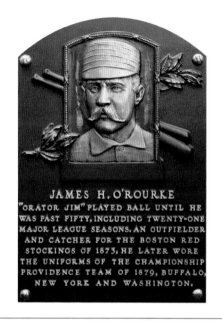

JAMES H. O'ROURKE

"ORATOR JIM" PLAYED BALL UNTIL HE
WAS PAST FIFTY, INCLUDING TWENTY-ONE
MAJOR LEAGUE SEASONS. AN OUTFIELDER
AND CATCHER FOR THE BOSTON RED
STOCKINGS OF 1873, HE LATER WORE
THE UNIFORMS OF THE CHAMPIONSHIP
PROVIDENCE TEAM OF 1879, BUFFALO,
NEW YORK AND WASHINGTON.

JAMES O'ROURKE

CLASS OF 1945

Jim O'Rourke could do it all, and he was eloquent enough to tell the world about it, too.

The ballplayer nicknamed "Orator Jim" put in at least one hundred games at six different positions. In total, O'Rourke played significant time at all three outfield spots, in addition to playing first, third, and catcher during his twenty-three-year career. By the time he left the big leagues in 1904, O'Rourke had played all infield and outfield positions, and, according to the *Baseball Encyclopedia,* he appeared as a pitcher six times, too.

"O'Rourke has made a brilliant record for himself as an outfielder," the *Sporting Life* reported back in the day. "As a thrower, too, he stands pre-eminent, being credited with a throw of 365 feet, the next to the longest yet accomplished by any player."

It was with the bat, though, that O'Rourke really solidified his reputation as one of the game's top players. During baseball's early days, only Cap Anson was better in many of the major hitting categories. Some regard O'Rourke as the Barry Bonds or Ted Williams of his era (1872–1904), as he hit .300 or better thirteen times in his career. Besides being so versatile, he is also considered one of the game's first iron men, as he appeared in 1,999 contests. O'Rourke was credited with the first base hit in National League history when he singled off Lon Knight on Opening Day 1876.

In 1877 O'Rourke put up a season for the ages when he batted .362 for Boston, leading the league in runs while remaining among the leaders in hits, total bases, and slugging percentage. The versatile right-handed hitter led the league in home runs during the 1874, 1875, and 1880 seasons, hits in 1884, and triples in 1885.

At a time when ballplayers didn't exactly go out of their way to take care of themselves, O'Rourke believed in clean living. "I never touched a drop of liquor," he said, "nor did I ever use tobacco. I always took care of myself. That's why I went along, while the other fellows hit the road which has no return route."

Even after his impressive playing career ended, O'Rourke continued to be a presence in the National Pastime. He managed several ball clubs, including Washington and Buffalo. In addition, O'Rourke umpired during the 1894 season. But, more important, he proved to be one of the few ballplayers who moved successfully from between the lines to the front office. O'Rourke operated the teams in his hometown of Bridgeport, Connecticut, from 1895 to 1908 and was president of the Connecticut League for six years. Even into his fifties, he demonstrated he could still play the game, frequently stepping in as catcher in Bridgeport.

O'Rourke had a brother (John) and a son (James "Queenie") who went on to play in the majors as well. He died of pneumonia in 1919.

—T. Wendel

O'ROURKE, 3d B., New Yorks

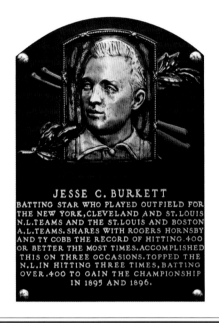

JESSE C. BURKETT
BATTING STAR WHO PLAYED OUTFIELD FOR
THE NEW YORK, CLEVELAND AND ST. LOUIS
N.L.TEAMS AND THE ST.LOUIS AND BOSTON
A.L.TEAMS. SHARES WITH ROGERS HORNSBY
AND TY COBB THE RECORD OF HITTING .400
OR BETTER THE MOST TIMES. ACCOMPLISHED
THIS ON THREE OCCASIONS. TOPPED THE
N.L. IN HITTING THREE TIMES, BATTING
OVER .400 TO GAIN THE CHAMPIONSHIP
IN 1895 AND 1896.

JESSE BURKETT

CLASS OF 1946

Over the years, several notable ball-players began their careers as pitchers and eventually found a better fit for themselves in the everyday lineup. But few made the jump with more success than one of the early pioneers of the game, Jesse "The Crab" Burkett.

Burkett grew up in Wheeling, West Virginia, and won twenty-seven games as a pitcher for Scranton in 1888. But his career appeared to be over when he won only three games in thirteen decisions and posted a 5.57 ERA with the New York Giants two seasons later. The following year he was sold to the Cleveland Spiders in the National League and was assigned to a minor league team in Lincoln, Nebraska. There he made the move to the outfield, and after hitting .316, he earned an August promotion to the big leagues and never looked back.

Burkett soon proved a natural with the bat. By his fourth big league season, Burkett was spraying line drives and raised his average nearly seventy-five points—hitting .348 in 1893.

From there he just kept going, hitting .358 in 1894. After that he hit better than .400 in consecutive seasons. Burkett often kept his hit parade alive by being proficient at bunting. Joe Quinn, who went on to be a major league manager, remembered Burkett telling the batting practice pitcher to throw as hard as he could. Then Burkett promptly laid down a pair of perfect bunts, the first along the third-base line and the second down the first-base line. He stroked the third offering over second base.

During his eight seasons in Cleveland, Burkett earned the moniker "The Crab" for his serious temperament and his occasional outbursts, sometimes at fans in the bleachers. But more important, he led the National League in hitting, averaging .405 in 1895 and .410 a season later.

In 1899 Burkett and Cy Young were transferred to St. Louis by Frank Robison, who owned the Spiders and Perfectos. Burkett didn't miss a beat as he again paced the league in hitting in 1901, this time with a .376 average. Between 1895 and 1901, Burkett collected more than two hundred hits in six seasons.

In 1902 Burkett jumped to the American League's St. Louis Browns, but his hitting soon began to tail off. Even though he would play another four seasons at the big league level, finishing with the Boston Red Sox, he didn't come close to another two-hundred-hit season.

Burkett went on to purchase the Worcester franchise in the New England League. While he owned the ball club, he also regularly patrolled the outfield. From 1906 to 1909, Worcester finished first four times and Burkett hit .323. He went on to coach and play for teams in Lawrence, Lowell, and Haverhill, Massachusetts; Lewiston, Maine; and Hartford. After brief stints coaching at Holy Cross College and with the New York Giants (managed by John McGraw), he returned to managing in the NEL, finishing up with Lowell in 1933.

Thirteen years later he was elected to the National Baseball Hall of Fame.

—C.M.

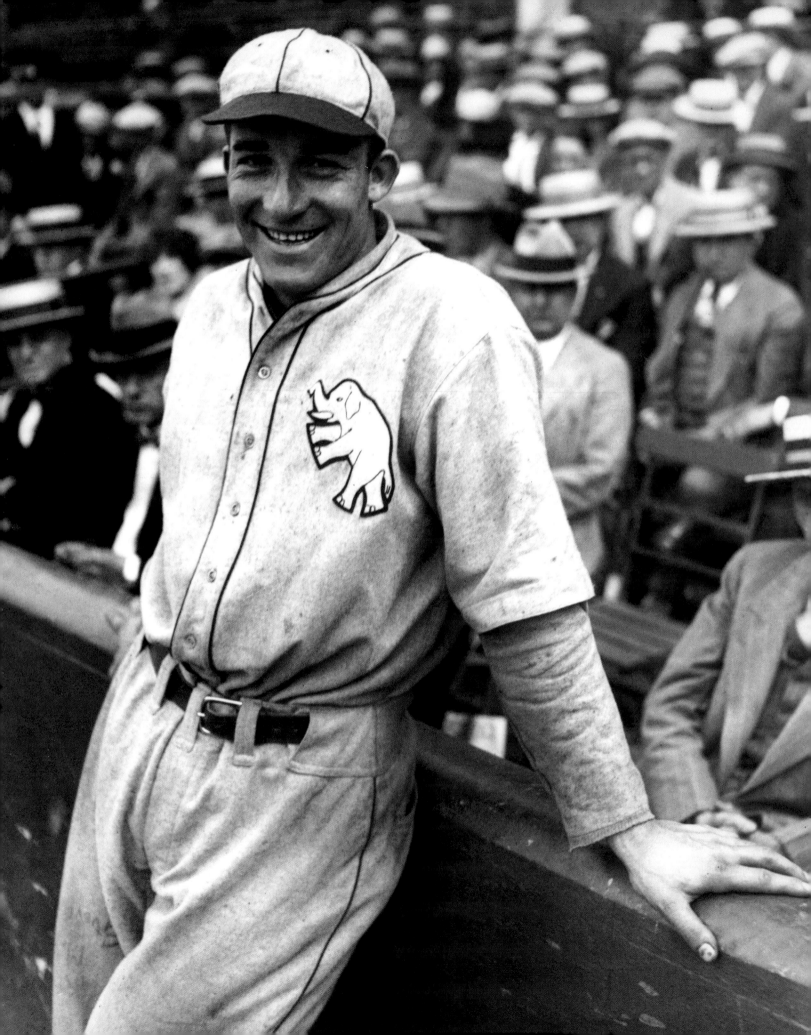

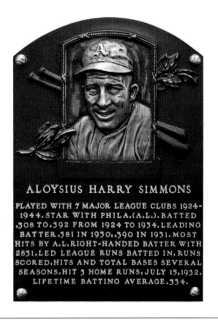

ALOYSIUS HARRY SIMMONS
PLAYED WITH 7 MAJOR LEAGUE CLUBS 1924-
1944. STAR WITH PHILA. (A.L.). BATTED
.308 TO .392 FROM 1924 TO 1934. LEADING
BATTER .381 IN 1930, .390 IN 1931. MOST
HITS BY A.L. RIGHT-HANDED BATTER WITH
2831. LED LEAGUE RUNS BATTED IN, RUNS
SCORED, HITS AND TOTAL BASES SEVERAL
SEASONS. HIT 3 HOME RUNS, JULY 15, 1932.
LIFETIME BATTING AVERAGE .334.

AL SIMMONS

CLASS OF 1953

He had an unorthodox approach to batting, one that would never have been taught by a hitting instructor. But the art of hitting is not always conventional, as Al Simmons showed all too many pitchers in the 1920s and 1930s.

The son of Polish immigrants, Simmons was born in Milwaukee, where he would begin his minor league career in 1922. He wrote letters to several major league clubs asking for a tryout, but was turned away until Philadelphia A's owner-manager Connie Mack finally purchased his contract.

Simmons reported to Philadelphia in 1924 and became the object of ridicule from his teammates, who made fun of his unusual batting stance. A right-handed hitter, Simmons stood with his left foot angled toward the third-base dugout; his foot moved that way as he began his swing, prompting the unflattering nickname "Bucketfoot Al." "Let the boy alone," Mack said sternly to Simmons's teammates. "I don't care how he stands up there the way he hits the ball."

Mack was right. Simmons batted .308 as a twenty-two-year-old rookie. In his second season he led the American League in total bases on the way to a second-place finish in the MVP voting. In 1927 he lifted his batting average to .392.

Three of Simmons's best seasons occurred from 1929 to 1931, when he won a pair of batting titles and helped Philadelphia claim three American League Pennants and two world titles.

Starring throughout the three World Series, the clutch-hitting Simmons ripped six home runs and drove home seventeen.

Simmons had especially long arms and liked to use a lengthy bat. "He had the best power to the opposite field of any hitter I saw," Detroit Tigers catcher Ray Hayworth told *Sports Illustrated*. "He used to hit the ball over the right field scoreboard like a left-handed hitter."

As much power as Simmons displayed, he featured an all-around game. He was a gifted outfielder and a tough base runner, adept at taking out middle infielders at second base. Simmons's intensity was never more evident than during one doubleheader. Playing in the first game, he ruptured a blood vessel in his knee. Rather than go to the hospital, he remained on the bench for the second game. With the bases loaded and Philadelphia trailing by three runs, Simmons limped to the plate as a pinch hitter and proceeded to hit a grand slam.

After 1932 Simmons became a victim of Mack's cost-cutting maneuvers. Sold to the Chicago White Sox, he put up two good seasons before age began to take its toll.

At his best, Simmons was one of the most feared hitters of his era. Opposing pitchers placed him among the game's legends. "I pitched against Babe Ruth, Ty Cobb, Al Simmons and a host of other great ones," Hall of Fame pitcher Urban "Red" Faber told the *Sporting News*. "For some reason, Ruth didn't give me as much trouble as Cobb and Simmons. I think Simmons was the toughest I ever faced. He had a peculiar stance, with his foot in the bucket, but he was hard to fool."

—B.M.

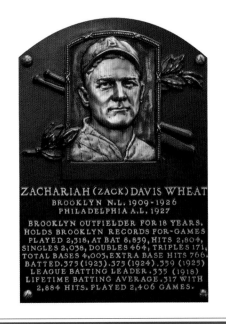

ZACHARIAH (ZACK) DAVIS WHEAT
BROOKLYN N.L. 1909-1926
PHILADELPHIA A.L. 1927
BROOKLYN OUTFIELDER FOR 18 YEARS.
HOLDS BROOKLYN RECORDS FOR-GAMES
PLAYED 2,318, AT BAT 8,859, HITS 2,804,
SINGLES 2,038, DOUBLES 464, TRIPLES 171,
TOTAL BASES 4,003, EXTRA BASE HITS 766,
BATTED .375 (1923) .375 (1924) .359 (1925)
LEAGUE BATTING LEADER .335 (1918)
LIFETIME BATTING AVERAGE .317 WITH
2,884 HITS. PLAYED 2,406 GAMES.

ZACK WHEAT

CLASS OF 1959

Among the greatest hitters in Dodgers history, Zack Wheat first appeared in the team lineup near the end of the 1909 season and played twenty-six games. One of the first players Wheat was introduced to was the incumbent left fielder, Wally Clement, who welcomed him cordially.

Clement, who could not predict the future, said it was nice that the team was bringing up some young players to give the "old fellows" a rest at the end of the year. "It turned out to be a pretty long rest," said Wheat, who was twenty-one when he made his debut, "because for the next 18 years I was the left fielder."

Wheat appeared in a National League–best 156 games for Brooklyn in 1910, hitting .284 with thirty-six doubles. By the end of the decade, Wheat had posted six seasons where he hit at least .300, including in 1918, when his .335 average led the NL.

Wheat also led the Dodgers to the World Series in both 1916 and 1920, where he hit a combined .283.

With the introduction of a livelier ball in the 1920s, Wheat became one of the most dangerous batters in the Senior Circuit. He recorded his three 200-hit seasons in 1922, 1924, and 1925 and batted no lower than .359 from 1923 to 1925.

In late 1926 Wheat hit a memorable home run in the tenth inning of a game against the St. Louis Cardinals. But it proved to be one of his last heroic moments with the Dodgers.

"I hit one over the right-field wall and darned if I didn't pull a charley horse running from first base to second," Wheat said. "I had to sit down on second base and rest. For a few minutes I thought I couldn't make it and Rabbit Maranville [another future Hall of Famer] came out from the bench to finish the job of running around the bases for me. That would have been something, wouldn't it? A pinch runner for a man who had just belted one out of the park! I still don't know how you would have scored it. I finally was able to limp the rest of the way."

Wheat said he was sure that manager Wilbert Robinson decided right then to get rid of him. In the offseason, Wheat was released and played his final season with the Philadelphia Athletics. "I think that Robbie decided to fire me right at that moment," Wheat said of the instant when his home run trot went bad. "It really hurt me to leave Brooklyn."

For the first half of the twentieth century, Wheat, whose nickname was Buck, was the most popular Dodgers player, a captain of the team and its best hitter. He said the fans were the most loyal in the game. "I'd make an error and those kids in the left field bleachers would yell, 'You'll get him next time, Buck!'"

Casey Stengel, a Dodgers teammate, supported Wheat's view. "He was the only great ball player who was never booed a single time," Stengel said.

Wheat retired in 1927 with a .317 lifetime average. He was elected to the Hall of Fame in 1959.

"It's wonderful," said Wheat of his Hall of Fame election. "This is as high as you can go."

—C.M.

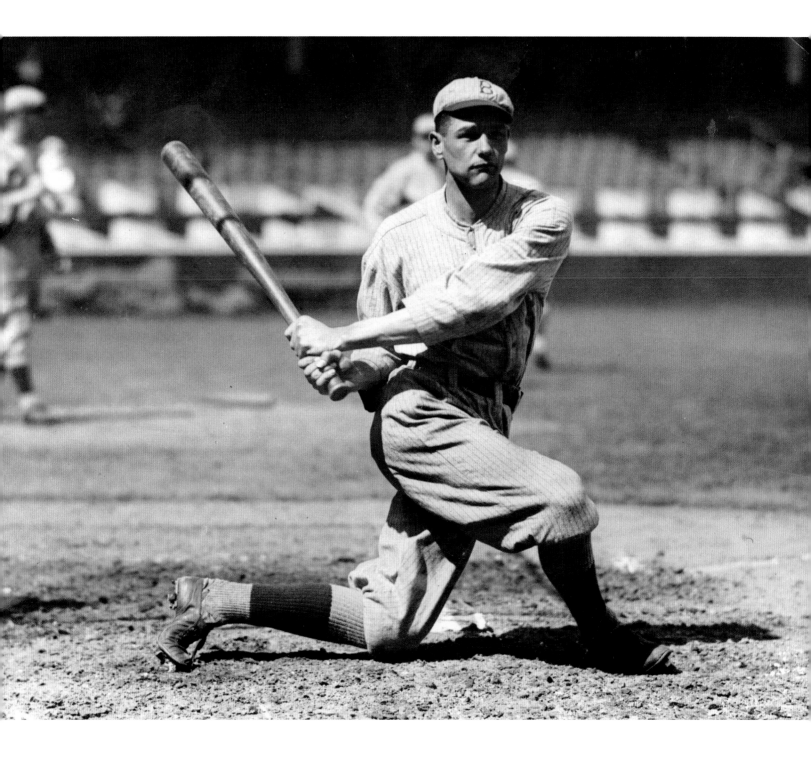

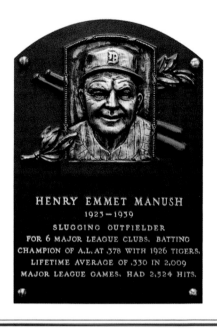

HENRY EMMET MANUSH
1923—1939
SLUGGING OUTFIELDER
FOR 6 MAJOR LEAGUE CLUBS. BATTING
CHAMPION OF A.L. AT .378 WITH 1926 TIGERS,
LIFETIME AVERAGE OF .330 IN 2,009
MAJOR LEAGUE GAMES. HAD 2,524 HITS.

HEINIE MANUSH

CLASS OF 1964

A lifetime .330 hitter across seventeen years in the big leagues, and winner of the 1926 American League batting title with a .378 average, Heinie Manush gave credit for his success to growing up in a family of sportsmen and taking good care of his eyesight.

"My family was athletic," Manush said. "I was one of a group of brothers, all ball players. My eyes were always good. I have been careful to avoid eye strain. I do not read much, particularly in the evening. No one ever gained a batting championship without confidence in his ability to hit. Anybody who beats out the field, no matter how lucky he may be, must be hitting about right. There's a fine edge to your work that you can feel, but can't describe."

The vast majority of Manush's career was spent roaming the outfield for the Detroit Tigers and the Washington Senators, and he had four 200-plus-hit seasons, so keeping those eyes sharp must have paid off.

One of seven boys in the family, Manush said his father came from Germany and didn't know a thing about the sport. "He didn't even know what a baseball looked like," Manush said. "I don't think my dad ever knew a base hit from an error. My dad died in 1924 and I made good in 1923, but I think he saw me play in a big league game."

Manush was lucky he even got into a big league game at that point in his career. When he attended his first Tigers spring training, up from the minors, Manush's competition for an outfield spot included Ty Cobb, Harry Heilmann, Ira Flagstead, Bob Veach, and Bob Fothergill. "It turned out at first I couldn't even get to take batting practice," Manush said. "They wouldn't let me. Finally, when Cobb's back was turned Heilmann got sorry for me and he said, 'Kid, take my turn.' I finally get into a few exhibitions somewhere and Cobb sends Flagstead to Boston and keeps me as an extra outfielder."

Having the demanding Cobb as manager was educational, Manush thought. Cobb was innovative and employed techniques that would become commonplace but were not in widespread use in the 1920s. "He made a lot of these rules in baseball about things to do and he did them," Manush said. "When I first joined the ball club he told me to hit back of the runner. I didn't know what he was talking about. Man on first base, pull that ball through that hole."

One game that Manush recalled well combined achievement and oddity. It occurred while he was playing for the St. Louis Browns. Jack Quinn was pitching for the Philadelphia Athletics when Manush went 5-for-5 against him. That was pretty cool in itself, but there was a "believe-it-or-not" part to the story, Manush said. "Not one of my hits reached the outfield and I broke five bats. I don't think any other ball player ever had an experience just like that one."

—L.F.

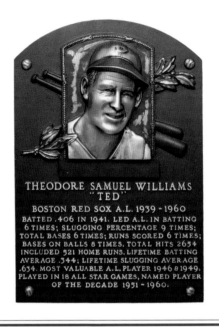

THEODORE SAMUEL WILLIAMS
"TED"
BOSTON RED SOX A.L. 1939 - 1960
BATTED .406 IN 1941. LED A.L. IN BATTING
6 TIMES; SLUGGING PERCENTAGE 9 TIMES;
TOTAL BASES 6 TIMES; RUNS SCORED 6 TIMES;
BASES ON BALLS 8 TIMES. TOTAL HITS 2654
INCLUDED 521 HOME RUNS. LIFETIME BATTING
AVERAGE .344; LIFETIME SLUGGING AVERAGE
.634. MOST VALUABLE A.L. PLAYER 1946 & 1949.
PLAYED IN 18 ALL STAR GAMES, NAMED PLAYER
OF THE DECADE 1951 - 1960.

TED WILLIAMS

CLASS OF 1966

In combining keen vision with quick wrists and a scientifically exacting approach to the strike zone, Ted Williams was arguably the game's most dynamic hitter. As the last man to hit .400 for a season, he put together a list of accomplishments that could go on for paragraphs. His achievements included two American League Triple Crowns and a place in history as a hero of war.

Born in San Diego to a mother of Mexican descent, Williams became a star in the Pacific Coast League before earning a promotion to the Boston Red Sox. In 1939 the twenty-year-old made his debut. He compiled a .327 batting average and a rookie record of 145 RBI.

Over the next three seasons Williams led the league in home runs twice, won a pair of batting titles, and led in on-base percentage all three times. Yet none of it came easy. "It's a hard thing to coach, you have to have some experience to do it, and you got to have some ability, got to have good eyes, and you have to have athletic ability where you can swing coordinated and quick," Williams said. "Making good contact with a round ball and a round bat, even if you know what's coming, is hard to do. . . . It's the hardest thing to do in baseball."

Off the field, Williams faced even greater challenges. Beginning in 1943, he missed three seasons while serving in World War II. Then came the Korean War, which took him away from baseball for most of two more seasons.

"I got to say this, how lucky I've been in life," Williams told Hall of Fame president Jeff Idelson. "I've lived a kind of precarious life style, precarious in sports, flying, and baseball. But the thing I'm proudest of in my life is that I became a Marine pilot. . . . I had to work hard as hell to keep going. . . . I think that was the greatest accomplishment I had in my life."

On the field, Williams's accomplishments carried less global importance but managed to instill awe in fans. One such example came in 1957, when he hit .388 at the age of thirty-eight. Another occurred in 1960, when he hit a monstrous home run in his final major league at bat.

Given his hitting prowess, Williams would have had plenty to boast about during his Cooperstown induction speech. Instead, he selflessly stated his case for the induction of less appreciated players: "Baseball gives every American boy a chance to excel, not just to be as good as someone else, but to be better than someone else. . . . And I hope that someday, the names of Satchel Paige and Josh Gibson in some way can be added as a symbol of the Negro players that are not here only because they were not given a chance." Williams's remarks paved the way for the induction of Negro Leaguers, beginning with Paige in 1971.

Once again, Williams gave up his own time for the benefit of others. "Nobody was more loyal, generous, courageous, more respected than Ted," Yogi Berra told the Associated Press. "He sacrificed his life and career for his country. But he became what he always wanted to be—the greatest hitter ever."

—B.M.

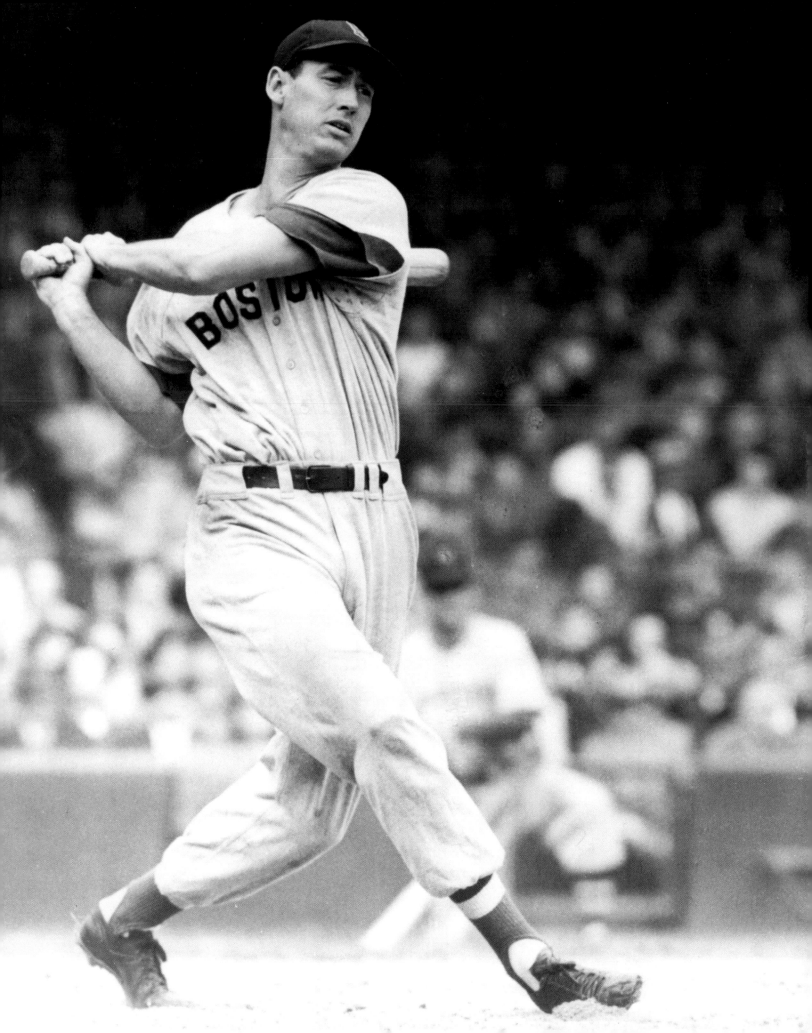

GOOSE GOSLIN

CLASS OF 1968

To his mind, Goose Goslin was born to play baseball and no one could convince him otherwise, not even his father, who gave him chores to do around the family farm in New Jersey. When he was just twelve years old, his dad told Goslin to make sure to keep the cows out of the tomatoes and corn.

Only, Goslin went off to play ball instead, and when he returned home, "the cows were just where they should not have been and I got mine. But dad was not always able to catch me and I managed to get into a game now and then." Eventually Goslin became the star of the local team, though once, the manager had to come by the farm and beg his father to let him play in an important contest. At sixteen Goslin left home to play for a touring semipro team, and by nineteen he was playing for more pay in the minors in South Carolina.

At first Goslin was a pitcher, but by the time he made his debut in the American League at age twenty in fourteen games for the Washington Senators, he was an outfielder. That kicked off an eighteen-year career with a .316 lifetime batting average, though it took time for Goslin to improve at the plate. "For several years they dusted me off persistently," Goslin said, "and now and then they got me sore. I remember how I all but got into a fist fight occasionally when some pitcher kept throwing them at my head. But they merely made me a better hitter. I got so I could drive those beanballs out of the lot. They thought I did not have the courage, but I showed them they could not drive me back."

The longer Goslin played, the more respect he gained. A big fan was New York Giants manager John J. McGraw. "Let me say that I regard Goslin as one of the most brilliant and effective championship players that I ever have seen," said McGraw, who saw plenty of Goslin in the 1924 World Series, when the Senators defeated his team.

Goslin's mound nemesis was Earl Whitehill of the Tigers. "That boy Whitehill certainly has caused me lots of trouble," Goslin said, "more than anything else in the world. Once, in a close game, I came in and picked off a three-bagger that snuffed off Detroit for that day. But I guess it was a toss-up which was the most surprised—Earl or me."

In 1935, playing for the Tigers by then, Goslin won the World Series over the Chicago Cubs with a single in the ninth inning of Game 6. A fisherman and rental boat operator in retirement back in south Jersey, Goslin closely followed 1960s baseball on TV and was impressed by Sandy Koufax and Maury Wills. Goslin said he'd thought he was a good base runner for stealing twenty-seven bases in a season once, "but compared to Wills I was slow as a turtle."

—L.F.

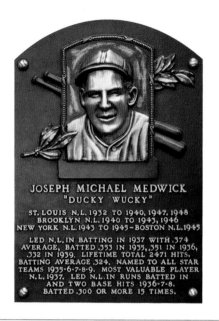

JOSEPH MICHAEL MEDWICK
"DUCKY WUCKY"

ST. LOUIS N.L. 1932 TO 1940, 1947, 1948
BROOKLYN N.L. 1940 TO 1943, 1946
NEW YORK N.L. 1943 TO 1945 – BOSTON N.L. 1945

LED N.L. IN BATTING IN 1937 WITH .374
AVERAGE, BATTED .353 IN 1935, .351 IN 1936,
.332 IN 1939. LIFETIME TOTAL 2471 HITS,
BATTING AVERAGE .324. NAMED TO ALL STAR
TEAMS 1935-6-7-8-9. MOST VALUABLE PLAYER
N.L. 1937. LED N.L. IN RUNS BATTED IN
AND TWO BASE HITS 1936-7-8.
BATTED .300 OR MORE 15 TIMES.

JOE MEDWICK

CLASS OF 1968

His physique consisted of muscles piled on top of muscles. He put on legendary displays in batting practice, sending balls barreling out of the ballpark. His swing tormented opposing pitchers, who came to despise the presence of Joe Medwick in the batter's box.

A native of New Jersey, Medwick signed with the St. Louis Cardinals, who promoted him to the majors in September 1932. He hit .349, convincing the Cardinals that they had found their new left fielder.

Medwick unfurled a reign of terror against National League hurlers. From 1933 to 1937 he improved his average almost every season, raising it from .306 to .374. His slugging percentage also jumped each year, from a low of .497 to a high of .641.

Medwick peaked in 1937. He won the Triple Crown and the MVP, and also led the league in runs, hits, and doubles. One of the great bad-ball hitters of all time, he had little interest in taking walks, instead swatting pitches outside the strike zone for doubles. In 1936 he reached a remarkable high of sixty-four two-baggers.

Like many of his "Gashouse Gang" teammates, Medwick carried himself with a distinctive style. "Every time I see that guy," Medwick's former manager Frankie Frisch told sportswriter Ed Rumill, "I think of the Gashouse Gang and the gray they put in my hair. Now it's funny. [Back] then it kept me awake at night. I'd walk into the clubhouse and Medwick or Pepper Martin would be wrestling on the cement floor with Dizzy Dean. A million dollars' worth of talent, wrestling on the cement."

Medwick earned the nickname "Ducky Wucky" when a female fan noticed that he waddled as he walked. Others called him "Muscles" on account of his rugged build. As tough as any player, Medwick raged with fiery competitiveness.

His heated approach came to a head during the 1934 World Series. In Game 7, he slid hard into Detroit's Marv Owen, who dug his spikes into Medwick's leg. Medwick responded by kicking the third baseman. The next half inning, Detroit fans pelted him with an array of fruit, garbage, and bottles. Given the unrelenting barrage, Commissioner Landis ordered Medwick to leave the field. By then, Medwick had done sufficient damage to Tigers pitching, hitting .379 to lead the Cardinals to a world championship.

In 1938 Medwick led the league in RBI, but he became trade bait in the middle of 1940. The Cardinals dealt him to Brooklyn for a package of four players and $125,000, an enormous sum of money for the time. The trade paid off for the Dodgers; in 1941 Medwick put up another great season and helped Brooklyn win the pennant. He also played well in 1944 before eventually returning to St. Louis in 1947 and closing out his career in 1948.

At his best, Medwick was one of the game's most dangerous hitters. He drew praise from a man who was considered the master of the art. "And Medwick? I rate him the NL's No. 2 right-handed hitter [of all time], just behind Rogers Hornsby," Ted Williams informed the *Sporting News*. "When Joe was in his prime, he absolutely owned the National League."

—B.M.

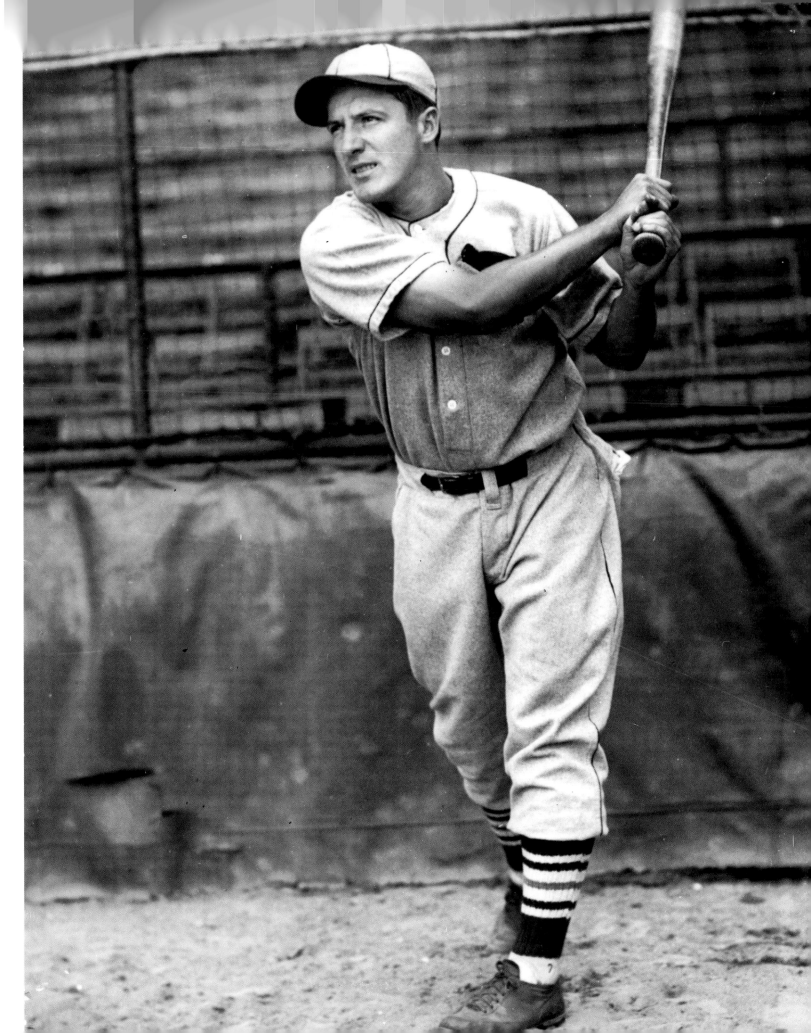

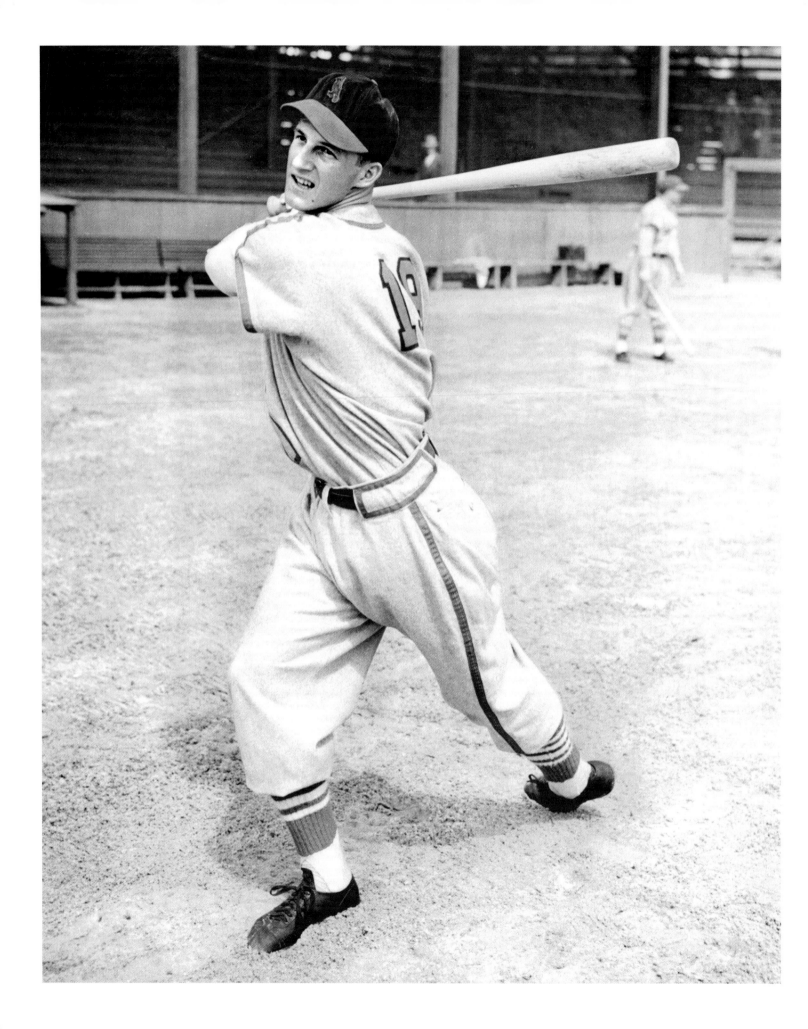

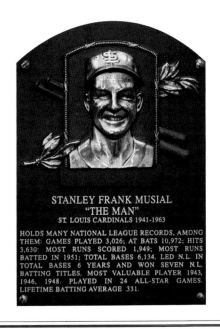

STANLEY FRANK MUSIAL
"THE MAN"
ST. LOUIS CARDINALS 1941-1963

HOLDS MANY NATIONAL LEAGUE RECORDS, AMONG
THEM: GAMES PLAYED 3,026; AT BATS 10,972; HITS
3,630: MOST RUNS SCORED 1,949; MOST RUNS
BATTED IN 1951; TOTAL BASES 6,134. LED N.L. IN
TOTAL BASES 6 YEARS AND WON SEVEN N.L.
BATTING TITLES. MOST VALUABLE PLAYER 1943,
1946, 1948. PLAYED IN 24 ALL-STAR GAMES.
LIFETIME BATTING AVERAGE .331.

STAN MUSIAL

CLASS OF 1969

May 2, 1954, was a day that exempli-
fied the baseball career of Stan Musial.
In a Sunday doubleheader against
the New York Giants, Musial was the
embodiment of balance, with four hits,
three home runs, and six runs batted in
during the first game, followed by two
more home runs and three RBI in the
second game. Before a St. Louis home
crowd, Musial achieved an epic day at the plate, slugging six hits,
five home runs, nine RBI, and twenty-one total bases.

Evenly distributing his numbers between the two games that
afternoon was characteristic of his astonishingly symmetrical
career: 1,815 hits at home and 1,815 hits on the road, to equal a
lifetime total of 3,630—still fourth on the all-time list half a cen-
tury after his 1963 retirement. Not bad for a skinny kid from the
steel town of Donora, Pennsylvania, who began his big league
stint as a sore-armed pitcher-turned-outfielder and who missed
the entire 1945 campaign owing to service in World War II.

Musial's enduring legacy as one of history's most consistent
hitters can be appreciated only by viewing the full scope of his
achievements. After twenty-two seasons, all with the National
League's Cardinals, he was among the lifetime leaders in hits,
games played, plate appearances, at bats, runs, doubles, runs
batted in, total bases, and times on base. His career .331 aver-
age and 475 home runs helped make him the first player to
accumulate both four hundred homers and three thousand hits.

He also was the first man to appear in three thousand National
League games.

So relentless were Musial's offensive skills that in 1946,
Brooklyn fans, beleaguered by his continual barrage against the
Dodgers, respectfully nicknamed him "The Man." Were it not for
a 1948 rainout of a game in which he'd homered, Musial would
have tied for most home runs in the Senior Circuit that year and
won the Triple Crown. Still, he attained seven NL batting crowns
and three NL Most Valuable Player Awards, and appeared in
twenty-four All-Star Games during his career.

Musial starred in four World Series wearing the Cardinals
uniform, winning three, and in his post-career stints as vice
president and general manager of the team, he helped guide the
Redbirds to additional championships. The Cardinals honored
him with two statues outside their ballpark. The first, erected in
1968, depicts Musial's corkscrew stance with an inscribed quota-
tion from former baseball commissioner Ford Frick: "Here stands
baseball's perfect warrior. Here stands baseball's perfect knight."

He was a first-ballot Hall of Fame inductee in 1969. For all
his diamond accomplishments, Musial was equally admired for
his character off the field. Fellow Hall of Famer Mickey Mantle
once said, "[Musial] was a better player than me because he was
a better man than me." Always affable and ever ready with his
harmonica, Musial was beloved in his later years, receiving the
nation's highest civilian honor, the Presidential Medal of Freedom,
in 2011, less than one year before his death at age ninety-two.

—J.A.

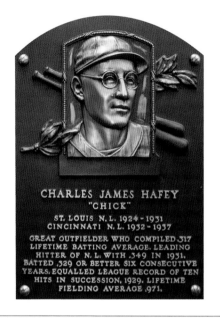

CHARLES JAMES HAFEY
"CHICK"

ST. LOUIS N. L. 1924-1931
CINCINNATI N. L. 1932-1937
GREAT OUTFIELDER WHO COMPILED .317
LIFETIME BATTING AVERAGE. LEADING
HITTER OF N. L. WITH .349 IN 1931.
BATTED .329 OR BETTER SIX CONSECUTIVE
YEARS. EQUALLED LEAGUE RECORD OF TEN
HITS IN SUCCESSION, 1929. LIFETIME
FIELDING AVERAGE .971.

CHICK HAFEY

CLASS OF 1971

Few star ballplayers had to overcome such a steady stream of physical ailments to succeed as did Chick Hafey during a thirteen-year career with the St. Louis Cardinals and Cincinnati Reds. Not only was his vision less than perfect—he was one of the first major leaguers to wear glasses—but also Hafey suffered from a chronic sinus condition and other unexplained illnesses.

Somehow, though he had to take long rests away from the game to cope with these debilitating obstacles, not to mention the everyday challenges of being a professional ballplayer, Hafey was able to protect the corners of the outfield assigned to him and bat .317.

"I always thought that if Hafey had been blessed with normal eyesight and good health he might have been the best right-handed hitter baseball had ever known," the great executive Branch Rickey observed.

Rickey was not the only one who had high praise for the outfielder who carried a big stick and possessed a wickedly impressive throwing arm. "With good eyes, Hafey would have been the greatest player who ever lived," said New York Giants manager John J. McGraw. "He also had the best outfielder's arm I ever saw," said another Hall of Fame manager, Bill McKechnie.

Despite the compliments, Hafey was always embroiled in salary disputes with Rickey. One time, the Californian got so exasperated trying to negotiate a contract with Rickey that he fled the Florida training camp for home, thousands of miles by car. "I was so angry I drove 90 miles an hour across the desert," Hafey said.

Hafey only started wearing glasses after he reached the majors. He wasn't getting out of the way of pitched balls fast enough, so he underwent an eye exam. "Nobody gave me a break because I wore glasses," Hafey said. "The only reference I can remember is one made by Van [Lingle] Mungo. I hit a home run off him when he was pitching for Brooklyn and he was really burning. 'That's the last time I'll respect those . . . things!'"

Andy High, a onetime teammate, witnessed the kind of problems Hafey endured from his sinus condition. "I remember one time when he was hitting .360 and his sinus flared up," High said. "He stood at one end of a Pullman car, and putting his hand over first one eye, then the other, saw a bright red light at the other end as only a faint blur."

When healthy, Hafey was noted as a powerful pull hitter. Brooklyn Dodgers third sacker Fresco Thompson played Hafey extremely deep. After surveying the situation, Hafey laid down a bunt along the third-base line and created an infield single. After Hafey was back in the Cardinals dugout, a ballpark vendor leaned in and handed him an ice cream bar. It was a gift from Thompson, with a message. "Compliments of Mr. Thompson," the vendor informed the astonished Hafey. "If you'll bunt again next time, Mr. Hafey, he said he'll send another one."

—L.F.

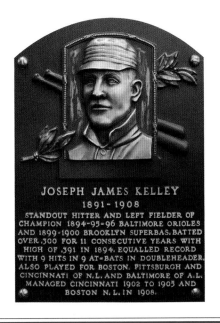

JOSEPH JAMES KELLEY
1891-1908
STANDOUT HITTER AND LEFT FIELDER OF
CHAMPION 1894-95-96 BALTIMORE ORIOLES
AND 1899-1900 BROOKLYN SUPERBAS. BATTED
OVER .300 FOR 11 CONSECUTIVE YEARS WITH
HIGH OF .391 IN 1894. EQUALLED RECORD
WITH 9 HITS IN 9 AT-BATS IN DOUBLEHEADER.
ALSO PLAYED FOR BOSTON. PITTSBURGH AND
CINCINNATI OF N.L. AND BALTIMORE OF A.L.
MANAGED CINCINNATI 1902 TO 1905 AND
BOSTON N.L. IN 1908.

JOE KELLEY

CLASS OF 1971

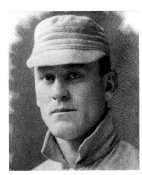

Joe Kelley was the kingpin of the great Baltimore Orioles teams in the 1890s, and many rank him as the best overall player on those classic ball clubs. The top of the old Orioles batting order was one for the ages, with John McGraw batting leadoff, followed by Willie Keeler and Hughie Jennings, and then Kelley often in the cleanup spot. Together they were known as baseball's "Big Four."

"Most of the old Orioles used to swagger on the field, but none more so than Kelley," wrote sportswriter Vincent de Paul Fitzpatrick. "The kids in all cities swarmed around him for Joe made it a practice to take at least one youngster into the ballpark every day, no matter where the team was playing."

Kelley broke in with the Boston Beaneaters in 1891, then moved on briefly to the Pittsburgh Pirates before soon finding a home and a mentor in Baltimore. Manager Ned Hanlon made Kelley, then just twenty, one of his pet projects and often worked with him on hitting and fielding fundamentals before games. The extra work transformed Kelley into one of the most complete ballplayers of his era.

He needed to be, because the Orioles were recognized as the best team of that period, winning the pennant three consec-

utive seasons. Under Hanlon's guidance, they employed many winning strategies that are still popular today. One of them was the hit-and-run. In addition, back in those days a foul ball wasn't counted as a strike, so Kelley and his cohorts would routinely spoil pitches to wear down opposing pitchers.

Other tactics, thankfully, haven't stood the test of time. The old-time Orioles, for example, were accused of hiding baseballs in the tall outfield grass, allowing them to throw out runners who dared go for an extra base on drives to the outfield gaps. But even without such tricks of the trade, Kelley was considered to have one of the best outfield arms in the game.

When the Orioles ran into financial difficulties, Kelley joined Hanlon and several of his teammates in Brooklyn in the 1899 season. They won the National League Pennant that year and again in 1900. After a return to Baltimore, Kelley headed to Cincinnati, where he also managed, before ending his career with the Boston Doves in 1908.

Kelley batted over .300 in eleven consecutive seasons and once went a record 9-for-9 in a doubleheader. Besides hitting for average, he exhibited good speed on the bases, ending his career with 194 triples and 443 stolen bases.

When Kelley died in 1943, he was buried in Baltimore, in the same cemetery with Hanlon and McGraw.

—T. Wendel

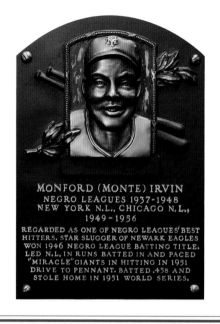

MONFORD (MONTE) IRVIN
NEGRO LEAGUES 1937-1948
NEW YORK N.L., CHICAGO N.L.,
1949-1956
REGARDED AS ONE OF NEGRO LEAGUES' BEST
HITTERS. STAR SLUGGER OF NEWARK EAGLES
WON 1946 NEGRO LEAGUE BATTING TITLE.
LED N.L. IN RUNS BATTED IN AND PACED
"MIRACLE" GIANTS IN HITTING IN 1951
DRIVE TO PENNANT. BATTED .458 AND
STOLE HOME IN 1951 WORLD SERIES.

MONTE IRVIN

CLASS OF 1973

Hall of Famer Roy Campanella said of Monte Irvin, "[He] was the best all-around player I ever saw," and historian Rob Ruck told MLB.com, "The only thing that kept [Irvin] from jumping into the major leagues before Jackie Robinson was he went away to the service. . . . He was just a terrific talent."

Hall of Famer Effa Manley, owner of the Newark Eagles, recalled, "Monte was the choice of all Negro National and American League club owners to serve as the number one player to join a white major league team. We all agreed, in a meeting, he was the best qualified by temperament, character, ability, sense of loyalty, morals, age, experience and physique to represent us as the first black player to enter the white majors since the Walker brothers back in the 1880s. Of course, Branch Rickey lifted Jackie Robinson out of Negro ball and made him the first, and it turned out just fine."

Irvin was all-state in football, basketball, track, and baseball growing up in Orange, New Jersey, where he earned a total of sixteen varsity letters. After high school, he began his professional baseball career in the Negro Leagues with the Newark Eagles.

Able to hit for average and power, the right-handed-hitting slugger played alongside such Negro League greats as Mule Suttles, Willie Wells, and Larry Doby during his stints in Newark. He won his first batting title in the Negro Leagues in 1941 and, shortly after capturing the crown, was drafted into service in World War II. He spent three years serving his country in the Army Corps of Engineers. Irvin returned home after the war and picked up right where he'd left off, leading the Newark Eagles to the 1946 Negro National League championship. He was a five-time All-Star in the Negro Leagues before leaving for the majors in 1949.

During his eight-year major league career, Irvin led the Giants to two National League Pennants and one World Series crown. In 1951 he led the league in RBI with 121, hit .312 with 24 home runs, and stole home in the World Series. In his two appearances in the Fall Classic, Irvin batted a combined .394. During his time with the Giants, he served as a mentor to a young Willie Mays.

Upon retirement, he went on to work in the commissioner's office as assistant director of public relations and promotions, and wrote an autobiography, *Nice Guys Finish First*. In addition, he remained an eloquent spokesman for the Negro Leagues and what might have been. "The pay wasn't much," he recalled. "We didn't stay in integrated hotels. We always stayed in second-, third- or fourth-class hotels. But people came out to watch us, and everywhere we played we were the toast of the town."

—F.B.

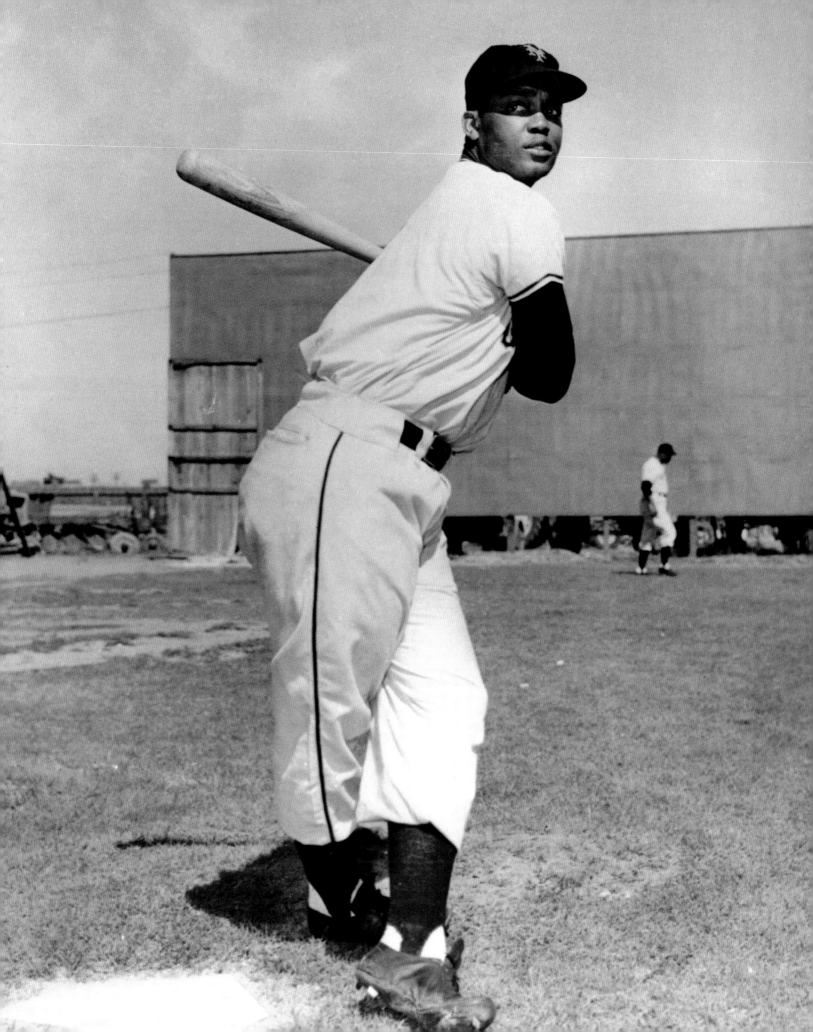

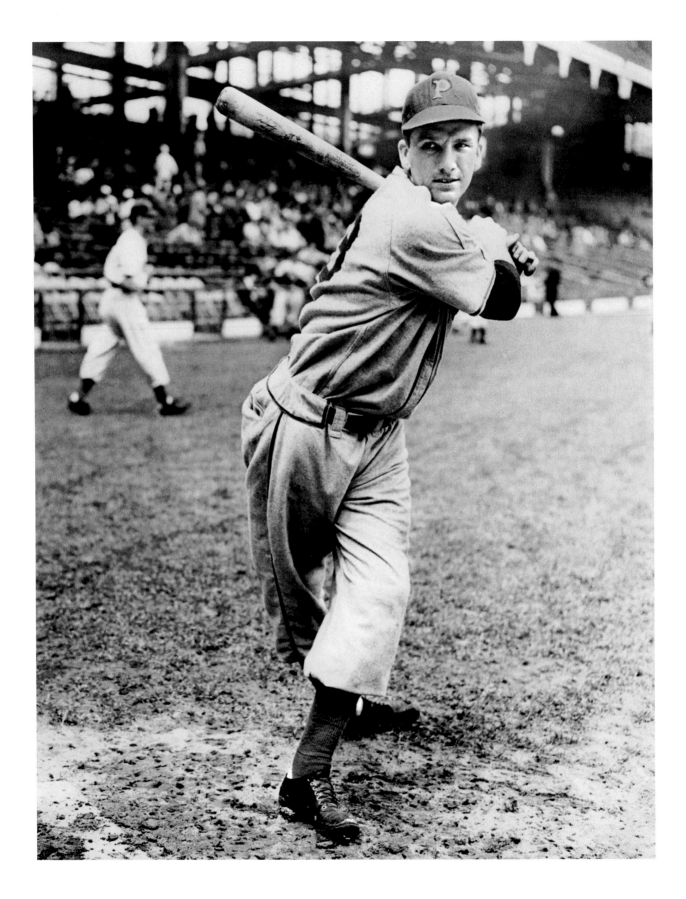

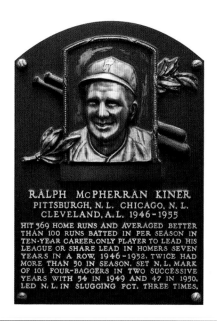

RALPH McPHERRAN KINER
PITTSBURGH, N. L. CHICAGO, N. L.
CLEVELAND, A.L. 1946-1955
HIT 369 HOME RUNS AND AVERAGED BETTER
THAN 100 RUNS BATTED IN PER SEASON IN
TEN-YEAR CAREER. ONLY PLAYER TO LEAD HIS
LEAGUE OR SHARE LEAD IN HOMERS SEVEN
YEARS IN A ROW, 1946-1952. TWICE HAD
MORE THAN 50 IN SEASON. SET N.L. MARK
OF 101 FOUR-BAGGERS IN TWO SUCCESSIVE
YEARS WITH 54 IN 1949 AND 47 IN 1950.
LED N.L. IN SLUGGING PCT. THREE TIMES.

RALPH KINER

CLASS OF 1975

He was a one-man show for some poor Pittsburgh Pirates teams of the late 1940s and early 1950s, a hitter who transcended mere wins and losses.

For ten years, Ralph Kiner may have been the greatest power source the game has ever known.

"Ralph Kiner can wipe out your lead with one swing," said Hall of Fame pitcher Warren Spahn.

Born October 27, 1922, in Santa Rita, New Mexico, Kiner was signed by the Pirates in 1941 but missed almost three full minor league seasons while serving as a Navy pilot in World War II. He made his big league debut in 1946, leading the National League with twenty-three home runs while also striking out a league-high 109 times.

That winter the Pirates obtained future Hall of Famer Hank Greenberg from the Tigers. The Bucs immediately shortened the fences in left field, creating "Greenberg Gardens" as a friendly target for the right-handed slugger.

Kiner also found the short wall inviting, and with the help of Greenberg's tutelage became one of the most feared hitters in the game. Kiner hit .313 with 51 homers and 127 RBI in 1947, the second of a record seven straight seasons when he led the league in home runs.

When Greenberg retired following the 1947 season, the Pirates renamed the short porch in left field "Kiner's Korner." In 1949 Kiner hit fifty-four home runs—just two short of Hack Wilson's then NL record of fifty-six—and became the first National Leaguer with two fifty-plus home run seasons.

The Pirates, however, were never able to surround Kiner with enough talent to produce winning teams. In his seven full seasons in Pittsburgh, Kiner and the Pirates finished above .500 just once and were relegated to last or next-to-last five times. Midway through the 1953 season, Pirates general manager Branch Rickey sent Kiner to the Cubs as part of a ten-player deal—with $150,000 coming to the Pirates as well.

"The hardest thing in the world is to play on a losing team," Kiner said. "I always had a strong competitive drive and I hated to lose. I took an awful lot of pride out on that field with me."

The fans at Forbes Field in Pittsburgh took notice, often staying through hopelessly lost games to catch Kiner's last at bat before heading toward the exits.

Kiner spent the remainder of 1953 and all of 1954 with the Cubs before appearing in just 113 games for the Indians in 1955. A chronic back injury forced Kiner to retire after the 1955 season at the age of thirty-two, with 369 home runs and 1,015 RBI in just ten big league seasons.

Kiner, who had always been a celebrity off the field, joined the White Sox broadcast team in 1961 and then moved to the Mets the following season in their debut campaign in the National League. Kiner quickly became a beloved broadcaster in New York, with his easygoing style and self-deprecating humor.

Kiner was elected to the Baseball Hall of Fame in 1975.

—C.M.

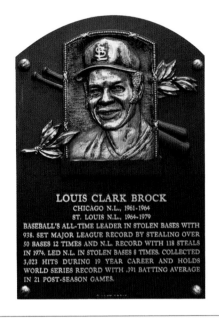

LOUIS CLARK BROCK
CHICAGO N.L., 1961-1964
ST. LOUIS N.L., 1964-1979
BASEBALL'S ALL-TIME LEADER IN STOLEN BASES WITH
938. SET MAJOR LEAGUE RECORD BY STEALING OVER
50 BASES 12 TIMES AND N.L. RECORD WITH 118 STEALS
IN 1974. LED N.L. IN STOLEN BASES 8 TIMES. COLLECTED
3,023 HITS DURING 19 YEAR CAREER AND HOLDS
WORLD SERIES RECORD WITH .391 BATTING AVERAGE
IN 21 POST-SEASON GAMES.

LOU BROCK

CLASS OF 1985

Before Reggie Jackson laid claim to the title of "Mr. October," Lou Brock was a contender for the crown. In three World Series, which ironically all went seven games, Brock hit .391, with four home runs and a record fourteen stolen bases. His presence on the base paths drove many a pitcher to distraction.

"He sometimes doesn't get the general credit that Babe Ruth or Lou Gehrig or Reggie Jackson get, but you talk about Mr. October," said Bob Broeg, the longtime sportswriter with the *St. Louis Post-Dispatch*. "In those games, he would combine power with speed."

Until Rickey Henderson surpassed him, Brock was the game's all-time steals leader, holding the modern record for most stolen bases (938) in Major League Baseball for thirteen years. In addition, he once held the single-season record with 118.

"Speed, running on the base paths, starts rallies," Brock once remarked, explaining, "When a team runs, it forces the other team into mistakes."

Brock's career took off when he was traded from the Chicago Cubs to the St. Louis Cardinals during the 1964 season. Not only did Brock join a veteran team that would go on to win the World Series that autumn, but also the Cardinals soon realized what an asset his blazing speed was. Brock became a fixture in left field, which had been a problem for St. Louis since Stan Musial retired the season before. According to author David

Halberstam, Cardinals manager Johnny Keane asked Brock to forgo hitting home runs in favor of stealing bases. With a regular spot in the lineup and a clear purpose, Brock went on to lead the National League in stolen bases each year from 1966 to 1969 and 1971 to 1974.

"If you aim to steal 30 or 40 bases a year, you do it by surprising the other side," Brock said. "But if your goal is 50 to 100 bases, the element of surprise does not matter."

In 1967 he led the NL in at bats and stolen bases, and tied Hank Aaron for most runs scored (113). The following season, he paced the Senior Circuit in doubles, triples, and stolen bases. During his nineteen-year career, he established a record of twelve straight seasons with more than fifty steals and reached the coveted three-thousand-hit plateau.

"Lou Brock, along with Maury Wills, are probably the two players most responsible for the biggest change in the game over the last 15 years," pitcher Tom Seaver said in 1987.

Larry Bowa noted, "Everybody in the park knows he's going to run and he makes it anyway."

Perhaps Brock's most memorable moment came on September 10, 1974, when the Cardinals outfielder stole his 105th base of the season to break Wills's single-season record. During a time-out, former Negro League speedster James "Cool Papa" Bell presented Brock with the base.

"We decided to give him his 105th base," Bell said, "because if we didn't, he was going to steal it, anyway."

—T. Wendel

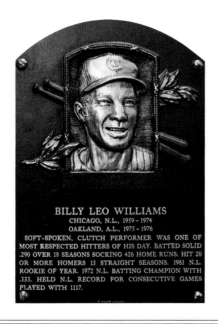

BILLY LEO WILLIAMS
CHICAGO, N.L., 1959 - 1974
OAKLAND, A.L., 1975 - 1976
SOFT-SPOKEN, CLUTCH PERFORMER WAS ONE OF
MOST RESPECTED HITTERS OF HIS DAY. BATTED SOLID
.290 OVER 18 SEASONS SOCKING 426 HOME RUNS. HIT 20
OR MORE HOMERS 13 STRAIGHT SEASONS. 1961 N.L.
ROOKIE OF YEAR. 1972 N.L. BATTING CHAMPION WITH
.333. HELD N.L. RECORD FOR CONSECUTIVE GAMES
PLAYED WITH 1117.

BILLY WILLIAMS

CLASS OF 1987

"Billy Williams is the best hitter, day-in and day-out, that I have ever seen," said longtime Cubs teammate Don Kessinger. "He's unbelievable. He didn't hit for just one or two days, or one or two weeks. He hit all the time."

Billy Williams was discovered in 1956 in Whistler, Alabama, just outside the baseball hotbed of Mobile, by a scout with a perfect name for the Cubs, Ivy Griffin. He signed for "a cigar and a bus ticket." His minor league apprenticeship was difficult, not because he wasn't hitting, but because the ways of the wider world were hitting him.

"I couldn't take the bigotry, discrimination, and overt racism," said Williams. Though he'd grown up in Jim Crow Alabama, the segregated hotels and restaurants on the road were new experiences for him, and in 1959, while playing in San Antonio, he quit and went home. The Cubs dispatched Buck O'Neil to talk him back into the game.

"Sweet-Swinging Billy from Whistler" was a hitter, first and foremost. In sixteen years with the Cubs and two with Oakland, Williams piled up the numbers: 2,711 hits, 426 home runs, and 1,475 RBI. He was a six-time All-Star and twice finished second in MVP voting. He may have been overshadowed by other superstar National League outfielders like Aaron, Clemente, and Mays, and even by other stars on his own club, like Banks and Santo, but those who know the game truly appreciated his talent.

"Billy is the best left-handed hitter I ever saw," said Willie Stargell. "But for all you hear about him you'd think he was playing in the dark. Can he hit the ball hard? I remember one time I was playing first base and he stung one through my legs before I could even move my glove. Bam. It was gone. I always keep my eyes open when Billy is batting. He could hurt you."

Williams was a very consistent hitter, launching twenty or more home runs in thirteen consecutive seasons, and setting a National League record of 1,117 consecutive games played between 1963 and 1970. "He's a well-disciplined man," Ernie Banks said of him. "Billy Williams' life is a system. He gets up at the same time. He eats at the same time, leaves for the park at the same time, gets home at the same time."

Part of Williams's approach to the game was to let his bat do the talking. "Billy had a saying," said Banks. "'When fish open their mouths, they get caught.' Billy didn't talk much. Billy just played." It was part of his even-keeled approach.

Joe Torre, whom Williams edged out for the 1961 NL Rookie of the Year Award, agreed: "He leads his club with his bat and just the way he plays."

Williams commented on the under-the-radar nature of his achievements in his autobiography: "People say I'm not an exciting player. I go out there and catch the ball and hit the ball and play the game like it should be played." Yet it all added up to a Hall of Fame career, a retired number, and a statue outside Wrigley Field that has just as much to say as Billy did.

—T. Wiles

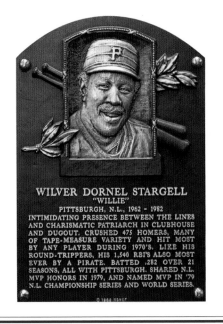

WILVER DORNEL STARGELL
"WILLIE"
PITTSBURGH, N.L., 1962 - 1982
INTIMIDATING PRESENCE BETWEEN THE LINES
AND CHARISMATIC PATRIARCH IN CLUBHOUSE
AND DUGOUT. CRUSHED 475 HOMERS, MANY
OF TAPE-MEASURE VARIETY AND HIT MOST
BY ANY PLAYER DURING 1970'S. LIKE HIS
ROUND-TRIPPERS, HIS 1,540 RBI'S ALSO MOST
EVER BY A PIRATE. BATTED .282 OVER 21
SEASONS, ALL WITH PITTSBURGH. SHARED N.L.
MVP HONORS IN 1979, AND NAMED MVP IN '79
N.L. CHAMPIONSHIP SERIES AND WORLD SERIES.

WILLIE STARGELL

CLASS OF 1988

Willie Stargell's ascent to the Hall of Fame did not take place overnight. He overcame a number of adversities, from growing up in a government housing project to encountering racism in the minor leagues.

Though born in Oklahoma, Stargell grew up in a poor neighborhood in Alameda, California. The Pittsburgh Pirates signed him in 1958 and assigned him to a low minor league in the South. Prevented from staying in hotels with his teammates, Stargell often slept on the back porches of homes owned by African Americans. He found little solace at minor league stadiums, where fans treated black players cruelly. "I'd get to the ballpark," Stargell told *Sport* magazine, "and the fans would be name-calling me—'Nigger,' 'Pork Chop.' They'd threaten to shoot me if I beat their ballclub. It scared the hell out of me. I would go home and cry."

When Stargell first joined Pittsburgh in 1962, he felt more comfortable in a clubhouse that included blacks and Latinos. But he didn't become a star overnight. He showed flashes of promise, hitting tape-measure home runs and intimidating pitchers with his windmilling bat, but it wasn't until later that he reached his potential.

After batting a disappointing .237 in 1968, he began a process of self-evaluation and challenged himself to become a star. Just a year later he hit .307 with twenty-nine home runs. Another epiph-

any came Stargell's way that winter. He made an offseason trip to Vietnam with the USO and credited the experience with improving his state of mind. "We were jumping in and out of choppers all the time," Stargell told the *New York Times*. "I really felt good. . . . I saw what a trip like that could mean to the GI's over there. They were tickled to death to see somebody take time out and come as far as we did to visit them."

Perhaps not coincidentally, Stargell put together his finest season in 1971. He clubbed a league-leading forty-eight home runs. Along with Roberto Clemente, Stargell pushed the Pirates to the world championship.

After the tragic death of Clemente on the last day of 1972, Stargell emerged as the Pirates' primary leader. "Pops" offered encouragement to younger teammates who harbored insecurities about their status as major leaguers. In the late 1970s, Stargell popularized the practice of handing out gold stars after Pirates wins, rewarding those players who had contributed to the victory.

In 1979 Stargell emerged as the co-winner of the NL MVP Award, as the Pirates won their second World Series of the decade. Much like the 1971 team, the 1979 Pirates represented a melting pot of races and ethnicities. "We have blacks, whites, Latinos, but we were family," Stargell told the *Washington Star*. "We had to scratch and crawl sometimes, but we did it together."

With Stargell, that should not have been surprising. "When he was playing," Hall of Famer Joe Morgan told the *San Francisco Examiner*, "Willie Stargell was respected by every player. Every one."

—B.M.

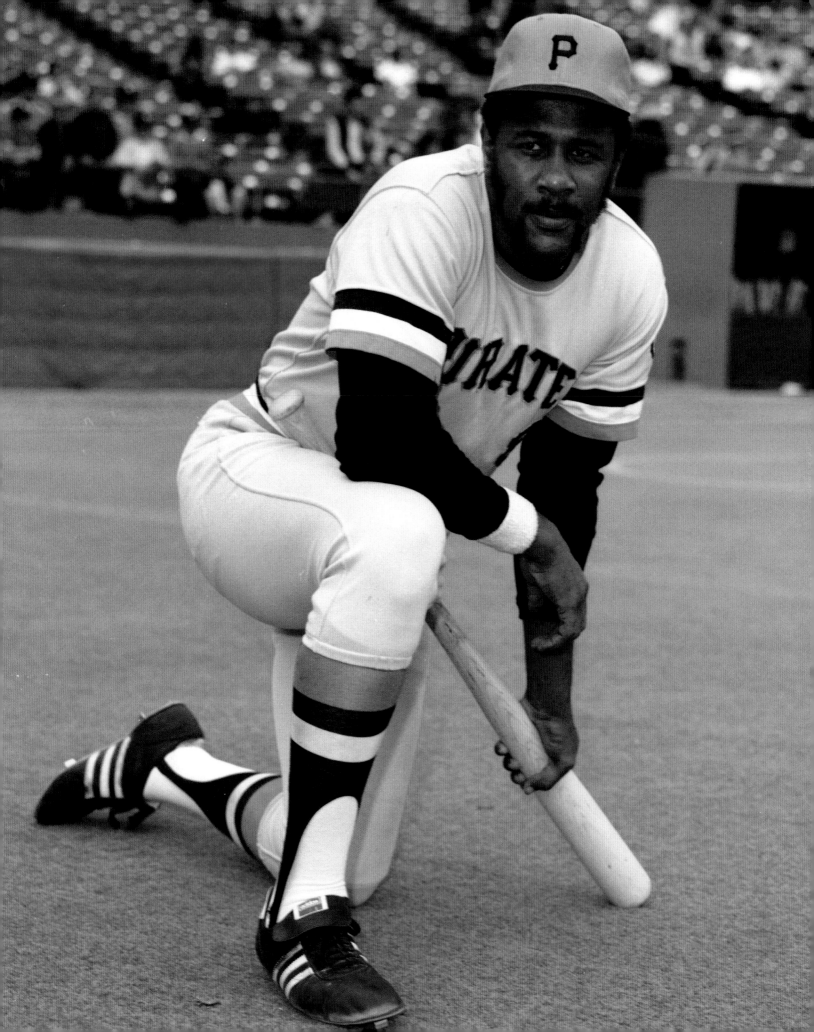

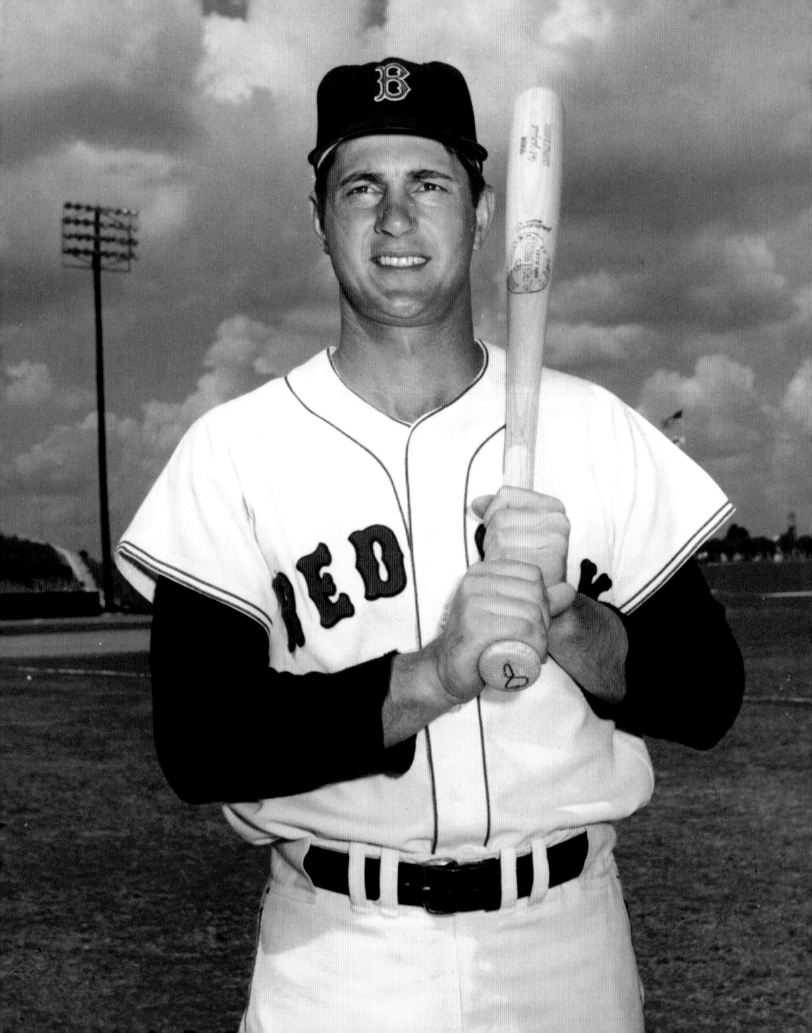

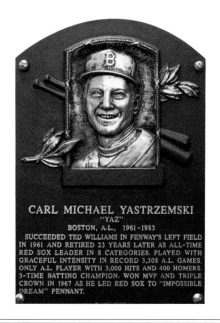

CARL MICHAEL YASTRZEMSKI
"YAZ"
BOSTON, A.L., 1961-1983
SUCCEEDED TED WILLIAMS IN FENWAY'S LEFT FIELD
IN 1961 AND RETIRED 23 YEARS LATER AS ALL-TIME
RED SOX LEADER IN 8 CATEGORIES. PLAYED WITH
GRACEFUL INTENSITY IN RECORD 3,308 A.L. GAMES.
ONLY A.L. PLAYER WITH 3,000 HITS AND 400 HOMERS.
3-TIME BATTING CHAMPION. WON MVP AND TRIPLE
CROWN IN 1967 AS HE LED RED SOX TO "IMPOSSIBLE
DREAM" PENNANT.

CARL YASTRZEMSKI

CLASS OF 1989

Carl Yastrzemski played his entire twenty-three-year Major League Baseball career with the Boston Red Sox. When he retired in 1983, he was the all-time Red Sox leader in games, at bats, runs, hits, doubles, total bases, runs batted in, and extra-base hits.

And yet it was one season—the "Impossible Dream" year of 1967—that made Yastrzemski a Boston icon.

While playing high school baseball, Yastrzemski attracted attention from MLB teams—but without what his father considered to be sufficient offers, Yastrzemski went on to attend the University of Notre Dame on a half-baseball, half-basketball scholarship. In November 1958, while in his sophomore year at Notre Dame, Yastrzemski received and accepted an offer from the Red Sox.

In 1960 Yastrzemski was invited to spring training with the big league club. His locker was located next to that of future Hall of Famer Ted Williams. That season Yastrzemski returned to the minors, where he trained to switch from second baseman to left fielder—a position then held by Williams.

Williams retired after the 1960 season. And at age twenty-one, with only two years of professional baseball experience, Yastrzemski was set to replace the legendary Williams. But his first season as the club's new left fielder got off to a slow start. The Red Sox even asked Williams to watch Yaz take extra batting practice. Williams told Yastrzemski he had a great swing, giving the youngster an extra boost of confidence.

"I think what dawned on me was that there can be a great swing that is not a home run swing at the same time," Yastrzemski said.

Yastrzemski quickly regrouped, hitting .266 while driving in eighty runs during his rookie season. He won the American League batting title in 1963 and led the league in doubles three times during his first six seasons—also capturing two Gold Glove Awards for his play in the outfield in the same span.

Then in 1967, following an offseason spent lifting weights, Yastrzemski led the American League in virtually every offensive category, including runs (112), hits (189), home runs (44), RBI (121), batting average (.326), on-base percentage (.418), and slugging percentage (.622). He won the Triple Crown en route to the AL Most Valuable Player Award, lifting a Boston team that had finished in ninth place the year before to the AL Pennant.

Yastrzemski would win his third batting title in 1968 with an average of .301 and go on to play for the Red Sox through the 1983 season. When he retired, Yastrzemski had totaled 3,419 hits, 452 home runs, 1,844 RBI, seven Gold Glove Awards, and eighteen All-Star Game selections.

He was elected to the Hall of Fame in 1989, his first year of eligibility.

Yastrzemski told the audience, "I'm so proud today to have played a role—however small—in a game which is America's pastime and a game which has been a big part of my life."

—C.M.

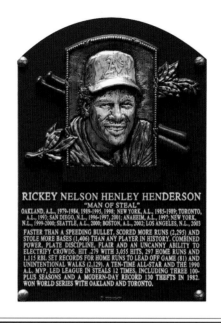

RICKEY NELSON HENLEY HENDERSON
"MAN OF STEAL"
OAKLAND, A.L., 1979-1984, 1989-1995, 1998; NEW YORK, A.L., 1985-1989; TORONTO,
A.L., 1993; SAN DIEGO, N.L., 1996-1997, 2001; ANAHEIM, A.L., 1997; NEW YORK,
N.L., 1999-2000; SEATTLE, A.L., 2000; BOSTON, A.L., 2002; LOS ANGELES, N.L., 2003
FASTER THAN A SPEEDING BULLET, SCORED MORE RUNS (2,295) AND
STOLE MORE BASES (1,406) THAN ANY PLAYER IN HISTORY. COMBINED
POWER, PLATE DISCIPLINE, FLAIR AND AN UNCANNY ABILITY TO
ELECTRIFY CROWDS. HIT .279 WITH 3,055 HITS, 297 HOME RUNS AND
1,115 RBI. SET RECORDS FOR HOME RUNS TO LEAD OFF GAME (81) AND
UNINTENTIONAL WALKS (2,129). A TEN-TIME ALL-STAR AND THE 1990
A.L. MVP, LED LEAGUE IN STEALS 12 TIMES, INCLUDING THREE 100-
PLUS SEASONS AND A MODERN-DAY RECORD 130 THEFTS IN 1982.
WON WORLD SERIES WITH OAKLAND AND TORONTO.

RICKEY HENDERSON

CLASS OF 2009

Called "The Man of Steal," baseball's all-time leading base stealer, Rickey Henderson, was a true Superman on the base paths. In his first full big league season, 1980, Henderson broke Hall of Famer Ty Cobb's sixty-five-year-old single-season American League stolen base record of ninety-six with one hundred swipes of his own.

During his illustrious twenty-five-year major league career, he established career records for stolen bases (1,406), runs scored (2,295), and home runs leading off a game (81). As Rickey described it, "I'm a walking record."

Born on Christmas Day 1958 in Chicago, Henderson spent most of his childhood in Oakland, California. An All-American running back in high school, Henderson turned down multiple football scholarships to sign with his hometown team, the Oakland Athletics, in 1976.

Henderson changed big league clubs twelve times in his career but kept finding his way back to the team that drafted him. Oakland A's general manager Billy Beane called him "the greatest leadoff hitter of all time" and followed that up by proclaiming, "And I'm not sure there's a close second." Legendary baseball statistician Bill James concurred: "If you split [Henderson] in two, you'd have two Hall of Famers."

Rickey stole 394 bases in his first four full big league seasons, and early on, it became a goal for him to break Lou Brock's record and become baseball's all-time stolen base king. In fact,

after seeing him play for the first time, Brock told him, "Rickey, you're going to be the one [who breaks the record]."

Henderson was traded from the Athletics after the 1984 season and headed for the bright lights of New York City, donning the Yankees' pinstripes for the better part of five seasons. During his time in New York, he earned the respect of teammates and management alike. Teammate Dave Winfield said, "He was one of the best players that I ever played with and obviously the best leadoff hitter in baseball." Yankees owner George Steinbrenner agreed: "There was only one Rickey Henderson in baseball. . . . He was the greatest leadoff hitter of all time."

One of the things that made Rickey Henderson so great was his fearlessness on the base paths. Tom Trebelhorn, a manager of Rickey's in the minor leagues, recalled, "Rickey was never afraid of the consequences of running. . . . If he got thrown out, he looked forward to getting back out there and beating them [the next] time. That cockiness, that fearlessness, that ability to hang yourself out—the quickness of yourself to beat the pitcher and the catcher. It's a challenge and Rickey thrives on challenges."

But what some considered "cockiness" Rickey merely considered competitiveness. "The only thing I wish I could figure out," he said, "is how I got misunderstood regarding the type of person I really am and what I accomplished. People who played against me called me cocky, but my teammates didn't."

Henderson earned baseball's ultimate honor when he was inducted into the National Baseball Hall of Fame in 2009, his first year of eligibility.

—F.B.

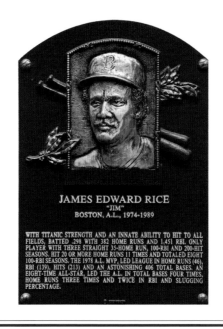

JAMES EDWARD RICE
"JIM"
BOSTON, A.L., 1974-1989

WITH TITANIC STRENGTH AND AN INNATE ABILITY TO HIT TO ALL
FIELDS, BATTED .298 WITH 382 HOME RUNS AND 1,451 RBI. ONLY
PLAYER WITH THREE STRAIGHT 35-HOME RUN, 100-RBI AND 200-HIT
SEASONS. HIT 20 OR MORE HOME RUNS 11 TIMES AND TOTALED EIGHT
100-RBI SEASONS. THE 1978 A.L. MVP, LED LEAGUE IN HOME RUNS (46),
RBI (139), HITS (213) AND AN ASTONISHING 406 TOTAL BASES. AN
EIGHT-TIME ALL-STAR, LED THE A.L. IN TOTAL BASES FOUR TIMES,
HOME RUNS THREE TIMES AND TWICE IN RBI AND SLUGGING
PERCENTAGE.

JIM RICE

CLASS OF 2009

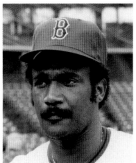

If you were an American League pitcher in the late 1970s or early 1980s, there was no one you wanted to face less than Jim Rice. With his short but fearsome swing, Rice terrorized opposition pitchers, hitting for equal amounts of both average and power.

Born in South Carolina, Rice was a highly touted high school player who signed with the Boston Red Sox as a first-round draft pick in 1971. He made his major league debut late in the 1974 campaign and had a sizable impact in his first full season, 1975. Using a compact swing that generated substantial power, he hit .309 and drove home 102 runs, numbers that normally would have won him the American League Rookie of the Year Award. Instead, he deferred to teammate Fred Lynn, who was impressive enough as a rookie to win the AL MVP as well.

Nicknamed "The Gold Dust Twins," Rice and Lynn served as the driving forces behind the Red Sox, who reached the World Series in 1975. Yet Rice was unable to play because of a broken bone in his hand.

After a solid 1976, Rice flourished the following two seasons. He led the American League in home runs and slugging percentage both years, but emerged as an awe-inspiring force in 1978. He slugged an even .600, a remarkable number for the era, and took home the league's MVP Award. How devastating was Rice as a hitter in 1978? At one point, Kansas City Royals manager Whitey Herzog attempted a "Rice Shift," in which he used *four* outfielders.

Rice continued his dominance into the early 1980s, unfazed by the pressure of playing in Boston. He also showed his toughness, playing with severely pulled hamstrings in 1982. "I've played with the man a lot of years," Carl Yastrzemski told the *Sporting News,* "and he goes to the post."

Even after the 1983 season, in which he led the league in both home runs and RBI, Rice remained a middle-of-the-order enforcer. He reached one hundred or more RBI over the next three seasons, giving him a total of eight 100-RBI campaigns.

In addition to leading the league in major offensive categories nine times, Rice was also an efficient defensive left fielder at Fenway Park. Through hard work and repetition, he became skilled at handling the caroms and bounces that came off the "Green Monster."

In 1986 Rice and the Red Sox returned to the World Series after an eleven-year absence. This time Rice played in the Series, hitting .333 in a tough seven-game loss to the New York Mets.

When Rice retired after the 1989 season, he did so as a member of the Red Sox, the only team for which he played over sixteen seasons. Rice succeeded in continuing a long tradition of great Red Sox left fielders, a line that started with Ted Williams and continued with Rice's teammate Carl Yastrzemski. Inevitably, Rice drew comparisons to past greats. "Rice has the same dedication toward hitting as Ted Williams," Red Sox legend Johnny Pesky told the *Sporting News.* "He's always looking to improve. He is never satisfied."

—B.M.

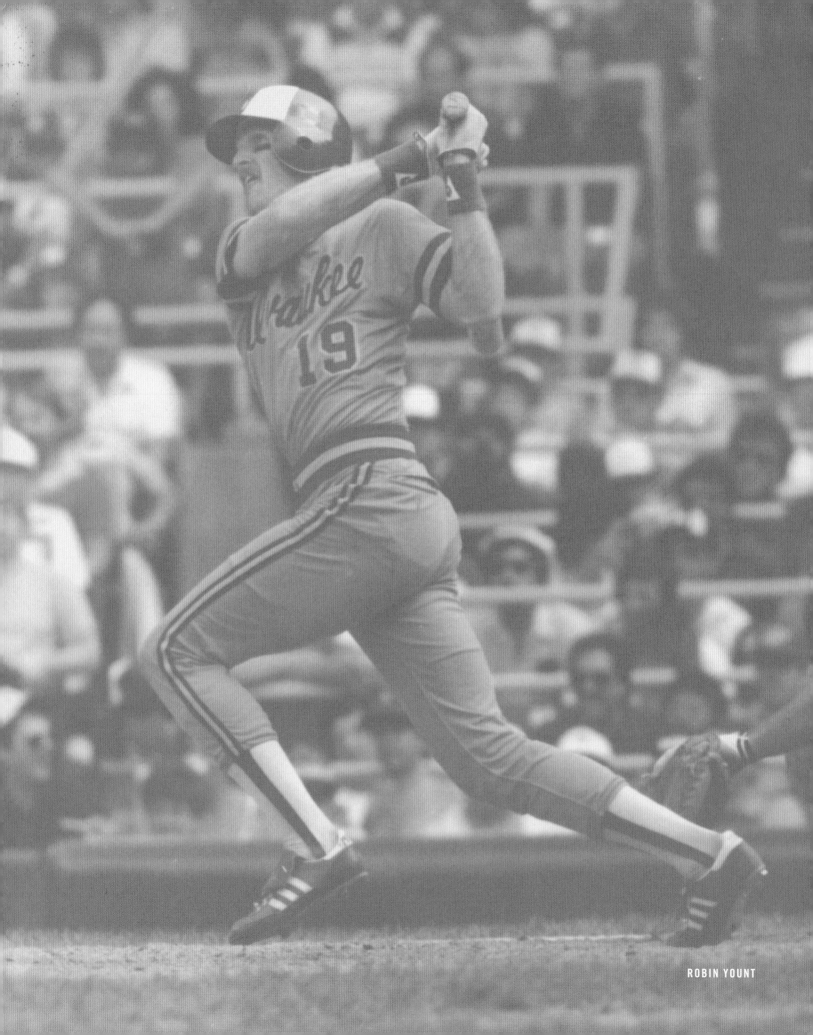

ROBIN YOUNT

CENTER FIELDERS

8

CENTER FIELDERS BY **ROBIN YOUNT**

So much for youth being wasted on the young. Robin Yount made his professional baseball debut as a seventeen-year-old with the Newark Co-Pilots in the Class A New York–Penn League in the summer of 1973 and by the following April was the starting shortstop for the Milwaukee Brewers. The man nicknamed "The Kid" and "Rockin' Robin" spent twenty seasons in the Brewers lineup, including the final eight in center field. Yount earned American League Most Valuable Player honors in 1982 as a shortstop and in 1989 as a center fielder, becoming just the third player ever to win that award at two different positions.

By my junior year in high school, I felt like there was a real possibility I could have a career in baseball. I was by no means a cocky kid; in fact, at that stage of my life I probably was one of the most introverted kids you'd ever run across. I felt I could play professionally because I had already had a little taste of pro ball, thanks to my older brother Larry. He was pitching in Triple-A at the time, and during the summers of both my sophomore and junior years of high school I spent long home stands with him in Oklahoma City, where he was playing. The guys would let me come out and take ground balls during batting practice, and I more than held my own. I'm not saying that I felt I was a Triple-A-caliber baseball player at that point, but I didn't feel like what they were doing was beyond what I could do. The other thing I had going for me was that I already was hitting against Triple-A pitching when I was in high school because I got to face Larry a lot in the batting cage during the winter. He did his best to get me out; he didn't take it easy on me. I know this to be true, because when I did start hitting him, he would get mad at me. So that gave me confidence that I could make a career out of this, that I wouldn't be overmatched.

That said, I never expected to be the everyday shortstop for a big league team as an eighteen-year-old. Yes, it took some talent on my part to go from high school to the Class A New York–Penn League to the Milwaukee Brewers in less than a year. But it also took a lot of luck. And I think it was more a case of me being in the right place at the right time, than me being some great prospect.

After being an All-American shortstop at Taft High School in Woodland Hills, California, I was drafted third overall in the 1973 draft by the Brewers, just one spot ahead of the great Dave Winfield. Milwaukee was an expansion team back then, and they were awful. Since moving from Seattle to Wisconsin in 1970, the team had recorded three straight seasons of ninety-one or more losses. But they were taking their lumps, in part, because they had decided to go with a youth movement that, in time, would pay huge dividends. I signed for $15,000—yes, the money was a lot less back then—and I was sent to the Brewers' lowest affiliate in Newark, New York. Even though I was just seventeen years old and going three thousand miles away, I don't remember feeling much nervousness. I was just so excited about playing professional baseball. I think the fact I had experienced a bit of the lifestyle while visiting my brother Larry really helped me. I felt like I was ready. I wound up having a solid season, hitting .285 in sixty-four games. The managers in the league voted me the player most likely to reach the majors, and that made me feel good. But it also made me a little embarrassed because, like I said, I was a pretty shy kid and I absolutely hated being the center of attention. I remember wanting to hide under my desk in high

school the morning after I was drafted by the Brewers because they mentioned it on the PA during homeroom announcements. I think I turned several shades of red. I just didn't like that stuff. Still don't.

The New York–Penn League was a competitive brand of ball with a good mix of players out of college and high school. The bus travel wasn't too bad, though there were some trips when we pulled back into Newark from Jamestown just as the sun was coming up. The Co-Pilots played in a tiny ballpark next to the Erie Canal. And the thing I remember most about it was that it was laid out in such a way that the sun would be in the batter's eyes by around seven or seven thirty on game nights. There would be times when it was so bad that they had to stop the game for about fifteen, twenty minutes to allow the sun to shift enough so it wasn't in the batter's eyes anymore. But even then it could be tricky. I remember one night, I squared to bunt and I lost the ball coming out of the pitcher's hand. The pitch wound up smacking me right between the eyes. Fortunately I was OK, but it was a scary moment. In anticipation of these "sun delays," managers would sometimes start relief pitchers, then bring their starters in to pitch after the game resumed. The other thing I remember about that summer is the humidity. Growing up near the desert in Southern California, I was used to warm weather, but not humidity. I got to experience that for the first time in upstate New York. It's really a beautiful part of the country. Overall, I had a great experience. I was just thrilled to be playing professional baseball.

Looking back, I didn't grow up dreaming about becoming a baseball player. I played the game—everybody did in those days. It's just what American kids did in the 1960s. And I had two older brothers playing it, so I naturally wanted to follow in their footsteps. But I did a lot of different activities as a kid. And they all pretty much pertained to the outdoors. As far as I'm concerned, there couldn't have been a better place for an outdoors-oriented kid like me to grow up than in Southern California. Like most kids there, I spent a lot of time at the beach in the summertime, just enjoying the waves and the girls. And I loved to fish and go target shooting and play golf and ride motorcycles. The motorcycle bug bit me when I was about eleven or twelve years old. We'd sometimes head to the desert to shoot .22s, and we'd see guys riding motorcycles out there. I was intrigued. Thinking back, I see it was Larry who really got me into wanting to ride them. He was five years older than me, and after he came home from one of his first seasons in the minor leagues, he bought a little trail bike to get around on. He wound up taking me to a motocross race and I was immediately hooked—to the point where, when Larry left for spring training the following February, I took the lights and everything else off that trail bike and converted it into a little motocross bike that I could ride. My dad, being an engineer, was pretty excited about what I had done. He helped me convert it and used the bike as a learning tool. I think he was more excited about me becoming mechanical than he was watching me compete in motocross races. Of course, my brother wasn't too pleased at first when he saw what I had done to his bike, but he got over it quickly.

There clearly was an adventurous side to me. And a somewhat fearless side. And I think that helped me achieve some of what I did as a baseball player, because you have to be fearless to succeed at most sports; you can't be afraid to take chances. I played a bunch of different positions in baseball—not surprisingly, they were positions where you were usually in the middle of the action. In Little League I pitched, caught, and played shortstop. I think I gave up catching in Pony

League [at thirteen or fourteen], but I continued to do some pitching in high school. Fortunately for me, the scouts liked me as a shortstop and not as a pitcher. I didn't want to become a pitcher because it meant I would play only every fourth or fifth day. And I wanted to play every day. I'm happy it worked out that way.

The February following my first season of pro ball, the Brewers invited me to their big league camp. I was just eighteen years old, but I didn't think anything of it because they had a tradition of inviting their number one pick from the previous year. I certainly had no expectations that I would make the Brewers' roster. It never even entered my mind. I just assumed I'd go there, spend a few weeks—if I was lucky—with the big club, then be reassigned to whatever minor league team they wanted me to play for that year. Now, that's not to say I wasn't excited about being invited. Heck, I was so excited that I forgot to take my equipment bag with me. Fortunately, I had reported a day early, and Arizona isn't too far from California, so my dad was able to overnight my bag to me in time for my first workout.

There have been many times in my life when I happened to be at the right place at the right time. Well, this was one of them. There was a practice field at our complex that was pretty rough and uneven. And one day I'm out there, and I'm fielding a lot of ground balls that are taking bad hops. I got beat up pretty good, but I didn't get flustered. I just kept at it. Del Crandall, who was the Brewers' manager at the time, happened to be watching me that day, and I guess it really impressed him how I had kept my cool during that difficult session, how I didn't panic or bitch and moan. I wound up getting off to a good start at the plate, and he kept writing my name on the lineup card as the exhibition season progressed. I kept waiting for the day I was going to be reassigned to the minor league camp, but that day never came. Toward the end of spring training we were busing to a game, and he came over to me and said I had made the team. He told me, "Don't worry about hitting. I just want you to catch the ball and throw guys out and make the plays in the field. And whatever you hit is fine." What's funny about that is that I always had confidence in my hitting, but I was never 100 percent sure about my defense. I was thinking, "Oh, no. I wish you hadn't put it that way."

So here I am, less than a year out of high school and about to be an everyday player in the big leagues. But it never would have happened had I not been drafted by the Brewers, who were firmly committed to a youth movement. There were other guys on that team not that much older than I was who were being given a similar opportunity. Now, if I had been drafted, say, by a team like the New York Yankees, I may not have gotten a chance for five years. Who knows? Again, right place, right time.

I was fortunate, too, because both Crandall and one of our coaches, Harvey Kuenn, who would later become our manager, had both begun their major league playing careers as youngsters. So I think they could relate to what I was feeling. And they did their best to put me at ease. I think Kuenn could really relate because, like me, he had come up as a young infielder, and his hitting style was somewhat similar to mine. Kuenn would pay extra attention to my at bats and offer advice. It's amazing how much he helped me. He became like a father figure to me. He and his wife, Audrey, were like a second set of parents. Can't thank them enough.

And I was lucky to have a veteran player like Ed Sprague take me under his wing. He was new to the Brewers that season—I think he had just come over from St. Louis—and a few days into spring training he said he needed someone to complete a golf foursome and asked if I would like to play. We played golf and started talking and found out that we had a lot in common, including the same birthday (although he was ten years older than me). Even our wives had the same first name—Michele. I also was blessed that, during my second or third year with the team, Hank Aaron joined the Brewers. For a nineteen-, twenty-year-old kid to be treated like one of the guys by arguably the greatest home run hitter in baseball history was huge. I'll never forget that.

I'm grateful to those guys and others. And I'm grateful I was given an opportunity to be a big league player probably before I deserved it. I never lost sight of the fact that I was basically learning how to become a big leaguer while in the big leagues. It would be a number of years before I actually felt like I was a bona fide big league ballplayer. I definitely had to grow into the job.

Considering my youth and inexperience, I guess you could say I had a decent rookie season. I played in 107 games and batted .250 with fourteen doubles, five triples, three homers, and twenty-six RBI. My second season, I jumped to a .267 average with twenty-eight doubles, two triples, eight homers, and fifty-two RBI. And that's pretty much how it went my first six seasons, though my average and my RBI totals began to get better as I gained more knowledge and those around me got better. It's funny, but by age twenty-two, I had already logged enough seasons to qualify for my baseball pension.

I mentioned how I didn't like being the center of attention, but I did something foolish before the 1978 season that wound up attracting attention I didn't want. About a month before spring training, I injured my foot while riding my motorcycle. I was too scared to tell anybody what happened, so I kept it to myself. After the first few days of camp, it was pretty apparent to me that I wasn't healthy enough to play up to major league standards. I was really frustrated and I remember saying to Timmy Johnson, one of our infielders who lockered next to me, that if I couldn't play baseball anymore, I'd give golf a shot. I was so upset with myself that I didn't bother showing up the next day. I actually didn't show up for the next couple of days. Went AWOL. I just didn't know what to do. And that's when Timmy made some comments to one of the writers that I was considering quitting baseball and would try to make a go of it on the PGA tour. The fact I hadn't signed my contract yet only added to the drama. And the next thing you know, the media ran with the story that if I didn't get the contract I wanted, I was going to quit baseball and give pro golf a shot. I never expected the story to explode the way it did, and my brother convinced me to go talk to Brewers general manager Harry Dalton right away about what had really happened, and I did. Thankfully, I wound up signing my contract and we put the golf story to rest. Now, I was a very, very good golfer, but even at my best, I was a long, long way from being good enough to be a pro. There's a huge difference between a three-handicapper and a PGA pro. I don't believe I could ever have played that sport professionally because I don't have the right mental makeup for it.

Something good did come out of my injury. I had to miss about a month that season, and that prompted the Brewers to call up a guy by the name of Paul Molitor from the minors to fill in at shortstop. And Paul took full advantage of the opportunity. In fact, he was so impressive that

when I was ready to return, they decided to move him over to second base. So I like to tell Paul that I gave him his first big break.

I hadn't been much of a power hitter my first six seasons, and it's easy to see why. I was kind of a string bean at six foot, 160 pounds. But leading up to the 1980 season, I took the advice of some other guys with similar builds and began lifting weights. I had seen a few guys who had been built kind of like me—I think Fred Lynn might have been one of them—who started lifting and saw immediate benefits. So I pumped the iron and got up to a whopping 172 pounds. The added muscle did me good, because that season I hit forty-nine doubles, ten triples, and twenty-three homers—all career bests at the time. I think I also was benefiting from the experience I had gained in the big leagues. I was twenty-four years old and just starting to hit my prime physically. I guess that was the first season I began to feel like I was a true major league ballplayer and that I might have the opportunity for a long career.

Two years later, it really all came together for me when I hit 29 homers, drove in 114 runs, and batted .331, marking the first time I went over the .300 mark. I also had career highs for hits (210) and runs scored (129) and led the league in doubles (46). I believe that everything fell into place, in large part, because of the people I had hitting around me. Those were the years of "Harvey's Wallbangers"—named after our manager, Harvey Kuenn—and, man, did we have a potent lineup. I had Paul Molitor batting in front of me and Cecil Cooper batting behind me, so how could I not do well? It seemed like every time I came up that season, Paul was on base. And pitchers had to pitch to me because they'd rather take their chances with me than Cecil. So I wound up getting a lot of really good pitches to hit. It really was a case of me reaping the benefits of being on a great offensive team. For about a five-year period, we fielded about as potent a lineup as there's ever been. And that '82 lineup, in particular, was something else. We had five guys who hit twenty-three or more homers, topped by Gorman Thomas's thirty-nine, and four guys drove in more than a hundred runs. There wasn't an easy out in that lineup.

There wasn't as much free agent movement as there is today, so we were able to keep that core group together for a while and we became really close. We all hung out together—not just the players, but our families, too. We'd have cookouts at each other's house, and when we were on the road, the guys would go to the same bar together after games. It was as close a team as I've ever been on.

We had a colorful cast of characters, but what really made that team memorable to Milwaukeeans to this day was that we made it to the World Series. The division race actually came down to the final day of the '82 season. We faced Jim Palmer, and I wound up hitting two home runs and went 3-for-4 as we beat the Baltimore Orioles to clinch the division. If I had to single out one game in my career that stood above the rest, it probably would be that one because of the circumstances. People forget that we had a pretty good guy going for us on the mound that day, too. A future Hall of Famer in Don Sutton. The only downside was that we clinched in Baltimore instead of Milwaukee. I would have liked to have won the division at home so the fans would have been able to share in it.

From Baltimore we headed to Anaheim to play the Angels, and we wound up losing the first two games. I think we were a little spent from having to beat the Orioles on the final day just

to make the playoffs, then flying cross-country. Fortunately, we beat the Angels three straight in Milwaukee to win the ALCS. I wound up becoming the only player in the history of the World Series to have two four-hit games, but I gladly would have traded them in for one more victory. We came up just a game short, losing to the St. Louis Cardinals in seven. Although we lost, I still look back on the experience of playing in a World Series as the highlight of my twenty-year career. When you are a young kid, this is what you dream about. And I got a chance to live out that dream. The only thing I would change in my career if I could would be the outcome of that seventh game. Even though it still stings, I consider that experience the most rewarding thing I accomplished in baseball. I tell people I'd rather have played seven games in a World Series and lost than to have never played in a World Series at all.

And one of the greatest things about that Series was the impact it had on Milwaukee. It's a city and a region with an incredibly loyal fan base. I love the people there and I love going back and doing things there. They are just very honest people. What you see is what you get, and I've always appreciated that about them. I don't know of any other town that has thrown a parade through downtown for their team after it's lost a World Series. But that's what Milwaukee did back in October of 1982. They insisted that we have a parade and they lined the streets by the thousands and we rode in these old classic cars and there was ticker-tape confetti raining down on us and about thirty thousand people waiting for us inside County Stadium. That says all you need to know about that town's loyalty. Great people.

I turned thirty in 1985 and that season is when I started to make the transition to the outfield. I didn't want to. I loved shortstop and still consider myself one, but I had no choice. I had hurt my arm the year before and had surgery in the offseason, but it didn't really work. And when I got to spring training in '85, I couldn't throw any better. And you can't have a weak-armed shortstop—not if you want to win. So they asked me to give left field a shot, and I did because playing left field was better than the alternative of not playing at all. Well, I didn't do very well in the beginning. I had never played the outfield before, and it showed. I remember being totally disgusted with myself about two weeks into the regular season after I misplayed a double into an inside-the-park home run.

And then fate—or whatever you want to call it—intervened again. Rick Manning, our Gold Glove center fielder, and I are going after a ball on the warning track in left-center when I come down on his big toe and break it. I arrive at the ballpark the next day and find out that he's going to be out for six weeks. I also find out that my name has been written on the lineup card with the letters "CF" next to it. I said, "What the heck. Maybe I can play better over there." And I did. Everything seemed easier to me out there. It was a lot more straightforward. I didn't have to worry about walls in foul territory or weird bounces in the corners. There was more ground to cover, but that didn't bother me because I still had good speed and could run balls down. So I picked it up a lot better than I did left field, and in six weeks, when Rick came back, they asked him to change positions, and he agreed. And I was happy and grateful he didn't make a stink about it, because he had been, after all, a Gold Glove center fielder, and probably should have been there. But this was a way to keep my bat in the lineup, and Rick was willing to do it for the good of the team. It was a number of years before I really became comfortable out there, but I eventually came to enjoy it.

In 1989 I had another one of those years where everything came together. I hit .318 with 21 homers and 103 RBI and became just the third player in baseball history to win MVP Awards at two different positions. Looking back, it probably means more to me that I was able to win it as a center fielder because that wasn't my natural position. I was proud of the award, but I still say that both my MVPs were more the result of my supporting cast than me. I never considered myself one of those great, powerful hitters who could carry a ball club on his shoulders. I was lucky to have played with some really good players that made me better. I'm not trying to be modest. That's just the way I truly feel.

I had decent power, but I considered myself more of a gap hitter who sprayed the ball all over the field. I think that's why I was able to finish with a healthy number of doubles (583) and triples (126) to go along with my home runs (251). I found the gaps.

After my second MVP I was eligible for free agency, and I seriously considered it. It had nothing to do with not wanting to play in Milwaukee. I loved the city, loved the fans. But I was thirty-four years old and my career was winding down and I really wanted to experience a World Series again, and I didn't know if the Brewers were going to be in contention any time soon. This was around the time when small-market cities like Milwaukee were having a tough time keeping and attracting players. It was tough for them to compete with the big boys. The Angels were making a full-fledged effort to try to win the World Series in owner Gene Autry's final years, and I was very intrigued. But then one day, a Brewers public relations guy showed up at my door with several bundles of letters and cards. I felt like Santa Claus at the North Pole. There were about six thousand pieces of mail, and they were from Brewers fans, young and old. I was touched. For the first time in my career I began to understand how much they cared about me and what an impact I had had on many people. I had been so focused on the game itself for so many years that I had failed to realize that I had brought them some enjoyment. That was the tipping point for me. I realized I couldn't do this to them; I couldn't leave Milwaukee. I knew I needed to stay and finish my career there.

Looking back, I'm glad I spent my entire career there. And I'm glad I went there in the first place. It was a good place for me, the right place for me, because I was a quiet guy who preferred to let my play speak for me, and that's the way Milwaukeeans are for the most part. I always wondered how I would have responded playing in New York. I came up as an eighteen-year-old kid in Milwaukee. I went through a lot of growing pains there that were tolerated in a way they never would have been in New York. I made forty-four errors my second year in the big leagues. You think I would have survived in New York making forty-four errors? Not a chance in you-know-where. They would have run me out of town in a heartbeat. Then again, I probably wouldn't have been playing in New York at that age. I probably would have been in the minors for several years. So it really worked to my advantage being in Milwaukee, where I was able to start my major league career early and learn the ropes at the major league level.

The biggest milestone of my career, of course, was joining the three-thousand-hit club. That number probably is what got me into the Hall of Fame. Without it I probably wouldn't have made it to Cooperstown. I don't mean to put the number down; I'm proud of it. But I think in my case it

was an achievement of longevity. Heck, if a guy gets up as many times as I did in his career, he'd better finish with three thousand hits. The thing I'm most proud of is that I gave it every ounce of energy I had for as long as I did. I played the game all out my entire career.

I'm also proud that I was able to make a successful transition to another position halfway through my career. I'll always consider myself a shortstop at heart, but I think I developed into a decent center fielder. The position has changed since I played, in large part because the ballparks have become smaller. When I played, there were some really big parks, and there was a lot more ground to cover. Yankee Stadium was huge. Detroit was huge. And the turf in places like Kansas City and St. Louis forced you to put a guy out there who could cover an awful lot of real estate.

The smaller ballparks and the lower fences in a lot of places have resulted in more opportunities for center fielders to climb walls and rob people of home runs. It's strange, but the new ballparks have led not only to more home runs to straightaway center and the power alleys, but also to more acrobatic wall-climbing plays. It's easier to get into position to make those plays because you have less ground to cover. That's not meant as a put-down to today's center fielders, because you have some great, great athletes playing the position today. It's just that the ballparks dictate the type of player you need out there, just as they did in my day.

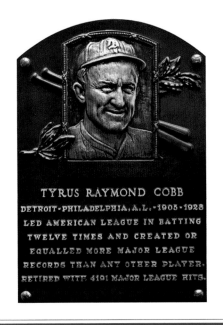

TYRUS RAYMOND COBB
DETROIT·PHILADELPHIA, A.L.·1905·1928
LED AMERICAN LEAGUE IN BATTING
TWELVE TIMES AND CREATED OR
EQUALLED MORE MAJOR LEAGUE
RECORDS THAN ANY OTHER PLAYER.
RETIRED WITH 4191 MAJOR LEAGUE HITS.

TY COBB

CLASS OF 1936

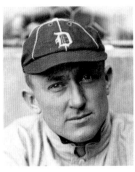

Long after he retired, Ty Cobb kept a keen eye on baseball, the sport that many say he was the best in the world at playing. There were rare players he picked out whom he admired, and sometimes he contacted them. In the late 1950s, he telephoned the Cardinals' Stan Musial on a whim and invited him to breakfast.

Whereupon the Georgia Peach provided dietary and nutritional advice to Stan the Man, then in the twilight of his own career. "Shouldn't do that," Cobb, the longtime Detroit Tiger, admonished Musial when he put two spoonfuls of sugar and cream into his coffee. "Bad for you. Leave out one or the other. Do you drink? Wine is a great stimulant, good for the system. Drink a little wine every day and you'll find it invigorating. It will prolong your career."

Musial adopted both practices, leaving out the cream and drinking the wine. As far back as 1913 Cobb preached commonsense eating, saying ballplayers needed no more than two meals a day and should drink buttermilk for their own good. "Condition is the principal feature the baseball player must look out for," Cobb said.

Cobb, who batted a record .366 and won twelve batting titles, was always regarded as fiery on the field and committed to victory full-time. Long after he died, when Pete Rose was closing in on

Cobb's all-time hits record, reporters sought out Cobb's children to hear what he was really like off the diamond and in private.

"He was driven," Cobb's daughter Beverly McLaren said. "I don't think he had a sense of humor. Life was serious and life was earnest and he had tremendous responsibilities. He used to worry about getting injured because he had a family of five children. He loved his grandchildren very much and he loved [his children] very much, although he wouldn't show it. He was tough on us because he expected us to have the same ambition and drive he had."

Al Munro Elias, co-founder with his brother Walter in 1913 of what evolved into the still-going-strong Elias Sports Bureau, wrote a story about Cobb after the 1916 season indicating that he was the "king of all batsmen." Elias used "the tables" he had developed from his statistical work to prove Cobb was the best, and that was years before Cobb quit.

Cobb believed that fans preferred contests with lots of hits. "From what I have seen and heard in the bleachers," Cobb said, "I am convinced that the fans would rather see a smashing, brawling, hitting game than one of those tight 'pitcher's battles.'"

Near the end of his life—he died in 1961 at seventy-four—after twenty-six years in California, Cobb, beckoned by his roots, moved back to Georgia. "There is a quality about the people where a fellow is born that makes him feel like he belongs," Cobb said. "I am in the evening of life. I want no loose ends to tie together."

—L.F.

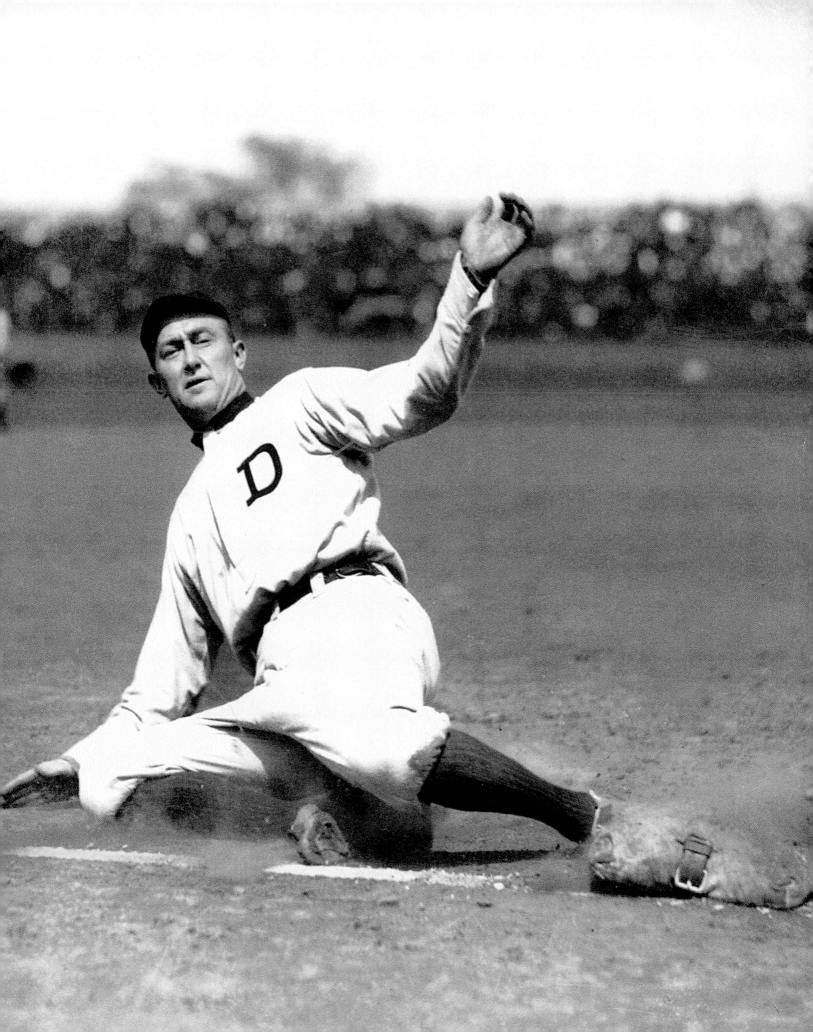

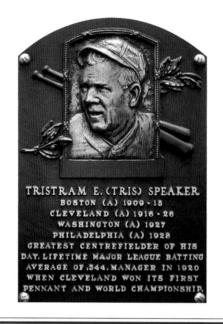

TRIS SPEAKER

CLASS OF 1937

Before baseball people began calling Tris Speaker "The Grey Eagle" for his fielding exploits and preternaturally gray hair, there was much discussion about his given name.

"I have often been asked how I came to be named Tris," the onetime Boston Red Sox and Cleveland Indians star related. "Many people, knowing that I was a native of Texas no doubt thought it was a given name of local origin. Down in my part of the country they have a way of carving a long name into something crisp and spicy, so the old English name of Tristram was simply abbreviated to Tris, and I was forced to be satisfied with about the shortest prefix a young man was ever handed out at a christening."

Speaker figured that the four-letter name would leave him free of catchy nicknames, but in Boston they took to calling him "Spoke." Speaker would have been content to remain with the Red Sox for the duration of his career, or at least that was true until the team showed considerable determination to cut his salary. Speaker was making around $18,000 a year, but the Red Sox wanted to cut his salary by half.

With the two sides at loggerheads, Speaker woke up one day in his hotel room to a phone call from the lobby from Cleveland Indians general manager Bob McRoy. When McRoy probed Speaker's mind-set about playing for the Indians, he was dis-

mayed to hear the response. Nope, he didn't want to play for Cleveland. "You've not only got a bad ball club, but you've got a bad baseball town," Speaker told him.

Speaker was certainly blunt, but that's when McRoy informed him he had been traded. "I wish you didn't feel that way. We made a deal for you," McRoy said. Speaker bargained for a bonus of $10,000, or part of the purchase price from his sale to the Indians, though in later years he made $30,000 a season from Cleveland.

Years earlier, and many, many years before baseball players would make the same argument to the owners when they sought free agency, Speaker's mother had reacted with vehemence when told Speaker had been purchased from a minor league club by another team for $800. "Buy my son. Why that's slavery!" she exclaimed.

Speaker played a shallower center field than any of his contemporaries. He was blessed with great speed and judgment when it came to playing fly balls, but he still had to justify his approach because of the fear that power hitters would hit the ball over his head for extra bases.

"I know it's easier, basically, to come in on a ball than go back," he said, "but so many more balls are hit in front of an outfielder . . . that it's a matter of percentage to be able to play in close enough to cut off those low ones or cheap ones in front of him. I still see more games lost by singles that drop just over the infield than triples over the outfielder's head."

—L.F.

HUGH DUFFY

CLASS OF 1945

In 1894 Hugh Duffy enjoyed one of the finest seasons ever in baseball history, averaging .440 at the plate, the best any hitter has ever done. That same season, Duffy led the National League with 237 hits, 51 doubles, 18 home runs, and 374 total bases. For good measure, he knocked in 145 runs, stole 48 bases, and scored 160 runs. On June 18 of that season he set a record that will probably never be broken, reaching base three times in a single inning.

When Duffy joined Cap Anson's Chicago White Stockings in 1888, he was first thought to be the new batboy because of his short stature; he was five foot seven and weighed only 168 pounds. But opposing pitchers soon learned not to underestimate him, and scouts took note of his massive forearms and thick shoulders.

"As a youngster, I worked in a blue dye shop, where I lifted heavy masses of wet cloth out of the machine," Duffy explained decades later, "and it gave me unusual development in the arms and shoulders. That's the only explanation I can think of for the power I used to have." In Duffy's sophomore season he hit .312, the first of nine consecutive seasons at .300 and above.

Duffy, who frequently jumped his contracts in baseball's formative years, played for six teams in seventeen big league seasons. He is the only player to hit .300 or better in four different major leagues: the National League, the American League, the Players' League, and the American Association.

In 1892 he tasted postseason play for the only time, as his Boston Beaneaters defeated the Cleveland Spiders in a championship series, with Duffy batting .462 and collecting nine RBI on twelve hits, six of them for extra bases.

For his career, the outfielder batted .326, knocked 550 extra-base hits, stole 574 bases, and scored 1,554 runs. He spent four seasons as a player-manager with the Milwaukee Brewers (AL) and the Philadelphia Phillies (NL). He managed the Chicago White Sox and Boston Red Sox for two seasons each.

He also coached, scouted, owned, and managed the Providence team in the Eastern League, and served as president and field manager of Portland in the New England League. He later scouted for the Boston Red Sox and Braves, and coached at Harvard and Boston College.

Duffy scouted and helped purchase the site where Fenway Park was built, and was a fixture on the Boston baseball scene. He was a good friend of Ted Williams's, and hoped that Williams would one day break his batting average record.

When Williams was hitting .3995 going into the final day in 1941, he could have sat out and been credited with a .400 average, thanks to the practice of rounding up. Duffy had also been encouraged by teammates to sit out to ensure that his average would not slip. But "hell no," he recalled. "I played." He encouraged Williams to play, too, and Williams went 6-for-8 to raise his average to .406, only thirty-four points behind his friend's average of forty-seven years earlier.

—T. Wendel

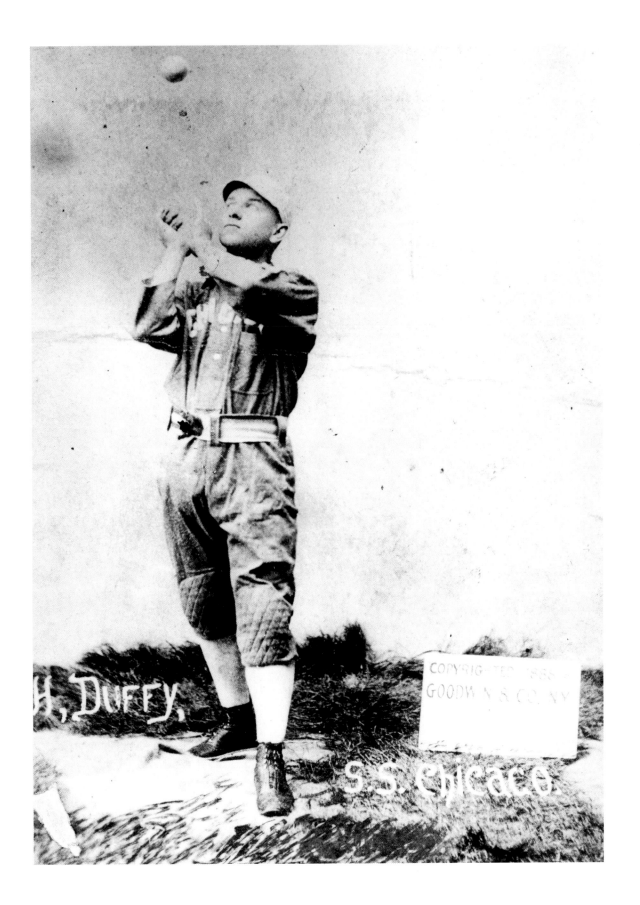

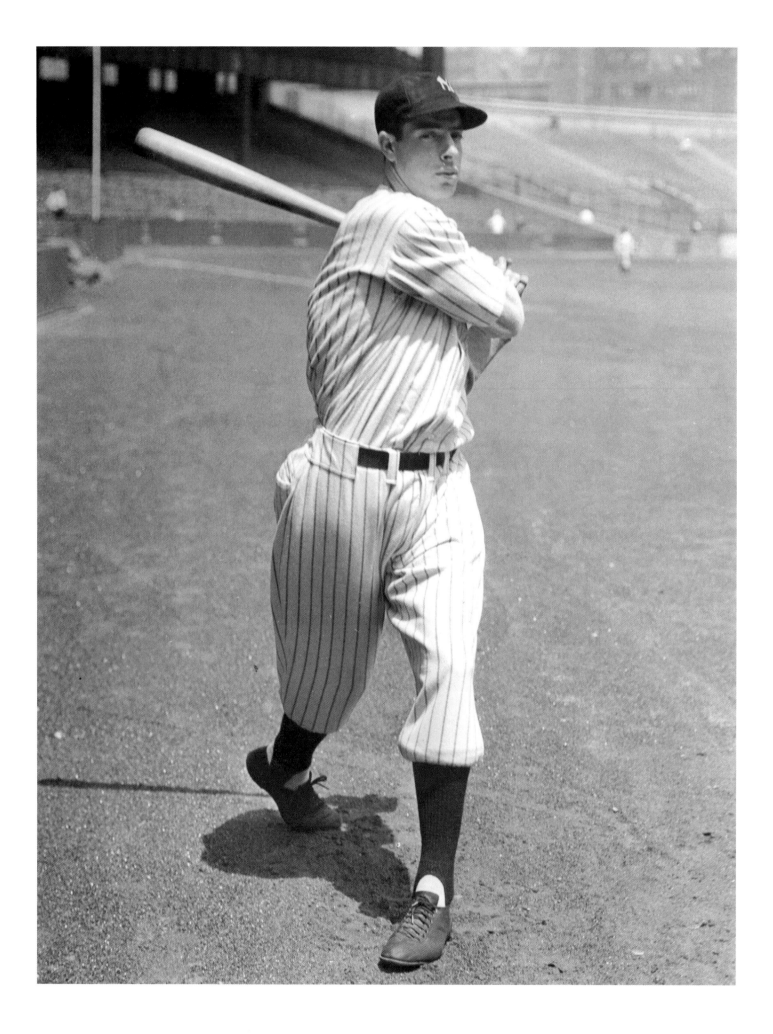

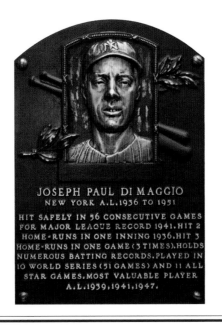

JOSEPH PAUL DI MAGGIO
NEW YORK A.L. 1936 TO 1951

HIT SAFELY IN 56 CONSECUTIVE GAMES
FOR MAJOR LEAGUE RECORD 1941. HIT 2
HOME-RUNS IN ONE INNING 1936. HIT 3
HOME-RUNS IN ONE GAME (3 TIMES). HOLDS
NUMEROUS BATTING RECORDS. PLAYED IN
10 WORLD SERIES (51 GAMES) AND 11 ALL
STAR GAMES. MOST VALUABLE PLAYER
A.L. 1939, 1941, 1947.

JOE DiMAGGIO

CLASS OF 1955

One of the game's most graceful athletes, Joe DiMaggio played in ten World Series during his thirteen-year big league career. Many consider the Yankees icon the best everyday player ever to pick up a bat, and his fifty-six-game hitting streak in 1941 has been called baseball's most enduring record.

A three-time American League MVP winner, DiMaggio was named to the All-Star team every year of his career. His career totals include a .325 lifetime batting mark, 361 homers, and an average of 118 RBI annually. His statistics arguably would have been even better if he hadn't missed three seasons during World War II.

"There was an aura about him. He walked like no one else walked. He did things so easily. He was immaculate in everything he did. Kings of State wanted to meet him and be with him. He carried himself so well. He could fit in any place in the world," recalled teammate and fellow Hall of Famer Phil Rizzuto. At baseball's 1969 centennial celebration, DiMaggio was named the game's greatest living player.

"Heroes are people who are all good with no bad in them," said Mickey Mantle, another Yankees great. "That's the way I always saw Joe DiMaggio. He was beyond question one of the greatest players of the century."

Born in Martinez, California, DiMaggio first made a name for himself playing for the San Francisco Seals of the Pacific Coast League. He followed his brother Vince onto the team and soon became its star. Three years later he was traded to the Yankees, but not before he hit .398 with 34 home runs and 154 RBI in his last season on the West Coast.

DiMaggio came to Gotham in 1936 and played all three outfield positions in his rookie year. The next year he became the everyday center fielder. He hit .323 in his rookie season and led the American League with fifteen triples. His second season he paced the Junior Circuit with a .673 slugging average.

"He never did anything wrong on the field," said teammate Yogi Berra. "I'd never seen him dive for a ball, everything was a chest-high catch, and he never walked off the field."

Cleveland Indians pitcher Bob Feller once said, "[Ted Williams was] the greatest hitter I ever saw, but DiMaggio was the greatest all-around player."

"There was never a day when I was as good as Joe DiMaggio at his best," declared Stan Musial. "Joe was the best, the very best I ever saw."

Such adulation between the lines made DiMaggio a celebrity off the field, too. He was married to actress Marilyn Monroe for a short time and is mentioned in cultural landmarks from Ernest Hemingway's novella *The Old Man and the Sea* to the song "Mrs. Robinson" by Simon and Garfunkel.

But especially for those who played during his era, there would never be another "Joltin' Joe."

"You saw him stand out there," said one teammate, pitcher Red Ruffing, "and you knew you had a pretty darn good chance to win the baseball game."

—T. Wendel

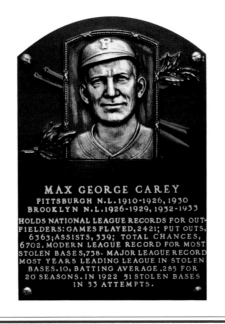

MAX GEORGE CAREY
PITTSBURGH N.L. 1910-1926, 1930
BROOKLYN N.L. 1926-1929, 1932-1933
HOLDS NATIONAL LEAGUE RECORDS FOR OUT-
FIELDERS: GAMES PLAYED, 2421; PUT OUTS,
6363; ASSISTS, 339; TOTAL CHANCES,
6702. MODERN LEAGUE RECORD FOR MOST
STOLEN BASES, 738. MAJOR LEAGUE RECORD
MOST YEARS LEADING LEAGUE IN STOLEN
BASES. 10. BATTING AVERAGE .285 FOR
20 SEASONS. IN 1922 51 STOLEN BASES
IN 53 ATTEMPTS.

MAX CAREY

CLASS OF 1961

A ten-time National League leader in stolen bases, Max Carey definitely knew how to run. For him it was the specialty of the house. As his résumé expanded with all of those titles, he was invariably asked by young players how to run the bases, starting with knowing when to try to take two on a hit.

Carey was born Maximillian George Carnarius, but chose the simpler name as a way of camouflaging his identity while playing pro ball and simultaneously seeking to protect his collegiate amateur status. Running the bases was simple in his mind, as long as the runner was conscientious and didn't fall into bad habits. Those were numerous, he said, including a "bad start, off balance, feet crossed, eyes on the ball too long to see whether it's a base-hit or not." Carey could pick apart a runner's mistakes and explain why a double got turned into a single and an out. "Bad turn," he said of coming around first. "Changing step or stride touching first. Bad slide."

In the minors, Carey's task in the field was to play shortstop, but that came as news to Honus Wagner when the Pirates brought in the youngster at the end of his minor league season. The Pittsburgh batting star greeted the new face in a friendly manner, asking, "And what would you be doing here, son?" Carey replied, "Why, Mr. Wagner, I'm the new shortstop." Wag-

ner stormed off to the clubhouse to see player-manager Fred Clarke. Wagner informed the boss that he was not relinquishing his position and asked why didn't he give his own left-field job to Carey. That's how Carey became an outfielder.

Casey Stengel was a longtime fan who believed that Carey's 738 stolen bases were more important in the context of the games than those swiped by the modern base runner, since Carey played a big chunk of his career during the dead ball era, when runs were harder to come by. "This was one-run baseball," Stengel said, "and a stolen base could beat you. The catchers had to throw and the pitchers had to hold the runners. You didn't steal on the pitcher then, or the catcher, either. They had to steal on their own."

Carey retired in 1929 and was elected to the Hall of Fame in 1961. Though he claimed not to be much of a speech giver, he managed to say a few words at his induction ceremony. "Once you go through this, you don't need to look for other goals," he said. "It was terrific and it happens only once. The pressure was great, but I managed to make a little talk." The ceremony was conducted in the rain, but Carey was not fazed by that. He defended the talents of the old-time players versus those of the 1960s, saying he'd like to manage a team made up of the old guard versus the present All-Stars. "I know who I'd bet on," he said.

—L.F.

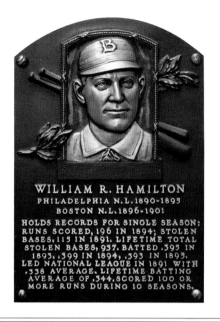

BILLY HAMILTON

CLASS OF 1961

Billy Hamilton "could race at the crack of the bat to the spot where the ball would fall, without looking," former Baseball Hall of Fame librarian Tom Heitz once told the *San Francisco Chronicle*. "Ballparks aren't quiet enough now to do that. . . . It's one of baseball's lost arts."

Nineteenth-century stolen base champ "Sliding Billy" Hamilton, not to be confused with another speedster, Cincinnati Reds top prospect Billy Hamilton, finished his big league career in 1901 with a record 914 bags swiped in fourteen years.

Standing only five foot six, Hamilton was the game's first prototypical leadoff hitter, hitting to all fields and always looking to work the count. He led the league five times each in walks and on-base percentage in his career. Also renowned as one of the best defensive outfielders of his era, the speedster led the league in stolen bases five times.

Like the man who would ultimately take the top stolen base spot in baseball's record book, Rickey Henderson, Hamilton was as confident as they came. He once wrote to the *Sporting News,* defending his claim that he was the "greatest stealer of all time."

Arguably Hamilton's best season came in Philadelphia in 1894, when he set the major league record for runs scored in a season with 198, a mark that has yet to be broken. Hamilton hit .403,

stole 100 bases, and led baseball with a .521 on-base percentage. He was part of one of baseball's best outfields that season, playing in center field, flanked by fellow future Hall of Famers Ed Delahanty and Sam Thompson. Collectively the trio combined to hit over .400.

Baseball's rules have changed since Hamilton broke in with Kansas City in 1888. Back in those days, a stolen base was awarded, for example, for going from first to third on a single. Still, there's no denying that Hamilton was one of the game's first stars. He twice led the league in hitting and four times in runs scored. Despite missing part of the 1893 season with typhoid fever and parts of 1898 and 1899 because of knee injuries, he still posted a .455 on-base percentage, second only to John McGraw among nineteenth-century players. That earned him a second nickname, "Good Eye Billy."

Contemporary outfielder Hugh Duffy said, "[Jesse] Burkett was one of the greatest hitters I've ever seen. . . . But Hamilton was one of the very best ballplayers."

After his playing days were over, Hamilton managed several minor league clubs in the New England area and Canada before he retired in 1916.

"Like a lot of players of that time, he's kind of a shadowy figure," according to Tom Heitz. "We know there's a lot of [Ty] Cobb about him. He was the kind of guy the home fans always loved but wasn't appreciated on the road."

—T. Wendel

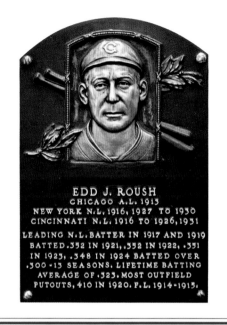

EDD J. ROUSH
CHICAGO A.L. 1913
NEW YORK N.L. 1916, 1927 TO 1930
CINCINNATI N.L. 1916 TO 1926, 1931
LEADING N.L. BATTER IN 1917 AND 1919
BATTED .352 IN 1921, .352 IN 1922, .351
IN 1923, .348 IN 1924 BATTED OVER
.300 - 13 SEASONS. LIFETIME BATTING
AVERAGE OF .323. MOST OUTFIELD
PUTOUTS, 410 IN 1920. F.L. 1914-1915.

EDD ROUSH

CLASS OF 1962

One of the most opinionated players of his era, or any other, Edd Roush was an all-time-great Cincinnati Red. As the last surviving player from the tainted 1919 World Series that revolved around the "Black Sox Scandal," Roush was the last defender of his guys near the end of his ninety-four years.

The Reds won that World Series, and eight White Sox players were banned from the sport for life after being accused of fixing it. But Roush never doubted that the Reds would have won the championship anyway. "They threw the first ballgame," Roush said. "But they didn't get their money after the first ballgame, so they went out and tried to win."

There were rumors that some Reds, too, were approached by gamblers, perhaps to participate in controlling the result, but Roush was indignant over the notion that he might have been sounded out about any crooked deal. "They knew better than to ask me," he said. "I would have knocked the hell out of them. And they knew that, too."

Roush wielded a forty-eight-ounce bat, presumed to be the largest ever used, while batting .323 lifetime. Known for covering territory in the outfield, Roush believed that the sportswriters who covered the American League in the early part of the twentieth century built up the AL players at the expense of National League players.

"Well, there wasn't anybody that covered any more ground than I did in the National League," Roush said. "I don't know much about [Tris] Speaker as far as that's concerned. He was in the American League. Of course, back then the American League was a lot better than the National League because they were paying the writers to write their league up. The National League wasn't paying anything to them. That made them a lot better ball players than we were, you see."

Roush played every game as if it were the last of his career, and he played out every at bat with the same determination. If anyone doubted his resolve, he pulled out a story about a game in the waning days of the season in his final year, 1931.

"We were so far in last place we couldn't even see the top," Roush said. "We were playing the Cubs. I come up with two men out. The pitcher keeps shaking his head. I said, 'There comes the duster.' So down I went. I said to the catcher, 'You're going to get somebody hurt with those dusters.' He didn't say anything. The pitcher shook his head again and down I went. I walked halfway out there and said, 'You won't have enough ball players to finish the game if I get to them.'"

Roush hit a grounder, and the throw went to Charlie Grimm at first. "I didn't step on the base," Roush said. "I stepped right on Grimm's [ankle]. I intended to break his leg."

As far as Roush was concerned, there was more than one way to keep score.

—L.F.

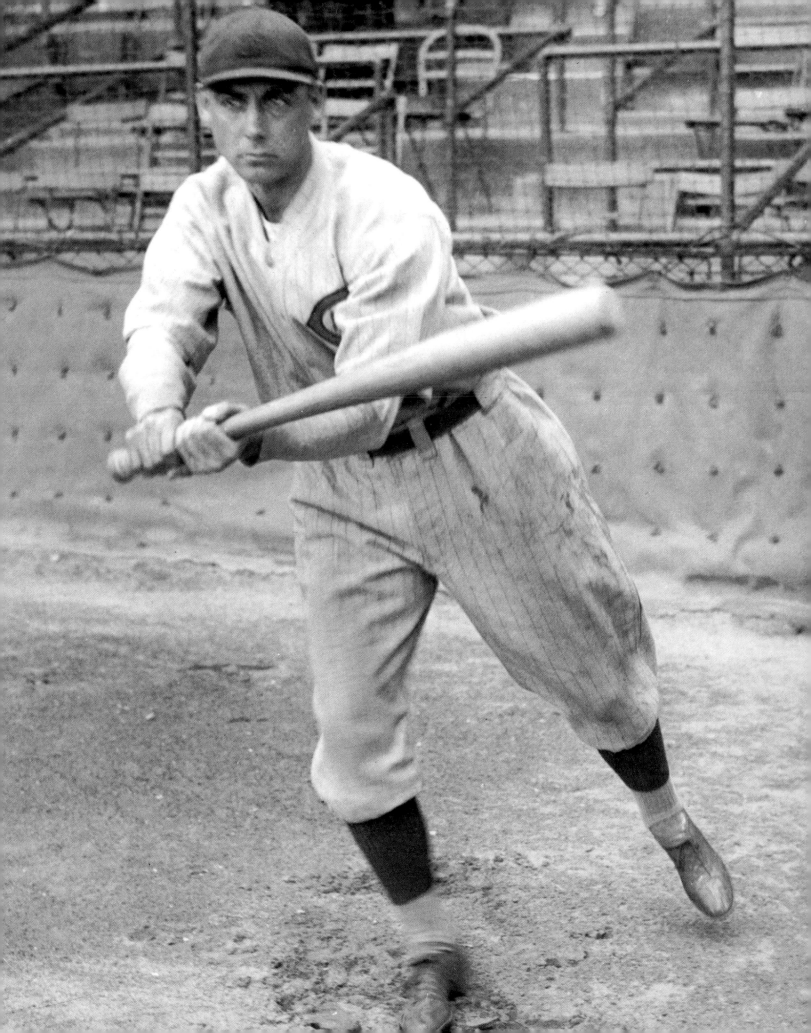

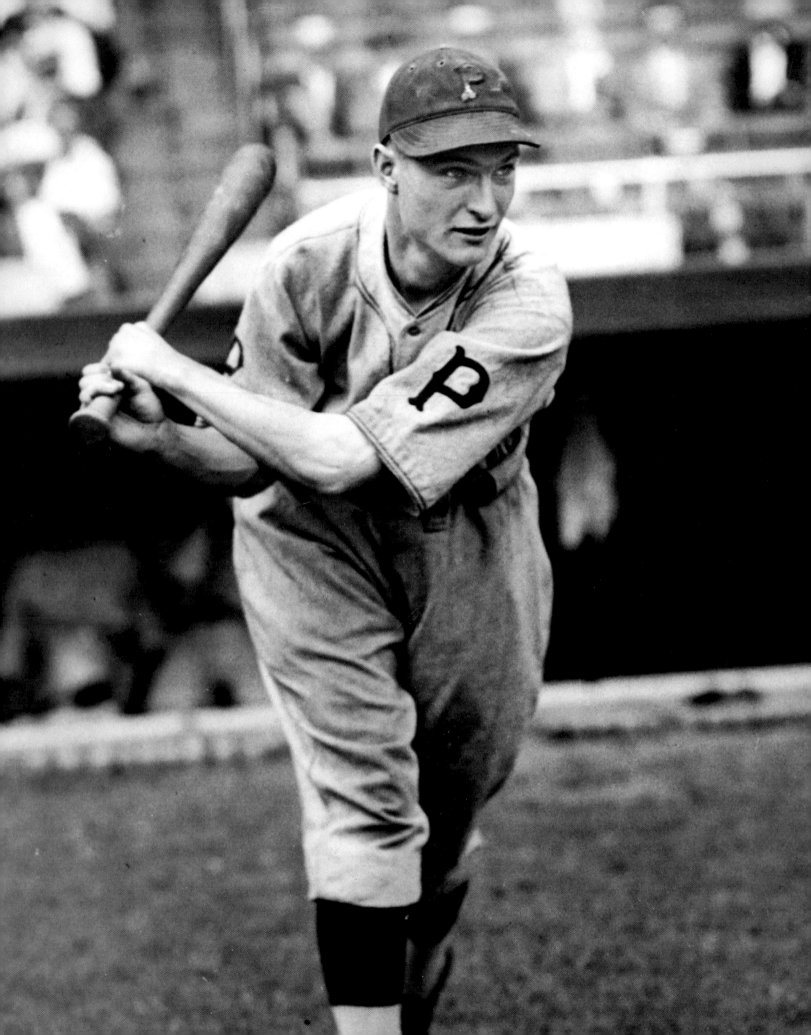

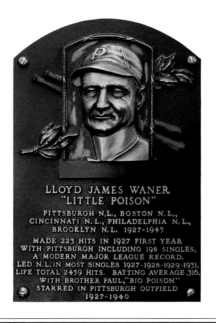

LLOYD JAMES WANER
"LITTLE POISON"
PITTSBURGH N.L., BOSTON N.L.,
CINCINNATI N.L., PHILADELPHIA N.L.,
BROOKLYN N.L. 1927-1945
MADE 223 HITS IN 1927 FIRST YEAR
WITH PITTSBURGH INCLUDING 198 SINGLES,
A MODERN MAJOR LEAGUE RECORD.
LED N.L. IN MOST SINGLES 1927-1928-1929-1931.
LIFE TOTAL 2459 HITS. BATTING AVERAGE .316,
WITH BROTHER PAUL, "BIG POISON"
STARRED IN PITTSBURGH OUTFIELD
1927-1940

LLOYD WANER

CLASS OF 1967

He played in the shadow of his big brother—a brother who would go on to record more than three thousand big league hits. But Lloyd Waner carved out his own legend on the diamond.

Lloyd was born in Harrah, Oklahoma, on March 16, 1906—three years after Paul. More often than not, Lloyd played second fiddle, being nicknamed "Little Poison" to his brother Paul's "Big Poison," allegedly after a sportswriter misinterpreted the local accent of a Brooklyn fan referring to that "little person." Lloyd, however, stood five foot nine—one inch taller than his brother.

Paul Waner debuted with the Pirates in 1926, and persuaded the Bucs to give Lloyd a tryout the following year. Quickly they became a national sensation.

Lloyd had an amazing rookie season, batting .355, leading the National League with 133 runs scored, and setting a rookie NL record of 223 hits in 1927. He helped the Pittsburgh Pirates win the pennant before losing the World Series to the Yankees.

"We went back home to Oklahoma," Paul said, "and darned if they didn't have a parade for us. Lloyd and I outhit Ruth and Gehrig, .367 to .357, so everybody was happy."

The brothers capitalized on their baseball fame by forming a vaudeville act in which Lloyd played violin while his brother played the saxophone.

"We got $2,100 a week, which was really big money in those

days," Lloyd once recalled. "The most I ever made in a [baseball] season was $13,500."

It has often been written that Pittsburgh actually lost the 1927 Series the day before it started by sitting in the Forbes Field stands and watching the Yankees crush ball after ball over the fence in batting practice. In an interview in 1967, however, when he was elected to the Hall of Fame by the Veterans Committee, Lloyd laid that theory to rest.

"Only one game wasn't close and I think that score was 8–1. We gave them a battle. Of course, those Yanks of '27 were the greatest ball team I ever saw. They had everything."

Lloyd posted four 200-hit seasons in his first five big league campaigns, missing out in 1930 because of injuries. He patrolled center field for the Pirates for thirteen years as a regular, then finished his career as a part-timer with the Braves, Reds, Phillies, and Dodgers before returning to the Pirates in 1944–45.

He compiled a career average of .316, with 2,459 hits (83 percent of which were singles), and struck out just 173 times, giving him an at-bat-to-strikeout ratio of 44.9, second only to Joe Sewell among players who began their careers after 1900.

And with the glove in center field, Lloyd had few peers.

"How good of a center fielder was he? I'd say this: Better than Willie Mays," said Hall of Fame teammate Pie Traynor. "Lloyd played a natural center field and he could go in and grab those balls [behind second base]. He was the fastest man in the league. He got a tremendous jump on the ball."

—C.M.

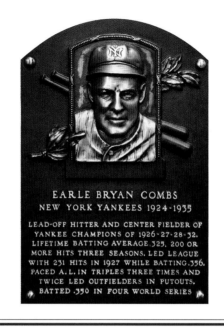

EARLE BRYAN COMBS
NEW YORK YANKEES 1924-1935

LEAD-OFF HITTER AND CENTER FIELDER OF
YANKEE CHAMPIONS OF 1926·27·28·32.
LIFETIME BATTING AVERAGE .325, 200 OR
MORE HITS THREE SEASONS. LED LEAGUE
WITH 231 HITS IN 1927 WHILE BATTING .356.
PACED A.L. IN TRIPLES THREE TIMES AND
TWICE LED OUTFIELDERS IN PUTOUTS.
BATTED .350 IN FOUR WORLD SERIES

EARLE COMBS

CLASS OF 1970

It is rare when a Hall of Fame player is underrated on his own team, but as a member of the 1927 "Murderers' Row" New York Yankees, Earle Combs fit that description. Although he batted .325 lifetime, Combs played in the shadow of Babe Ruth and Lou Gehrig and sometimes mound Hall of Famers Red Ruffing and Waite Hoyt, too.

Combs's real distinguishing specialty was the graceful way he covered territory in Yankee Stadium's vast center field. Growing up in a small town in Kentucky, Combs attended Eastern Kentucky University to train as a teacher. Once working, he filled his spare time playing semipro baseball and was so good his reputation spread around the state.

Future Hall of Famer Joe McCarthy, who was managing the Louisville Colonels, offered Combs more money than he made as a teacher, so he took it. Ironically, Combs's first splash as a fielder was an embarrassing incident when he lost the ball in the air and his team lost the game because of it. Combs wanted to return to the classroom, but a McCarthy pep talk kept him going.

Later, as a star fielder for the champion Yankees, Combs was given carte blanche to chase any fly because he could outrun Ruth in right and Bob Meusel in left. "I was just helping out like a teammate should," Combs said. "I always had a good pair of legs and loved to do it. When [manager Miller] Huggins put me out in center he said to take all you can get and don't worry about Ruth or Meusel. They'll never run into you. You know, he was right."

Combs's abandon in the field, however, nearly cost him his life and likely ended his career prematurely. In a 1934 game at Sportsman's Park in St. Louis, Combs ran into the wall, was knocked unconscious, and fractured his skull. The hospital put him on the critical list. "You see, I'm made of tough stuff," Combs said at the time. "They said I was through in 1924 when I broke my ankle. I fooled them once and I believe I will do it again." He played one more season.

An exceptional hitter, Combs got on base frequently, and power hitters Ruth and Gehrig drove him home. Huggins said that was the perfect scenario. "Up here we'll call you 'the waiter,'" the manager told him. "When you get on first base you just wait there for Ruth or Gehrig, or one of the other fellows to send you the rest of the way around."

Combs was popular in the clubhouse, with the sportswriters, and around baseball. He was nicknamed "The Kentucky Colonel" before it became a cliché, and his teammates admired him. "The only one I could guarantee as a full-fledged gentleman was Earle Combs," said Hall of Fame catcher Bill Dickey.

Combs realized how privileged he was to play for the Yankees of the period. "The Yankees of 1927 had to be the greatest baseball team of all time," he said.

—L.F.

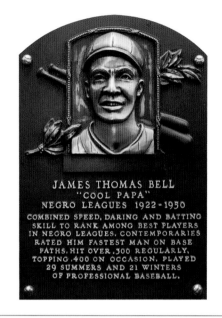

JAMES THOMAS BELL
"COOL PAPA"
NEGRO LEAGUES 1922-1950
COMBINED SPEED, DARING AND BATTING
SKILL TO RANK AMONG BEST PLAYERS
IN NEGRO LEAGUES. CONTEMPORARIES
RATED HIM FASTEST MAN ON BASE
PATHS. HIT OVER .300 REGULARLY,
TOPPING .400 ON OCCASION. PLAYED
29 SUMMERS AND 21 WINTERS
OF PROFESSIONAL BASEBALL.

COOL PAPA BELL

CLASS OF 1974

Considered one of the fastest base runners of all time, James "Cool Papa" Bell played from 1922 to 1946 in the Negro Leagues and Mexico, with such teams as the St. Louis Stars, the Pittsburgh Crawfords, and the Homestead Grays. Because of segregation, he never played in the major leagues, as his career ended before Jackie Robinson broke the color barrier.

"They used to say, 'If we find a good black player, we'll sign him,'" Bell once said. "They was lying."

But that didn't stop Bell from putting together a memorable career. He often starred in exhibition games, hitting .392, for example, against such big league pitchers as Bob Feller and Dizzy Dean. Unfortunately, records from this era are often sketchy at best. Bell recalled a game in which he once had "five hits and stole five bases, but none of it was written down because they didn't bring the scorebook to the game that day."

Bell migrated from Mississippi and followed his half brother Fred Bell into the game, beginning his career as a pitcher. His great speed soon made him an everyday player, though, and he was an excellent leadoff hitter and a superb defensive center fielder.

Decades later, Bell is remembered for his outstanding speed. Stories abound regarding his prowess on the base paths. He once scored from second base on a sacrifice fly and another time went from first to third on a bunt. In Ken Burns's documentary *Baseball*, there's the anecdote about how he scored from first base on a sacrifice bunt. Bell reportedly was clocked rounding the bases in twelve seconds.

Onetime Negro Leaguer Jimmie Crutchfield (in a story repeated by others) said that Bell was so fast, he once hit a grounder up the middle that struck him when he slid into second base after rounding first.

Satchel Paige claimed that the Negro League speedster would have beaten Olympic gold medalist Jesse Owens in a footrace. And of course it was Paige who said that Bell was so fast, he could flick the light switch and be in bed before the lights went out.

What we do know for certain is that Bell won the Triple Crown in the 1940 Mexican League, where his .437 batting average was seventy-three points higher than another Hall of Famer's, Martín Dihigo. With the Pittsburgh Crawfords, he played alongside Crutchfield and Ted Page, forming perhaps the best outfield ever in the Negro Leagues. He spent his last four professional seasons with the Homestead Grays, and the team won the title three times. Though Negro League statistics are incomplete, recent research has found that Bell hit .316 over his career, with 51 known triples and 33 known home runs.

After his playing days were over, Bell coached for the Kansas City Monarchs and often managed one of their barnstorming teams. In that capacity he helped groom such future major leaguers as Ernie Banks, Elston Howard, and Jackie Robinson.

In 1999 the *Sporting News* ranked Bell sixty-sixth on its list of the game's all-time top players.

—T. Wendel

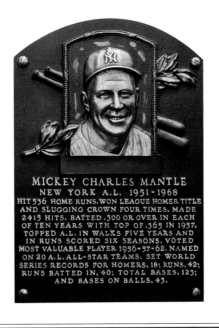

MICKEY CHARLES MANTLE
NEW YORK A.L. 1951-1968
HIT 536 HOME RUNS. WON LEAGUE HOMER TITLE
AND SLUGGING CROWN FOUR TIMES. MADE
2415 HITS. BATTED .300 OR OVER IN EACH
OF TEN YEARS WITH TOP OF .365 IN 1957.
TOPPED A.L. IN WALKS FIVE YEARS AND
IN RUNS SCORED SIX SEASONS. VOTED
MOST VALUABLE PLAYER 1956-57-62. NAMED
ON 20 A.L. ALL-STAR TEAMS. SET WORLD
SERIES RECORDS FOR HOMERS, 18; RUNS, 42;
RUNS BATTED IN, 40; TOTAL BASES, 123;
AND BASES ON BALLS, 43.

MICKEY MANTLE

CLASS OF 1974

Few ballplayers become icons. To achieve such status, a player must combine on-field excellence with an appealing personality and a commanding charisma. Mickey Mantle qualified on all counts.

Born in the rural America of Spavinaw, Oklahoma, Mantle was named after Hall of Famer Mickey Cochrane. He would more than live up to the moniker. Visionary New York Yankees scout Tom Greenwade signed Mantle to a $1,000 contract at the age of seventeen. Only two years later, the rawboned Oklahoman made his major league debut.

"He was a real country boy, all shy and embarrassed," Whitey Ford once told ESPN. "He arrived with a straw suitcase and two pairs of slacks and one blue sports jacket that probably cost about eight dollars." Given his green innocence, it was no surprise that Mantle's rookie season did not go smoothly. Struggling badly at the outset, he received a demotion to Triple-A Kansas City. Mantle learned from the experience; he returned later that summer, hitting well enough to finish with thirteen home runs and sixty-five RBI.

Throughout the 1950s, Mantle impressed observers with the length of his home runs, prompting the concept of the "tape-measure" home run. Facing Chuck Stobbs in 1953, Mantle ripped a 565-foot shot at Washington's Griffith Stadium. On Opening Day in 1956, Mantle hit a pair of home runs, each top-ping five hundred feet. Then in late May, when Mantle crushed a Pedro Ramos pitch off the upper-deck façade, 396 feet away, he came within inches of being the only major leaguer to hit a fair ball out of Yankee Stadium.

From 1956 to 1962, Mantle collected three MVP Awards. In actuality he could have won the MVP just about every year during that span, if not for the presence of Roger Maris and the desire of sportswriters to spread the wealth. Some of his slugging percentages, like .705 and .687, are eye-opening. His on-base percentages, like .512 and .486, are just as stunning. He also performed brilliantly in the World Series. When Mantle took the field at his height, he simply controlled the game.

Combined with his on-field prowess, Mantle's down-home personality would make him a fan favorite in the Bronx. As he aged, he became more patient with fans and their demands for his time. Even as his physical skills declined, his stature as an icon grew.

Mantle's teammates praised him universally. They never ceased talking about him as the best of teammates, a superstar who supported anyone who needed help within the confines of the clubhouse.

"Mick was never a contrived person, he was a genuine person," his former teammate Tony Kubek told the *New York Times*. "He brought a lot of Oklahoma with him to New York and never changed. He showed a certain amount of humility and never let the stardom go to his head."

—B.M.

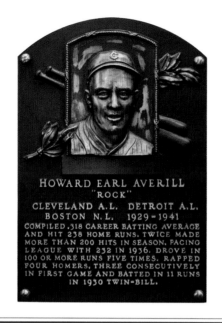

HOWARD EARL AVERILL
"ROCK"
CLEVELAND A.L. DETROIT A.L.
BOSTON N.L. 1929-1941
COMPILED .318 CAREER BATTING AVERAGE
AND HIT 238 HOME RUNS. TWICE MADE
MORE THAN 200 HITS IN SEASON. PACING
LEAGUE WITH 232 IN 1936. DROVE IN
100 OR MORE RUNS FIVE TIMES. RAPPED
FOUR HOMERS, THREE CONSECUTIVELY
IN FIRST GAME AND BATTED IN 11 RUNS
IN 1930 TWIN-BILL.

EARL AVERILL

CLASS OF 1975

It's a ten-year stretch that rivals or tops the first big league decade of any player in history. After those ten years, Earl Averill was never again a regular—and his career was finished after his thirteenth season. But for that decade, Averill was one of the most dangerous hitters in the game.

Born May 21, 1902, in Snohomish, Washington, Averill broke into the big leagues at the age of twenty-six after two years in the low minors and three years of success in the Pacific Coast League—which at the time was nearly strong enough to be considered a third "major league." Averill averaged 250 hits per season while playing in at least 180 games annually in the expanded PCL season.

Purchased by the Cleveland Indians prior to the 1929 season, the five-foot-nine center fielder was an immediate hit in the American League, batting .332 with 18 homers, 96 RBI, and 110 runs scored in his debut campaign—to go along with 198 hits, which still ranks number eight on the all-time list for rookies.

In his last season as a regular in 1938, Averill posted nearly the same numbers: a .330 average, 14 homers, 93 RBI, and 101 runs scored.

In between, Averill scored one hundred or more runs seven times, topped thirty homers three times, and knocked in one hundred or more runs in five seasons. During his first ten big league seasons, Averill averaged 22 home runs, 108 RBI, and 115 runs scored per season and hit .323.

"I thank the good Lord he wasn't twins," said Hall of Fame pitcher Lefty Gomez, whose Yankees battled the Indians in the American League throughout the 1930s. "One more like him probably would have kept me out of the Hall of Fame."

Averill was traded to the Tigers on June 14, 1939, and the next year as a bench player he helped Detroit win the American League Pennant. Averill retired after spending part of the 1941 season with the Boston Braves.

For his career, Averill hit .318 with 238 home runs (his 226 homers with Cleveland were an Indians record for more than fifty years), 2,019 hits, and 1,224 runs scored. He hit at least .301 in eight of his first ten big league seasons, topping out at .378 in 1936, when he led the AL with 232 hits and fifteen triples. He still holds Indians career records for runs, triples, total bases, RBI, and extra-base hits.

Averill finished in the top four of the AL Most Valuable Player voting in three seasons and was named to six All-Star teams.

He also owns a place in All-Star Game lore. In the 1937 Midsummer Classic, Averill lined a ball off the left foot of National League pitcher Dizzy Dean—an injury that eventually left Dean with a permanently sore arm from altering his motion to compensate for a broken toe.

Averill was elected to the Hall of Fame in 1975, and he passed away August 16, 1983.

"I could have gotten in sooner," said Averill of his Hall of Fame election. "But it's sure better late than never."

—C.M.

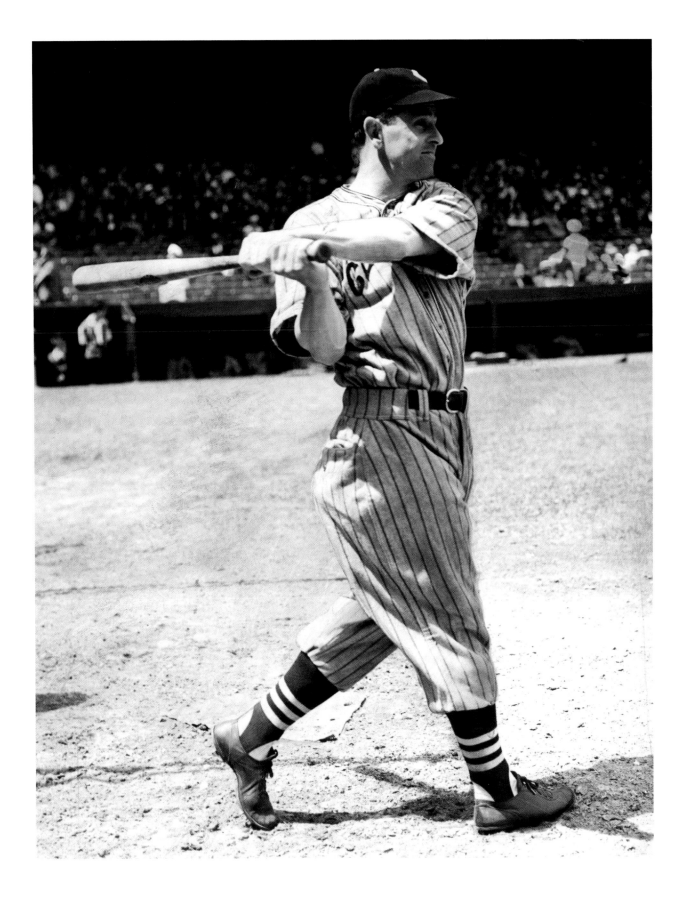

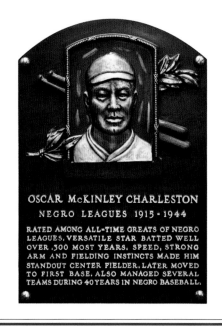

OSCAR McKINLEY CHARLESTON
NEGRO LEAGUES 1915-1944
RATED AMONG ALL-TIME GREATS OF NEGRO
LEAGUES. VERSATILE STAR BATTED WELL
OVER .300 MOST YEARS. SPEED, STRONG
ARM AND FIELDING INSTINCTS MADE HIM
STANDOUT CENTER FIELDER. LATER MOVED
TO FIRST BASE. ALSO MANAGED SEVERAL
TEAMS DURING 40 YEARS IN NEGRO BASEBALL.

OSCAR CHARLESTON

CLASS OF 1976

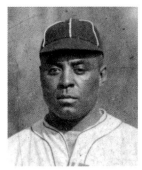

Oscar Charleston was one of the first superstars of the Negro Leagues, and many consider him to be the best all-around player ever to participate in those ranks.

Hall of Famer John McGraw told the *Sporting News* that Charleston was the best player he ever saw.

"It's impossible for anyone to be a better ballplayer than Oscar Charleston," agreed sportswriter Grantland Rice.

According to the Negro Leagues Baseball Museum, first baseman and manager Ben Taylor said that Charleston was the "greatest outfielder that ever lived . . . greatest of all the [players regardless of race]. He can cover more ground than any man I have ever seen. His judging of flyballs borders on the uncanny."

A barrel-chested slugger, Charleston hit for average and power while revolutionizing defensive play in center field. He regularly played shallow in the field and ran down almost anything hit over his head. In addition, Charleston deployed his blazing speed on the base paths and in the outfield and was often compared to Ty Cobb.

"Some people asked me, 'Why are you playing so close to the right-field foul line?'" said Dave Malarcher, Charleston's former teammate. "What they didn't know was that Charleston covered all three fields, and my responsibility was to make sure of balls down the line and those in foul territory."

Charleston's career began in 1915 with the Indianapolis ABCs in the years prior to the Negro National League. During his twenty-six-year career he also played in Chicago, Detroit, St. Louis, Toledo, Philadelphia, Harrisburg, and Pittsburgh. In 1921, with the St. Louis Giants, he batted .444 while leading the Negro National League in doubles, triples, home runs, and stolen bases. The following season he hit .395 and again led the league in home runs and stolen bases. Charleston also played nine seasons of winter ball in Cuba.

In 1931 Charleston was a member of the Homestead Grays, whose roster included Joe Williams, Jud Wilson, Ted "Double Duty" Radcliffe, and Josh Gibson. Charleston hit .346 for the Grays that year.

In his final seasons, mostly with the Pittsburgh Crawfords, Charleston moved to first base, but he continued to hit for average and was named to the first three East-West All-Star Games. During this period, the Crawfords were arguably the best Negro League team ever assembled, as Charleston was joined by Gibson, Judy Johnson, James "Cool Papa" Bell, and Satchel Paige.

Charleston was also a very successful manager in the Negro Leagues, often taking the role of player-manager. He was the manager of the Brooklyn Brown Dodgers of the short-lived United States League, which disbanded when Jackie Robinson integrated organized baseball.

—T. Wendel

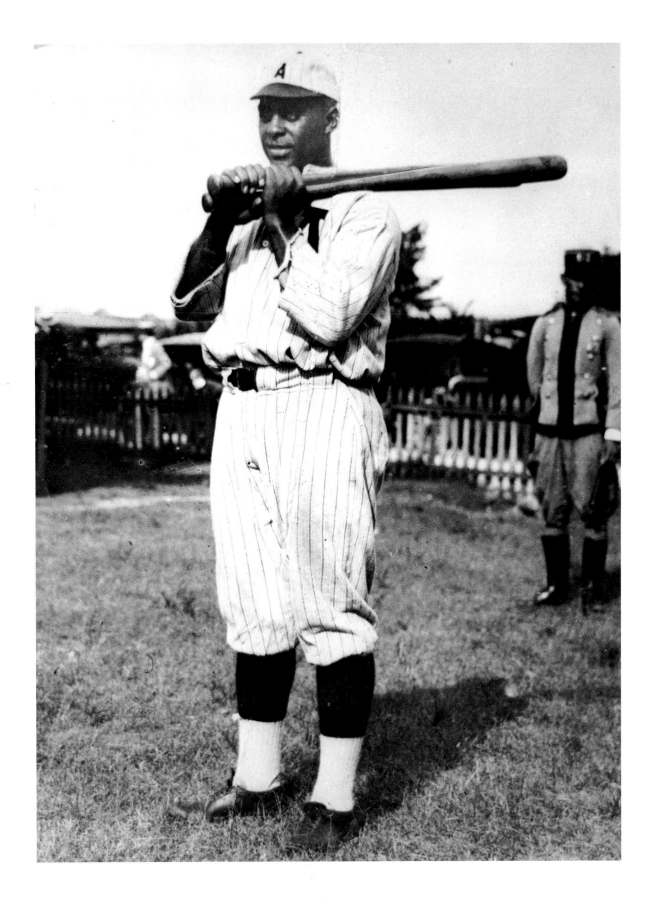

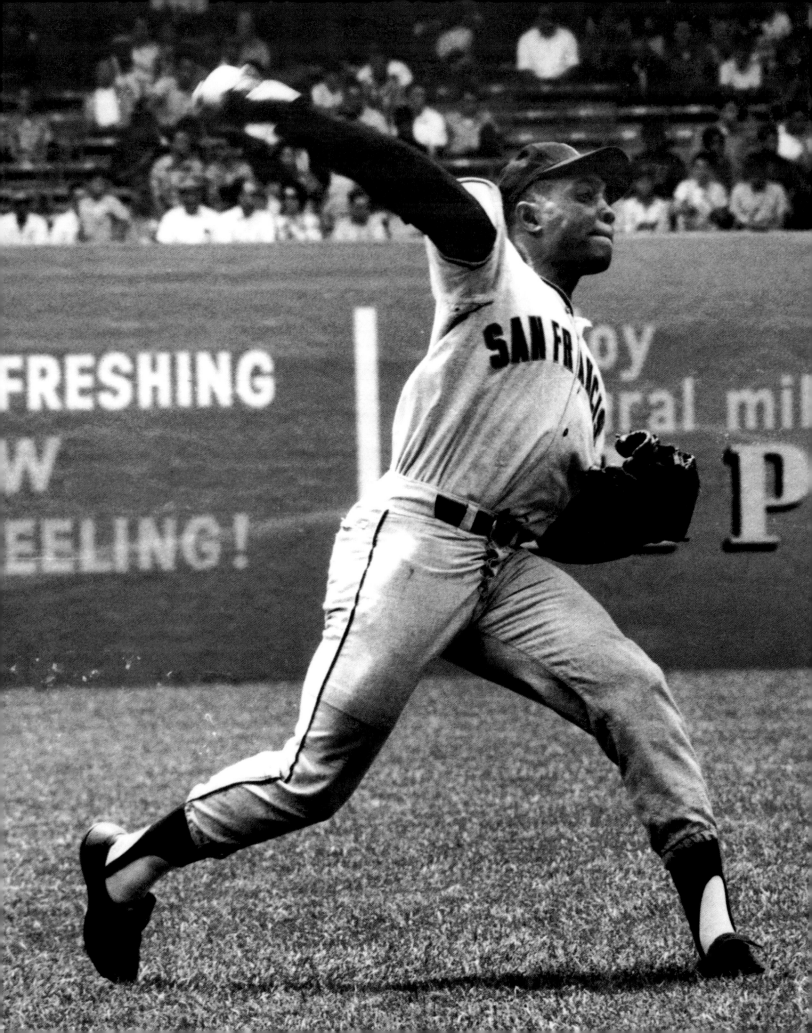

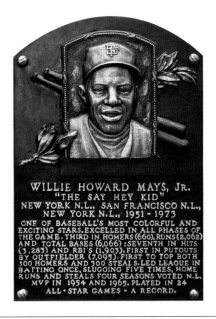

WILLIE HOWARD MAYS, JR.
"THE SAY HEY KID"
NEW YORK N.L., SAN FRANCISCO N.L.,
NEW YORK N.L., 1951 - 1973
ONE OF BASEBALL'S MOST COLORFUL AND
EXCITING STARS. EXCELLED IN ALL PHASES OF
THE GAME. THIRD IN HOMERS (660), RUNS (2,062)
AND TOTAL BASES (6,066) ; SEVENTH IN HITS
(3,283) AND RBI'S (1,903). FIRST IN PUTOUTS
BY OUTFIELDER (7,095). FIRST TO TOP BOTH
300 HOMERS AND 300 STEALS. LED LEAGUE IN
BATTING ONCE, SLUGGING FIVE TIMES, HOME
RUNS AND STEALS FOUR SEASONS. VOTED N.L.
MVP IN 1954 AND 1965. PLAYED IN 24
ALL-STAR GAMES - A RECORD.

WILLIE MAYS

CLASS OF 1979

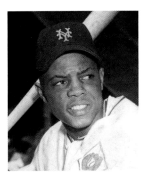

Whether it was playing stickball in the streets or making incredible plays on the World Series stage, Willie Mays entertained fans with unmatchable flair.

Born in the segregated South of Alabama, Mays made his professional debut with the Birmingham Black Barons of the Negro American League. After he spent two seasons in black ball, the New York Giants signed him, beating out several other teams that hesitated because of Mays's skin color.

The Giants promoted Mays early in 1951. When he collected his first hit, a home run against the Boston Braves' Warren Spahn, it ended a string of twelve hitless at bats to start his career.

As a rookie, Mays had severe doubts about his readiness. He suggested to Leo Durocher that he be sent back to the minor leagues, but the Hall of Fame manager believed in his five-tool center fielder. He kept Mays in the lineup and watched him rebound to hit twenty home runs and win National League Rookie of the Year, as the Giants completed a miracle second-half comeback against the Brooklyn Dodgers.

"Willie could do everything from the day he joined the Giants," Durocher told the *New York Times*. "He never had to be taught a thing. The only other player who could do it all was Joe DiMaggio."

Still, there were setbacks beyond his control. With the Korean War raging, Mays was called up for military service in May 1952. He would miss the balance of the season and all of 1953.

Returning in 1954, Mays exploded into stardom. Spearheaded by Mays, who led the National League in batting and slugging, the Giants advanced to the World Series. In Game 1, Mays made an all-out pursuit of a very deep drive by Cleveland's Vic Wertz and, with his back toward the infield, completed a remarkable over-the-shoulder catch. Considered by many the finest fielding play in Series history, Mays's grab helped the Giants to a world championship.

Mays's on-field brilliance made him a star. He added to his popularity by playing stickball with youthful fans in the streets of New York. Thanks to his boyish enthusiasm, he emerged as the darling of Giants fans.

After the Giants moved to San Francisco, Mays continued his amazing feats at Candlestick Park, where he battled the high winds. He remained such a dominant player that the *Sporting News* named him Player of the Decade for the 1960s.

For fans of baseball in the sixties and early seventies, one of the most lasting images involved the sight of Mays rounding the bases. By the time Mays reached home, his cap was often sitting abandoned between third and home, or resting between second and third, waiting to be retrieved by a diligent ball boy. There should be little doubt that Mays was the most memorable base runner of the television era. And he just may have been the most dynamic player of the era, too.

—B.M.

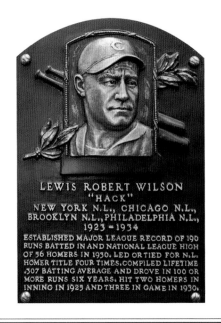

HACK WILSON

CLASS OF 1979

One season does not make a Hall of Famer. But for Lewis "Hack" Wilson, that single season still resonates as one of the greatest compilations of statistics in baseball history.

Wilson, born April 26, 1900, in Ellwood City, Pennsylvania, was a five-foot-six, 190-pound outfielder with a vicious swing. After building up his strength while working in a locomotive factory as a teenager, Wilson tore up the minor leagues before future Hall of Fame manager John McGraw brought him to the Giants in 1923.

By the next season, Wilson was a regular in New York's outfield, hitting .295 with 10 homers and 57 RBI while helping the Giants win the National League Pennant. But during a slump in 1925, McGraw sent Wilson back to the minors—where he was selected by the Cubs in the Rule 5 draft following the season.

From 1926 to 1930, Wilson led the NL in homers each season except for 1929—a year when he led the league in RBI with 159. In 1930 Wilson became just the second player—after Babe Ruth—to eclipse the fifty-home-run mark in a single season when he totaled fifty-six, a National League record that would stand for more than sixty years.

Wilson drove in 191 runs that year, a big league record that still holds and has rarely been approached.

He slumped to just thirteen homers and sixty-one RBI in 1931, leading the Cubs to trade him to the Cardinals after the season.

But in less than two months he was traded again—this time to Brooklyn, where he hit twenty-three home runs and drove in 123 runs in his last great season.

"They told me in Chicago that I'd have to quit this and that, but I'm not signing any pledges," Wilson said. "I have a wife and boy and baseball is my livelihood, and I'm not going to do anything that will prevent me from earning my living that way. I'm smart enough to know the eyes of the baseball world will be on me next season, on and off the field, and I'll have to watch my step more than the average player. I also realize that I will have considerable box office value to . . . whatever club gets me."

Injuries began to take their toll on Wilson, and his big league career ended after the 1934 season.

"He had real small feet and ankles, which helped to make him look funny, that big body sitting on those little feet," said teammate Al Lopez, who would one day join Wilson in the Hall of Fame. "He had his ankles taped before every game, the only player I ever knew of at that time that did."

Wilson was elected to the Hall of Fame in 1979, more than thirty years after his death. He finished his twelve-year big league career with 244 home runs, 1,063 RBI, and a .307 batting average.

"Today there are many kids in and out of baseball who think that just because they have some natural talent they have the world by the tail," Wilson once said. "It isn't so. In life you need many more things besides talent. Things like good advice and common sense."

—L.F.

EDWIN DONALD SNIDER
"DUKE"
BROOKLYN N.L., LOS ANGELES N.L.,
NEW YORK N.L., SAN FRANCISCO N.L.,
1947-1964
HIT 407 CAREER HOME RUNS AND TIED N.L.
RECORD WITH 40 OR MORE ROUND-TRIPPERS
FIVE YEARS IN A ROW, 1953-1957. BATTED .300
OR BETTER SEVEN TIMES IN COMPILING .295
LIFETIME AVERAGE. TOPPED LEAGUE IN SLUGG-
ING PCT. TWICE AND TOTAL BASES THREE TIMES.
FIRST TO HIT FOUR HOMERS IN A WORLD SERIES
TWICE -- IN 1952 AND 1955. SET N.L.
RECORD FOR SERIES HOMERS (11).

DUKE SNIDER

CLASS OF 1980

He lived in the same neighborhood as his fans, making him a favorite of the common people. That quality, coupled with his ample abilities as a center fielder and a slugger, made Duke Snider one of the most revered of the "Boys of Summer."

Born in California, Snider would become the Brooklyn Dodgers' chief object of affection. He reached the major leagues at age twenty, briefly taking the place of an injured Pete Reiser. Snider recalled meeting Brooklyn's famed president as a rookie. "Branch Rickey called me and Gil Hodges into his office," said Snider at his Cooperstown induction. "He said we would be the power of the Dodgers. I looked at Gil and he looked at me. He was the third-string catcher and I was the sixth outfielder. I guess Mr. Rickey knew something the rest of us didn't."

Rickey did. Although Snider returned to the minor leagues, he would become Brooklyn's regular center fielder in 1949, hitting .292 and scoring one hundred runs. On the season's final day, he drove in the game-winning run to clinch the pennant.

Snider played even better in 1950, hitting .321 with thirty-one home runs. Two years later he hit .303 to lead the Dodgers to another pennant. He elevated his game further in the World Series, clubbing four home runs.

With his smooth left-handed swing, Snider enjoyed arguably his finest season in 1955, when he led the league in runs and RBI. Spurred by Snider, the Dodgers won the pennant and earned a rematch with the New York Yankees. Snider tormented the Yankees, belting four home runs and batting .320 to lead Brooklyn to its only world championship.

Yet there was more to Snider's game than hitting and slugging. He was a graceful center fielder with a strong arm. During one game, left fielder Gene Hermanski failed to make a shoestring catch, allowing the ball to roll toward the corner. Racing all the way from center field to the foul line, Snider scooped up the ball bare-handed and made a terrific throw to third, nailing the unsuspecting runner. "An ordinary ballplayer wouldn't have started from center field to back up the play," an admiring Rickey told the *Saturday Evening Post*. "Only a great player can do things like that—see them or feel them before they happen!"

Though Snider's play was instinctive, he had displayed a moody streak early in his career. His tendency to sulk concerned the Dodgers. Veteran shortstop Pee Wee Reese befriended Snider, providing a calming and wise influence. Snider would eventually succeed Reese as team captain. Brooklyn fans adored "The Duke of Flatbush," and when he and the Dodgers left for Los Angeles, the borough of Brooklyn mourned their departure.

Few players are adopted by fans as one of their own, especially when they hail from the other side of the country. Snider, who played stickball in the streets of Brooklyn and became a vested member of the community, was one of those rarities.

—B.M.

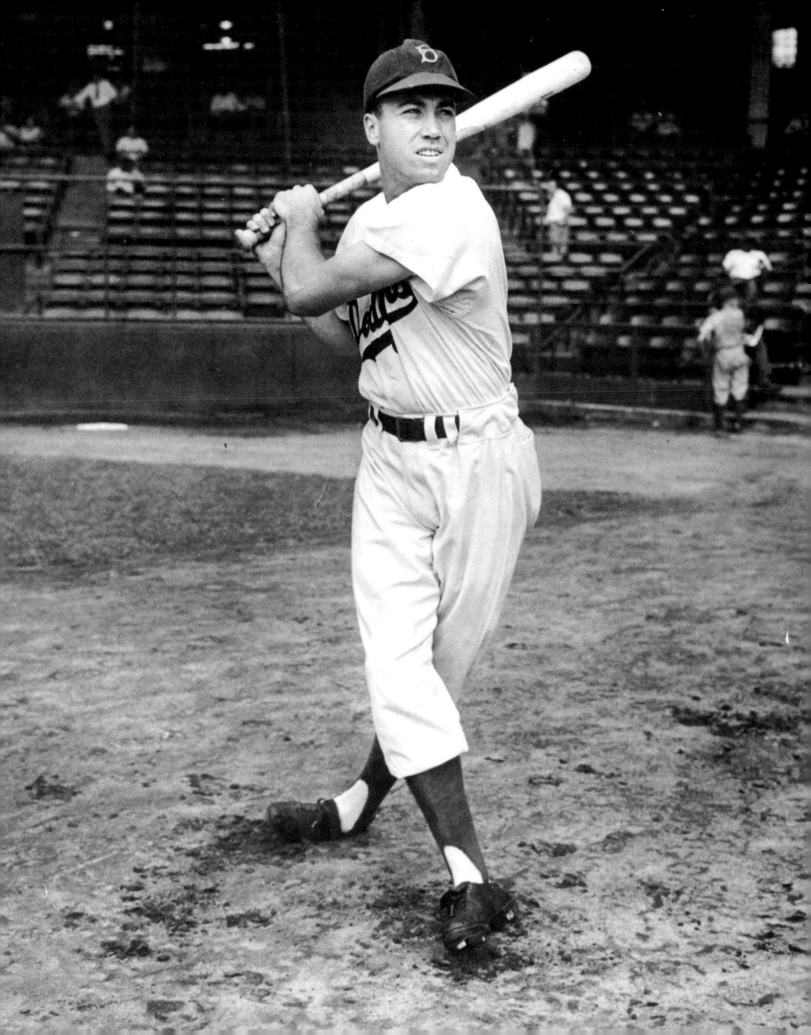

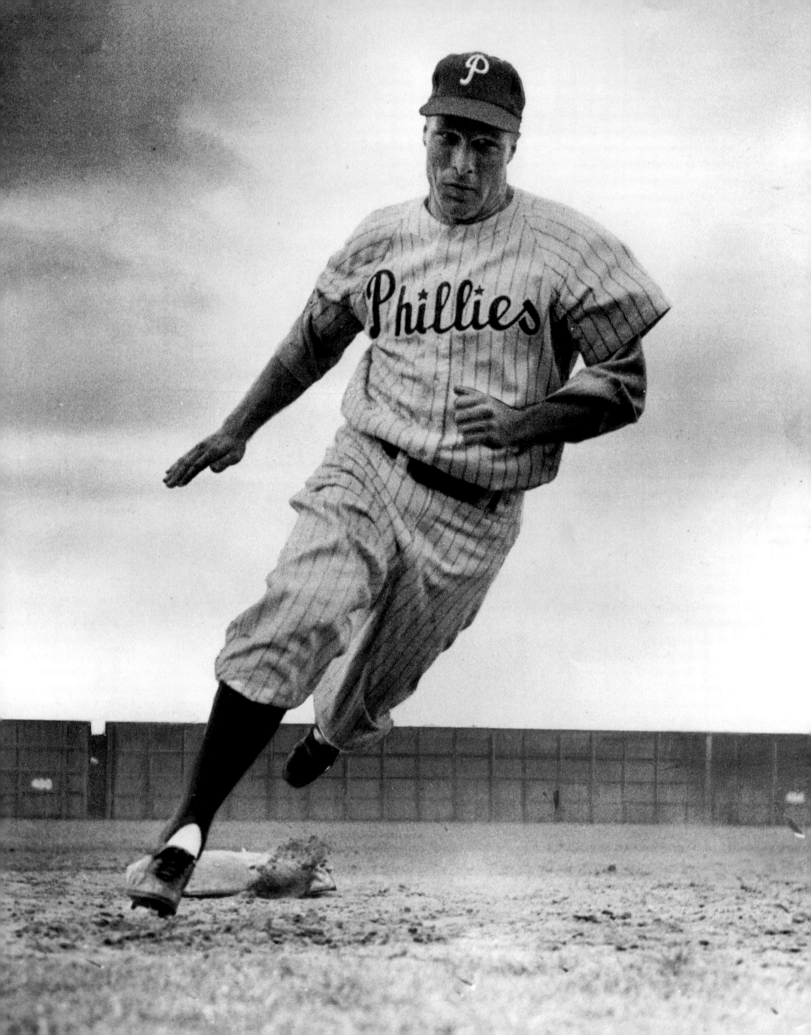

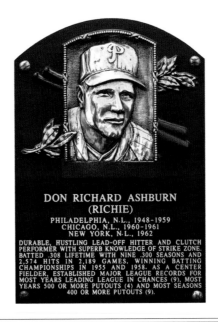

DON RICHARD ASHBURN
(RICHIE)
PHILADELPHIA, N.L., 1948-1959
CHICAGO, N.L., 1960-1961
NEW YORK, N.L., 1962
DURABLE, HUSTLING LEAD-OFF HITTER AND CLUTCH
PERFORMER WITH SUPERB KNOWLEDGE OF STRIKE ZONE.
BATTED .308 LIFETIME WITH NINE .300 SEASONS AND
2,574 HITS IN 2,189 GAMES, WINNING BATTING
CHAMPIONSHIPS IN 1955 AND 1958. AS A CENTER
FIELDER, ESTABLISHED MAJOR LEAGUE RECORDS FOR
MOST YEARS LEADING LEAGUE IN CHANCES (9), MOST
YEARS 500 OR MORE PUTOUTS (4) AND MOST SEASONS
400 OR MORE PUTOUTS (9).

RICHIE ASHBURN

CLASS OF 1995

Few men have equally profound effects on a fan base as both a player and a broadcaster. Richie Ashburn was just such a beloved figure in the city of Philadelphia.

Ashburn's connection to Philadelphia began after a stint in the U.S. Army and some time in the minor leagues as a catcher and outfielder with the Utica Blue Sox. As a Phillies rookie, Ashburn batted .333 with a .410 on-base percentage. Many observers felt that he should have been named Rookie of the Year, but the honor went to Alvin Dark.

"[Ashburn] started in 1948," Hall of Famer Mike Schmidt told the *Philadelphia Inquirer.* "That's a hell of a long period of time—and especially in Philadelphia. To do that in Philadelphia, wow! More power to you. To stay in good graces with this city says something for your character. And he did it."

Nicknamed "Whitey" because of his light blond hair, Ashburn endeared himself to the demanding Phillies fans. The consummate leadoff man, he perennially reached the .300 mark and stole bases with regularity. Choking up on the bat, Ashburn scattered line drives to all fields, but he also possessed a keen eye; he led the National League in walks and on-base percentage four times apiece. On-base percentage was an overlooked statistic in his era, but Ashburn was its master.

In 1950 he steered the "Whiz Kids" to the National League Pennant, courtesy of a .303 average and a league-leading fourteen triples. On the final day of the regular season, Ashburn helped preserve the pennant by throwing out the Dodgers' Cal Abrams at the plate in the bottom of the ninth.

After a down season in 1959, the Phillies traded Ashburn to the Cubs for Dark and two lesser players. Ashburn wasn't done; he resuscitated his career by leading the league in walks and on-base percentage.

The expansion New York Mets eventually acquired Ashburn in a cash transaction and watched him emerge as one of the few bright spots on a comically inept team. Ashburn hit .306 and appeared to have life left in his bat, but he decided to call it quits.

Unlike some retired players, Ashburn made a smooth transition to a second career. Joining the Phillies' broadcast booth in 1963, Ashburn enhanced his popularity with his insight, humor, and bond with the common man. He teamed with Harry Kalas to form a charismatic broadcast duo.

Ashburn died in 1997 shortly after broadcasting a Phillies-Mets matchup at Shea Stadium. "He had a great feel for the game," Kalas told MLB.com. "And his down-home humor was another reason he was beloved. He was just a joy to be around. . . . To this day, something will happen in the booth or away from the stadium that will make me think of Whitey, and it will bring a warmth to my heart and a smile to my face."

Those good feelings were shared by thousands of Phillies fans, who still recall the two lifetimes of good service that Richie Ashburn gave to Philadelphia.

—B.M.

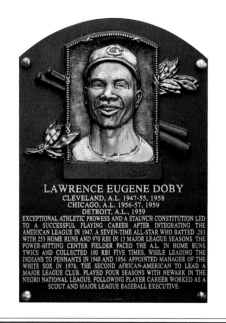

LAWRENCE EUGENE DOBY
CLEVELAND, A.L. 1947-55, 1958
CHICAGO, A.L. 1956-57, 1959
DETROIT, A.L., 1959
EXCEPTIONAL ATHLETIC PROWESS AND A STAUNCH CONSTITUTION LED
TO A SUCCESSFUL PLAYING CAREER AFTER INTEGRATING THE
AMERICAN LEAGUE IN 1947. A SEVEN-TIME ALL-STAR WHO BATTED .283
WITH 253 HOME RUNS AND 970 RBI IN 13 MAJOR LEAGUE SEASONS. THE
POWER-HITTING CENTER FIELDER PACED THE A.L. IN HOME RUNS
TWICE AND COLLECTED 100 RBI FIVE TIMES, WHILE LEADING THE
INDIANS TO PENNANTS IN 1948 AND 1954. APPOINTED MANAGER OF THE
WHITE SOX IN 1978, THE SECOND AFRICAN-AMERICAN TO LEAD A
MAJOR LEAGUE CLUB. PLAYED FOUR SEASONS WITH NEWARK IN THE
NEGRO NATIONAL LEAGUE. FOLLOWING PLAYER CAREER WORKED AS A
SCOUT AND MAJOR LEAGUE BASEBALL EXECUTIVE.

LARRY DOBY

CLASS OF 1998

As the first black player in the American League, Larry Doby played a major role in the game's social history. That association with the breaking of baseball's color barrier enhanced a stellar career in both the Negro Leagues and the major leagues.

The teenaged Doby launched his professional career in 1942, when he debuted as a second baseman for the Newark Eagles. After a stint in the U.S. Navy during World War II, Doby returned to the Eagles before finally receiving the call to the major leagues.

On July 5, 1947, just eleven weeks after Jackie Robinson debuted for the Brooklyn Dodgers, Doby broke in with the Cleveland Indians. Much like Robinson, Doby endured searing opposition from racist fans and opponents. On one occasion Doby slid into second base, only to be treated to a spitting shower from the opposing shortstop.

"Don't forget Larry Doby," Willie Mays told the *New York Times* in discussing his role as a civil rights pioneer. "From what I hear, Jackie had Pee Wee Reese and Gil Hodges and Ralph Branca [on his side], but Larry didn't have anybody." In particular, Doby faced the predicament of having no black teammates until 1948, when Satchel Paige arrived. So Doby had to deal with much of the racism on his own.

"It was tough on him," teammate Bob Feller told the Associated Press. "Larry was very sensitive, more so than Robinson or Satchel

Paige or Luke Easter or some of the other players who came over from the Negro Leagues. He was completely different from Jackie as a player. He was aggressive, but not like Jackie was."

The Indians converted Doby from the middle infield to the outfield. In 1948 he moved into the starting outfield, playing both center and right field, and helped the Indians to the world championship. That fall's World Series provided a moment of poignancy. "I hit a home run off Johnny Sain to help Steve Gromek win, and in the clubhouse the photographers took a picture of Gromek and me hugging," Doby told the *New York Times*. "That picture went all over the country. I think it was one of the first, if not the first, of a black guy and a white guy hugging, just happy because they won a ballgame."

A fine defensive outfielder who possessed speed and power, he enjoyed arguably his best season in 1952, when he led the league in home runs, runs, and slugging percentage. Two years later he led the league again with thirty-two home runs and 126 RBI, pushing the Indians to the pennant.

After his playing days, Doby continued to make headlines. In 1978 the Chicago White Sox named him manager, making him the second African American skipper after Frank Robinson.

Historians have often emphasized Doby's habit of being second behind both Robinsons, Frank and Jackie. In reality, he faced much of the same hatred and many of the same insults. Though he didn't receive the same publicity, he was every bit as much the civil rights hero.

—B.M.

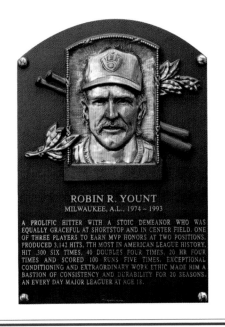

ROBIN YOUNT

CLASS OF 1999

Robin Yount left everything on the field during his twenty-year big league career with the Milwaukee Brewers.

In fact, Yount left it all *over* the field, winning the American League Most Valuable Player Award at two positions and establishing himself as one of the most versatile players in history.

Drafted by the Brewers with the third overall pick in 1973, Robin Yount made his debut for Milwaukee at the age of eighteen in 1974 and quickly became the Brewers' starting shortstop. With almost two full seasons as a regular before he turned twenty, Yount broke Mel Ott's long-standing record for most MLB games played as a teenager, with 243.

By 1980 Yount had established himself as a power-hitting shortstop, blasting an AL-leading forty-nine doubles with ten triples and twenty-three home runs. It started a streak of eleven out of twelve seasons in which he posted double-digit home run totals from 1980 to 1991. He also collected more hits—1,731—than any other player in the 1980s.

In 1982 Yount led the American League with 210 hits and forty-six doubles for a league-leading .578 slugging percentage, won a Gold Glove Award at shortstop, and also led the Brewers to their first pennant. Milwaukee lost the 1982 World Series in seven games to the St. Louis Cardinals, but Yount hit a blistering .414 with a home run, six runs scored, and six RBI.

Yount was a near-unanimous pick for AL MVP in 1982. Before then, only three AL shortstops had won the MVP Award: Lou Boudreau in 1948, Phil Rizzuto in 1950, and Zoilo Versalles in 1965.

"It's quite an honor," Yount said. "It's the type of award you can't win without help from everybody else on the team. When I'm 50 years old, sitting around with my kids, I'm gonna have a pile of cash over here and 1982 over there. What do you think I'll want to talk about?

"I don't get goose bumps when I open my pay envelope. But look at me when I start talking about 1982."

Injuries short-circuited Yount's career at shortstop and forced him to move to the outfield in 1985. He proved a quick study, and in 1989 Yount won his second Most Valuable Player Award—at the time only the third player to win MVPs at two different positions.

That season Yount hit .318 with 21 home runs and 103 RBI.

The durable Yount averaged better than 142 games per season over twenty years, and his career totals continued to mount into his thirties. In the seventh inning of the Brewers' September 9, 1992, game against the Indians, Yount singled for his three-thousandth hit, becoming only the seventeenth player—and the third-youngest—to achieve that mark. He still holds the Brewers' franchise records for games, at bats, runs, hits, doubles, triples, home runs, RBI, total bases, and walks.

Yount was elected to the Hall of Fame in 1999 in his first year of eligibility.

—J.Y.

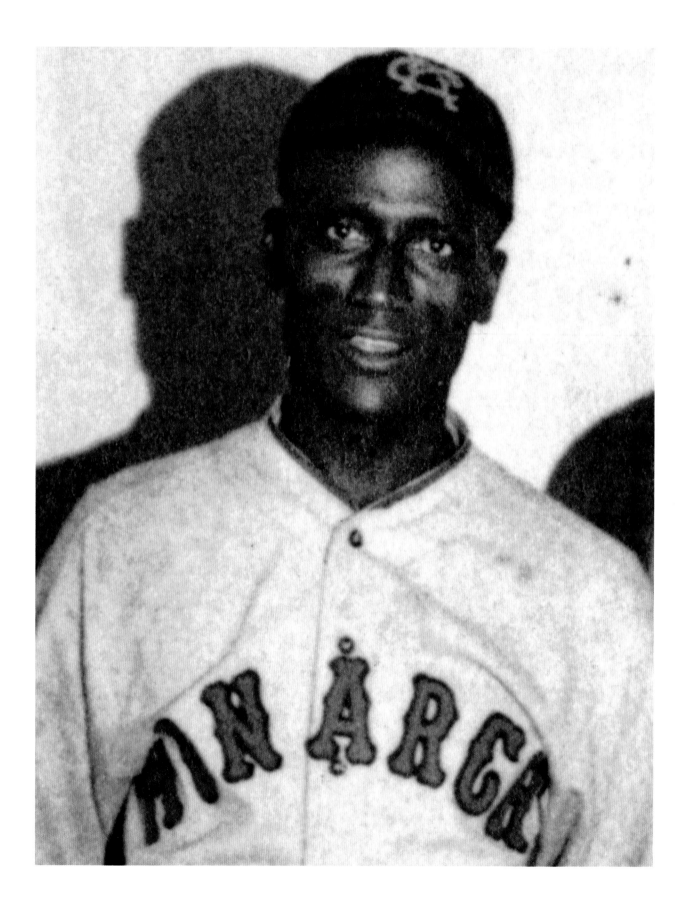

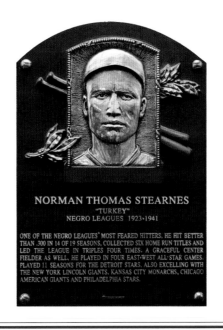

NORMAN THOMAS STEARNES
"TURKEY"
NEGRO LEAGUES 1923-1941

ONE OF THE NEGRO LEAGUES' MOST FEARED HITTERS, HE HIT BETTER
THAN .300 IN 14 OF 19 SEASONS, COLLECTED SIX HOME RUN TITLES AND
LED THE LEAGUE IN TRIPLES FOUR TIMES. A GRACEFUL CENTER
FIELDER AS WELL. HE PLAYED IN FOUR EAST-WEST ALL-STAR GAMES.
PLAYED 11 SEASONS FOR THE DETROIT STARS. ALSO EXCELLING WITH
THE NEW YORK LINCOLN GIANTS, KANSAS CITY MONARCHS, CHICAGO
AMERICAN GIANTS AND PHILADELPHIA STARS.

TURKEY STEARNES

CLASS OF 2000

Norman "Turkey" Stearnes was a player who could win a game for you in so many ways. He could hit a home run from the three or four hole in the lineup, bat leadoff and beat out a bunt for a base hit, and he could track down gappers in left-center field like a gazelle. There was almost nothing Turkey Stearnes could not do on a baseball field. Hall of Famer Cool Papa Bell recalled, "That man could hit the ball as far as anybody. But they don't say too much about him. . . . And he was one of our [the Negro Leagues'] best all-around players. He could field, he could hit, he could run. He had plenty of power."

One of the Negro Leagues' most prolific power hitters, he once stated, "I never counted my home runs. I hit so many, I never counted them, and I'll tell you why: If they didn't win a ball game, they didn't amount to anything."

Stearnes played for numerous teams during his career, as most Negro Leaguers did, including the Chicago American Giants, who won the 1932 pennant in the Negro Southern League and the 1933 pennant in the Negro National League. It was during his time with the American Giants that Stearnes was selected to play in the first East-West All-Star Game. During the voting to determine which players would compete in the contest, Turkey received more votes than any other outfielder.

It is claimed that Stearnes earned the nickname "Turkey" because of the unusual way he ran, which made him look like a turkey, arms flapping all around, but Turkey himself said it was because he had a potbelly as a young boy. Regardless of how the nickname came to be, Turkey was widely regarded as one of baseball's greatest all-time players, both during and after his career. Negro Leaguer Jim Canada, who played against Stearnes, said, "He hit the ball nine miles. He was a show; people would go to see him play."

Jimmie Crutchfield, a former teammate of Stearnes's, described him as a "quirky-jerky sort of guy who could hit the ball a mile." He elaborated: "Turkey had a batting stance that you'd swear couldn't let anybody hit a baseball at all. He'd stand up there looking like he was off balance. But, it was natural for him to stand that way, and you couldn't criticize him for it when he was hitting everything they threw at him!"

Anything but reserved on the baseball diamond, Stearnes off the field had a quiet, unassuming personality and no vices. According to teammate Paul Stevens, "[He was] very quiet. About all he would say were 'yes' and 'no'—he was never a fellow to pop off." A Tennessee native, Stearnes was a five-tool player and a five-time selection to the Negro Leagues' East-West All-Star Classic.

Legendary Negro Leagues hurler Satchel Paige said that Turkey Stearnes was "one of the greatest hitters we [Negro baseball] ever had. He was as good as Josh [Gibson]. He was as good as anybody who ever played ball."

—F.B.

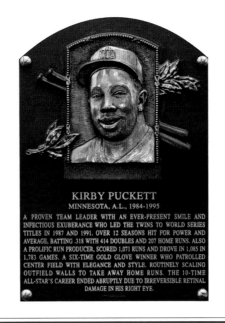

KIRBY PUCKETT
MINNESOTA, A.L., 1984-1995

A PROVEN TEAM LEADER WITH AN EVER-PRESENT SMILE AND
INFECTIOUS EXUBERANCE WHO LED THE TWINS TO WORLD SERIES
TITLES IN 1987 AND 1991. OVER 12 SEASONS HIT FOR POWER AND
AVERAGE, BATTING .318 WITH 414 DOUBLES AND 207 HOME RUNS. ALSO
A PROLIFIC RUN PRODUCER, SCORED 1,071 RUNS AND DROVE IN 1,085 IN
1,783 GAMES. A SIX-TIME GOLD GLOVE WINNER WHO PATROLLED
CENTER FIELD WITH ELEGANCE AND STYLE. ROUTINELY SCALING
OUTFIELD WALLS TO TAKE AWAY HOME RUNS. THE 10-TIME
ALL-STAR'S CAREER ENDED ABRUPTLY DUE TO IRREVERSIBLE RETINAL
DAMAGE IN HIS RIGHT EYE.

KIRBY PUCKETT

CLASS OF 2001

Few had more fun playing the game of baseball than Kirby Puckett. Thanks to his ever-present smile and his ability to hit under pressure, he was the leader of the Minnesota Twins' World Series championship teams (1987 and 1991).

Growing up on Chicago's South Side, Puckett somehow beat the odds and eventually reached the major leagues. The feat appeared next to impossible early on because the outfielder stood only five foot eight and received no offers to play baseball after high school. So he went to work at the local Ford plant, continued to lift weights religiously, and eventually caught on with the Bradley University squad.

"It was no secret I wasn't going to be tall," Puckett once told *Sports Illustrated*. "So I figured if I can't be tall, I'll be strong."

He made the Twins in 1984 and was soon considered to be, inch for inch, the strongest man in the game. He hit .339 to lead the American League in batting average in 1989 and led the Junior Circuit in hits four times.

What was perhaps Puckett's shining moment came in Game 6 of the 1991 World Series. His Minnesota Twins trailed Atlanta three games to two, one game from elimination, when Puckett told his teammates to hop on his back. He would carry them to victory. It didn't matter that Puckett was only 3-for-18 coming into that contest, because he ended up a double short of hitting for the cycle and won the game with a walk-off home run in the

eleventh inning off the Braves' Charlie Leibrandt. Yet what many remember from that evening was his catch to rob Atlanta's Ron Gant of a certain homer in the third inning. ESPN's Tim Kurkjian called Puckett's game "the kind of performance that elevates a player to legendary status."

Twins manager Tom Kelly noted, "This isn't the first time he's had that kind of game."

Maybe so, but this was the first time a prime-time audience was there to witness it all.

Puckett spent his entire twelve-year career in Minnesota, where he had an overall batting average of .318, won six Gold Glove Awards, and appeared in ten All-Star Games.

During spring training in 1996, Puckett awoke one morning to find himself blind in his right eye. The diagnosis was glaucoma, and it forced him to retire before his time.

Puckett died a decade later from a stroke at only forty-five, the second-youngest person to die having already been enshrined in the National Baseball Hall of Fame. Lou Gehrig, at thirty-seven, was the only Hall of Famer to die at a younger age than Puckett.

"A seven- or eight-year-old kid watching the game would pick him out, and he just looked different," sportscaster Bob Costas once said of the Twins star. "He had an affection for the game, and there was a kind of energy about it that was fun.

"I'm sure he took it seriously. You have to take it seriously in order to be a great player, but there was nothing grim about the way he went about it."

—T. Wendel

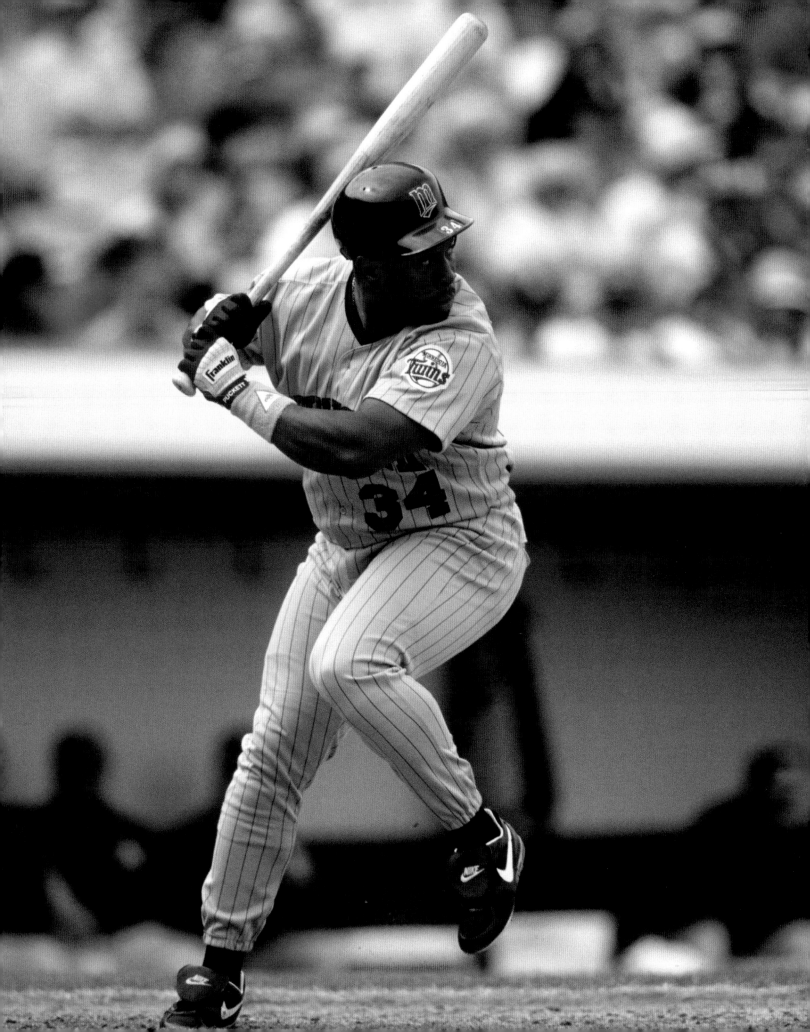

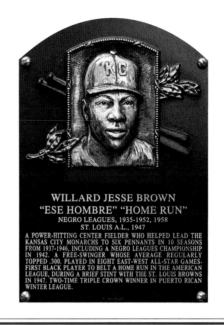

WILLARD JESSE BROWN
"ESE HOMBRE" "HOME RUN"
NEGRO LEAGUES, 1935-1952, 1958
ST. LOUIS A.L., 1947
A POWER-HITTING CENTER FIELDER WHO HELPED LEAD THE
KANSAS CITY MONARCHS TO SIX PENNANTS IN 10 SEASONS
FROM 1937-1946, INCLUDING A NEGRO LEAGUES CHAMPIONSHIP
IN 1942. A FREE-SWINGER WHOSE AVERAGE REGULARLY
TOPPED .300. PLAYED IN EIGHT EAST-WEST ALL-STAR GAMES.
FIRST BLACK PLAYER TO BELT A HOME RUN IN THE AMERICAN
LEAGUE, DURING A BRIEF STINT WITH THE ST. LOUIS BROWNS
IN 1947. TWO-TIME TRIPLE CROWN WINNER IN PUERTO RICAN
WINTER LEAGUE.

WILLARD BROWN

CLASS OF 2006

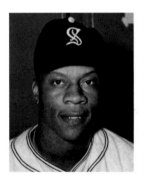

Josh Gibson called Willard Brown "Home Run," and the moniker stuck, for Brown is remembered as one of the premier long-ball hitters ever to play outside the major leagues.

A notorious free swinger, Brown starred on the great Kansas City Monarchs teams that dominated the Negro American League. Thanks in large part to Brown's prowess at the plate, the Monarchs won five pennants in six seasons (1937–1942). Brown's average regularly soared above .300 during that stretch. In one of his best seasons ever, Brown batted cleanup for the West squad in the 1942 East-West All-Star Game.

Such accomplishments turned heads at the major league level, especially after Jackie Robinson broke the color barrier in 1947. Brown and Hank Thompson were signed by St. Louis Browns owner Bill Veeck later that season, yet Brown wasn't afforded much of a chance, as he appeared in only twenty-one games that year, hitting one home run.

Brown had borrowed a bat from a white teammate before hitting that milestone home run. Yet in an indication of the resistance he met in the big leagues, the teammate broke the bat after Brown rounded the bases. Brown and Thompson were released by the end of the season.

"Willard knew he didn't get a fair shake from the Browns," Negro Leagues legend Buck O'Neil said, "but there wasn't anything he could do about it."

In a 1976 interview, Brown said he "felt cheated in a way" by what happened in St. Louis.

Some wondered if his demeanor rubbed those in baseball the wrong way at times. According to *The Biographical Encyclopedia of the Negro Baseball Leagues,* he would sometimes carry a copy of the *Reader's Digest* in his back pocket to read during slow moments in the outfield.

Former Negro Leagues catcher Sammie Haynes told the *Cleveland Plain Dealer* that Brown would "walk to the outfield, even in the majors. He never ran unless he had to."

But O'Neil claimed that Brown "was like Hank Aaron, you always thought he could do a little more. Both Brown and Aaron were so talented, they didn't look as if they were hustling. Everything looked so easy for them."

Brown enjoyed many of his best moments playing winter ball in Puerto Rico. After serving in World War II, he twice won the Triple Crown there, playing for Santurce (1947–48 and 1949–50), and led the league in home runs three times.

In 1947 to 1948 in Puerto Rico, he hit twenty-seven home runs in sixty games, breaking Gibson's record of thirteen. Brown's mark remains the standard for winter ball in Puerto Rico, with Reggie Jackson's twenty home runs in 1971 a distant second.

O'Neil once re-created scouting reports on many of the players he saw in person in the Negro Leagues. He rated Brown as "outstanding offensively" with "home-run power to all fields."

After two decades in the game, Brown retired to Houston, where he died in 1996. He was elected to the Hall of Fame in 2006.

—T. Wendel

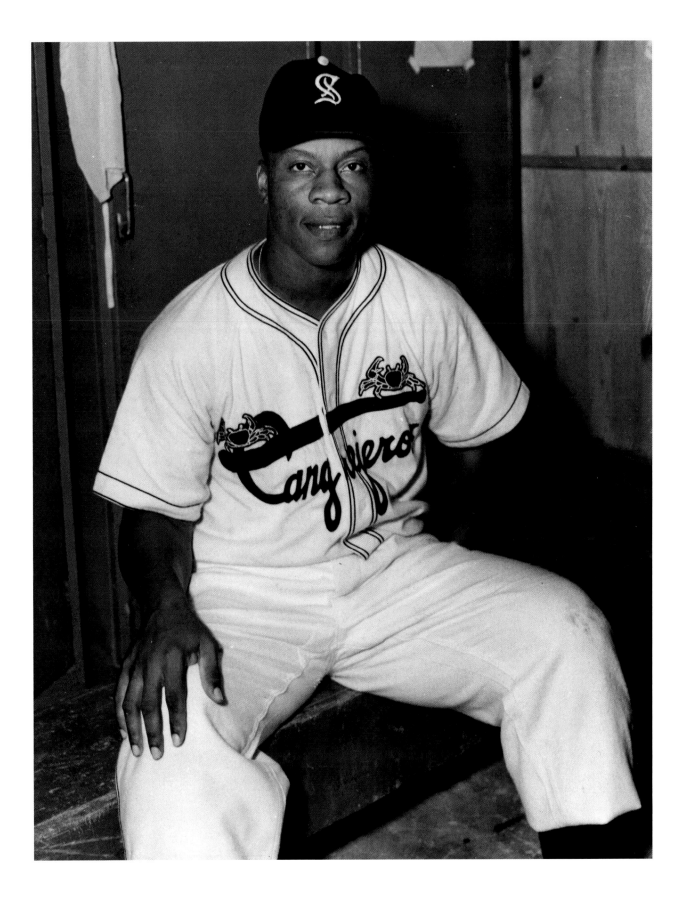

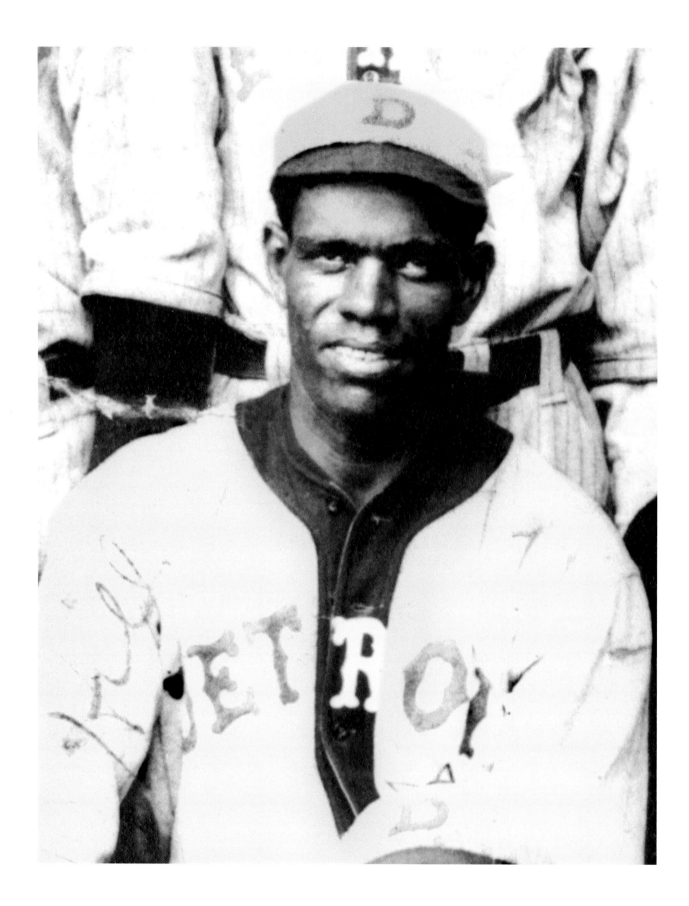

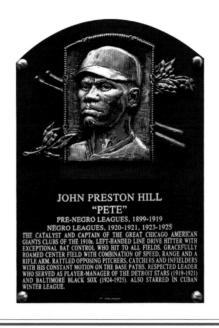

JOHN PRESTON HILL
"PETE"
PRE-NEGRO LEAGUES, 1899-1919
NEGRO LEAGUES, 1920-1921, 1923-1925
THE CATALYST AND CAPTAIN OF THE GREAT CHICAGO AMERICAN
GIANTS CLUBS OF THE 1910s. LEFT-HANDED LINE DRIVE HITTER WITH
EXCEPTIONAL BAT CONTROL WHO HIT TO ALL FIELDS. GRACEFULLY
ROAMED CENTER FIELD WITH COMBINATION OF SPEED, RANGE AND A
RIFLE ARM. RATTLED OPPOSING PITCHERS, CATCHERS AND INFIELDERS
WITH HIS CONSTANT MOTION ON THE BASE PATHS. RESPECTED LEADER
WHO SERVED AS PLAYER-MANAGER OF THE DETROIT STARS (1919-1921)
AND BALTIMORE BLACK SOX (1924-1925). ALSO STARRED IN CUBAN
WINTER LEAGUE.

PETE HILL

CLASS OF 2006

Emerging from rural Culpeper County, Virginia, John Preston "Pete" Hill enjoyed a pre–Negro Leagues era career from 1889 to the mid-1920s. He is considered to be one of the pioneers of black baseball. As stated in the *Chicago Defender,* Hill is "among the players who helped put Negro Baseball on the map."

A great center fielder with a rocket arm and excellent glove, Hill had talents that also extended to the batter's box. His entry in *The Biographical Encyclopedia of the Negro Baseball Leagues* states, "An amazingly consistent line drive hitter who used the entire field and excelled at bunting for base hits, he was a superior contact hitter with a near perfect eye for the strike zone and seldom struck out."

Hill played for some of the great Negro baseball teams, including the Pittsburgh Keystones, Cuban X-Giants, Philadelphia Giants, Leland Giants, and Chicago American Giants. His knowledge of the game was highly respected, and he closed his career by serving as the player-manager for the Detroit Stars, Milwaukee Bears, and Baltimore Black Sox. His baseball wisdom and smooth temperament made him a stabilizing presence for any team. After retiring from baseball and moving to Buffalo, he also helped

found the Buffalo Red Caps. There was no part of the game in which he was not involved.

Baseball historian James Riley has said that if an All-Star outfield were created from the pre-1920 era, it would include Ty Cobb, Tris Speaker, and Pete Hill. A 1910 article in the *Chicago Defender* supports this assessment, stating, "[Hill can] do anything a white player can do. He can hit, run, throw and is what is termed a wise, heady ballplayer."

Fellow Hall of Fame inductee Ben Taylor is quoted as saying, "The time was he was numbered among the greatest in the game, and will probably never have an equal as a hitter. I think he is the most dangerous man in a pinch in baseball." In 1944 Hall of Famer Cumberland Posey selected Pete Hill to his all-time All-Star team and referred to him as "the most consistent hitter of his lifetime."

In a special election held in 2006, Pete Hill was among the great players from the segregated era who were elected to the National Baseball Hall of Fame. For historians of the game, this was no surprise, and for everyone else, the name Pete Hill would no longer languish in baseball obscurity. "A lot of people forget about the baseball players who were pioneers of the game. They're forgotten like they never existed, but they were part of American history," said Hill's great-nephew Ron Hill. "How can you talk about baseball without talking about Pete Hill?"

—J.G.

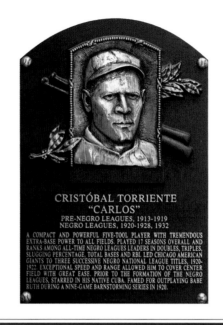

CRISTÓBAL TORRIENTE
"CARLOS"
PRE-NEGRO LEAGUES, 1913-1919
NEGRO LEAGUES, 1920-1928, 1932
A COMPACT AND POWERFUL FIVE-TOOL PLAYER WITH TREMENDOUS
EXTRA-BASE POWER TO ALL FIELDS. PLAYED 17 SEASONS OVERALL AND
RANKS AMONG ALL-TIME NEGRO LEAGUES LEADERS IN DOUBLES, TRIPLES,
SLUGGING PERCENTAGE, TOTAL BASES AND RBI. LED CHICAGO AMERICAN
GIANTS TO THREE SUCCESSIVE NEGRO NATIONAL LEAGUE TITLES, 1920-
1922. EXCEPTIONAL SPEED AND RANGE ALLOWED HIM TO COVER CENTER
FIELD WITH GREAT EASE. PRIOR TO THE FORMATION OF THE NEGRO
LEAGUES, STARRED IN HIS NATIVE CUBA. FAMED FOR OUTPLAYING BABE
RUTH DURING A NINE-GAME BARNSTORMING SERIES IN 1920.

CRISTÓBAL TORRIENTE

CLASS OF 2006

"If I should see Torriente walking up the other side of the street, I would say 'There walks a ballclub,'" said Indianapolis ABCs manager C. I. Taylor.

Cristóbal Torriente was a powerful, stocky outfielder who possessed all of the traditional five tools: hitting for average and power, fielding, throwing, and running. He had good hands and good instincts as a base runner. After two seasons in his native Cuba, Torriente came stateside in 1914 to play, appropriately enough, for the Cuban Stars.

He was a left-handed bad-ball hitter with dramatic power to all fields. He regularly hit well above .300. He was a quick and fast runner who stole many bases. In the outfield, his speed seemed odd for such a stocky player, but he covered a lot of ground and had an accurate and powerful arm. He could play almost anywhere on the field and even had decent numbers as a pitcher, compiling a 21–14 career record.

He joined the Chicago American Giants in 1918, helping the team capture the first three Negro National League Pennants in 1920–1922. He won the league batting title in 1920 and again in 1923. In Chicago he teamed with Dave Malarcher and Jelly Gardner to form one of the greatest outfields in history. He joined the Kansas City Monarchs in 1926, and then moved on to the Detroit Stars. He wound up his North American career in the early 1930s with Gilkerson's Union Giants, the Atlanta Black Crackers, and the Cleveland Cubs.

Like many players, Torriente had a parallel career in the Cuban Winter League. In thirteen seasons in his homeland, he hit over .300 eleven times and won two batting titles. His teams won six Cuban championships in those thirteen seasons.

"The Black Babe Ruth" was the nickname Torriente acquired in the fall of 1920. The New York Giants (plus Ruth) visited Torriente's native Cuba for a nine-game series versus Almendares—Torriente's team. In one game, Torriente homered in his first two at bats, doubled in two runs against relief pitcher Ruth the third time up, and homered again later in the game. Torriente outhit and out-homered Ruth in the series, and the home team won the series by one game.

As a light-skinned Cuban, Torriente might have been able to play in the major leagues, but the scouts who looked at him thought that his hair was too kinky. Regardless of his hair, he was a great all-around ballplayer. "We have never given Torriente the credit he deserved," said another Hall of Famer from Cuba, Martín Dihigo. "He did everything well, he fielded like a natural, threw in perfect form, he covered as much field as could be covered; as for batting, he left being good to being something extraordinary."

Torriente was among the ten original inductees into the Cuban Baseball Hall of Fame in 1939, and was voted into the National Baseball Hall of Fame in 2006.

—T. Wiles

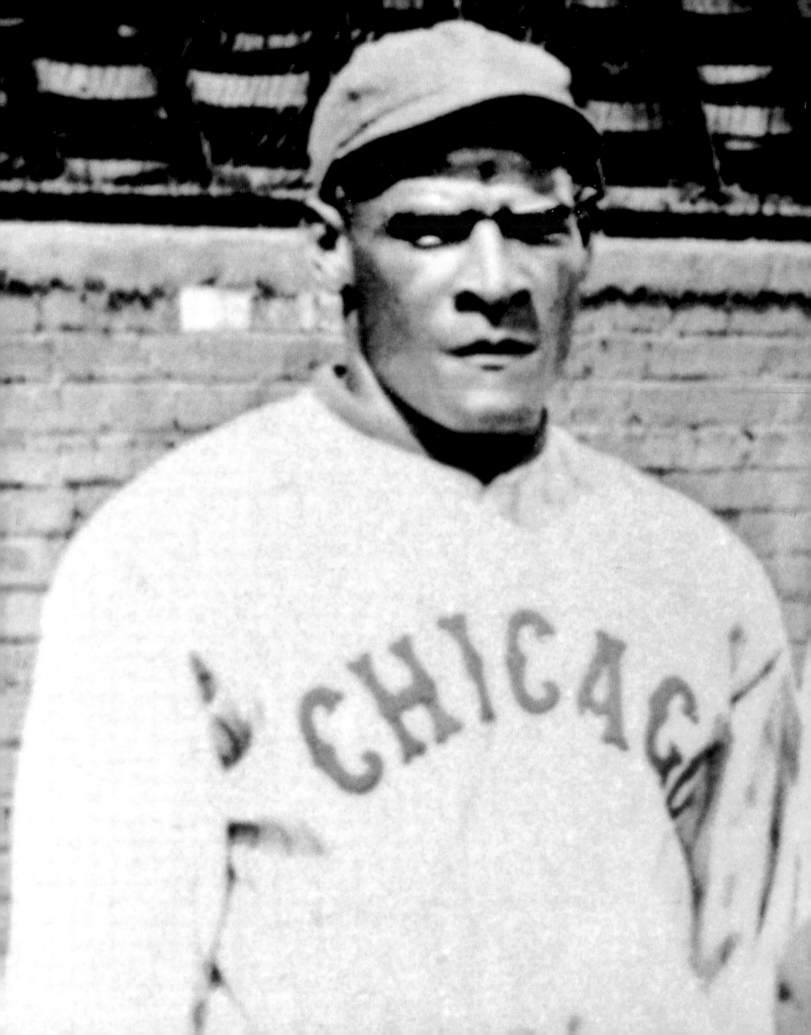

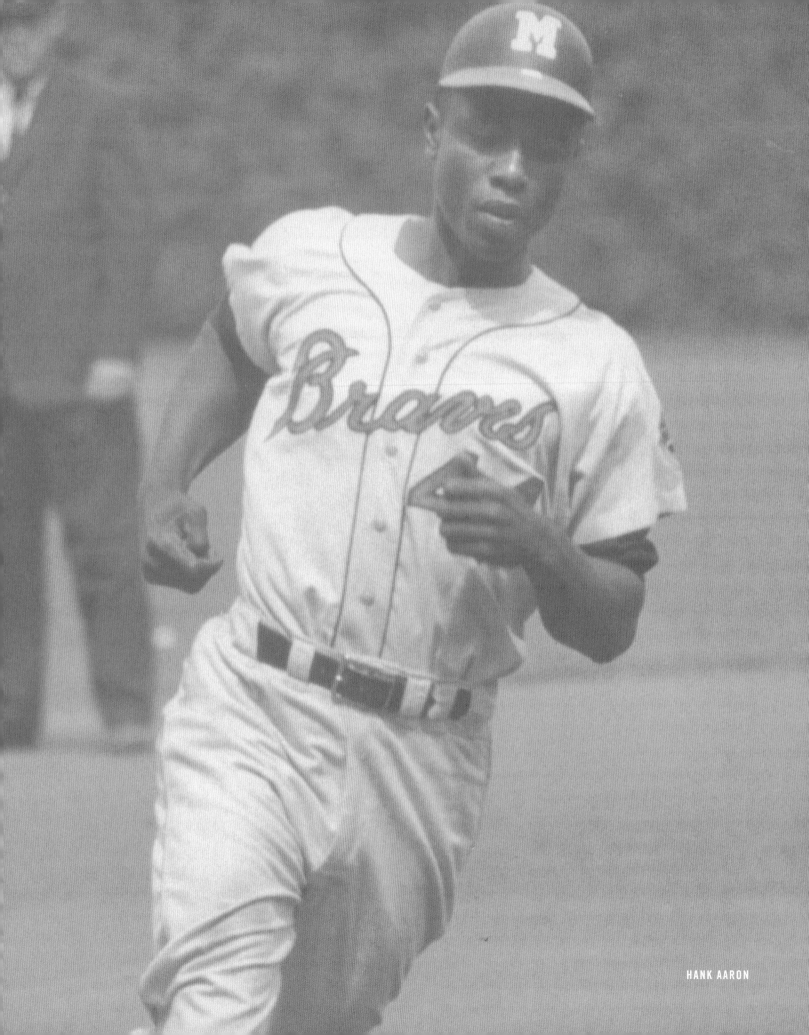

HANK AARON

RIGHT FIELDERS BY **HANK AARON**

He will forever be remembered as the man who broke Babe Ruth's hallowed career home run record, but Hank Aaron was much more than a prodigious slugger. He was a superb all-around player, a man who could do it all. In addition to clubbing 755 home runs, he drove in 2,297 runs, won two National League batting titles, batted over .300 fourteen times, earned three Gold Glove Awards, and was successful in nearly 80 percent of his stolen base attempts. Aaron also was a big-game performer, as evidenced by his three homers and .393 batting average in the 1957 World Series. Hammerin' Hank's greatest legacy, though, is the courage and dignity he displayed while battling racism on his way to baseball immortality.

Growing up in Alabama, I sometimes listened to games of the minor league Mobile baseball team on one of those big Trans-Oceanic radios at a friend's house. The Bears were a farm club of the Brooklyn Dodgers, and as the announcer described what was happening, I occasionally would let my mind wander and dream about what it would be like to play big league ball. But I knew that dream was just that—a dream—because this was the late 1930s, early 1940s, when the major leagues, minor leagues, and so many other parts of our society were segregated. So I had resigned myself to the fact I was never going to play ball for the Bears or any major league club because of the color of my skin. Then one day in 1946, we got word that this guy I'd never heard of by the name of Jackie Robinson had been signed by the Dodgers organization, and suddenly my outlook changed. Like millions of other African American boys, I felt that if this Jackie Robinson guy could play well enough in the all-white major leagues, then someday I might get the same opportunity that he had. It really boosted my spirits, gave me and so many other people of color a flicker of hope.

My family and everyone in my neighborhood and the surrounding neighborhoods were pretty poor. Our house didn't even have indoor plumbing, electricity, or windows at first. We couldn't really afford to take a daily newspaper—so we depended on word of mouth to find out how Jackie was doing. You'd run into a friend, who'd say, "Hey, did you hear? Jackie got three hits last night," things like that. And whenever we heard he had done something good, we'd feel good, almost like we had gotten those hits ourselves. That's how we all felt about Jackie. He was batting not only for himself but for every African American.

We all knew the racism he was facing, because many of us had to deal with similar obstacles in our everyday lives. I know my father, Herbert Aaron, had to put up with that stuff at his work-place, too. My daddy was the great-grandson of a slave, and he worked long, hard hours holding up steel plates for the riveters at Alabama Dry Dock and Shipbuilding, which built and repaired warships for the Navy during World War II. It was backbreaking work, and sometimes dangerous work. One night Daddy came home with this bandage on his hand. He had lost the top of his right middle finger when it got wedged between two plates. The physical pain was only part of what he had to endure. There also was the verbal abuse. Some of his white bosses were pretty hard on him. Every day they would call him horrible names because he was black, but he just ignored it as best he could. It wasn't easy having to deal with that hatred in silence.

Jackie, of course, went through a lot of terrible stuff, but, like my dad, he found the courage to turn the other cheek and go about his job. And Jackie's courage *not* to fight back obviously opened the door for me and so many other black kids to pursue our dreams.

In 1973 and '74, when I was chasing down Babe Ruth's home run record and dealing with the hate mail and the death threats, I thought about Jackie a lot. And I truly began to understand the hell he had been through, because I was going through some similar stuff. The big difference was that Jackie had to do it on his own. He was the only black player in the big leagues when he started out. He couldn't go and talk to black teammates and commiserate with them, because there weren't any other black players or coaches. That had to be awfully tough. When I was going through it, the color barrier already had been broken; there were many established African American players in the game, and they seemed to appreciate what I was dealing with. I definitely felt a kinship with Jackie during the chase. I thought back to how he had handled everything with such dignity and class. He realized that the only thing he could control was his performance between those white lines. And that's what I tried to focus on when I was facing so much hatred from people who didn't want to see a black man break Babe Ruth's record. Just go out there every day and give it your best when you are between those white lines. Control what you can control.

It was sad that all that ugliness was resurfacing twenty-six, twenty-seven years after Jackie had integrated the game. But it had, and it turned what should have been a joyous achievement for me and for baseball into a nightmare. The important thing, though, is that I was able to endure. Jackie Robinson was the right person at the right time to break down the color barrier in baseball and in society, and I hope that I, too, was the right person at the right time to handle what I had to handle.

I remember meeting Jackie before an exhibition game we were playing against the Brooklyn Dodgers in Nashville, Tennessee, when I was a rookie with the Milwaukee Braves. The black players from both teams were staying in a hotel in the black part of town, and I saw Jackie and Roy Campanella and Don Newcombe playing cards at a table in the bar. I was so in awe of them, especially of Jackie, that I wanted to pinch myself to make sure I was really in the same room as these pioneers. But I was too nervous to even go shake hands with them at first; that's how starstruck I was. I wound up getting to know Jackie by playing against him for several years and being at All-Star Games with him. He was a great, great player—a player who could really take control of a game—but I was more impressed with him as a person. I will always have enormous respect for that man.

As I mentioned, we were poor. There weren't a lot of things for a young black kid to do in Mobile, so most of our activities, when we weren't in school or working odd jobs, revolved around sports. Both of my parents were strict disciplinarians. Herbert and Estella Aaron weren't educated people, but they had good values. They stressed the Golden Rule and taught us to treat others how we'd like to be treated, and I've tried to live my life that way. That's been my mantra, and why my wife and I have been so heavily involved through the years in giving back to our community and to people.

My daddy always stressed that hard work doesn't hurt anybody, and he certainly lived his life that way. I mentioned how hard he worked at the shipbuilding company as a rivet bucker. He

worked those long, hard hours and was lucky to bring home $100 a week, just enough to buy some groceries and clothe us.

My brother and I wound up working a bunch of odd jobs to help out the family. We'd go out and mow lawns and deliver ice and load cement bags into cement mixers. People who saw me play in the big leagues often commented about how quick and strong my wrists and forearms were. Part of it was a result of what the good Lord blessed me with, but I think a part of it was the result of delivering those blocks of ice. You had to pick up these twenty-five-, fifty-pound chunks with these tongs, and sometimes you had to carry them from the truck up two, three flights of stairs to put them in people's ice chests. Most people didn't have refrigerators in my neighborhood, so this was how they kept their food and milk chilled. I was a skinny kid, and I swear some of those blocks of ice weighed about a third of what I weighed. But it was a great workout for me, and it made the strong hands and wrists and forearms I was born with even stronger. And that helped me not only to drive a baseball, but to wait until the last split second to judge a pitch and swing at it. Having quick wrists helped me tremendously throughout my career. It prompted someone to say, "Trying to sneak a fastball past Hank Aaron is like trying to sneak the sunrise past a rooster."

I was a decent athlete at pretty much every sport I played and even received some scholarship offers to play football at some of the historically black colleges, but I turned those down because I didn't weigh that much and didn't know if I really was big enough to play at that level. Plus, I loved baseball best and thought that was my best sport. My parents were big on education. They felt if I was going to make anything of myself, it was going to be as a result of a good education. But to be honest, I wasn't really into school; I was into baseball, and I had to convince my mom to let me pursue that when the Indianapolis Clowns of the Negro Leagues invited me to come play with them. I had been playing with a black semipro team in Mobile, and we happened to play the Clowns in an exhibition game, and I had a big day—three or four hits, a home run, what have you—and Bunny Downs, who owned the Indianapolis club, offered me a contract once the game ended. My mom reluctantly agreed to let me go to spring training with them, but she said, "If you don't do well, you're coming right back here and you're going to get yourself ready to go to college." Well, I joined the Clowns and I did well, and I never looked back. The competition I was facing was stiff. I was going against guys who probably already would have been in the big leagues if there hadn't been those restrictions on the basis of skin color. The money and the playing conditions weren't very good, but I loved what I was doing. I was just seventeen, eighteen years old and playing ball. And this was around the time when Jackie and others were just starting to integrate the major leagues, so I said to myself, "Let's give this a try and see where it takes you."

I did so well with Indianapolis that I caught the eyes of the major league scouts who had begun to show up at Negro League games in hopes of finding more Jackie Robinsons and Roy Campanellas. Although I was a somewhat erratic-throwing shortstop, scouts from the Braves and the Giants really liked the way I hit the ball and ran the bases. After my first twenty-six games of the 1952 season, I was leading the Negro Leagues in hitting (.427) and doubles, and my manager, Buster Haywood, predicted that I would "develop into one of the great shortstops of baseball within a couple of years." Our general manager, Syd Pollock, also sang my praises. He told some-

one, "I feel this youngster is another Ted Williams in the hitting department and can hit to all fields as well as lay down bunts, and his fielding right now leaves little to be desired, outside of a bit of polishing on getting off his throws." I know they were talking me up because Negro League teams received money each time one of their prospects signed with a Major League Baseball organization, but I was flattered to hear them talk about me that way, and it certainly boosted my confidence. I wound up signing with the Braves in June that year because they offered me about $50 a month more than the Giants did. Just think, another $50 and I would have been playing in the same outfield as Willie Mays.

The Braves assigned me to their Class C team in Eau Claire, Wisconsin, and I had a decent season, batting .336 with nineteen doubles, four triples, and nine homers in eighty-seven games. After I was done with Eau Claire, I was allowed to return to the Clowns and play in the Negro League World Series against the Birmingham Barons. I wound up having a huge Series, belting five homers and batting .402 as we defeated the Barons, seven games to five. (The Series was played like a barnstorming tour in different cities down south. We played games in Memphis, Tennessee; Little Rock and Hot Springs, Arkansas; Nashville, Tennessee; Welch and Bluefield, West Virginia; Newport News and Norfolk, Virginia; Columbus, Georgia; Mobile, Alabama; Biloxi, Mississippi; and New Orleans, Louisiana.)

From the time I first picked up a baseball bat, I had swung cross-handed, meaning that, unlike most right-handed batters, I had my left hand on top of my right hand. I don't know why I did it that way, but I did, and I had a lot of success. Although the Braves didn't want to mess with success, they thought I would be even better if I swung the traditional way, so I adjusted my hands and had no problems making the transition. The funny thing is that after hitting the way I had been hitting, I truly believe I also could have made a smooth transition to becoming a switch-hitter, because I already was used to positioning my hands the way a left-handed batter would—left hand on top of right. But I never gave it a shot. I stuck with being a right-handed batter, and, looking back, I guess you could say that everything worked out just fine.

In 1953 the Braves assigned me to their Class A team in Jacksonville, Florida. I wound up having an even better year, batting .362 with 208 hits, 36 doubles, 14 triples, and 22 home runs. That was the season they moved me to second base in hopes I'd be able to cut down on my throwing errors. Despite the shorter throw from second to first, I still had problems and wound up making thirty-six errors. After the season, the Braves sent me to winter ball in Puerto Rico, where they had me play right field. I got off to a terrible start, and if it wasn't for Mickey Owen, the former Brooklyn Dodgers catcher, who was my manager, and my teammate Félix Mantilla, I probably would have been sent back home. There were a lot of good ballplayers in winter ball. I was facing some veteran major league pitchers, and I was really struggling. One day, Mickey came up to me and said, "Henry, you need to learn to hit the ball to right field and everything will be OK." So we went out in the heat several hours before a game—must have been close to a hundred degrees— and Mickey threw me batting practice for about an hour, and I learned how to hit the ball to right field. And Félix kept boosting my confidence, kept telling me I had the talent to play in the big leagues and that everything would be all right. Those two guys believed in me and helped me an awful lot.

Before the 1954 season the Braves made a big trade, acquiring outfielder Bobby Thomson from the New York Giants. Thomson had been a productive slugger, best known for his playoff home run off Ralph Branca to give the Giants the 1951 pennant. Milwaukee also had an outfielder returning by the name of Jim Pendleton, who had a pretty good season for them the year before. So it looked like there wasn't going to be an opportunity for me. I figured I would be sent back to the minors, but Thomson wound up breaking his ankle while sliding into a base during the exhibition season, and Pendleton reported to spring training really out of shape. Meanwhile, I reported in great shape because of those extra games I had played in Puerto Rico. The Braves essentially threw me a glove and told me to head out to right field. They said, "The position is yours until you play yourself out of it."

I had a good spring and stuck with the big club, but I was still unsure of myself. I was just twenty years old and I was scared. I didn't know if I belonged in the big leagues. I remember telling my wife, "Don't meet me in Milwaukee because I don't know how long I'm going to be in the big leagues. I'm probably going to be shipped out to the Braves' Triple-A team in Richmond within a few weeks. So, you might as well stay in Mobile until I know where I'm going to be." I didn't get off to a great start, but they kept me in the starting lineup and I eventually settled down. I had an OK year, hit .280 with 13 homers and 69 runs batted in. But my season was cut short when I broke my ankle sliding during a game in Cincinnati in early September.

People ask me when I started to feel really comfortable about my big league status, and they are surprised when I tell them it took a long time. Even after ten, eleven, twelve, thirteen years, I still put a lot of pressure on myself. I just had this approach that no matter how good a season I had, I needed to do a little better the next year. It wasn't that I was still doubting my ability at that point. It's just that I always had this desire to keep improving, to keep trying to squeeze a little bit more out of my body.

My second season in 1955, I started putting up some solid numbers. I led the National League in doubles (37), hit 27 homers, drove in 106 runs, and hit .314. The following year, I won my first batting title with a .328 average and also led the league in hits (200) and doubles (34). I spent twenty-three seasons in the big leagues, and the one year that still probably ranks as the most enjoyable was 1957, because that's when we won it all. I was just twenty-three years old, and I came close to winning the Triple Crown. I led the league with 44 homers and 132 RBI and missed out on the batting title with a .322 average. Despite my big numbers and the fact we won the pennant, I barely beat out Stan Musial of the St. Louis Cardinals for the National League Most Valuable Player Award.

It would wind up being the only MVP I won, and when I look back at some of the great seasons I had, I think I probably should have won it a few more times. I don't know why I didn't. Maybe it was because I didn't play in New York or Chicago or Boston. And some of it also might have been because I wasn't a flashy ballplayer. I prided myself on being consistent, being productive every time I took the field. If you saw me on a Monday, you might see me go out there and get three hits and a homer. On Tuesday, I might have a double and a single. On Wednesday, I might have a homer and a single, and make a couple of solid plays in the field. I wasn't flamboyant. My hat wasn't going to fly off when I made a catch, and I wasn't going to hit fifty-five, sixty home runs

in a season. That wasn't me. But that was OK. I was just somebody you could depend on game after game, season after season. And when I look back on my career, I'm proud of the fact that I put up good numbers just about every year. There weren't any serious drop-offs. One hundred or more runs batted in, one hundred or more runs scored, thirty-five to forty-five homers, an above-.300 batting average—that's what you could expect from me just about every season.

All that said, 1957 was indeed very, very special because everything went right for me and my team. One of my biggest thrills in baseball came on September 23 of that season when I hit a two-run walk-off home run in Milwaukee that clinched the pennant for us. My teammates wound up carrying me off the field. That was a dream come true. We had a very, very good ball club that season. Our pitching was solid, with Warren Spahn and Lew Burdette leading the way. And I was surrounded by good protection in the lineup with guys like Eddie Mathews, Joe Adcock, and Del Crandall. I still think that's one of the best clubs to ever play the game. We didn't have many weaknesses.

And it couldn't have ended any better than it did, because we wound up beating the Yankees in the World Series. I remember being scared to death the first time I played in Yankee Stadium. You read so much about the mystique of the Yankees and you start to wonder if you belong on the same field as them. They beat us that first game, but we came back and won the second game, and that helped settle me and the rest of the guys down. Spahn was one of the few guys on our team who had been in a World Series, so we were not used to this kind of pressure, but after that first win, we stopped worrying about the Yankees being superhuman. We realized that they had to play the game just like we did. They had to hit the ball and field the ball and throw the ball the same as us. And we knew we had a lot of talented players on our club, too. Burdette was sensational on the mound for us, winning three games, including Game 7. I had myself a nice little Series, with three homers, seven RBI, and a .393 average.

Maybe the thing I remember most is the celebration in Milwaukee after we won it all. They threw a parade for us, and I'd never seen anything like it. The streets were lined with more people than I knew existed, and we rode in convertibles and waved to the fans. I still get goose bumps just thinking about it. It was quite an experience.

I really, really enjoyed my years in Milwaukee with the Braves and, later at the end of my career, with the Brewers. I'd experienced some difficult moments when I played for Jacksonville because of my race, but the people in Milwaukee treated me with respect, and I had a good relationship with the people there. That's not to say that racism didn't exist there, because it did—there and everywhere else in our country. But the people were good to me, and I'll always have a special place in my heart for Milwaukee. It's a great baseball town.

My numbers fell off a bit in 1958, but I did hit four points higher, and we made it back to the World Series. We met the Yankees again, and this time they turned the tables on us and beat us in seven games. After we won three of our first four games, I thought for sure we were going to repeat, but they battled back and won behind the pitching of Bob Turley.

The Braves wound up leaving Milwaukee for Atlanta following the 1965 season, and I was kind of sad because I had spent my first twelve seasons in Wisconsin and I enjoyed playing there. But Atlanta proved to be a great city, too, and it's a place I still call home. My first season there, I led

the National League in homers (44) and RBI (127). I won my fourth home run title the next season, and in 1971 I hit a career-high forty-seven homers.

I wound up becoming known for my home run totals because I hit 755 in my career. But I never wanted to be known strictly as a slugger. Like I said, I prided myself on my consistency, but I also prided myself on being a complete player, an all-around player, and the home run totals tend to overshadow that. I batted over .300 fourteen times in my career and won two batting titles, and I never struck out a hundred times in a season, so I wasn't a guy swinging for the fences every time I stepped in that batter's box. I was successful almost 80 percent of the time I tried to steal a base, but I only tried when our team needed it. I think I could have stolen forty, fifty bases a season if our team needed me to, but they didn't. I also worked hard on my defense. I wound up winning three Gold Glove Awards in my career, and I think I might have won a few more if there wasn't this guy named Roberto Clemente playing right field for the Pittsburgh Pirates at the same time I was playing. Roberto was as good a defensive player as I've ever seen—not just in right field but at any position. And he obviously was also a great hitter and an even better man and humanitarian. So there was no shame in being beaten out for Gold Glove Awards by Roberto.

A lot of people thought I spent a lot of my career thinking about breaking Babe Ruth's record, but in reality, I didn't even start thinking about the record until I got to around 680 or so. And I couldn't help but think about it then because the media started focusing on it. Even if I hadn't broken the record, I think my career would have been very special; my numbers would have stacked up well against most anyone who ever played the game.

In 1973, at age thirty-nine, I hit forty home runs in just 392 at bats, and it looked like I might pass the Babe that summer. But I finished the season with 713 career homers, just one shy of Ruth's record. That's the season when the mail really started pouring in. We got thousands of letters each week, and the Braves had to hire extra people just to sort through all of it. Most of the letter writers were in favor of me breaking the record, but there were a lot of people who said seeing a Negro do it—they used descriptions much worse than that—would be terrible. And over the winter, before the 1974 season, the hate mail began to increase and my family and I started receiving death threats. The stress was unbelievable and I really feared for my family. But I remembered what Jackie went through and I just tried to control what I could control on the ball diamond.

On April 8, 1974, I put an end to the chase when I homered off Al Downing of the Los Angeles Dodgers my second time up. As I went around those bases at Atlanta–Fulton County Stadium, I remember feeling a tremendous sense of relief because I had been through so much. At that point I was so exhausted I was just glad it was over.

I kept all those letters I received in boxes because I think it's important for people to remember what happened in our country not all that long ago. It's a part of history, just as the Holocaust is a part of the history of World War II, and it's important not to forget things like that so that, hopefully, they never happen again. After the passage of so much time, I've come to appreciate my achievement, and I feel blessed to have accomplished what I did under those circumstances.

The bitterness about it has subsided. I'm a happy man, a fulfilled man who doesn't want for many things. I was fortunate enough to have accomplished just about everything I set out to

achieve in my career. I don't feel like there are any holes there. I played twenty-three years in the major leagues. I played in All-Star Games, won a World Series and played in another one. I made it to the Hall of Fame. I set a few records along the way. I gave it my all. I don't have any regrets. I have a loving wife. My kids are all grown. I have grandkids and great-grandkids. I've had a successful business career outside of baseball. My wife and I have been able to do good things with my foundation, follow through on the Golden Rule my parents taught me.

Yes, I had to go through a lot, but life has a way of evening out in the end. That's how I look back on things. Baseball was very good to me and life's been very good to me. I never, ever thought growing up that I would even get a chance to play Major League Baseball. That just wasn't an option for a black kid in America in the 1930s and '40s. The world was a different place back then, but I think in the back of my mind I'd always hoped that things might one day get better. And they did when Jackie Robinson came along. He opened the doors. Without Jackie doing what he did, none of this ever would have happened for me. He showed us the way.

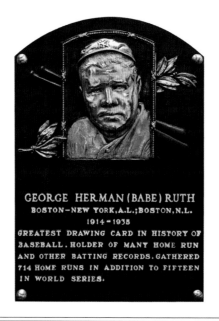

> GEORGE HERMAN (BABE) RUTH
> BOSTON-NEW YORK, A.L.; BOSTON, N.L.
> 1914-1935
> GREATEST DRAWING CARD IN HISTORY OF
> BASEBALL. HOLDER OF MANY HOME RUN
> AND OTHER BATTING RECORDS. GATHERED
> 714 HOME RUNS IN ADDITION TO FIFTEEN
> IN WORLD SERIES.

BABE RUTH

CLASS OF 1936

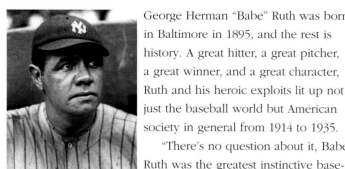

George Herman "Babe" Ruth was born in Baltimore in 1895, and the rest is history. A great hitter, a great pitcher, a great winner, and a great character, Ruth and his heroic exploits lit up not just the baseball world but American society in general from 1914 to 1935.

"There's no question about it, Babe Ruth was the greatest instinctive baseball player who ever lived. He was a great hitter, and he had been a great pitcher," said Leo Durocher.

Ruth's minor league apprenticeship lasted just one season, in which the left-handed pitcher went 22–9 for Baltimore and Providence, and slugged exactly one home run. On July 11, 1914, the Red Sox brought him to the majors. He was a key contributor to Red Sox world championships in 1915, 1916, and 1918, twice winning more than twenty games. But the Red Sox couldn't ignore his bat, as he hit .308 with 49 homers and 230 RBI in Boston. As Ruth once said, "I swing big, with everything I've got. I hit big or I miss big. I like to live as big as I can."

The Yankees couldn't ignore him either, and on January 3, 1920, they pulled off both the deal and the steal of the century, buying Ruth from the Red Sox for the unimaginable sum of $100,000. It was the best money Jacob Ruppert ever spent, and ended up establishing the Yankees as baseball's preeminent team.

Ruth played right field every day for the Yankees, and a star was born. He essentially invented the home run as we think of it in modern terms. Prior to that time, many home runs were legged-out, inside-the-park jobs, and the leading strategists of the game eschewed the homer as a simple, undesirable victory of brawn over brains—which negated the prevailing theory of "inside baseball."

But Ruth could hit them like no one who'd ever come before him. He was the first to hit thirty, forty, fifty, and even sixty home runs in a season. Those home runs were considered so exciting by fans that the Yankees had to build a monumentally large stadium—this was no mere ballpark—to hold everyone who wanted to see him.

"The House That Ruth Built" was the unofficial name given to the Yankees' new stadium when it opened on April 18, 1923. What did Ruth do that day? He hit the park's first home run, naturally.

It wasn't the only time Ruth rose to the occasion. His famous "called shot" home run in the 1932 World Series remains one of baseball's most magical—and hotly debated—moments.

Ruth's other remarkable offensive achievements include leading the league in slugging percentage thirteen times, home runs twelve times, walks eleven times, on-base percentage ten times, runs scored eight times, and runs batted in six times. He led the Yankees to seven pennants and the franchise's first four World Series victories.

Ruth even went out with a bang, hitting three home runs at Forbes Field in Pittsburgh in his swan song, a week before he played his final game. "If he didn't exist, we'd have had to invent him," wrote sportswriter Steve Rushin.

—T. Wiles

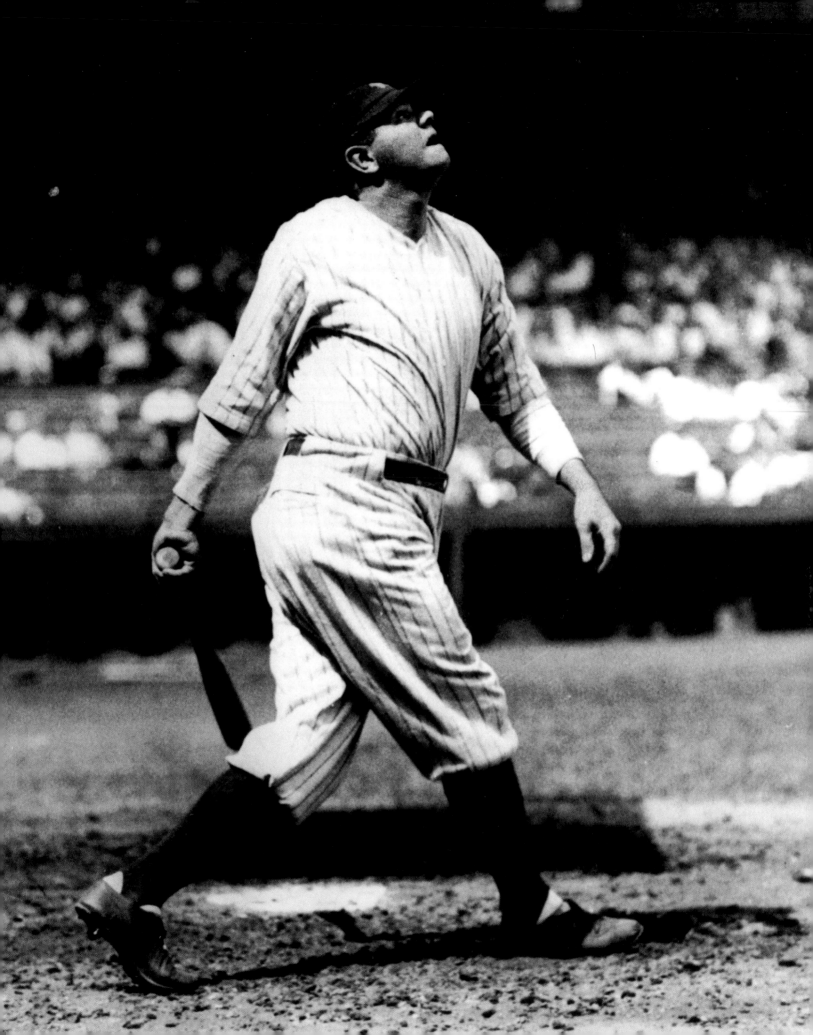

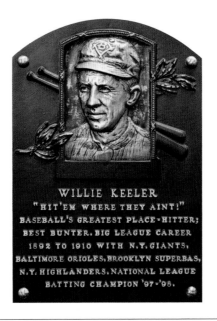

WILLIE KEELER
"HIT 'EM WHERE THEY AINT!"
BASEBALL'S GREATEST PLACE-HITTER;
BEST BUNTER. BIG LEAGUE CAREER
1892 TO 1910 WITH N.Y. GIANTS,
BALTIMORE ORIOLES, BROOKLYN SUPERBAS,
N.Y. HIGHLANDERS, NATIONAL LEAGUE
BATTING CHAMPION '97·'98.

WILLIE KEELER

CLASS OF 1939

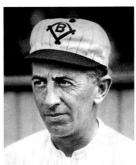

Willie Keeler was a little man who carried a big stick, or at least a heavy one. The hitting star from baseball's early years used one of the shortest yet heftiest bats in major league history. It was just thirty inches long but forty-six ounces.

With that bat in his hand, "Wee Willie" regularly delivered on his motto, "Hit 'em where they ain't." He garnered two batting titles, collected two hundred or more hits in eight consecutive seasons, and put together a forty-five-game hitting streak in 1897 (which began in 1896), when he hit .424. Gifted with a keen eye and exceptional speed, Keeler had place-hitting prowess that resulted in thirteen straight seasons batting over .300 and a career mark of .341. Though he began his professional career as a left-handed third baseman, the diminutive Keeler went on to become an outstanding right fielder.

"He may have been small in size," Ted Williams said, "but he was huge with the bat."

Honus Wagner claimed that Keeler "could bunt any time he chose. If the third baseman came in for a tap, he invariably pushed the ball past the fielder. If he stayed back, he bunted." Sam Crawford, in a piece compiled by the Society for American Baseball Research, claimed that Keeler routinely choked up on his thirty-inch bat. By doing so, the five-foot-four-and-a-half outfielder could place the ball just about anywhere he wanted.

The son of Irish immigrants, Keeler played for all three

of the New York teams during his nineteen-year career (the Highlanders, Giants, and Brooklyn Superbas). But he had his biggest impact after he and first baseman Dan Brouthers came to Baltimore in exchange for Billy Shindle and George Treadway in one of the most lopsided trades of all time.

In Baltimore, Orioles manager Ned Hanlon put Keeler atop the batting order with John McGraw. They were the consummate table-setters for a power-packed lineup that included Hughie Jennings, Wilbert Robinson, and Joe Kelley. With Keeler and McGraw at the top of the lineup producing "Baltimore Chops"—base hits coming after the batter pounded the pitch into the dirt and legged out the hit—the Orioles seemingly always had runners on base for their sluggers.

"The ball would bounce so high that [Keeler] was across the bag before he could be stopped," Wagner said.

The ploy, combined with an effective hit-and-run tactic, helped make the Baltimore Orioles one of baseball's first dynasties. The 1894 Orioles finished 89–39, winning the National League Pennant.

Although Keeler was regarded as the quiet man, the little guy who was easily overlooked on those rowdy Baltimore teams, he soon gained a reputation as "the greatest slap hitter of all time," according to Donald Dewey and Nicholas Acocella in *The Biographical History of Baseball.*

"Keeler had the best batting eye I have ever seen," McGraw said.

As a result, one of the smallest men to play in the history of the majors was often the most important guy on the field.

—T. Wendel

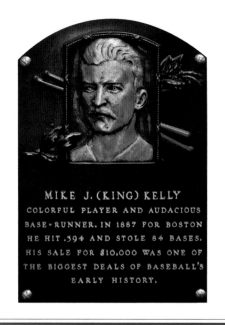

MIKE J. (KING) KELLY
COLORFUL PLAYER AND AUDACIOUS
BASE-RUNNER. IN 1887 FOR BOSTON
HE HIT .394 AND STOLE 84 BASES.
HIS SALE FOR $10,000 WAS ONE OF
THE BIGGEST DEALS OF BASEBALL'S
EARLY HISTORY.

KING KELLY

CLASS OF 1945

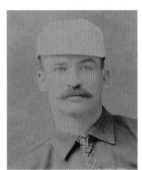

Michael Joseph Kelly, not only one of the top players of his day but also one of the most popular, was one of the first ballplayers to become a full-fledged celebrity—so much so that he was nicknamed "The King of Baseball," or simply "King."

The multitalented Kelly starred in the major leagues for sixteen seasons, beginning in 1878, during which time he was arguably the biggest drawing card in the sport. After spending his first two seasons with the Cincinnati Reds, he helped the Chicago White Stockings to five pennants in seven years before being sold to the Boston Beaneaters on February 14, 1887.

Reportedly, Chicago patrons were so upset by the loss of Kelly that many boycotted a number of home games that season. The attendance for the White Stockings' home opener was abysmal, but when the Beaneaters came to Chicago, the fans poured through the gates to see their favorite player even though he was sporting a rival uniform.

Always popular with the fans, Kelly made sure he was paid well, too. After winning his second batting title in Chicago in 1886 at .388, he was sold to Boston for the princely sum of $10,000. To put that in perspective, the other top-paid players of this period, Buck Ewing and Fred Dunlap, got less than $5,000 a year.

In Beantown, Kelly was a member of four pennant winners, including a stint managing the Boston Players' League champions in 1890. Though he would spend most of his time in the outfield or catching, his versatility was evident in the fact that he did play every position on the diamond, including a dozen games as a pitcher.

One of the first to use the hook slide, Kelly excelled on the base paths. He stole eighty-four bases in 1887, his first season with the Beaneaters, and followed that up with fifty-six thefts the next season and sixty-eight in 1889. Fans chanted "Slide, Kelly, slide" whenever he got on base. He once scored six runs in a game, and on another occasion stole six bases in a game.

Always looking for an edge, Kelly was known for his gamesmanship. New York Giants manager John McGraw called Kelly one of the smartest players he ever saw play. Perhaps he admired how Kelly occasionally went from second to home without touching third base, if the umpire wasn't looking.

"He played the umpire as intelligently as he did the opposing nine," said teammate Fred Pfeffer. "He would engage his confidence and in various ways get the best of close decisions."

Off the field, Kelly enjoyed his fame. A flashy dresser, he sometimes made the rounds with a pet monkey on his shoulder. It seemed that the animal nicely complemented his stylish cane and thick mustache. Kelly's talents extended to writing and acting as well. His 1888 book *Play Ball: Stories of the Diamond Field* was the first autobiography written by a ballplayer, and he recited "Casey at the Bat" on the vaudeville circuit.

But in the end, the fast lifestyle may have been too much even for King Kelly. He died of pneumonia in 1894 at the age of thirty-six. Tens of thousands lined the funeral route in Boston as the horse-drawn hearse passed by.

—B.F.

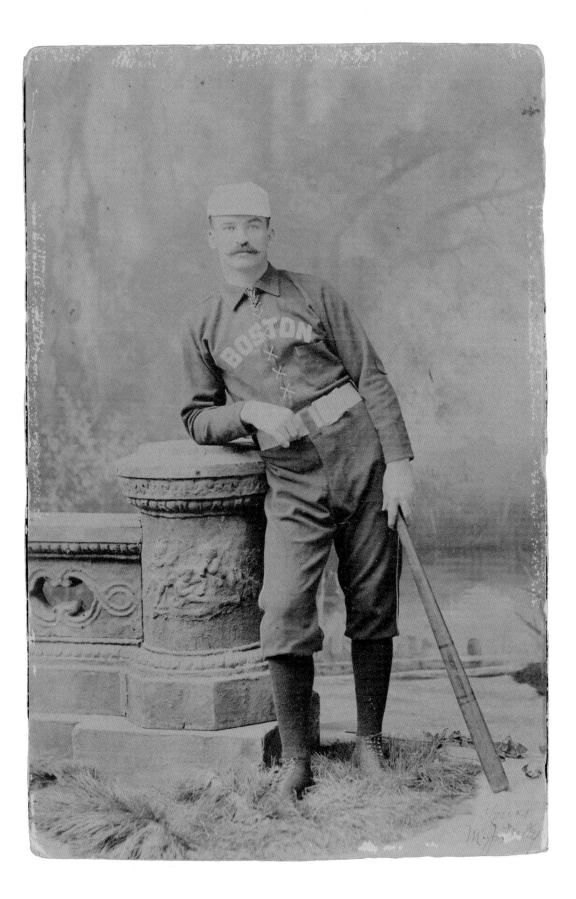

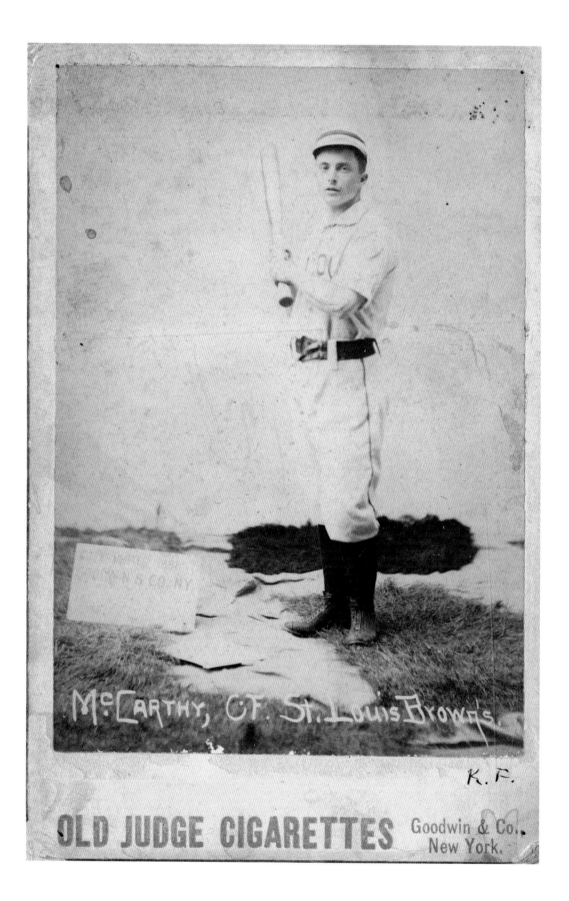

McCARTHY, CF. St. Louis Brown's.

K. F.

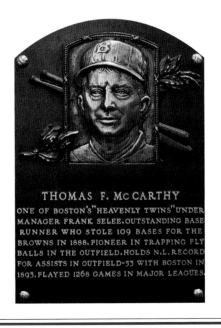

THOMAS F. McCARTHY
ONE OF BOSTON'S "HEAVENLY TWINS" UNDER
MANAGER FRANK SELEE. OUTSTANDING BASE
RUNNER WHO STOLE 109 BASES FOR THE
BROWNS IN 1888. PIONEER IN TRAPPING FLY
BALLS IN THE OUTFIELD. HOLDS N.L. RECORD
FOR ASSISTS IN OUTFIELD—53 WITH BOSTON IN
1893. PLAYED 1268 GAMES IN MAJOR LEAGUES.

TOMMY McCARTHY

CLASS OF 1946

Some players are always looking for an edge, and baseball is a sport that often rewards such initiative. One has only to look to Tommy McCarthy.

Long recognized as one of the smartest players ever to play the game, McCarthy tricked opposing base runners by juggling or trapping fly balls and then making accurate throws back into the infield. Rules involving the infield fly and tagging up are reputedly linked to McCarthy's exploits. In addition, he was an expert at faking the bunt and teamed up with his friend Hugh Duffy to devise the hit-and-run play. Giants manager John McGraw called McCarthy "the best in the business" at such trick strategy.

Perhaps McCarthy was always looking for an extra edge because it took him a while to find a place for himself at the big league level. Growing up on the Boston sandlots, McCarthy caught on with his hometown team, the Boston Reds of the Union Association, in 1884. He struggled early on, hitting only .215 for the season and going winless (0–7) as a right-handed pitcher. McCarthy, who stood just five foot seven, decided to try his luck in the National League. But his batting average didn't rise above .200 in his first three seasons there.

After a good year with Oshkosh, followed by an impressive spring, manager Charles Comiskey put McCarthy on his St. Louis Browns roster, in the American Association, in 1888. McCarthy made the most of the opportunity, stealing ninety-three bases and leading outfielders with forty-two assists and twelve double plays—thanks in part to his juggled ball trick. On July 17 McCarthy went 5-for-5, with six stolen bases.

McCarthy starred in St. Louis over four seasons, hitting .306. But his best days took place after he returned home to Boston, where he helped the Beaneaters repeat as NL champions in 1892 and 1893. There he also combined with Hugh Duffy, forming the "Heavenly Twins" outfield.

Duffy played center field, with McCarthy in right. According to newspaper accounts, McCarthy studied every batter and knew exactly where to position himself. He wasn't afraid to take chances in getting an out, either. One dispatch had him positioning himself behind an infielder, where he could quickly corral singles to the outfield. When the unsuspecting base runner advanced, after seeing the ball go through the infield, McCarthy was ready to throw him out.

McCarthy, a right-handed hitter and thrower, played thirteen years at the big league level, with a career .292 batting average, and scored 1,066 runs. He also finished with 2,016 putouts and 266 assists. He did pitch in thirteen games but never recorded a victory.

After retiring in 1896, he partnered once again with his old friend Duffy as the two of them operated a bowling alley. McCarthy briefly managed the St. Louis Browns in 1890 before going on to coach at Dartmouth and Holy Cross.

—T. Wendel

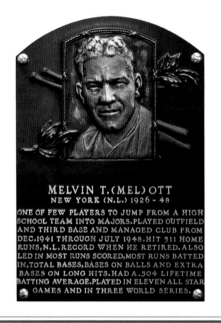

MELVIN T.(MEL)OTT
NEW YORK (N.L.) 1926 - 48
ONE OF FEW PLAYERS TO JUMP FROM A HIGH
SCHOOL TEAM INTO MAJORS.PLAYED OUTFIELD
AND THIRD BASE AND MANAGED CLUB FROM
DEC.1941 THROUGH JULY 1948.HIT 511 HOME
RUNS,N.L.RECORD WHEN HE RETIRED. ALSO
LED IN MOST RUNS SCORED,MOST RUNS BATTED
IN,TOTAL BASES,BASES ON BALLS AND EXTRA
BASES ON LONG HITS.HAD A .304 LIFETIME
BATTING AVERAGE.PLAYED IN ELEVEN ALL STAR
GAMES AND IN THREE WORLD SERIES.

MEL OTT

CLASS OF 1951

A player who was once considered too small to compete at the professional level, Mel Ott became the first National League player to reach the five-hundred-homer plateau.

By deploying a high and prolonged leg kick, the five-foot-nine Ott was able to generate plenty of power at the plate. So much so that the distinctive left-handed slugger hit 511 career home runs. He blasted thirty or more homers in a season eight times and won or shared home run honors on six occasions.

While his unorthodox batting style puzzled some, many baseball experts soon recognized it as genius. "He is a standout with me," Hall of Famer John McGraw said. "Ott is the best-looking young hitter in my time with the Giants."

McGraw compared Ott's stroke to a golfer's, in which "the body moves, but he keeps his head still with his eyes fixed on the ball."

Ott broke in with the Giants at age seventeen in 1926. He played sparingly his first few years, due to his youth, and developed a knack for pinch-hitting. His forty-two homers and 151 RBI in 1929 were the most ever for a player twenty or younger when the season began.

Besides becoming one of baseball's top sluggers, Ott also excelled in the field. As the Giants' right fielder, he was part of twelve double plays in 1929 and became adept at playing the tricky caroms at the Polo Grounds.

Later Ott shifted to third base. In 1938, despite being at the new position, he hit .311 and led the league in home runs (36) and runs scored (116), also driving in 116 runs.

Ott was an extremely popular player. When a cereal company ran a contest to determine the most popular man at each position, Ott garnered the most votes for both right field and third base. He was voted the most popular sports hero of all time in 1944, beating out Joe Louis, Lou Gehrig, Christy Mathewson, and Babe Ruth.

"I never knew a baseball player who was so universally loved," said Dodgers manager Leo Durocher. "Why, even when he was playing against [us] he would be cheered and there are no more rabid fans than in Brooklyn."

Ott played his entire twenty-two-year career with the Giants and appeared in three World Series, hitting .295 with four home runs and ten RBI. When he retired, he held the NL records for runs scored, bases on balls, and RBI.

Ott was the Giants' player-manager from 1942 to 1947, but his best finish was third place in 1942. Durocher's saying "Nice guys finish last" was reportedly directed, at least in part, toward Ott's lack of managerial success.

Ott also worked for three seasons as a broadcaster for the Detroit Tigers. When he died from injuries suffered in an automobile accident in 1958, he was only forty-nine years old.

—T. Wendel

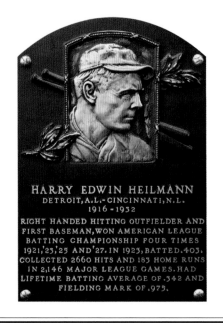

HARRY HEILMANN

CLASS OF 1952

Originally from San Francisco, Harry Heilmann became a baseball icon in Detroit, making his first appearance in the majors by the time he was nineteen, in 1914. He was so raw, though, that Heilmann's averages during the first few years of his career did not warrant the boasting cables being sent to the West Coast branch of the family.

Heilmann used to say that he was fortunate he got into baseball. One time, while he was working as a bookkeeper, he left his regular Saturday shift at the office at noon, but didn't get far before realizing he'd left his coat behind. When he returned to retrieve it, Heilmann bumped into an old high school teammate who was then coaching a semipro team. The man was looking for Heilmann to ask him to fill in.

"Luck was with me," Heilmann said. That afternoon, in an eleven-inning game, he didn't make any mistakes in the field and knocked in the winning run.

Four seasons into his career with the Tigers, Heilmann had never hit higher than .282. Then Ty Cobb, the player-manager of Detroit, got involved. Cobb's coaching helped transform Heilmann into one of the best of all time. Heilmann won four batting titles, hitting as high as .403 one season and better than .390 three other times.

"I learned one valuable lesson from Ty Cobb which I shall never forget," Heilmann said. "This is not to let down until after the final time at-bat, even though I may have had a good day with the stick. You have probably noticed that Ty never let down, even when he had made four hits. He was in there trying just as hard for the fifth hit as he was for the first. This sort of playing might mean a gain of a dozen hits in a season."

Heilmann recalled that Cobb was of the if-it's-not-broke-don't-fix-it philosophy, but whenever someone got into a slump, he was right there trying to smooth out the swing or resolve the problem. "Ty never told any of us how to hit as long as we were getting our base knocks," Heilmann said. "But whenever we got into a rut or a slump and were just carrying the wood up to the plate and back, Ty would tell us what was wrong and how to get started again."

From not being able to hit .300, Heilmann became a star player, always among the league leaders in hitting. He considered his batting to be off when his average dipped to the low .300s. "Slumps are but temporary," Heilmann said. "If you fail to get any hits, or only one a day for a week, you do not worry if you are actually hitting the ball hard."

At various times and in various places, Heilmann was sought out to make public appearances in front of audiences of children, and he developed a simple routine phrase of encouragement that could apply to any field of endeavor if they weren't thinking about baseball as a career. "Take your job seriously," Heilmann said. "Study it."

—L.F.

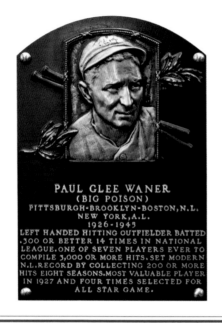

PAUL WANER

CLASS OF 1952

When Paul Waner joined the three-thousand-hit club in 1942, only six other players had managed to reach that milestone.

More than seventy years later, Waner still stands out as one of the most prolific batters in baseball history.

Born April 16, 1903, in Harrah, Oklahoma, Waner was raised on the family farm—he learned to hit by swinging at corncobs—and graduated from Central High School in Oklahoma City. Following his prep career, he enrolled at East Central State Teachers College in Ada, Oklahoma, but soon abandoned plans to become an educator after posting a 23–4 record on the mound for East Central in 1922.

Waner quickly found himself with the legendary San Francisco Seals of the Pacific Coast League. A sore arm prompted his manager to move him to the outfield, where he hit .369 in 112 games in 1923. By the end of the 1925 season, Waner was hitting .401 with an astonishing 280 hits and 75 doubles in 174 games. In the fall of 1925, the Seals sold Waner and shortstop Hal Rhyne to the Pittsburgh Pirates in exchange for $100,000.

Waner stood just five foot eight and weighed 153 pounds, so he had to manufacture his own impression in the spring of 1926. He did so by continuing to hit as few players have before or since.

"That little punk don't even know how to put on a uniform," a scout told Giants manager John McGraw.

"That little punk don't know how to put on a uniform, but he's removed three of my pitchers with line drives this week," McGraw countered.

Waner quickly won the job as the Bucs' right fielder and hit .336 with 101 runs scored, 79 RBI, and a National League–best 22 triples. The next year, Waner's little brother Lloyd joined the Pirates and was stationed in center field, where he watched as Paul hit an NL-best .380 while also leading the loop in hits (237), triples (18), and RBI (131). Paul won the National League's Most Valuable Player Award and led the Pirates to the pennant.

He remained one of the top hitters in baseball throughout the 1930s, posting eight 200-hit seasons and leading the NL in batting in both 1934 (.362) and 1936 (.373). In 1932 Waner smashed 62 doubles—one of only six 60-double seasons in big league history and still a record for NL left-handed batters.

His easy stroke at the plate left teammates and opponents amazed at his see-the-ball, hit-the-ball approach.

Though already age thirty by the time of the first All-Star Game in 1933, Waner was named to four of the first five NL squads. After fourteen years as Pittsburgh's regular right fielder, Waner eased into a utility role and was released by the Pirates after the 1940 season. He spent his final five major league seasons with the Dodgers, Braves, and Yankees before being released by New York during the 1945 season.

Waner finished his career with 3,152 hits (still seventeenth all-time), 605 doubles, 1,627 runs scored, and a .333 batting average.

"Those 24 years that I played baseball from 1923 to 1946—somehow, it doesn't seem like I played even a month," Waner said. "It went so fast."

—C.M.

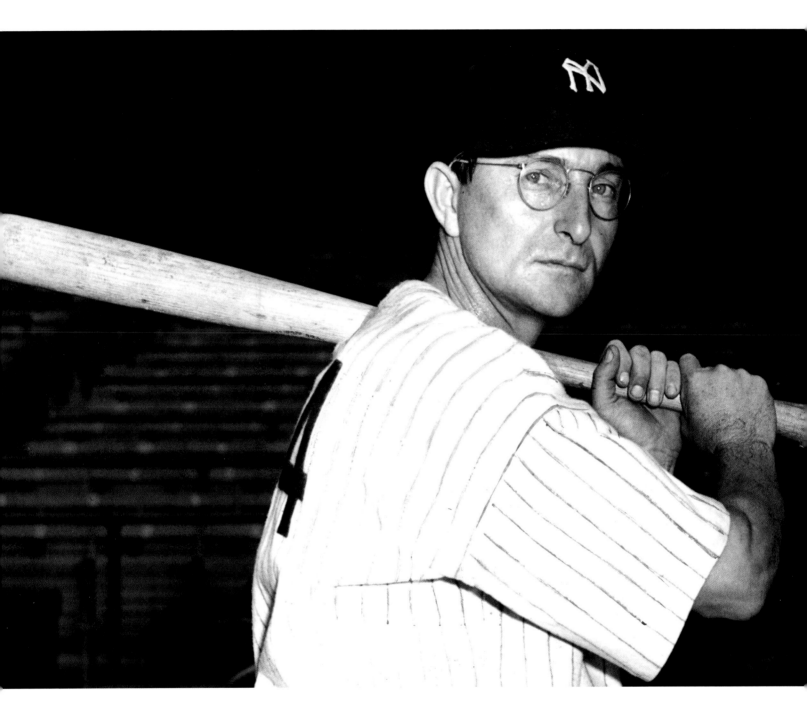

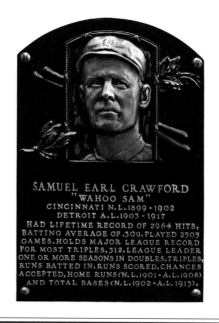

SAMUEL EARL CRAWFORD
"WAHOO SAM"
CINCINNATI N.L.1899-1902
DETROIT A.L.1903-1917
HAD LIFETIME RECORD OF 2964 HITS,
BATTING AVERAGE OF .309. PLAYED 2505
GAMES. HOLDS MAJOR LEAGUE RECORD
FOR MOST TRIPLES, 312. LEAGUE LEADER
ONE OR MORE SEASONS IN DOUBLES, TRIPLES,
RUNS BATTED IN, RUNS SCORED, CHANCES
ACCEPTED, HOME RUNS (N.L.1901 • A.L.1908)
AND TOTAL BASES (N.L.1902 • A.L.1913).

SAM CRAWFORD

CLASS OF 1957

The reason Sam Crawford's nickname was "Wahoo" was not because he made that celebratory declaration his own, but because he was from Wahoo, Nebraska. His earliest days as a ballplayer in the 1890s saw him traveling from town to town in a lumber wagon, and when he jumped to pro ball for the cash, he left behind an apprenticeship as a barber.

A brilliant hitter during his days with the Detroit Tigers, Crawford could seemingly do just about anything with a bat and still owns the record for most triples, with 309. Once, Crawford quieted a crowd of chatty players who were raving about the speed of a youngster coming into the league who supposedly could steal bases until foes went dizzy. "That's all great stuff," Crawford said, "but can he steal first?"

Crawford seemed to have a droll wit at the ready at the ballyard. To one teammate he relayed details of a confrontation with an umpire that he was laughing about. "Yesterday I had an argument with Jack Egan," Crawford said of his banter, "about a bad one he called and I told him that he reminded me of a drama I had seen the previous night. He became so curious that I finally had to tell him the name of the play. Now the old boy don't speak to me." The name? *The Thief.*

Crawford said that in the occasional brief appearance in the infield before reaching the majors, he was "a babe in the woods." Playing in what he called "the outer garden" was the place for him. "The hardest and most important part of fielding is to be able to judge at a glance just the distance a ball will travel," Crawford said. "As soon as the ball raises in the air you must be able to tell, within a few feet, where it will land, and then manage to get under it. Practice and a good pair of legs will turn the trick."

Crawford said that in his nineteen seasons in the majors between 1899 and 1917, there was an abundance of characters, many more than played later, when society as a whole seemed to become less colorful. Pitcher Rube Waddell was as much of a nonconformist as anyone. "He used to pour ice water over his pitching arm," Crawford said. Waddell claimed he had to do it to slow down or he'd burn up the catcher's mitt. Detroit manager Hughie Jennings used to go to "the dime store and buy little toys like rubber snakes or a jack-in-the-box. He'd get in the first-base coach's box and set them down on the grass." The idea was to make Waddell laugh and disrupt his pitching focus.

After he had been in the majors for a decade, Crawford was already being described as old—though he was only thirty. "I started early, that's the reason," he said. "People never think of that. They only think of the length of time I have been in the big leagues."

—L.F.

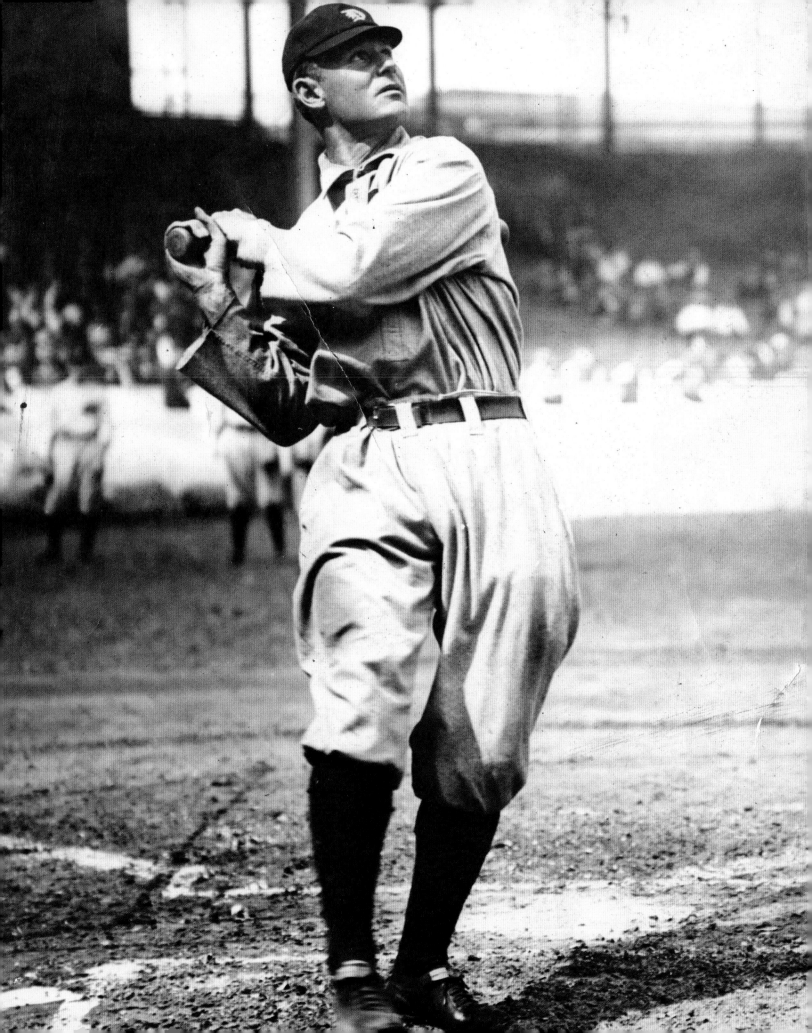

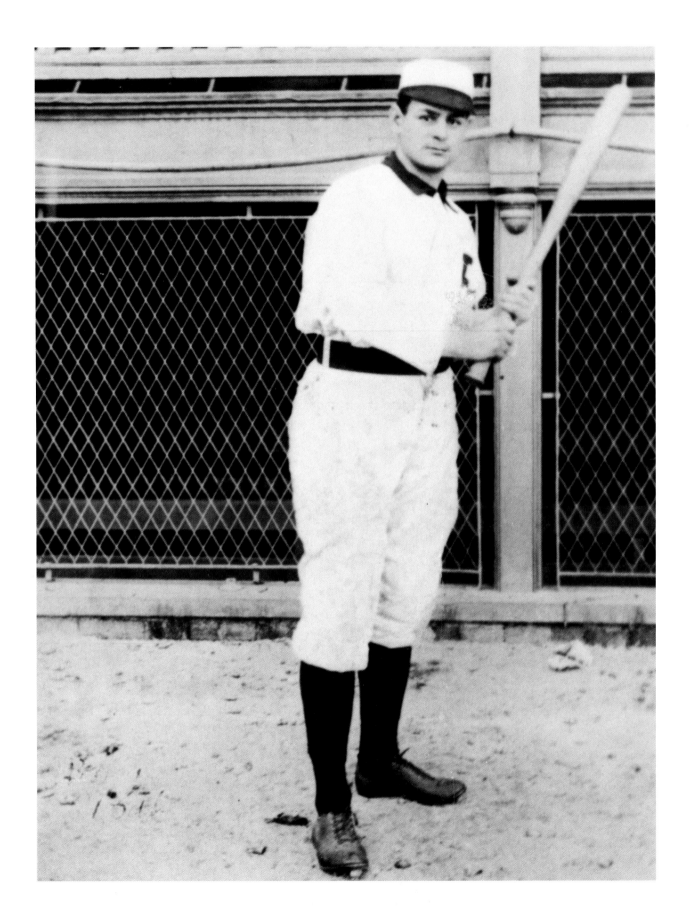

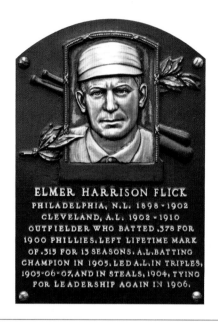

ELMER HARRISON FLICK
PHILADELPHIA, N.L. 1898-1902
CLEVELAND, A.L. 1902-1910
OUTFIELDER WHO BATTED .378 FOR
1900 PHILLIES. LEFT LIFETIME MARK
OF .315 FOR 13 SEASONS. A.L. BATTING
CHAMPION IN 1905. LED A.L. IN TRIPLES,
1905-06-07, AND IN STEALS, 1904, TYING
FOR LEADERSHIP AGAIN IN 1906.

ELMER FLICK

CLASS OF 1963

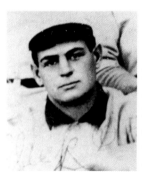

Elmer Flick's start in baseball sounds like something from *The Natural.*

Legend has it that a fifteen-year-old Flick went down to the railroad station in his hometown of Bedford, Ohio, to join in a send-off for the local ball team. As the train was about to pull out, it was discovered that only eight players were on board. So the young Flick was asked if he'd like to come along. Even though he was barefoot at the time, Flick agreed to play.

From such humble beginnings, Flick never looked back, eventually becoming one of the top base stealers in the game and a solid outfielder in Philadelphia and, later, Cleveland. In 1900 the left-handed hitter led the league with 110 runs batted in and five seasons later was the top hitter, sporting a .308 average. That was the lowest league-leading mark to that point and would remain so until Carl Yastrzemski won the American League batting title in 1968 with a .301 average.

In addition to his prowess at the plate, Flick twice was baseball's top base stealer. But he really made his mark when it came to triples. For three consecutive years (1905–1907), while with the Cleveland Naps, Flick led this category and once had twenty-two triples in a single season.

Early in his career, Flick swung a bat he had made himself, back at his father's shop in Ohio. Even though he was called a sure-handed fielder, Flick liked to focus on his hitting. "I wasn't much in the field," he once said, "but I could larrup up that ball."

In fact, Flick had such success that he was nearly traded for Ty Cobb. After the 1907 season, the Detroit Tigers approached Cleveland about a straight-up deal—Cobb for Flick. They did so despite Cobb's hitting a league-leading .350, with 212 hits the season before. Accounts differ about why the Tigers were so eager to peddle Cobb at the time. Some said Detroit management feared that Cobb wouldn't have a long career because of his aggressive base stealing. Others note that the feisty Cobb had already gotten into several fights with his teammates. Whatever the reason, the offer was made and Cleveland decided to pass.

Unfortunately, Flick was the one who would struggle with his health. While Cobb went on to play for twenty-four years, retiring after the 1928 season, Flick contracted a stomach illness that left him a part-time player. He never played a full season again and retired from the major leagues in 1910, but he continued playing in the minor leagues through the 1912 season.

After his playing days were over, Flick became a builder in northern Ohio and also raised horses. Back in his hometown of Bedford, the local ballpark is named after him.

—T. Wendel

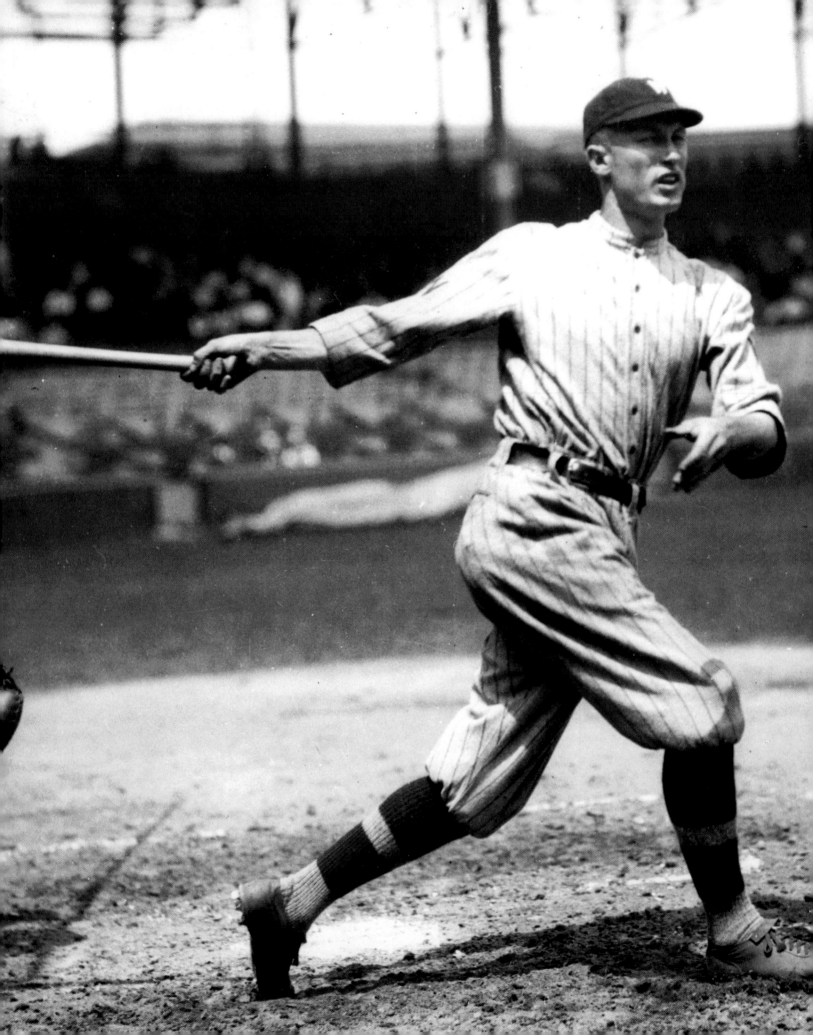

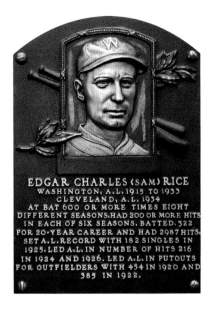

EDGAR CHARLES (SAM) RICE
WASHINGTON, A.L. 1915 TO 1933
CLEVELAND, A.L. 1934
AT BAT 600 OR MORE TIMES EIGHT
DIFFERENT SEASONS. HAD 200 OR MORE HITS
IN EACH OF SIX SEASONS. BATTED .322
FOR 20-YEAR CAREER AND HAD 2987 HITS.
SET A.L. RECORD WITH 182 SINGLES IN
1925. LED A.L. IN NUMBER OF HITS 216
IN 1924 AND 1926. LED A.L. IN PUTOUTS
FOR OUTFIELDERS WITH 454 IN 1920 AND
389 IN 1922.

SAM RICE

CLASS OF 1963

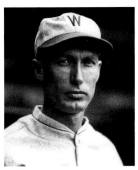

Baseball players come in all shapes and sizes and from all backgrounds. They also evolve in different ways. Sam Rice credited his time in the Navy for making him into a Hall of Fame ballplayer.

The Washington Senators outfielder did not play for any school growing up but sought tryouts from teams in his home area near the Indiana-Illinois state line—until his wife, daughters, sisters, and mother were all killed in a tornado while he was away. That's when Rice joined the Navy.

"When I was a kid I never played baseball, or practically never," Rice said. "I will gamble I took part in half a dozen games at the most until I left town. I was a poor country boy without many advantages. But I had a desire to see the world and I took the first opportunity offered. Every battleship had a ball team, so I tried for the team along with a lot of others. I was naturally fast, always seemed able to hit well, and anyway, I made the team."

Rice learned quickly that the better he played the more likely he was to get promoted on his ship, the USS *New Hampshire,* and the more likely he was to avoid the nastiest assignments. The Navy team played Columbia University and a minor league team in Virginia. Rice so impressed the man running the Virginia club that he wanted to buy Rice out of the service. Rice declined, but six months later, on another swing, he accepted the offer.

"This time he had his voice keyed up to the tune of $135 a month," Rice said. "It looked like a lot of money and he offered

in addition to buy my release. So I received my papers and became a full-fledged ballplayer. Still, I can't complain of the Navy. It gave me my first opportunity to see the world and it made a ballplayer out of me."

Rice didn't enter the majors until he was twenty-five years old. He started in the big leagues as a pitcher and developed into a great hitter, with a .322 lifetime average, 2,987 total hits, and six seasons with more than 200 hits. As a *Washington Star-News* columnist noted, "Rice was the most consistent of the Washington hitters in the happy years of 1924 and 1925. Plaudits went to Goose Goslin and Bucky Harris and Walter Johnson and Joe Judge, but Sam was quietly lining out his base hits, stealing when it was appropriate and, during his and the Senators' heyday, scoring 100 runs a year."

The right fielder batted .299 in his first full year and followed with a total of fourteen seasons with an average over .300 by the time he finished playing in 1934. Rice was part of the only three Washington Senators teams that ever won pennants. Near the end of his career, Rice signed with Cleveland. He played in ninety-seven games for the Indians at the age of forty-four and had a .293 average. In total, he played 543 games after turning forty, hitting .321 for that span.

Elected to the National Baseball Hall of Fame by the Veterans Committee in 1963, Rice said, "I don't think there are words to use on a day like this. It's the biggest thing any of us can have."

—L.F.

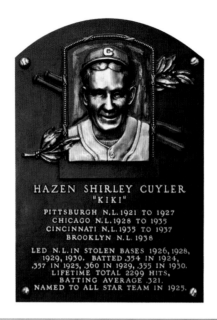

HAZEN SHIRLEY CUYLER
"KIKI"
PITTSBURGH N.L. 1921 TO 1927
CHICAGO N.L. 1928 TO 1935
CINCINNATI N.L. 1935 TO 1937
BROOKLYN N.L. 1938
LED N.L. IN STOLEN BASES 1926, 1928,
1929, 1930. BATTED .354 IN 1924,
.357 IN 1925, .360 IN 1929, .355 IN 1930.
LIFETIME TOTAL 2299 HITS,
BATTING AVERAGE .321.
NAMED TO ALL STAR TEAM IN 1925.

KIKI CUYLER

CLASS OF 1968

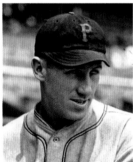

In 1968, when former star Kiki Cuyler was inducted into the Hall of Fame, U.S. representative Elford A. Cederberg of Michigan read a statement of praise for the outfielder into the *Congressional Record*.

It said in part, "I am pleased to announce today that Mr. Cuyler has appropriately, though belatedly, been selected for the National Pastime's Hall of Fame." The congressman then read from an article printed in Cuyler's hometown newspaper: "The Hall of Famer's greatest athletic feats were performed while a member of the Pittsburgh Pirates and the Chicago Cubs. His speed, daring and batting prowess earned for him the name of 'the right-handed Ty Cobb.' He compiled a lifetime batting average of .321 and year after year was among National League leaders in stolen bases."

Cuyler was born in Michigan and died in Michigan—at only fifty-one. His widow, Bertha, however, kept her own personal collection of news clippings in scrapbooks commemorating her husband's baseball exploits. "I think I have 25 of them," she said. "Looking through them brings back so many memories. We knew Babe Ruth quite well. His wife and I were well-acquainted. I wasn't really surprised when Hazen was named to the Hall of Fame. . . . He deserved it. I knew he'd make it some day."

The player christened Hazen picked up his nickname as a minor league outfielder in Nashville. As Cuyler retreated for a fly ball, his shortstop yelled "Cuy!" He was calling off the other outfielders for him. Fans chimed in, calling "Cuy, Cuy." Eventually sportswriters modified the nickname to "Kiki" and used it in their stories. The name stayed with Cuyler when he moved into the majors.

Probably the worst stretch of Cuyler's career came in 1927, when he should have been at his happiest because the Pirates won the National League flag and met the Yankees in the World Series. Only, Cuyler was feuding with manager Donie Bush, who refused to play Cuyler the entire Series, even for an inning. Bush wouldn't budge, even in the face of chants from Pittsburgh fans screaming, "We want Kiki! We want Kiki!"

Later, Cuyler discussed his dispute with Bush. "During that season Bush seemed to dislike me for no reason in the world," Cuyler said. "He ordered me to bat second, not third in the lineup. I said to Bush, 'You're the manager and I'll hit anyplace you say, but I'm not adapted to second place. I am a free swinger and I take a long cut at the ball, and therefore miss a lot of swings. Neither can I place a hit as a man in that position should be able to do.'"

In one game, with Cuyler on first base, a teammate hit a grounder. While trying to break up the double play, Cuyler chose not to slide and went into second standing up. If he'd slid, he would have been safe. Bush fined Cuyler $50 and benched him. Cuyler could never again get on the same wavelength as Bush.

—L.F.

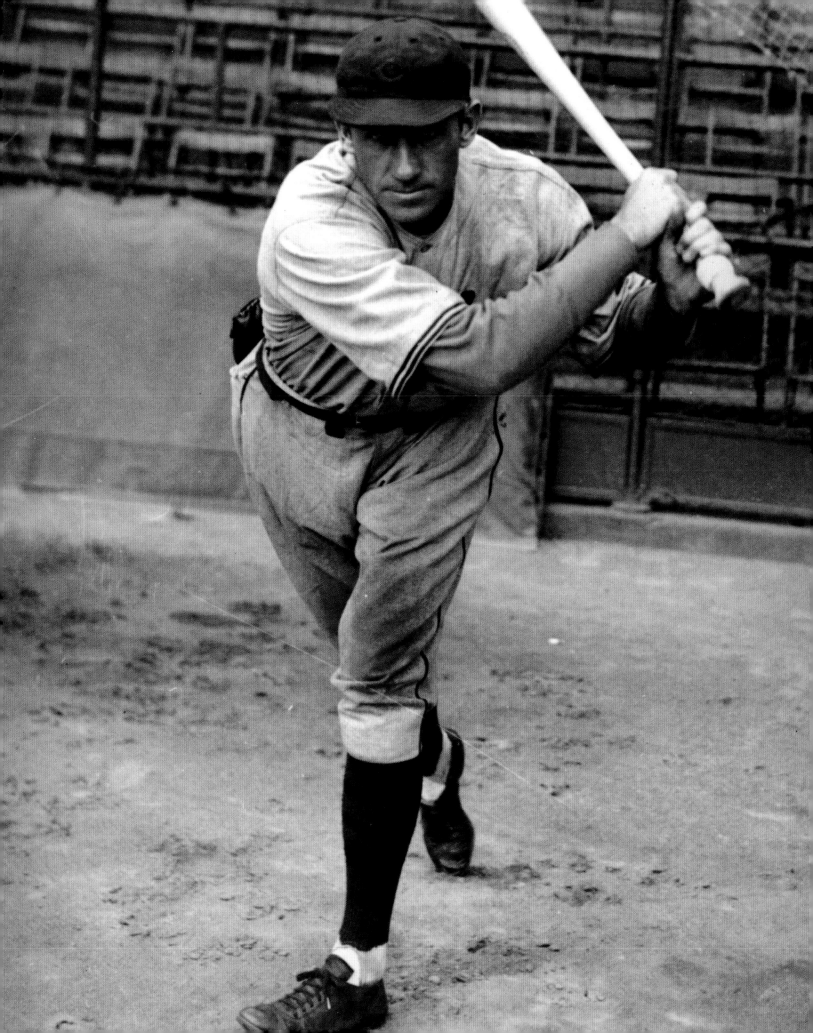

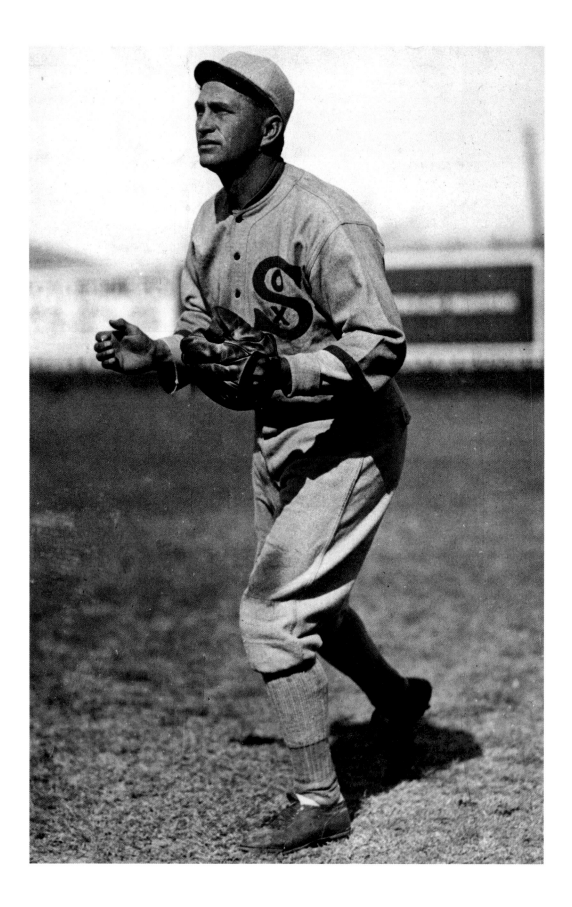

HARRY BARTHOLOMEW HOOPER
BOSTON A.L. 1909-1920
CHICAGO A.L. 1921-1925

LEADOFF HITTER AND RIGHT FIELDER OF
1912-15-16-18 WORLD CHAMPION RED SOX.
NOTED FOR SPEED AND STRONG ARM.
COLLECTED 2,466 HITS FOR .281 CAREER
AVERAGE. HAD 3,981 PUTOUTS AND 344
ASSISTS. LIFETIME FIELDING AVERAGE .966.

HARRY HOOPER

CLASS OF 1971

The leadoff hitter in the lineup, and one of the most impressive fielders for four Boston Red Sox World Series champions, Harry Hooper did the little things that don't always show up in the box score. He was a solid hitter but a superb all-around player more than he was an attention-getting slugger. During Hooper's heyday there was actually a song that featured his exploits in lyrics mentioning his walks and bunts.

After Hooper retired in 1925, Babe Ruth was one of those asked to name the best fielder he had ever seen. "Harry Hooper of the old Red Sox," Ruth said. "No doubt about it. He could do anything any other outfielder could and on top of that he was a great position player. His instinct for where the ball was going to be hit was uncanny. I'm sure, too, that he made more diving catches than any other outfielder in history. With most outfielders, the diving catch is half luck. With Hooper, it was a masterpiece of business."

The Red Sox won the World Series in 1912, 1915, 1916, and 1918 with Hooper as their right fielder, and according to Hooper, the players just felt no one could take them. "We never did lose a World Series," he said. "We used to feel that they had no way to beat us. Fifteen, in my opinion, was the greatest club we ever had; 1915, we had five of the greatest pitchers that ever stepped on a ball field."

Everyone knows that Ruth was an excellent pitcher as a young player before being sold to New York, where he set all sorts of home run records. Hooper remembered the young Ruth as a muscular 198 pounds, not heavyset as he became. "Slim waisted, big biceps, Babe was a wonderful specimen," Hooper said. "For a number of years with the Red Sox he never drank anything except soda pop. But he ate too much. Used to have a tremendous appetite. He'd stop along the road when we were traveling and order up a half-dozen sandwiches and a half-dozen bottles of pop and think nothing of it."

Tris Speaker, one of Hooper's regular Sox outfield partners, has always been praised for his fielding skills, but he thought there was a lot to recommend about Hooper's defense. "Harry was not only a great fielder," Speaker said, "but he had the best arm of the three of us. He actually threw strikes from the outfield."

Hooper was in his eighties and had been retired for nearly fifty years when the Hall of Fame Veterans Committee elected him in 1971. Hooper's son John led the lobbying campaign after reading his father's scrapbooks and studying the statistics and reports about his play. "I discovered that in the history of baseball my dad did more than any other full-time leadoff batter," John Hooper said. "I think he was hurt, you know, that they took so long to finally recognize him."

—L.F.

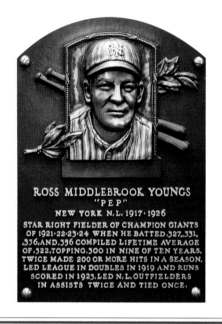

ROSS MIDDLEBROOK YOUNGS
"PEP"
NEW YORK N.L. 1917·1926
STAR RIGHT FIELDER OF CHAMPION GIANTS
OF 1921·22·23·24 WHEN HE BATTED .327,.331,
.356,AND.356 COMPILED LIFETIME AVERAGE
OF.322,TOPPING.300 IN NINE OF TEN YEARS.
TWICE MADE 200 OR MORE HITS IN A SEASON.
LED LEAGUE IN DOUBLES IN 1919 AND RUNS
SCORED IN 1923.LED N.L.OUTFIELDERS
IN ASSISTS TWICE AND TIED ONCE.

ROSS YOUNGS

CLASS OF 1972

Ross Youngs made an indelible first impression when the New York Giants brought him to the major leagues in 1917 at age twenty. He hustled so much the veterans nicknamed him "Pep." And he gave manager John McGraw a headache because Youngs insisted he was an infielder and McGraw insisted he was not.

McGraw shipped Youngs to the minors to learn the outfield and he returned to New York a star. "He thought he was a third baseman," McGraw said. "I told him that he would have to play the outfield . . . that he did not have the hands for an infielder. But he refused to give up. He would stay out there for hours, fighting the ball, trying time after time. I sent him to Rochester with orders to convert him to an outfielder."

Al Schacht, one of baseball's early funnymen, said he influenced a discouraged Youngs in the minors. "I don't often brag," Schacht said, "but I can brag about this: I was responsible for making an outfielder out of Ross Youngs. When the ball would come to him, he would fumble it and juggle it, and when he got hold of it he would hurl it over to first base. He wasn't just wild. He would hurl it into the right field bleachers."

Schacht said Youngs had packed his trunk and was going home to Texas until he talked him out of it. Almost immediately another outfielder was injured, and Youngs learned on the job.

Energetic and hardworking, Youngs returned to become the Giants' right fielder. Between his daring on the base paths and his routinely hitting over .300, some called him "Ty Cobb Junior."

Youngs was a key player on four McGraw pennant winners, hitting better than .300 in seven full seasons. But the native of Shiner, Texas, originally hoped to be picked up by a different team.

"When you have a pretty good year in the minors, you always hear rumors of big league clubs which want you," Youngs said. "I knew Detroit was after me and I rather preferred to go there. I wasn't anxious to come to New York, not that I had any objection to the city or the club, but because I thought my chance to land a regular berth wouldn't be as good as at Detroit. The Giant outfield looked like a fixture for years."

Youngs, however, pushed his way into the lineup, but his stay in New York ended in tragedy. Suffering from Bright's disease, a kidney ailment, Youngs spent parts of ten seasons with the Giants but died in San Antonio when he was just thirty. Some forty-five years later, he was elected to the Hall of Fame.

Frank Frisch, who served on the Hall of Fame Veterans Committee that elected Youngs, endorsed his teammate.

"He was a small-sized Ty Cobb, a good [hitter], a very good outfielder with a strong arm," Frisch said. "And he played the carom off the right field wall at the Polo Grounds as if he'd majored in billiards."

—C.M.

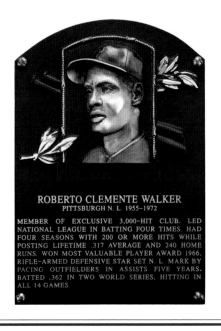

ROBERTO CLEMENTE WALKER
PITTSBURGH N. L. 1955-1972

MEMBER OF EXCLUSIVE 3,000-HIT CLUB. LED
NATIONAL LEAGUE IN BATTING FOUR TIMES. HAD
FOUR SEASONS WITH 200 OR MORE HITS WHILE
POSTING LIFETIME .317 AVERAGE AND 240 HOME
RUNS. WON MOST VALUABLE PLAYER AWARD 1966.
RIFLE-ARMED DEFENSIVE STAR SET N. L. MARK BY
PACING OUTFIELDERS IN ASSISTS FIVE YEARS.
BATTED .362 IN TWO WORLD SERIES, HITTING IN
ALL 14 GAMES.

ROBERTO CLEMENTE

CLASS OF 1973

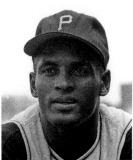

The long litany of Roberto Clemente's achievements included twelve consecutive Gold Glove Awards, a World Series MVP Award, four batting titles, and two world championships. He left vivid impressions with his slashing hitting style, his game-breaking speed, and his throwing arm. He also left an enormous impact as a relief worker and humanitarian.

After struggling in his first five seasons, Clemente emerged as a star in 1960. A breakout campaign, including a .314 batting mark, signaled the beginning of superstardom. In 1966 he set career highs with twenty-nine home runs and 119 RBI.

Clemente's stellar fielding in right field embodied his athletic talent and his work ethic. As Willie Stargell once said, practice and preparation helped Clemente become a premier defender. "He worked at it," said Stargell. "One of the things that he taught me was every time we'd go into a stadium—or even at home—to spend a little extra time working on things: have balls hit to you, not just fly balls or ground balls, but hit 'em off the wall at different angles. Find the sun, hit the ball into the sun, and be able to shield the sun in such a way that you don't lose the ball. . . . His ability was no accident. He put a lot of time and effort and intelligence into his game. And what people saw was the finished product."

Similarly, Clemente honed his throwing prowess. "It was something that he worked on," said Stargell. "He would take a garbage can and put it at third base where the opening was facing him. He would have somebody hit him the ball in right field, he would run in, bring his body under control, pick up the ball, and throw it one-hop into the can. Tough to do. But that's what made him shine a little brighter, stand a little taller."

Clemente's career reached its culmination in 1971. He led the Pirates to the World Series, where he batted .414 with two home runs to carry the Bucs to a monumental upset of the Baltimore Orioles. Through his many successes, Clemente never forgot his modest roots. Each winter he returned to his native Puerto Rico, where he staged free baseball clinics for low-income children. During the season, Clemente quietly visited patients at Pittsburgh's Children's Hospital.

The events of December 1972 solidified Clemente's unquestioned status as a humanitarian. After a devastating earthquake struck Managua, Nicaragua, Clemente took action. He organized a collection of relief supplies to be sent to that country. When he heard that the Nicaraguan militia had intercepted the supplies and sold them for profit, he organized another collection and accompanied the flight.

Shortly after takeoff, the overloaded DC-7 exploded and plunged into the Atlantic Ocean, killing all five passengers, including the thirty-eight-year-old Clemente. In death, Clemente became an American hero. "Any time you have the opportunity to accomplish something for somebody who comes behind you and you don't do it," Clemente said, "you are wasting your time on this Earth."

—B.M.

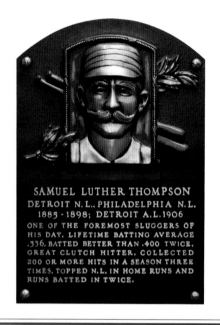

SAMUEL LUTHER THOMPSON
DETROIT N.L., PHILADELPHIA N.L.
1885·1898; DETROIT A.L. 1906
ONE OF THE FOREMOST SLUGGERS OF
HIS DAY. LIFETIME BATTING AVERAGE
.336, BATTED BETTER THAN .400 TWICE.
GREAT CLUTCH HITTER. COLLECTED
200 OR MORE HITS IN A SEASON THREE
TIMES. TOPPED N.L. IN HOME RUNS AND
RUNS BATTED IN TWICE.

SAM THOMPSON

CLASS OF 1974

"Big Sam" Thompson was a left-handed-hitting right fielder who posted some of the most impressive offensive numbers of the nineteenth century.

He came by his nickname honestly, standing six foot two and weighing over two hundred pounds. When he debuted with the National League's Detroit Wolverines in 1885, they initially couldn't find a uniform large enough for him. That may have been a contributing factor when, in his first at bat, he split his pants open while hustling into second base with a double. He would hit 342 more over his fifteen-year career.

As teammate Charlie Bennett once said, "No one ever quarreled with Sam. No one ever knew him with all his strength to be rough or brutal. He was always even tempered, simple and plain."

He had his best year in 1887, leading the Wolverines to the NL Pennant with a .372 batting average, 118 runs, and 166 RBI. His 203 hits marked the first time anyone crossed the two-hundred-hit mark in the National League. He also led the league with twenty-three triples and 308 total bases. "Thompson helped to make up a team whose bat work was the terror of the pitchers and the leading factor in the winning of more than one pennant," according to one press report. Thompson played in all fifteen games of the World Series against the St. Louis Browns, leading Detroit to a win by hitting .362 with twenty-one hits, seven runs batted in, and two home runs.

Following the 1888 season, he was purchased by the Philadelphia Quakers, now known as the Phillies. The Phillies outfield was one of the greatest of all time, with three future Hall of Famers in Thompson, Ed Delahanty, and Billy Hamilton. In 1894 all three outfielders batted .400 or better.

Charlie Bennett said, "When anyone thinks of Sam Thompson, they think of his strength, of his activity, of those phenomenal hits he made, and those almost unbelievable one-hand catches. You can't forget those things when you have seen them."

Between 1889 and 1896 Thompson drove in one hundred or more runs seven out of eight years, and drove in ninety in his "off year." He scored one hundred or more runs each of those seasons as well. Thompson was the first member of the 20-20 club, leading the league with twenty home runs and stealing twenty-four bases in 1889.

He retired in 1898 because of back problems, but made a brief comeback with the Tigers in 1906, notching seven hits in eight games. Those who saw him play did not forget. "Sam took the breath away from the crowds, both in batting and fielding," said Charlie Bennett more than a quarter century after Thompson retired. "But while we think of Sam as a wonderful player, don't ever forget the other things about Sam. He was a wonderful friend."

—T. Wiles

Thompson - R.F. PHILADELPHIA.

OLD JUDGE CIGARETTES Goodwin & Co., New York.

ALBERT WILLIAM KALINE
DETROIT A.L., 1953-1974
TWELFTH PLAYER TO REACH ELITE 3,000-HIT
PLATEAU, SOCKED 399 HOMERS AND ATTAINED
.297 CAREER AVERAGE, WITH NINE YEARS IN
.300 CLASS. FINISHED IN ALL-TIME TOP 15
WITH 2,834 GAMES, 3,007 HITS, 1,583 RUNS
BATTED IN AND 4,852 TOTAL BASES. PLAYED
100 OR MORE GAMES 20 YEARS AND HAD 242
CONSECUTIVE ERRORLESS GAMES IN OUTFIELD,
1970-1972, FOR A.L. RECORDS. LED IN HITS
AND WON BATTING TITLE IN 1955 AT AGE 20.

AL KALINE

CLASS OF 1980

With one full season already behind him as a regular in the Detroit Tigers lineup, Al Kaline won the 1955 batting title with a .340 mark at age twenty, making him the youngest batting champion the game had ever seen. It is a record that still stands more than a half century later.

Al Kaline was the face of the Detroit Tigers franchise for more than twenty years. Through last-place finishes and World Series triumphs, Tigers fans always had consistent performances from their sweet-swinging right fielder to root for.

Kaline came to the Tigers as an eighteen-year-old in 1953, directly from Baltimore's Southern High School, bypassing the minor leagues entirely. He later recalled, "When I first came up to the Tigers, I was scared stiff, but I had desire. Desire is something you must have to make it in the majors. I was never satisfied with just average." And average was something Kaline certainly was not.

A fifteen-time All-Star, he accumulated 3,007 hits, 399 home runs, and ten Gold Glove Awards in his impressive career. Although he was never named the American League Most Valuable Player, he was consistently among the best players in the league, finishing in the top ten in MVP voting nine times between 1955 and 1967.

Consistency was one of Kaline's trademarks. "You almost have to watch him play every day to appreciate what he does," said veteran pitcher and former Tigers teammate Johnny Podres.

"You hear about him, sure, but you really can't understand until you see him. He just never makes a mistake." A superb defender with a strong arm, and a great line-drive hitter, Kaline could also display power, as he finished twenty of his twenty-two big league seasons in double digits in home runs. Such consistency caused former Tigers manager Mayo Smith to say that "Kaline was the kind of player an organization builds around."

As consistent as he was on the ball field, he was as humble off the field and in the clubhouse. Kaline missed sixty games with a broken arm in 1968, and when the Tigers finally made it to the Fall Classic, Kaline, showing humility, told Smith that he didn't deserve to play because Jim Northrup, Mickey Stanley, and Willie Horton had become the regular outfield during that span. Smith would hear none of it and juggled the lineup to get all four men in. Kaline responded by leading the Tigers to the World Series title, batting .379 with two home runs and eight RBI. After the Series, Horton unequivocally stated, "We don't win that title without Al back where he belonged."

Upon retirement from the game in 1974, Kaline went on to broadcast Tigers games for the next twenty-five years. Legendary statistician Bill James would rank Kaline as the fifth-best career right fielder of all time. Kaline's former manager Chuck Dressen said Kaline was "the best player who ever played for me."

"People ask me, was it my goal to play in the majors for 20 years? Was it my goal to get 3,000 hits someday? Lord knows, I didn't have any goals," Kaline once said. "I tell them, My only desire was to be a baseball player."

—F.B.

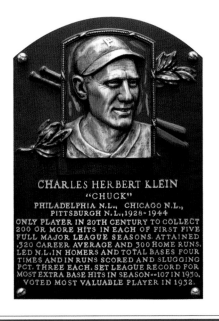

CHARLES HERBERT KLEIN
"CHUCK"
PHILADELPHIA N.L., CHICAGO N.L.,
PITTSBURGH N.L., 1928-1944
ONLY PLAYER IN 20TH CENTURY TO COLLECT
200 OR MORE HITS IN EACH OF FIRST FIVE
FULL MAJOR LEAGUE SEASONS. ATTAINED
.320 CAREER AVERAGE AND 300 HOME RUNS.
LED N.L. IN HOMERS AND TOTAL BASES FOUR
TIMES AND IN RUNS SCORED AND SLUGGING
PCT. THREE EACH. SET LEAGUE RECORD FOR
MOST EXTRA BASE HITS IN SEASON--107 IN 1930.
VOTED MOST VALUABLE PLAYER IN 1932.

CHUCK KLEIN

CLASS OF 1980

There is perhaps no player who adapted better to his home environment than Chuck Klein. Playing at Philadelphia's Baker Bowl, with its extremely short right-field porch, Klein made a conscious effort to pull the ball. As a right fielder, he played particularly shallow so as to maximize his chances of throwing out runners at first base.

The son of German immigrants, Klein grew up on a midwestern farm. By his own admission, he avoided work at school and concentrated most of his efforts on the ball field. Making his major league debut for the Phillies in the middle of the 1928 season, he left a distinct impression in a half season of work. Hitting .360, the twenty-three-year-old rookie established his superior hitting credentials right from the start.

The following year, Klein hit .356 while dramatically improving his power. In leading the National League with forty-three home runs, he took full advantage of the dimensions of the unusually shaped Baker Bowl, where the right-center-field wall stood only three hundred feet away.

From 1929 to 1933, no other hitter dominated the National League like Klein. He led the league in home runs four times while winning the NL MVP Award in 1932 and the Triple Crown in 1933.

Defensively, Klein also found a way to contribute. He led National League outfielders in assists three times, including a modern-day league record of forty-four assists in 1930. An expert at playing caroms off the right-field tin wall, Klein frequently put himself in position to throw out surprised base runners.

Klein was clearly the team's best player, but he lacked a competent supporting cast. His brilliance on a bad team prompted a memorable remark from famed sportswriter Red Smith in the *New York Times*. "It used to be said in jest," Smith wrote, "that the Philadelphia newspapers of the early thirties kept a headline standing in type to eliminate the expense of constant resetting. It read: 'Klein Hits Two As Phils Lose.'"

Although Klein was still in his prime at age twenty-eight, the seventh-place Phillies decided to rebuild after 1933. They sent him to the Chicago Cubs for a package of three players and $65,000.

His numbers in Chicago paled in comparison with those he'd compiled in Philadelphia. So in the middle of the 1936 season, the Cubs sent Klein, still a productive player, back to the Phillies, who would eventually move from the Baker Bowl to Shibe Park in 1938. On July 10, 1936, Klein blasted four home runs at massive Forbes Field in Pittsburgh, his single greatest game as a major leaguer and the hallmark of the second of his three stints in Philadelphia.

Klein was best known for his power, but he was truly a well-rounded player who excelled at everything required of an All-Star. As *Philadelphia Inquirer* sportswriter Allen Lewis once wrote, "Klein could do the four things that make superstars. He could run, throw, hit, and hit with power. It's difficult to imagine what else is needed to qualify the greatest hitter in the history of the Phillies for admission to Cooperstown."

—B.M.

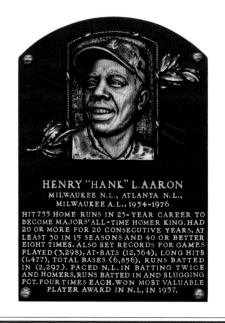

HENRY "HANK" L. AARON
MILWAUKEE N.L., ATLANTA N.L.,
MILWAUKEE A.L., 1954-1976
HIT 755 HOME RUNS IN 23-YEAR CAREER TO
BECOME MAJORS' ALL-TIME HOMER KING. HAD
20 OR MORE FOR 20 CONSECUTIVE YEARS, AT
LEAST 30 IN 15 SEASONS AND 40 OR BETTER
EIGHT TIMES. ALSO SET RECORDS FOR GAMES
PLAYED (3,298), AT-BATS (12,364), LONG HITS
(1,477), TOTAL BASES (6,856), RUNS BATTED
IN (2,297). PACED N.L. IN BATTING TWICE
AND HOMERS, RUNS BATTED IN AND SLUGGING
PCT. FOUR TIMES EACH. WON MOST VALUABLE
PLAYER AWARD IN N.L. IN 1957.

HANK AARON

CLASS OF 1982

Hank Aaron may have gone about his business in an understated way, but he certainly got results, ranking among the top home run hitters ever. Not only did he hit 755 home runs, but also he collected 3,771 career hits and set major league records for total bases, extra-base hits, and RBI.

Aaron was the 1957 National League MVP, won three Gold Glove Awards for his play in right field, and was named to a record twenty-five All-Star squads. He began his big league career in 1954 when Bobby Thomson broke his ankle, opening a spot in the Braves' outfield for Aaron.

Aaron moved with the team when it headed to Atlanta before the 1966 season, and according to statistician Bill James, he would have hit even more home runs "had he been playing in an average home-run park; playing his best years in Atlanta (or Wrigley Field) he absolutely would have hit more than 60 home runs in a season."

As it was, Aaron gained a following no matter where he played. "In Atlanta, they're convinced he's a combination of Mary Poppins and Clark Kent, that when he takes his uniform off, there's a block 'S' on the front of his sweatshirt and a cape on his back," *Los Angeles Times* columnist Jim Murray wrote in 1968.

When it came to the long ball, Aaron was nothing if not methodical. Although he led the league in home runs only four times in his twenty-three-year career, he hit twenty-five or more home runs in eighteen seasons.

"As far as I'm concerned, Aaron is the best ball player of my era," Mickey Mantle told *Baseball Digest* in 1970. "He is to baseball of the last 15 years what Joe DiMaggio was before him. He's never received the credit he's due."

Aaron demonstrated tremendous grace under pressure as he closed in on Ruth's all-time home run mark in 1973. Numerous death threats forced him to hire a bodyguard. In addition, his daughter reportedly was the target of an aborted kidnapping plot.

Despite the racial hatred, Aaron hit forty home runs that season, finishing 1973 one home run short of Ruth's record. After tying the Babe on the road in Cincinnati to start the 1974 season, Aaron set a new standard of 715 when, on April 8, he connected with a fastball thrown by the Dodgers' Al Downing in the fourth inning before a capacity crowd in Atlanta.

"I never worried about the fastball," Aaron once said. "They couldn't throw it past me, none of them."

The record-setting homer was like many of Aaron's clouts through the years. It sailed just over the left-center fence and settled into the Braves bullpen.

"I cannot understand why they want to hit it so far over the fence," Aaron said decades later about a younger generation of power hitters. "Just putting the ball a few rows into the bleachers was good enough for me."

—T. Wendel

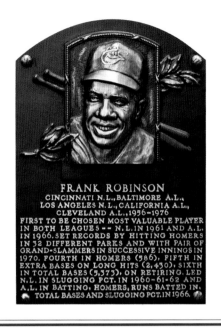

FRANK ROBINSON
CINCINNATI N.L., BALTIMORE A.L.,
LOS ANGELES N.L., CALIFORNIA A.L.,
CLEVELAND A.L., 1956-1976
FIRST TO BE CHOSEN MOST VALUABLE PLAYER
IN BOTH LEAGUES -- N.L. IN 1961 AND A.L.
IN 1966. SET RECORDS BY HITTING HOMERS
IN 32 DIFFERENT PARKS AND WITH PAIR OF
GRAND-SLAMMERS IN SUCCESSIVE INNINGS IN
1970. FOURTH IN HOMERS (586), FIFTH IN
EXTRA BASES ON LONG HITS (2,430), SIXTH
IN TOTAL BASES (5,373), ON RETIRING. LED
N.L. IN SLUGGING PCT. IN 1960-61-62 AND
A.L. IN BATTING, HOMERS, RUNS BATTED IN,
TOTAL BASES AND SLUGGING PCT. IN 1966.

FRANK ROBINSON

CLASS OF 1982

Some players are destined to be underrated. They tend to be overshadowed by other players of their time, perhaps by those who performed in larger markets. Often overlooked, Frank Robinson was legitimately one of the game's immortals, a true five-tool player and a pioneer as a manager.

Robinson was a product of the Bay Area, a community that became a hotbed of talent in the 1950s and 1960s, producing phenoms like Joe Morgan, Willie Stargell, and Vada Pinson. Robinson drew strong interest from the Cincinnati Reds, who signed him in 1953. Promoted to Cincinnati three years later, Robinson ripped thirty-eight home runs and was named National League Rookie of the Year.

In the early 1960s, Robinson evolved into full-blown superstardom. He led the league in slugging for three straight seasons and won the NL MVP Award in 1961, when he spearheaded Cincinnati's run to the World Series. "I never played with a guy I wanted more on my team," Reds pitcher Jim Maloney told the *San Francisco Chronicle*. "Whatever you needed, he'd do it—a home run, a stolen base, a great catch—and he'd do it when it was needed most.

When Robinson's numbers dipped slightly in the mid-1960s, the Reds deemed him to be "an old thirty" and traded him to the Baltimore Orioles. It was a huge mistake by the Reds, as Robinson went on to win the American League Triple Crown in 1966.

As a hitter, Robinson was both patient and aggressive; he was selective enough to draw walks but daring enough to take a stance that placed half of his body in harm's way. Robinson's courage was noticed by his manager in Baltimore. "Nobody has ever had more guts at the plate than Frank, who [in 1969] had resumed the death-defying batting stance he'd always used before suffering [from] double vision."

Robinson also showed courage in becoming one of the game's greatest base runners. He ran with unmatched abandon and urgency. On potential double plays, few runners equaled Robinson's intensity in knocking down middle infielders with hard slides.

"In a lot of ways, he reminded me of Jackie Robinson," Duke Snider told the *San Francisco Chronicle*. "If he was on the other team, you might have thought he was too aggressive. If he played on your team, you loved him."

Like Jackie, Frank played a role as a civil rights pioneer. In 1975 he became the major leagues' first African American manager. As player-manager for the Cleveland Indians, Robinson ran the team with fire and aggressiveness. He later won an American League Manager of the Year Award with Baltimore.

Few men have combined a Hall of Fame playing career with an exemplary tenure as a manager. Frank Robinson deserves recognition for both; he was one of the game's immortals on the field, and one of its most inspiring leaders in the dugout.

—B.M.

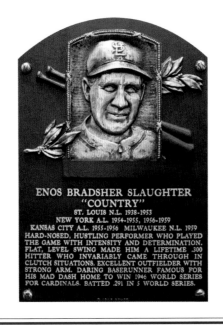

ENOS BRADSHER SLAUGHTER
"COUNTRY"
ST. LOUIS N.L. 1938-1953
NEW YORK A.L. 1954-1955, 1956-1959
KANSAS CITY A.L. 1955-1956 MILWAUKEE N.L. 1959
HARD-NOSED, HUSTLING PERFORMER WHO PLAYED
THE GAME WITH INTENSITY AND DETERMINATION.
FLAT, LEVEL SWING MADE HIM A LIFETIME .300
HITTER WHO INVARIABLY CAME THROUGH IN
CLUTCH SITUATIONS. EXCELLENT OUTFIELDER WITH
STRONG ARM. DARING BASERUNNER FAMOUS FOR
HIS MAD DASH HOME TO WIN 1946 WORLD SERIES
FOR CARDINALS. BATTED .291 IN 5 WORLD SERIES.

ENOS SLAUGHTER

CLASS OF 1985

The Hustler's Handbook was written by Bill Veeck, but the title could just as easily have applied to Enos "Country" Slaughter. Learning early in his career about the importance of playing and running hard, Slaughter turned constant effort, a ferocious line-drive swing, and an accurate throwing arm into a Hall of Fame career.

A native of North Carolina, Slaughter began a quick rise through the St. Louis Cardinals' farm system in 1935. While stationed in the South Atlantic League in 1936, Slaughter was reprimanded by his manager, Eddie Dyer, for failing to run hard off the field. Given a stern lecture, Slaughter took the message to heart. He vowed never again to walk or jog on a playing field.

Two years later, Slaughter stepped onto a major league field for the first time. He played well as a rookie, then blossomed in his second year—enough to earn some consideration for National League MVP. He continued to improve each year through 1942, when he led the league in hits and triples and helped the Cardinals to a world championship. With his slashing left-handed swing and aggressive style on the bases and in the outfield, Slaughter had arrived as an all-out star.

Just as Slaughter peaked, he was summoned to military service and missed three full seasons in World War II. The call to duty wiped out what would have been his age twenty-seven, twenty-eight, and twenty-nine seasons—in other words, the prime years of his career.

By the time Slaughter received his discharge, he was already thirty, but he hardly skipped a beat. His first year back, he led the league with 130 RBI and batted .300.

Slaughter also established a reputation as one of the game's toughest, most driven players. He offered no apologies for his constant exertion and intense desire to beat his opponent.

The 1946 World Series showcased that desire at its best. Playing in the eighth inning of Game 7, Slaughter scored all the way from first on a shot by Harry Walker to left-center that would have been a single had Slaughter stopped at third base. Slaughter completed his famed "Mad Dash" around the bases, scoring what turned out to be the Series' deciding run.

"On that particular play, he outran that ball the last 10 yards," longtime teammate Stan Musial told the Associated Press. "He just outran it. It was an exciting play and won the Series for us."

When Slaughter finally started to show some slippage at the age of thirty-seven, the Cardinals traded him to the New York Yankees. He struggled in his first stint with the Yankees, revived his career with the Kansas City Athletics (where he was said to outhustle the rookies), and then became an effective part-time player and pinch hitter during his second go-round with New York.

"He was one of the great hustlers in baseball," Musial told the Associated Press. "He loved baseball. He always ran hard and played hard." Slaughter took that early lesson from Eddie Dyer and ran with it—all the way to Cooperstown.

—B.M.

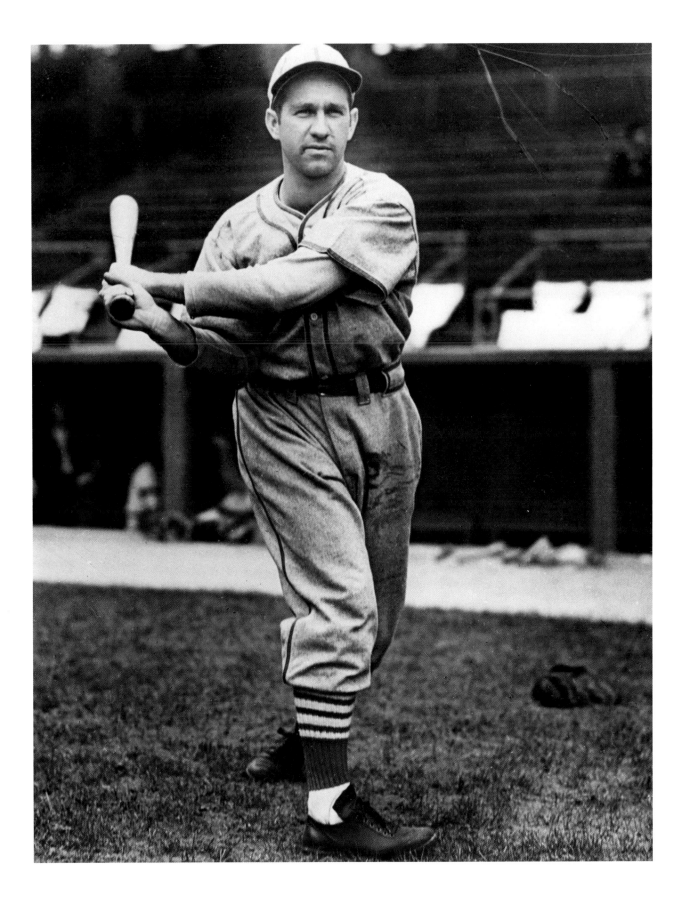

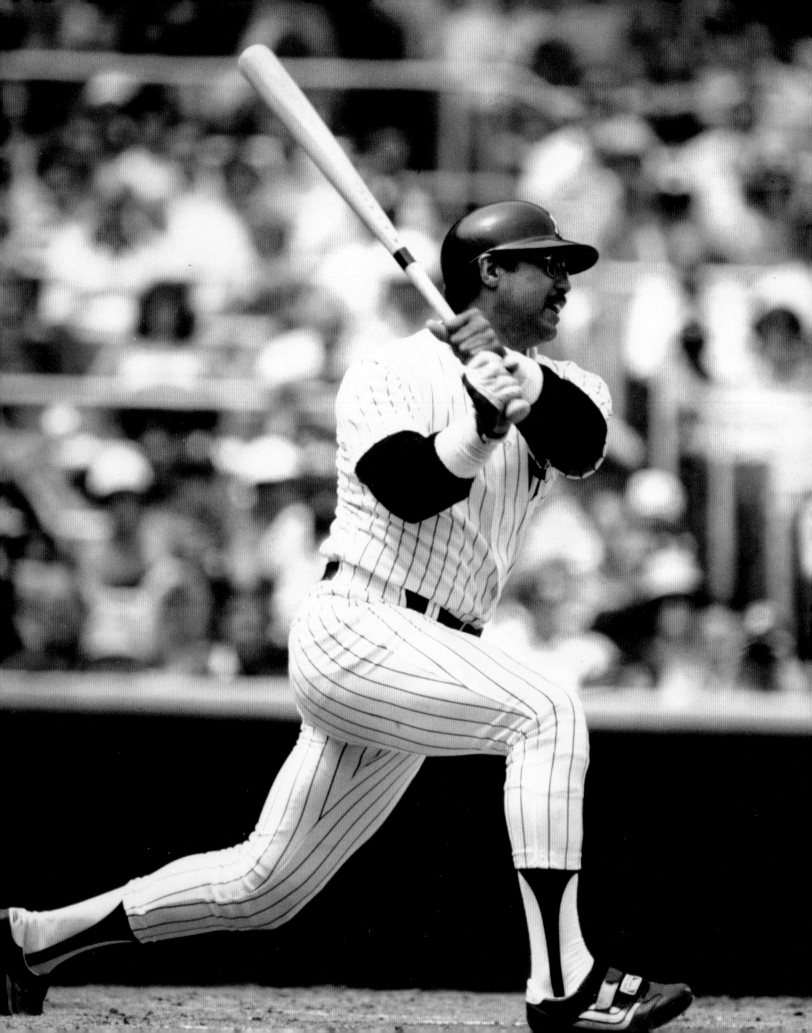

REGINALD MARTINEZ JACKSON
"MR. OCTOBER"
KANSAS CITY, A.L., 1967
OAKLAND, A.L., 1968-1975, 1987
BALTIMORE, A.L., 1976
NEW YORK, A.L., 1977-1981
CALIFORNIA, A.L., 1982-1986
EXCITING PERFORMER WHO PLAYED FOR 11 DIVISION WINNERS AND
FOUND SPECIAL SUCCESS IN WORLD SERIES SPOTLIGHT WITH 10 HOME
RUNS, 24 RBI'S AND .357 BATTING AVERAGE IN 27 GAMES. IN 1977
SERIES, HIT RECORD 5 HOMERS, 4 OF THEM CONSECUTIVE, INCLUDING
3 IN ONE GAME ON 3 FIRST PITCHES OFF 3 DIFFERENT HURLERS.
MAMMOTH CLOUT MARKED 1971 ALL STAR GAME. 563 HOMERS RANK
6TH ON ALL-TIME LIST. A.L. MVP, 1973.

REGGIE JACKSON

CLASS OF 1993

Reggie Jackson was a showman. Not only was he a devastating slugger, but he also showed a knack for hitting his best when the pressure reached its peak. The end result was a tantalizing combination of success and entertainment.

Drafted by the Kansas City A's in 1966, Jackson became the recruiting target of owner Charlie Finley, who visited Reggie at his house. "He came driving up in a big Cadillac," Jackson told *Sport* magazine. He "kept talking about what a big star I was going to be and how we were going to be champions."

Finley was right on both counts. But first Jackson had to overcome the racism that he faced while playing minor league ball in Birmingham, Alabama. Having grown up in the racially mixed community of Wyncote, Pennsylvania, Jackson did his best to integrate himself with other ethnic groups. He would eventually room with Chuck Dobson, a white pitcher, something that was nearly unprecedented at the time.

When the A's moved to Oakland in 1968, Jackson worked daily with a famed batting coach, Joe DiMaggio. For over an hour each day, the Hall of Famer schooled Jackson in the art of making contact. "Reggie is still green as grass," DiMaggio told sportswriter Ed Rumill. "We've just got to bring his talents to the surface. They're all there, no question."

As DiMaggio predicted, Jackson blossomed into a well-rounded four-tool talent. He terrorized pitchers during the first half of 1969, setting a record with thirty-seven home runs before the All-Star break. In addition to enormous power, Reggie could steal bases, range far in right field, and heave cannon shots toward the infield.

Jackson supplied the linchpin of the Oakland offense. Leading the A's in home runs over a three-year span, he emerged as the everyday superstar of a baseball dynasty, as the A's captured three consecutive titles.

Making headlines in one of the most celebrated free agent signings ever, Jackson moved on to the New York Yankees, where he became known for displays of raw power. He saved his finest for the final games of the 1977 season. Jackson ripped five home runs in the World Series, including a momentous trio of long balls in Game 6, leading the Yankees to their first world championship since 1965. "Mr. October" was born.

Reggie delivered more heroics in 1978. In the top of the eighth inning of the famed tiebreaking game against the Boston Red Sox, Jackson gave the Yankees a three-run lead with a monstrous home run to center field. Bucky Dent's home run gained more notoriety, but Jackson's blast actually provided the winning margin in a 5–4 thriller.

After leaving New York, Jackson continued to win. In 1982 he hit thirty-nine home runs to lead the California Angels to the Western Division title. By the end of his career, he had appeared in eleven postseasons.

At his best, Jackson provided grand entertainment.

—B.M.

DAVID MARK WINFIELD
SAN DIEGO, N.L., 1973-1980, NEW YORK, A.L., 1981-1990
CALIFORNIA, A.L., 1990-1991, TORONTO, A.L., 1992
MINNESOTA, A.L., 1993-1994, CLEVELAND, A.L., 1995
A COMPLETE PLAYER WHO INTIMIDATED THE OPPOSITION WITH HIS
IMMENSE STATURE, POWER, AGGRESSIVE BASERUNNING AND DOMINANT
DEFENSE. ADVANCED DIRECTLY FROM COLLEGE TO THE MAJOR LEAGUES, THE
12-TIME ALL-STAR COMPILED 3,110 HITS, 465 HOME RUNS, 1,833 RBI AND A
.283 CAREER AVERAGE. THE MULTITALENTED OUTFIELDER, RENOWNED FOR
LONG STRIDES AND A ROCKET ARM, EARNED SEVEN GOLD GLOVE AWARDS.
AMONG ALL-TIME LEADERS IN HITS, RBI, GAMES, DOUBLES, EXTRA BASE HITS,
TOTAL BASES AND PUTOUTS. HIS 11TH INNING, TWO-OUT DOUBLE IN GAME SIX
CLINCHED TORONTO'S 1992 WORLD SERIES TITLE.

DAVE WINFIELD

CLASS OF 2001

In terms of pure athleticism, few players could better the attributes possessed by Dave Winfield. Drafted in three major sports (including the NFL, NBA, and ABA), he used his strength, speed, and agility to craft a Hall of Fame career.

The native Minnesotan chose the San Diego Padres, who took him as a pitcher-outfielder in 1973. Bypassing the minor leagues completely, he made his debut just a few days after the draft. Playing part-time, Winfield hit a respectable .277. As a second-year player, Winfield was ready for full-time duty. Showing enough speed to play all three outfield positions, he also hit twenty home runs.

In the mid-1970s, Winfield made the transition from being a good player to a great one. "He's got all of the prime requisites scouts look for—speed, power, and a strong arm," teammate Willie McCovey told sportswriter Earl Lawson in 1975. Winfield also impressed McCovey with his ability to stay upbeat on a losing team. "He had that winning attitude last spring and maintained it throughout the season, and on this club it wasn't an easy thing to do."

In 1977 Winfield earned his first All-Star Game selection. In 1979 he led the National League in RBI with 118, despite being surrounded by a weak supporting cast. After another fine season in 1980, which was highlighted by his second Gold Glove Award, Winfield became a free agent and signed an unprecedented ten-year contract with the New York Yankees.

One famous New York sportswriter lamented that the Yankees had spent millions of dollars on a "singles hitter." The assessment was ludicrous. In 1982, his second season in the Bronx, Winfield hit thirty-seven home runs.

Making a smooth switch from right field to left field, Winfield helped the Yankees immensely, four times slugging .500 or better, and six times reaching the one-hundred-RBI mark. With his six-foot-six frame and ferocious swing, Winfield frightened pitchers. "If you accidentally get the ball up to Winfield, there's only one way he can hit—back up the middle," Hall of Famer Bert Blyleven told the *New York Post*. "And that's where we are. He may kill a pitcher before he's through."

After slugging a robust .530 in 1988, Winfield experienced back pain during the spring of 1989. A herniated disk required surgery, knocking him out for the season and jeopardizing his career. Winfield worked hard to return in 1990, but after a slow start, the Yankees traded him to the Angels. His diligence paid off, as he hit nineteen home runs and slugged .466 for California.

Prior to 1992, Winfield signed a free agent contract with the Toronto Blue Jays. Although he was now forty and limited mostly to DH duty, he hit twenty-six home runs, helping the Jays reach the World Series for the first time.

Despite the severity of his back surgery, Winfield lasted twenty-two seasons. His work ethic allowed him to fulfill his five-tool talents. It turns out that, in choosing baseball, Dave Winfield made the right decision after all.

—B.M.

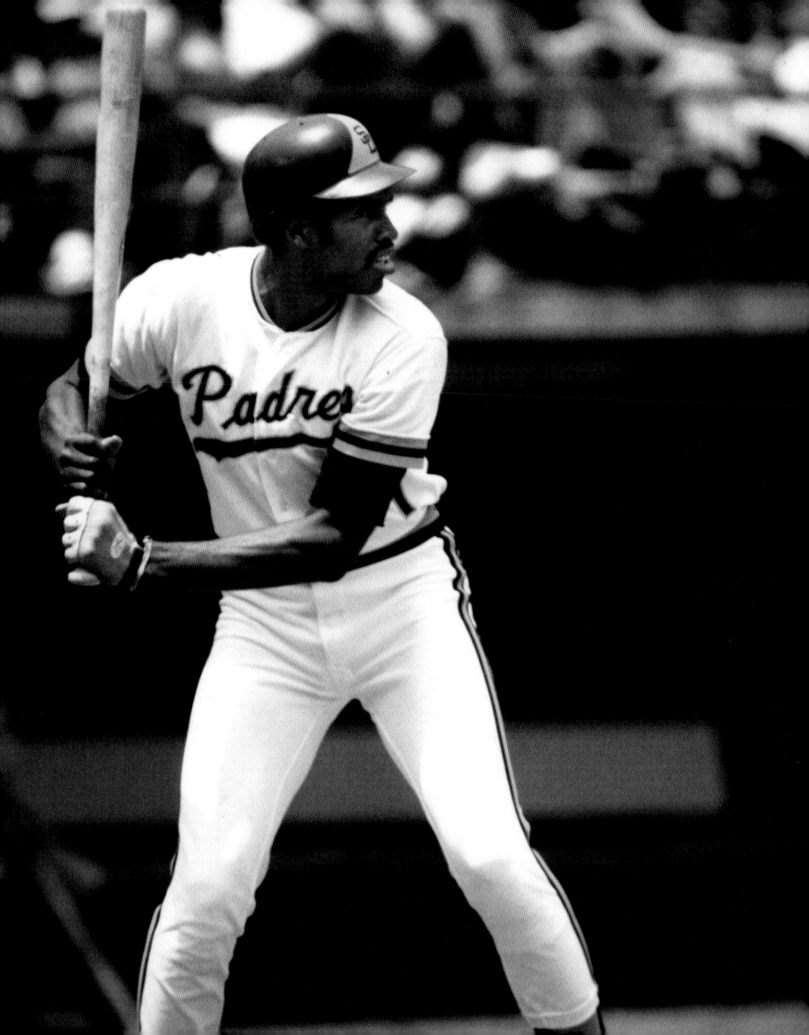

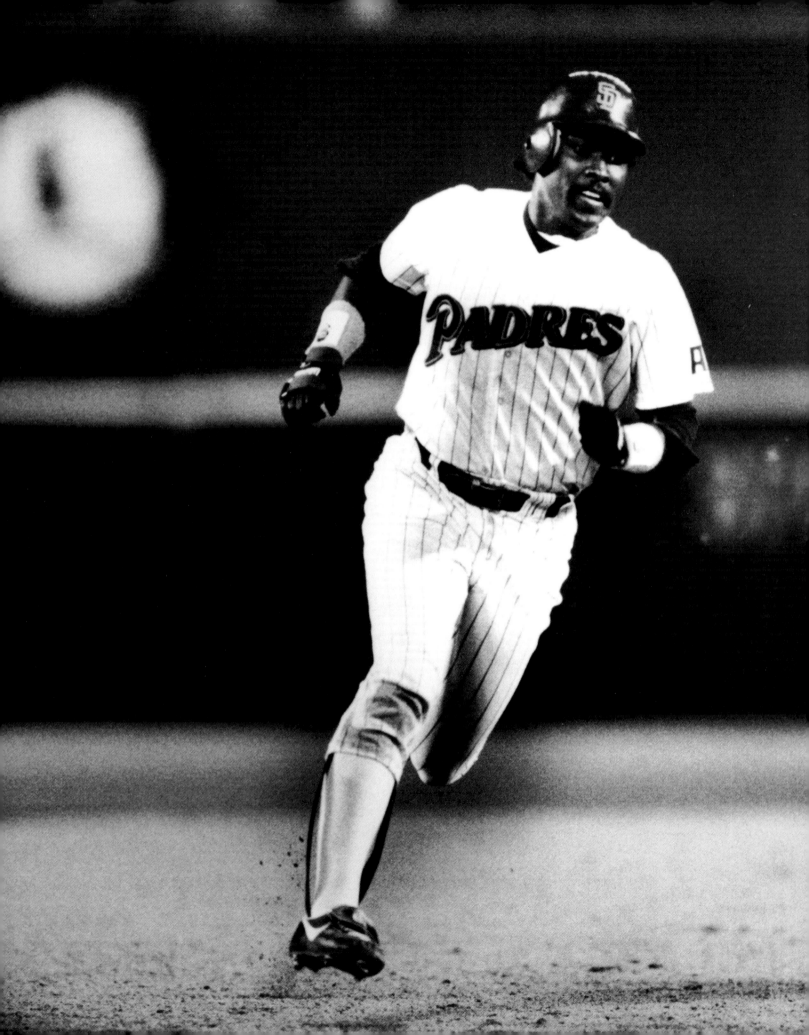

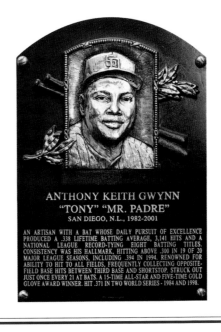

ANTHONY KEITH GWYNN
"TONY" "MR. PADRE"
SAN DIEGO, N.L., 1982-2001

AN ARTISAN WITH A BAT WHOSE DAILY PURSUIT OF EXCELLENCE
PRODUCED A .338 LIFETIME BATTING AVERAGE, 3,141 HITS AND A
NATIONAL LEAGUE RECORD-TYING EIGHT BATTING TITLES.
CONSISTENCY WAS HIS HALLMARK, HITTING ABOVE .300 IN 19 OF 20
MAJOR LEAGUE SEASONS, INCLUDING .394 IN 1994. RENOWNED FOR
ABILITY TO HIT TO ALL FIELDS, FREQUENTLY COLLECTING OPPOSITE-
FIELD BASE HITS BETWEEN THIRD BASE AND SHORTSTOP. STRUCK OUT
JUST ONCE EVERY 21 AT BATS. A 15-TIME ALL-STAR AND FIVE-TIME GOLD
GLOVE AWARD WINNER. HIT .371 IN TWO WORLD SERIES - 1984 AND 1998.

TONY GWYNN

CLASS OF 2007

By the time he retired in 2001, Tony Gwynn had posted four of the highest batting averages since Ted Williams became the last player to hit .400 in 1941.

A highly recruited point guard, Gwynn attended San Diego State University on a basketball scholarship. Although he didn't play baseball for the Aztecs as a freshman, preferring to concentrate on basketball, he was back on the field by his second year.

"Baseball was just something to do in the spring and summer," Gwynn once said. "I told my mom I didn't think I would try baseball in college. She and my dad told me it was something I might want to fall back on."

Gwynn would become the first athlete in Western Athletic Conference history to be honored as an all-conference performer in two sports.

At the major league level, the longtime San Diego Padres outfielder was known as a student of hitting. An early advocate of using videotape to study his swing, the left-handed hitter became a master at driving the ball between the shortstop and third baseman, or the "5.5 hole," as he called it.

"I love to hit," Gwynn said. "I can't wait until it's my turn. Sometimes, I think that's all baseball is. I root for the other team to go down 1-2-3 so I can hit again."

Gwynn went on to collect 3,141 career hits, a lifetime .338 batting average, and eight batting crowns, a National League record he shares with Honus Wagner. In addition, he garnered

five outfield Gold Glove Awards, 319 career stolen bases, and fifteen All-Star Game selections.

"He was one of the best players I ever saw," Padres manager Bruce Bochy said, "and he was probably the smartest and most dedicated."

From 1993 to 1997, Gwynn hit .350 or better every year, becoming only the fourth player in modern history to top the .350 mark in five consecutive seasons, a feat previously accomplished only by Ty Cobb (11 seasons), Rogers Hornsby (6), and Al Simmons (5).

In 1994 Gwynn hit .394, the highest average in the National League since 1930, and ended his playing days ranked seventeenth in career hits.

Pitching legend Greg Maddux once said of Gwynn, "He's easily the toughest hitter for me. I can't think of anyone who hits me harder. He handles the pitch away as well as anybody, and he's able to stay inside the ball when the pitch is in. His holes are just very small."

Always possessed of a keen eye at the plate, he struck out just 434 times in 10,232 plate appearances, an average of once every 23.6 plate appearances. In addition, Gwynn became the first player in major league history to win four batting titles in two separate decades.

"One of the things I'm proudest about is that I played for one team," Gwynn said. "My baseball card looks awesome because it has San Diego all the way down. I grew up in an environment where that kind of stuff was important."

—B.F.

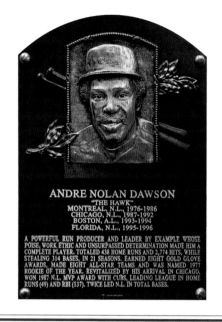

ANDRE NOLAN DAWSON
"THE HAWK"
MONTREAL, N.L., 1976-1986
CHICAGO, N.L., 1987-1992
BOSTON, A.L., 1993-1994
FLORIDA, N.L., 1995-1996

A POWERFUL RUN PRODUCER AND LEADER BY EXAMPLE WHOSE
POISE, WORK ETHIC AND UNSURPASSED DETERMINATION MADE HIM A
COMPLETE PLAYER. TOTALED 438 HOME RUNS AND 2,774 HITS, WHILE
STEALING 314 BASES, IN 21 SEASONS. EARNED EIGHT GOLD GLOVE
AWARDS, MADE EIGHT ALL-STAR TEAMS AND WAS NAMED 1977
ROOKIE OF THE YEAR. REVITALIZED BY HIS ARRIVAL IN CHICAGO,
WON 1987 N.L. MVP AWARD WITH CUBS, LEADING LEAGUE IN HOME
RUNS (49) AND RBI (137). TWICE LED N.L. IN TOTAL BASES.

ANDRE DAWSON

CLASS OF 2010

He was baseball's most complete player for a decade—a five-tool star who won three Silver Slugger Awards and six Gold Glove Awards in his first nine big league seasons.

But as spring training of 1987 approached, Andre Dawson found himself out of work. And he wasn't at all certain what his future held.

"I wanted to convince the baseball world that I would indeed perform better under different circumstances," said Dawson, who turned down a two-year $2 million offer from the only club he had ever played for, the Montreal Expos, to test the free agent market. "Those circumstances being: To get away from the AstroTurf and onto a natural playing field."

Dawson eventually agreed on one of baseball's most unusual contracts with the Chicago Cubs. And by the end of the 1987 season, Dawson was the National League's Most Valuable Player.

An eleventh-round draft pick by the Expos in 1975, Dawson shot through Montreal's minor league system and made his big league debut on September 11, 1976. The following year, Dawson was named the club's starting center fielder by future Hall of Fame manager Dick Williams. Dawson responded with nineteen homers, sixty-five RBI, and twenty-one stolen bases en route to the National League Rookie of the Year Award.

In 1981 Dawson helped Montreal qualify for the postseason for the first time, as the Expos won their division series against the Phillies before losing the NLCS to the Dodgers.

But playing all those seasons on the rock-hard artificial surface at Olympic Stadium took its toll on Dawson's knees.

By the winter of 1987, Dawson knew he had to make a change.

"I had 12 knee operations during my playing days," Dawson said. "It wasn't just some cartilage tear, it was no cartilage. Bone-on-bone."

So Dawson targeted the Cubs, and in spring training, Dawson and his agent Dick Moss presented Cubs general manager Dallas Green with a blank one-year deal. Green filled in the amount: $500,000, plus $150,000 if Dawson was not on the disabled list with a knee injury before the All-Star break, and $50,000 for making the All-Star team.

By the end of the 1987 season, Dawson had become the first player from a last-place team to be named Most Valuable Player, after hitting forty-nine home runs and driving in 137 runs for the Cubs.

Dawson spent five more productive seasons there, helping Chicago win the NL East title in 1989 while averaging twenty-five homers and ninety RBI. He finished his career playing two seasons apiece with the Red Sox and the Marlins—highlighted by winning the Hutch Award for baseball spirit and competitive drive in 1994 with Boston—before retiring after the 1996 season.

By then, Dawson had undergone enough procedures on his knees that joint replacement eventually became necessary.

"I can honestly say that I probably would not be a Hall of Famer if I hadn't gone to Chicago," Dawson said. "I don't know if I would've lasted more than another two or three years."

—C.M.

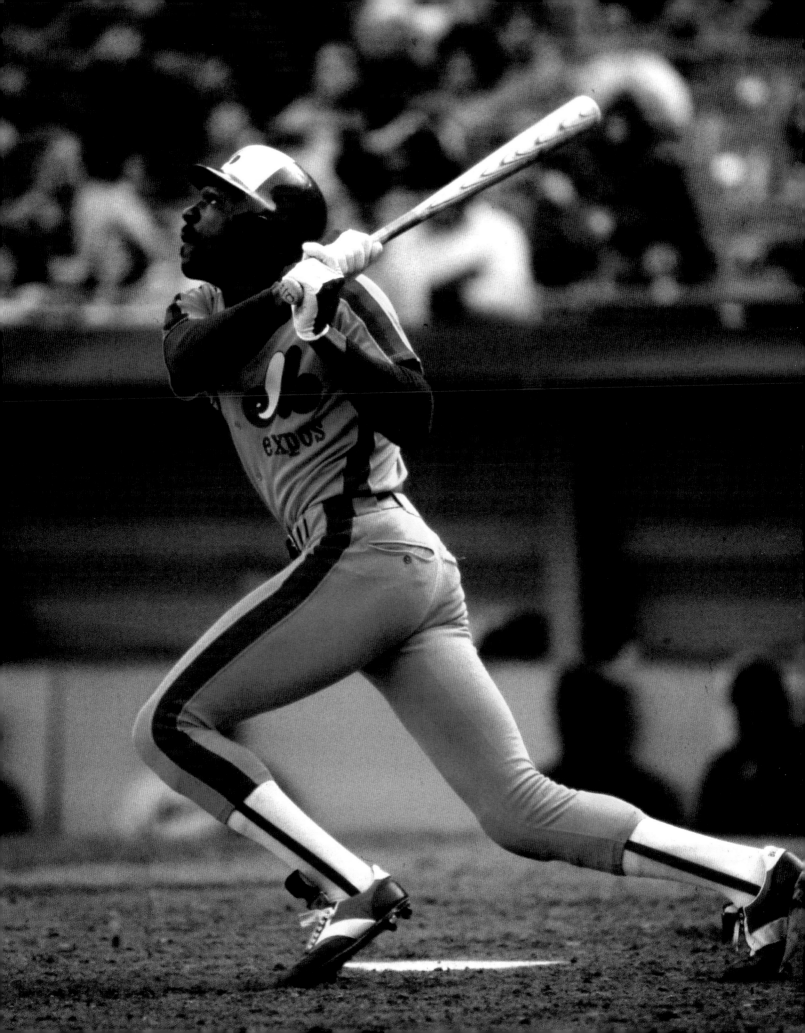

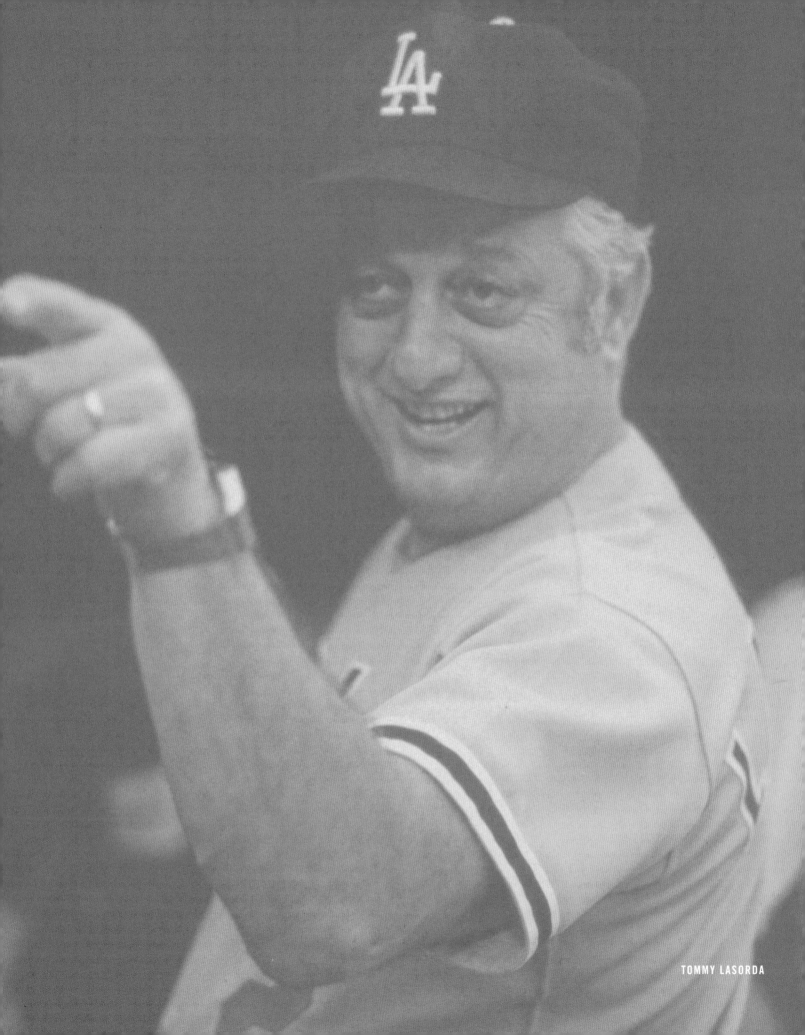

TOMMY LASORDA

MANAGERS

MANAGERS BY **TOMMY LASORDA**

Hall of Fame manager Tommy Lasorda has been bleeding Dodger blue for more than six decades. During much of that time he's been a gregarious baseball ambassador. He managed his teams to seven division titles, four pennants, two World Series championships, and an Olympic gold medal. He also may hold the major league record for most honorary doctorate degrees earned, with ten. Not bad for a guy who never went to college.

My father was an Italian immigrant who worked in a stone quarry and did his best to raise a family of five boys—who ate like mules—on seventy dollars a week. He didn't have a formal education and spoke in broken English, but he was a very wise man. One of the great lessons he taught me was that in everyone's lifetime there comes a time when one door will close on you. And if you are so concerned with the door that closes, you will never find the next one that's opened. I really took his words to heart after my career as a professional baseball player ended in 1960. I had given it my all and had made it to the big leagues with the Brooklyn Dodgers in 1954. But for some reason the manager, Walter Alston, never pitched me much, so I believe I didn't get a true opportunity to show what I could really do. The Dodgers were loaded with talent in those years. We had twenty-six farm teams at one point. Twenty-six! So the competition to climb the ladder was fierce. And look at the talent they had at the top of that ladder. Where were you going if you were a good catcher when you had a guy like Roy Campanella, a three-time MVP, in front of you in Brooklyn? Where were you going if you were a good center fielder? Were you going to knock Duke Snider out of the starting lineup? I don't think so. And it was the same with the pitching staff. I kept trying to stick with the big club. I spent nine years in Montreal, the Dodgers' top farm team, won 107 games. But it didn't work out for me. The door closed. But, fortunately, another one opened.

When I was through playing, the Dodgers offered me a job as a scout for $6,000 a year. I didn't realize it at the time, but it was the best training I could ever get for becoming a manager. You've got to learn how to evaluate talent, and that's so important when it comes time to fill out that lineup card or go out there to make a pitching change. My advice for anyone interested in becoming a manager is to spend some time in the scouting department. It's great experience. After a few years of scouting, I got the itch to get back into uniform, either as a coach or a manager. I missed the action of the game, of being in the trenches, and since I could no longer do it as a player, I figured coaching or managing was the next-best thing. And just as I had done when I signed my first playing contract with the Philadelphia Phillies organization in 1945, I was dreaming big. I was dreaming of returning to the big leagues as a manager. That was my new goal.

I'll never forget being at Dodger Stadium in Los Angeles with the team's other scouts for the 1963 World Series against the New York Yankees. They had all of us and our families sitting in these seats in the third deck behind home plate that were so high up the players looked like midgets. And I remember talking to my wife, Joan, who I call Jo. I said, "Jo, see that dugout down there? One day, I'm going to be in that dugout managing the Dodgers against the Yankees in the World Series." She probably thought I was crazy. But fourteen years later I was in that dugout,

managing the Dodgers against the Yankees in the World Series. And believe you me, I was thinking about my late father that night and thanking him for teaching me about looking for that open door instead of worrying myself sick about the one that slammed in my face.

I loved baseball from the moment I started learning about the game as a kid growing up in Norristown, Pennsylvania. I remember learning about Babe Ruth and Jimmie Foxx and Lou Gehrig and Chas Gehringer and Joe DiMaggio. I knew their statistics like the back of my hand because I would study and memorize the backs of their bubble gum cards. Those guys were my heroes. I dreamed about following in their footsteps. I was going to become a Major League Baseball player. Of course, a lot of kids from my neighborhood felt the same way. When we'd go play sandlot ball, we'd pretend we were major league players. Each of us would choose a guy and we would call him by that name. It would be like, "Hey, Jimmie Foxx, you're up," and "Hey, Lou Gehrig, you're on deck." I loved to throw the ball, so I became a pitcher early on. And for some reason, I decided to take the name of Van Lingle Mungo, a guy who pitched for the Brooklyn Dodgers. I didn't know if he was right-handed or a southpaw like me. All I knew was that he was a good pitcher and I thought he had a cool name. So my nickname forever in Norristown was Mungo. Years later it all came full circle for me when Peter O'Malley invited a bunch of the old Brooklyn Dodgers who had been National League All-Stars to Los Angeles for a reunion. And one of the guys was Van Lingle. So I went over to him and told him the story about how I had taken his name when I was kid playing ball, and he got such a kick out of it. It made his day.

I was a feisty ballplayer who was known to get into a fight or two during my professional baseball career, and I was very aggressive as a manager. So people are always asking me where I got my fierce competitive spirit from. And I tell them I got it at Elmwood Park in Norristown. See, we'd play these pickup baseball games there at the diamond. There would be all different teams that would gather to play at Elmwood. We'd have the Italian kids from my neighborhood and the Irish kids who went to St. Patrick's High School and the kids from the black neighborhood and we'd play games all day long. There was only room for two teams at a time to play, so when you lost, you had to go over to the swings at the playground and wait until the next game or two was done before you could play ball again. And if you won, you kept on playing. So that's where I developed my love of winning and my hatred for losing. I loved playing ball and I wanted to play as many games as I could, and the more you won, the more you played.

Norristown isn't far from Philadelphia, so I would follow both Philly teams—the Phillies and the Athletics—on radio. We never went to any games, because times were tough and my father wasn't going to waste precious money on baseball. I was blessed with a good arm, and fortunately I caught the attention of the Phillies, who wanted to sign me while I was still in high school. You could do that in those days. It wasn't until a few years after I signed that they changed the rules to where you couldn't sign until you graduated from high school. My dad, being an immigrant, really didn't know anything about baseball. So he was understandably reluctant to have me sign that contract. I remember him telling me, "Thomas, I want you to go to school and get an education." And I told him, "Pops, I don't want to continue my education. I want to play baseball." He finally gave in, but he said, "I'll let you sign that contract, but don't you come back to me someday and

say, 'Pops, why didn't you stop me from doing that and make me go to school?'" He said, "You are going to make your own bed and you are going to have to sleep in it." Years later, when I had my success as a Dodgers manager, I wound up receiving ten honorary doctorate degrees from various colleges, including one from Caltech. Ten of them to a guy who barely graduated high school and never went to college. When I look at those degrees, I think of my dad. I know he would have gotten a big kick out of that. He would have been more proud of that than my World Series trophies.

I wasn't exactly what you would call a "bonus baby" back then. I signed for the whopping total of $100—about three dollars and thirty-three cents a day—to play minor league ball. The Phillies sent me to play for the Concord Weavers in Concord, North Carolina. I had never been farther than eighteen miles from Norristown my entire life, so I was scared to death.

I mentioned that I had a little bit of a temper on the field, and it got the better of me my first game as a pro. I pitched the distance and we lost the game in the bottom of the ninth when our shortstop let a ball go through his legs. I was furious, and when we got into the clubhouse I started fighting the kid who made the error. Our teammates broke it up and my manager, John "Pappy" Lehman, called me immediately into his office. He said, "Lasorda, you better straighten up in a hurry. You can't go fighting your teammates. The shortstop didn't try to make that error. He feels bad enough. And you make mistakes, too. You aren't going to win games as a pitcher without the help of your teammates." Well, I felt like such a jerk. Pappy was absolutely right. From that moment on, if one of my teammates made a mistake, I tried to boost his confidence, pick him up. Later that season, Pappy wound up releasing me and told me that I had better find a job in another field because I would never make it in baseball. I told him I would prove him wrong—and I did.

I got drafted by the Army the next year and spent 1946–47 in the military. The experience helped me mature both mentally and physically, and when I came out of the service I was assigned to the Phillies' team in Schenectady, New York. My manager was Lee Riley, father of the great Los Angeles Lakers coach Pat Riley, and, man, was he one mean, tough guy. But I loved that man. When I look back on the biggest influences on my career, Lee Riley and former Yankees manager Ralph Houk rank at the top. They were the two best managers anybody could ever want to play for. Lee taught me the discipline you need to be good. And Ralph taught me how to treat your players like you would want to be treated. Two different approaches, to be sure. But they were approaches I used in my career. I'll never forget it, but when I won my first World Series as a manager in 1981, Mrs. Riley called me and said, "Tommy, if Lee were alive today, he would have been so proud of you." Those were among the greatest words I've ever heard. Made me feel like a million dollars.

I had my greatest game as a pitcher with the Schenectady Blue Jays during the summer of '48. I struck out twenty-five batters in fifteen innings—which at the time was a league record for most Ks in a single game—and I also singled home the winning run as we beat the Amsterdam Rugmakers. I had fifteen and thirteen strikeouts in my next two starts, and that attracted the attention of the Dodgers, who wound up drafting me from the Phillies organization. I had a lot of success in the Dodgers' minor leagues and also spent winters pitching in Cuba and Panama. But, like I said, for some reason Walter Alston never gave me much of a chance, and my major league career consisted of just four decisions, all losses, in parts of two seasons with the Dodgers and one season

with the Kansas City Athletics. The Dodgers released me in July 1960. And that was the end of my playing career. Door closed. But then another one opened with the opportunity to scout. And that led to an opportunity to manage and make it back to the big leagues, this time for good.

My first managing job came in 1965 with the Pocatello Chiefs, a rookie league team in Idaho. It was a real learning curve for me. My scouting experience had taught me how to judge talent. But it hadn't taught me how to understand players as people. I learned right away about treating them like a parent would his child. When they're struggling is when they really need you. That's the time when you've got to put your arm around them and encourage them. After one year there, I was promoted to Ogden, Utah, where I managed that Pioneer League team to three straight titles. That earned me a promotion to the Dodgers' Triple-A team in Spokane, Washington, and my success continued, as we won our division by twenty-six games in my second season, 1970. After another successful season in 1972, I got a call from Dodgers general manager Al Campanis, saying that they wanted me to become Alston's third-base coach. I wasn't thrilled. I told Al I wanted to manage, not coach, and that I would be content to return to Triple-A and manage again. I told him that Walter never wanted to pitch me when I was a player and that I didn't think he really wanted me as his coach. But Al convinced me otherwise. He said Walt wanted me as his coach, so I said, under those conditions, I'll take the job, and I wound up coaching for him for four years.

The good thing for me is that I had coached all the young guys who were joining the Dodgers. I was familiar with them, they were familiar with me, so I had their respect and their ear. One night Billy Buckner hit a ground ball to first that he thought was foul and didn't run the ball out. The ump called him out, and when Billy came back to the dugout, Walt got in his face about not hustling. Buckner gave him some mouth. I told Billy to stay in the dugout after the final out of the game because I needed to talk to him. After everyone had cleared out of the dugout, I grabbed him by the shirt and said, "Billy, don't you ever let me see you show up a manager like that again." He said he didn't like Alston and said he wasn't going to listen to him. I said, "I don't care if you like him or not. You need to respect him." He said, "I'm not going to do it." I said, "Billy, you need to go apologize to him or you are going to have a problem with me." The next day I show up at the ballpark, and Walt called me into his office and said, "Hey, Tommy, you're not going to believe this. Buckner was just in here and apologized to me." Walt didn't know that I talked to Billy, nor did I want him to know. I said, "That's great, Walt. That shows me a lot that he did that." Again, I think the fact I had managed Billy and so many of these other guys helped in situations like that.

On September 29, 1976, Peter O'Malley told me that Alston was retiring and that I was the new manager of the Los Angeles Dodgers. Tears started flowing down my cheeks. I couldn't help but think back to the '63 World Series and how I made that bold prediction to my wife, Jo. And I also started thinking about my dad. I only wished he could have been alive to see how much his influence impacted me. I used many of his philosophies of life to get to where I was. And I would continue to use them as a big league manager.

My approach to managing was similar to what I did in the minors. My goal was to try to extract from the players every ounce of energy and ability they had to offer. If you can maximize your players' abilities, get them to live up to their potential, your odds of succeeding go

way up. And I tried to convince all of them to play for the name on the front of their shirts, not the name on the back. I think I was able to get them to buy into that because I really worked at creating a family atmosphere.

I believe that a good manager has to be a psychologist as well as a strategist. Yes, you can't succeed if you don't know the ins and outs of the game. But you're also not going to succeed if you don't know how to motivate people. It's always been that way in baseball and it always will be. You have to handle each guy individually. They are like snowflakes and fingerprints: no two are alike. Some guys need a kick in the butt. Others need a pat on the back. You've got to convince each guy ultimately to do what's best for the team. Let me give you a few examples. I had to really work on Davey Lopes to convince him to make the move from outfield to second base. He didn't want to convert. He said, "Tommy, I'm an outfielder. That's my natural position." He was a good outfielder, but we felt he could be an even better second baseman, and we felt it would help the team if he made the move. He fought me for a while but eventually decided to give it a try, and look what happened. He became an All-Star at the position and wound up playing there sixteen, seventeen years. Joe Ferguson did not want to become a catcher, but I got him to give it a shot and he wound up catching fourteen years in the big leagues. Steve Garvey is another guy I got to convert. He went from third to first, and look at the career he had. I think in each of those cases my scouting background helped. It taught me how to envision which positions guys were best suited for and how the pieces of an organization fit together.

They say pitching is 75 percent of the game, so I never understood why there weren't more managers who had been pitchers. Having that background as a pitcher certainly helped teach me about when a guy had had it and I needed to make a pitching change. I had a better feel for it, having been out there on the mound for all those years, than a manager who had been a position player.

Handling the media also is a big part of managing, and it's become even more important through the years, especially now that every game is televised and you have sports commentary around the clock. If you can't manage the media, you're in trouble, because they can make or break you; they have the ear of the fans. And, ultimately, it's the fans who force the final decisions. I always preached to my players that this game doesn't belong to you and it doesn't belong to me and it doesn't belong to the owners. It belongs to the fans. And I made sure my players treated the fans well. I told them that the people who come through the turnstiles pay your salaries, so be good to them. Go sign autographs. Let them take their pictures with you. Go out into the community and the schools and speak to them. Be good to the kids because they look up to you more than they do to almost anybody else in society.

When I took over the Dodgers in 1976, I knew I was inheriting a really good ball club because I had managed many of them in the minor leagues and had worked with them as a big league coach. I would say I had worked with about eighteen of the twenty-five guys on the roster, so there was a feeling of mutual respect and familiarity right off the bat. We had great young talent, and I believed we could be very good for a long time—and we were. My first season as Dodgers manager we wound up making it to the World Series against the Yankees, and the first thing I thought about was that '63 Series when I was a scout dreaming of this moment. Unfortunately, Reggie Jackson ruined the victory party I had planned when he hit those three home runs on three

pitches in Game 6. It's still one of the greatest performances I've witnessed on a ball diamond. I just wish it hadn't been at our expense.

The next year we returned to the Series to play the Yankees and we hoped to get our revenge. And it looked like we would make amends after winning the first two games in Dodger Stadium. But Yankees third baseman Graig Nettles made two acrobatic plays in the third inning of Game 3 that killed what would have been a huge inning for us. If he doesn't make those plays, I think we could have beaten their ace, Ron Guidry, and gone up three games to none instead of leading the Series just two games to one. But the pivotal play of the Series occurred in the next game after we had taken a 3–0 lead in the fifth inning. With Thurman Munson on second and Reggie on first, Lou Piniella hit a low liner that our shortstop, Bill Russell, couldn't handle. He quickly picked up the ball and stepped on second to force Jackson, but his throw to first that would have completed the double play caromed off Jackson's hip and allowed Munson to score. Reggie continues to deny it, but there's no doubt in my mind that he intentionally moved his hip into the ball. It should have been ruled interference and Piniella should have been called out. That was a huge, huge play. Instead of being up 3–1, we're only up by a run. I argued my ass off on that one, to no avail. You could feel the momentum of that game and that Series shift at that moment. The Yankees came back to win that game and the next one at Yankee Stadium, then clinched the Series with a 7–2 victory at Dodger Stadium. All these years later, that Series really bothers me because we had a great team and I really think we deserved to be world champions. But baseball can be a cruel game at times, and you can't change history.

In 1981 we finally got over the hump; we finally beat the Yankees and won it all. That was the year the season was split into two halves because of the strike. We won the first half but finished fourth in the second-half standings. We beat a very good Houston Astros team, three games to two, in the opening playoff series, then defeated a very good Montreal Expos team by the same margin in the National League Championship Series. The World Series opened in New York, and after we lost the first two games in Yankee Stadium, I'm saying to myself, "This can't really be happening again, can it?" But we had a very good ball club that year, so I was still confident we could turn it around. This was the year when Fernandomania had captivated all of baseball. Fernando Valenzuela had won National League Rookie of the Year honors that season, and although he wasn't his sharpest in Game 3, he did manage to grit out a 5–4 complete-game victory that turned the Series around. We wound up winning the next three games—including a 9–2 victory in the clinching game at Yankee Stadium. For the first and only time ever, the World Series MVP Award was given to three players—Ron Cey, Steve Yeager, and Pedro Guerrero. But if I had a vote, I would have divided it twenty-five ways because this truly was a team effort.

My other World Series title came in 1988 in a Fall Classic that will forever be remembered for Kirk Gibson's dramatic "I don't believe what I just saw" game-winning homer against the Oakland A's in Game 1. Gibby's legs were hurting so badly that he didn't even bother coming out for the pregame introductions. Instead, he stayed back in the trainer's room getting treatment. At the end of each inning I'd go down to the trainer's room and say, "How you feel, big boy?" and he'd give me two thumbs down. So we come to the bottom of the ninth and I don't bother going back because I figure Kirk isn't going to be available and I need to plot out my strategy. We're trailing

4–3 and the A's are bringing in their Hall of Fame reliever Dennis Eckersley, who's been lights-out every game he's closed all season for them. We got our catcher, Mike Scioscia, leading off, followed by Jeff Hamilton, Alfredo Griffin, and our pitcher. So I walk down the dugout and tell Mike Davis, "You hit for Griffin." As I'm doing this, Mitch, our clubhouse kid, is pestering me. "Tommy, Tommy, Tommy!" he's yelling. "Come here quick." I say, "Mitch, leave me alone. I've got to get this inning set up." But he keeps badgering me. "Come here, come here." So I follow him up the tunnel and Gibson's in full uniform and has a bat in his hand. He says, "Skip, I can hit for you." Well, that's all I had to hear. Eckersley gets the first two guys out, so it's not looking good. But Davis manages to work a walk and out comes Gibson. I had purposely not let him go out in the on-deck circle while Davis was up because I didn't want to tip the A's off. I actually sent Dave Anderson, who had hit something like .250 for us during the regular season, to be a decoy in the on-deck circle. Davis was a more dangerous hitter, so I think Eck might have been thinking in the back of his mind, "If I walk Davis it's no big deal because Anderson isn't much of a hitter." Well, he walks Davis, and the instant Gibson emerged from the dugout, there was so much electricity in Dodger Stadium that I got goose bumps. The ovation they gave him as he hobbled to the plate was unlike anything I'd ever seen in all my years in baseball.

A lot of people told me later on that I was crazy to put the guy in there in his condition. Eck winds up going to a full count on him and then Gibson connects. I swear to God, it was like that scene from *The Natural*. That might as well have been Roy Hobbs hobbling around the bases because that's what it felt like. I still get emotional just thinking about it. The other thing I remember is the looks on the faces of Eckersley and his teammates. They just stood there in a state of shock. It was like they were paralyzed and couldn't move. And even though that was just the first game of the Series, it pretty much was over then and there. They never recovered as we won three of the next four. That was Gibson's only at bat in the Series.

What made winning that World Series even more gratifying was that nobody, and I mean nobody, had given us a chance against the Bash Brothers [Mark McGwire and Jose Canseco] lineup and their closer, who never, ever blew a save. The A's were supposed to roll over us. But we had a roster filled with guys with a lot of grit and heart. And we had a very strong pitching staff, led by the Bulldog, Orel Hershiser. Orel had a great, great year for us. He won twenty-three games and broke Don Drysdale's record by throwing fifty-nine consecutive scoreless innings. Think about that. That's almost seven complete games without allowing a run. So we didn't go into that Series thinking we were going to get steamrolled. We knew we could play with the big boys.

One of the greatest thrills of my life occurred in 1997, when I was inducted into the Baseball Hall of Fame. It still boggles my mind that my plaque is hanging in the same room as Babe Ruth and Lou Gehrig and Jimmie Foxx and all those other guys I dreamed about becoming when I was a kid. From Norristown, Pennsylvania, to Cooperstown, New York, it's been quite a journey.

This is going to surprise a lot of people, but when I'm asked to name my greatest thrill in baseball, it isn't winning the World Series or National League Manager of the Year Awards or even being inducted into the Hall of Fame. My biggest thrill is beating Cuba at the 2000 Olympics in Australia to win the gold medal. The reason I say that is the three letters on the front of my uniform that summer—USA. A lot of other people thought I was nuts when I lobbied for that job.

I was in my seventies at the time, and Jo says to me, "Why are you going halfway around the world for a month to do that at your age?" I said I was doing it for one reason—for my country. When I met the players on that roster for the first time in San Diego, I told them, "Hey, I don't know who you guys are. I don't know if you are good, great, mediocre, or bad. All I know is this: together we're going to bring that Olympic medal back to where it belongs, back to the United States of America, where this great game of baseball was invented." And I think they all realized the importance of this, that they weren't representing their families or their schools or the organization that had signed them. They were representing their country. The Cubans were supposed to be invincible. We weren't supposed to have a chance against them. Well, we took it to them that last game with a young bulldog of a pitcher named Ben Sheets. He threw gas and shut them down completely in that gold medal game. The funny thing was that all these pitchers had pitch counts, and I remember in the later innings Bob Watson, who was the general manager of our Olympic team, told me that Sheets had hit his pitch count. I told him, "I don't care if Sheets has thrown a thousand pitches. I'm not taking this kid out even if God tells me to at this point." He wound up pitching nine innings that day. He had never pitched nine innings before.

I think that pitch count baloney is the biggest change I've seen in baseball in the past ten, fifteen years. As a manager, I've never believed in those limitations. We baby these kids so much. The only way you're going to learn how to pitch is to pitch a lot. Hell, Bobby Valentine and I sat down one time and figured out that I must have thrown three hundred pitches in that minor league game where I struck out twenty-five guys in fifteen innings. My arm didn't fall off. I wound up pitching another dozen years of professional ball.

The other big change I've noticed is this overreliance on computer readouts. Too many guys are managing by computers. I spoke to this convention of computer geeks once and told them that I was the first guy to manage with a computer in the dugout. I related how I fed all this information about the players into this computer and asked it what I should do. And it said, "Fire the manager," so I got the darn thing out of there in a hurry.

The enormous rise in players' salaries also has impacted a lot of managers. It used to be that the manager made more than most of his players. Now the last guy on his roster makes more than him. But a manager still holds the trump card. It's called playing time. A guy can be making $25 million a year, but you have the final say whether he's out on that diamond. Sitting somebody's butt on the bench is a good way to get his attention and make him see things your way.

I believe the basics of managing haven't changed much through the years. I once said managing is like holding a dove in your hand. If you hold it too tightly, you kill it. But if you hold it too loosely, you lose it; it will fly away. It's a balancing act. You need to know people and what buttons to push to make twenty-five different personalities want to do what's best for that name on the front of your uniform.

I was fortunate to have directed my teams to more than 1,500 big league victories, a bunch of pennants, two World Series championships, and an Olympic gold medal. And I was able to achieve that because I heeded my father's wisdom. I didn't obsess over the doors that were slammed in my face. I went looking for the next open door. I walked through it as a manager and didn't stop walking until I reached Cooperstown.

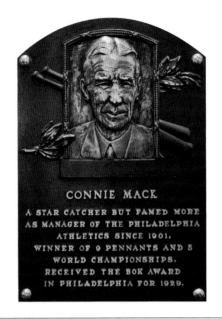

CONNIE MACK

CLASS OF 1937

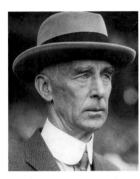

He did not look the part of a manager. He was tall and thin, nearly frail in appearance. He always wore a business suit. There was little that was typical with Connie Mack, who brought a gentleman's dignity to the dugout.

Born to Irish immigrants in East Brookfield, Massachusetts, Mack made his major league debut for the Washington Nationals in 1886. A light-hitting catcher who relied on strong fielding skills and wily intelligence, he lasted eleven seasons before finding his true calling.

Mack became a player-manager with the Pittsburgh Pirates, but he encountered interference from the front office. He then managed the minor league Milwaukee Brewers before becoming part owner and manager of the Philadelphia Athletics in 1901. At first he owned only 25 percent of the team, but he made all of the on-field decisions. It did not take long for Mack to develop a winner, as the Athletics won American League Pennants in 1902 and 1905.

Mack also acquired players for the Athletics, who won their first World Series in 1910. By 1913 they had garnered three world championships in four seasons.

As much talent as Mack gathered, financial concerns prevented him from keeping the team together. He sold off some of his stars, while others signed for more money in the Federal League.

As a manager, Mack brought a distinctive style to the ballpark. He never wore a uniform, and other than pregame meetings, rarely entered the clubhouse, which he considered the players'

sanctum. Yet he applied a hands-on approach during games, as he frequently positioned his players with a wave of his scorecard. "It surprised me one day when I was playing in deep right that Mr. Mack waved me in closer and over towards center," Ty Cobb told the *Sporting News*. "I was certain he was wrong, but followed orders. You guessed it—the ball was hit squarely to me. I wouldn't have even been near it if I had used my own head."

Unlike many managers, Mack rarely yelled, instead preferring to voice his instructions calmly. When he did confront a player, he did so privately rather than within earshot of others. He was also one of the first managers to use advance scouts as a way of preparing for future opponents.

By the mid-1920s, Mack had sown the seeds for another dynasty. Aided by stars like Jimmie Foxx and Lefty Grove, Mack won three consecutive pennants and two World Series from 1929 to 1931.

Unfortunately, declining attendance and the effects of the Great Depression forced Mack, who was now principal owner, to conduct another fire sale. He sold his star players and watched his team fall into the second division.

Mack remained the manager of the A's throughout the rest of the 1930s and 1940s, leading his final team in 1950. By the time "The Tall Tactician" stepped aside, he had managed the A's for fifty years and won more games than any other manager in history.

"Mr. Mack was practically 'Mr. Baseball' himself," Commissioner Ford Frick told the *Sporting News*. "He always will be remembered for the gentleness, kindliness, leadership, and continuity he gave to our great National Game."

—B.M.

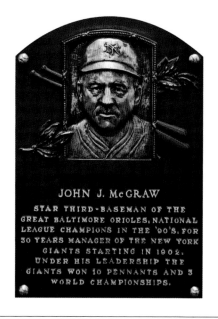

JOHN J. McGRAW

STAR THIRD-BASEMAN OF THE
GREAT BALTIMORE ORIOLES, NATIONAL
LEAGUE CHAMPIONS IN THE '90'S, FOR
30 YEARS MANAGER OF THE NEW YORK
GIANTS STARTING IN 1902.
UNDER HIS LEADERSHIP THE
GIANTS WON 10 PENNANTS AND 3
WORLD CHAMPIONSHIPS.

JOHN McGRAW

CLASS OF 1937

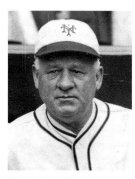

"Blunt," "hard-driving," and "pugna-cious" were all words used to describe John J. McGraw as a ferocious player for the old Baltimore Orioles and in three decades as manager of the New York Giants. The ultimate my-way-or-the-highway guy, McGraw made the term "manager" seem benign. "Dictator" was more like it, and the nickname "Little Napoleon" suited him.

The original Napoleon sought to conquer the world, McGraw merely the World Series. And he had a certain kind of ballplayer in mind for his roster as he assumed the challenge.

"Seeking for young players to strengthen my team for future championship struggles, I would prefer, other things being any-where near equal, a boy whose mind has been trained as well as his body," McGraw said. "That is why they charge me with hav-ing a partiality for college players. I plead guilty to that charge, and I have a preference for high school boys also."

As opposed to farm boys who never went near a secondary school. And as for college fellows, watching Christy Mathewson of Bucknell University pitch—that was a good endorsement in favor of those who invested some time in a classroom.

"Such a boy has been taught to THINK!" McGraw emphasized. "He has the habit of arguing things out in his mind. And if he is a naturally bright and adaptable and sensible fellow to start with, he will again figure for himself the logic of how success is achieved and maintained and the proper proportion of values."

It is somewhat ironic to read of McGraw making the case for players with smarts who think things through, because that same type of player might be inclined to question the manager. McGraw did not brook such insubordination. His rule was the law.

McGraw was born in 1873, played in the majors between 1891 and 1906, managed the Orioles and Giants from 1899 to 1932, and died in 1934. America changed dramatically during that time period, and so did baseball.

"Baseball is now run along the lines of any other big business endeavor," McGraw said. "The owners must have men who are dependable and who will give their best to the game. The strain of playing 150 games every summer is terrific. Only those young men who have the force of character to keep in top condition can go through the grind with credit to those who employ them and those who admire them from the stands."

For all this theoretical discussion, McGraw was a hard task-master who asked a lot of his men. On a day when he was scheduled to pitch, Art Nehf was haunting a hotel lobby look-ing piqued when McGraw came upon him and asked what was wrong. "Ptomaine or something," Nehf said. "I couldn't sleep all night. I can't eat. And I still have a lot of pain." McGraw told him he'd be fine if he pitched. Nehf threw a four-hitter. "See? It was just a bellyache," Dr. McGraw said.

—L.F.

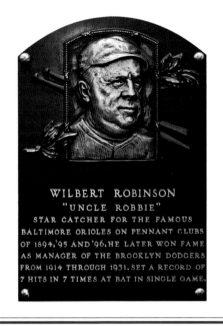

WILBERT ROBINSON
"UNCLE ROBBIE"
STAR CATCHER FOR THE FAMOUS
BALTIMORE ORIOLES ON PENNANT CLUBS
OF 1894,'95 AND '96, HE LATER WON FAME
AS MANAGER OF THE BROOKLYN DODGERS
FROM 1914 THROUGH 1931. SET A RECORD OF
7 HITS IN 7 TIMES AT BAT IN SINGLE GAME.

WILBERT ROBINSON

CLASS OF 1945

As reported in his *Los Angles Times* obituary, Wilbert Robinson was "known and idolized as 'Uncle Robbie' everywhere, but particularly among the fans of Flatbush, native stronghold of the Brooklyn 'Trolley Dodgers.' Robinson gained recognition as one of the shrewdest strategists and most expert handlers of pitching talent in the major leagues. His success as manager largely was due to his uncanny ability in developing young twirling prospects and rejuvenating veteran timber." According to the *Brooklyn Eagle*, "So many of his best ball players were cast offs from other clubs, veterans who knew what it was all about and who had a year or two left in which to flash."

Robinson was also appreciated by his charges. Hall of Fame pitcher Rube Marquard, whom he rescued from the Giants when the hurler fell out of favor with McGraw, loved him. "Old Robbie treated me like a father, not a manager," Marquard said. "I spent some of the happiest days of my life with Robbie in New York and Brooklyn."

A solid player with the old Baltimore Orioles, Wilbert Robinson learned the game as a hard-nosed catcher. He played over 1,300 games behind the plate during his seventeen-year career with four teams in three leagues. His manager, Hall of Famer Ned Hanlon of the Orioles, said, "'Robbie' is a hard worker for the success of his team, and is universally popular on and off the field. He has no superior as catcher, and no equal as

a coacher of colt pitchers." It was during these years as a player that Robinson developed a deep knowledge of strategy and learned the art of handling pitchers.

Robinson's playing career ran between 1886 and 1902, and his managerial career from 1914 to 1931, thereby making him one of the historic baseball figures who helped the game make the transition from the old era to the new century. For Robbie, the game "was a simple earthy creature. To him, baseball was a game involving a baseball, a bat, and a glove. The rest of it . . . the science, the percentages, the strategy . . . that was a lot of malarkey," said sportswriter Harold Burr.

During one entire Brooklyn road trip, Robinson never gave a sign of any type to his players during a game. "Most of those fellows out there are too dumb to read signs," he said. "Our trouble ain't signs. It's too many dumbbells who think they're smart managers. From now on, I'm the only dumbbell giving signals around here."

An accurate summary of his management career and style appeared in the *Brooklyn Eagle,* when Tommy Holmes said, "His teams invariably played the old-fashioned 'army game' from start to finish. There was nothing in the slightest degree subtle about his strategy. He wanted hitters who could bust 'em and pitchers who could blow 'em by the other fellows."

Not always blessed with the highest level of talent, Robinson was still able to capture two National League Pennants, both with Brooklyn, though he retired in 1931 never having won the coveted World Series. But in 1945 his skills were recognized at the highest level when he was elected to the National Baseball Hall of Fame.

—L.F.

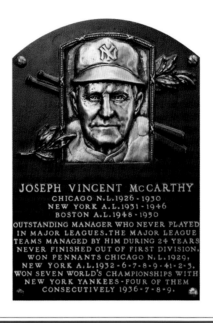

JOSEPH VINCENT McCARTHY
CHICAGO N.L. 1926-1930
NEW YORK A.L. 1931-1946
BOSTON A.L. 1948-1950
OUTSTANDING MANAGER WHO NEVER PLAYED
IN MAJOR LEAGUES. THE MAJOR LEAGUE
TEAMS MANAGED BY HIM DURING 24 YEARS
NEVER FINISHED OUT OF FIRST DIVISION.
WON PENNANTS CHICAGO N.L. 1929,
NEW YORK A.L. 1932-6-7-8-9-41-2-3.
WON SEVEN WORLD'S CHAMPIONSHIPS WITH
NEW YORK YANKEES-FOUR OF THEM
CONSECUTIVELY 1936-7-8-9.

JOE McCARTHY

CLASS OF 1957

There are skeptics who contend that one must play in the major leagues in order to be a successful manager. Those skeptics fail to take into account the career of Joe McCarthy.

Born in Philadelphia, the hard-working McCarthy started his managerial career at the age of twenty-six. Taking over the reins at Wilkes-Barre in 1913, McCarthy began a slow climb up the organized ball ladder.

After more than a decade of minor league apprenticeship, McCarthy finally reached the big leagues in 1926, when the Chicago Cubs named him manager. Three years later, he guided the Cubs to the World Series.

A fallback in 1930 led to a hasty firing, but McCarthy resurfaced with the franchise where he would make his name. Some of the New York Yankees wanted no part of McCarthy; they had hoped that Babe Ruth would be named manager. At first, the players resisted "Marse Joe," in part because he'd never played in the majors, but after a while they came to admire his loyalty and intelligence.

In his second season with New York, McCarthy guided the Yankees to the World Series, becoming the first manager to win pennants in both leagues. As fortune would have it, McCarthy faced his former Cubs team, with the Yankees sweeping the Series.

Three straight second-place finishes had skeptics branding McCarthy a bridesmaid. Undeterred, McCarthy and the Yankees won the World Series in 1936, marking the first of four straight titles.

Under McCarthy, the Yankees won so methodically, so relentlessly, that some critics called him a "push-button" manager. The insinuation was clear: the Yankees were winning because they had the best talent. Such criticism ignored McCarthy's masterly leadership. "Never a day went by," Joe DiMaggio revealed to the Associated Press, "that you didn't learn something from McCarthy."

McCarthy instilled discipline and a dress code, stressed the fundamentals, and demanded that his players not repeat the same mistakes twice. Respecting his words and his wisdom, the players responded in full. The Yankees added two more titles and three pennants to McCarthy's trophy case in the 1940s, cementing his reputation.

During the World War II years, Larry MacPhail replaced Ed Barrow as Yankees president. Clashing with the fiery MacPhail and ailing with a stomach malady, McCarthy announced his resignation early in 1946.

By the end of his storied career, McCarthy had won nine pennants and seven World Series championships. He had also forged a winning percentage of .615, the best mark of all time. Just as significantly, McCarthy earned the loyalty and admiration of his players. "He was the most wonderful person I knew in baseball," Phil Rizzuto told the Associated Press. "He would never dehumanize a player, never second-guess him in public, or embarrass him. He was very, very strict, but very fair, and as a result, won everybody's respect."

—B.M.

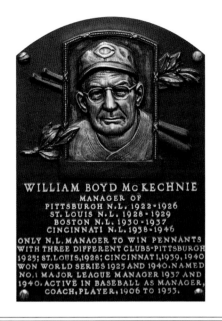

WILLIAM BOYD McKECHNIE
MANAGER OF
PITTSBURGH N.L. 1922·1926
ST. LOUIS N.L. 1928·1929
BOSTON N.L. 1930·1937
CINCINNATI N.L. 1938·1946
ONLY N.L. MANAGER TO WIN PENNANTS
WITH THREE DIFFERENT CLUBS·PITTSBURGH
1925; ST.LOUIS,1928; CINCINNATI,1939,1940
WON WORLD SERIES 1925 AND 1940.NAMED
NO.1 MAJOR LEAGUE MANAGER 1937 AND
1940. ACTIVE IN BASEBALL AS MANAGER,
COACH,PLAYER, 1906 TO 1953.

BILL McKECHNIE

CLASS OF 1962

Brought up in a home where religion and respect were emphasized, Bill McKechnie instilled discipline with a touch of gentlemanly restraint.

A player of limited talents but enormous intelligence, "Deacon Bill" lasted eleven seasons as a backup infielder. Never a star, McKechnie avoided the nightlife, did not drink or curse, and studied the game intently.

Seven years after a brief stint as a player-manager in the Federal League, McKechnie became a coach with the Pittsburgh Pirates. In the middle of 1922, the front office called on him to manage the team. The Pirates improved immediately, jumping from fifth place to a tie for third.

The club showed steady improvement under McKechnie, who continually emphasized the importance of pitching and defense. Then came the tipping point of 1925. The Pirates won the pennant, setting up a World Series victory over the Washington Senators.

Hall of Famer Paul Waner appreciated the opportunity to play for McKechnie. "It was the best break I ever got in baseball," Waner told sportswriter Ed Rumill, "because he was a great manager, in every way. . . . He could be a father to you when he felt he had to be, and a taskmaster when that was needed. And of course, he knew baseball—the complete book. He knew the percentages and he applied them to the ability of his players with amazing accuracy. I played for other good men, but McKechnie was in a class by himself."

When McKechnie left Pittsburgh after the 1926 season, he started over by working as a coach with St. Louis. One year later he became the manager and led the Cardinals to the 1928 World Series. Unfortunately, the Redbirds were swept by the powerhouse New York Yankees. Cardinals owner Sam Breadon unfairly punished McKechnie by demoting him to manage in the minor leagues.

After a difficult stint with a series of mediocre Boston Braves teams, McKechnie eventually returned to the postseason. Taking over the last-place Cincinnati Reds in 1938, he led them to a respectable fourth-place finish. The following summer they won the pennant. And the next season they took an additional step with a World Series victory over the Detroit Tigers.

In 1946 McKechnie's managerial career ended with his firing, but Reds general manager Warren Giles admitted that he'd made the move only to appease angry fans. "I don't ever expect to get a manager who will do a better job," Giles told sportswriter Joe Williams. "He became the symbol of the club's frustration, and I was forced to make him the scapegoat."

McKechnie still found a way to have an impact in the waning years of his career. He joined the coaching staff of the Cleveland Indians, where he helped former Negro Leagues star Larry Doby make a difficult transition to the American League.

Whether as a coach or manager, McKechnie showed sympathy toward his players. He won plenty of games, too, while always exuding patience, keen wisdom, and a quiet dignity.

—B.M.

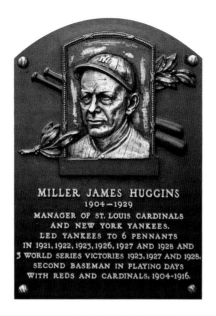

MILLER JAMES HUGGINS
1904–1929
MANAGER OF ST. LOUIS CARDINALS
AND NEW YORK YANKEES.
LED YANKEES TO 6 PENNANTS
IN 1921, 1922, 1923, 1926, 1927 AND 1928 AND
3 WORLD SERIES VICTORIES 1923, 1927 AND 1928.
SECOND BASEMAN IN PLAYING DAYS
WITH REDS AND CARDINALS, 1904–1916.

MILLER HUGGINS

CLASS OF 1964

Small in stature at five foot six, Miller Huggins was huge in accomplishment as the man who shepherded the New York Yankees through their first dynasty. Huggins was the manager when the Yankees won their first pennant in 1921, and he remained in charge for six pennants and three World Series championships until his sudden death near the end of the 1929 season.

Huggins prepared for his moment in the sun during a thirteen-year career as a second baseman and by managing the Cardinals from 1913 to 1917. Huggins was under excessive job pressure with the Yankees from the start because co-owner Jacob Ruppert hired him when partner Tillinghast L'Hommedieu Huston was out of the country. The choice divided the duo and led Huston to sell his shares in the team to Ruppert.

Whether he had solid confidence because he had always had to battle or because he had earned a law degree, Huggins never backed down against his famous players. He fined and suspended Babe Ruth for raucous conduct and believed that the Yankees should have triumphed even more often in the 1920s. "They would have won five pennants in succession if they hadn't loafed in 1920 and '24," Huggins said.

In 1925, when Huggins fined Ruth $5,000 and suspended him indefinitely for his insubordinate ways, Ruth threw a fit. "Why that fine is ridiculous," Ruth said. "They don't fine bootleggers

$5,000. They get out of murder charges for less. I haven't killed anybody." Except for the Yankees' pennant chances.

New York was the hub of the publicity universe, and with the Yankees, Giants, and Brooklyn Dodgers competing for attention, the previously downtrodden Yanks had to develop winning ways before they could compete for the entertainment dollar. John J. McGraw was a larger-than-life figure in the game, and with him managing across town, Huggins felt overlooked despite his victories.

Huggins complained that he could walk down Broadway and no one would know him, while McGraw would be mobbed. Once, to prove his point, he told the story of how a stranger had approached him in a train car and boasted that he knew Ruth and Huggins. Huggins bet him $5 he didn't. That was one bet Huggins knew was a sure thing.

"Hug" was only fifty-one when he became ill near the end of September 1929, after his team was out of the pennant race. Before he was taken to the hospital where he died, he was already thinking ahead to the 1930 campaign, when he was sure the Yankees would bounce back. "We're licked this year," he said, "but next year I'll have another winner."

Health issues had plagued Huggins over time, and some of his friends urged him to retire. But they didn't comprehend how important baseball was to him. "Baseball is my life," he said. "I'd be lost without it. Maybe, as you say, it will get me some day, but as long as I die in harness I'll be happy."

—L.F.

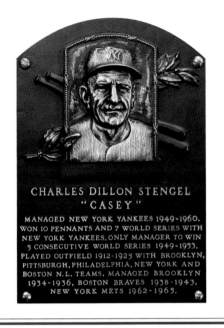

CHARLES DILLON STENGEL
"CASEY"
MANAGED NEW YORK YANKEES 1949-1960.
WON 10 PENNANTS AND 7 WORLD SERIES WITH
NEW YORK YANKEES, ONLY MANAGER TO WIN
5 CONSECUTIVE WORLD SERIES 1949-1953.
PLAYED OUTFIELD 1912-1925 WITH BROOKLYN,
PITTSBURGH, PHILADELPHIA, NEW YORK AND
BOSTON N.L. TEAMS, MANAGED BROOKLYN
1934-1936, BOSTON BRAVES 1938-1943,
NEW YORK METS 1962-1965.

CASEY STENGEL

CLASS OF 1966

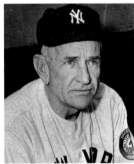

Most managers, even great ones, are overshadowed by their players. That was not true of Casey Stengel, whose comic persona gave him a style unique among the game's most accomplished managers.

A product of Kansas City, Stengel made the major leagues as an outfielder in 1912. Stengel was a good player—he once led the National League in on-base percentage—but he would become an iconic figure in his second career.

After nondescript managerial tenures with the Brooklyn Dodgers and Boston Braves, Stengel found his true calling when the conservative New York Yankees shocked everyone by hiring him. Even though the Yankees were a team in transition that did not yet have Mickey Mantle or Whitey Ford, Stengel immediately led them to a world championship in 1949.

With Ford and Mantle coming aboard in 1950 and 1951, respectively, the Yankees won two more titles, and proceeded to win the World Series in 1952 and 1953. Stengel added two more world championships in 1956 and 1958. He would win more World Series games than any other manager.

Stengel didn't just favor his stars. He could also reach players who were simply trying to make the team, like Whitey Herzog in 1956. "When [the Yankees] gave me No. 74, I didn't think my chances of making the club were very good," Herzog told MLB.com. "But Casey was the man I looked up to the most. He spent an awful lot of time with me and taught me an awful lot about fundamentals I had never heard before. He had a great influence."

Stengel employed an unorthodox style, revolutionizing the game with widespread platooning. "He could evaluate the right player for the right situation," Hall of Famer Ralph Kiner told writer Leonard Koppett. "He made platooning work, because he had the knack of making the man who was playing part time—which players hate—still do his best."

Stengel also provided entertainment like no one else. His sessions with the media, a combination of wisdom and hilarity, became legendary. Never answering questions directly, he gave long-winded responses that some called "Stengelese," complete with rambling thoughts and run-on sentences.

In 1962 the expansion New York Mets hired Stengel. He poked fun at the Mets' many mistakes and occasionally fell asleep mid-game, but he succeeded in charming the media. Through the force of his personality, Stengel made an awful Mets team bearable to watch.

During his 1966 Hall of Fame induction, Stengel delivered one of the most memorable speeches ever, rambling off on nonsensical tangents and drawing loud laughs. Even in retirement, Stengel's act overshadowed all else. "Casey knew his baseball. He only made it look like he was fooling around," Hall of Famer Sparky Anderson once said. "He knew every move that was ever invented and some that we haven't even caught on to yet."

—B.M.

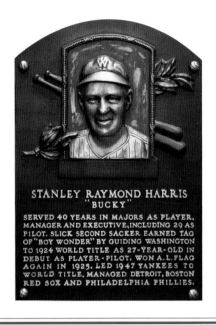

STANLEY RAYMOND HARRIS
"BUCKY"
SERVED 40 YEARS IN MAJORS AS PLAYER,
MANAGER AND EXECUTIVE, INCLUDING 29 AS
PILOT. SLICK SECOND SACKER EARNED TAG
OF "BOY WONDER" BY GUIDING WASHINGTON
TO 1924 WORLD TITLE AS 27-YEAR-OLD IN
DEBUT AS PLAYER-PILOT. WON A.L. FLAG
AGAIN IN 1925. LED 1947 YANKEES TO
WORLD TITLE, MANAGED DETROIT, BOSTON
RED SOX AND PHILADELPHIA PHILLIES.

BUCKY HARRIS

CLASS OF 1975

Stanley "Bucky" Harris got a head start on managing by accepting his first dugout job for the Washington Senators when he was twenty-seven, in 1924. He also earned his nickname "The Boy Wonder" quickly when he led his first team to the American League Pennant and a World Series championship.

In an era when communication was a bit slower than it is today, Senators owner Clark Griffith sent a letter to Harris while he was in Florida on a golf vacation. "I think you can do a good job for us as manager," Griffith wrote. "If you want the job it is yours. But I must know quickly. Call me on long-distance telephone if you'd like to be our manager."

Harris had no inkling such a job offer was on the way. But the funniest part of the negotiation occurred when Harris tried to telephone his acceptance. He had a lousy connection and Griffith couldn't understand what he was saying. Harris dashed over to Western Union and sent a telegram saying that, yes, he wanted the job.

A .274-hitting infielder, Harris managed for twenty-nine years and won 2,158 games. Griffith was able to spot those leadership instincts early. Harris was a tough but fair manager—overall he was popular with his players. Twice when he was fired, players circulated petitions trying to get him his job back. Once, Hall of Famer Joe DiMaggio said of Harris, "If you can't play for Bucky, you can't play in the majors."

Harris was also a hard-nosed player. He had worked in the Pennsylvania coal mines starting at age thirteen, and he refused to be pushed around by anyone in the game. The ruthless Ty Cobb issued a threat to Harris, saying if the rookie tried to block second base when Cobb was sliding, "I'll cut you up." Harris didn't flinch but retorted, "I'll drill the baseball between your eyes if you try."

Harris managed the Senators for three different stretches, the last in the early 1950s. That period overlapped with the famous home run the Yankees' Mickey Mantle blasted at Griffith Stadium on April 17, 1953. Estimated at 565 feet, it was declared the longest home run of all time. As part of the publicity blitz that followed, the Senators erected a sign at the park taking note of the smash. Harris was incensed when he saw it. "Tell them to take that . . . thing down immediately," he said. "Why the hell must we have a daily reminder of a hit that helped beat us in a ball game?" The sign came down.

Although Harris also managed the Tigers, Red Sox, Phillies, and Yankees, he always came back to Washington when the need arose. Or when Griffith thought he needed a job. "If we had not won the pennant in 1924, it would have forced Mr. Griffith to sell the team because he was that desperate for funds," said Calvin Griffith, the boss's adopted son. "Bucky saved our baseball lives."

—L.F.

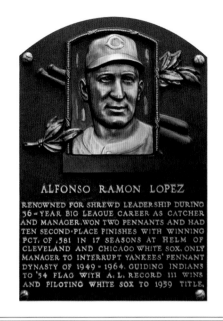

ALFONSO RAMON LOPEZ

RENOWNED FOR SHREWD LEADERSHIP DURING
36-YEAR BIG LEAGUE CAREER AS CATCHER
AND MANAGER. WON TWO PENNANTS AND HAD
TEN SECOND-PLACE FINISHES WITH WINNING
PCT. OF .581 IN 17 SEASONS AT HELM OF
CLEVELAND AND CHICAGO WHITE SOX. ONLY
MANAGER TO INTERRUPT YANKEES' PENNANT
DYNASTY OF 1949-1964. GUIDING INDIANS
TO '54 FLAG WITH A.L. RECORD 111 WINS
AND PILOTING WHITE SOX TO 1959 TITLE.

AL LOPEZ

CLASS OF 1977

Some are elected to the Hall of Fame on their performance as players. Others are selected on the strength of their efforts as managers. In the case of Al Lopez, he excelled at both, first as a strong defensive-minded catcher and then as a patient voice of reason among managers.

Born in Tampa, Lopez started his career with that city's minor league franchise in 1925. Three years later he would make a brief three-game debut as a twenty-year-old catcher with Brooklyn.

In 1930 Lopez emerged as Brooklyn's starting receiver. Though known mostly for his catching skills, he hit a surprising .309. For six seasons he would endure as Brooklyn's number one catcher, playing well enough to earn an All-Star Game selection and MVP consideration.

Lopez later played for the Pittsburgh Pirates, where he qualified for his second All-Star Game. A durable catcher who frequently appeared in more than 115 games a season, he set the record for most games caught until Bob Boone surpassed him in 1987. Lopez brought good hands and a strong throwing arm to his teams during a nineteeen-year career.

The postseason eluded Lopez as a player, but it would become a two-time occurrence during his managerial career. After a successful stint with Indianapolis of the American Association, Lopez received an offer to manage the Cleveland Indians, where he treated his players with patience and fairness.

Throughout much of the 1950s, Lopez kept the Indians in contention; they did not finish any worse than second during his tenure. In 1954 Lopez guided Cleveland to a stunning 111 victories and a World Series berth against the New York Giants.

In 1957 Lopez took his leadership skills to the Chicago White Sox. In his first two seasons, the Sox posted strong second-place finishes. As with the Indians, Lopez's White Sox challenged the New York Yankees for American League supremacy. "Anyone who sells Lopez short is crazy," Yankees manager Casey Stengel informed *Baseball Yearbook* in 1959. "You ain't going to any picnic when you tangle with the Chicagos."

Lopez's troops became especially troublesome that summer, when the "Go Go" Sox used speed and defense to win ninety-four games and force the Los Angeles Dodgers to six games in the World Series. "Lopez is a great believer in speed and hustle," White Sox second baseman Nellie Fox told a sportswriter in 1960. "No other manager is so determined a foe of stodgy baseball, lack of hustle and slipshod practices, and so powerful an advocate of the unexpected."

"What a man," Giants Hall of Famer Monte Irvin told the *Tampa Tribune.* "If he was your manager, you respected him. If you played against him, which I did, you looked up to him. He had such a standing in the game, that you could never hold a grudge against him. . . . He was special."

—B.M.

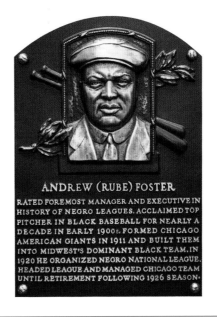

RUBE FOSTER

CLASS OF 1981

Andrew "Rube" Foster was the father of the Negro Leagues and a pretty good pitcher, too.

An imposing right-hander, Foster headed north from his native Texas in 1902 to play for the Chicago Union Giants and soon became a star pitcher in the dead ball era. Even though statistical data from those early days remain sketchy, Foster had to be an intimidating sight on the mound, standing six feet tall and weighing two hundred pounds.

"Do not worry" was Foster's advice when faced with a difficult situation. "Try to appear jolly and unconcerned. I have smiled often with the bases full with two strikes and three balls on the batter. This seems to unnerve [the hitter]."

In 1903 Foster posted four victories in a seven-game series as his Cuban X-Giants defeated Philadelphia for the "Colored Championship of the World." The following season, it was reported, he earned his nickname by outdueling future Hall of Famer Rube Waddell in an exhibition game against the Philadelphia Athletics.

"He was the smartest pitcher I have ever seen in all my years of baseball," said Hall of Fame shortstop Honus Wagner.

Foster went on to become the player-manager for the Chicago Leland Giants and soon "won a reputation as a managerial genius equal to his friend, John McGraw," historian Jules Tygiel wrote in *Past Time: Baseball as History*.

In 1911 he entered into a partnership with John Schorling, son-in-law of Charles Comiskey. Schorling had leased the old White Sox grounds, and Foster provided the Chicago American Giants, a black team, to play there.

Foster created the Negro National League in 1920. He was president and treasurer of the eight-team league and promoted economic development in black communities.

"If the talents of Christy Mathewson, John McGraw, Ban Johnson, and Judge Kenesaw Mountain Landis were combined in a single body," said Robert Peterson, author of *Only the Ball Was White*, "and that body were enveloped in a black skin, the result would have to be named Andrew (Rube) Foster."

Foster passed away in 1930, and thousands braved bad weather to view his funeral procession. "When Rube Foster died," said fellow owner Joe Green, "Negro baseball died with him."

Soon after Foster's death, an editorial in the *Chicago Defender*, one of the leading African American newspapers in the country, declared that "Foster was not a 'Colored' baseball man—he was a person of consequence wherever baseball was discussed. He proved to a doubtful public that white people have no monopoly on baseball, either from the playing or box office point of view. He proved that persistency, ability and a knowledge of the game are all the attributes essential to a successful undertaking in any game.

"Even the color of his skin was no barrier to the success of Rube Foster—it may be said that he profited by it. Certainly he climbed to heights untrod before by a baseball man of his color, and he made some steps that have already proved most difficult to follow."

—B.F.

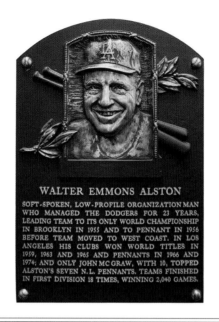

WALTER EMMONS ALSTON

SOFT-SPOKEN, LOW-PROFILE ORGANIZATION MAN
WHO MANAGED THE DODGERS FOR 23 YEARS,
LEADING TEAM TO ITS ONLY WORLD CHAMPIONSHIP
IN BROOKLYN IN 1955 AND TO PENNANT IN 1956
BEFORE TEAM MOVED TO WEST COAST. IN LOS
ANGELES HIS CLUBS WON WORLD TITLES IN
1959, 1963 AND 1965 AND PENNANTS IN 1966 AND
1974; AND ONLY JOHN McGRAW, WITH 10, TOPPED
ALSTON'S SEVEN N.L. PENNANTS. TEAMS FINISHED
IN FIRST DIVISION 18 TIMES, WINNING 2,040 GAMES.

WALTER ALSTON

CLASS OF 1983

If his major league playing career was any indication, Walter Alston might not have been expected to do much as a manager. He played in one big league game, in which he struck out and committed an error in three innings. In Alston's case, however, a short playing tenure had no bearing on a long and thriving managing career.

As a young man, Alston acquired the nickname "Smokey" for his blazing fastball, but he played mostly first base in thirteen minor league seasons, while also picking up vital experience as a player-manager. In 1944 Branch Rickey hired him as manager at Trenton, triggering a thirty-three-year run in the Dodgers organization. In 1954 owner Walter O'Malley rewarded him with the top job in Brooklyn.

In contrast to his predecessors, who were charismatic and colorful, Alston brought a dignified, low-key presence to Brooklyn. He was the quiet man in the dugout. "He expected you to go out and play hard every day, and if you didn't, he told you about it," Hall of Famer Duke Snider told *USA Today*. "He was the type of man who was very easy to play for. He put your name in the lineup, and there wasn't a lot of conversation."

Alston mixed the wisdom of a teacher with the discipline of the military. "He had a school teacher's patience and understanding," Hall of Fame catcher Roy Campanella told sportswriter Bob Broeg, "but he could be stern, too, and he could whip the hell out of a player if he had to."

Within two years, Alston guided the Dodgers to an elusive title. Preseason turmoil had plagued the Dodgers in the spring of 1955, but Alston quickly calmed the clubhouse. Bringing a team of stars together, Alston led the Dodgers to a National League Pennant, followed by a stunning seven-game win over their usual tormentors, the New York Yankees. For the first time in Brooklyn franchise history, the borough could brag of a world championship team.

Alston oversaw another Dodgers pennant in 1956, confirming that he was no one-season wonder. By now it was evident that Alston was one of the game's best managers. Yet he continued to operate without the benefit of a long-term contract.

When the Dodgers moved to Los Angeles, Alston remained a fixture—and a successful one. He also exhibited an ability to adapt to his talent. In the 1960s his pitching-rich Dodgers staffs helped the team win three pennants and two world championships. In the next decade, Alston's power-hitting club, buttressed by a strong infield, advanced to the 1974 World Series.

By the time Alston stepped aside, he had won six Associated Press Manager of the Year Awards. Along the way, he maintained close relationships with many of his Dodgers players. "His legacy is unspoiled by anything petty," Hall of Famer Don Drysdale told the *Sporting News*. "I can't think of anybody ever holding a grudge against Walt. . . . If you couldn't play for Walt, you couldn't play for anybody."

—B.M.

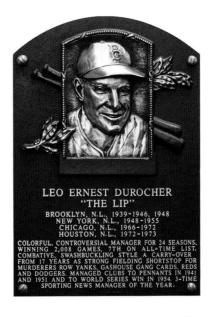

LEO DUROCHER

CLASS OF 1994

Only results mattered to Leo Durocher. Colorful and dynamic, he used every advantage he could find in trying to win, while combining a fiery personality—his nickname was "Leo the Lip"—with a demanding sense of discipline.

As a ballplayer, Durocher was a light-hitting shortstop, but he fought his way to the major leagues at the age of twenty, making his debut for the 1925 New York Yankees. Though he was nicknamed "The All-American Out" by teammate Babe Ruth, Durocher overachieved as a player. He found a way to make three All-Star teams, largely on the basis of his acrobatic fielding.

A stop with the St. Louis Cardinals afforded him the opportunity to learn from the famed Gashouse Gang, who played the game rough, even violently, and went all out to win. Durocher would draw from those experiences in becoming a player-manager with the Brooklyn Dodgers.

Durocher's boss with Brooklyn, Branch Rickey, recognized his determination and desire to win. "He's like a turkey in a tobacco patch that sees a worm," Rickey told *Sports Illustrated*, "and knocks down every stalk to get it."

Durocher led the Dodgers to the National League Pennant in 1941. Yet the highlight of his tenure as Brooklyn's skipper may have occurred in spring training 1947, when he learned that some of the Dodgers were planning a rebellion because of the arrival of Jackie Robinson. Showing no tolerance for racism or team division, Durocher put down the uprising immediately.

Durocher's greatest success as a manager came with the New York Giants. That's where he developed a special relationship with Giants superstar Willie Mays. "He always made sure I knew what suit to buy and how to dress," Mays told the *New York Times*. "He'd never holler at me. If he had something to say, he'd talk soft."

Led ably by Durocher, Mays and the Giants staged an incredible comeback against his former Dodgers team in 1951; three years later, Durocher oversaw a Giants world championship.

Aided by a killer instinct, Durocher believed in capitalizing on the mistakes of opponents. "Some guys are admired for coming to play, as the saying goes," Durocher told the *Sporting News*. "I prefer those who come to kill."

After the 1955 season, Durocher left managing and did not return until 1966. During the interim, he used his outgoing personality and his Hollywood connections (he was married to the actress Laraine Day) to forge a side career in television and movies. He usually portrayed himself, including a memorable appearance on *The Munsters*, in which a wide-eyed Durocher looked on as lead character Herman Munster belted one tape-measure home run after another.

But it was managing and the will to win that would drive him, right up until his retirement in 1973. "I never did anything I didn't try to beat you at," Durocher wrote in *Nice Guys Finish Last*. "If I pitch pennies I want to beat you. . . . I would make the loser's trip to the opposing dressing room to congratulate the other manager because that was the proper thing to do. But I'm honest enough to say that I didn't like it."

—B.M.

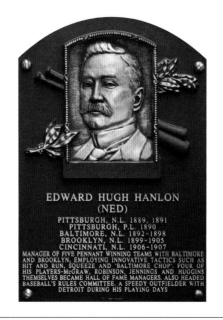

EDWARD HUGH HANLON
(NED)
PITTSBURGH, N.L. 1889, 1891
PITTSBURGH, P.L. 1890
BALTIMORE, N.L. 1892-1898
BROOKLYN, N.L. 1899-1905
CINCINNATI, N.L. 1906-1907
MANAGER OF FIVE PENNANT WINNING TEAMS WITH BALTIMORE
AND BROOKLYN, EMPLOYING INNOVATIVE TACTICS SUCH AS
HIT AND RUN, SQUEEZE AND 'BALTIMORE CHOP'. FOUR OF
HIS PLAYERS-McGRAW, ROBINSON, JENNINGS AND HUGGINS
THEMSELVES BECAME HALL OF FAME MANAGERS, ALSO HEADED
BASEBALL'S RULES COMMITTEE. A SPEEDY OUTFIELDER WITH
DETROIT DURING HIS PLAYING DAYS

NED HANLON

CLASS OF 1996

"I always rated Ned Hanlon as the greatest leader baseball ever had," Hall of Fame manager and owner Connie Mack said. "I don't believe any man lived who knew as much baseball as he did."

Ned Hanlon was an influential and intelligent manager who won five pennants in seven seasons from 1894 to 1900. He was also a quality major league outfielder for thirteen seasons. He was respected for both his base running and his leadership as a player. Hanlon's teams in Baltimore and Brooklyn perfected rough, aggressive "inside baseball," favoring bunts, base stealing, and defense. Some of his players, including Hughie Jennings, Wilbert Robinson, and John McGraw, became very successful managers.

Nobody expected much when Ned Hanlon was hired to manage the Baltimore Orioles in 1892. The Orioles had been quite a subpar team, but Hanlon soon transformed them, turning Baltimore into one of the greatest teams of all time.

Early on, Hanlon acquired John McGraw, Wilbert Robinson, and Joe Kelley, later adding Willie Keeler, Hughie Jennings, and Dan Brouthers. All six are now enshrined in Cooperstown.

In addition to having a sharp eye for talent, Hanlon is also credited with developing many of baseball's now common strategies, including situational bunting, the hit-and-run, and the platoon system.

A ferocious team on the field, the Orioles under Hanlon always battled to the last. Away from the ballpark, they were more like a band of brothers, thanks in large part to Hanlon's leadership, and they became lifelong friends, too.

The camaraderie and friendship, nurtured by Hanlon, were there for everyone to see. For instance, Keeler, Jennings, McGraw, and Kelley lived together in a boardinghouse in Baltimore. "The residence was conveniently located about 10 minutes from Union Park, where they worked together," Frank Deford wrote, "and perhaps a similar distance to St. Ann's Church, where they prayed together, often with Silent Ned Hanlon himself leading them to the pews."

In 1899 Baltimore and Brooklyn merged clubs and, with Hanlon at the helm, captured the National League Pennant the next two seasons. As a manager, Hanlon guided teams in four cities (Pittsburgh, Baltimore, Brooklyn, and Cincinnati) and accumulated a 1,313–1,164 record over nineteen seasons.

In 1914 he was part of an ownership group that tried to buy the St. Louis Cardinals and move them to Baltimore. Rebuffed, Hanlon and his partners sued, which eventually led to the U.S. Supreme Court's landmark decision that the game was exempt from federal antitrust regulations.

Through it all, Hanlon will always be remembered for his great Orioles teams. He is buried in New Cathedral Cemetery in Baltimore, which is also the resting place of McGraw, Robinson, and Kelley.

—T. Wendel

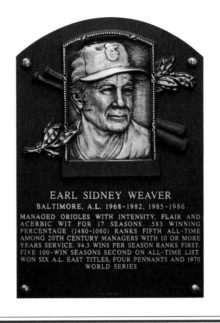

EARL SIDNEY WEAVER
BALTIMORE, A.L. 1968-1982, 1985-1986
MANAGED ORIOLES WITH INTENSITY, FLAIR AND
ACERBIC WIT FOR 17 SEASONS. .583 WINNING
PERCENTAGE (1480-1060) RANKS FIFTH ALL-TIME
AMONG 20TH CENTURY MANAGERS WITH 10 OR MORE
YEARS SERVICE. 94.3 WINS PER SEASON RANKS FIRST.
FIVE 100-WIN SEASONS SECOND ON ALL-TIME LIST.
WON SIX A.L. EAST TITLES, FOUR PENNANTS AND 1970
WORLD SERIES

EARL WEAVER

CLASS OF 1996

Any manager is always looking for an edge. But few were as creative or determined in doing so as Earl Weaver.

The Baltimore Orioles skipper was one of the first to embrace radar guns to measure a pitcher's velocity, and he persuaded his batters, most notably Frank Robinson and Brooks Robinson, to study video of opposing pitchers long before others embraced the technology.

"A manager's job is simple," Weaver once said. "For one hundred sixty-two games you try not to screw up all that smart stuff your organization did last December."

But Weaver wasn't reluctant to get involved once the first pitch was thrown, either. He regularly got into arguments with umpires, especially if he felt his team or pitcher had been the victim of a bad call. As a result, he was ejected ninety-four times during his seventeen years in the major leagues. If anything, that was part of Weaver's plan.

"The job of arguing with the umpire belongs to the manager," Weaver said, "because it won't hurt the team if he gets thrown out of the game."

After gaining a reputation for winning in the Orioles farm system, Weaver took over the parent club in 1968, giving the Detroit Tigers, the eventual World Series champions, a run for the American League Pennant. Weaver had the Orioles back on top in the AL the following season. They advanced to the World Series,

only to be upset by the New York Mets. But Weaver got his revenge the next season, when Baltimore defeated the Cincinnati Reds for the 1970 championship.

Weaver put together an impressive .583 winning percentage at the big league level, which included five 100-win seasons (1969–1971 and 1979–1980). In total, his Baltimore teams won 1,480 games, six American League East titles, four pennants, and the 1970 World Series. His players included Cal Ripken, Davey Johnson, Eddie Murray, Boog Powell, and Jim Palmer.

"The impact Earl had on my career has been well documented," Ripken told MLB.com. "He had faith in me when I was a young and struggling player and stuck with me. . . . He is a legendary manager and a large part of Orioles history."

Weaver demanded that his players pay attention to the game's smallest details and keep themselves in top physical condition.

"The Chinese tell time by 'The Year of the Horse' or 'The Year of the Dragon,'" said Weaver, who expected nothing less than a player's best effort at all times and was known for not accepting anything less. "I tell time by 'The Year of the Back' and 'The Year of the Elbow.'"

A seven-foot statue of Weaver now stands beyond the center-field fence at Camden Yards, in the team's Garden of the Greats. It's surrounded by statues of many of the players he helped make household names—a tribute to the manager who preached the importance of pitching, fundamentals, and the three-run homer.

—T. Wendel

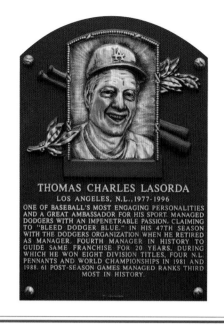

THOMAS CHARLES LASORDA
LOS ANGELES, N.L., 1977-1996
ONE OF BASEBALL'S MOST ENGAGING PERSONALITIES
AND A GREAT AMBASSADOR FOR HIS SPORT. MANAGED
DODGERS WITH AN IMPENETRABLE PASSION, CLAIMING
TO "BLEED DODGER BLUE." IN HIS 47TH SEASON
WITH THE DODGERS ORGANIZATION WHEN HE RETIRED
AS MANAGER. FOURTH MANAGER IN HISTORY TO
GUIDE SAME FRANCHISE FOR 20 YEARS. DURING
WHICH HE WON EIGHT DIVISION TITLES, FOUR N.L.
PENNANTS AND WORLD CHAMPIONSHIPS IN 1981 AND
1988. 61 POST-SEASON GAMES MANAGED RANKS THIRD
MOST IN HISTORY.

TOMMY LASORDA

CLASS OF 1997

As a left-handed pitcher, Tommy Lasorda never won a game for the Brooklyn or Los Angeles Dodgers, but as a manager of the team, he won 1,599 of them and became one of the most popular personalities in team history, at least partially because he announced that he bleeds blue.

Lasorda has been married to his wife and associated with the Dodgers for more than sixty years. It seems as if he has been linked to the team forever, although he managed the club for twenty full years, plus four games in 1976, winning two World Series titles and eight division titles. Outgoing, chatty, and devoted to the sport, Lasorda has been recognized internationally, in Japan and the Dominican Republic, for his contributions to baseball.

When he ran the Dodgers clubhouse, Lasorda used to hold court, entertaining reporters and frequently talking about his favorite dishes, stemming from his Italian heritage. "When I win, I'm so happy I eat a lot," Lasorda said. "When we lose, I'm so depressed I eat a lot. When we're rained out, I'm so disappointed I eat a lot."

Always a salesman for the game, Lasorda made a gaggle of new friends when he arrived in Hollywood. Frank Sinatra sang the national anthem for Lasorda's first home opener in 1977. Lasorda had met Sinatra years earlier through Leo Durocher, and Sinatra promised if Lasorda ever became manager of the Dodgers, he would sing at his home debut—and he came through.

Lasorda and Sinatra became close friends. On a visit to the singer's home, Lasorda played golf at the course nearby using clubs and clothing borrowed from him. "Turns out, when you go to Sinatra's house, you don't have to bring your toothbrush," Lasorda said.

Don Rickles was named an honorary Dodgers batboy, and Lasorda once turned the comedian, who specialized in insult humor, loose in the locker room to fire up his team. "You would have had a better idea?" Lasorda said.

"Not a bad year," the manager noted. "Started it with Sinatra and ended it with Rickles."

Lasorda could be tough with his players, but sentiment also coursed through his body. He once said that none of his players would remember him, then on the occasion of one of his late-in-life birthdays, a flood of gifts and cards arrived at his home and he started to cry.

"I told them [the players] that I would mold their careers and, in the end they wouldn't even send me a gift basket." That was why most of the birthday wishes came as gift baskets.

Because the 2000 Sydney Olympics took place during the major league season, Lasorda did not have active-duty, top-tier players for the roster he managed. Instead, it was a team of mostly minor leaguers and former major leaguers. But he had pledged that the United States would beat Cuba—and it did in the gold medal game. It was clearly one of the best managing jobs of his life.

"I cried that night because I did something for my country," Lasorda said.

—L.F.

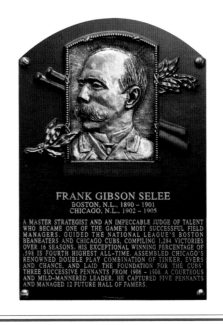

FRANK GIBSON SELEE
BOSTON, N.L., 1890 – 1901
CHICAGO, N.L., 1902 – 1905

A MASTER STRATEGIST AND AN IMPECCABLE JUDGE OF TALENT
WHO BECAME ONE OF THE GAME'S MOST SUCCESSFUL FIELD
MANAGERS. GUIDED THE NATIONAL LEAGUE'S BOSTON
BEANEATERS AND CHICAGO CUBS, COMPILING 1,284 VICTORIES
OVER 16 SEASONS. HIS EXCEPTIONAL WINNING PERCENTAGE OF
.598 IS FOURTH HIGHEST ALL-TIME. ASSEMBLED CHICAGO'S
RENOWNED DOUBLE PLAY COMBINATION OF TINKER, EVERS
AND CHANCE, AND LAID THE FOUNDATION FOR THE CUBS'
THREE SUCCESSIVE PENNANTS FROM 1906 – 1908. A COURTEOUS
AND MILD-MANNERED LEADER, HE CAPTURED FIVE PENNANTS
AND MANAGED 12 FUTURE HALL OF FAMERS.

FRANK SELEE

CLASS OF 1999

Baseball is a long-run game; it takes place over the length of a season and over the seasons of a career. Rare is the manager who handles clubs for any length of time who can win 60 percent of his games. Frank Selee's winning mark of 59.8 percent shows the stuff he had with the Boston Beaneaters and Chicago Cubs between 1890 and 1905.

Selee was at the helm of the Beaneaters (forerunners of the Braves) for five National League Pennants in the 1890s and in the early days of the twentieth century. A shrewd strategist and practitioner of the kind of small ball prevalent during his era, Selee emphasized the hit-and-run and stolen bases. He seemed to possess an almost mystical understanding of which players would make the grade and which would not. He was called a talent spotter who could "tell a ballplayer in his street clothes." In all, thirteen Hall of Famers played for Selee in Boston and Chicago.

The Chicago Cubs teams that Selee assembled between 1902 and 1905 would go on to dominate baseball as few other teams ever had, winning four pennants and two World Series between 1906 and 1910. Player-manager Frank Chance would reap the benefits of Selee's good planning, after Selee's retirement due to tuberculosis.

When Selee died at forty-nine in 1909, Bill Everitt, a former Chicago player, spoke of Selee as a wise man on the field. "There is no question about it," Everitt said. "Frank was one of the brightest men baseball ever saw. He was the greatest judge of ballplayers I ever saw."

Among those Selee signed for the Cubs were Joe Tinker and Johnny Evers, two members of the famed double-play trio renowned both on the diamond and in poetry. It was the third member, Frank Chance, who took over the Cubs and reaped the championship benefits after Selee retired young because of his health.

Tinker was adamant that he was a third baseman, but Selee saw a shortstop in him and made him shift. Evers was so small at 130 pounds that teammates thought he had no chance of success. After a bad day in his debut, Evers thought he would be cut from the Cubs. Selee soothed him. "We don't do things that way in the big leagues," Selee said. "I'll bet a bat that you have a better day tomorrow." Many better days followed, and Evers ended up in the Hall of Fame.

Selee grew up in the Boston area and was working at a suburban watch factory when he decided that he had "the baseball fever" in 1884 and raised $1,000 to start a team. He stayed in the game for the next two decades. It made good geographical sense that Selee grabbed the job with the Beaneaters. "During my 12 year stay in Boston it was my good fortune to be surrounded by a lot of good, clean fellows who got along fine together. To tell the truth, I would not have anyone on a team who was not congenial."

At his funeral, praise was heaped on Selee for his manner, the presiding minister eulogizing "Mr. Selee, who achieved success because of his strong personality to command respect and because of his kindliness and manliness."

—L.F.

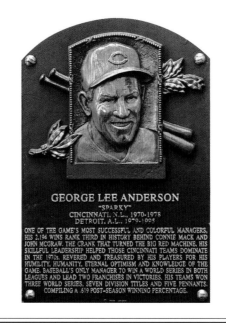

SPARKY ANDERSON

CLASS OF 2000

As a player, he was known as George Anderson. He played only one season in the major leagues and might have been excused for giving up the game. Instead he kept at it, became known as Sparky Anderson, and evolved into one of baseball's great managers.

Making his debut for the Philadelphia Phillies in 1959, Anderson struggled at bat and found himself back in the minor leagues. Sensing that a return to Philadelphia would not happen, the spirited Anderson soon turned to managing. In 1964 he received his first opportunity at Toronto, but he fought repeatedly with umpires and lost his job.

Anderson realized that he needed to change. Reining in his temper, he received a minor league offer from St. Louis Cardinals general manager Bob Howsam. Impressed with Anderson, Howsam later offered him the Cincinnati Reds managing job.

The media famously responded to the hiring by asking, "Sparky who?" Undeterred, Anderson quickly made a name for himself in the Queen City. In his first season, he led the 1970 Reds to the World Series.

As the dugout leader of the "Big Red Machine," Anderson oversaw a powerhouse offense that combined speed, power, and attack-dog hitting. Furthermore, knowing that his starting rotation lacked dominance, he turned to his bullpen often. As "Captain Hook," Anderson carefully massaged a deep Reds relief corps.

With Anderson at the helm, Reds players felt confident in his abilities as a master strategist. "It's a lot like a chess game," Hall of Famer Johnny Bench explained to the Associated Press. "Sparky was a chess master."

Anderson had plenty of talent to work with, but he also succeeded because of his relationships. "He was a people person," Hall of Famer Joe Morgan told the Associated Press. "I don't think anybody else could have managed that team nearly as well as he did. We had a lot of different personalities. Sparky was able to deal with all of us on an individual basis but also collectively as a team. Because he was close to you and cared about you as a person, you were always willing to do more for him than you were for somebody else."

After 1978 the Reds made a change, firing Anderson and infuriating their fans. The Detroit Tigers snapped him up. In 1984 Anderson led the Tigers to a World Series victory, becoming the first manager to win titles in both leagues.

By the time Anderson called it quits, he had not only guided his teams to three world championships and won two Manager of the Year Awards but also become famous for his wit and wisdom. "There's two kinds of managers," Anderson said at his Cooperstown induction. "One, it ain't very smart. He gets bad players, loses games and gets fired." Anderson was obviously the other kind of manager. "I got good players, stayed out of the way, let 'em win a lot, and then just hung around for 26 years." Humble to the end, Sparky Anderson made the best of having those good players.

—B.M.

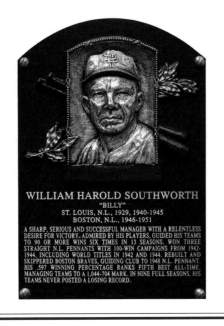

WILLIAM HAROLD SOUTHWORTH
"BILLY"
ST. LOUIS, N.L., 1929, 1940-1945
BOSTON, N.L., 1946-1951
A SHARP, SERIOUS AND SUCCESSFUL MANAGER WITH A RELENTLESS
DESIRE FOR VICTORY. ADMIRED BY HIS PLAYERS, GUIDED HIS TEAMS
TO 90 OR MORE WINS SIX TIMES IN 13 SEASONS. WON THREE
STRAIGHT N.L. PENNANTS WITH 100-WIN CAMPAIGNS FROM 1942-
1944, INCLUDING WORLD TITLES IN 1942 AND 1944. REBUILT AND
SKIPPERED BOSTON BRAVES, GUIDING CLUB TO 1948 N.L. PENNANT.
HIS .597 WINNING PERCENTAGE RANKS FIFTH BEST ALL-TIME,
MANAGING TEAMS TO A 1,044-704 MARK. IN NINE FULL SEASONS, HIS
TEAMS NEVER POSTED A LOSING RECORD.

BILLY SOUTHWORTH

CLASS OF 2008

Where Billy Southworth arrived to manage, pennants followed. He won three of them, including two World Series titles, with the St. Louis Cardinals, and then led the Boston Braves to their last pennant before moving to Milwaukee. Southworth won nearly 60 percent of his games as a field boss and batted nearly .300 as a player before that.

What distinguished him was bold game strategy and firm application of his authority. In one Braves game against the Phillies, after starting Vernon Bickford, Southworth made the trek to the mound to yank him, although the score was 1–1.

Bickford protested. "What does a guy have to do to finish a game on this club?" he yelled. "I've given them one hit in the last five innings. Now because a guy hits a blooper to the opposite field, you're taking me out."

Southworth offered a soothing response, saying he was pulling Bickford because of a "sincere effort to win this game." He told Bickford he wouldn't blame him if the team lost. Then he told incoming reliever Nelson Potter, who specialized in screwballs, to walk the first two enemy batters intentionally and force the Phils to hit the ball on the ground. Once the bases were loaded, Potter struck out two hitters and got the third to ground out. After the game, Bickford apologized to Southworth.

Southworth first managed the Cardinals in 1929, but it was not a good match. In his early days as a skipper, Southworth's wife died and he became an alcoholic. Too close to the players because they had been teammates, Southworth changed and became the world's harshest disciplinarian. "I used to think you were a great guy," said Jimmie Wilson, a player and former drinking partner of Southworth's. "Now I know you're just a no-good [son of a gun]."

The manager was a changed man the second time around with the Cardinals. No longer a drinker, more mature as a person, Southworth also learned how to win. Pitcher Lon Warneke developed an impression of Southworth that was the polar opposite of Wilson's. "Bill's the most considerate manager I ever worked for," Warneke said. "He never second-guesses you and I never saw any manager in my life who could build up what you call morale like this guy does."

Southworth's 1942 team won the Series, besting the New York Yankees in five games. A team that was unheralded at the beginning of the season became a juggernaut at the end, winning forty-two of their final fifty-two games, for an .827 winning percentage.

"It was the greatest sustained streak in the history of modern baseball," Southworth said. "In no sense was it a normal pace. The players' belief in themselves was so profound that the spectacular was taken as the commonplace."

—L.F.

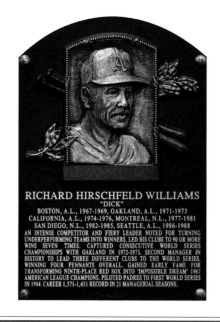

RICHARD HIRSCHFELD WILLIAMS
"DICK"
BOSTON, A.L., 1967-1969, OAKLAND, A.L., 1971-1973
CALIFORNIA, A.L., 1974-1976, MONTREAL, N.L., 1977-1981
SAN DIEGO, N.L., 1982-1985, SEATTLE, A.L., 1986-1988
AN INTENSE COMPETITOR AND FIERY LEADER NOTED FOR TURNING
UNDERPERFORMING TEAMS INTO WINNERS. LED HIS CLUBS TO 90 OR MORE
WINS SEVEN TIMES. CAPTURED CONSECUTIVE WORLD SERIES
CHAMPIONSHIPS WITH OAKLAND IN 1972-1973. SECOND MANAGER IN
HISTORY TO LEAD THREE DIFFERENT CLUBS TO THE WORLD SERIES,
WINNING FOUR PENNANTS OVERALL. GAINED EARLY FAME FOR
TRANSFORMING NINTH-PLACE RED SOX INTO 'IMPOSSIBLE DREAM' 1967
AMERICAN LEAGUE CHAMPIONS. PILOTED PADRES TO FIRST WORLD SERIES
IN 1984. CAREER 1,571-1,451 RECORD IN 21 MANAGERIAL SEASONS.

DICK WILLIAMS

CLASS OF 2008

Dick Williams made heavy demands on his players, but he extracted productive results throughout his managerial career. Tough and fair, the St. Louis native took three losing franchises to the World Series, all the while putting a stamp of solid, balanced baseball on each of his teams.

As a minor league player, Williams was strongly influenced by his Texas League manager, Bobby Bragan. Williams wisely noticed Bragan's strengths as a manager: principally the ability to teach and instill discipline. These attributes would become essential parts of the Williams dossier once he moved on from a career as a journeyman outfielder, including a stint with the Brooklyn Dodgers, to the ranks of major league managing.

In leading the 1967 Boston Red Sox to the American League Pennant as the culmination of an "Impossible Dream," Williams changed a country-club atmosphere to an environment of discipline and direction. He achieved even greater success with the Oakland A's. Working amidst a swirl of controversy fueled by an unpredictable owner in Charlie Finley, Williams guided the A's to two straight world championships in the early 1970s.

Among his many strengths, Williams was a master at massaging the Oakland pitching staff. One of his best decisions involved Rollie Fingers, who had struggled as a starting pitcher. Realizing that Fingers sometimes worked himself into a frenzy as he awaited his next start, Williams turned him into a relief pitcher. "I just couldn't handle a starting job," Fingers told this author years

later. "If Dick Williams hadn't moved me to the bullpen in 1971, I would have been out of baseball a long time ago."

A fierce, militaristic kind of leader, Williams patterned his managerial style after those of Branch Rickey and Vince Lombardi. Williams stressed the importance of basic execution, demanded absolute effort from his players, and challenged them to play for more than themselves and the desire for a new contract. "He's got two rules," Reggie Jackson told *Sports Illustrated*. "You hustle all the time and you don't make the same mental mistake twice."

For Williams, it was win or else. "If you don't win," Jackson said, "he's ready to fight. I'm loyal to him. He's the best baseball man I've ever known. He keeps you scared enough so you've gotta do your job."

In most cases, his players responded to him, first with the Red Sox and the A's, then with the Montreal Expos, and later with the San Diego Padres. In total, he took three different teams to the World Series, each in a different decade under differing rules and circumstances—but with the common denominator of discipline. Prior to his arrival, the Red Sox hadn't been competitive since the fifties, the A's had never gone to the postseason during the Finley era, and the Padres had won nothing as a franchise.

Then, within two years of Williams's arrival, World Series shares started appearing in the players' bank accounts. Those teams won in part because Williams demanded a work ethic and effort, while always stressing sound fundamental play buttressed by an emphasis on pitching and defense. For Williams, it was a winning formula that worked time and time again.

—B.M.

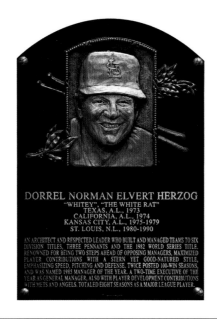

WHITEY HERZOG

CLASS OF 2010

Talent evaluator is only part of the job description of a successful major league manager. Fortunately for Dorrel Norman Elvert "Whitey" Herzog, recognition of his own limitations came early in his baseball career.

"Baseball has been good to me since I quit trying to play it," Herzog has said frequently throughout his life in the game.

After an eight-year big league playing career from 1956 to 1963, Herzog managed for eighteen seasons in the major leagues. He won six division titles, three pennants, and the 1982 World Series, was named the 1985 National League Manager of the Year, and finished his managerial career with a .532 winning percentage.

Herzog has held almost every position in baseball, serving as a player, scout, general manager, coach, farm system director, and manager. But it was in management where Herzog found his true calling. "My goal was to manage in the minor leagues and help young players," he said.

Herzog made a name for himself in the Mets organization in the 1960s as a coach and a talent evaluator. He also received a nonstop education from Mets skipper Casey Stengel.

Herzog landed his first major league managerial position in 1973 with the Texas Rangers but was dismissed 138 games into the season. In 1974 Herzog was named interim manager for four games for the California Angels, before landing with the Royals in Kansas City midway through the 1975 season.

He skippered Kansas City to a 41–25 mark in the final sixty-six games of 1975, positioning the Royals for three straight ninety-win seasons and first-place finishes from 1976 to 1978.

He brought his determination and positive attitude to a young team that had talent but lacked experience in winning.

Over the next fifteen seasons—from 1976 to 1990—Herzog led his team to first- or second-place finishes nine times. The Royals won three straight American League West titles (1976–1978) under Herzog, whose style of play was dubbed "Whitey Ball." He believed successful teams featured speed, defense, and a strong bullpen.

"I don't think you can find a player that dislikes [Herzog]," said Gene Tenace. "He's blessed with a special gift to deal with players."

Midway through the 1980 season, Herzog landed in St. Louis, replacing interim manager Jack Krol one game after the firing of Ken Boyer. On August 29, Herzog was promoted to general manager, handing over the managerial reins to Red Schoendienst, who had previously managed the club from 1965 to 1976.

Herzog held both general manager and field manager positions for the 1981 and 1982 seasons, acquiring many of the players who would carry the Cardinals to three World Series appearances in the decade—and a Fall Classic win in 1982.

It was as a field manager, though, where Whitey's most legendary contributions will be remembered, with a career record of 1,281–1,125.

—C.M.

UMPIRES

TOM CONNOLLY

1953

BILL KLEM

1953

BILLY EVANS

1973

JOCKO CONLAN

1974

CAL HUBBARD

1976

AL BARLICK

1989

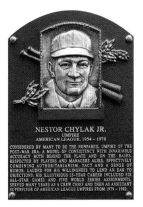

BILL McGOWAN

1992

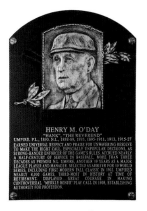

NESTOR CHYLAK

1999

DOUG HARVEY

2010

HANK O'DAY

2013

EXECUTIVES

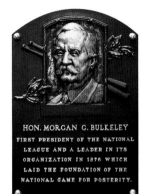

MORGAN BULKELEY

1937

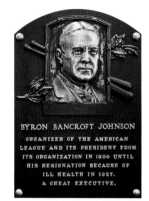

BAN JOHNSON

1937

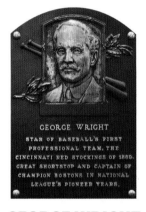

GEORGE WRIGHT

1937

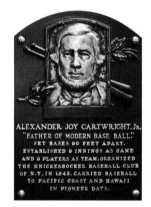

ALEXANDER CARTWRIGHT

1938

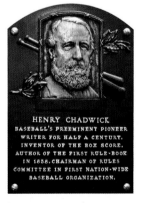

HENRY CHADWICK

1938

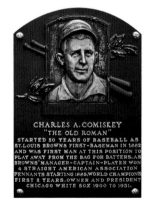

CHARLES COMISKEY

1939

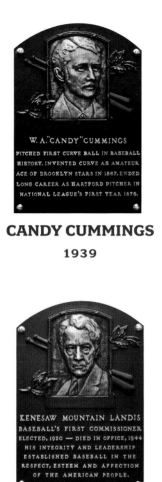

CANDY CUMMINGS

1939

ALBERT SPALDING

1939

KENESAW MOUNTAIN LANDIS

1944

CLARK GRIFFITH

1946

ED BARROW

1953

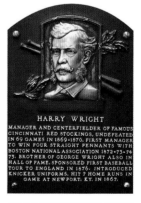

HARRY WRIGHT

1953

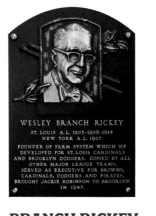

BRANCH RICKEY

1967

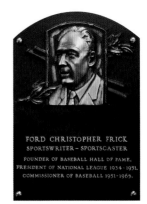

FORD FRICK

1970

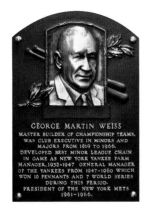

GEORGE WEISS

1971

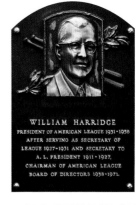

WILL HARRIDGE

1972

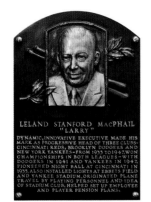

LARRY MacPHAIL

1978

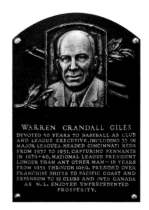

WARREN GILES

1979

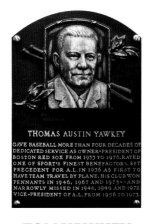

TOM YAWKEY
1980

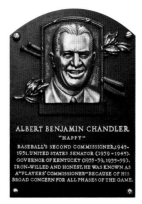

HAPPY CHANDLER
1982

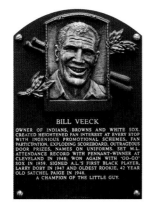

BILL VEECK
1991

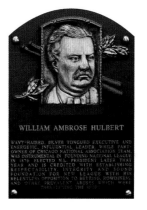

WILLIAM HULBERT
1995

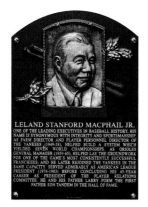

LEE MacPHAIL
1998

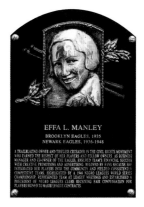

EFFA MANLEY
2006

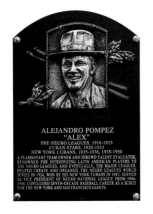

ALEX POMPEZ

2006

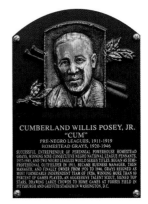

CUMBERLAND POSEY

2006

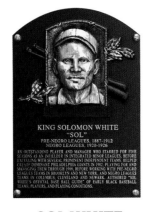

SOL WHITE

2006

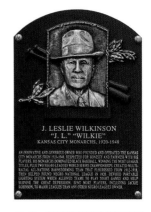

J. L. WILKINSON

2006

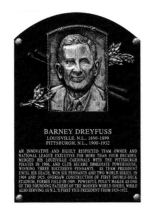

BARNEY DREYFUSS

2008

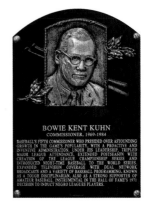

BOWIE KUHN

2008

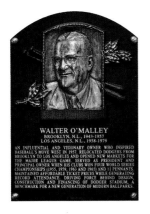

WALTER O'MALLEY
2008

PAT GILLICK
2011

JACOB RUPPERT
2013

ACKNOWLEDGMENTS

A special thanks to all of the Hall of Fame members—particularly the ten featured within this volume, who have shared their time, stories, and memories—for their contributions in helping the National Baseball Hall of Fame and Museum celebrate its 75th Anniversary in 2014.

The National Baseball Hall of Fame and Museum extends thanks to the following contributors for their work on this book:

Scott Pitoniak

Lew Freedman

Bruce Markusen

Tim Wendel

Craig Muder

Jeffrey Arnett

Freddy Berowski

Jim Gates

Tim Wiles

Cody Eding

Bill Francis

Nicole Pappas

James Yasko

The Museum would also like to acknowledge the following project supporters:

Fran Althiser

Jackie Brown

Sean Gahagan

Bill Haase

Brad Horn

Jeff Idelson

Pat Kelly

Roger Lansing

Donny Lowe

Scot Mondore

Rose Morley

Nate Owens

Erik Strohl

Denise LaCongo

Karen Landry

John Parsley

Michael Pietsch

Allie Sommer

Jennifer Joel

Clay Ezell

Karen Berry

Dana Edwards

CREDITS

Photographs not listed below are courtesy of the National Baseball Hall of Fame Library, Cooperstown, New York.

NBL / John Cordes: xii, 134

NBL / Charles Conlon: 12, 13, 15, 16, 24, 27, 28, 29, 30, 36, 37, 40, 41, 167, 168, 228, 264, 265, 266, 269, 354, 356, 357, 361, 374, 375, 407, 425, 467, 516, 527, 531, 534, 555, 574, 579

NBL / Carl Horner: 14

NBL / Louis Van Oeyen: 34, 65, 66, 74, 475

NBL / Herman Seid: 48

NBL / Look Magazine: 73, 221

NBL / Look / Rothstein: 81

NBL / Don Wingfield: 84, 85, 102

Photo File: 89, 101, 106, 274, 290, 298, 329, 556

NBL / Fred Roe: 97, 484

NBL / Doug McWilliams: 105, 107, 110, 112, 116, 129, 198, 234, 241, 243, 250, 279, 280, 441, 444, 450, 558

NBL / Rich Pilling: 117, 149, 151, 189, 242, 297, 396, 398, 563

NBL / Brad Mangin: 141, 340, 392, 395, 499

NBL / Lou Sauritch: 153, 281, 394, 446

MLB / Rich Pilling: 296, 333

NBL / Michael Ponzini: 331

NBL / George Napolitano: 342

NBL / Paul Thompson: 350

Brad Mangin: 391

NBL / Don Sparks: 437, 506, 543

NBL / Hank Koshellek: 494

INDEX

*Page numbers in **boldface** refer to players' and managers' biographical profiles and likenesses of umpires and executives.*

Aaron, Hank, 2, 243, 312, 315, 318, 439, 453, 500, **550;** quoted, 237, 276, 288, 508–15
Abrams, Cal, 491
Adair, Jerry, 378
Adams, Babe, 350
Adcock, Joe, 513
Alexander, Grover, **17,** 29, 136
Allen, Bob, 287
Allen, Dick, 8
Allen, Newt, 139
Allen, Richie, 315
Almendares (Cuban baseball club), 146, 504
Alomar, Roberto, 205, **297**
Alomar, Sandy Sr., 297
Alou, Felipe, and brothers, 99, 205, 237
Alston, Walter, 566, 568, 569, **584**
Altobelli, Joe, 346
Anderson, Dave, 572
Anderson, Sparky, 255–56, **590;** quoted, 186, 240, 254, 322, 331, 580
Anson, Cap, 51, **207,** 462
Antonelli, Johnny, 202
Aparicio, Luis, ix, **378**
Appling, Luke, 45, **362,** 378
Armbrister, Ed, 254
Ashburn, Richie, **491**
Aspromonte, Ken, 111
Atlanta Black Crackers, 504
Atlanta Braves, 7, 111, 116, 128, 238, 318, 390, 513–14, 550; in Series, 498, (win) 243
Averill, Earl, 42, **480**

Bacharach Giants (Atlantic City), 126
Backman, Wally, 191
Baker, Frank "Home Run," 29, 261, **312**
Baltimore Black Sox, 334, 503
Baltimore Elite Giants, 120, 176
Baltimore Orioles, l7, 22, 30, 88, 103,

104, 213, 280, 297, 308, 321, 342–48, 353, 378, 431, 454, 519, 553, 575, 576, 586; in Series, 7, 543, (win) 243, 322, 346, 393, 587
Bancroft, Dave, **368**
Bancroft, Frank, 18
Bando, Sal, 112
Banks, Ernie, 131, 337, **371,** 439, 476
Barlick, Al, **594**
Barrow, Ed, 171, 577, **597**
Barry, Jack, 261, 312
Battle Creek Belles, 368
Beane, Billy, 444
Becker, Joe, 108
Beckley, Jake, **222**
Beckwith, John, 194
Belanger, Mark, 345
Bell, Buddy, 307
Bell, Cool Papa, 126, 143, 244, 315, **476,** 482; quoted, 192, 386, 436, 497
Bell, Fred, 476
Bellamy, Ron, 99
Bench, Johnny, **186,** 191, 240, 250, 254–55, 257, 402; quoted, 149, 278, 590
Bender, Charles "Chief," **40,** 136, 194
Bengough, Benny, 34
Bennett, Charlie, 39, 544
Benson, Gene, 120
Berardino, Dick, 400
Bercovich, Sam, 250
Berger, Wally, 244
Berra, Yogi, 171, **179,** 180; quoted, 420, 465
Bevis, Charlie, 58
Bickford, Vernon, 591
Birmingham Black Barons, 244, 485, 511
Black Panthers, 108
"Black Sox Scandal," 45, 55, 470
Blyleven, Bert, **152,** 558
Bochy, Bruce, 561
Boggs, Wade, **332**

Bolton, Todd, 120, 246
Bonds, Barry, 180
Bonilla, Bobby, 347
Bonner, Bobby, 344–45
Boone, Bob, 582
Bostock, Lyman, 303
Boston Americans (later Red Sox), 308
Boston Beaneaters (later Braves), 39, 51, 292, 308, 431, 520; NL champions, 462, 523, 589
Boston Braves, 80, 185, 213, 244, 272, 311, 315, 318, 354, 368, 462, 473, 480, 528, 578, 580, 589, 591; in Series, 367, 492
Boston Doves (later Braves), 431
Boston Reds of the Union Association, 523
Boston Red Sox, 21, 30, 63, 115, 124, 140, 150, 156–62, 171, 182, 213, 216, 275, 300, 321, 332, 361, 367, 381, 398–405, 420, 443, 447, 460, 462, 562, 581, 592; as "Red Stockings," 338; sell Babe Ruth to Yankees, 34, 188, 516, ("Curse of the Bambino") 161; in Series, 191, 204, 240, 255, (win) 188, 539; Yankees v., 159–61, 321, 402, 557
Bottomley, Jim, 222, **228**
Boudreau, Lou, 87, **367,** 390
Bowa, Larry, 291, 436
Boyd, Dennis, 191
Boyer, Ken, 593
Bragan, Bobby, 592
Branca, Ralph, 492, 512
Breadon, Sam, 578
Bresnahan, Roger, **167,** 316
Brett, George, 9, **328,** 331; brothers John, Ken, Bobby, 300–1; quoted, 88, 300–7
Brickhouse, Jack, 367
Brinkman, Joe, 305–6
Brock, Lou, 203, 238, **436,** 444
Brooklyn Brown Dodgers, 482

Brooklyn Dodgers, ix, 22, 39, 46, 56, 115, 200, 213, 272, 315, 321, 353, 364, 382, 416, 424, 427, 473, 485, 486, 528, 580, 582, 585, 586, 592; and Jackie Robinson, 73, 180, 270, 508–9; move to Los Angeles, 176; "Trolley Dodgers," 576; win Series, 100, 381, 488, 566–67, 584

Brooklyn Robins, 185

Brooklyn Superbas, 519

Brooks, Hubie, 191

Brouthers, Dan, **213,** 519, 586

Brown, Mace, 158, 400

Brown, Mordecai "Three Finger," **36**

Brown, Raymond, **143**

Brown, Willard, **500**

Bruton, Bill, 315

Buckner, Bill, 140, 404, 569

Buffalo Bisons, 60, 213, 292, 338, 410

Buffalo Red Caps, 503

Bulkeley, Morgan, **596**

Bunning, Jim, **124**

Burdette, Lew, 80, 513

Burkett, Jesse, **412,** 469

Burleson, Rick, 403

Burroughs, Jeff, 390

Bush, Donie, 536

Bush, Joe, 194

California Angels, 2, 7, 132, 135, 152, 280, 306–7, 347, 454–55, 456, 557, 558, 593

Camnitz, Howard, 350

Campanella, Roy, **176,** 192, 509, 566; quoted, 381, 432, 584

Campanis, Al, 569

Canada, Jim, 497

Canseco, Jose, 572

Carew, Rod, 9, 108, 234, **280,** 303, 307

Carey, Max, **466**

Carlton, Steve "Lefty," **119**

Carrasquel, Chico, 378

Carroll, Clay, 149

Carter, Gary "Kid," **191**

Carter, Joe, 297

Cartwright, Alexander, **596**

Cash, Dave, 288

Cepeda, Orlando, ix, 99, 237, **238;** quoted, 198–205

Cepeda, Perucho, 198–201, 205, 238

Cey, Ron, 291, 571

Chadwick, Henry, 338, **596**

Chambliss, Chris, 304

Chance, Frank, **214,** 265, 354, 589

Chandler, Happy, **599**

Chapman, John "Jack," 292

Chapman, Ray, 374

Charleston, Oscar, 126, 136, 315, **482**

Chase, Hal, 312

Chesbro, Jack, **21**

Chicago American Giants, 126, 139, 144, 194, 244, 315, 386, 497, 503, 504, 583

Chicago Colleens, 368

Chicago Cubs, 17, 36, 88, 108, 140, 149, 172, 216, 226, 266, 272, 291, 316, 337, 358, 367, 371, 435, 436, 439, 470, 486, 491, 536, 549, 562; as "Colts," 207; famous double play, 214, 354; in Series, 115, 422, (win) 265, 577, 589

Chicago Union Giants, 583

Chicago White Sox, 8, 29, 45, 79, 94, 103, 116, 119, 150, 156, 161–62, 171, 175, 188, 261, 284, 321, 346, 362, 378, 415, 435, 462, 492, 582; win Series, 55, 388

Chicago White Stockings, 51, 58, 338, 462, 520

Chylak, Nestor, **595**

Cincinnati Reds "Big Red Machine," 18, 52, 67, 68, 93, 116, 146, 152, 164, 228, 237, 250, 254–56, 338, 381, 428, 431, 470, 473, 520, 553, 586; as "Red Stockings," 287; in Series, 322, 587, (win) 160, 185, 186, 188, 240, 255, 278, 394, 402, 470, 578, 590

Clark, Dick, 144

Clark, Stephen C., xi

Clarke, Fred, **406,** 456

Clarkson, John, **51,** 83

Claussen, Phil, 162

Clemens, Roger, 346

Clement, Wally, 416

Clemente, Roberto, 90, 198, 200, 204–5, 280, 297, 439, 440, 514, **543;** quoted, 99

Cleveland Cubs, 504

Cleveland Forest City club, 338

Cleveland Indians, 48, 51, 73, 79, 87, 111, 115, 119, 128, 140, 152, 159, 202, 220, 294, 297, 321, 324, 374, 435, 460, 480, 535, 553, 578, as

"Naps," 94, 258, 530; in Series, 103, 243, 582, (win) 64, 367, 492

Cleveland Infants, 409

Cleveland Spiders, 357, 388, 412, 462

Clyde, David, 5

Coakley, Andy, 208

Cobb, Ty, viii, 29, 280, 353, 357, 377, 415, **458,** 503, 536, 540; as player/manager, 33, 83, 122, 269, 350, 419, 526, 533, 581; quoted, 10, 136, 175, 211, 574; record broken, 444, 561

Cochrane, Mickey, **168,** 192, 216, 269, 479

Cohane, Tim, 272

Coleman, Gene, 8

Collins, Eddie, 29, 40, 258, **261,** 275, 297, 312

Collins, Jimmy, **308**

Colorado Silver Bullets, 128

Combs, Earle, **474**

Comiskey, Charles, 55, 207, 261, 523, 583, **596**

Concepción, Dave, 257

Conigliaro, Tony, 108

Conlan, Jocko, 126, **594**

Connolly, Tom, **594**

Connor, Roger, 58, **231**

Coombs, Jack, 40

Cooper, Andy "Lefty," **144**

Cooper, Cecil, 454

Corrales, Pat, 240

Costas, Bob, 498

Coveleski, Harry, 64

Coveleski, Stan, **64**

Cowans, Russ J., 144

Craig, Roger, 238

Cramer, Doc, 30

Crandall, Del, 452, 513

Crawford, Sam, 353, 409, 519, **530**

Criger, Lou, 93

Cronin, Joe, 30, **361**

Crosetti, Frank, 282

Crutchfield, Jimmie, 476, 497

Cuban Giants, Cuban X-Giants, 292, 503, 583

Cuban Stars, 80, 504

Cuellar, Mike, 107, 158

Cummings, Candy, **597**

Cuyler, Kiki, **536**

Dalrymple, Clay, 99

Dalton, Harry, 453

Dandridge, Ray, **324,** 386

Daniel, Dan, 63

Dark, Alvin, 491

Davis, Al, 250

Davis, George, **388**

Davis, Mike, 573

Dawson, Andre, 291, **562**

Day, Leon, **120,** 244

Dean, Dizzy, **42,** 131, 266, 424, 476, 480; quoted, 73

Dean, Paul, 42

DeCinces, Doug, 343–44

Decker, Ben, 122

Deer, Rob, 135

DeJesus, Ivan, 291

Delahanty, Ed, **409,** 469, 544

Dent, Bucky, 402, 557

Detroit Stars, 144, 324, 503, 504

Detroit Tigers, 8, 33, 124, 144, 146, 158, 161, 168, 182, 220, 243, 269, 321, 353, 364, 419, 435, 480, 524, 526, 530, 533, 544, 578, 581; in Series, 122, 266, 424, (win) 115, 150, 422, 546, 587, 590

Detroit Wolverines, 213, 338, 544

Detroit Wolves, 143

Devens, Charlie, 171

Devine, Bing, 96

Dickey, Bill, 63, 168, **171,** 474

Dickey, R. A., 128

Digby, George, 332

Dihigo, Martín, **90,** 131, 476, 504

DiMaggio, Dominic, 403

DiMaggio, Joe, 74, 179, **465,** 550, 567; quoted, 48, 557, 577, 581

DiMaggio, Vince, 465

Dixon, Phil, 246

Dixon, Walt, 201, 238

Dobson, Chuck, 557

Dobson, Pat, 107

Doby, Larry, 192, 432, **492,** 578

Doerr, Bobby, **275,** 403

Dolson, Frank, 124

Downing, Al, 514, 550

Downs, Bunny, 510

Doyle, Jack, 83

Doyle, Larry, 213

Dressen, Chuck, 546

Dreyfuss, Barney, 122, 406, **600**

Drysdale, Don, 96, **100,** 132, 176, 237, 572, 584

Duffy, Frank, 111

Duffy, Hugh, 83, **462,** 469, 523

Duncan, Dave, 135, 140

Duncan, Frank, 131

Dunlap, Fred, 292

Dunn, Jack, 30

Durocher, Leo, 103, 337, 382, **585,** 588; quoted, 108, 485, 516, 524

Durst, Cedric, 63

Dykes, Jimmy, 371

Easter, Luke, 492

Ebbets, Charles, 56

Eckersley, Dennis, **140,** 297, 572

Eckert, William, 116

Egan, Dick, 354

Egan, Jack, 530

Ehret, Philip "Red," 409

Eisenhardt, Roy, 257

Elberfeld, Kid, 218, 377

Elias brothers and Elias Sports Bureau, 458

Evans, Billy, **594**

Evans, Dwight, 255, 401, 402

Everitt, Bill, 589

Evers, Johnny, 214, **265,** 354, 589

Ewing, Buck, 58, 60, 83, **164,** 180, 231, 315

Faber, Red, **55,** 415

Farrell, Duke, 93

Feller, Bob, 5, 14, **48,** 73, 79, 93, 131, 476; quoted, 87, 115, 171, 294, 367, 385, 465, 492

Fernandez, Tony, 297

Ferrell, Rick, **182**

Fields, Wilmer, 143

Fingers, Rollie, 104, **112,** 149, 150, 592

Finley, Charlie, 104, 557, 592

Fisk, Carlton, 182, **188,** 255, 402; quoted, 156–63

Flagstead, Ira, 419

Flanagan, Mike, 243

Flick, Elmer, **533**

Flood, Curt, 203, 250

Florida Marlins, 562

Fogel, Horace, 52

Forbes, Frank, 194

Ford, Whitey, **84,** 104, 385, 479, 580

Fort Wayne (Indiana) Daisies, 216

Fort Worth Wonders, 194

Foster, Bill, **126**

Foster, Rube, 194, **583**

Fothergill, Bob, 419

Fox, Nellie, 250–51, 253–54, **284,** 378, 582

Foxx, Jimmie, 180, **216,** 567, 574

Fregosi, Jim, 7, 108, 188

Frey, Jim, 280, 291

Frick, Ford, 427, 574, **598**

Frisch, Frank, 56, 83, 211, 226, 228, **266,** 424, 540

Gaetti, Gary, 307

Galvin, Pud, 58, **60,** 338, 364

Gant, Ron, 498

Garagiola, Joe, 179

Garcia, Mike, 79, 87

Gardner, Jelly, 504

Garvey, Steve, 570

Gehrig, Lou, 83, 171, 180, **208,** 220, 222, 348, 374, 474, 524, 567; death of, 498; record broken, 342, 393, 473

Gehringer, Charlie, 126, **269,** 275, 386, 567

Gentry, Gary, 6

Gerónimo, César, 152, 254

Giamatti, Bart, ix, 188

Gibson, Bob, 5, 68, **96,** 100, 120, 203, 237

Gibson, Josh, 136, 143, **180,** 192, 194, 198–99, 244, 315, 420, 482, 497; quoted, 334, 500

Gibson, Kirk, 140, 150, 571–72

Gilbert, Andy, 99

Giles, Warren, 578, **598**

Gilkerson's Union Giants, 504

Gillick, Pat, 297, **601**

Giordano, Tom, 342–43

Gleason, Kid, 388

Gomez, Lefty, 33, **74,** 216, 269, 480

Gooden, Dwight, 191

Goodman, Billy, 252

Gordon, Joe, 275, **294**

Gordon, Sid, 324

Goslin, Goose, **422,** 535

Gossage, Goose, **150,** 305

Gottlieb, Eddie, 225

Grady, Mike, 388

Grant, Frank, **292**

Grant, Jim, 112

Green, Dallas, 562

Green, Joe, 583

Greenberg, Hank, **220,** 231, 437

Greenwade, Tom, 479

Griffin, Alfredo, 572

Griffin, Ivy, 439

Griffith, Clark, 10, 18, 21, 244, 308, 581, **597**

Grimes, Burleigh, **56,** 350

Grimm, Charlie, 56, 262, 470

Gromek, Steve, 492

Grote, Jerry, 5

Grove, Lefty, 14, **30,** 34, 60, 107, 374, 574

Gubicza, Mark, 306

Guerrero, Pedro, 571

Guidry, Ron, 150, 403, 571

Guillén, Ozzie, 378

Gwynn, Tony, 9, 280, **561**

Haddix, Harvey, 6

Hadley, Bump, 168

Haefner, Mickey, 182

Hafey, Chick, **428**

Haines, Jesse "Pop," **68**

Hamilton, Billy, **469,** 544

Hamilton, Jeff, 572

Hanlon, Ned, 353, 431, 519, 576, **586**

Harder, Mel, 79

Hargrave, Bubbles, 52

Harper, Tommy, 250

Harrelson, Ken, 161

Harridge, Will, **598**

Harris, Bucky, 208, 535, **581**

Harris, Vic, 90

Hartnett, Gabby, 52, **172**

Harvey, Doug, **595**

Havlicek, John, 156

Haynes, Sammie, 500

Haywood, Buster, 510

Hayworth, Ray, 415

Heilmann, Harry, 419, **526**

Heitz, Tom, 469

Helms, Tommy, 254

Henderson, Rickey, 306, 436, **444,** 469

Hendricks, Elrod, 107

Herman, Billy, 33, **272**

Hermanski, Gene, 488

Hernandez, Keith, 191

Hershiser, Orel, 572

Herzog, Buck, 213

Herzog, Whitey, 149, 302, 390, 447, 580, **593**

High, Andy, 428

Hill, Pete, **503**

Hilldale Daisies, 194

Hilldale Stars, 315

Hodges, Gil, 488, 492

Hoffman, Trevor, 140

Holmes, Tommy, 576

Holtzman, Ken, 280

Holway, John, 131

Homestead Grays, 90, 126, 136, 143, 180, 225, 315, 334, 476, 482

Hooper, Harry, **539**

Hornsby, Rogers, 17, 228, 257, **262,** 280, 424, 561

Horrigan, Kevin, 116

Horton, Willie, 546

Hough, Charlie, 128

Houk, Ralph, 84, 203, 378, 568

House, Tom, 8

Houston Astros, 2, 8, 88, 132, 135, 250, 254, 318, 571; as "Colt .45s," 251, 253, 278, 284

Houston Buffaloes, 228

Howard, Elston, 171, 203, 476

Howell, Jay, 140

Howsam, Bob, 580

Howser, Dick, 306

Hoyt, Waite, **67,** 136, 168, 226, 474

Hriniak, Walt, 332

Hubbard, Cal, **594**

Hubbard, Jesse, 194

Hubbell, Carl, **33,** 34, 83, 204, 272

Huggins, Miller, 171, 208, 474, **579**

Hughes, Sammy T., 139

Hulbert, William, **599**

Hunter, Catfish, **104**

Idelson, Jeff, 420

Indianapolis ABCs, 143, 482, 504

Indianapolis Clowns, 510, 511

Irvin, Monte, 192, **432;** quoted, 120, 139, 143, 180, 324, 386, 582

Jackson, Danny, 306

Jackson, Darrell, 243

Jackson, Grant, 304

Jackson, Reggie, 9, 403, 436, **557,** 570–71; quoted, 104, 135, 592

Jackson, Travis, **377**

Jackson Senators, 171

Jenkins, Ferguson, **108,** 337

Jennings, Hughie, 18, **353,** 431, 519, 530, 586

Jeter, Derek, 348, 349

Johnson, Ban, 14, 29, 261, 583, **596**

Johnson, Darrell, 401

Johnson, Davey, 587

Johnson, Deron, 254

Johnson, Judy, 180, **315,** 482

Johnson, Magic, 348

Johnson, Randy, 5, 25, 346

Johnson, Richard A., 188

Johnson, Timmy, 453

Johnson, Walter, viii, 5, **10,** 14, 17, 93, 124, 131, 136, 535; record broken, 119, 211

Jones, Sam, 156

Jordan, Pat, 104

Josephson, Duane, 159

Joss, Addie, **94**

Judge, Joe, 535

Kalas, Harry, 491

Kaline, Al, 318, **546**

Kansas City Athletics (A's), 104, 112, 303, 554, 557, 569

Kansas City Monarchs, 126, 131, 136, 139, 144, 146, 244, 270, 315, 371, 476, 500, 504

Kansas City Royals, 8, 204, 300, 301–7, 328, 447, 593; win Series, 306

Kasko, Eddie, 253

Keane, Jonathan, 404, 436

Keefe, Tim, **58,** 83

Keeler, Willie, 83, 213, 308, 353, 431, 519, 586

Kell, George, 182, **321,** 322

Kelley, Joe, 353, **431,** 519, 586

Kelly, George, **226**

Kelly, King, 292, **520**

Kelly, Tom, 498

Kendrick, Bob, 139

Kennedy, Terry, 152

Kessinger, Don, 439

Killebrew, Harmon, 108, **234**

Killefer, Bill, 316

Kiner, Ralph, 220, 318, **435;** quoted, 48, 88, 128, 291, 580

Klein, Chuck, **549**

Klem, Bill, 68, 358, 406, **594**

Kling, Johnny, 354

Kluszewski, Ted, 278

Knowles, Darold, 149

Koosman, Jerry, 5, 6, 7

Koufax, Sandy, 2, 5, 8, **76,** 96, 100, 132, 152, 220, 422

Krol, Jack, 593

Kubek, Tony, 479

Kuenn, Harvey, 452, 454

Kuhn, Bowie, **600**

Lachemann, Rene, 332
Lajoie, Napoleon "Larry," 14, **258**
Lamb, Bill, 388
Lancaster Red Roses, 64
Landis, Kenesaw Mountain, 45, 424, 583, **597**
Lange, Bill, 226
Lansford, Carney, 332
Larkin, Barry, **394**
Larsen, Don, 179
LaRussa, Tony, 140
Lary, Lyn, 361
Lasorda, Tommy, **588;** quoted, 100, 132, 566–73
Lau, Charlie, 300, 302–4
Lazzeri, Tony, 17, **282, 294**
Leach, Tommy, 222, 409
Lee, Bill, 240
Lee, Leron, 159–60
Lee, Scrip, 194
Lehman, John "Pappy," 568
Leibrandt, Charlie, 498
Leifer, Elmer, 377
Leifield, Lefty, 350
Leland, Frank, and Leland Giants, 135, 503, 583
Lemon, Bob, 79, **87,** 321, 367
Lemon, Meadowlark, 96
Leonard, Buck, 90, 126, 143, **225, 246**
Leonard, Dutch, 103, 182
Lindstrom, Freddie, **316**
Little Rock Travelers, 377
Lloyd, Pop, 146, 315, **372**
Lockman, Whitey, 201
Lofton, Kenny, 243
Lolich, Mickey, 158
Lombardi, Ernie, **185**
Lopes, Davey, 256, 570
Lopez, Al, 79, 87, 172, 185, 284, 486, **582**
López, Héctor, 179
Los Angeles Dodgers, 103, 124, 132, 152, 203, 243, 256, 514, 566–73, 588; move from Brooklyn, 176, 381, 488, 584; win Series, 76, 140, 284, 566, 571, 582
Louisville Colonels, 158, 308, 406, 474
Lunte, Harry, 374
Lynn, Fred, 157, 160, 398, 401–3, 447
Lyons, Ted, **45,** 216, 362

Mack, Connie, 14, 26, 40, 60, 216, 261, 415, **574;** quoted, 13, 22, 30, 34, 168, 312, 338, 586
Mackey, Biz, 126, **192,** 194
MacPhail, Larry, 577, **598**
MacPhail, Lee, 305–6, 328, **599**
Maddox, Garry, 257
Maddux, Greg, 561
Magowan, Peter, 204
Malarcher, Dave, 126, 482, 504
Maloney, Jim, 553
Manley, Effa, 386, 432, **599**
Manning, Rick, 455
Mantilla, Félix, 511
Mantle, Mickey, 2, 108, 179, 262, 378, **479,** 580, 581; quoted, 427, 465, 550
Manush, Heinie, **419**
Maranville, Rabbit, **358,** 416
Marichal, Juan, ix, **99,** 237
Maris, Roger, 479
Marquard, Rube, **70,** 136, 312, 576
Martin, Billy, 87, 280, 305, 328
Martin, Fred, 149
Martin, Pepper, 42, 424
Martinez, Buck, 301, 303
Mathews, Eddie, **318,** 327, 513
Mathewson, Christy, viii, **13,** 17, 22, 29, 33, 36, 40, 68, 83, 93, 94, 136, 146, 354, 524, 575, 583; quoted, 312
Matthews, Walt, 252
Mattingly, Don, 9
Mauch, Gene, 76
May, Lee, 254
Mays, Willie, 73, 90, 200, 202, 237, 243, 256, 432, 439, 473, **485,** 511; quoted, 327, 492, 585
Mazeroski, Bill, 257, **288,** 297
McCarthy, Joe, 74, 171, 172, 175, 266, 294, 474, **577**
McCarthy, Tommy, **523**
McCarver, Tim, 96, 203
McClelland, Tim, 305–6, 328
McCloskey, John, 308
McCovey, Willie "Stretch," 201–3, **237,** 238, 558
McDowell, Jack, 162
McDowell, Sam, 111
McGinnity, Joe "Iron Man," **22**
McGowan, Bill, **595**
McGraw, John, 14, 33, 220, 316, 377, 412, 486, 528, 540, **575,** 576, 579,

583; as player, 353, 431, 469, 519, 575, 586; quoted, 22, 55, 70, 93, 146, 213, 218, 261, 350, 422, 428, 482, 523, 524
McGregor, Scotty, 301
McGriff, Fred, 297
McGwire, Mark, 9, 572
McInnis, Stuffy, 29, 40, 261, 312
McKechnie, Bill, 428, **578**
McKeon, Jack, 302
McNally, Dave, 107
McPhee, Bid, **287**
McRae, Hal, 303, 305, 307
McRoy, Bob, 460
Meany, Tom, 25
Medwick, Joe "Ducky," **424**
Mele, Sam, 400
Memphis Red Sox, 126
Méndez, José, ix, **146**
Menke, Denis, 254
Merkle, Fred, 213
Meusel, Bob, 474
Miller, Ray, 152
Miller, Rick, 159–60
Milwaukee Bears, 503
Milwaukee Braves, 80, 276, 318, 509–13, 591; win Series, 2, 508, 513
Milwaukee Brewers, 132, 450–56, 462, 495, 574; in Series, 112, 331
Minneapolis Millers, 201, 324
Minnesota Twins, 119, 234, 243, 280, 303, 331; in Series, 76, (win) 152, 498
Miñoso, Minnie, 79, 90, 205
Mitchell Kernels (South Dakota), 228
Mize, Johnny, **233**
Molitor, Paul, **331,** 453–54
Monday, Rick, 128
Montgomery, Bob, 159
Montreal Expos, 191, 562, 571, 592
Moore, John, 400
Moore, Red, 244
Morgan, Joe, 240, **278,** 297, 331, 402, 553; quoted, 250–57, 284, 440, 590
Morgan, Tom, 7
Moriarty, George, 67, 222
Moss, Dick, 562
Mungo, Van Lingle, 428, 567
Munson, Thurman, 8, 160–61, 403, 571
Murcer, Bobby, 128

Murff, John "Red," 4–5

Murnane, Tim, 308

Murphy, Johnny, 74

Murray, Eddie, **243,** 345–46, 587

Musial, Stan, 280, **427,** 458, 512; quoted, 233, 276, 465, 554

Mutrie, Jim, 231

Nee, Johnny, 171

Nehf, Art, 575

Nettles, Graig, 307, 403, 571

Newark Co-Pilots, 450, 451

Newark Eagles, 120, 244, 324, 386, 432, 492

Newcombe, Don, 14, 509

Newhouser, Hal "Prince Hal," **115,** 269

Newnan Cowetas, 218

New York Cubans, 90

New York Giants, viii, 10, 13, 22, 33, 58, 67, 70, 93, 111, 136, 167, 185, 198, 200, 213, 218, 233, 238, 261, 312, 316, 353, 364, 388, 412, 427, 504, 510–12, 519, 524, 540; as "Gothams," 83, 164; in Series, 40, 55, 266, (win) 103, 207, 226, 432, 485, 582, 585

New York Highlanders, 21, 312, 519

New York Lincoln Giants, 136, 146, 194

New York Mets (Metropolitans), 4–6, 58, 116, 119, 124, 128, 135, 251, 491, 580, 593; win Series, 7, 191, 404, 447, 587

New York Yankees, 46, 48, 63, 67, 74, 84, 87, 88, 104, 111, 168, 208, 220, 222, 233, 251, 255–56, 301, 374, 444, 474, 479, 513, 528, 554, 558, 582, 591; Babe Ruth sold to, games with, Red Sox, *see* Boston Red Sox; in Series, 17, 207, 226, 566–67, 570–71, (win) 2, 34, 150, 179, 185, 194, 203, 282, 288, 324, 332, 385, 473, 516, 557, 571, 577, 579, 580

Nichols, Kid, **39**

Niekro, Joe, 128

Niekro, Phil "Knucksie," **128**

Niggeling, Johnny, 182

Northrup, Jim, 546

Oakland Athletics (A's), 8, 107, 132, 140, 250, 257, 278, 439,

557; in Series, 394, 571–72, (win) 104, 112, 186, 251, 255, 303, 592

Oakland Oaks, 185

O'Connell, Legs, 36

O'Connor, Jack, 409

O'Day, Hank, **595**

O'Farrell, Bob, 172

Oliva, Tony, 108

O'Malley, Peter, 567, 569

O'Malley, Walter, 200, 584, **601**

O'Neil, Buck, 73, 120, 131, 136, 139, 144, 192, 500

O'Neill, Steve, 34

O'Rourke, James, 58, **410**

O'Rourke, John and James "Queenie," 410

Ott, Mel, 179, 495, **524**

Owen, Marv, 424

Owen, Mickey, 511

Pagán, José, 200

Page, Ted, 315, 334, 476

Page Fence Giants, 292

Paige, Satchel, **73,** 120, 126, 131, 136, 139, 143, 198–99, 244, 258, 315, 334, 420, 482, 492; quoted, 476, 497

Palmeiro, Rafael, 347, 393

Palmer, Jim, **107,** 342, 454, 587

Parker, Dave, 257

Pendleton, Jim, 512

Pennock, Herb, **34,** 126, 168

Pérez, Tony, **240,** 250, 255, 256, 402

Perry, Gaylord, **111,** 306, 328

Pesky, Johnny, 160, 361, 398–99, 402, 403, 447

Peters, Hank, 342

Petrocelli, Rico, 159

Pfeffer, Fred, 51, 520

Phelps, Brad, 333

Philadelphia Athletics (A's), 22, 25, 26, 29, 30, 34, 39, 64, 168, 216, 261, 284, 315, 321, 374, 415, 416, 419, 444, 567, 583; in Series, 13, (win) 40, 312, 574

Philadelphia Giants, 90, 194, 292, 503

Philadelphia Nationals, 17

Philadelphia Phillies, 17, 52, 88, 99, 108, 124, 136, 216, 254, 256, 291, 304, 315, 409, 462, 473, 491, 549, 566–68, 581, 590; as "Quakers,"

54; in Series, 278, 331, 346, (win) 119, 327

Philadelphia Stars, 120, 334

Philley, Dave, 252

Piazza, Mike, 188

Piniella, Lou, 402–3, 571

Pinson, Vada, 250, 553

Pipp, Wally, 208

Pittsburgh Alleghenys, 222, 338

Pittsburgh Crawfords, 180, 315, 334, 476, 482

Pittsburgh Keystones, 503

Pittsburgh Pirates, viii, 21, 33, 46, 60, 124, 150, 172, 214, 220, 222, 266, 272, 288, 301, 311, 361, 381, 382, 394, 406, 431, 435, 514, 574, 582, 586; in Series, 308, 440, 473, 536, (win) 122, 152, 265, 350, 440, 473, 541, 578

Plank, Eddie, **25,** 146

Pocatello Chiefs, 569

Podres, Johnny, 546

Pollock, Syd, 510–11

Pompez, Alex, **600**

Posey, Cumberland, 126, 143, 192, 324, 503, **600**

Potter, Nelson, 591

Powell, Boog, 107, 587

Preston, Walter, 308

Providence Grays, 18, 364, 462

Puckett, Kirby, **498**

Pujols, Albert, 180

Quinn, Jack, 419

Quinn, Joe, 412

Quisenberry, Dan, 112

Radbourn, Charles, **18**

Radcliffe, Ted, 482

Ramos, Bombo, 99

Ramos, Pedro, 479

Redding, Cannonball, 194

Reemes, Jackie, 136

Reese, Pee Wee, **381,** 488, 492

Reiser, Pete, 488

Remy, Jerry, 402

Renfroe, Othello, 244

Reynolds, Allie, 294

Rhyne, Hal, 526

Rice, Jim, 150, **447;** quoted, 398–405

Rice, Roger, 399, 403

Rice, Sam, **535**

Richards, Paul, 150, 251–52

Richardson, Bobby, 203
Richardson, Hardy, 213
Richman, Milton, 84
Rickey, Branch, ix, 211, 233, 432, 435, 584, 592, **598;** quoted, 115, 228, 270, 428, 488, 585
Righetti, Dave, 140
Rigney, Bill, 202, 237
Riley, James, 143, 503
Riley, Lee, 568
Ripken, Bill, 393
Ripken, Cal Jr., 297, **393,** 587; quoted, 107, 243, 342–49
Ripken, Cal Sr., 342–44, 393
Rivera, Mariano, 140
Rixey, Eppa, **52**
Rizzuto, Phil, 74, 378, **385,** 465, 577
Roarke, Mike, 149
Roberts, Robin, **88,** 237
Robinson, Brooks, 303, 307, 315, 321, **322,** 337, 345, 346, 378, 587; quoted, 152
Robinson, Frank, 250, 252, 256, 347, 492, **553,** 587; quoted, 107, 318
Robinson, Jackie, 250–52, 256, **270,** 386, 432, 476, 492, 553; breaks color barrier, ix, 73, 108, 136, 176, 180, 205, 225, 381, 482, 500, 508–9, 514–15, 585; quoted, 382
Robinson, Wilbert, 56, 353, 416, 519, **576,** 586
Robison, Frank, 412
Rodgers, Johnny, 399
Rodriguez, Alex, 348, 349
Rodriguez, Iván, 188
Rogan, Bullet Joe, 126, **131**
Rose, Pete, 9, 250, 254, 255, 256, 280, 458; quoted, 128, 240, 278
Rothrock, Jack, 266
Roush, Edd, **470**
Rowe, Jack, 213
Rowland, Pants, 68
Rudi, Joe, 112
Rue, Joe, 131
Ruffing, Red, **63,** 362, 465, 474
Ruppert, Jacob, 516, **601**
Rusie, Amos, 14, **93,** 353
Russell, Bill, 571
Ruth, Babe, viii, 17, 29, 73, 131, 168, 171, 180, 208, 266, 348, 474, **516,** 536, 567, 577; fined, 579; pitchers facing, 33, 64, 415; players compared to, 194, 198,

312; popularity of, 258, 374, 524; quoted, 539, 585; record challenged, 216, 220, 231, 486, 504, 550, (broken) 84, 318, 473, 508–9, 514; Red Sox sell to Yankees, *see* Boston Red Sox
Ryan, Nolan, xii, 25, 93, 104, 119, **135,** 343; quoted, 2–9

Saberhagen, Bret, 306
Sadecki, Ray, 238
Sain, Johnny, 492
Sakata, Lenn, 345
Sandberg, Ryne, **291**
San Diego Padres, 111, 112, 128, 297, 390, 558, 561, 592; in Series, 150
San Francisco Giants, 33, 99, 111, 119, 198, 201–4, 237, 238, 250, 251, 256, 276, 278, 485; in Series, 324
San Francisco Seals, 465, 526
Santo, Ron, **337,** 439
Santop, Louis, **194**
Santurce Crabbers, 199, 200, 204–5, 500
Saylor, Olin, 400
Scales, George, 90
Schacht, Al, 362, 540
Schalk, Ray, 45, 55, **175**
Scheinblum, Richie, 303
Schenectady Blue Jays, 568
Schmidt, Mike, 116, 291, 315, **327,** 491
Schoendienst, Red, 96, **276,** 288, 593
Schorling, John, 583
Schuerholz, John, 305, 328
Scioscia, Mike, 572
Seattle Mariners, 111, 331
Seaver, Tom, 6, 7, 13, 104, **116,** 191, 436
Seay, Dick, 324
Selee, Frank, **589**
Selkirk, George, 208
Sewell, Joe, **374**
Shannon, Mike, 203
Sheets, Ben, 573
Sherry, Norm, 76, 191
Shindle, Billy, 519
Silas, Paul, 96
Simmons, Al, **415,** 561
Sisler, George, **211,** 266
Slapnicka, Cy, 48

Slaughter, Enos, **554**
Smith, Hilton, **139,** 144, 192
Smith, Mayo, 546
Smith, Ozzie, 243, 324, **390**
Smith, Red, 549
Smith, Reggie, 159
Smith, Robert, 93
Smith, Tal, 256
Smoltz, John, 140
Snider, Duke, 176, 381, **488,** 553, 566, 584
Snodgrass, Fred, 312
Society for American Baseball Research (SABR), 22, 120
South Bend Blue Sox, 368
Southworth, Billy, **591**
Spahn, Warren, 52, **80,** 362, 435, 485, 513
Spalding, Albert, 207, **597**
Speaker, Tris, 14, 45, **460,** 470, 503, 539
Sprague, Ed, 453
Stallings, George, 311
Stanley, Mickey, 546
Stapleton, Dave, 404
Stargell, Willie, 250, **440,** 553; quoted, 76, 88, 240, 288, 439, 543
Staub, Rusty, 237
Steadman, John, 103
Stearnes, Turkey, **497**
Steinbrenner, George, 332, 444
Stengel, Casey, 39, 131, **580,** 593; quoted, 84, 179, 222, 237, 284, 416, 456, 582
Stevens, Bob, 99
Stevens, Paul, 497
Stewart, Jimmy, 254
St. Louis Browns, 18, 182, 211, 218, 228, 266, 412, 419, 500, 523; in Series, 58, 544
St. Louis Cardinals, 39, 46, 68, 103, 122, 179, 203, 222, 228, 233, 238, 297, 390, 412, 416, 427, 428, 486, 590, "Gashouse Gang," 42, 266, 424, 485, 586; in Series, 96, 578, (win) 17, 119, 149, 198, 204, 266, 275, 276, 361, 436, 455, 495, 554, 591, 593
St. Louis Giants, 482
St. Louis Stars, 476
Stobbs, Chuck, 479
Stoneham, Horace, 200, 324
Stout, Glenn, 188

Sukeforth, Clyde, 52
Sullivan, Haywood, 161
Sunday, Billy, 94
Sutter, Bruce, **149,** 150
Suttles, Mule, 194, **244,** 324, 386, 432
Sutton, Don, **132,** 454

Tanner, Chuck, 150
Taylor, Ben, and brothers Steel Arm John and Candy Jim, **246,** 482, 503
Taylor, C. I., 246, 504
Templeton, Garry, 390
Tenace, Gene, 593
Terry, Bill, **218**
Terry, Ralph, 203, 288
Texas Rangers, 2, 8, 111, 135, 152, 593
Thomas, Gorman, 454
Thomas, Ira, 146
Thompson, Fresco, 428
Thompson, Hank, 324, 500
Thompson, Sam, 469, **544**
Thomson, Bobby, 324, 512, 550
Thorn, John, 364
Tiant, Luis, 159
Tinker, Joe, 214, 265, **354,** 589
Toledo Mud Hens, 167
Toporcer, George "Specs," 17
Torborg, Jeff, 76, 135
Toronto Blue Jays, 8, 128, 590; win Series, 297, 331, 558
Torre, Joe, 6, 80, 238, 393, 439
Torriente, Cristóbal, **504**
Traynor, Pie, 262, **311,** 315, 473
Treadway, George, 519
Trebelhorn, Tom, 331, 444
Troy (New York) Trojans, 58, 164
Turley, Bob, 513

Uecker, Bob, 128
Utica Blue Sox, 491

Valentine, Bobby, 103, 573
Valenzuela, Fernando, 571
Vance, Dazzy, **46**
Vander Meer, Johnny, 185

Vaughan, Arky, **382**
Veach, Bob, 419
Veeck, Bill, 79, 220, 324, 500, 554, **599;** quoted, 73, 180, 378
Ventura, Robin, 4
Vernon, Mickey, 79
Vizquel, Omar, 297, 357, 378

Waddell, Rube, **26,** 29, 70, 530, 583
Wagner, Honus, viii, 17, 29, 280, **350,** 388, 409, 466, 561; quoted, 372, 382, 519, 583
Wakefield, Tim, 128
Walker, Harry, 554
Wallace, Bobby, **357**
Walsh, Ed, **29,** 94
Walsh, Ed Jr., 29
Waner, Lloyd, **473,** 528
Waner, Paul, 473, **528,** 578
Ward, John, 58, 231, **364**
Warneke, Lon, 591
Washington Nationals, 574
Washington Senators, 21, 79, 182, 234, 361, 364, 409, 410, 419, 479, 535; in Series, 578, (win) 10, 422, 581
Wathan, John, 306
Watson, Bob, 573
Watson, Jim, 2, 4
Weaver, Earl, 107, 342, 344–46, 349, **587;** quoted, 104, 322, 393
Weiss, George, **598**
Welch, Mickey, 58, **83,** 164
Wells, Willie, 90, 324, **386,** 432
Wheat, Zack, **416**
White, Bill, 201–2
White, Deacon, 213, **338**
White, Frank, 305
White, Sol, 292, **600**
Whitehill, Earl, 422
Whitney, Art, 51
Whitted, George, 316
Wight, Bill, 251
Wilhelm, Hoyt, **103,** 140
Wilkinson, J. L., 131, **600**
Williams, Billy, 324, **439**

Williams, Dick, 112, 150, 280, 562, **592**
Williams, Smokey Joe, 131, **136,** 146, 194, 482
Williams, Ted, 73, 180, 233, 237, 275, 321, 398, 403, **420,** 443, 447; hits .400, 304, 328; quoted, 79, 103, 280, 361, 424, 519; struck out, 124; "Williams Shift," 367
Willis, Vic, **122,** 350
Wills, Maury, 422, 436
Wilson, Big Chief, 214
Wilson, Hack, 73, 435, **486**
Wilson, Jimmie, 272, 591
Wilson, Jud "Boojum," 126, 136, **334,** 482
Wilson, Mookie, 404
Winfield, Dave, 9, 331, 444, 450, **558**
Wise, Rick, 119
Wolff, Roger, 182
Wood, Joe "Smoky Joe," 93, 136
World Series. *See individual teams*
Wright, George, 14, **596**
Wright, Harry, **597**
Wynn, Early, **79,** 84, 87
Wynn, Jimmy, 254

Yancey, Bill, 372
Yastrzemski, Carl "Yaz," 158–59, 161, 162, 398, 401–3, **443;** quoted, 188, 447
Yawkey, Tom, 405, **599**
Yeager, Steve, 571
York, Rudy, 220, 275
Young, Cy, **14,** 22, 93, 94, 214, 258, 412
Youngs, Ross, **540**
Yount, Larry, 450, 451, 453
Yount, Robin, **495;** quoted, 331, 450–57

Zeek, Al, 303
Zimmer, Chief, 14
Zimmer, Don, 403
Zorrilla, Pedro, 198, 200, 201, 205